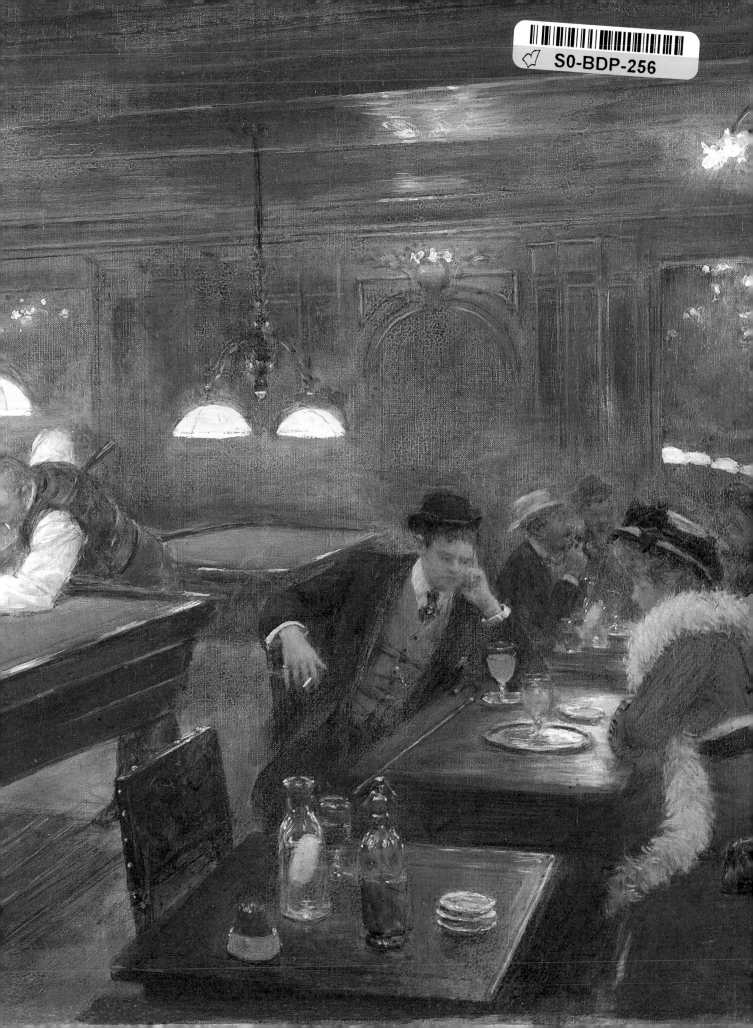

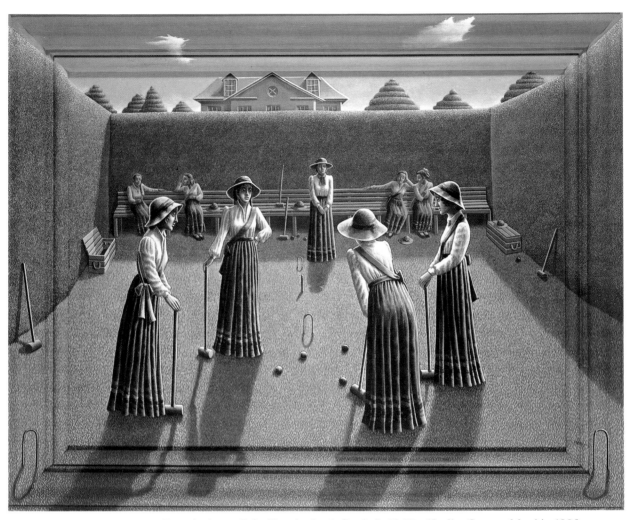

Frontispiece: *P.J. (Pamela June) Crook (b.1945). 'Ladies Croquet Match', 1986. 45in. x 55in.* The Portal Gallery, London.

SPORT
and the
ARTIST

Volume 1: Ball Games

Mary Ann Wingfield

Antique Collectors' Club

ISBN 1 85149 071 X

Published for the Antique Collectors' Club
by the Antique Collectors' Club

British Library CIP Data
Wingfield, Mary Ann
Sport and the artist.
Vol. 1: Ball games
1. Visual arts. Special subjects. Sports
I. Title
704.9′49796

Printed in England by
the Antique Collectors' Club Ltd.
Woodbridge, Suffolk

Contents

Colour Plates

Acknowledgements

A book of this complexity could never have been undertaken without the unstinting help and encouragement of a great number of people.

In particular, I would like to thank all art galleries and auction houses that have kindly contributed material. I would also like to extend a special word of thanks to my long suffering secretaries, Karen Young, Georgiana Hayward and Pam Waley-Cohen; to Mr. Hugh Kelly for his kind help with photographs; Mr. Greg Way for his help with reference books; Brigadier Peter Thwaites and Mr. I.D. Wright.

Every reasonable effort has been made to trace the ownership of copyright material and to make due acknowledgement.

The following people have generously given their expertise, advice and, above all, their time to check the accuracy of my text:

Introduction. Professor E.J. Evans, Department of History, University of Lancaster; Dr. A. Mason, Senior Lecturer, Centre for the Study of Social History, University of Warwick. ***American Football.*** Colin Jarman, Chief Executive, The Budweiser League, London; David Wakefield, National Football League, New York, USA. ***Association Football.*** David Barber, Press Officer, Football Association Ltd., London; Richard Humphreys, Tate Gallery, London. ***Billiards and Snooker.*** Norman Clare, acknowledged historian of the Billiards and Snooker Control Council; Jocelyn Wingfield. ***Cricket.*** Stephen Green, Curator, Marylebone Cricket Club; G.A. Beldham, son of G.W. Beldham; Andrew Piercy. ***Croquet.*** B.C. MacMillan, Secretary, Croquet Association, Hurlingham Club, London. ***Curling.*** Sheriff D.B. Smith, author of *Curling an Illustrated History*; Royal Caledonian Curling Club, Edinburgh. ***Eton Wall and Field Game.*** Roderick P.C. Forman, Eton College; P. Quarrie, College Librarian and Keeper of College Collections, Eton College. ***Fives.*** Roderick P.C. Forman, Eton College; G.A. Tiffin, Rugby School; Alastair MacKenzie, historian of Rugby Fives, St. Paul's School, London. ***Golf.*** David Stirk, author of *Golf in the Making*; Robert Burnet, Historian, Royal and Ancient Golf Club of St. Andrews, Fife. ***Field Hockey.*** Nevill Miroy, Editor, *Hockey Digest*. ***Street Hockey.*** Alistair Gordon, Chairman of British Street Hockey Association, London. ***Lawn Bowls.*** J.F. Elms, Past Secretary of the English Bowling Association; Donald Newby, Bowls Correspondent, *Daily Telegraph* and Editor of *Bowlers Times*. ***Lawn Tennis.*** Lance Tingay, tennis historian; William Stephens, Secretary, Queens Club, London; Rex Bellamy, author and sports correspondent. ***Netball and***

Basketball. Mark Hannen, Information Officer, English Basketball Association, Leeds; Mary Thomas, National Technical Assistant, All England Netball Association Ltd., London; The Naismith Memorial Basketball Hall of Fame, Springfield, Massachusetts, USA. *Polo.* Major J.N.P. Watson, author of *The World of Polo Past and Present*; Mrs. J. Duke-Woolley, Secretary, Hurlingham Polo Association, Midhurst, West Sussex; D.F.A. Trewby, Secretary, Hurlingham Club, London. *Water Polo.* Derek Newbold, water polo referee in international competition; Austin Rawlinson, Past President of the Amateur Swimming Association; Fédération Internationale de Natation Amateur (FINA), Lausanne, Switzerland. *Rackets.* John Thompson, Rackets Master, Marlborough College; Lord Aberdare KBE, author of *The Willis Faber Book of Tennis and Rackets*; I.D.W. Wright, author of *One Hundred Years of Squash Rackets*. *Squash Rackets.* Ian Wright, Archivist, Honorary Custodian of Squash Rackets Association; Mrs. S. Powell, (*née* Susan Noel), author of *More About Squash Rackets* and *The Sportswoman's Manual* and former Ladies Champion, 1932, 1933 and 1934; Rex Bellamy, author and sports correspondent; R.I. Morris, Chief Executive, Squash Rackets Assocation. *Real Tennis.* Lord Aberdare, KBE; Henry Wollaston, President of the Royal Tennis Court, Hampton Court Palace; Christopher Ronaldson, former World Champion 1981-86; Roland Bossard, Secretaire de Documentation, Ministère de la Culture, Musée National du Château de Versailles, France. *Rugby Football.* John V. Smith, Past President of the Rugby Football Union; D.E. Wood, Secretary of the Rugby Football Union; Mrs. P.J. Macroy, Librarian, Rugby School.

Foreword

By Morys Bruce, KBE, PC, 4th Baron, Lord Aberdare, Chairman of the Football Trust, President of the Tennis and Rackets Association and President of the British Association of Physical Training.

This is the first of three books on Sport and the Artist and is concerned with ball games. It fills an existing gap in the literature of sport by recording various ways in which games have been portrayed in paintings and prints. Those of us who for many years have been collectors of sporting pictures in one field or another have cause to be very grateful to Mary Ann Wingfield, who bears a name greatly honoured in lawn tennis, for this achievement. She has already spent five years in painstaking research (and more lies ahead before the final two volumes are completed) and in order to ensure the accuracy of the text she has had it checked by leading authorities on each game. The result is a book that deserves its place in the libraries of all lovers of sport.

Introduction

Whilst the research for this book has often been frustrating and inevitably time consuming, it has become one of the most absorbing occupations through which I have been able to draw certain conclusions about the development of sport and its relationship to art during a period of immense social change in Britain.

Sporting art is a term used to describe a form of art which depicted the field and blood sports which were so popular from the seventeenth to the nineteenth centuries and which were almost uniquely part of the British heritage. More recently the term has also embraced the newer sports, many of them ball games, which include Rugby, polo and lawn tennis. Paintings of these subjects have recently achieved high prices in the salerooms, which has perhaps helped to establish them in the public eye, but to the purists they remain 'new' and do not fit the traditional image. In this book we shall see how each sport evolved and how the relationship between art and sport grew or did not. While it still remains perhaps for an historian of merit to explore this intriguing subject in depth, for sports and games are social activities of historical importance, this book may have made some small attempt to bridge the gap. By the twentieth century the relationship between sport and art had changed dramatically, brought about by 'A mighty revolution which has taken place in the sports and pastimes of the common people', as William Howitt wrote in *Rural Life, 1840*. In order to understand the 'mighty revolution', it may be helpful to take a brief look at the background.

From man's earliest beginnings, the chase has always been important; originally an occupation to obtain food, later it became a sport pursued relentlessly by royalty and the aristocracy alike. The peasants, who were seldom permitted to hunt on their own account since the great lords guarded hunting rights with care and great ferocity, turned to games like football as an alternative outlet for their energies and until football became organised in the mid-nineteenth century, it remained one of the most vicious of all games. Football was included in the list of banned sports which operated from 1361 and continued with varying degrees of enforcement until as late as 1845. Indeed for several hundred years the main objections to popular football stemmed from the concern for public order. According to Harold Perkin in *The Origins of Modern English Society 1780-1880* (published in 1969): 'Between 1780-1850 the English ceased to be one of the most aggressive, brutal, rowdy, outspoken, riotous, cruel and bloodthirsty nations in the world' and became instead 'one of the most inhibited, polite, orderly, tender minded, prudish and hypocritical.' This change was not confined within the seventy year period indicated by Perkin; it had begun before 1780 and continued after 1850 forming part of a long term process. Nor did human nature change

dramatically; the rowdy, riotous, aggressive instincts were merely repressed in favour of the image of respectability and awaited opportunities to reassert themselves. It could be said that when the need to fight for survival is removed, as in times of peace and affluence, and outlets for physical sports are reduced to that of spectator participation, men sometimes turn to crime and hooliganism to satisfy their unspent energies.

In order to present the background effectively I have chosen three main themes: (1) The emergence of the industrial/urban society (2) The impact of sport on the new society, and (3) The changes in sporting art.

1. The emergence of the industrial/urban society

The Industrial Revolution was the term used by the German socialist Friedrich Engels (1820-1895) in 1844, to describe the radical changes that took place in Britain between 1730 and 1850, the effect of which was to transform a mainly agricultural country into one that was predominantly industrial. It was preceded by a consumer boom in the eighteenth century and came about as the result of a number of circumstances deep rooted in earlier centuries. The Industrial Revolution was fully established by the end of the eighteenth century and effectively changed the class structure which had survived so long in Britain.

A number of famous landowning families were created as the result of successful careers and fortunes made in the City of London. A typical example was that of Sir Peter Delmé (1667-1728), of French Huguenot descent; knighted on the accession of George I, Delmé was Governor of the Bank of England (1715-17) and Lord Mayor of London in 1723. His daughter, described as 'the great fortune in the City', married Lord Ravensworth in 1733, and his son acquired large estates in Hampshire and was painted, with his hounds in 1738 by the equestrian artist James Seymour (c.1702-1752). Lady Betty Delmé and her children were superbly painted by Sir Joshua Reynolds, a sure sign of arrival for this family.

As late as 1900, landowners still exercised decisive influence in the government of Britain at central and local levels; that influence was nowhere stronger than in the army where, despite administrative reforms passed in the wake of the chastening experience of the Crimean War (1854-1856), an overwhelming number of commissions went to the sons of landowners, expensively educated at the country's leading public schools. The new industrial capitalists, destined to attain great social and political influence, began to replace the country squires as the ruling class and related changes took place in all aspects of social life — in art, leisure, politics, religion, literature and morals. Sports and games flourished under the influence of patrons and their money, whilst sports and games which did not appeal, did not. It followed also that if a sport was not pursued by the influential, then commissions for paintings of that subject were extremely rare.

The population grew rapidly over a very short period of time. In 1801 the first modern census revealed a population of 10,500,000 for England, Scotland

and Wales; by 1851 it had increased to 21,000,000 and in 1901 to 37,000,000. During Queen Victoria's reign (1837-1901), the population had therefore doubled with a similar increase in Western Europe and North America. In the late seventeenth century, more than 75% of all people lived in the country, but by the end of the nineteenth century as much as 75% of the population lived in urban areas, a movement of population greatly facilitated by the spread of the railway system.

There was always a wide division between the successful entrepreneurs and the very poor workers, a situation which deteriorated until the second half of the nineteenth century. The extension of the franchise, and successive extensions, especially those between 1867 and 1918, made the voting potential of the working class a factor to be reckoned with. In 1865 out of 5,300,000 adult males there were still only 900,000 voters and the working classes were practically excluded. By 1867 the Reform Bill went some way towards the new era of democracy; by 1884 and the Franchise Bill, a further 2,000,000 voters were registered, nearly twice the number of 1867 but women were still excluded. Nevertheless, some redress had been made and by the mid-nineteenth century, state provision for the poor and the Factory Acts 'symbolised the stirring of a collective conscience'.[1]

With the benefit of hindsight, it now seems clear that the way of life of millions of people changed more dramatically in the late nineteenth and early twentieth centuries than at any other time, as indeed did the whole concept of the sport and leisure pursuits of the public. Wages showed a remarkable rise of 80% between 1850 and 1914, and food, much of which was now imported from other parts of the world (grain from America, livestock and dairy products from the Antipodes) became cheaper. These undoubted advantages paradoxically screened the deprivation and poverty which were rife at this time, a situation highlighted by the number of contemporary paintings reflecting social conditions which were exhibited by eminent artists during the 1870s and 1880s. Further disadvantages were a slowing down of business and a major crisis of confidence in arable agriculture.

2. The impact on sport of the new society

In the second half of the nineteenth century the populace, which included a greatly enlarged middle class, began to make itself felt in the world of sport. New sports, often hitherto the old sports of the working classes, such as football and Rugby, gained in popularity and the professional player made his appearance. He was still not accepted on social terms by anybody other than contemporaries from his own background, but his sporting talents were recognised and acknowledged and artists were increasingly commissioned to record professional players on canvas and paper. Professionalism grew in relation to competitive sport. Sportsmen were chosen to play on merit and not just because they had money or position (unless, of course, they had both, in which case it led to a greater conflict between amateurs and professionals —

12

a ticklish problem by no means resolved at the present day). With the birth of professionalism, the important difference between a game and a sport became less clearly defined. In general, sport had previously implied physical outdoor contest whereas games implied, with the exception of football, less aggressive pastimes. With the changing role of sport, the division became even more blurred. (This was highlighted by a fascinating argument recently (*Sunday Express,* 27.9.1987) between an Insurance Company and the owner of a stolen snooker cue. The Insurance Company paid for the loss of a pair of golfing shoes stolen at the same time and insured under the sportsman's special policy for sporting gear but refused to pay for the cue on the grounds that it did not consider snooker to be a sport and therefore the cue was not sporting equipment. The former World Snooker Champion, Cliff Thorburn was reported to say 'Rubbish, of course snooker is a sport. One man plays against another head to head and only one wins. If that is not sport, what is?')

Between the 1860s and the First World War, sports and games developed rapidly. A large number of ball games and many other sports so popular today owe their development or transition to recognisably modern forms, to rapidly growing middle class influences of this period including bicycling, polo, croquet, pigeon racing, squash, lacrosse and golf. To this period also belongs the highly important role of the public schools and universities in influencing and encouraging sport. The popular belief that the English athletic sports system was originally due in large measure to the excellent Dr. Arnold (headmaster of Rugby School, 1795-1842), is not borne out by fact. A moral and educational reformist, games did not hold a strong attraction for him and his most positive action was to watch passively the boys on Big Side. In any case, the era of compulsory games and sports in public schools took place after his death, between the 1840s and 1903, when contest was still defined in physical terms, and not in mental ability.

Two World Wars largely demolished the remaining social barriers but unlike the period after the Second World War which saw high inflation and heavy taxes, the period after the First World War saw little inflation after the collapse of prices in 1920. After 1929 prices fell and the living standards for those in work rose substantially in the 1930s due to deflation. One result of the increase in working class purchasing power was that sport and leisure gradually became more readily available for everyone. The urban world expanded and the countryside disappeared with alarming rapidity until environmental considerations produced some cautionary, but not always effective legislation between the Wars. After the Second World War, landowners who had survived the agricultural crisis began to switch their financial holdings into industry and commerce but the transition was slow; their education had been in land culture and not in an urban based economy.

'The man in the street' wanted the sports and games that he knew and understood like football, bar billiards, greyhound racing, snooker and bowling. During the 1950s and 1960s, many more sports became international

and the 'man in the street' who could afford to travel, discovered more sophisticated sports like skiing, a sport which has become widely and rapidly popular in the second half of the twentieth century. The most successful sports from the spectator's point of view are those with which the viewer can identify and understand. It therefore stands to reason that expensive or complicated games like polo and real tennis have had, until recently with the spread of television, less popular spectator appeal than for example football and snooker.

3. The changes in sporting art

During the twentieth century sporting art in general stagnated. The rich patrons, whose power had derived primarily from the ownership and control of land, and on whom for so long sport and sporting art had depended, were a disappearing breed. The numerous magazines that had provided a talented band of sporting illustrators with their bread and butter from the 1880s to 1918 were on the decline and photography on the increase. This sorry state of affairs caused *The Connoisseur* magazine to comment on 15th March, 1922: 'Apart from horse racing, our national sports and past-times do not seem to have made much appeal to artists, partly no doubt because only in a few cases do such contests lend themselves to pictorial treatment...' Action photography of sporting scenes began with the well-known pioneers such as G.W. Beldham (1868-1937) who gave this previously static art form a new dimension. Sporting paintings and sporting photographs are complementary yet two separate art forms; this was not apparent earlier in the century when it was feared that photography would threaten the existence of sporting art. Photography has since come to be regarded as a necessary adjunct to artists to remind them of the positioning of sportsmen in action.

Except for equestrian art which produced some outstanding artists between the wars, very little sporting art was produced between 1914 and 1960. Blood sports enthusiasts during this period found that they were increasingly defending a system which, while part of their rural heritage, was not understood or even wanted by the new urban dwellers. Sporting art, already in the doldrums, reached its lowest point in the late 1940s. In an effort to reverse the situation, Mr Philip James, Art Director of the Arts Council called for public and official institutions to come forward and replace private patronage to encourage artists to play their part in the decoration of public buildings 'and all the many places in which we congregate for one purpose or another'. The response of artists to a national football painting competition launched in 1953 fully justified Mr James's request. Unfortunately the public were not yet ready for football and the ensuing touring exhibition, seen by 85,000 people, caused one eminent curator to comment 'It irritated those that knew about football and failed to satisfy those that knew about art.'

By the late 1950s, sport had become a large industry, helped by improved means of travel and communication which of course included television. Sport was increasingly funded by commercial companies hoping to attract the

millions of sports followers by publicity through the growing channels of broadcasting and television. New paintings of different sports began to be commissioned by Sports Associations and sponsors, but the demand from the USA in the late 1960s and early 1970s for eighteenth and nineteenth century British paintings of traditional rural sporting scenes sent prices soaring and rekindled interest. The demand also sent impoverished British landowners, teased by high inflation and taxes, scurrying to the auction houses with forgotten treasures retrieved from lofts where they had gathered dust during the wilderness years (a phenomenon noted by the witty Nöel Coward in his song, 'The Stately Homes of England'). By the early 1980s, the demand for traditional sporting art was high and so were prices. Equestrian art for this period had enjoyed considerable patronage which meant that twentieth century purchasers could afford to discriminate with a greater choice of pictures but paintings of other sports like fishing, cricket and shooting were in less plentiful supply with prices predictably higher.

The 1980s saw an increasing public demand for twentieth century art from all schools, but where was contemporary British sporting art? Few of the newer sports had been painted during the first half of the century since few had been commissioned. In particular, there were virtually no paintings of any of the court games such as fives, badminton, squash, basket and netball, rackets, real tennis and even lawn tennis had suffered, possibly from the limited facilities of spectator viewing which had not helped to promote and popularise them. The sports scenes that had been painted, certainly during the 1920s and 1930s began to reach very high prices reflecting the specialist demand for these subjects. While the influential (more likely today to be celebrities in show business than the landed gentry) still wield enormous power in the fortunes of our leisure industry, increasingly it is the power of the populace that dictates the direction of many of our leisure and social activities.

It now seems apparent that there is a large public demand for paintings of most sports. Why were so few sporting paintings produced during the earlier twentieth century? Were there few patrons to commission them? Was it perhaps that artists no longer waited for commissions but struck out on their own, selling their paintings direct to the public? In view of the experience of the football exhibition in 1953, did a gulf exist between the art establishment and popular sport? Was it more likely that until sport became big, and therefore serious business, it could not be considered a subject of sufficient importance to merit the talents of dedicated artists? Whatever the solution, and perhaps there is no single answer, there is still much confused thought about this form of art. With the role of sport now secure as an important leisure industry and the public perhaps more confident in their artistic tastes, the future for a closer association between sport and art looks promising.

FOOTNOTE

1 Sir John Plumb, Neil McKendrick, John Brewer, *The Birth of a Consumer Society,* Europa Publications Ltd., London, 1982.

CHAPTER 1

American Football

The modern game of American football is an eleven a side team game and is played with an inflated oval leather ball which is aerodynamically designed to promote forward passing. This design, developed in the mid-1930s, revolutionised the game into a fast, exciting sport, with a distinct character of its own. Nowadays, it is played all over the world, and in Britain alone, there are currently 10,000 active players and 171 teams. A direct descendant of the British games of rugby and Association football, American football evolved at the Ivy League Universities of Yale, Harvard and Princeton during the 1860s. In 1876, the Intercollegiate Football Association (IFA), was founded by five colleges, forming the basis for the modern game.

The man who perhaps did more for American football than anybody else in its early days, was Walter Chauncy Camp (1859-1925); known as 'The Father of American College Football', he was a member of College Football's legislative committee from 1878 until his death. Camp drew up most of the basic rules that shaped American football in its early transformation from rugby. He substituted the rugby scrummage with the scrimmage at Yale and

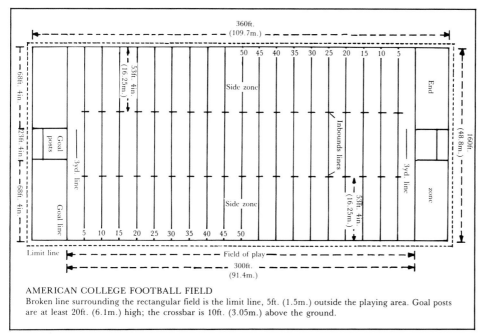

AMERICAN COLLEGE FOOTBALL FIELD
Broken line surrounding the rectangular field is the limit line, 5ft. (1.5m.) outside the playing area. Goal posts are at least 20ft. (6.1m.) high; the crossbar is 10ft. (3.05m.) above the ground.

Plate 1/1. Plan of American college football field.

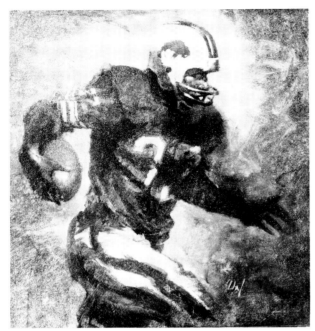

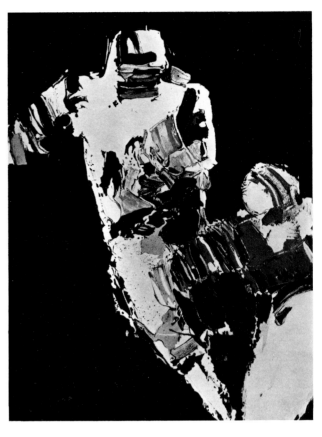

Plate 1/2. David Leffel. 'O.J. Simpson, Buffalo Bill's running back', 1974. National Football League, New York.

Plate 1/3. Pierre Doutreleau. 'Football players'. National Football League, New York.

it was he who reduced the number of players to eleven a side. Despite these reforms, the game became so brutal during the late 1880s and early 1890s, that it attracted increasingly heavy criticism. To reduce the many and often fatal injuries, the rules were again revised in 1894: the 'flying wedge' (a body of players who linked arms and hurled themselves ahead of the ball carrier to clear a path through the ranks of the opposition) was banned and the duration of the game reduced from ninety minutes to seventy. Although the 'flying wedge' had been prohibited, teams soon discovered other brutal methods of attack with tragic consequences.

Despite further efforts in 1903 and 1904, to improve the rules, the roughness continued, culminating in one of the worst seasons in 1905, with eighteen deaths reported. Urged on by the storm of protest over these figures, President Theodore Roosevelt (1858-1919), felt compelled to take action and summoned representatives from the colleges to insist that the barbarism cease. In December of that year, the sixty-two colleges who formed the Intercollegiate Athletic Association (IAA), appointed a Rules Committee, to 'clean up the sport'. Over the ensuring decade, a number of far-reaching changes were introduced: interlocked interference was banned, a neutral zone between the opposing teams was introduced, playing time was reduced to sixty minutes and assisting the ball carrier was banned. Whilst these amendments allowed a safer game, defences gained an unfair advantage, which resulted in the reduction of the length of the playing field, from 110 to 100 yards, in 1912.

In 1916, after a fourteen year break from its inaugural game in 1902, the Rose Bowl in Pasadena, California, commenced its annual pageant. The Rose Bowl is the oldest college 'Cup Final', and is played annually on New Year's

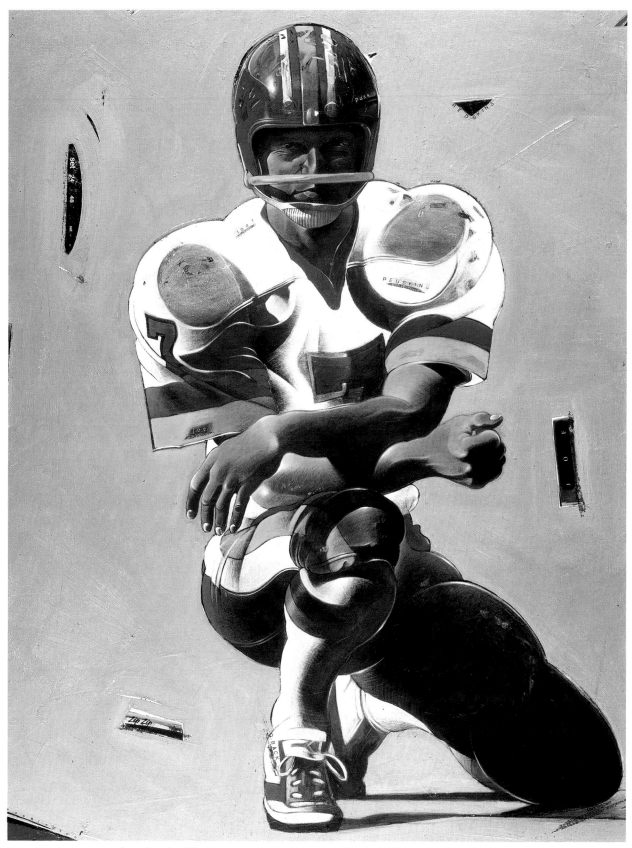

Colour Plate 1. Larry Carroll. 'Joe Theisimann', 1980. National Football League, New York.

Day, between the Champions of the Pacific Coast and the Big Ten (Midwest) Conferences. By the mid-1930s, there were a number of other 'Bowls' to be competed for, including the Sugar Bowl, New Orleans 1935, the Sun Bowl, El Paso, Texas 1936, the Orange Bowl, Miami and the Cotton Bowl, Dallas in 1937.

In 1919, the American Professional Football Association (APFA), was formed, with its origins in the professional ranks, dating back to August 1895, when Latrobe played host to Jeanette in Pennsylvania. The APFA became the National Football League (NFL) in 1922, and in 1933, the eleven teams that

formed the franchises of the NFL, were divided into two divisions, Eastern and Western.

In 1934, a full inch was taken off the girth of the football (which still resembled a rugby ball, despite all the previous rule changes from the British game), and the inflating pressure was reduced. This aerodynamic missile prompted the introduction of the forward pass (anywhere behind the line of the scrimmage) and ushered in the modern passing game.

Professional football, which has a few rule differences from college football, developed a more open, high scoring format over its college counterparts, by narrowing the hashmarks in the centre of the playing field, where the ball is returned before each new play. This gave offences more room to operate in and goal kicks a better angle.

February 8th, 1936 saw the first college draft in which the professional teams took turns to select the best college leavers. Players nowadays, have a maximum of four years in a college team. Early NFL policy, in attempting to keep competition equal, allowed the team with the worst playing record to select first in the draft. (The rival American Football League, that had been formed a year earlier, folded in 1937.) The NFL championship, played between the divisional Washington Redskins and the Chicago Bears, was first broadcast on the radio in 1940, at a fee of $2,500. A year before, on 22nd October, 1939, professional football had entered the television age, with the first television broadcast by NBC, of a game between the Philadelphia Eagles and the Brooklyn Dodgers, at a time when there were approximately 1,000 television sets in the New York viewing area.

After the Second World War spectator attendances climbed back to over 1,000,000 for the 1945 season, and pressure mounted to expand the league. The NFL, however, were wary: over forty teams had gone to the wall since the early 1920s and three rival leagues had failed because of premature attempts at expansion. The college game increasingly recognised black players and in 1946, Henry Washington, from the University of California in Los Angeles became the first black athlete to sign for a major professional team, for over twenty-five years. He was also joined by Woody Strode of the Rams and two other black players joined the newly formed All American Football Conference (AAFC).

In 1949, Hugh Ray achieved for professional football what Walter Camp had done for the college game, in making a number of changes, resulting in the amateur and professional games being 150 rules apart, despite being identical a decade earlier. Ray pressed for free substitutes, thus moving professional football into the area of specialisation and sixty minute action. The AAFC was finally merged with the NFL, in 1949, thus ending a stormy five year relationship between the two, but retained the title of National Football League.

The title games of 1958 and 1959, were struggles between the Baltimore Colts and the New York Giants; the 1958 play off changed the whole face of

Colour Plate 2. Patrick Burnham. 'American Football'. The Wingfield Sporting Gallery, London.

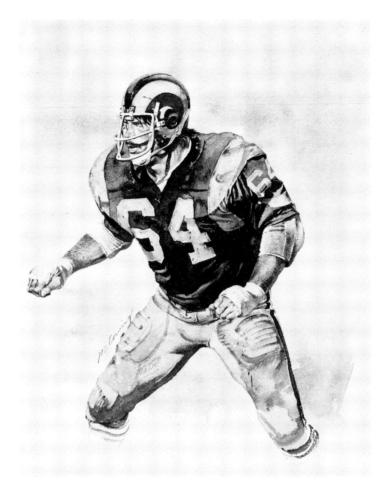

professional football, with the first 'sudden death' overtime period, which became part of American football law. The excitement generated by the game, confirmed the acceptance of professional football as a leading television attraction. By the mid-1950s the plastic helmet with its web suspension had become standard and it also became practical for players to wear face masks.

A further threat appeared on the horizon at the end of 1959, in the form of another rival league; launched by a group of Texans, the newly named American Football League (AFL), looked set to divide the clubs' college talent by offering the students staggering salaries, and to inflict heavy losses on the established NFL. The biggest threat of all came with the five year contract that the AFL arranged with the National Broadcasting Company, to televise their weekly matches for a total fee of $36,000,000, with each club to share in the revenue, thus assuring a firm financial basis for the new league.

Disaster was again averted by the merger of the leagues, which was announced at a press conference in New York on 8th June, 1966. With the presence of teams from both leagues on the same field, professional football had once again entered a new era. The new era included America's first indoor domed stadium, the Astrodome, which became known as the eighth wonder of the world (it was later said that the rent was the ninth). The 'Great Indoors', which is also the home of baseball's Astros, was the first to have luxury suites, Astroturf, an animated score board and air conditioning. The new era also included the launch of the Super Bowl interleague championship, first played for in 1967 and named Super Bowl I. Each annual Super Bowl championship has subsequently been numbered, so that in 1987, Super Bowl XX was viewed live in Great Britain by an estimated 12,000,000 people on Channel 4, and fifty-eight other countries, either live or via what is technically known as 'tape delay'.

In 1970, the league was divided into two conferences, the National Football Conference (NFC) and the American Football Conference (AFC), each comprising thirteen teams (fourteen since 1976, with the addition of Seattle (AFC) and Tampa Bay (NFC)); each conference in turn has three divisions,

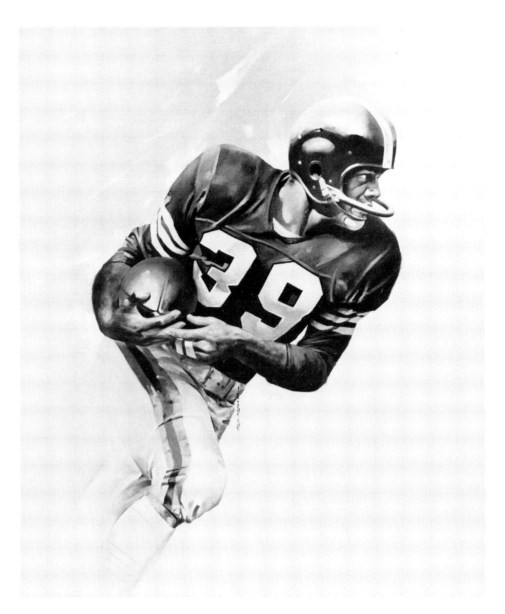

Plate 1/6. Lou Keller.
'Hugh McElhenny', 1973.
National Football League,
New York.

with the winner of each division and the second place team with the best record, conducting semi-final play offs. The winners then meet for the divisional championship and the divisional champions in the Super Bowl.

Although college football pioneered the game from which professional football has evolved, and from whose ranks virtually all professional players are drawn, it is fair to say that from the 1950s, television has been instrumental in bringing professional football to its peak of popularity as a spectator sport and the income from this source helps keep the twenty-eight teams solvent. In a 1971 opinion poll, football (particularly professional football) was rated as the favourite spectator sport of twenty-six per cent of all Americans. (Seven years before, football polled twenty-one per cent to baseball's thirty-four per cent.) Television in the 1980s reaches a record audience of 35,330,000 homes, according to the Nielsen TV index and more than 75,000,000 people watch at least one NFL game every week.

Although it may perhaps be difficult for many to comprehend, even in the 1980s, the average salary in the NFL in 1985 for example, reached $202,000

and did not include pre-season pay, post season pay or incentive bonuses, which together added another $23,000 to the average player's compensation in that year, quite apart from possible 'spin offs', which include commercials and endorsements. In 1986, NFL corporate sponsors spent more than $150,000,000 promoting their products through NFL themed promotional campaigns. The net result, according to the NFL, is quality promotion exposure, for both the NFL and its corporate sponsors, illustrating how sport all over the world is nowadays influenced by money and television.

Canadian football developed independently and while very similar to the American game, differs primarily in the size of the pitch and has twelve players to a team.

In the United Kingdom, a few matches had been played since 1910 but American football really began in the early 1980s with the first recorded game which took place at Chelsea Football Ground between the London Ravens and the USAF Chicksands in 1983. The Ravens lost 8-0 but, despite this, a great deal of enthusiasm was generated from the game and the formation of other teams was encouraged. In February 1984 an historic meeting between the existing teams took place at Bedford which led to the formation of not one, but two leagues. This immediate split in the organisation of football was to be a major stumbling block over the following seasons. The American Football League with twenty-five teams and the British American Football Federation with nine teams went their own way. These thirty-four teams paved the way for the first official season, whilst other teams sprang up during the season, with a host of others existing without enough equipment to kit a full squad.

Crowds of over 7,000 were reported at some of these games, although most teams still played out their fantasies on park pitches, with few spectator facilities. Players soon realised that the United Kingdom was not prepared for the invasion of the 'gridiron'. Expensive equipment, lack of coaching ability, unconditioned part-time players and little medical cover or experience, were obscured by an almost fanatical devotion to making the sport succeed in this country. Various meetings were held to bridge the gap between the rival leagues, but these attempts at reconciliation only spawned a third league structure in the form of the United Kingdom American Football Association.

At the beginning of the 1985 season the AFL had forty fully equipped member teams ready to play a full sixteen week campaign; BAFF membership stood at some twenty clubs, many of whom had little or no equipment at all. The 1985 season confirmed the London Ravens' supremacy. No British team had beaten them and no British team managed to break their stranglehold. The Ravens finished the season with a perfect 16-0 record. The 'Big Black Shadow' defeated the Streatham Olympians 45-7, in a one sided Summerbowl contest in front of 10,000 fans at Villa Park, Birmingham. A month later in London, the Rockingham Rebels won the BAFF Championships beating the Croydon Coyotes by 13-0. The only ray of hope that emerged from this disappointing bowl game, was the announcement of a merger between the

AFL and BAFF which created the British American Football League (BAFL) who were soon to find another, more powerful rival in Manheuser Busch when they decided to sponsor a football league of their own. When the Ravens and Olympians decided to join the Budweiser League ranks, another split was created in the sport.

The regular season opened with thirty-five faithful teams entering the BAFL season whilst seventy-one teams played under the Budweiser banner. The number of teams in the UK at this time was estimated to be over 250. In the Budweiser owned league, the Ravens were again the team to beat and they emerged bowl winners over the Olympians, the Cinderella team. The Birmingham Bulls proved too powerful for the BAFL clubs and took Summerbowl II with a crushing victory over the Glasgow Lions. Three months later, after constant wrangling, the leagues were finally united. The BAFL folded due to financial difficulties and the Budweiser League flourished, under the ownership of its member teams.

In an attempt to rectify the perpetual problem of control within the sport, the British American Football Association was formed in 1987 to act as the sole governing body of one of the fastest growing sports in the UK. Combining the various leagues, Referees Association, Coaches Association and Junior Football Associations, the BAFA has gone some way to settling old problems. Under its auspices the Great Britain national team qualified for the European Championships in Finland in August 1987. Two overpowering performances against the French national team saw Great Britain victors by an aggregate score of 92-7. This result has shown the tremendous growth of American football in the UK, after only three full league seasons. The standard of British American football is the envy of the whole of Europe, where some teams have been playing for almost a decade.

In April 1987, the second Budweiser League season commenced with the whole future of the sport in the balance. The enthusiasm, drive and committment are all still there, but the sport sorely lacks any definite format and the required depth of coaching, training and medical back-up necessary to convert the gridiron craze into a permanent reality.

American football, perhaps more than any other sport, emphasises the difference in attitudes in the way the Americans and the British view the sports industry. American priorities of expenditure, drive and enthusiasm include a high proportion of each for sport. In Britain the idea of sport as a major industry is comparatively recent. The same differences extend to sporting paintings; contemporary paintings of American football find a ready market in the USA, whereas football art in Britain is not so readily acceptable, stemming perhaps from preconceived ideas of tradition. There are signs that the tastes of the British public are widening; who could fail to admire the lithe and colourful American footballers as they leap towards the ball or be unmoved by the drama, action and colour combined to illustrate figure painting at its most vibrant and lively?

CHAPTER 2

Association Football

Long before Julius Caesar (c.101-44BC) and the Romans brought their game of harpastum to Britain, football was being played in China as Tsu Chü (Tsu to kick with the foot and Chü a stuffed leather ball). This evidence is documented in the history of the Han Dynasty covering the period 206BC-AD25 where Tsu Chü or football played an important part in military training. The game was held in such high regard that one player was promoted General of the Army for his football skill only to later lose an eye playing an early form of polo. For this carelessness he lost his job as well, but was later appointed President of the Board of Public Works as some small consolation. According to Li Yu (AD50-130), the game of football suggested something rather different; he wrote: 'A round ball and a square goal suggest the shape of the yin and the yang.'

Football, called kemari, was also played in Japan some fourteen centuries ago and took place on a ground about fourteen metres square with two teams usually of eight players. In Italy, the medieval game of calcio still survives and is played in Florence between two teams of twenty-seven players in the Piazza della Signoria twice a year on the first Sunday in May and on 24th June, the feast of John the Baptist, the Patron Saint of Florence.

Whether the early game played in the British Isles owes its origins to the Roman game of harpastum or the Greek version played with a very large ball called episkyros seems uncertain, but it remains without doubt the oldest ball game in the British Isles. In England, football was played in the twelfth century at Smithfields, the fields that surrounded part of the City of London. When the game was taken into the streets in the fourteenth century it caused King Edward II (1284-1327) in 1314 to issue the first of many edicts banning the game as follows: 'For asmuch as there is a great noise in the City caused by the hustling over large balls, from which many evils may arise, which God forbid, we command and forbid, on behalf of the King, on pain of imprisonment, such game to be used in the city in future.' Neither that law, nor indeed subsequent ones made by successive kings in 1349, 1389, 1401 and the Scottish statutes of 1457 and 1491 had much effect in preventing the people playing football. Even the lure of archery put forward as a substitute by Richard II (1367-1400), who was less concerned about the noise and 'the many evils' than he was about his subjects' lack of interest in military archery practice, did not have the desired effect.

By the seventeenth century the game (most popularly played on Shrove

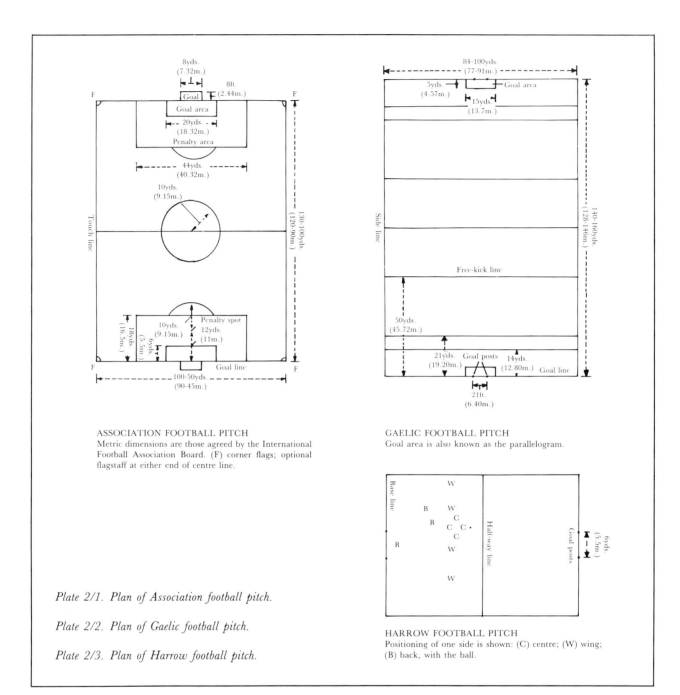

8yds.
(7.32m.)

8ft.
(2.44m.)

Goal

Goal area

20yds.
(18.32m.)

Penalty area

44yds.
(40.32m.)

10yds.
(9.15m.)

F

F

Touch line

18yds.
(16.5m.)

10yds.
(9.15m.)

6yds.
(5.5m.)

Penalty spot
12yds.
(11m.)

F

F

Goal line

100-50yds.
(90-45m.)

130-100yds.
(120-90m.)

ASSOCIATION FOOTBALL PITCH
Metric dimensions are those agreed by the International
Football Association Board. (F) corner flags; optional
flagstaff at either end of centre line.

84-100yds.
(77-91m.)

5yds.
(4.57m.)

Goal area

15yds
(13.7m.)

Side line

Free-kick line

50yds.
(45.72m.)

21yds.
(19.20m.)

Goal posts

14yds.
(12.80m.)

Goal line

21ft.
(6.40m.)

140-160yds.
(128-146m.)

GAELIC FOOTBALL PITCH
Goal area is also known as the parallelogram.

Base line

W

B
B

W
C
C C
C
W

W

Half-way line

Goal posts

6yds.
(5.5m.)

B

HARROW FOOTBALL PITCH
Positioning of one side is shown: (C) centre; (W) wing;
(B) back, with the ball.

Plate 2/1. Plan of Association football pitch.

Plate 2/2. Plan of Gaelic football pitch.

Plate 2/3. Plan of Harrow football pitch.

Tuesday) had become dangerous and extremely violent, a combination of all-in wrestling and unarmed combat in which the pursuit of the ball through the streets by an unlimited number of players became known as 'mob' football. Royal patronage by Charles II (1630-1685) who approved of the game, no doubt as 'good manly exercise', failed to have the desired effect of organising football into anything more than a brutal scrum although the match he is known to have applauded in 1681 between the Duke of Albermarle's servants and those of the Royal Household may well have been 'gentrified' for the occasion. Nor was the game in the seventeenth century confined to men, for matches took place at Midlothian and at Inverness between teams of married and single women.

By 1801, Joseph Strutt was busy compiling *The Sports and Pastimes of the People*

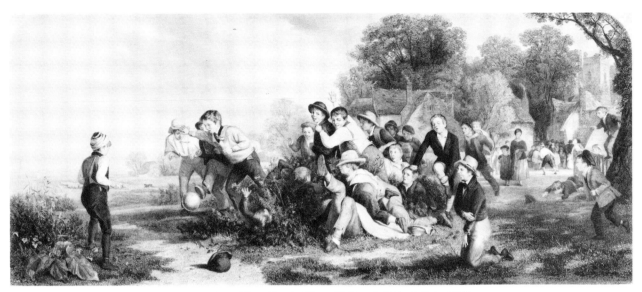

Plate 2/4. Thomas Webster, RA (1800-1886). 'Football', c.1839. Exhibited RA 1839, No.363. From a print after the painting by Henry Lemon, published by Moore McQueen & Co., 1864. British Museum.

of England and had the following to say on the subject of football: 'The abilities of the performers are best displayed in attacking and defending the goals and hence the pastime was more frequently called a goal at football than a game at football. When the exercise becomes exceeding violent, the players kick each other's shins without the least ceremony and some of them are overthrown at the hazard of their limbs.'

A type of unorganised football existed in some of the public schools at the beginning of the nineteenth century and earlier (*see* Eton Wall and Field Games). The majority of these schools were based in the south of England, with Eton, Winchester, Westminster, Harrow (*see* Plate 2/3) and Charterhouse amongst the most prominent but Rugby was to become the model from the 1830s onwards. The game of football varied from school to school, which made inter-school matches impossible to organise. Whilst this was not a major problem for the boys at school, on their arrival at the Universities it became a big problem because of the impossibility of finding a mutually acceptable form of play and the game of football lapsed in favour of hockey as the winter game. Clearly, if organised football was to be played seriously a mutually acceptable form of play and rules had to be found. In 1846, two Old Salopians, H. de Winton and J.C. Thring succeeded in forming a club at Cambridge with some Old Etonians for the purpose of playing a few football matches on Parker's Piece. The Club did not survive long but in 1848 another attempt was recorded in a letter written many years later in 1897, by Mr. H.C. Malden of Godalming, as follows:

'I went up to Trinity College, Cambridge. In the following year an attempt was made to get up some Football in preference to the Hockey then in vogue. But the result was dire confusion, as every man played the rules he had been accustomed to at his public school. I remember how the Eton men howled at the Rugby men for handling the ball. So it was agreed that two men should be chosen to represent each of the public schools and two who were not public school men, for the 'Varsity. G. Salt

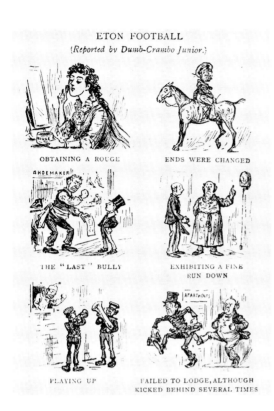

ETON FOOTBALL

(Reported by Dumb-Crambo Junior.)

OBTAINING A ROUGE ENDS WERE CHANGED

THE "LAST" BULLY EXHIBITING A FINE RUN DOWN

PLAYING UP FAILED TO LODGE, ALTHOUGH KICKED BEHIND SEVERAL TIMES

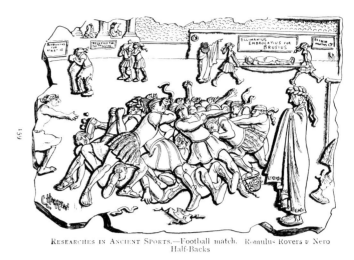

RESEARCHES IN ANCIENT SPORTS.—Football match. Romulus Rovers v Nero Half-Backs

Plate 2/5. *'Eton Football', from* Mr. Punch's Book of Sports, *1912.* Reproduced by permission of *Punch.*

Plate 2/6. *'Researches in Ancient Sports', from* Mr. Punch's Book of Sports, *1912.* Reproduced by permission of *Punch.*

and myself were chosen for the 'Varsity. I wish I could remember the others. Burn of Rugby, was one; Whymper, of Eton, I think, also. We were 14 in all I believe. Harrow, Eton, Rugby, Winchester and Shrewsbury were represented.

'We went in my room after Hall. Every man brought a copy of his school rules, or knew them by heart, and our progress in framing new rules was slow. On several occasions, Salt and I being unprejudiced, carried or struck out a rule when the voting was equal. We broke up five minutes before midnight.'

The rules that were painstakingly put together by this team became the 'Cambridge Rules' and were used by the Football Association after their formation in London in 1863 as the basis of the official rules of the game. The formation of the Football Association (FA) was not without hiccups for the public schools refused at first to join, preferring (paradoxically since it had been former public schoolboys who first sought uniformity) their own individual games. The main objection appeared to be their reluctance to accept the abolition of running with the ball and hacking (which was later the cause of the break away in 1871 by Blackheath and other clubs to form the Rugby Union). Until 1871 the main and original objective of the Association was to frame a code of laws that would embrace the best and most acceptable points of all the various methods of play under the one heading of football. It is interesting to note that of the original ten rules suggested for the government of the game, numbers 1, 3, 5, 7 and 10 have remained applicable for over one hundred years of organised football. (The colloquial term 'soccer' is derived from As'soc'iation football.)

The modern game takes place between two teams of eleven players, one of whom on each side is the goalkeeper. The ball, which is usually leather

Colour Plate 3. W.G. Morden. 'The F.A. Cup Final at Wembley, 1959', signed.
Wiggins Teape Group.

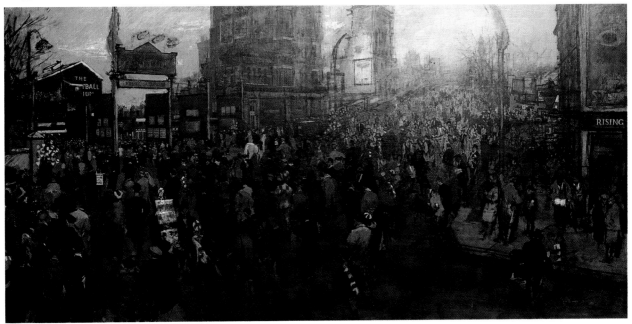

Colour Plate 4. Christopher Chamberlain (1918-1984). 'Chelsea plays Arsenal', signed. 47½ in.
x 95¾ in. Painted for the 90th Anniversary of the Football Association, and exhibited at the Football
Exhibition in 1953. Football Association Collection.

How the goal-keeper appears to the opposing forward, who is about to shoot.

And how the goal-keeper *feels* when the opposing forward is about to shoot.

covered, has a circumference of not more than 28in. (0.71m.) and not less than 27in. (0.69m.), weighs not more than 16oz. and not less than 14oz. (453g.-396g.) and the game takes place on a pitch not more than 130yds. x 100yds. (120m. x 90m.) and not less than 100yds. x 50yds. (90m. x 45m.). The pitch must always be rectangular in shape so that the length exceeds the breadth. The fundamental object of the game is for one team to kick or head the ball into the goal formed by a pair of upright posts across which is a crossbar. Each team consists of a goalkeeper, defenders, midfield players and strikers; the number of each depends on the playing system adopted by the coach. Number 1 of the FA Rules which has remained virtually unchanged since 1863 states: 'A goal is scored when the whole of the ball has passed over the goal line, between the goal posts and under the crossbar providing that it has not been thrown, carried or propelled by hand or arm, by a player of an attacking side, except in the case of a goalkeeper, who is within his own penalty area.'

The period of twenty-two years between 1863 and 1885 represents an historic phase in the growth of the Association and bridges the gap between the amateur and professional game. The social changes that took place in the eighteenth and nineteenth centuries greatly influenced both sport and its relationship to art. In no game was this seen to better effect than in football. The effect of the Industrial Revolution, pre-empted by the commercial boom of the eighteenth century, changed Britain from an economy based on agriculture to one based on industry. Between 1770 and 1900, the population not only increased dramatically, but became concentrated in those areas of the Midlands and the North where coal powered textile, iron and shipbuilding industries flourished. The resulting urban populace was unaccustomed to country ways and to the sports of the countryside, but they did understand football for, despite earlier edicts, it was one of the street games in which the people had always indulged when inevitably, the rural sports pursued by the landowners were beyond their reach. Although organised football was played and developed by the public schools and universities, it was very quickly adopted by the working people as their game.

Sheffield probably saw the greatest population growth outside London during the period 1863-1885. The Sheffield Football Club had originally been formed in 1855, largely due to the efforts of a group of Old Harrovians, based in the district, who followed this success with the formation of the Hatton Club in 1857 and the neighbouring Forest Club in 1859. The Sheffield Club was one

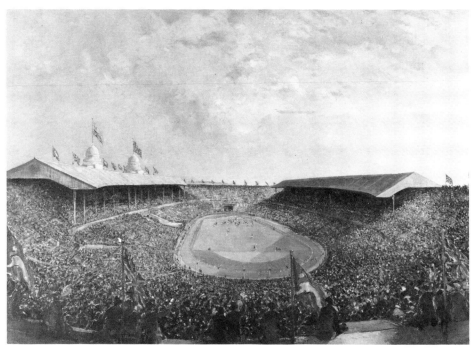

Plate 2/8. Charles Cundall, RA, RWS, RP, RSMA, NS, NEAC (1890-1971). 'Arsenal v. Sheffield United' at Wembley, signed and dated 1936. 24¾ in. x 35¾ in. Phillips.

of the first provincial clubs to seek election to the FA in 1863 and by 1867 was able to form its own Football Association which was the forerunner of the County Football Associations, later to become an integral part of the organisation in England. Meanwhile, in 1860 two matches between teams from Sheffield and London were successfully played which encouraged the FA to plan further games between county sides.

By 1870, despite some progress, the FA only had effective authority over the Southern County Clubs but in 1871 it was suggested by the newly elected Honorary Secretary, C.W. Alcock, that the Clubs be invited to subscribe according to their means towards a Challenge Cup, cost £20, to be competed for by all the Clubs belonging to the FA. This suggestion had the desired effect of capturing the imagination of Clubs throughout the British Isles, the support of which was still necessary to the successful establishment of the FA as football's authority. The final of the elimination rounds took place on 16th March, 1872 before a crowd of some 2,000 spectators at Kennington Oval between the Royal Engineers and Wanderers (formerly the Forest Club) who beat the Engineers 1-0 to become the first winners of an FA Cup competition. Within six years the number of entries for the competition had grown from the original fifteen (Royal Engineers, Barnes, Wanderers, Harrow Chequers, Clapham Rovers, Hampstead Heathens, Civil Service, Crystal Palace, Upton Park, Hitchin, Maidenhead, Marlow, Donnington School, Reigate Priory and Queen's Park Glasgow) to forty-three, the condition of entrance being membership of the FA.

New clubs were speedily formed in the industrial areas which meant that most areas had their own Football Association (Lancashire in 1878, Birmingham in 1875; Sheffield New, Northumberland and Durham and

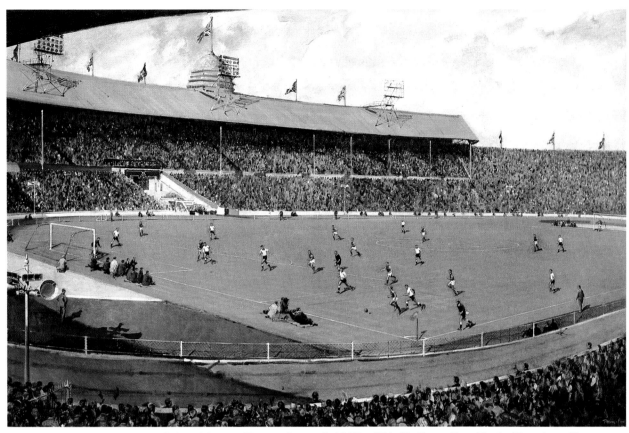

Colour Plate 5. Terence Cuneo (b.1907). 'FA Challenge Cup Final, Tottenham Hotspurs v. Burnley', signed and dated 1962. 48in. x 72in. Painted for the FA Centenary in 1963. Terence Cuneo and FA Collection.

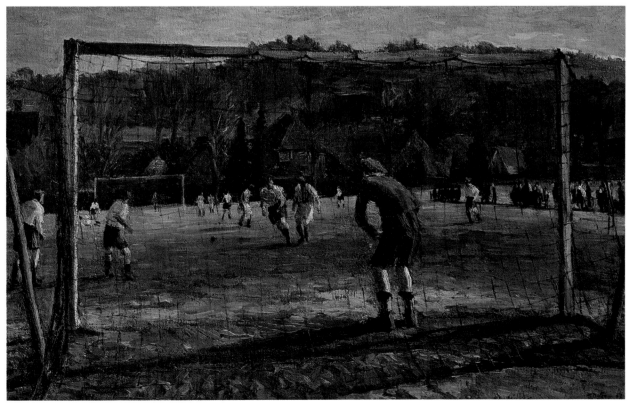

Plate 2/9. Ernest Prater (op.1897-1914). 'The Football Match', c.1913, signed. Pencil, body and watercolour, 10¾in. x 18in. This work was probably used for illustration purposes and bears the stamp of a Leeds agent, Alfred Cooke Ltd., on the reverse, dated 31st March, 1913. Bonhams.

Staffordshire followed in close succession). The newer county and district associations started their own Challenge Cups but the ultimate target always remained the FA Cup. The final of this Challenge Cup took place at the Oval until 1892 except when it was played at Lillie Bridge, Fulham, in 1873. In 1892, the members of the Surrey County Cricket Club became worried about what increasing spectator attendance, now grown to 25,000, might do to the pitch at the Oval. In 1893 the venue for the final was Fallowfield at Manchester where 45,000 spectators watched the game between Wolverhampton, founded in 1877, and Everton, founded in 1878. The final was played the following year at Goodison Park at Everton, but thereafter until the First World War the venue was moved to Crystal Palace since the London based FA considered that as the cup was theirs, the final should be played in the capital.

Along with the great wave of enthusiasm for football in the 1880s came a decline in the standards of management. The Northern Clubs became so competitive that they embarked on a policy of importing players from Scotland, of poaching from each other, and of taking underhand payments to further their progress in much the same way as in Rugby football (*see* p.324) which had led to a breakaway and the formation of Rugby League and professionalism. This issue came to a head in 1884 when first Accrington and then Preston North End were excluded from competition on the grounds that they were using professional players, i.e. players who earned their money by

Colour Plate 6. Paul Nelson. 'Village Football', signed and dated 1953. 19¾in. x 29¾in. Exhibited at the Football Exhibition in 1953.

playing football. The FA Council diplomatically decided to legalise professionalism so that a repeat of the Rugby breakaway was averted, but their decision led to the formation in March 1888 of the Football League which grew out of professionalism and which, with the growth of professional clubs, has gone hand in hand ever since. Although the Football League was intended and formed to be a national league it was some years before this intention was fulfilled. London and the south were ready for League football but unfortunately, those who governed the London FA were not and they determined to retain amateur status for their clubs, which led to a breakaway of dissenting clubs in the south who formed their own Southern League in 1894-5. The Southern League for a quarter of a century remained not only the principal professional league outside the Football League in England but almost an equal partner with the Senior League. Other countries coming later to football managed to streamline their organisation to incorporate all aspects of football into one national body but in England they still remain separate bodies with the headquarters of the Football League at Lytham St. Annes in Lancashire, and that of the Football Association at Lancaster Gate in London.

The first offical international football match took place in 1872 (before professionalism entered the arena), between Scotland and England and ended in a draw. After 1887 football found its way to Austria, Russia and Poland; the game's popularity spread to the rest of Europe from the 1890s onwards and in 1902, Austria beat Hungary 5-0 in Vienna in the first international match between non-British countries; as overseas travel was difficult, international matches were confined to neighbouring countries.

In May 1904, representatives from Belgium, Denmark, France, The Netherlands, Spain, Sweden and Switzerland met in Paris to form the Fédération Internationale de Football Association (FIFA), largely for the purpose of organising a World Football Championship. (This did not, in effect, take place until 1930 and the trophy was called the Jules Rimet Cup, after the French President of FIFA.) Noticeably absent from the meeting were representatives from the Football Associations in the British Isles who continued to hold out until 1906, when they finally joined FIFA. In 1919, after the First World War, the British Isles, France, Belgium and Luxembourg claimed to FIFA that they were not prepared to renew relationships with formerly hostile countries such as Germany, Austria and Hungary. After the 1920 Olympics, the British Isles Associations broke from FIFA for a period of four years and Ireland formed the Football Association of Ireland (FAI) in order to be readmitted to FIFA in 1923. The Football Association was quite another matter, for it was felt that as originators of the governing rules of football and as the official authority of the game for so long, they did not wish to hand their authoritative position to a larger organisation in which they would have a less powerful role. FIFA eventually agreed to the four FA proposals, one of which was that FIFA would not interfere with the rules of the FA in relation to its internal management. These four points resolved the

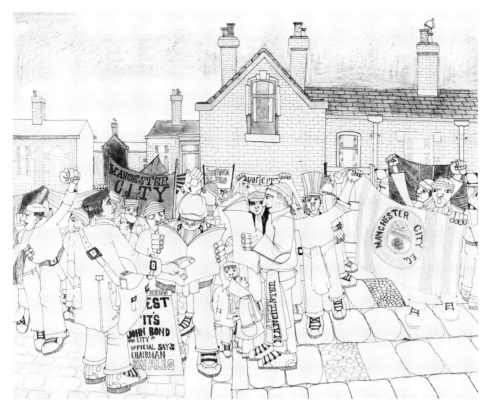

Plate 2/10. John Hopkinson (b.1940). 'Manchester City Football Club Supporters', 1980s. Ink and coloured crayons. 18 ⅞ in. x 23 ¼ in. The Wingfield Sporting Gallery, London.

way to Britain rejoining FIFA but the outstanding matter was the major issue of the definition of amateur status. The Football Association had very clear cut ideas on this issue which could not be accepted by either FIFA or the Olympic Games Committee. An unfortunately worded response from FIFA declared that: '. . . it considers FIFA as the highest authority on all Football matters, and that it cannot accept the interference or guidance of anybody else in such matters'. A clear case of noses put out of joint and many diplomatic letters were needed to smooth ruffled FA feathers.

The Olympic Committee remained firm in their decision that broken time payments could not be made to professional players to enable them to take part in the 1928 Olympics and Britain subsequently withdrew. It was not until 27th January, 1975 that the professional versus amateur issue was finally and satisfactorily resolved when it was decided to call all footballers 'players'. The days of the amateur player in top class sport were by then numbered, particularly in the case of football.

The question of women's football clubs was not raised officially, until after the death of Queen Victoria (1819-1901). The FA Council issued instructions on 25th August, 1902 to its affiliated associations not to permit matches against 'lady teams'. This had the desired effect of satisfactorily quelling any possible female uprising until 1921, when the Consultative Committee passed the following resolution: 'Complaints having been made as to Football being played by women, the Council feel impelled to express their strong opinion that the game of Football is quite unsuitable for females and ought not to be encouraged'. This resolution had to be enforced again in 1946; although the

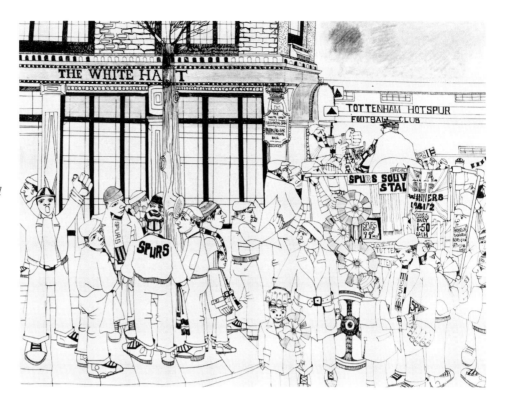

Plate 2//11. John Hopkinson (b.1940). 'Supporters Outside Tottenham Hotspur Football Club', 1980s. Ink and coloured crayons. 19¼ in. x 23¾ in. The Wingfield Sporting Gallery, London.

subject of women's football never developed into a crisis, it was an issue over which the FA always took an unwavering stand. They were equally resolute on the issue of betting and rough play, and on the whole successful in controlling this, although it had caused 'Borderer' to write in *Baily's Magazine* in 1898 '. . . that ruffianism is confined to the Turf I thoroughly deny for, unfortunately, Football, as at present carried on, is anything but an innocent amusement such as we used to think of it in our school days fifty years ago — gate money attracts professionalism, and their betting accompaniments have drawn together the rough elements of our populous towns and caused the game to become a byword of disorder and ill behaviour.'

The behaviour of our spectators and supporters has long been a problem but is perhaps beyond the control of the FA. The FA was also unhappy about their association with greyhound racing for which sport in 1927 they had reluctantly allowed their grounds to be used; greyhound racing on football grounds was officially phased out in 1946. A further controversial problem was that of Sunday football. This was not a new problem, for Philip Stubbes had written as long ago as 1583 in *The Anatomie of Abuses in the Realme of England* that football was among the 'develyshe pastimes' practised on the Sabbath day. Stubbes loathed football on a Sunday only a shade more than he loathed it on any other day in the week and it was this attitude, which had it origins in sixteenth century Puritanism, which became incorporated into Rule 25 of the FA: 'Matches shall not be played on Sundays within the jurisdiction of this association. . .'

From the late 1920s to the outbreak of the Second World War standards of play in Britain had not kept pace with that of other countries and the withdrawal of the FA from FIFA was perhaps the main reason for what amounted to stagnation. International play was resumed after the war; football had been developing rapidly in many countries all over the world, and steadily

growing in South America since 1886, particularly in Uruguay, Brazil and Argentina from 1902. Uruguay and Argentina made the first of their long series of matches for the Lipton Cup, presented and donated by the great sportsman, Sir Thomas Lipton (1850-1931) better known perhaps for his assocations with tea and yachting. Membership of FIFA continued to expand from fifty-one in 1938, to seventy-three in 1950 and to eighty-four in 1954 when the World Championship was held in Switzerland. Although FIFA commanded world-wide respect, it was felt that area organisations could better serve the interests of the many confederations being formed throughout the world. In 1954, therefore, the Union des Associations Européenes de Football (UEFA) was founded as well as the Asian Football Confederation in the same year, followed in 1956 by the African Football Confederation. The Confédération Norte-Centro Americano de Caribe de Fútbol (CONCACAF) followed in 1961 and finally the Oceania Football Confederation (OFC) covering Australia, Fiji, New Zealand, and Papua New Guinea in 1966. These Federations and the stronger, reconstituted Confederatión Sudamericana de Futból (CONMEBOL) have played important roles in the development of the game in recent years. In 1954 with the televising of the World Championship matches and Wolverhampton's friendly matches with Hungarian teams, the impact on the British viewing spectators was immense, and led indirectly to more competitions such as the Inter City Industrial Fairs Cup and the European Champion Clubs Cup, the brain children of a Committee which included the then President of FIFA, Britain's Sir Stanley Rous CBE (1961-1974), who did as much as anyone to bring wider understanding of the way in which football was developing outside the boundaries of the UK. He also encouraged young footballers and was influential in the decision of the FA to return with other British Associations to FIFA.

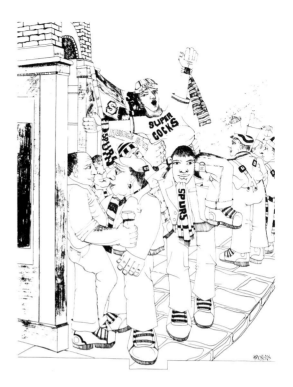

Plate 2/12. John Hopkinson (b.1940). 'Spurs Supporters', 1980s. Ink and coloured crayons. 23½in. x 19in. The Wingfield Sporting Gallery, London.

In this short history of the foundation of the modern game of football, it has not been possible to dwell at length on individual matches and personalities, or the great influence that international football has exerted on this widely played and most popular of all games. From a game of modest beginnings less than 150 years ago, football has grown into not only a multinational sport but one which has a spectator following all over the world second to none. Above all it is a sport with which the man in the street can easily identify. Any man can play football and usually has since a small boy, it doesn't cost a fortune and when his playing days are over he can watch television from his armchair or as a paying spectator at a match and play, in his imagination, every shot that is made.

ART

Early paintings of football are rare, partly because until the game became organised in the mid-nineteenth century, few people from the leisured classes played it, there was little patronage, and partly because it was officially banned for so many years owing to its apparent disruptive influence. In general, football paintings originate from the time that the game became the pastime of the leisured upper classes. The talented, but light fingered Robert Dighton (1752-1814) was an early exception and painted 'Football in the Market Place, Barnet', as part of a series of sporting watercolours.[1] Isaac Robert Cruickshank (1786-1856), is known to have drawn barrack square football scenes, from which hand coloured engravings were published by George and Charles Hunt of Covent Garden in 1820 and 1827. Cruickshank, who served as a midshipman with the East India Company until 1814, produced lively sketches of the rough and tumble football battles in the barrack square, between men of all ranks. Somewhat later that sporting enthusiast, Thomas Webster, RA (1800-1886) exhibited his 'Football Match' at the Royal Academy in 1839 (*see* Plate 2/4). During the 1880s the game attracted the talents of many top rate artists including James Aumonier, RI (1832-1911)

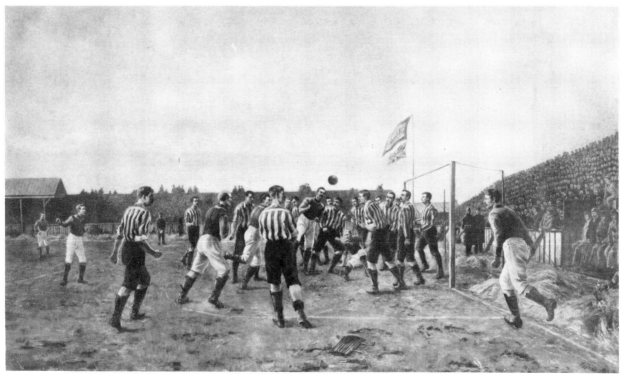

Plate 2/13. Thomas Marie Madawaska Hemy (1852-1937). 'Sunderland v. Aston Villa', signed and dated 1895. 17¼in. x 29in. Football Association Collection.

whose 'Football Match' was exhibited at the Royal Academy in 1888.

As the vogue for magazines and periodicals grew at the end of the nineteenth century, a number of artists illustrated popular stories about the game with football scenes for *The Boys' Own Magazine* and informative football accounts were featured in serious sports magazines. Although photography eventually replaced the era of black and white illustration a legacy of talented sports drawings remained. Amongst those artists who contributed football scenes were William Barnes Wollen, RI, ROI, RBC (1857-1936) who drew for *Cassell's Magazine* and Lucien Davis, RI (1860-1941) for the *Badminton Magazine,* and of course, the team of artists who worked for *Punch. Mr. Punch's Book of Sports* (*see* Plates 2/5-2/7) remains a treasure trove of sporting drawings featuring amongst other games, football, rugby and the Eton Wall and Field Games, drawn sometimes wickedly, by Linley Sambourne, Phil May, Lawrence Raven Hill, F.H. Townsend, Arthur Hopkins, Frank Reynolds, Lewis Baumer and many more. The jokes are dated by late twentieth century standards (for example the cartoon of a young lady watching a cricket match who asks her companion 'By the way are they playing Rugby or Association?'), but the drawings are delightful and are accurate in the details of dress and play.

Football art in the first half of the twentieth century suffered from two World Wars and the General Strike in 1926 which reflected an overall period of poverty, discontent and insecurity. Furthermore, many of the private patrons had disappeared and had not been replaced by the sponsorship of companies and corporate bodies. Nevertheless, outstanding artists to paint football scenes during this time were Charles Cundall, RA, RWS, RP, SMA, NS, NEAC (1890-1971), whose 'Match between Arsenal and Sheffield United at Wembley in 1936' (*see* Plate 2/8) is greatly more prized today than when it was first painted, as indeed is his 'Chelsea v. Arsenal at Stamford Bridge', now in the collection of the Chelsea Football Club. Ernest Prater (op.1987-1914, *see* Plate 2/9) and Carel Weight, CBE, RBA, RWA, LG, RA (1908), were both drawn to this sport, as was Frank Gillett, RI (1874-1927) who painted the Cup Final at Crystal Palace between Southampton and Sheffield United in 1902 which ended in a draw. John Cosmo Clark, RA, RWS, NEAC (1897-1967), a painter of many futuristic sporting scenes, featured football in his series of sporting murals for the Peacock public house, Islington in 1931. The Peacock, along with Clark's murals, disappeared during the war.

In 1953, the Football Association came up with a winner of an idea. To mark their ninetieth anniversary, they staged a national competition open to all contemporary schools of British art for the best football paintings to be judged by a panel of four judges whose choice would be final. The four judges were Sir John Rothenstein, Mr. Philip James, Sir Philip Hendy and Professor (later Sir) William Coldstream and their task was by no means an easy one. To attract the artists, prizes were offered for the best work. The exhibition was the first of its kind to be held in this country and was welcomed with

enthusiasm by the press and the many sports and arts authorities alike as reported in the *Football Association Year Book, 1954/55.* In the words of the Arts Council: 'It will be generally agreed that the response of the artists on this occasion has entirely justified the Football Association's highest hopes'. Out of the 1,700 items submitted for the competition, 150 were selected for the exhibition in London in the autumn at Park Lane House, 45 Park Lane, W.1., 21st October – 7th November; the competition attracted artists of the highest distinction who worked in every kind of media including sculpture. H.R.H. Princess Alice, Countess of Athlone, opened the exhibition which was attended by a large number of guests. After the exhibition closed in London, a tour was arranged with the co-operation of the Arts Council to thirteen provincial centres.

The question that inevitably follows such an artistic triumph must be that if this could be so successfully achieved for sporting art by the Football Association, why could not the same criteria be applied to other sports? In 1962, the artist, Terence Tenison Cuneo, RGI, PIPG (b.1907), was commissioned to paint a scene from the FA Challenge Cup Final between Tottenham Hotspurs and Burnley to commemorate the centenary of the FA in 1963. This large canvas (*see* Colour Plate 5) illustrates the quality of contemporary sporting paintings, but more encouragement is needed in the form of commissions and sponsorship from influential supporters of the sport, to provide opportunities for the many talented contemporary football artists to acquire a wider market for their work.

FOOTNOTES

1 In 1806 Robert Dighton was discovered to have stolen (since May 1795) a number of prints from the Cracherode Collection in the British Museum, leaving copies in their place. The unfortunate Rev. William Beloe (1765-1817), who was appointed the under librarian and keeper of printed books at the Museum in 1803, was hoodwinked by Dighton. He was accused of negligence in his duties by the Museum Trustees and discharged in 1806. Dighton went free after confessing to his crimes on a promise not to prosecute. He had been stealing for eight years, five of them prior to Beloe's appointment. Beloe, upset by this apparent miscarriage of justice, wrote 'Comparisons will infallibly be drawn between the case of the real offender who cannot be brought to punishment and that of the person on whom his dishonesty imposed and who is doomed to positive ruin'.

Plate 2/14. Henry Deykin (b.1905). 'The Cup Final at Wembley, 1951', in which Newcastle United beat Blackpool 2-0. Inscribed 'Milburn scores again, April 28th 1951'. 20in. x 26in. Henry Deykin.

The following artists exhibited at the Football Exhibition in 1953:

Acheson, Joseph (b.1918), 'Saturday Afternoon Farnham Park, Surrey', 14in. x 10½in.

Adams, Robert (b.1917), 'The Two Captains', 43in. x 67½in.

Alexander, C.J., 'Not All Glamour', etching, 7in. x 5½in.

Armstrong, John, ARA (1893-1973), 'A game in the Park', 29in. x 25½in.

Atkinson, Eric Newton, NEAC (b.1928), 'Full Time', 20½in. x 47in.; 'Club Fans', 28½in. x 21in.

Badmin, S.R., ARCA, RWS, 'Here they come! — the Valley', watercolour, 15½in. x 9½in.

Bailey, John, 'The Crowd Roars', 41in. x 29in.

Bailey, RA, 'The Cup Tie', 19in. x 15in.

Bale, Kenneth, 'The Penalty', lithograph, 24in. x 14in.

Bayes, Walter, RWS (1869-1956), 'Trajectory of a Football called Tobias', 39in. x 22½in.

Benson, Susan, 'Spectators at Stamford Bridge', 10½in. x 5in.; two pen drawings, 'Stamford Bridge Stadium', 13in. x 8in. and 17½in. x 7in.; 'Saving a Goal', etching, 6¼in. x 3½in.

Bone, Stephen, NEAC (1904-1958), 'Arromanches' 1944, 39½in. x 29½in.

Boswell, James, ARCA (b.1906), 'In the Goal Mouth', watercolour, 21in. x 15½in.

Bradshaw, B., 'Burnden Park, Bolton', engraving, 12½in. x 9in.

Bromly, Thomas, 'Footballers in the Snow', 24½in. x 29in.

Bruce, C.W., 'The Valley', 59in. x 39in.

Bullard, Paul, ARCA (b.1918), 'On the Heath', 39½in. x 15½in.

Cains, Gerald A., NDD, ATD, RWA, ADAE (b.1932), 'Saturday Taxpayers', 35½in. x 29in.

Carr, Henry, 'Here They Come!', 28½in. x 24½in.

Chamberlain, Christopher, 'Chelsea Plays the Arsenal', 1953 (*see* Colour Plate 4); 'Going to the Match', 94½in. x 46½in.;

Chart, Daphne, 'Clapham Common', 29½in. x 24½in.

Clark, John McKenzie, DA (Dundee), NDD (b.1928), 'A Shy from the Stand', pen and watercolour, 9½in. x 7in.

Critchlow, M.B., 'Craven Cottage', 23½in. x 36in.

Cross, Jack, 'The Goal', 41in. x 35in.

Cuming, Frederick, 'Football Crowd', 34½in. x 29in.; 'The Valley', 53½in. x 44in.

Cutler, Vanda, 'After the Game', wash and chalk, 20in. x 17½in.

Daniels, Alfred, RWS, ARCA, FRSA (b.1924), 'Fulham F.C.', 48in. x 31½in.

Deane, Frederick A., 'A Portrait of Frank Swift', 27in. x 35in.

De Maistre, Leroy Leveson Laurent Joseph (1894-1968), 'Scherzo', 53in. x 35in.

Dunstan, Bernard, RA, NEAC, PRWA (b.1918), 'Arsenal Scores', 41½in. x 23in.

du Plessis, H.E., 'Saturday Afternoon on Blackheath Common', 29½in. x 20in.

Durrant, Roy Turner (b.1925), 'Football, A Preliminary Sketch for an Abstract Painting', watercolour, 15in. x 11in.

Elwyn, John. ARCA, RI, AR Cam.A (b.1916), 'Sun and Snow', 47½in. x 55in.

Entract, T.H.F., 'Saturday Afternoon', watercolour, 22in. x 14in.

Eyton, Anthony, ARA (b.1923), 'Fog at St. James's Park', 43in. x 24in.

Feiler, Paul (b.1918), 'Mousehole v. Paul, Cornwall, 1953', 42½in. x 32½in.

Fishwick, Clifford, ATD (b.1932), 'Changing Rooms', 39½in. x 26½in.; 'Waterground', watercolour, 22in. x 14in.

Foldes, Peter, 'Footballers', 106in. x 82in.

Ford, R.F. Spencer, 'Raich Carter', 19½in. x 23½in.

Forrest, Eric H., 'By the Corner Flag', 40in. x 30in.

Fothergill, I.D.H., 'Local Boys', 36in. x 22½in.

Fowler, Derek, 'Wally Barnes', 44in. x 72in.'

Fox, Lilla, 'Boys Playing Football', drawing, 25in. x 17½in.; 'A Corner of Coventry City Football Ground'.

Freeth, H. Andrew, PPRWS, RA, RP, RWS, RE (1912-1986), 'Footballers in the Snow', engraving, 10in. x 6in.; 'Watford Football Club Dressing Room', 36in. x 28in.

Frost, Terry L.G. (b.1915), 'Half-Time Lemon Suckers', 35½in. x 27½in.

Galley, Roy, 'Eye Witness Report', 34in. x 19in.

Gaunt, William, 'Night Football in the East End', lithograph, 7in. x 6¼in.

Ginger, Phyllis, RWS (b.1907), 'Cliff Holton', lithograph, 11½in. x 17½in.

Goodwin, Arthur, 'Saturday Afternoon', etching, 7in. x 5in.

Grant, Alistair, RBA, ARCA (b.1925), 'Who's Wrong This Time?', 36in. x 28½in.; 'Snow at Stamford Bridge', lithograph, 12in. x 18in.

Hackney, Arthur, VPRWS, RE, ARCA (b.1925), 'Spectators returning Home after Port Vale v. Accrington Stanley', watercolour, 27in. x 14in.

Hart, Dick, 'Football Players', 46½in. x 31in.

Hartwell, William, 'In the Goal Mouth', watercolour, 11½in. x 16½in.

Hewison, William, NDD, ATD, MSIA (b.1925), 'Final Whistle', watercolour, 15in. x 19in.

Hewitt, Geoffrey, 'North-Eastern League', 27½in. x 35in.; 'Junior Trial Match', wash, 8in. x 6in.

Holland, James (b.1905), 'Captain, Supporter and Mascot', 29½in. x 56½in.

Horne, Edwin, 'Floodlight Incident', pen and gouache, 17in. x 12½in.

Hoyle, Walter, ARCA (b.1922), 'Goal', 35in. x 27½in.

Hussey, Harold, 'The End of the Game', 46in. x 26½in.

Irvin, Albert (b.1922), 'Goalkeeper', 30in. x 29½in.

Isherwood, Travis, 'The Stand, Maine Road', 24½in. x 20in.

Jacobs, Dennis, 'The Football Match', lithograph, 12in. x 18in.

Jones, Stanley R., ATD (b.1927), 'Final Whistle', 19½in. x 29in.

Kessell, James E., RBSA (b.1915), 'Coventry v. Bournemouth, March 14th, 1953', 26½in. x 34¼in.

Kinsey, Anthony, 'Down at the Valley', 29in. x 21½in.

Kuell, Victor John, 'Offside Dispute', 29½in. x 23¾in.

Lamb, Lynton Harold, LG, SWE (b.1907), 'Village Football', 29in. x 24½in.

Leeson, Lawrence Joseph, ATD (b.1930), 'Football Jerseys', 25in. x 30in.

Lek, Karel, RCA, ATD (b.1929), 'Off to the Match', wood engraving, 8in. x 6in.

Lucas, Stephen, ARCA (Lond.) (b.1924), 'Centre Forward', 24in. x 29in.

Macdonald, Richard, RWS, ARCA (Lond.) (b.1919), 'The Local Game, Gloucestershire', 67in. x 23in.

Macdonald, Tom, 'Big Game Up North', pastel, 18in. x 14in.

McStocker, N., 'Southampton v. Sunderland by Floodlight', ink and wash, 26in. x 17½in.

Nelson, Paul, 'Village Football', 19¾in. x 29½in. (*see* Colour Plate 6).

Newton Taylor, W.H., 'Tomorrow's Professionals', watercolour, 17½in. x 13½in.

Noble, John Rushton, 'Red Heigh Park, Gateshead', watercolour, 19in. x 14in.

Norris, L., 'The Local Team', 48in. x 35in.

Palmer, Albert, 'Willie Hall', 19½in. x 23½in.

Palmer, James, 'Players on Cinders', 35in. x 27½in.

Payne, Wilfrid, 'Our National Game', 90in. x 19½in.

Peri, Peter L., 'The Village Game', etching, 20in. x 10½in.

Pope, Hilda Chancellor, 'After the Game', watercolour, 22in. x 16½in.

Reid, Patrick, 'Torquay Supporters', engraving, 8in. x 6in.

Ribbons, Ian, 'Red Wins', watercolour, 25in. x 36in.

Robb, Brian (b.1913), 'Football', 39in. x 29½in.

Roberts, William, 'The Lesson', 35½in. x 27½in.

Rodgers, Sydney, 'The Village Match', wood engraving, 5in. x 3in.

Rosenbaum, Julius, 'The Tackle', engraving, 9½in. x 8in.

Rothenstein, Michael, RA, 'Moment of Victory', engraving and aquatint, 12in. x 16½in.

Salaman, Michael (b.1911), 'Miners Game at Sandown', 30½in. x 23¾in.

Sanders, Christopher, 'The Pitch Shall Be . . .', 30½in. x 26½in.

Sayce, Harry H., FIAL, NDD, 'Football by Floodlight', 27½in. x 19½in.

Sewell, John, 'QPR Entrance', gouache, 27in. x 19in.

Shelton, Harold, 'Carlisle United v. Bradford City', drawing, 21½in. x 14½in.

Slater, Richard E., 'Entering the Stands', 38in. x 29in.

Smith, Howard, 'Fleeting Impression of Jesse Pye', litho mezzotint, 11½in. x 9½in.

Speechley, G.S., 'The Crowd', 20in. x 26½in.

Tavener, Robert, RE, ATD, NDD (b.1920), 'The Changing Room', lithograph, 6½in. x 10½in.

Taylor, Francoise, 'Burnden Park', watercolour, 25in. x 19½in.

Toovey, C.W., 'Boys Practising', engraving, 4in. x 5in.

Toynbee, Lawrence, 'Mid week practice at Stamford Bridge', 48in. x 34½in.

Tucker, James W., ARWA, ARCA (Lond.) (1898-1972), 'A Promising Lad', 39½in. x 29½in.

Turner, W., 'The Night Before Cup-Tie', 22½in. x 14½in.

Watson, John, 'Tossing the Coin', watercolour, 19in. x 13½in.

Weake, David Brian, 'Five Minutes Before Full Time', 26in. x 20in.

Webster, Norman, RWS, RE, ARCA (b.1924), 'Shoot', 9½in. x 14in.; 'Football on the Village Green', etching, 10in. x 8in.

Wesley, Gordon H., 'Saturday Afternoon', 27in. x 18½in.

Whitlock, J. (b.1913, also known as Codner, John after 1958), 'Ray Warren', 27in. x 35in.

Wilkinson, Clifford, 'Off the Bar', lithograph, 18½in. x 13in.

Wood, P.M., RSMA (b.1914), 'Going to the Match', 29½in. x 23¾in.

Yates, F.J., 'Saturday Afternoon', 47½in. x 39½in.

CHAPTER 3

Badminton, Battledore and Shuttlecock

The modern game of badminton is derived from the earlier game of battledore and shuttlecock and takes its name from the game that the Duke of Beaufort is alleged to have introduced to his guests (mostly young army officers on leave from India) at his home at Badminton, c.1870. The room in which they played had two large doors opening inwards on the side walls. In order to allow spectators to enter and leave the room without disturbing the game in progress, it was arranged that although the baselines occupied the width of the room, the court was narrowed considerably at the net, and thus the 'hour glass' shaped court originated. Major Clopton Wingfield's game of tennis, later to become lawn tennis, was originally designed to be played indoors and was first played with the same strange 'hour glass' shaped court. It may well be that the Major suffered the same inconvenience of the side doors at his home in Wales. This ridiculously shaped court was dropped very quickly in the case of tennis but remained for badminton the accepted shape until at least 1901. Three All England Championships were played under these conditions.

By 1873, the game in a primitive form was being played in India, presumably taken there by the young army officers who discovered it at

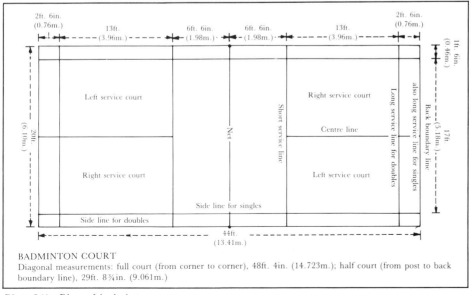

BADMINTON COURT
Diagonal measurements: full court (from corner to corner), 48ft. 4in. (14.723m.); half court (from post to back boundary line), 29ft. 8¾in. (9.061m.)

Plate 3/1. Plan of badminton court.

Plate 3/2. 'Shuttlecock', from a MS. in the Douce Collection. Illustrated in Joseph Strutt's The Sports and Pastimes of the People of England, *1801.* Topham Picture Library.

Badminton, but it didn't 'catch on' in England as a covered court game until about 1890. An 18th century print exists of a game similar to that of badminton played in France at an earlier date and indeed an extract from Cassell's book of *Outdoor Sport and Indoor Amusements* which was reproduced in an early edition of the *Badminton Gazette* gives rise to the theory that the game was in existence before the Duke of Beaufort 'invented' it in 1870.

The first official set of rules for the game was drawn up by Colonel H.O. Selby, RE, in 1877, and published in book form. In the early days of the game there were never less than three and usually four players on each side of the net (doubles and singles games were not played) and it was not until much later that the number each side was reduced. From these early rules it seems that a team consisted of several players who in turn served until they were put out. The next member of the team would then take his place and so on in somewhat the same way as a rounders team. This old formation is no doubt the origin of the term 'side in' 'side out' used in modern scoring. In 1887 Colonel Selby's rules were revised by J.H.E. Hart, who with G.W. Vidal was the greatest pioneer in this country of the modern game of badminton. In 1890 the rules were again revised and were used for the formation of the Badminton Association in 1893 by Colonel Dolby.

By 1890 there were badminton clubs in England at Folkestone, Teignmouth, Bath, Southsea, Southampton and Bognor, and these were followed by clubs at Ealing, Guildford and Crystal Palace. There were very few inter-club matches and those played were far from satisfactory owing to the different interpretations of the rules and regulations adopted by each club especially with reference to the size of the court, which apparently varied enormously. This seems to have been an almost universal problem in the early years of most sports and games.

In 1898, badminton made great progress with the first open tournament held at Guildford. There were twelve entries in the Mixed Doubles, six in the

Plate 3/3. Alexander Hohenlohe Burr (1835-1899). 'A game of Battledore'. 10¾in. x 17¾in. Bonhams.

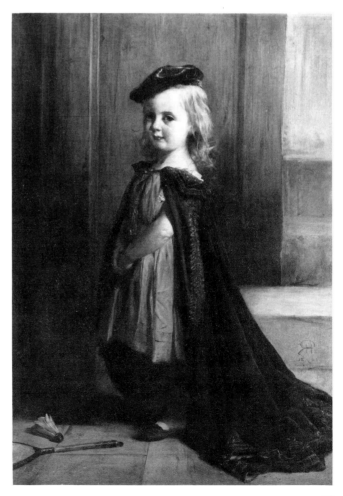

Plate 3/4. Robert Herdman, RSA, RSW (1829-1888). 'Little girl with shuttlecock', signed with monogram and dated 1866. 45in. x 32½in. Lawrence, Crewkerne.

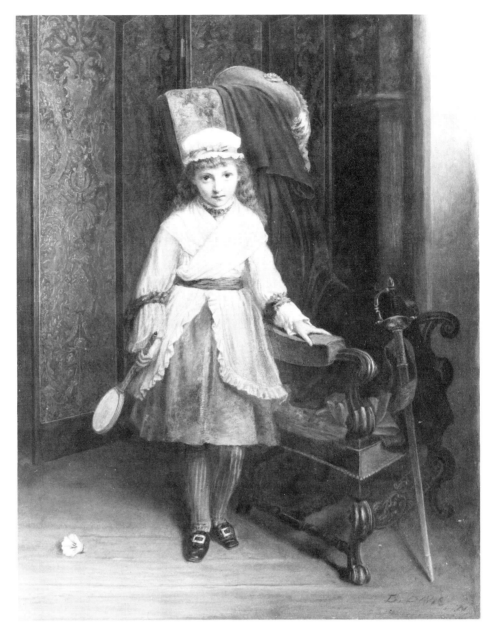

Ladies' Doubles, and seven in the Mens' Doubles, but no singles. (It is of particular interest to note that from its very early days this game was played by women even in an age when women were not encouraged to take part in sports and games.) The success of the Guildford tournament encouraged the inauguration of the All England Championships the following year. These were held at the Drill Hall, Buckingham Gate, in London and were played entirely in one day, 4th April 1899, but still no singles were held until the following year. In 1902 the championships were held in the central transept of the Crystal Palace and the following year were transferred to the London Rifle Brigade Drill Hall at Bowhill Row, EC, where they remained an annual event until 1910. Because of the increased popularity of the game for both players and spectators, the venue of the championships was moved yet again to the Royal Horticultural Hall, Westminster, where they were played until the outbreak of the Second World War in 1939.

Badminton suffered particularly badly during the war, for the halls in which

Colour Plate 7. Unknown artist, early 19th C. 'Young Boy with Shuttlecock Bat'. Private
Collection.

Plate 3/6. Maud Tomlinson (b.1859). 'Not played at Badminton for some time — kept turning my back on the Shuttlecock'. Book illustration reproduced in Country Life, *12.12.1985.*

the game was played were requisitioned, often as warehouses, by the War Department. Very few clubs survived, but the few that did, such as Wimbledon, kept the game alive. After the war the game was restarted with great difficulty and it was not until the 1950s, and the inauguration of the Thomas Cup, which was presented in 1949 by Sir George Alan Thomas, Bt. (1881-1972), the first class badminton player and sportsman, that the game really took off and gained international popularity. It was also realised that badminton was a strenous, highly scientific and fascinating game to play, and as a spectator sport, fast, exciting and attractive: it was no longer a glorified children's game of battledore and shuttlecock.

All games that require physical activity on the part of the players have a ball in common. Badminton is the outstanding exception with a shuttlecock instead of a ball. The game is almost entirely one of volleying as the shuttlecock rarely bounces, resulting in long rallies. As in lawn tennis, which has often been erroneously described as the sister game to badminton, each game is played by two or four players who, with a racket, attempt to hit an object over a net into a marked court of a given size. In each game the aim of the player is to place the object in such a way as to cause the opponent to be unable to return it. In both cases, the service is delivered diagonally across the net, but the badminton court is smaller than that of lawn tennis, being only 44ft. x 20ft. (13.41m. x 6.09m.).

In 1924, the game of badminton had become firmly established in both Canada and the USA, and in that year Canada held its third Annual Championship. The Canadian Badminton Association had twenty-six clubs and a total membership of 2,500 players. In the same year the Honorary Secretary of the Boston Badminton Club made a visit to England. Although the New York Badminton Club is one of the oldest in the world having been started sometime in the 1880s, the game never had quite the following of that in Canada. It was not until 1949 that the Americans sent a strong team to contest the All England Championships against teams from Malaya, Denmark, England, India, Sweden, Ireland and Scotland.

Denmark has had a very keen interest in the game since the 1920s and has been a formidable opponent. By 1948, there were in Copenhagen alone more

Colour Plate 8. 'Girl with Shuttlecock', signed with monogram A.T. and dated 92. Watercolour. 15in. x 10¼in. Chris Beetles Ltd.

Colour Plate 9. Eveline Lance (1859-1893). 'Outdoor Play', signed with monogram. Watercolour. 8in. x 6in. Chris Beetles Ltd.

than 150 clubs with three or more courts, and in 1947 there were 567 affiliated to the Dansk Badminton Forbund and some 25,300 active members. Malaya, South Africa, India and France were all countries where badminton flourished in the '20s and '30s. France had established an international Badminton Championship as early as 1908.

In 1934, the International Badminton Federation was formed under the presidency of Sir George Thomas, Bt. (q.v.), and it now has fifty-eight organisations which are full members, and twenty-eight associate members. The IBF runs two major competitions named after great English players: the Thomas Cup for men's events and the Uber Cup for ladies' events, presented in 1956 by that fine lady champion, Betty Uber (b.1907), one of the finest doubles players and tacticians the game has ever known. In addition, it also runs the World Championships which since 1983 are held bi-annually with the European Championships. Further advances were made when the Olympic Committee adopted badminton as a demonstration sport in the 1972 Games in Munich.

In 1987, with $151,050 in prize money at the finals in Hong Kong and the total prize fund for the Grand Prix circuit exceeding $1,000,000, the financial rewards for the game looked attractive. Despite this and its popularity in Europe, there is some unease amongst players that badminton is fast becoming the game of the Far East where enthusiasm for the sport encourages sponsors to dig deep into their pockets to outbid rival countries for the top events. Perhaps the great rewards will encourage commissions for contemporary paintings of the sport.

BATTLEDORE AND SHUTTLECOCK

This is an ancient children's game played by two people with wooden bats, or battledores, with a shuttlecock which is a small piece of weighted cork or other light material with feathers projecting in a ring from one side. The object of the game is to strike the shuttlecock from one player to the other without missing a strike. There is evidence that this game was being played by the North American Indians before the Spaniards arrived there, although they

Plate 3/8. George Knapton (1698-1778). 'Portrait of Master Francis Burrell', three-quarter length in a brown coat and blue and silver embroidered waistcoat, holding a battledore, a shuttlecock on a table beside him. Indistinctly signed and dated 175?. 29⅞in. x 25in. Christie's.

used their hands instead of bats. One of the earliest records in this country is represented by a fourteenth century engraving of two children playing with wooden bats and a feathered shuttlecock very similar to the one used in modern badminton (*see* Plate 3/2). The word battledore, meaning a small racket, first occurs in 1598, but according to the British Museum the game was first called battledore and shuttlecock in 1719.

In the reign of James I (1566-1625), it seems to have been a fashionable game played by adults as well as children, and in the *Two Maids of More-Clacke,* a comedy published in 1609, it is said 'to play at Shuttlecock me thinks is the game now.'

Among the many sporting anecdotes related of Prince Henry, the son of James I, is the following, 'His highness playing at Shittle-cocke with one far taller than himself, and hittyng him by chance with the shuttlecock upon the forehead, ''This is,'' quoth he, ''the encounter of David with Goliath.'''

CHAPTER 4

Billiards and Snooker

The exact origin of billiards has not been clearly established nor is it known with any certainty in which country the game was first played. Indisputably an ancient game it is said to derive from field sports played with balls and sticks by the Romans and Greeks. According to Reilly's English translation of the Abbé McGeoghegan's *The History of Ireland*[1] there is a reference to billiards in the will of Cathire More, a sub King of Ireland, who died in the early part of the second century AD. Much later the French writer Bouillet ascribed its invention to England in his *Academie des Jeux.*[2] The word 'billiard', like the French 'billard', comes from 'ball words', like 'billas' (medieval Latin) and 'bille' (French), and 'stick words' like 'billart' (Old French). From c.1400 AD illustrations show a lawn game like croquet called 'Paille Maille' in which players are using batons and wooden balls of a type which are familiar in later engravings and woodcuts (*see* Plates 4/1 and 4/2).

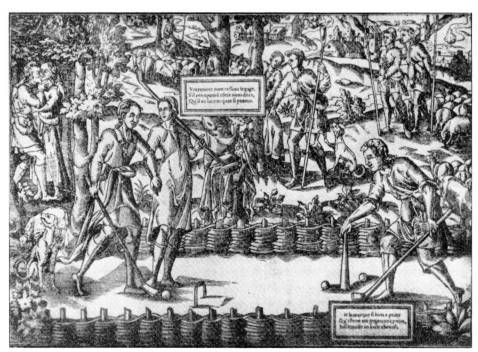

Plate 4/1. A French woodcut depicting Shepherds playing billiards on the ground in 1480. Clare-Padmore-Thurston Group of Billiard Table Manufacturers.

Plate 4/2. The game of Paille-Maille from Joseph Strutt's The Sports and Pastimes of the People of England, *1801.*

This game was also traditionally thought to be affiliated with such games as croquet and golf (*see* Chapters 6 and 10).

Pall Mall, the famous London street, derives its name from this game, which was certainly being played by Charles I (1600-1649) in 1629, although the road itself which was built on the old Paille Maille course was not named as such until after Charles II came to the throne in 1660 (*see* p.172). Some time between 1350 and 1450, billiards ceased to be an outdoor sport and became miniaturised and converted into an indoor recreation. In his *History of Billiards - A Compleat Historie of Billiard Evolution,* which he published in 1974 as a private pamphlet, the contemporary American writer, William Hendricks, showed Louis XI of France, who reigned from 1461 to 1483, leading the fashion amongst the French nobility for the game, and showed it being played on a table. By the Elizabethan era, there were many public tables in London (according to references in the works of Spenser, Shakespeare and Johnson) as

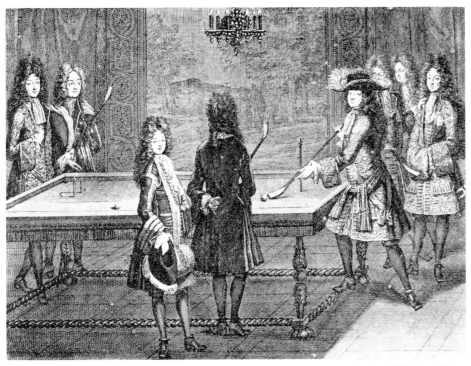

Plate 4/3. Antoine Trouvain. An engraving of Louis XIV of France playing billiards. Clare-Padmore-Thurston Group.

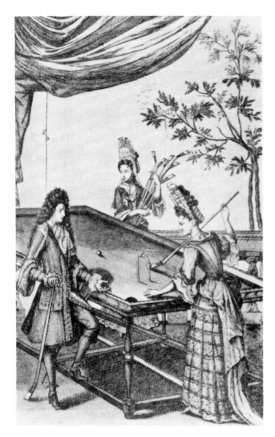

Plate 4/4. The Duchess of Burgundy playing billiards, 1694. Clare-Padmore-Thurston Group.

Plate 4/5. The Table in 1704. Clare-Padmore-Thurston Group.

well as private tables in the more advanced country houses. In 1588 the Duke of Norfolk was said to own 'a billyard board covered with a green cloth, three billyard sticks and eleven balles of yvery'.

The plural 'billiards', first appears in the English language in 1591 according to the *Oxford English Dictionary*. A decade later it appeared in Shakespeare's *Anthony and Cleopatra* (Act II Scene V) when Cleopatra says: 'Give me music, music moody food of us that trade in love, Let it alone, Let's to Billiards, Come Charmian'. Charles II (1630-1685) is known to have played billiards in his exile in or near Paris from 1651 to July 1654 and the French King Louis XIV (1638-1715) was also a keen billiards player, encouraged by his doctor for health reasons (*see* Plate 4/3). This is no doubt why the French *Encyclopaedia* describes the game as 'hygienic and amusing' though it later became very far from hygienic when played in the overheated and smoky conditions of clubs and bars. In 1674 *The Complete Gamester* described billiards as 'the most gentile, cleanly and ingenious game', and by the early eighteenth century, virtually every café in Paris boasted a table (*see* Plates 4/5 – 4/7). The game was first recorded in Holland in the eighteenth century, although an inventory of the possessions of the exiled King of Bohemia in the 1620s shows that he had a billiard table when he lived in The Hague. Since he was married to Elizabeth Stuart, the elder sister of Charles I, the table may well have come from England where the game was established much earlier.

Potting and scoring 'in-off' were recorded in 1770, by which time a red ball had also appeared to join the two wooden or ivory balls. The cannon (which causes the cue ball to strike the other two balls in the same shot) was imported from France through carombolage, a game still played in France, Spain, Belgium, Germany and in countries colonised by those nations. The Spaniards

introduced the game to the USA where it is still played. (The 'carom' is a word of Indian origin for a round sour fruit.) The carom or cannon became such an obsession with the French that they gave up potting balls altogether and designed tables without any pockets. In Britain, however, the cannon did not replace the potting game, but was absorbed into it, although some tables without pockets have been discovered from time to time (The *Birmingham Post* recently illustrated a painting of one found in Malvern.)

In Europe, the mace turned into a recognisable cue c.1807 and within a few years the cue had completely taken over from the mace in Britain, which very quickly made the game more popular in taverns, coffee houses and public gaming rooms. The word 'cue' derives from 'queue' (French for tail) from the practice of striking the ball with the 'tail', or small end of the mace, when the ball was trapped under the lip of a cushion. Originally the billiard cue was a stick about one yard long and flattened out at one end into a kind of a spoon with which butt end the player hit the ball. As well as being played in public houses and gaming rooms, billiards were certainly played in the London prisons for John Howard wrote in 1776 in his report on the Fleet Prison: 'I mentioned the Billiard table, they (the prisoners) also play in the yard at Skittles, Mississippi Fives and Tennis.' (The game of Mississippi was a variety of bagatelle played on a board with several numbered arches, the aim of which was get the ball through the arches off the cushion.) By the end of the eighteenth century the game had spread more widely on the Continent, certainly to Vienna (*see* Plate 4/17 and Colour Plate 11).

Thurston, the London furniture manufacturers (established in 1799) turned to the business of making billiard tables and equipment in 1814. Wooden balls were replaced by ivory from the centre of the female elephant tusk; until then ivory balls had been a luxury afforded only by aristocrats. (By the end of the century the appalling slaughter of about 12,000 elephants a year was

Plate 4/7. The game in 1720. Clare-Padmore-Thurston Group.

Plate 4/8. A Billiard Room in 1770. Clare-Padmore-Thurston Group.

occurring, as a sacrifice for the billiard tables of Britain.) Cushions, originally there simply to prevent the balls falling off the table, were stuffed with cotton to make the balls rebound, and thereafter became an integral part of the game. The value of chalk on the cue was first appreciated by John Carr, a marker at John Bartley's Billiards Rooms in Bath (*see* Plate 4/11), who started selling it. Before that, players used to twist the point of the cue into the plaster of a wall or ceiling to secure more grip on the ball. Carr and Bartley were also the first to use 'side' or spin on the cue ball.

From 1826, Thurston began to experiment with slate instead of wood as a table bed surface and gradually brought the manufacture of tables to perfection (*see* Plate 4/12). Some early beds were made of iron and can still be found rusting in Ireland, and until recently there was a table with a massive cast iron bed in a Liverpool staff canteen. This table had a cast iron underframe but the bed was made of concrete slabs in five sections, the work of Marsden & Saffley, c.1880, in Liverpool. The early cushions were made of strips of felt and other substances such as hair, Russian duck and white swankin. All were tried before natural rubber cushioning was introduced by John Thurston in 1835. Ten

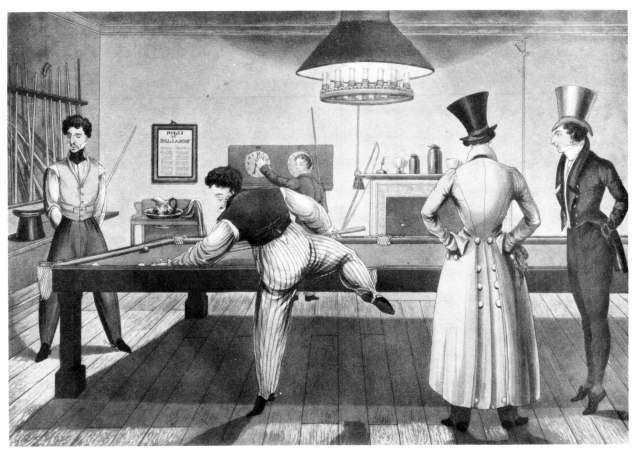

Plate 4/9. William Henry Pyne (1769-1843). A print after his painting of 'Billiards', engraved by G. Hunt. British Museum.

years later in 1845, he patented and introduced the first 'frost proof' vulcanised rubber cushions. In 1868 an American, John Wesley Hyatt, the man who invented ball bearings, patented a synthetic plastic made from collodion, a hardening mixture containing cellulose nitrate, camphor and ground up bones which printers used to rub on their hands. This was called celluloid, and billiard balls became one of its many by-products, others were false teeth and piano keys. Celluloid was much cheaper than ivory and more easy to manoeuvre on the table, also the balls made the same familiar clicking noise (which had become so much part of the game) as the ivory ones. One early problem was that celluloid was highly flammable so that a ball struck too hard was liable to explode.

Today's super crystalate balls are made by high technology — they have to be exactly $2^{1}/_{16}$in. (52.5mm.) in diameter. The pockets are approximately $3\frac{1}{2}$in. (89mm.) wide although no actual size is specified in the rules which state: 'Rule 1c (ii) 'the pocket openings shall conform to the template authorised by the Billiards and Snooker Control Council'. Apart from the cloth, nothing fundamental has changed in the manufacture of the table itself since the introduction of slate by Thurston 160 years ago. The woods most commonly used in the manufacture of billiard tables are mahogany, oak and walnut. The $1\frac{3}{4}$in. (57mm.) slates weigh almost a ton so that the balance of the table is unaffected if a large player lies across it to play a shot. Thin slates are liable to warp and become hollow and do not provide a sound base for the cushions which then sound hollow — also a ball rolling on a thin slate bed can produce a slight 'rumbling' sound. The cloth for modern tables is made from

Plate 4/10. A Continental billiards scene, early 19th century, in woven silk. 13in. x 7in. Clare-Padmore-Thurston Group.

Plate 4/11. The Billiard Room at Bartley's, in Bath, c.1825, where chalk was first used on cues. Clare-Padmore-Thurston Group.

fine merino wool imported from Queensland, Australia. The cloth has nearly always been dyed green, presumbly to resemble grass from the game's early days as an outdoor sport.

An interesting account of a billiards match which took place in Brighton on Thursday, 24th March, 1825, is given by Pierce Egan, the celebrated sporting journalist, in his book *Boxiana,* published in 1829.

'This gay watering place was all alive in consequence of Brighton having been selected for the decision of the above match. The Billiard touch was made upon the BUSTLE rather early one morning between Mr. Hayne and Mr. Carney, well known in the S.P. The Cue match was for 100 guineas aside p.p; — 100 up, out of which Mr. Carney was to receive 70 points. Mr. Hayne, always full of pluck and liberality, backed Jonathan Kentfield[3] [*see* Plate 4/13] the Brighton marker, acknowledged to be the first Champion Billiards player of England, without asking the marker a single question upon the subject. Jonathan won the toss: and his own table, of course, in Manchester Street was selected as the place for the

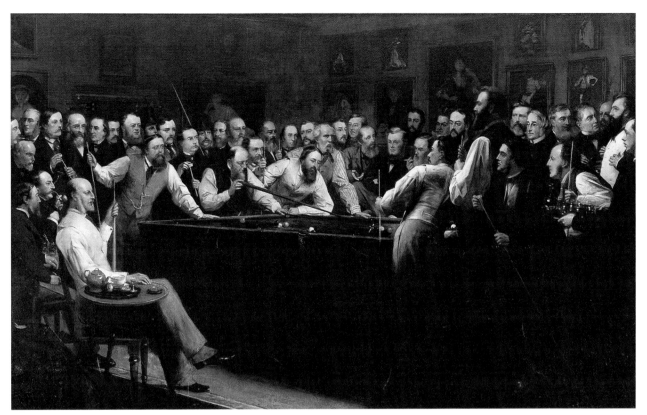

Colour Plate 10. Henry Nelson O'Neil, ARA (1817-1880). 'Billiard Room of the Garrick Club', signed with monogram and dated 1869. 37½in. x 61in. The Garrick Club; E.T. Archive Ltd.

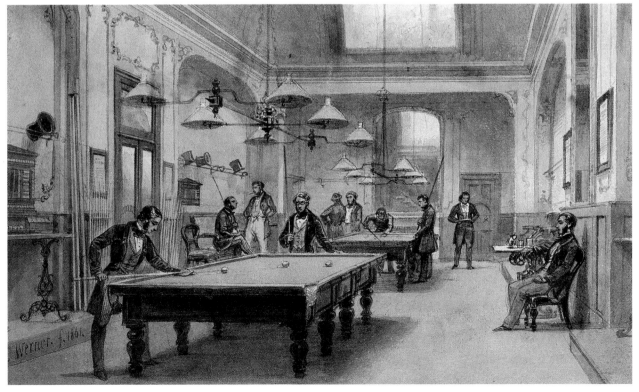

Colour Plate 11. Carl Friedrich Heinrich Werner, RI (1808-1894). 'A Continental Billiards Game', signed and dated 1861. Watercolour. 9in. x 13¼in. The Wingfield Sporting Gallery, London.

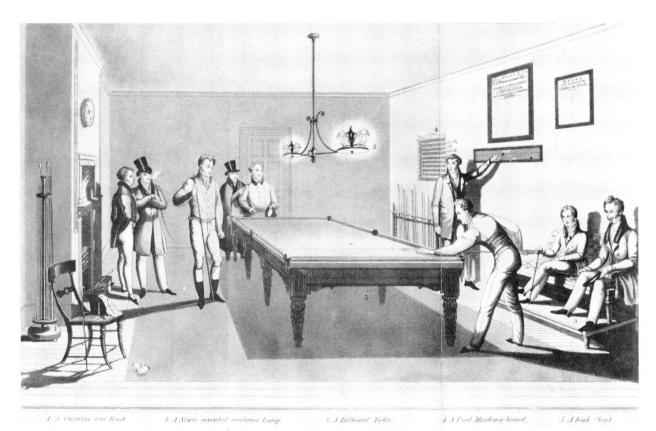

Plate 4/12. Thurston's Catherine Street Match Hall in London, 1831. Clare-Padmore-Thurston Group.

trial of skill. Jonathan was also continually at play; and on the day previous to the match he got 101 off the balls in a game with a good player at Billiards... Between one and two o'clock on the Thursday strangers were admitted at Jonathan's rooms in Manchester Street at 2s 6d. each person. Scarcely any betting took place, although the table was surrounded with Sporting Gentlemen, on the game, as it was evident that Jonathan with all his excellence was over matched; and Cannon (the boxing champion) offered to back his opponent Carney at £20 to £15. It was decided in 18 minutes; and was one of the most gentlemanly matches we ever witnessed. Jonathan, most certainly, is a great player; and we have little doubt but he can give 50 out of every 100 to Carney with success. We also think it was no triumph over the talents of Kentfield. Carney was cool and collected throughout the match; he viewed every situation of the balls like a player, and won the match with great credit to himself.'

It was not until the second half of the nineteenth century that John Roberts, jun., the English champion, went on a tour of India and in the absence of a railway chartered some elephants to carry his billiard tables to Jaipur. The Maharajah of Jaipur, a renowned sportsman, not only ordered half a dozen tables, but dubbed Roberts his 'Court Billiards Player' for life with a retainer of £500 per year and expenses to cover an annual return visit. Roberts coached the Maharajah, and brought over from England, no doubt at vast expense, billiards players to entertain him.

Plate 4/13. Unknown artist. Portrait of Edwin Kentfield.
Clare-Padmore-Thurston Group.

*Plate 4/14. Capt. John Longstaff. Portrait of Walter
Lindrum. 50in. x 40in.* Clare-Padmore-Thurston Group.

The introduction by Roberts of billiards to India was to have a significant effect on the history of the game and on the birth of snooker, which was first played in the Officers' Mess of the Devonshire Regiment in 1875 and rules were agreed at Ootacamund in 1882. In 1885 at an historic meeting with the Maharajah of Cooch Behar at the Calcutta Club, close to the billiard table factory which Roberts established, Cooch Behar passed on to Roberts the rules of snooker. Snooker was a favourite variation of billiards for officers of the 11th Devonshire Regiment, the rules of which Cooch Behar had taken down from a young subaltern called Neville Chamberlain (1856-1944, later Colonel) who was credited with inventing the name and who was an enthusiastic player of the game. The word 'snooker', which is military slang for a raw recruit, was used at the Royal Military Academy at Woolwich in the nineteenth century and was probably a corruption of the French word 'neux', the original word for a cadet. The term was adopted by the army after Chamberlain, its credited inventor, used it to describe a fellow officer's play.

Roberts took the rules back with him to England and this is now the accepted official version of how snooker began, although conflicting versions exist. A controversial claim by *The Field* in 1938 to the effect that the great Lord Kitchener had himself taken out the rules of snooker from Woolwich to the

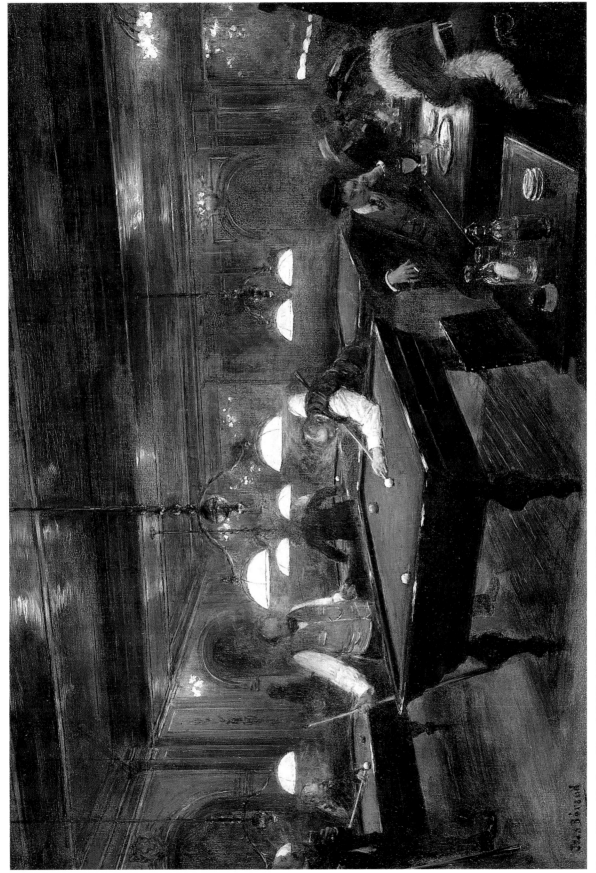

Colour Plate 12. Jean Béraud (1849-1936). 'La Partie de Billard', signed. 13in. x 19in. Richard Green Gallery, London.

Plate 4/15. John Hamilton Mortimer, ARA (1741-1779). 'The Reverend Charles Everard and two others playing billiards'. The National Trust, The Bearstead Collection.

Plate 4/16. William Henry Bunbury (1750-1811). 'Billiards', a print after a painting published in 1780 by Watson & Dickinson, London. Clare-Padmore-Thurston Group.

Army in India, sparked off a heated correspondence in *The Times*, and even as late as 1937 it had been confidently stated in print that the game was invented by a certain 'Captain Snooker', an officer in the Bengal Lancers.

There are other assertions that snooker, or a game very like it, may have started in a London Club in the 1860s and then found its way out to India probably through the Army before being taken up there and exported back to England. Snooker was almost certainly a marriage between the popular Victorian game of 'Pool' (or Life Pool) and the even older game of 'Pyramids' which was played with fifteen red balls and one white cue ball. A picture in the Garrick Club in London, dated 1869, sixteen years before Roberts' historic meeting in Calcutta with the Maharajah of Cooch Behar, certainly substantiates this theory. Whichever version is favoured and indeed all the known versions carry some element of truth, snooker was officially established in England and India in the second half of the nineteenth century.

Attempts to establish snooker in other parts of the world, such as the USA and Europe, remained largely unsuccessful even though billiards was introduced to Florida in the USA by Spanish colonists in 1565, but the game (carambolage) was played on a table without pockets. Snooker had better success in New Zealand and Australia which produced many champions

Plate 4/17. Batt. An impression of Mozart at the billiard table. Clare-Padmore-Thurston Group.

Plate 4/18. Lance Thackeray, RBA (d.1916). A set of four prints after this artist. Clare-Padmore-Thurston Group.

including the World Billiards Champion, Walter Lindrum, who was born in Kalgoorlie in 1898 (*see* Plate 4/14).

Royal enthusiasts included Prince Albert, Queen Victoria's Consort, a keen billiards player, and in 1845 the Royal Family took delivery of a billiard table with vulcanised rubber cushions, as patented by John Thurston. The billiard table and cue stand at Osborne, Isle of Wight, were made by G.E. Magnus, and the scoreboard by Messrs. Thurston. King George V (1865-1936) played snooker frequently after dinner at York Cottage, Sandringham, but when he was at the 'Big House', as he records in his diary, he played billiards! Lord Palmerston (3rd Viscount, Henry John Temple, 1784-1865), Prime Minister to Queen Victoria, is said to have died on the billiard table in his home at Brocket Hall after chasing a parlour maid around the table in an attempt to pinch her bottom.

Billiards was played, to some small degree, by women and had Major General A.W. Drayson writing in 1890 for the *Handbook of Games:*[4] 'It [billiards] can be played by daylight or gaslight by both sexes and there is no reason why a lady should not play equally as well as a gentleman: In fact, I

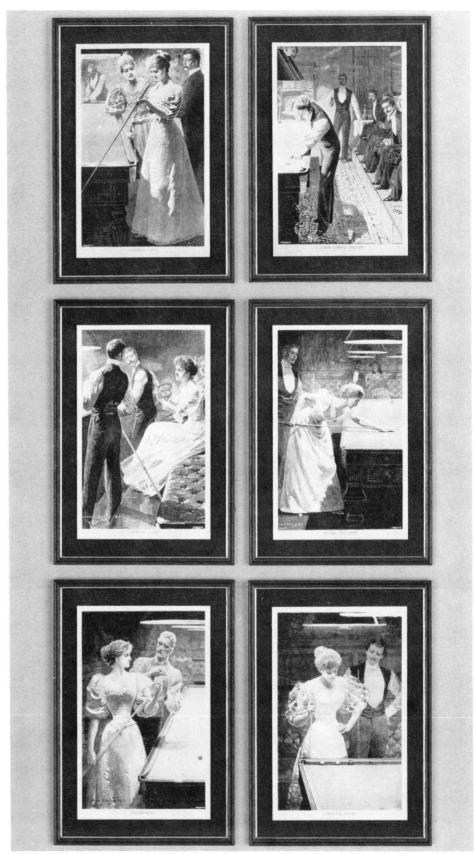

Plate 4/19. Lucien Davis, RI (1860-1941). 'Billiards', from the Badminton Library Series, 1896. Clare-Padmore-Thurston Group.

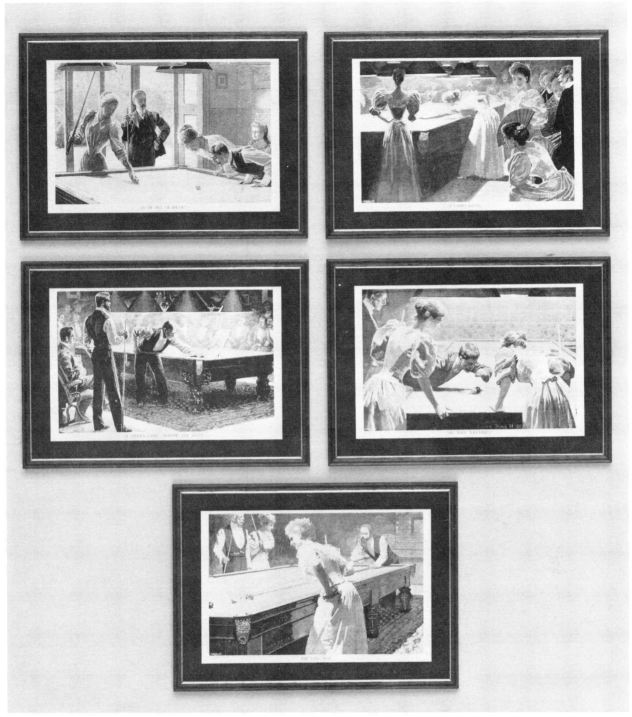

Plate 4/19.

have played with a lady who has scored a break of thirty.' Undoubtedly this was true and there was no reason why women should not play as well as men, as indeed they did in private houses, but in general they were not encouraged. Billiard tables were placed in inaccessible male preserves such as clubs, libraries and public houses where the players were not always from the respectable classes.

A number of factors conspired to cause the virtual demise of professional billiards as a spectator sport in the 1930s, not least was the return to Australia in 1934 of Walter Lindrum, the World Billiards Champion, with the

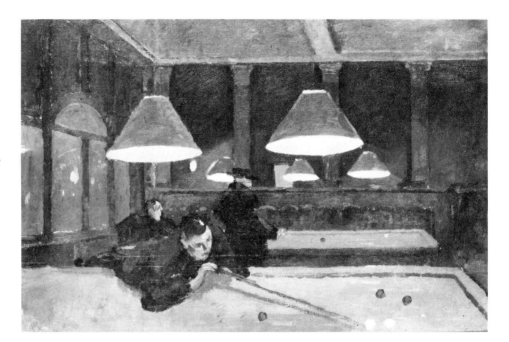

Plate 4/20. Derwent Lees, NEAC (1885-1931). 'The Billiard Hall', 1914. 16in. x 24in. Sotheby's.

championship trophy which he refused to give back, and who subsequently made impossible conditions for defending it. This, together with the move made by the *Daily Mail* in 1936 to switch its sponsorship from billiards to snooker, plus the fact that the rules of billiards had grown so complicated and the play so repetitive, ensured that snooker rapidly replaced billiards as the people's game. The main difference between billiards and snooker is that snooker is played with many balls of different colours and billiards is played with only three. Snooker presented more visual stimulation and variety as far as the spectator public was concerned. Billiards did not of course die overnight,

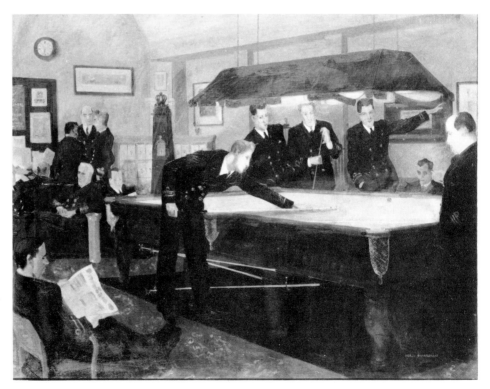

Plate 4/21. Percy Shakespeare (1907-1943). 'Billiards in the Officers' Mess of H.M.S. Vernon' (a land based training college), signed. 28in. x 36½in. Sotheby's.

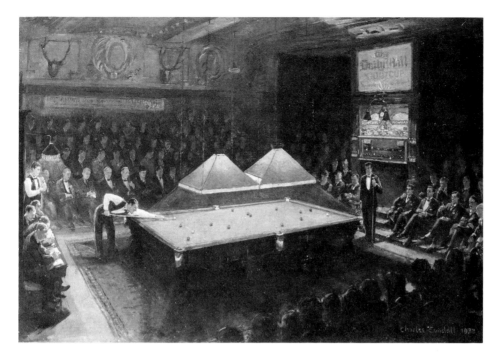

Plate 4/22. Charles Cundall, RA, RWS, RSMA, NA, NEAC (1890-1971). 'Thurston's Leicester Square Match Hall'. Signed and dated 1938. Clare-Padmore-Thurston Group.

but with the arrival of the Second World War, it had definitely waned in popularity in favour of snooker.

The first snooker championship took place in 1927 and was won by the legendary Joe Davis who went on to win every snooker championship until he retired, undefeated, from tournament play in 1946. Over the following years, professional snooker suffered a decline in popularity from its peak in 1946 to virtual extinction, although the amateur game continued to flourish and was bursting with talent. With hindsight, another contributory factor to the demise of both snooker in the 1950s and billiards in the 1930s was the closed shop in which the professional players operated, making it virtually impossible for new talent to join from the amateur ranks. The public grew bored with the same faces and the games went out of fashion. Curiously enough, snooker for women never caught on, no doubt due in part to tradition, and although a women's association was formed as long ago as 1931, it lapsed in 1950 through lack of support. Efforts to revive women's snooker since the 1970s have been brief and controversial. Undoubtedly television in the 1960s and '70s helped to promote professional snooker back into the limelight to the present level of public spectator enthusiasm.

As befits a game with a long history, there were and are a number of variations of billiards, including the previously mentioned Victorian Pyramids. The Americans have, for example, twelve or thirteen different games of Pool (more correctly known as Pocket Billiards) although this game is really a coin operated amusement and actually derived from the game '8 ball' to which it is most closely related. Pool should not be confused with the old English gambling game of Pool, or Russian Pool which was variously known as 'Indian Pool', 'Toad in the Hole', and 'Slosh', as in 'Slosh-in-the-Posh'. As long ago as 1779, Hoyle listed twelve different varieties of billiard games alone without the game of Pool, which began to appear in the English rule books, c.1819. Nowadays, the Billiards and Snooker Control Council are responsible for publishing the rules of the many variations of the games.

ART

It is an interesting phenomenon that although court and indoor games are not well documented in paintings, the game of billiards is an exception. For some inexplicable reason, billiards has captured the imagination of artists and there are numerous paintings in most media by all kinds of artists throughout the game's history. Apart from the delightful early prints and woodcuts illustrated in this chapter (*see* Plates 4/1-4/8), one of the earliest representations of the game is shown in a miniature by the Dutch artist Adriaen van de Venne (1589-1662) now in the British Museum. The portrait painter John Hamilton Mortimer, ARA (1741-1779), in his portrait of 'The Rev'd. Charles Everard and Two Companions' (*see* Plate 4/15) hedged his bets over the change from the mace to the cue and painted the gentleman on the right in white shirt

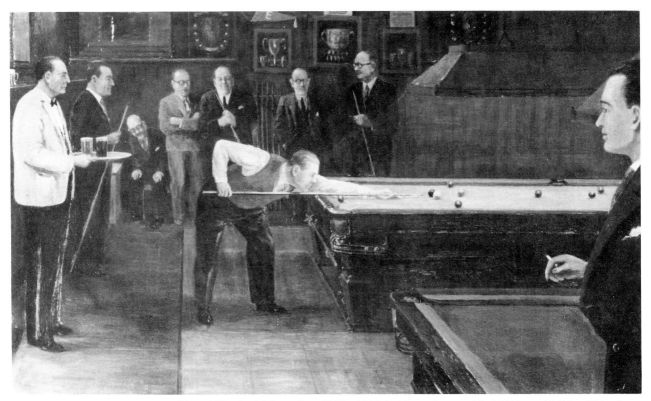

Plate 4/23. Jos McInnes (op. 1920s-1940s). 'A snooker match'. 11¾ in. x 18¾ in. This picture may well represent a snooker match at the old Eccentric Club in Ryder Street, St. James's, which closed in 1986. The snooker tables are by Burroughs and Wells and the metal type pockets came into fashion after the Second World War. The Victorian marking board on the left of the painting has life pool scoring, and the lamps above the tables have Hartley shades, distinguished by the upturns; these were made for general use by the man who pioneered the Hartley headlamps for cars at Greenfield, nr. Oldham, Lancs. The players are as yet unidentified. The Wingfield Sporting Gallery, London.

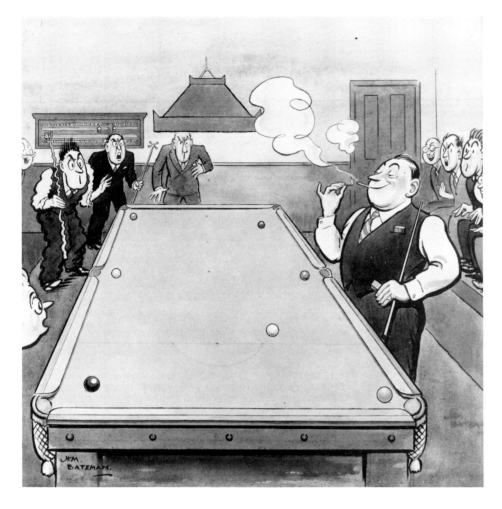

Plate 4/24. Henry Mayo
Bateman (1887-1970).
'A Good Leave', signed and
dated 1921. 13in. x 13in.
Christie's.

sleeves, holding a billiard cue and the gentleman in the middle of the group,
holding a mace. The deciding vote lies with the seated gentleman, who would
appear to be holding a mace, although the head is not sufficiently visible to be
one hundred per cent accurate. Since Mortimer died in 1779, the cue must
have been in use for some time in England. Mortimer's close contemporary,
the amateur painter, Henry William Bunbury (1750-1811) exhibited a picture
entitled 'The Billiard Table' at the Royal Academy in 1784. (Unfortunately
the whereabouts of this painting is unknown: it would have been interesting
to see whether Bunbury showed maces or cues being used at this date.) A print
entitled 'Billiards', after a painting by H. Bunbury (*see* Plate 4/16), was
published by Watson and Dickinson of 158 New Bond Street on
15th November 1780. In this picture the players are using cues but there are
seven maces clearly visible hanging in a wall rack.

William Henry Pyne (1769-1843) painted a pair of pictures, one depicting
whist and the other showing Regency dandies grouped round a billiard table
engaged in a game. Here the spectators are wearing top hats and the
illumination of the table is by candlelight. A print of this painting was
published by Pyall & Hunt (*see* Plate 4/9). The famous composer, Wolfgang
Amadeus Mozart (1756-1791), was a keen billiards player and a painting by
Batt (*see* Plate 4/17) shows him apparently working on one of his music scores
using a billiard table as a desk. There is a mace and a hoop on the table whilst

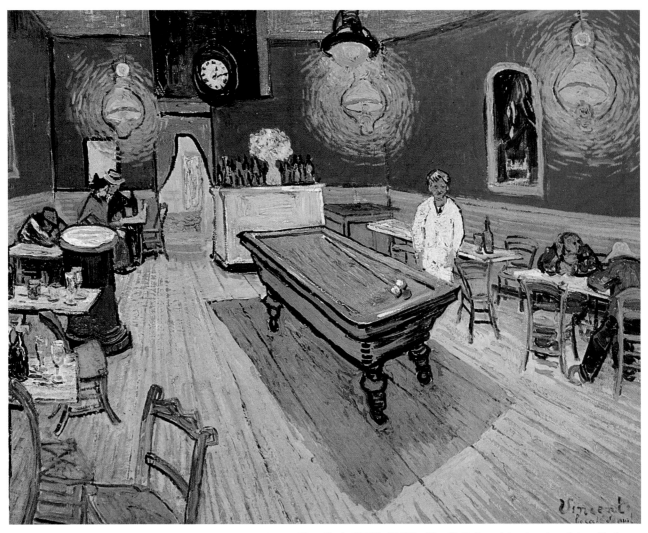

Colour Plate 13. Vincent Van Gogh (1853-1890). 'Le Café de nuit', signed and inscribed.
Yale University Art Gallery, Bequest of Stephen Carlton Clark.

the room lighting is by candles mounted in wall brackets. The Cruikshank brothers, Robert Isaac (1789-1856) and George (1792-1878) are known to have included billiards in their large output of sporting sketches, as did Robert Dighton (1752-1814) and Thomas Rowlandson (1756-1827).

The watercolour by Carl Friedrich Heinrich Werner, RI (1808-1894) shows billiards being played abroad in 1861 (*see* Colour Plate 11) as does the later painting by the French artist Jean Béraud (1849-1936, *see* Colour Plate 12). Two later oil paintings by the unrecorded artist, John Hamilton, although English in title, are interesting for they show Continental billiard room scenes, probably in France (*see* Colour Plates 14 and 15). The tables do not have any pockets and the style of the legs and the underframing of the table are definitely Continental, furthermore, the tables stand on four legs and are clearly smaller than their British counterparts. The painting by Henry Nelson O'Neil, ARA

(1817-1880) of the Garrick Club, shows the forty-three members sitting in the billiard room in 1869, grouped around the table (*see* Colour Plate 10). Interestingly, the group includes a self-portrait of the artist, and the writer, Anthony Trollope (1815-1882). Several other distinguished artists in the group include Sir John Everest Millais, Bt., PRA, William Powell Frith, RA, Thomas Creswick, RA and Sir John Gilbert, RA. One of the greatest of all Impressionist painters, Vincent Van Gogh (1853-1890) in 1888

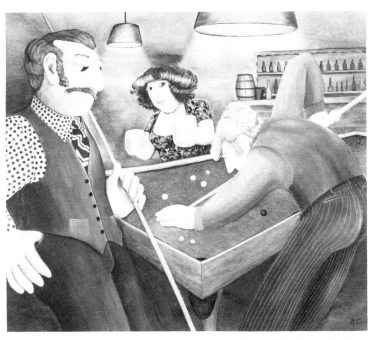

Plate 4/25. Beryl Cook. 'Bar Billiards', signed and dated 1978. 26in. x 30in. Bonhams.

based his 'Le Café de Nuit'[5] completely round a billiard table which dominates the picture (*see* Colour Plate 13).

A number of talented illustrators depicted the game in the late nineteenth century including Lucien Davis, RI (1860-1941), who illustrated the Badminton Library edition of *Billiards* by Major Broadfoot in 1896 (*see* Plate 4/19). Interestingly, Davis's pictures show both ladies and gentlemen playing. Lance Thackeray, RBA (who died in 1916), was another illustrator who produced a set of billiard room prints which were published in 1902 and which became extremely well known (*see* Plate 4/18). These also show ladies and gentlemen playing together. Harold Earnshaw, the artist husband of Mabel Lucie Attwell (1879-1964), who painted mainly between 1908 and 1926 and who died in 1937, was a great billiards player. He loved the game and even the loss of an arm in the First World War did not deter him for he subsequently played with a hook which must initially have given lovers of the green baize a nervous moment or two. Derwent Lees, NEAC (1885-1931) painted a billiards scene possibly for his first one-man show held in 1914 at the Chenil Galleries (*see* Plate 4/20).

Percy Shakespeare (1907-1943) was a promising young artist who painted in the 1930s. 'The Officers of H.M.S. Vernon' playing billiards (*see* Plate 4/21) was painted c.1940. (Shakespeare was killed in action during the Second World War.) The newer game of snooker has fared, quite illogically, less well than billiards in the matter of paintings. One of the first artists of note to cast his eyes at snooker was the Victorian master Sir Edwin Henry Landseer, RA (1802-1873) whose tiny pen and ink sketch entitled 'The Snooker Player' must be one of the earliest portrayals of the game, as it was executed sometime between the 1860s and the artist's death in 1873. That great artist of many twentieth century sporting scenes, Charles Cundall, RA, RWS, RP, SMA, NS, NEAC (1890-1971) painted one of the *Daily Mail's* Gold Cup Snooker Tournaments at 'Thurston's, Leicester Square Match Hall in 1938' (*see* Plate 4/22). The painting shows the professional, Tom Newman playing, Joe Davis, the non striker, standing under the light and Charles Chambers, the famous

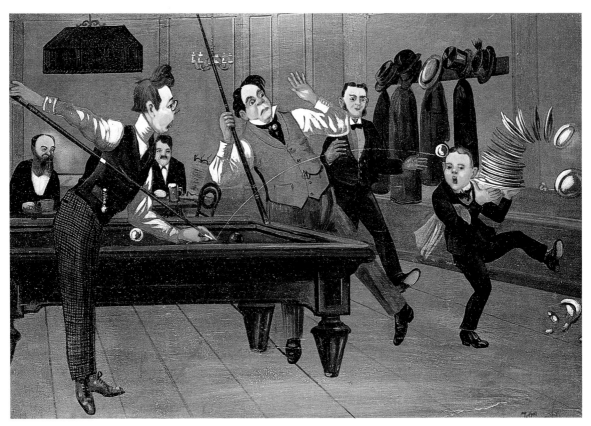

*Colour Plate 14. John Hamilton (op. 1920s). Billiards cartoon, signed. One of a pair.
13½in. x 19in. The Wingfield Sporting Gallery, London.*

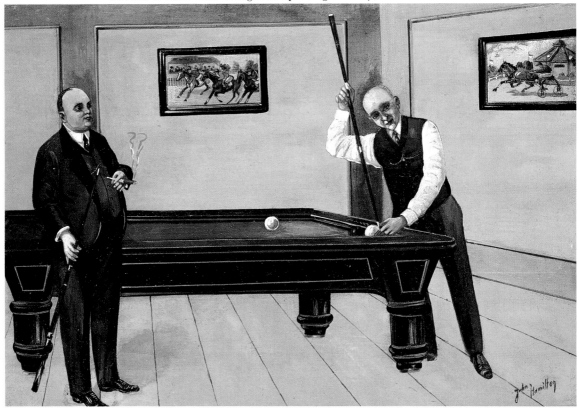

*Colour Plate 15. John Hamilton (op. 1920s.) 'The Billiards Match', signed. One of a pair.
13½in. x 19in. The Wingfield Sporting Gallery, London.*

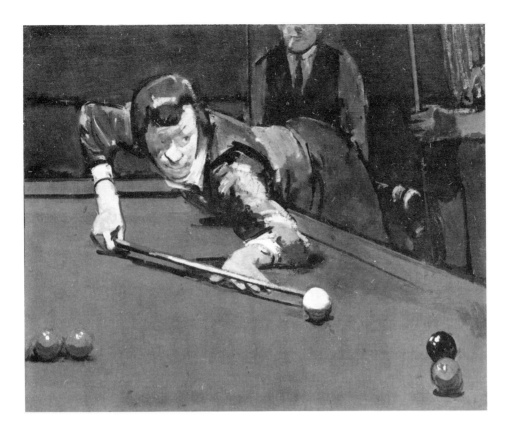

Plate 4/26. Ruskin Spear, CBE, RA (b.1911). 'Alex Higgins playing a snooker shot'. 15in. x 18in. Sotheby's.

referee, standing underneath the marking board on the right of the picture. The man sitting in the front row of the spectators with a notepad on his knee is Tom Webster, the famous *Daily Mail* cartoonist, and the gentleman smoking a pipe is Major Craggs, then Chairman of Thurston's & Co. Ltd. Thurston's Match Hall in Leicester Square was destroyed during the Second World War and a watercolour painting by the artist, George Ray, shows the building ravaged by bomb damage in 1940. A picture of a totally different calibre is by an unrecorded artist, Jos McInnes, who painted a club room scene with a snooker game in progress during the 1930s (*see* Plate 4/23). The group does not appear to include professional players or to depict famous celebrities but is an interesting and scarce record of the game played at that time. (Note the table lighting and the type of pocket rail fitted to the table.)

FOOTNOTES

1 Abbé James MacGeoghegan, *The History of Ireland,* published Sadlier & Co., New York, 1868. Originally written in Latin in 1685.
2. Bouillet, *Nouveau Dictionnaire et Academie des Jeux,* cited in Joseph Bennett's *Billiards,* published Thomas de la Rue & Co., London, 1873, p.2.
3. Although Kentfield is referred to throughout Egan's report of the story as Jonathan, his more generally known name was Edwin, which he used as author of his own book *The Game of Billiards,* published in 1839 (1st edn.).
4. Ed. D. W. Pole, published George Bell, London, 1890.
5. Van Gogh wrote of the scene 'the interior of the café at Arles where I eat. The painting expresses the violent passions of humanity by means of red and green. The room is blood red and dark yellow with a billiard table in the middle'. From letters quoted in *Vincent Van Gogh,* by Alfred H. Barr, New York Museum of Modern Art, 1935.

CHAPTER 5

Cricket

Cricket is an eleven aside bat and ball game played mainly in countries where English is spoken. The game has also been described as 'casting a ball at three straight sticks and defending the same with a fourth'. Most modern ball games have their roots in ancient history, but as recognisable sports their history begins with written records. Whilst variations of games similar to cricket undoubtedly existed before the sixteenth century, it is only possible to date with any accuracy the birth of the game from this period. As with many ancient games, perhaps cricket evolved from the old English game of club ball, a theory supported by the eighteenth century writer, Joseph Strutt. Cricket does not appear, as was once thought, to have come from France; indeed the word 'cricket' may well have come from the Anglo Saxon word 'cricce' meaning a crooked staff. Perhaps the first pictorial evidence of cricket may be found in Canterbury Cathedral in a window in the north-east transept, c.1180. The boy with the curved bat and ball represents boyhood — Puerita, one of the six ages of man. A similar figure can also be found at Gloucester Cathedral in the Great East window made to commemorate the Battle of Crecy in 1346 (*see* Plate 5/2). Now known as the 'Golfer', which clearly he is not, the figure holds a curved bat very similar to that used 300 years later in the game that we now know as cricket. The significance of the cricketer, if that is the game the figure represents in the battle window, is unknown. Other pictorial figures exist of the same date. A manuscript in the Bodleian Library, Oxford depicts what appears to be a group of monks and nuns playing a game of cricket, c.1340, which may answer the question as to what monks and nuns did in their spare time (*see* Plate 5/3).

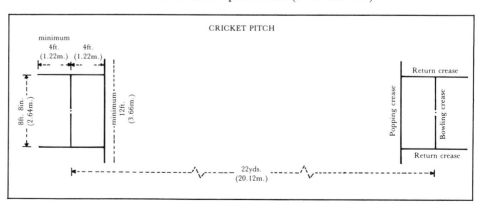

Plate 5/1. Plan of cricket pitch.

Plate 5/2. The stained glass roundel of the base of the Crecy window depicting a 14th century golfer, c.1350. Detail of a stained glass window at Gloucester Cathedral.

Plate 5/3. Portion of a manuscript, written in 1338 and illuminated by Jehan de Grise, probably in Flanders 1338-44. Bodleian Library, Oxford.

One of the first written references to the game is found in a manuscript in the possession of the Mayor and Corporation of Guildford (*see* Plate 5/4) and is dated 16th January, 1598, which records the evidence of a certain John Derrick, aged 'fyfty and nyne years or thereabouts', one of the coroners of the County of Sussex, concerning a disputed piece of land. 'When he [John Derrick] was a scholler in the free school of Guldeford, he and several of his fellowes did runne and play there at crickett and other plaies. And also that the same was used for the baytinge of beares in the saide towne.' It would seem from this early reference, therefore, that cricket was being played by boys during the reign of Henry VIII. By 1598, the game had found its way into Giovanni Florio's English translation of his *Italian Dictionary* as 'Cricket-a-wicket'. There is no evidence that cricket was played in Italy at that time but

"CRICKET" - The first time in English

The word "cricket" occurs for the first time in English in one of the Guildford Borough Records — a Court Book covering the years 1586 to 1675. The record is evidence that cricket was played in Guildford by boys of the Royal Grammar School about 1550.

This photocopy gives the entries on three pages.

Translation of heading

Court Leet held there Monday next after the Feast of St. Hilary the fortieth year of the reign of our Lady Elizabeth, queen of England, France and Ireland, Defender of the Faith etc.
(This date was 17 January 1598)

Memo. that att this day came John Derrick of Guldeford aforesaid gent one of the Queenes Majestes Coroners of the County of Surrey beinge of the age of fyfty and nyne yeeres or thereabouts and voluntarily sworne and examined saith upon his oath that he hath known the parcell of land lately used for a garden and sometime in the occupacon of John Parvishe late of Guldeford aforesaid Inhoulder deceased lyinge in the parishe of the Holy Trinity in Guldeford aforesaid betweene the garden somtymes Thomas Northall on the north parte and the high way leadinge through the North Towne ditch of the said Towne of Guldeford on the south

parte for the space of fyfty yeeres and more And did knowe that the same lay waste and was used and occupied by the Inhabitantes of Guldeford aforesaid to lay Timber in and for sawpittes and for makinge of frames of Timber for the said Inhabitantes And that ould Butler a carpenter deceased dwellinge in the Towne aforesaid did commonly use to make frames of Timber there, And also this deponent saith that hee being a scholler in the free Schoole of Guldeford hee and divers of his fellowes did runne and play there at CRECKETT and other Plaies And also that the same was used for the Baytinge of Beares in the said Towne untill the said John Parvishe did inclose the said parcell of land

Plate 5/4. Manuscript copy of John Derrick's deposition, from Guildford Borough Court Book, Ref. BR/OC/1/2. Guildford Borough Council and Guildford Muniment Room.

in any case Florio lived most of his life in England and had not visited Italy for some years.

Strangely enough there was no mention of cricket in the list of sports printed in 1618 under the title of *The King's Majesties Declaration to his subjects concerning lawfull sports to be used.* Mention of cricket, along with bear baiting, was conspicuous by its absence. That Puritan spoilsport, Oliver Cromwell (1599-1658), specifically forbade most sports after he became Lord Protector in 1652 and authorised fines to the considerable sum of two shillings for each person found playing cricket on the Lord's Day. This action had the most amazing effect on the game for far from killing it, it positively took off. Most of the aristocracy were forced to retire to their estates during the Protectorate and many found their estate workers playing an early unorganised version of cricket, particularly those who lived in the Wealds of Kent and Sussex, where it seems the game took a particularly strong hold. Initially, perhaps through boredom, the landowners took up the game, but soon found a new and interesting relaxation, for although betting was illegal, the gambling instinct never died. The players found that they could make small private wagers and thus increase the excitement of the newly discovered game.

Once either Royalty or the aristocracy became involved in a sport, it was 'discovered', organised and made popular, and sporting artists became involved in commissions to depict their masters 'at play'. In turn prints were made to satisfy popular demand from those unable to afford either the original work from the artist or to participate in the sport. Few cricket pictures exist before the Restoration in 1660, and the Frenchman, Hubert Gravelot (1699-1773) and the artist of many sporting pictures, William Hogarth (1697-1764), are probably among the first artists to depict cricket.

In the first few years of the reign of Charles II (1660-85), families such as the Sackvilles of Knole House, Sevenoaks, the Sidneys of Penshurst, the

Richmond family of Goodwood and the Gages of Firle were amongst the game's first influential supporters. One of the earliest cricket clubs to be formed was at St. Albans in 1666 and John Churchill (1650-1722, later 1st Duke of Marlborough) was known to be playing cricket at the Old St. Paul's School around this date. By May 1676, the naval diary of Henry Teonge reveals that he found cricket being played at Aleppo by the English residents and 'several pastimes and sports as duck hunting, fishing, shooting, handball, krickett, scrofilo'. The earliest written description of a cricket match was found in a collection of Latin poems published in 1706 by William Goldwin, an old Etonian, but the first full description was of a match between Kent and All England in 1744, the year in which a code of rules governing the game was drawn up. The description of the match was written in the form of a poem by James Dance entitled 'Cricket — An heroic Poem'. Kent won the match by one wicket due to a dropped catch by a confused Mr. Waymark. The first county match can be fairly said to have taken place in 1709 between Kent and London but to satisfy meticulous enthusiasts who might claim that London is not a county, it is fairer to claim that the later matches of 1728 were real county matches.

The father of Kent cricket was Edwin Stead, who died in 1735. He did much

EVOLUTION OF THE CRICKET BAT
(1) The oldest bat in existence (1750); (2) eighteenth-century curved bat; (3) bat inscribed 'Ring little Joey 1793'; (4) bat stamped 'E. Bagot'; (5) bat of Robert Robinson; (6) bat used by W.G. Grace (1900); (7) bat used by Denis Compton (1947).

Plate 5/5. Evolution of the cricket bat.

Plate 5/6. Cricket bats. MCC Collection.

to promote the game amongst the nobility and encouraged Frederick, Prince of Wales (1707-1751), the son of George II (1685-1760) to play in several cricket matches, and as a result cricket earned royal patronage in 1723. Although the Prince of Wales was not a particularly good player, he was a great enthusiast and became the life and soul of Surrey cricket. Unfortunately, he died at the early age of forty-four, ironically as a direct result of the game he loved so much. He was hit on the head by a cricket ball while playing in a match at Cliveden in Buckinghamshire; the blow to his head caused an internal abscess, which burst some months later and killed him. He is remembered for the famous epitaph 'Here lies poor Fred who was alive and is now dead!'

After the death of Edwin Stead, Kent continued under the leadership of the Earl of Middlesex (1711-1769) who became the second Duke of Dorset, and his brother, Lord John Sackville (1713-1765); Kent's main challenge in county cricket in those early days was from Surrey, as other counties did not begin to play until later in the eighteenth century. By 1729, the game had spread to most counties in England, although as late as 1824, the Rev. James Pycroft, author of the *Cricket Field* [1] was complaining that there were still only three or four cricket clubs in the West of England, at Bath, Clifton, Sidmouth and Teignbridge.

Cricket was probably introduced into North America towards the end of the seventeenth century, although there is no evidence available until 1709 when William Byrd (who was educated at Felsted) played many games of cricket with his friends along the James River in Virginia. Cricket was played first in Ireland by 1656, India in 1721, Scotland by 1750, Canada in 1785, Italy by 1792 and Germany by 1796.

Nearer to home, cricket grounds that were to become famous included the Foundation of Malling in 1705, White Conduit Fields, Islington in 1718, Broadwater Green in 1772, Kennington Common in 1724 and in 1725 the most celebrated ground of all, the Artillery Ground (*see* Plate 5/19) in Finsbury just outside the City of London, the home of the Honourable Artillery Company.

The first known length of pitch was the twenty-three yards from wicket to wicket of the 1727 Articles of Agreement between the Duke of Richmond and Mr. Brodrick. The 1744 laws, however, expressly refer to twenty-two yards and a Danish account of 1801 refers to twenty-five to thirty paces.

Cricket was also played at Moulsey Hurst (of boxing fame) in 1726, Henfield in 1727, Gloucester in 1729 and Clapham Common. Clapham Common was the venue for an amusing match in 1828 between eleven blacksmiths and the Wandsworth Vulcans, for a supper held afterwards at 'The Windmill', Clapham Common. Both sides, we learn, wore white leather aprons 'brand new for the occasion', and the match was won by the Clapham blacksmiths. No thanks to Dr. Beech, one of the Clapham heroes who weighed upwards of twenty stones and was it seems full of 'half and half' obtained, no doubt, from a preview visit to 'The Windmill'. He rolled about the ground like a 'sick elephant' when attempting to pursue the ball from where he had been placed as long stop.

Around 1760 a Club was formed in the small downland village of Hambledon in Hampshire. Backed by the great cricket patrons of the time, Sir Horace Mann, the Duke of Dorset and the Earl of Tankerville, this club was to make its name mainly between 1770 and 1787 and to produce some outstanding cricketers from the craftsmen and neighbouring farmers. William Beldham ('Silver Billy', 1766-1862) played at the highest level for thirty-five seasons; David Harris (c.1755-1803), was a brilliant under arm bowler for twenty years until crippled with gout; John Small (1737-1826), was the finest batsman of the period who spanned the transition from crooked to straight bats c.1755 (*see* Plates 5/5-5/7), and John Nyren (1764-1837), a left handed player, compiled the fascinating book *The Cricketers of My Time* (first published in 1833) about the Hambledon cricketers.

By the end of the 1790s, the centre of the game was established at Lords where the Marylebone Cricket Club (MCC) had had its headquarters since 1787. Founded by a group of distinguished patrons including, of course, the dedicated Duke of Dorset, Lord Charles Lennox, the Duke of York and the Earl of Winchelsea, Lords was in essence only a change of name for the White

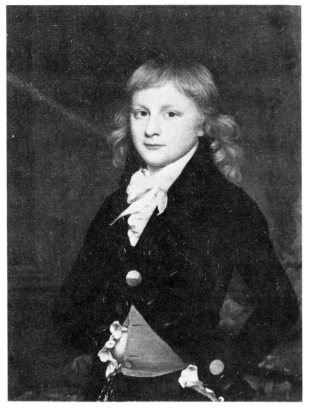

Plate 5/9. Sir William Beechey, RA (1753-1839). 'The Revd. Lord Frederick Beauclerk as a boy'. 28¾in. x 23¼in. MCC Collection.

Plate 5/10. Nicholas Wanostrocht, 'Felix', (1804-1876). Self portrait. Pencil drawing, 8in. x 6in. MCC Collection.

Conduit Cricket Club which had been formed in 1782. Thomas Lord (1755-1832), after whom the Club was named, had established his first ground at Dorset Square in 1787 where it remained until 1810. The laws were now revised by the new Club (*see* Plate 5/8) which became the ruling body for cricket and remained so until 1969 when the government of the game became the official responsibility of the newly formed Cricket Council. The MCC has had its present site at St. John's Wood since 1814 and has owned the freehold since 1866 which it purchased for around £18,000. Prior to the St. John's Wood site, the Club had its headquarters and ground at Lord's second site at North Bank (1809-13) which had to be given up because of the construction of the Regent's Canal.

The period between the formation of the MCC in 1787 and 1845 when William Clarke (1798-1856) started his tours with the All England XI was, for cricket, a time of many changes and saw its development from a skilful but unsophisticated country game to an institution of national importance. During this time several further notable events took place: in 1805, the first Eton and Harrow match was played; in 1806, the first match between gentlemen and players and in 1827, the first of a long series of matches between Oxford and Cambridge Universities. One of the greatest all round amateur cricketers between the days of the Hambledon 'greats' and the wandering XIs was undoubtedly the Rev. Lord Frederick Beauclerk (1773-1850) who was a great grandson of King Charles II (1630-1685) and Nell Gwynn (*see* Plate 5/9). His cricket play was in a class in which he was joined by only a few: William Beldham, one of the first and most illustrious players and William Gilbert

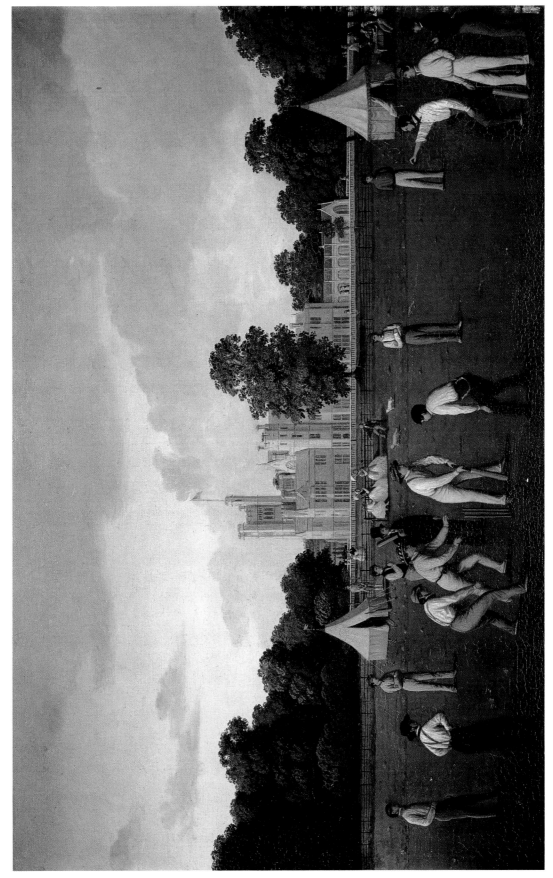

Colour Plate 16. English School, 'A Cricket Match at Canford Manor, Dorset'. 18½in. x 29in. Reproduced in A Country House Companion, by Mark Girouard, published by Century Hutchinson Ltd., London, 1987. Lord Wimborne.

Plate 5/11. Bernard Partridge. 'Ne "Plum" Ultra'. Punch cartoon, 1904, depicting 'The Ashes'. Topham Picture Library.

NE " PLUM " ULTRA.

BRITISH LION. "THINK WE 'VE HAD MOST OF THE LUCK ! "
AUSTRALIAN KANGAROO. " NOT MORE THAN YOU DESERVED ! "

Grace (1848-1915), the greatest of all cricketers, share it with him.

Lord Frederick was not above gambling which was rife in all sports at that time and which was felt added excitement and zest to the game. Indeed playing cricket against such as Squire Osbaldeston (1787-1866), that most professional of all amateur sportsmen, Lord Frederick would have needed both cunning and gamesmanship, as well as ability. On one notable occasion, he clearly failed to get the mixture right since he lost the two a side single wicket match and the wager of fifty guineas against his opponent who was on that occasion superior in the art of gamesmanship. From the ranks of the professionals came an even more talented all rounder than Lord Frederick Beauclerk, William Lambert (1779-1851), the great Surrey player, who was first seen at Lords in 1801. Unfortunately, in 1817, he was accused of taking a bribe during the famous match between England and Nottingham at Trent Bridge — his subsequent dismissal was a great loss to cricket but it also led to the bookmakers being warned off the turf at Lords which was undoubtedly beneficial to the game.

One of the best loved cricket personalities during this period was the amateur artist and schoolmaster, Nicholas Wanostrocht (1804-1876), who wielded his bat as skilfully as his pencil (*see* Plate 5/10). Of Flemish extraction, he had a bubbling sense of humour and made cricket what it really should be 'a lively, amusing as well as a scientific game', according to a contemporary sports writer of the time. 'Felix', the pseudonym he used for his drawings and writings was chosen in order to disguise his identity from the parents of his pupils who might have regarded his cricketing activities as too light minded for

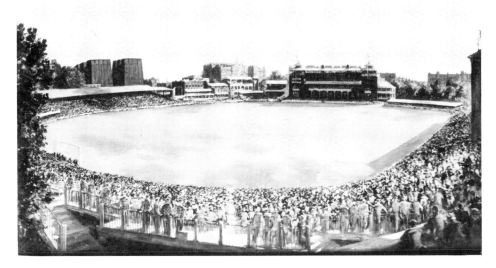

Plate 5/12. Charles Cundall, RA, RWS (1890-1971). 'The Test Match'. Lords, England v. Australia, June 24th to 28th, 1938. 42in. x 60in. MCC Collection.

a schoolmaster. He wrote and illustrated an instructional book on cricket called *Felix on the Bat;* his collection of lively and informative watercolours is much prized by the MCC.

One of the finest exponents of single wicket cricket was the outstanding batsman, Fuller Pilch (1803-1870) who from 1836 to 1854 helped to create a formidable Kent side. If he was the most famous batsman of his time, the most famous of the early nineteenth century bowlers was William Lillywhite (1792-1854) who came from Sussex. His nickname of 'Nonpareil' was earned for his qualities of high integrity as well as for his cricketing skill and intelligence; he perfected the art of round arm bowling so successfully that the law was amended in 1835 to allow the ball to be delivered below the level of the shoulder. It was not until 1864 that the bowler was allowed complete freedom as to the height of his arm.

At the time that William Clarke founded his All England XI in 1846 for the purpose of touring the countryside, county cricket hardly existed. The importance of these tours was therefore immense and when Clarke died in 1856, his valuable work was carried on by George Parr (1826-1891), the Nottinghamshire batsman, whose biggest hits at Trent Bridge were commemorated by 'Parr's Tree'. Major county cricket clubs such as Yorkshire and Lancashire were formed as cricket spread to the remoter counties.

In July 1864, two days before his sixteenth birthday, the budding cricketer W.G. Grace (1848-1915) scored 170 and 56 not out against the gentlemen of Sussex at Brighton for a side raised by his elder brother in South Wales. (It was also the year that saw the first issue of Wisden's *Cricketer's Almanack* which is still the major reference book on the game. John Wisden (1826-1884) was a fast round arm bowler who played for Sussex and the All England XI.) Despite his obvious skill and talent, it could be said that there were better cricket players than W.G. Grace but with his magnificent physique and presence, he was to dominate English cricket for the next thirty years or so (*see* Plate 5/48). The Victorians worshipped masculine authority and success, W.G. fitted the role and the cricket loving public had found their national

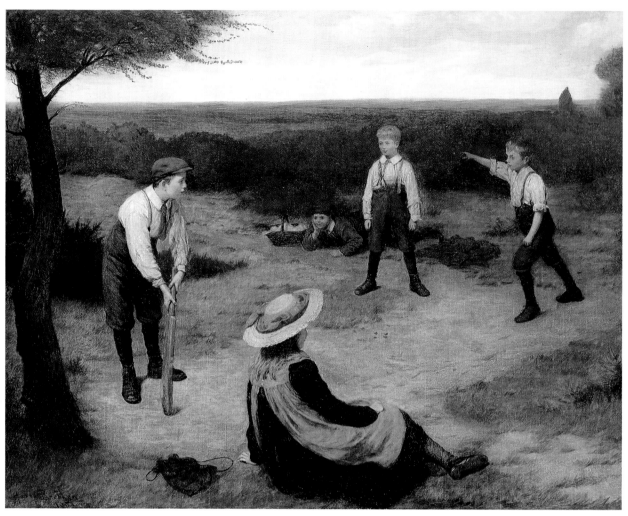

Colour Plate 17. Harry Brooker (op.1895-1918). 'The Game of Cricket', signed and dated 1904. 27½ in. x 35½ in. Royal Exchange Art Gallery, London.

hero. Grace, who was also a bowling enthusiast (*see* p.225) was one of five talented cricket playing brothers. He and his brothers E.M. and G.F., the youngest (who died at the age of thirty in 1880), were sons of one of the most remarkable cricket loving ladies. Mrs. Grace is the only woman to this day whose name is honoured in the pages of Wisden's births and deaths.

With the arrival of the era known as the 'years of grace', dominated by the Grace family from the early 1860s, cricket saw great changes in dress as well as play. The tall hat, whether of white or black beaver, so beloved of cricketers in the 1830s and '40s, gave way in the 1860s to the billy cock, or to dashing caps seen worn in portraits of and by 'Felix' (q.v.). Hardly anybody at that time, male or female, played bareheaded; trousers and skirts were almost always white but belts with a clasp were replacing sashes. The dangerous buckled shoes worn at the beginning of the century, gave way to black boots, then brown or white or a combination of both colours.

The greatest change of all was probably in the condition of the ground

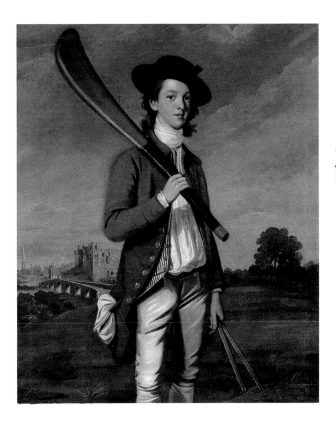

Colour Plate 18. English School. 'Boy with a Bat'. Private Collection.

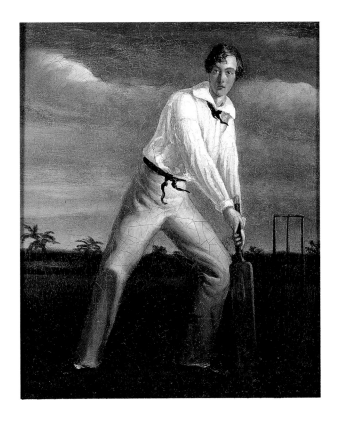

Colour Plate 19. English School. A Young Cricketer, c.1830. 11¾in. x 9½in. The Wingfield Sporting Gallery, London.

surface on which cricket was played. It is said that at an earlier match at Truro, one of the fielders put up a brace of partridge in the long field and another story is told of a visiting team to Glasgow who had to borrow a scythe before they could play the match. Even the classic grounds were, by modern standards, pretty primitive and it was said of Lords that the only respect in which it resembled a billiard table was in the pockets! In 1849, permission was given for the pitch to be swept and rolled at the beginning of each innings. Up until that date, the pitch had remained untouched from the beginning to the end of a match. (Wides and no balls were first scored in 1830 and leg byes in 1850.)

The first colonial team ever to play at Lords was composed of Australian Aborigines who toured England in 1868, ten years before the first white Australian touring team, and fourteen years before the invention of the Ashes; they played forty-seven matches in all, from March until October. Before 1868 there had only been eight overseas cricket tours.

The introduction of qualification rules in 1873 brought the unofficial form of county championship, which existed in the 1860s, up to a level where first class cricket was centred increasingly on the county championship. Nine counties competed in the first championship in 1873 — Derbyshire, Gloucestershire, Kent, Lancashire, Middlesex, Nottinghamshire, Surrey,

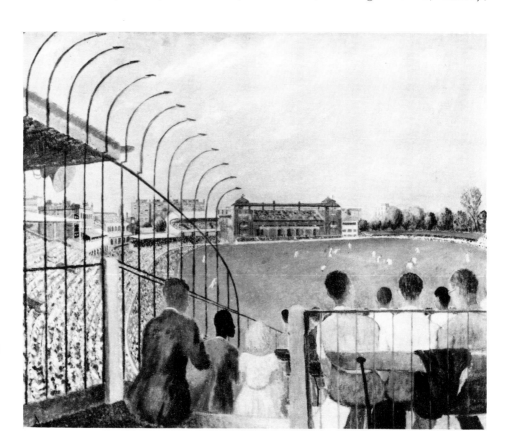

Plate 5/13. Henry Deykin (b.1905). 'Lords. England v. West Indies, 2nd Test match of the 1950 series', May 1950, signed. 19½ in. x 23½ in. Henry Deykin.

Sussex and Yorkshire and the position remained the same until the end of 1887 when five more counties were added to the 1895 championship to mark the start of what historians generally agree to be cricket's 'Golden Age'. These five counties were Hampshire, Leicestershire, Somerset, Warwickshire and Essex. When the 1895 season began, W.G. Grace was in his forty-seventh year but he was still the foremost batsman in the country scoring 1,000 runs in May and passing his century of centuries in first class cricket. After the expansion in 1895, Worcestershire and Northamptonshire joined the English county championship which reached its final number of seventeen participants with the admission of Glamorgan in 1921.

The twenty years prior to the beginning of the First World War in 1914 were the golden age of cricket, and also the heyday of English country house parties. The talented amateur played a larger part in cricket at all levels and indeed in most sports, than he was to do thereafter. It was an age of elegance and style (*see* Colour Plate 21) and an age too in which famous amateur clubs flourished. Free Foresters, I Zingari, founded in 1845 (*see* Plate 5/31), Eton Ramblers and Harrow Wanderers, were just a few but there were many others.

Despite the important role of the amateur at this time and the high standards of play at both public schools and universities, the mainstay of county cricket was nevertheless still supplied by the professional. His status at that time, whilst established, was not high and nor was his remuneration. The days of the massive fees and celebrity status were still a long way off but if he were fortunate, he could acquire a coaching post at a public school on his retirement. Lord Hawke, who captained Yorkshire from 1883 to 1910, paid particular attention to the welfare of the professionals in his team and Yorkshire produced such a high record during this period that it was clear that his policy worked.

One of the greatest amateur cricketers at the end of the nineteenth century was Ranjitsinhji (Kumar Shri, 1872-1933), a great stylist, who broke many batting records during the 1890s. He was also the Maharaja Jam Sahib of Nawangar 1906-1933. In 1899 he became the first batsman to score 3,000 runs in a season and in 1896 he scored two centuries in one day against Yorkshire. He also made centuries in his first Test against Australia, both at home and abroad and captained Sussex from 1899 to 1903. His cricket exploits were followed by those of his nephew, Kumar Shri Duleepsinhji (1905-1959) who played top class cricket from 1924 to 1933.

If W.G. Grace was the 'Champion' and Ranjitsinhji the 'Prince', the 'Master' was certainly Sir John Berry Hobbs (1882-1963), the world's leading batsman between the eras of Grace and Sir Donald George Bradman, the Australian, born in 1908. Hobb's career extended from 1905 to 1934 and no one has yet exceeded his aggregate of 61,237 runs or his 197 centuries, 98 of which were made after his fortieth birthday; he was knighted in 1953.

Test matches started between Australia and England in 1876-7, with the first match played in Melbourne and won by the Australians. The Australians lost

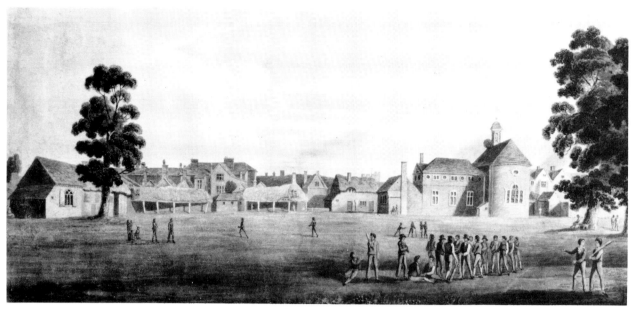

Plate 5/14. E. Pretty (op.1809-1811). 'Rugby School as it appeared in the year 1809'. Hand coloured etching, 10¼ in. x 18¼ in., aquatinted by R. Reeve, published at Rugby by E. Pretty (drawing master), June 1811. Christie's.

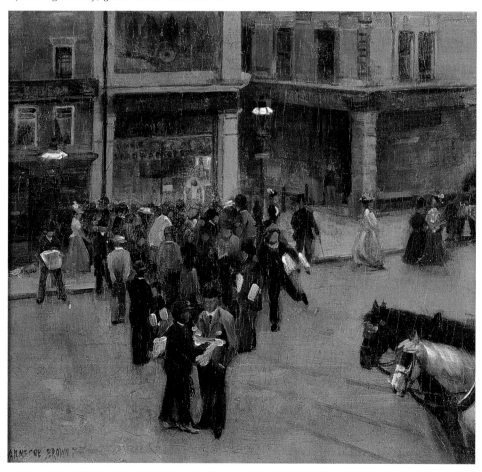

Colour Plate 20. Sir John Alfred Arnesby Brown, RA (1866-1955). 'Waiting to Hear the Results of the great Notts. v. Surrey match, August, 1892', signed. 9½ in. x 10½ in. Sotheby's.

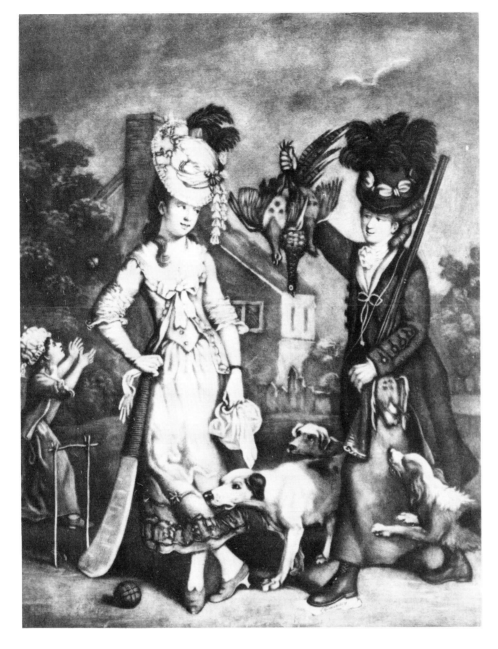

Plate 5/15. John Collet (c.1725-1780). 'Miss Trigger and Miss Wicket', c.1780. Mezzotint. 13in. x 10in. MCC Collection.

the next test in England in 1880; the regular exchange between the two countries has existed ever since, except during the two World Wars. The mythical trophy 'The Ashes' played for between England and Australia originated from a report in the *Sporting Times,* 29th August, 1882 which printed a mock obituary after Australia had beaten England for the first time; it ended: 'The body will be cremated and the Ashes taken to Australia'. An urn given by two ladies to the Honourable Ivo Bligh when his English team beat Australia the following year remains always at Lords, but it postdates the team (*see* Plate 5/11). South Africa entered the test match arena in 1888-9 although the game was firmly established there by the 1840s. When South Africa became a Republic in 1962, leaving both the Commonwealth and the Imperial Cricket Conference, proposed tours by England in 1968-9 and by South Africa in 1970 were cancelled; tests between the countries have been suspended ever

since. England's last official tour to South Africa took place in 1964-5 and that of South Africa to England in 1965.

England's Test Match programme widened dramatically with the entry of the West Indies in 1928, New Zealand in 1928/29, India in 1932 and Pakistan in 1954. These countries were played both at home and abroad as were, of course, South Africa and Australia. In 1930 the first four day Test Match was introduced (*see* Plate 5/12) and that year marked the first visit to England of 'Don' Bradman. He scored a record number of 974 runs in the Test series at the phenomenal average of 139·14.

Bradman's devastating success caused England's captain, Douglas Robert Jardine (1900-1958), to put into action at the next meeting with Australia in 1932-3 a questionable method of bowling, which caused heated argument and dissention and became known as the infamous 'body line'. Harold Larwood, who was amongst the fastest bowlers of all time, was chosen with Bill Voce to execute the leg bowling, which earned him a place in cricket history in perhaps the most memorable test series against Australia. In 1935 the MCC issued formal instructions to prevent the recurrence of 'body line' bowling.

The Second World War caused a major disruption to most sports, including cricket, which suffered a particularly long break, but immediate post-war interest in the top class game was immense. Five day Test Matches were first introduced in 1948 but their success was followed in the 1950s by the steady decline of the three day inter county championship. Many of the county clubs began to show financial losses which were only offset by the share they received from annual Test Match profits. The 1950s were also memorable for the outstanding cricket played by the touring West Indians who had first joined Test Match cricket in 1928 (*see* Plate 5/13). By 1963 the distinction between amateur and professional in first class cricket was abolished and with it, of course, the traditional match between Gentlemen v. Players first played in 1806. All players in county or Test cricket thereafter were known simply as 'cricketers'. Any player was free to negotiate a contract with the county for whom he played and any county was free, after 1968, to offer a contract to an overseas player without residential qualification; the services of the gifted Gary (Garfield) Sobers (b.1936) were hotly competed for before he accepted the offer of Nottinghamshire.

In 1968, a new governing body was formed called the Cricket Council, following a request from the Government to the MCC to create a body that would be eligible for grant aid along the lines of other sports. Its headquarters remain at the MCC ground at Lords, St. John's Wood and its Chairman and Vice Chairman are respectively the President and Treasurer of the MCC.

Since the 1960s the sponsorship of sports has been gradually increasing although not perhaps as fast as it should have done. Important sporting events are now often associated with the company promoting them, especially if they have been promoted over a long period of time. In cricket, the Benson and Hedges Cup introduced in 1972 for a one day competition, the National

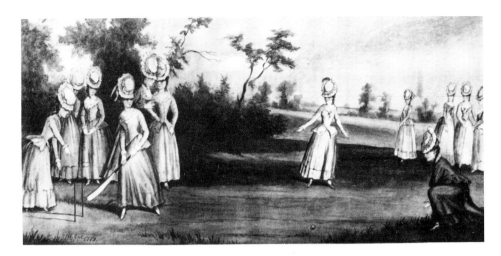

Plate 5/16. 'The Countess of Derby and other Ladies at the Oaks, Surrey', signed T.H. and dated 1779. MCC Collection.

Plate 5/17. Thomas Rowlandson (1756-1827). 'Rural Sports' or 'A Cricket Match Extraordinary'. Watercolour. MCC Collection.

Westminster Bank Trophy inaugurated in 1963 and the John Player League for Sunday competition, first played in 1969, demonstrate that the sponsorship system does work and that the brand name or sponsor are automatically connected with the sporting event in the minds of the public.

Women's Cricket

The third Duke of Dorset became famous for his memorable and rhetorical line 'What is human life but a game of cricket?' What few people know is that he actually continued the line with 'and if this be so, why should not the ladies play it as well as we?' By 1745, women were recorded playing cricket as reported in the *Derby Mercury* of 16th August: 'The greatest cricket match that was ever played in the South part of England was on Friday the 26th of last month, on Gosden Common, Nr. Guildford between 11 maids of Bramley and 11 maids of Hambledon dressed all in white. The Bramley maids had blue ribbons and the Hambledon maids red ribbons on their heads. The Bramley girls got 119 notches and the Hambledon girls 122. There were of both sexes

the greatest number that was ever seen on such an occasion. The girls bowled, batted, ran and caught as well as any men could do in that game.'

Cricket matches between women continued to be played and distinguishing colours were worn by opposing sides, usually in the form of coloured ribbons in the hair. In a match in 1747, we learn that 'the women of the Hilles of Sussex will be in Orange and those of the Dales in Blue'. In 1770, John Collet (c.1725-1780) painted his famous picture of 'Miss Wicket and Miss Trigger' (*see* Plate 5/14); Miss Wicket is shown standing cross-legged, leaning on her bat, in a pose undreamed of for eighteenth century ladies but one quite common in the artistic poses of men. Another point scored for women's liberation (although very little was needed in the eighteenth century) is seen in the action of Miss Trigger who stands one sturdily booted foot upon a booklet entitled *Effeminacy*. Beneath the picture is the following rhyme:

'Miss Trigger you see is an excellent shot.
And 45 notches Miss Wicket just got.'

Seven years later in 1777 a remarkable cricket match was played in private by the Countess of Derby and some of her friends. The Duke of Dorset was so enthused by this match that he wrote an essay in the form of a letter to the 'Ladies' and implored them to follow the recent example set by the Countess and 'some other ladies of quality and fashion' in playing cricket. The essay, accompanied by a drawing by the Duke of the ladies in the cricket field was published after the Duke's death in the *Sporting Magazine* in April 1803. A watercolour of ladies playing cricket signed T.H. and dated 1779, entitled 'The Countess of Derby and other Ladies at the Oaks, Surrey'[2] is in the collection of the MCC at Lords (*see* Plate 5/15). In Thomas Rowlandson's caricature 'The Cricket Match Extraordinary' (*see* Plate 5/16) which took place in 1811 and was apparently played for high stakes, he shows the ladies wearing bunched up skirts of all colours and no hats. Even allowing for artistic licence and the fact that it was a rural match, it is doubtful that the ladies wore anything remotely similar in the dress they chose for playing cricket. Furthermore, the ladies that Rowlandson has depicted can only be described as romping in what looks suspiciously like bare legs. Writers of the time, such as Pierce ⌐gan (*see* Plate 5/17) in his book *Book of Sports and Mirror of Life* (published in 1832) and the *Gentleman's and London Magazine*, 1777, described the lady cricketers as wearing a neat jacket, a mid-calf skirt or petticoat, stockings or loose trousers and always the bergère hat in which the ladies may have had coloured ribbons. The sleeves of the jacket were mid-arm, or long and ruffled at the wrist. By the end of the nineteenth century, while the bergère hat had been exchanged in turn for the feather trimmed bonnet, the peaked cap and the boater, ladies' hats ceased to be worn during play.

Egan's account of a ladies cricket match is as follows: 'A grand Cricket match has been played this month (October) between eleven women of Surrey and eleven women of Hampshire for 500 guineas... The combatants were

dressed in loose trousers with short fringed petticoats descending to the knees and light flannel waistcoats with sashes round the waist. The performers were of all ages and sizes from 14 years to upwards of 50 and were distinguished by coloured ribbons, Royal purple for the Hampshire team, orange and blue for Surrey.'

Many famous cricketers owe a debt to the enthusiasm and encouragement they received from their womenfolk; Mrs. Small, the wife of the legendary batsman, John Small (1737-1826) is known to have attended the matches at Hambledon always accompanied by a vast green umbrella which she flourished excitedly when her husband was batting, shouting 'Run man run, you'll be out!'. Later on, the remarkable Grace family had their mother to thank for the early encouragement she gave her sons; once their fame was established, it is said she used to state her arrival at important functions by announcing 'I am the mother of the three Graces'. George Osbaldeston's mother was a keen follower of her son's sporting triumphs, watching many of his cricket matches from her carriage. Miss Mary Russell Mitford (1787-1855), author of *Our Village*, first published in 1832, wrote a delightful chapter on a country cricket match. In a later edition of the book the illustrations were by the talented Charles Edmund Brock, RI (1870-1938), the painter of many sporting scenes.

Despite the flourishing start made by women cricketers at the beginning of the eighteenth century, their progress considerably slowed down in the Victorian and Edwardian eras. Women did still play cricket but their freedom of movement was increasingly dominated by the strict code of Victorian morality which held sway over the female. Queen Victoria (1819-1901) had always made it quite clear that she considered any form of sport unseemly in

a woman although, on occasions, they might be welcome as onlookers of the sporting activities of their male counterparts. The White Heather Club, of which Stanley Baldwin's wife was a member before her marriage, was the first cricket club for ladies formed in 1887 and in 1890 the 'Original English Lady Cricketers' under assumed names, toured the country playing exhibition matches much to the disapproval of that chauvinist W.G. Grace, who predicted the early demise of this venture. Although the team attracted large crowds during its tour, regrettably true to W.G's predictions, it disbanded at the end of the season. Honour was to some extent satisfied, however, in the late 1890s when the Clifton Ladies team was formed in which W.G's daughter, Bessie, played a leading bat.

After the First World War, cricket began to be played in girls' schools and with the increasing emancipation of women, the Women's Cricket Association (WCA) was formed in 1926. The newly formed WCA adopted the MCC laws of cricket except that the ball was to be smaller, 5oz. (142g.) as opposed to the heavier ball used by the men of $5\frac{1}{2}$-$5\frac{3}{4}$oz. (156-163g.). By 1939, seventeen county associations had been formed and the first women's Test Matches took place in 1934-5 when an English team visited Australia and New Zealand. In 1973, a World Cup was staged for the first time, with England as the host country and also subsequently the winner. The International Women's Cricket Council was formed in 1958 to ensure the future of women's

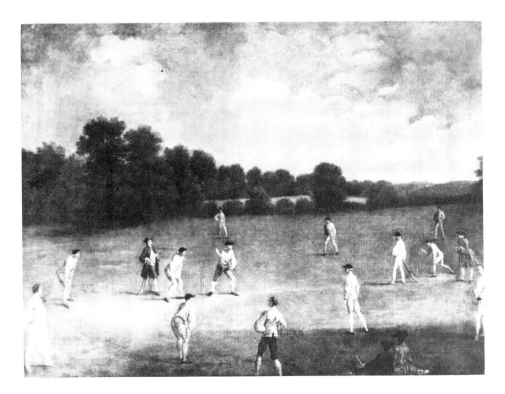

Plate 5/19. Francis Hayman, RA (1708-1776). 'Cricket in Marylebone Fields', c.1740. 28½in. x 36½in. MCC Collection.

international cricket at the highest level. Owing to the slow progress of women's cricket over a period of approximately eighty years, paintings of lady cricketers and matches are understandably few. The game, however, had some formidable patronesses and is, therefore, not totally devoid of paintings.

ART

The problem with cricket paintings has been what to leave out. The game has been fortunate in appealing to a great many talented artists, the best of whom, as with the best of all sporting artists, played the game themselves. Others were fortunate in acquiring great cricket playing patrons, without whom sporting art does not flourish.

William Hogarth, a keen cricketer himself, and Hubert Gravelot have already been mentioned as early artists of cricket paintings. Gravelot taught drawing at the St. Martin's Lane Academy and was a close associate of Francis Hayman (1708-1776) who also taught there, as did John Collet (c.1725-1780). Through this association Hayman was undoubtedly encouraged to produce his two known paintings of the game in the 1740s 'Cricket in Mary Le Bone Fields' (see Plate 5/18) and the better known 'Cricket at the Artillery Ground' under its original name of 'The Play of Cricket' (see Plate 5/19). This painting, which used to hang in a supper room at Vauxhall Gardens, is thought to be lost but is known through its many engravings; it shows a game of single wicket cricket as distinct from the double wicket game which is shown in 'Cricket in Mary Le Bone Fields' which now hangs in the Long Room at Lords. The game depicted in the latter does not appear to differ much from the game described in 1706 in William Goldwin's Latin poem, in which the main features are the double wicket (at that time two forked sticks with another stick, the bail, lying between the forks), the two umpires, the shape of the wicket, scoring with notches on sticks and the touching of the umpire's bat to score a run. This explains why in many early paintings of cricket, each umpire stands close to the wicket and carries a bat. This system, discarded later in the mid-eighteenth century in favour of the 'popping crease' is further confirmed in an agreement for a game played in 1727 between the second Duke of Richmond and a Mr. Broderick: 'Fourteenth: The batt Men for every one they count are to touch the Umpires stick.' In the painting by Louis Philippe Boitard (op. 1737-1763) 'An Exact Representation of the Game of Cricket', 1743 (see Plate 5/20), the two umpires are clearly shown.

In the early days of bowling, the ball was rolled along the ground underarm. Several variations of this delivery must have been used but the main development of 'bowling to a length' was the work of 'Lumpy' Stevens and David Harris in the 1770s. The painting of 'Lumpy' (christened Edward) is by the itinerant artist, Mr. Almond and was painted in 1783 (see Plate 5/21). The legendary 'Lumpy', a great length bowler, was officially employed as a

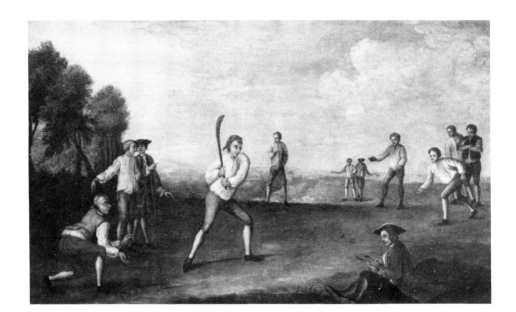

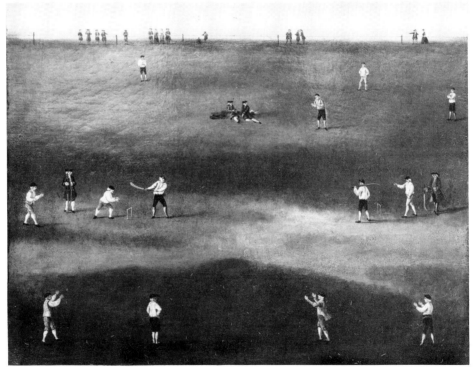

gardener by the fourth Earl of Tankerville at his home, Mount Felix, near Walton on Thames, Surrey, but he often played in the Duke of Dorset's team as indeed did Tankerville. All three men were certainly in the same team due to play in Paris in 1789, which match was abandoned because of the French Revolution. (It may be that this incident led to the comment from G.M. Trevelyan, the social historian, that 'if the French noblesse had been capable of playing cricket with their peasants, their chateaux would never have been burnt'[3].) As with all great early players, 'Lumpy' was often 'lent' to other patrons' teams — presumably for a fee and in order to balance the odds,

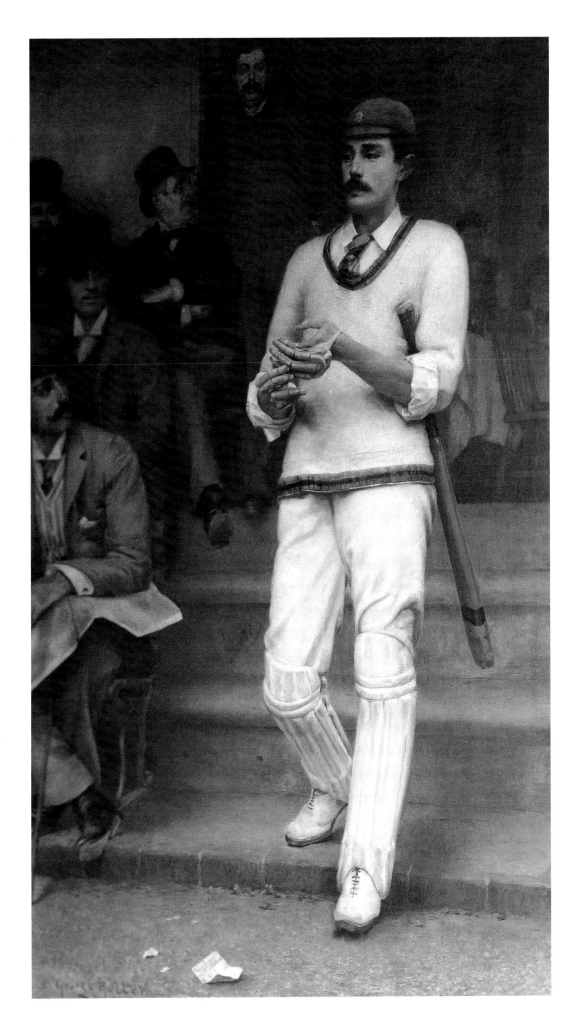

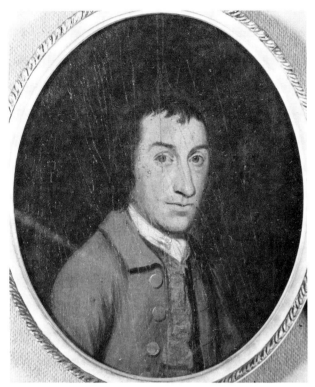

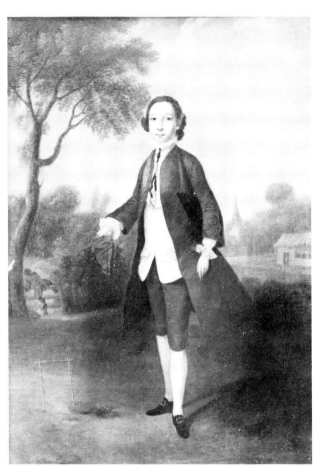

Plate 5/22. Mr Almond. 'Lumpy Stevens', 1783.
The Courtauld Institute of Art and Lord Sackville.

Plate 5/23. Edward Penny, RA (1714-1791). 'Portrait of Sir William Benett', c.1743-44. 20in. x 14in.
Laing Art Gallery and Tyne and Wear Museum Service.

gambling being a necessary accompaniment to the game in the eighteenth and early nineteenth centuries. He was probably the first professional cricketer to be painted.

The type of wicket with two forked sticks and the single bail lying between the forks is clearly shown in the portrait of Sir William Benett of Fareham, (*see* Plate 5/22) allegedly painted by Edward Penny, RA (1741-1791), a pupil of Thomas Hudson (1701-1779), and shows Benett standing by the wicket, but for some unaccountable reason without a bat. The double wicket was superseded by the introduction of the third stump and the second bail in 1776. Thereafter paintings show not only three stumps but show them with notches cut in the tops on which the two bails rested. The portrait of William Wheatley aged fourteen painted by Francis Alleyne (op.1774-90) in 1786 shows three stumps (*see* Plate 5/23), as does Thomas Henwood's memorable but later painting of 'The Scorer' in 1842 (*see* Plate 5/24).

The wicket in Edward Penny's portrait looks very low but even under the 1744 rules, the height of the wicket was only standardised at 22in. and 6in. wide. Other contemporary pictures also show noticeably low wickets, which may bear out the theory that at the beginning of the eighteenth century, the wicket was said to be wider than higher, a fact which the earlier artists might have remembered from their cricket playing childhood days. Thomas Hudson, for a time the most successful portrait painter of his day, was a close associate of Francis Hayman which may have accounted for his sympathetic approach to cricket. Into his upper class portrait groups he has, in several instances,

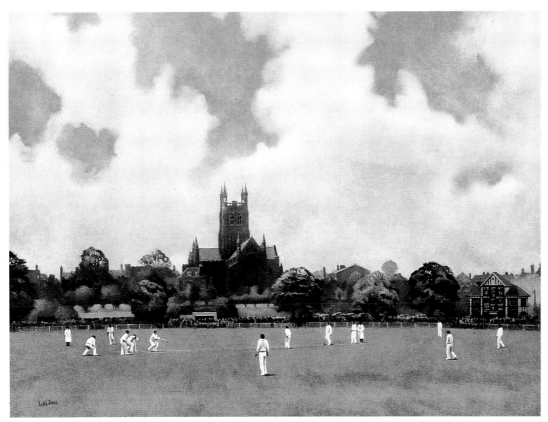

Colour Plate 22. Ralph Bruce. 'Tourists opening match at Worcester, 1954', signed. Wiggins Teape Group.

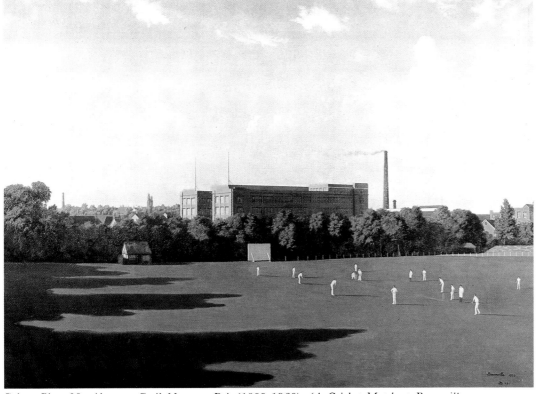

Colour Plate 23. Algernon Cecil Newton, RA (1880-1968). 'A Cricket Match at Bournville, 1929', signed with initials and dated. 38½ in. x 50½ in. Cadbury Schweppes.

introduced a cricket bat, as in his portrait of Mrs. Mathew Michell and her children, c.1757-8 (*see* Plate 5/25), and his sketch of the family of the third Duke of Marlborough, which hangs at Blenheim Palace; the boys in both groups carry cricket bats over their shoulders.

The curved cricket bat which was used from the game's earliest days until the end of the eighteenth century when it was discarded in favour of the straight bat, invented to cope with the longer length of bowling, features in many of the earlier paintings of cricket but does not appear at that time to have had any standard weight or size. The bat in the MCC collection, c.1750 and weighing 5lb. 5oz. is a particularly large example and is by no means typical of the size of bat in use at the time (*see* Plate 5/5 and 5/6). Nevertheless, wooden bats frequently weighed over 4lb. as is clear from a letter written to Fanny Burney (Mrs. d'Arblay) by Mrs. Rishton, 6 June, 1773.[4]

A number of artists of the time had a definite connection with the game of cricket. William Hogarth, Hubert Gravelot, Francis Hayman and John Collet were all associates and had connections with the Art Academy at St. Martin's Lane, in which thoroughfare John Boydell, the successful print publisher, had

Plate 5/24. Francis Alleyne (op.1774-1790). 'Portrait of William Wheatley', 1786. Oval panel 14in. x 11in. MCC Collection.

Plate 5/25. Thomas Henwood (op.1842-1854). 'The Scorer', 1842. 14in. x 12in. MCC Collection.

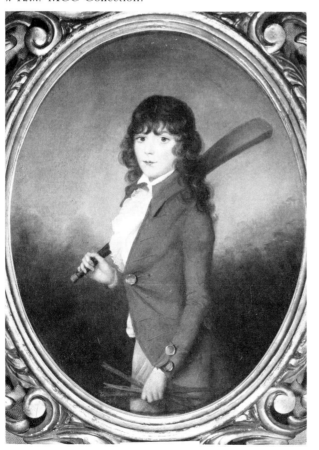

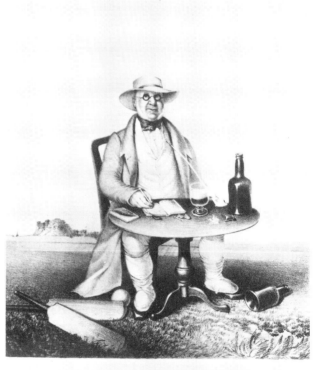

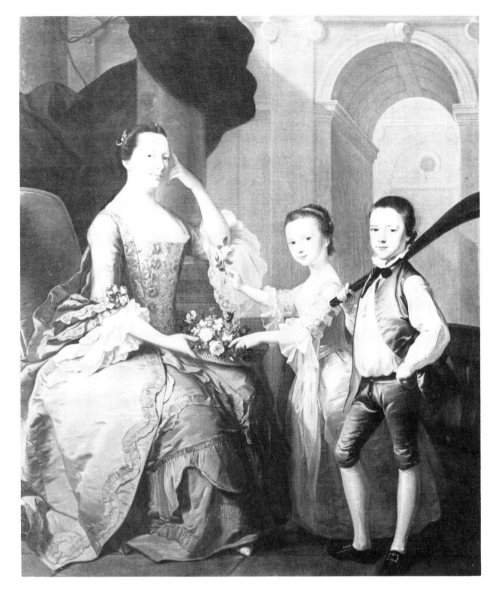

his flourishing business. Edward Penny was a pupil of Thomas Hudson who was himself a close associate of Francis Hayman, and William Redmore Bigg, RA (1755-1828) was a pupil of Edward Penny. Hudson, in his time, taught Sir Joshua Reynolds (1723-1792), Joseph Wright, ARA, of Derby (1734-1797), and John Henry Mortimer, ARA (1741-1779) who was in turn pupil to Robert Edge Pine (c.1730-1788), a very keen cricketer. Robert Scaddon (op.1743-74) was probably also a pupil of Hudson. All these artists produced fine cricket paintings and were clearly influenced by each other's interest in the game. Furthermore, many of their patrons had, in the eighteenth century, a close association with the arts. The Duke of Dorset, a founder member of the MCC, is known, for example, to have patronised the artists Reynolds, Gainsborough, Opie, Humphry, Hoppner and Romney. Sir Joshua Reynolds was a close associate of the Duke who was a pall bearer at Reynolds' funeral in 1792. Gainsborough painted the Duke in 1782.

Both Reynolds and Gainsborough painted the Duke's mistress, the ravishing cricket playing Giovanna Baccelli, who is alleged to have run the

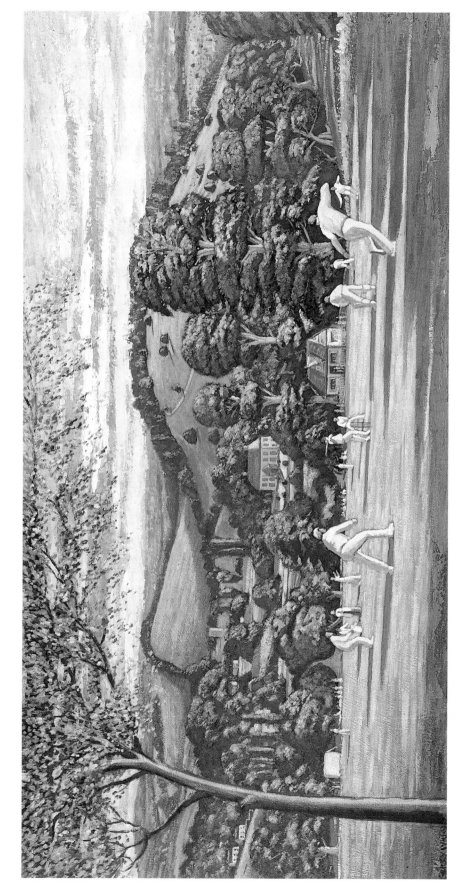

Colour Plate 24. Gerry Wright (b.1931). 'Cricket on a Summer's Evening', signed. 24in. x 47½in. The Wingfield Sporting Gallery, London.

108

Duke out at cricket and, as a result, was dismissed
from his keeping, which is an unlikely story since
she was with him for at least ten years until 1789
when he made a respectable dynastic marriage.
Sir Ozias Humphry, RA (1742-1810), another of
the artists that the arts and cricket loving Duke
patronised was, of course, the brother of William
Humphry, his own steward: a clear case of wheels
within wheels.

Since Thomas Beach (1738-1806) was probably
the most distinguished of Sir Joshua Reynolds'
pupils and highly influenced by him, it continues
the theory of the possible connecting thread
between the artists and the game (see Plate 5/26).
Johan Zoffany, RA (1733-1810) who also painted
a cricket portrait group was patronised by the

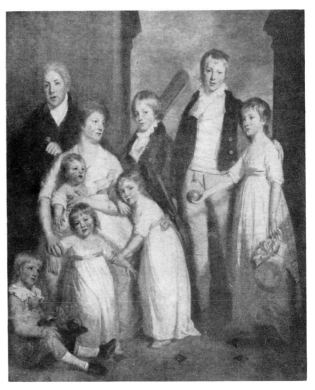

great actor, David Garrick, himself a highly enthusiastic cricketer and a close
friend of the artist Robert Edge Pine. Hugh Barron (1747-1791), another gifted
pupil of Sir Joshua Reynolds, painted at least two portrait groups in which
cricket featured. He shared a love of playing both cricket and the violin with
his contemporary, the batsman John Small of Hambledon, who was presented
with a violin by the Duke of Dorset, 22nd May, 1775, after battling to win a
match. The connecting threads suggest that the game of cricket introduced,
apparently casually, into so many portrait groups of the eighteenth and early
nineteenth centuries was no coincidence.

American painters were also prominent in depicting the game. Cricket was
being played at Virginia at the surprisingly early date of 1709-10, which is
borne out by a number of contemporary American prints and drawings. 'The
Cricketers' by Benjamin West, PRA (1738-1820) shows an unusual group of
Americans playing the game in England after completing their education in
this country. West, a Pennsylvanian, left America for good in 1760 and
painted his cricket portrait group in 1763. John Wollaston (op.1738-75, son of
the London portraitist, John Wollaston, c.1672-1749), conversely left England
for America in 1749 where he developed a large practice in a number of cities
from New York to Virginia. He painted a portrait of Warner and Rebecca
Lewis, c.1760, where the boy is shown holding a cricket bat with a ball lying
beside him.

John Singleton Copley, RA (1738-1815) followed his fellow countryman
Benjamin West to London in 1775. Originally self taught, he was much
influenced by Sir Joshua Reynolds; he painted Richard Heber (1773-1833) as
a boy complete with his long curved cricket bat and ball with prominent seam,
c.1783 (the midget sized fallen wicket of the forked stick variety can surely be
no more than an artistic symbol?). When David Allan (1744-1796), the
Scottish portrait and history painter painted the Cathcart family (see Plate 5/27)

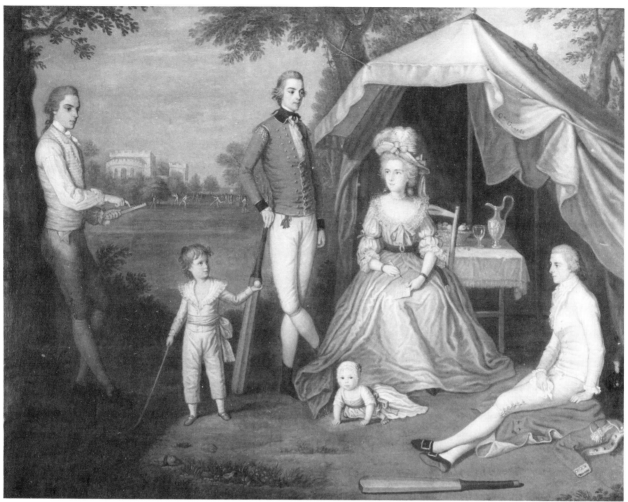

Plate 5/28. David Allan (1744-1796). 'The Cathcart Family', c.1784-5. 47½in. x 61½in. Royal Academy of Arts and the Cathcart family.

at Schawpark, near Alloa, in 1784-5, cricket was already established in Scotland. The painting shows straight cricket bats, which had only recently been introduced, but the scorer is still using the notched stick system although score cards had been in use since the 1740s. Other Scottish artists to depict cricket portraits or scenes were Allan Ramsay (1713-1784) and David Martin (1737-1797) who was his pupil — the connecting thread again.

Eton and Harrow have both featured in cricket paintings over the years. Henry Walton (1746-1813), a pupil of Zoffany, painted a cricket scene at Harrow School in 1771, and later on in the nineteenth century Harrow featured again in the Eton v. Harrow match at Lords in 1886 (*see* Plate 29), painted by Albert Chevallier Tayler, RBC (1862-1925). William Evans, RWS (1798-1877) of Eton, who followed family tradition as a drawing master at the school, also featured the game in his 'Cricket on College Field, Eton'. Henry Edridge, ARA (1769-1821) featured Harrow in the background of his portrait of Philip Wodehouse, aged thirteen, indicating the enormously important role that cricket played in nineteenth century public school life. Valentine Walter Bromley (1848-1877) painted 'At the Eton and Harrow Match' after which an engraving was made in 1877 (*see* Appendix).

By the early nineteenth century, the large scale society cricket portrait in oil had lost favour; small scale portraits and landscapes in which cricket featured

Plate 5/29. Albert Chevallier Tayler, RBC (1862-1925). 'Eton v. Harrow at Lords, 1886'. MCC Collection.

took their place until the large full length cricket portraits were to appear again at the end of the century. By the 1840s the cricket professional had made his appearance thereby bridging the gap which had previously existed between gentlemen and players. The cricket professional began to be featured in small but understated portraits, presumably in keeping with his new status. In the previous century the only professional cricketer to be painted was 'Lumpy' Stevens by Almond. Also by the early nineteenth century, increasing use was made of watercolour, pencil and pastel; the development of the lithographic process made prints more easily available for an increasingly enthusiastic public.

With the foundation of the Royal Academy in 1776 and the election of Sir Joshua Reynolds as its first President, British art can be said to have taken on a new importance and a truly European status which continued into the nineteenth century, but so far as cricket art was concerned, with formal cricket portraiture in temporary mothballs, the artists turned very often to picturesque landscape cricket, dear to the heart of Mary Mitford, that enthusiastic follower of the game. As she was to explain in *Our Village* (published in 1832), neither the cricket promoted at Lords or the grand private matches were what she considered to be the real heart of cricket: 'No, the Cricket I mean is a real solid old fashioned match between neighbouring parishes where each attacks the other for the honour and a supper, glory and a half crown a man'. One artist to successfully achieve Miss Mitford's ideal was Joseph Mallord William Turner, RA (1775-1851, described by the writer and art critic, John Ruskin (1819-1900), in *Modern Painters* 'as the greatest painter of all time') who featured cricket matches in several of his memorable landscapes painted during this period of change in cricket art. Another was John Robertson Reid (1851-1926), the Scottish landscape and genre painter, and a pupil of George Paul Chalmers (1833-1878), an artist much influenced by Turner. Reid's 'Country Cricket Match' painted in 1878 (*see* Plate 5/30), is a superb illustration of the country game and shows that the artist knew how to play

himself. Other artists to depict village cricket were John Ritchie (op.1858-1875) and Sir David Murray, RA, RSA, RSW, RI (1849-1933), another Scottish landscape painter who was much influenced by French Impressionism.

Cricket has not always been an attractive subject to paint. Without commissioned portraiture, the nineteenth century artist was faced with a dilemma — either to depict the game with the utmost accuracy which, although it might appeal to an enthusiast, might not give the painting a wide market — or to paint a decorative landscape in which the players were purely incidental. It certainly caused the caricaturist, Harry Furniss (1854-1925) to write in 1896: 'Cricket is a most unattractive subject for the artist. It is, in fact, impossible to make a satisfactory picture of our national game: a crowd of ordinary sightseers in the foreground and also in the distance, and between these, a large expanse of green grass, with a few white spots representing Cricketers — dotted here and there, is all the material the artist has at his command, and, twist it as he may, or take it from any point of sight he selects, it remains formal, flat and unattractive.'

With imagination and ingenuity, this problem that can also apply to all sports to find an interesting decorative and unusual angle, was possible to overcome either by painting the spectators in the foreground as distinguished personalities as in the painting by George Hamilton Barrable (op.1873-87) and Sir Robert Ponsonby Staples, Bt. (1853-1943) of an imaginary Test Match between England and Australia at Lords in 1887 (*see* Plate 5/31), or by featuring small groups of players. Later and subsequent nineteenth century artists pandered to the fashion popular with the Victorian public and depicted children games or sports. William Henry Hunt, RWS (1790-1864), another artist who earned the praise of the benevolent Ruskin, painted several boy

cricketers in both watercolour and oil as did Robert James (1809-1853), Thomas Webster, RA (1800-1886, *see* Appendix), John Morgan, RA, RBA (1823-1886), and Alexander Hohenlohe Burr (1835-1899) who specialised particularly in genre children (*see* Appendix). Perhaps the most famous of all the paintings to depict children playing cricket currently fashionable at that time was the portrait by Philip Hermogenes Calderon, RA (1833-1898) entitled 'Captain of the Eleven' (*see* Plate 5/32), which became well known for its use in the promotion of Pears' Soap in 1898. George Frederick Watts, OMRA (1817-1904), a pupil at the school at Blackheath run by Nicholas 'Felix' Wanostrocht, chose to depict the game in a different way making a number of preliminary sketches for a series of lithographs illustrating batting strokes, commissioned by Felix and dedicated to several notable personalities at Lords.

The end of the nineteenth century saw the return to fashion, to some extent,

Plate 5/31. George Hamilton Barrable (op.1873-87) and Sir Robert Ponsonby-Staples, Bt. (1853-1943). 'England v Australia at Lords', 1886. 58in. x 117in. (Lords is seen here from the 'A' enclosure, the view is towards the Tavern. The scene is imaginary although all the players are identified.) MCC Collection.

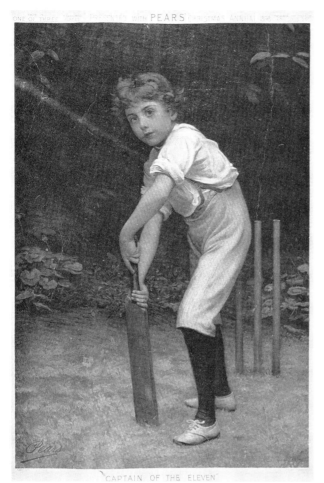

Plate 5/33. Lowes Cato Dickinson (1819-1908). 'Portrait of Sir Spencer Ponsonby-Fane, founder of the I Zingari Cricket Club', signed. 52in. x 38in. Sotheby's.

Plate 5/32. Philip Hermogenes Calderon, RA (1833-1898). 'Captain of the Eleven', 1898. Exhibited posthumously at the FAS, 1907. Thames County Primary School, Blackpool.

of the formal cricket portrait. Notable sporting personalities now required to be painted full length in their chosen sporting setting, and artists like George R. Roller, RPE (op.1887-96) who painted his brother, the Surrey batsman, W.E. Roller going out to bat in 1883 (*see* Colour Plate 21), Archibald Stuart Wortley (1849-1905), a pupil of Sir John Everett Millais, Bt. (1829-1896) who painted the legendary 'W.G.', and The Hon. John Collier (1850-1934), the historical and portrait painter (whose full length portrait of A.N. Hornby, Esq.,[5] Captain of the Lancashire Eleven is in the collection of the Blackburn Museum and Art Gallery, *see* Appendix), were among the artists commissioned to do so. Hornby was also painted three-quarter length by the Royal Academician, Walter William Ouless (1845-1933) which portrait was commissioned by Lancashire Cricket Club in 1900 (*see* Appendix). Ouless, an immensely successful society artist, was commissioned by the MCC in 1897 to paint Sir Spencer Ponsonby-Fane (*see* Plate 5/33), co-founder of the I Zingari Club and the Treasurer of the MCC.

Inevitably there followed in the wake of W.G. an enormous number of paintings, drawings, watercolours and prints. The sporting illustrator, Harry Furniss, drew one hundred sketches of the bearded giant to commemorate his 100 centuries, which were incorporated into a small book in 1896, entitled *How's That?*. Other talented illustrators (illustration was an art currently much in demand from the 1890s to the First World War and before photography was really into its stride) to include cricket in their work were Henry Mayo

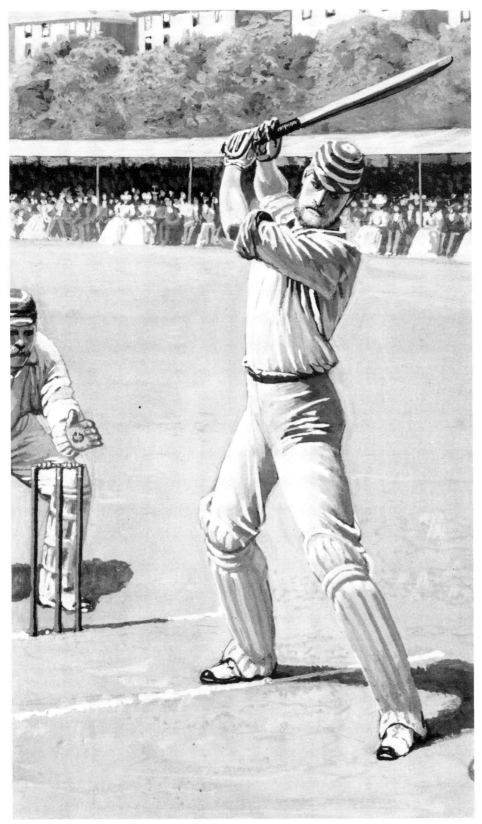

Plate 5/34. Lucien Davis, RI (1860-1941). 'Bonnor stood still at the Crease at Lords, Sherman keeping wicket.' Grisaille, 9in. x 6in. Original illustration for July/December issue of Badminton Magazine, *1896.* The Wingfield Sporting Gallery, London.

Bateman (1887-1970), Lucien Davis, RI (1860-1941, *see* Plate 5/34) who illustrated the *Badminton Magazine* Edition of Cricket and Sir Leslie Ward ('Spy', 1851-1922). 'Spy', who was encouraged to become a portrait painter by the artist William Powell Frith (1819-1909) was, perhaps, better known as a caricaturist and in this role submitted his cartoons of sporting personalities to the magazine *Vanity Fair*. Another caricaturist, who managed at a very early age to depict W.G. was Sir Max Beerbohm (1872-1956); his cartoon (*see* Plate 5/35) shows W.G. holding a cheque for £10,000 bearing the signature of Edward Lawson, the editor of the *Daily Telegraph*, who had organised a sitting fund for him in 1895 after W.G.'s famous run of 1,000 in May. Many of the highly versatile illustrators were also keen cricketers and enthusiasts, like James Thorpe (1876-1949). Frank Reynolds, RI (1876-1953) formed a cricket team from fellow artists of the London Sketch Club which often played against the MCC at Lords. On the only known occasion when the formidable W.G. was playing and G. Hillyard Swinsted made a century, Frank Reynolds bowled them out.

In 1886 the New English Art Club (NEAC) was formed, largely as England's answer to French Impressionism. Founder members included the artists Whistler, Clausen, Wilson Steer and La Thangue. 'The Village Cricket Scene' painted by Sir David Murray, RA, RSW, RI (1849-1933), who was also a member of this group, clearly shows the influence of French Impressionism. One of the French leaders of Impressionism was Camille Pissarro (1830-1903) who found, on his numerous visits to England, that cricket made an ideal foreground subject for several of his stunning land-scapes. From a cricket enthusiast's point of view, neither the game portrayed in Pissarro's 'Cricket on Hampton Court Green' (1890) or his 'Cricket at Bedford Park' painted in 1897 gives much idea of the game being played, as the foreground figures are blurred in the impressionistic style, but an impression is after all part of the charm of the style.

Plate 5/35. Sir Max Beerbohm (1872-1956).
'W.G. Grace'. 8in. x 12¾in. MCC Collection.

*Plate 5/36. Spencer Frederick Gore (1878-1914). 'The Cricket Match', signed and dated 1909.
16in. x 18in.* City of Wakefield Metropolitan District Council.

Another artist who was influenced by the French Impressionists was Spencer
Gore (1878-1914), one of the founders of the Camden Town Group in 1911
of which he became President. His early death deprived England of one of her
finest exponents of Impressionism but, fortunately for lovers of cricket art, his
painting of the 'Cricket Match' (set perhaps in Hertfordshire) was executed in
1909 (*see* Plate 5/36). Painting at a similar time was the portrait artist, George
Elgar Hicks (1824-1914); whilst he was born fifty years before Gore and was
clearly influenced by the earlier school of Victorian genre, his later work, as
in his group portrait of 'Three Young Cricketers' painted in 1883 (*see* Plate
5/37) shows distinct signs of French Impressionism. Hicks, after all, was born
only six years before Pissaro outliving him by eleven years and dying in the
same year as Gore, so it would have been surprising, painting as he did over
such a long span, if he had not been influenced to some extent by this strong
school. An artist working at the turn of the century who appears to have
escaped any kind of Impressionistic influence was the landscape painter, Frank
Batson (op.1892-1904); his picture 'Playing out Time in an Awkward Light'
(*see* Plate 5/38) was painted in 1901 and exhibited at the RA.

 Alfred Chevallier Tayler (q.v.), whilst a Victorian by birth, spanned both
the Edwardian era and the 1920s. His cricket painting of 'Eton and Harrow
Match at Lords' painted in 1886 (*see* Plate 5/29) shows clear signs that he was
also influenced by the Impressionist School. In the quite different style of an
illustrator are his series of forty-eight drawings for *The Empire's Cricketers* which
were published by the Art Society in 1905, in weekly parts and later as a bound
edition with a text by G.W. Beldham (q.v.), the Middlesex cricketer and the
pioneer of action photography.

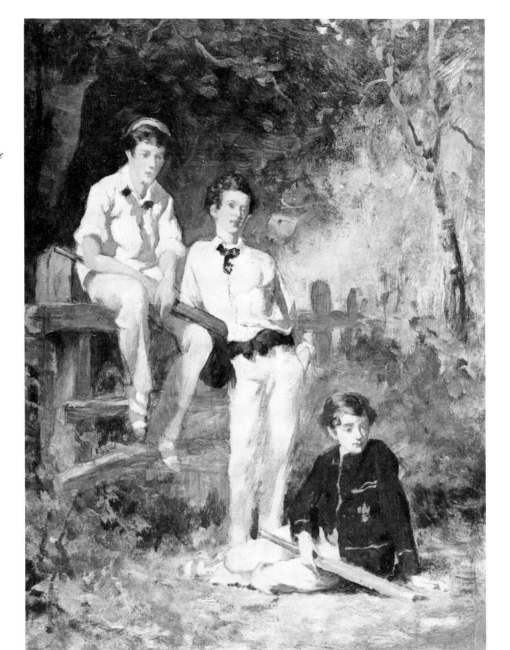

Photography, initially feared to be the death knell of all sporting art, did, for a time, deal it a savage blow, but photography could be used to advantage and as early as 1905, Tayler is said to have used Beldham's famous series of cricket photographs as the basis of his own drawings produced in the same year. Throughout the twentieth century, photography has increasingly been used in subject and portrait painting, to enable artists to portray a sport accurately without necessarily being players themselves.

After the First World War a time of assessment took place which continued into the 1920s. It was an age of machines in which art was dominated by painters such as Percy Wyndham Lewis, LG (1882-1957), Sir Jacob Epstein, LG (1808-1959), and Paul Nash (1889-1946). Commissions for art work were increasingly obtained from commercial institutions and public companies — a trend that was to continue and is illustrated in the period up to the Second

Plate 5/38. Frank Batson (op.1892-1904). 'Playing out time in an awkward light'. 48in. x 72in. Exhibited RA, 1901. Nottinghamshire County Cricket Club.

World War by the painting of 'A Cricket Match at Bournville' in 1929 (*see* Colour Plate 23). Commissioned from the artist, Algernon Newton, RA (1880-1968) by William Cadbury, a director of Cadbury Ltd from 1899 to 1937, as a Jubilee gift to the firm, the painting depicts the cricketers and background buildings in a precise style as does the later painting of the fourth Test Match at Headingley, 1953, by the artist Joseph Appleyard (1908-1960) which he exhibited at the Yorkshire Artists in that year (*see* Appendix). After the war came the period of abstract painting which was to dominate the 1950s and continue into the 1960s; the use of colour became important, and styles were individualistic. The portrait painter, Ruskin Spear, CBE, RA, was commissioned to paint the leading fast bowler of the time, Frederick Sewards ('Fiery Fred') Trueman (b.1931), who broke all records by taking 307 wickets in Test Matches (*see* Plate 5/39). In his first season with England in 1952, he took 29 wickets against India, including 8 for 31 at Old Trafford. Spear has portrayed Trueman as an aggressive figure in a highly individualistic way in a strong painting unrelieved by the picturesque softness of earlier portraits; Trueman's casual dress compares interestingly with the suave elegance of Roller's earlier portrait (*see* Colour Plate 21) or Collier's portrait of Hornby (*see* Appendix).

Plate 5/39. Ruskin Spear, CBE, RA (b.1911). 'Portrait of F.S. (Fiery Fred) Trueman', 1963. 82in. x 26½in. MCC Collection.

FOOTNOTES

1. *Boys' Own Magazine* (Midsummer) 1863.
2. The Oaks was the name given to the famous race for fillies, founded by the 12th Lord Derby in 1779.
3. Trevelyan, G.M., *English Social History,* first published by Longmans, 1942.
4. Ed. Annie Raine Ellis, *The Early Diary of Frances Burney,* Vol.1, (2 vols.) London, 1889. 'Mrs Rishton begs Miss Burney to Buy Mr Rishton two cricket batts made by Pett, of 7 Oaks [i.e., where the 3rd Duke of Dorset maintained his great Sevenoaks Vine ground]. You will get them at any of the great toy shops, the maker's names always stamp'd upon them. Ask for the very best sort, which cost 4s. or 4s. 6d. each. Let them weigh 4oz. [i.e. 4lbs.] and a quarter, or 4oz. and half each. Send them by the Exeter post coach.'
5. The cricket loving poet and writer Francis Thompson (1859-1907) is responsible for immortalising Albert Neilsen Hornby in a poem entitled 'At Lords', which includes the following lines:
'. . . As the run stealers flicker to and fro, to and fro
O my Hornby and my Barlow long ago! . . .'

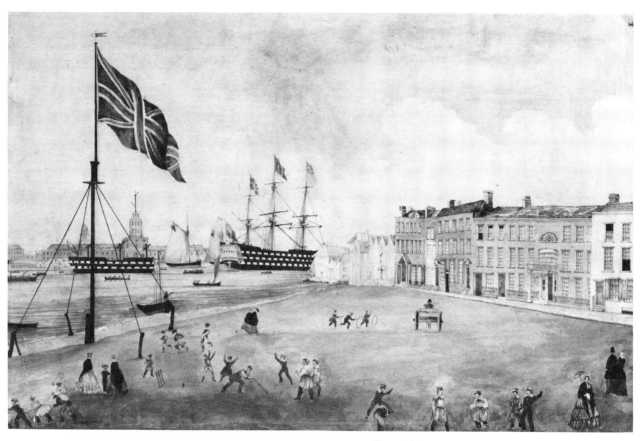

Plate 5/40. Lt. James Burney 'Students playing cricket at the Royal Naval Academy, Gosport' (Cold Harbour). 14in. x 21½in.
Rutland Gallery, London.

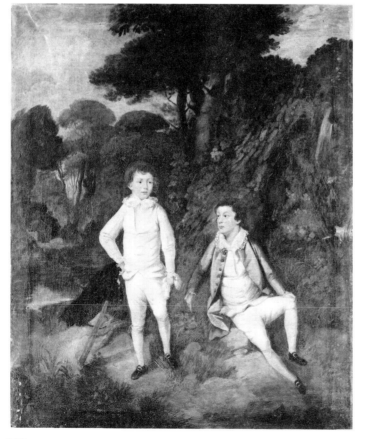

Plate 5/41. Conrad Martin Metz (op.1809-1811). 'Portrait of two boys dressed for cricket, one holding a bat in a wooded landscape', signed and dated 1776. 36in. x 20in. Sotheby's.

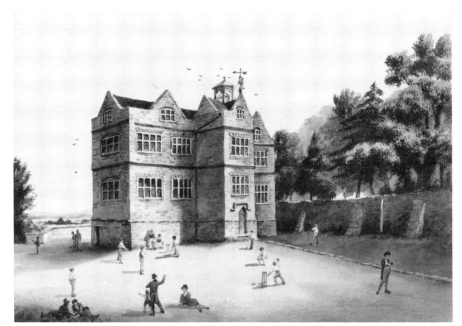

Plate 5/42. T. Rickards (fl.1819). 'A cricket match, School House, Harrow'. Watercolour. 8¾ in. x 12¼ in. Sotheby's.

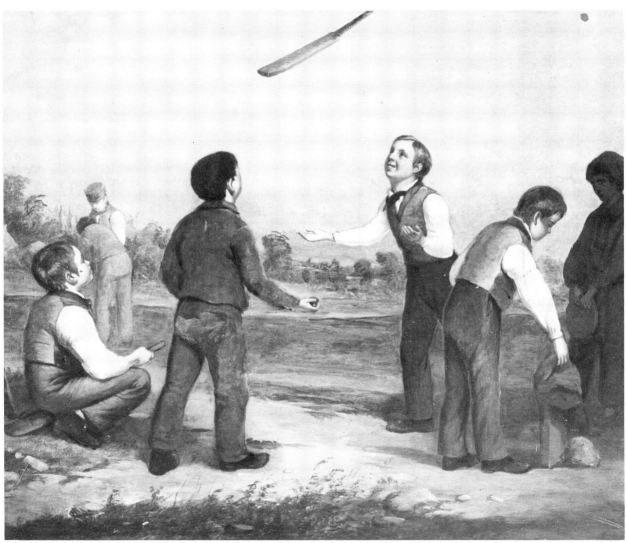

Plate 5/43. Artist unknown. Boys tossing up a cricket bat. Topham Picture Library.

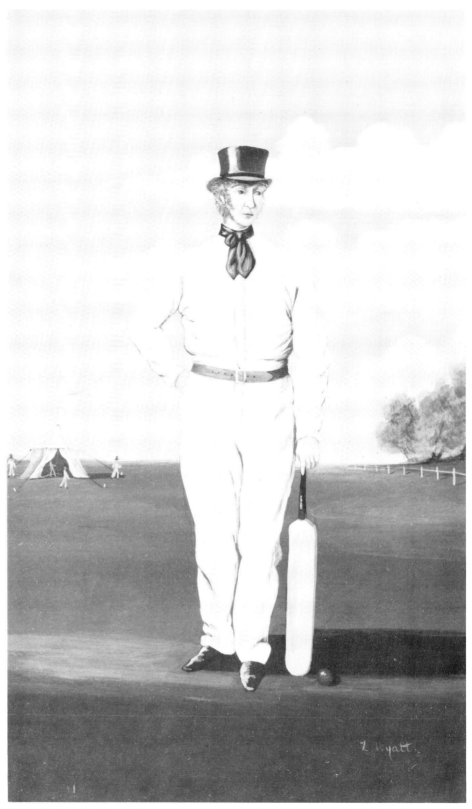

Plate 5/44. L. Wyatt. 'A 19th century cricketer standing before a tent', signed. 12 ¾ in. x 7 ¾ in. Christie's.

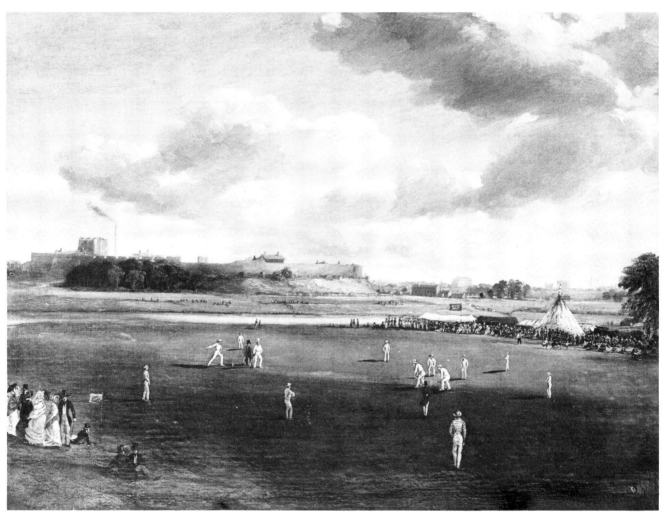

Plate 5/45. Samuel Bough, RSA (1822-1878). 'Cricket match at Edenside, Carlisle', c.1850.
24in. x 35in. Carlisle Museum and Art Gallery.

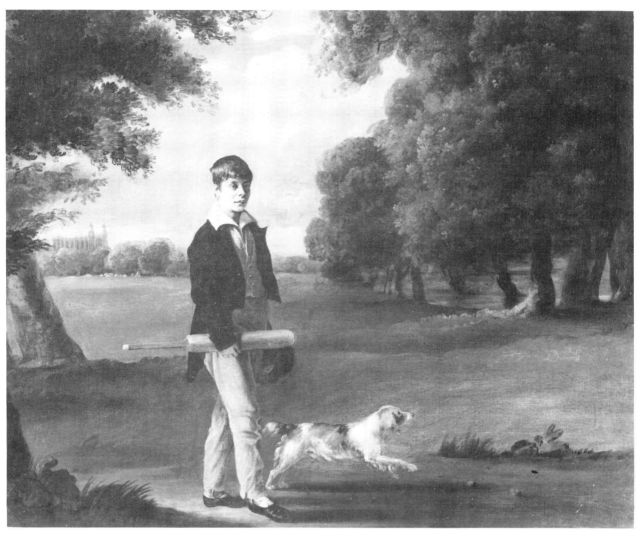

Plate 5/46. Attributed to Ramsay Richard Reinagle, RA (1775-1862). 'A young man with cricket bat'. 20½in. x 24in. Bonhams.

Colour Plate 25. William Bowyer, RA. 'Botham', 1985, signed and dated 85. William Bowyer.

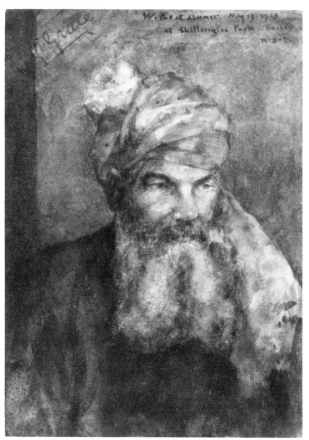

*Plate 5/48. Henry Scott Tuke, RWS (1858-1929).
'W.G. in Ranjitsinhji's turban, at dinner, May 19, 1908,
at Shillinglee Park, Sussex', signed. Watercolour.
9½in. x 6¾in.* Christie's.

*Plate 5/47. E.P. Kinsella.
'The hope of his side',
c.1900, signed. 13in. x
8½in.* Christie's.

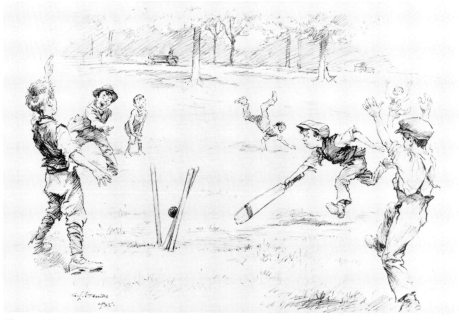

*Plate 5/49. George Loraine Stampa (1875-1951). 'The Field " 'ow's that?'' The umpire
(throwing in the ball) ''Hout'' ', signed and dated 1925. 10in. 14in.* The Wingfield Sporting
Gallery, London.

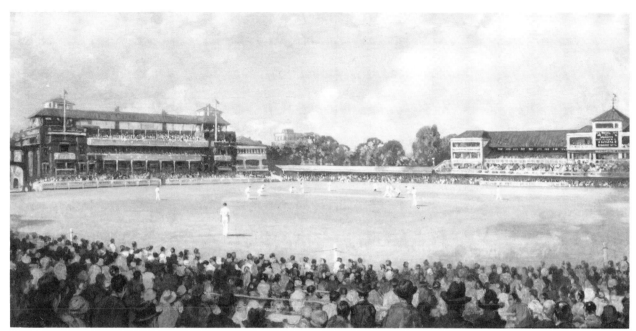

Plate 5/50. Alfred Egerton Cooper, RBA, ARCA (1883-1974). 'A cricket match at Lords',
signed and dated 1938. 26½ in. x 59¼ in. Sotheby's.

Plate 5/51. Peter Brookes. Drawing for the
Folio Society edition of England, Their
England, *published 1986.*
The Folio Society.

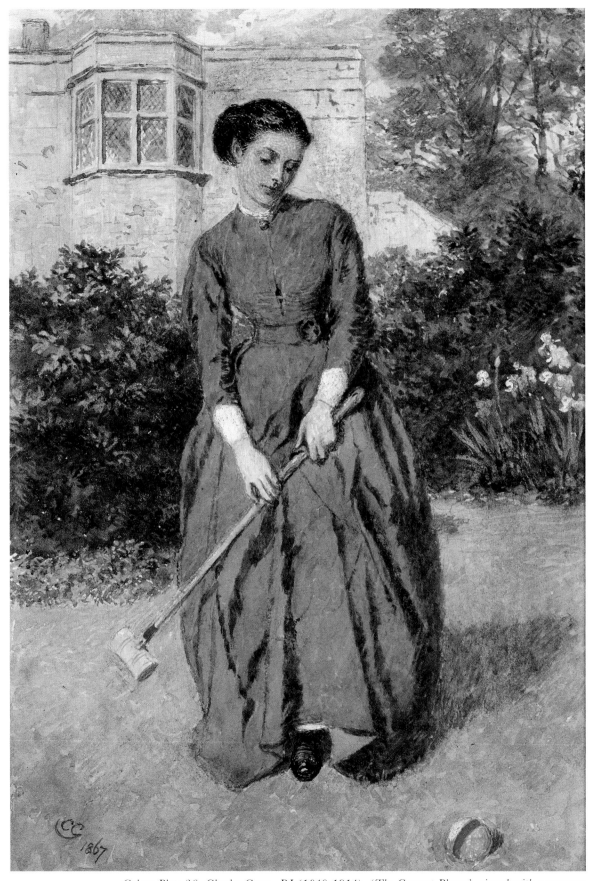

Colour Plate 26. Charles Green, RI (1840-1914). 'The Croquet Player', signed with monogram and dated 1867. Watercolour. 6½ in. x 4½ in. The Maas Gallery, London.

CHAPTER 6

Croquet

Croquet is aptly described in the *Oxford Companion to Sports & Games,* 1975, as a lawn game played with balls and a mallet on a court measuring 35 x 28yds. (31.95 x 25.56m.) on which are set out six hoops and one central peg. To many of us, the game conjures up youthful memories of time spent pursuing or searching for the ball in wet undergrowth, croqueted there by an opponent with malicious not romantic intent, and of a sport where the Conference Laws of croquet drawn up in 1870 had not always percolated to country houses or vicarage lawns by the twentieth century.

In reality croquet is a highly skilled game, the object being to score all twelve hoops (each hoop in both directions) and the peg point in the correct order with each ball. The number of strokes taken to achieve this is immaterial. The hoops are made of round iron ⅝in. (16mm.) thick and have a square top (crown) coloured blue for the first hoop and red for the last hoop known as the 'Rover'. The hoops stand 1ft. (30.5cm.) out of the ground and the inside

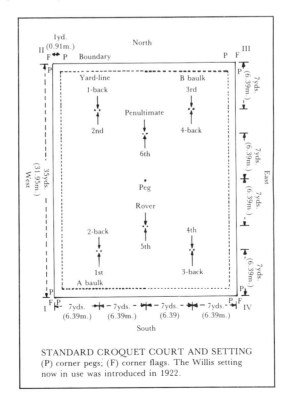

STANDARD CROQUET COURT AND SETTING
(P) corner pegs; (F) corner flags. The Willis setting now in use was introduced in 1922.

Plate 6/1. Standard croquet court and setting.

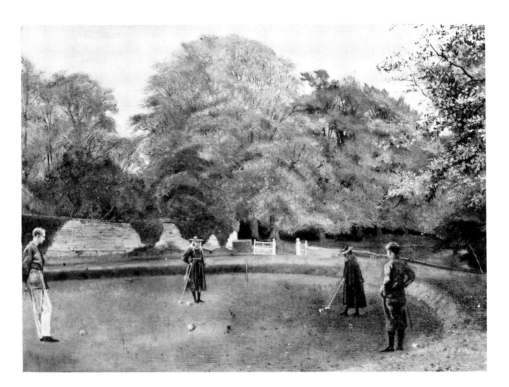

measurement between the uprights through which the ball passes is 3¾in. (9.53cm.). The balls, originally made of boxwood, are now made of compressed cork covered with a layer of plastic or composition material and coloured respectively blue, red, black and yellow, are 1lb. (0.4536kg.) in weight and 3⅝in. (9.2cm.) in diameter. The mathematically inclined will, therefore, deduce that the balls are only ⅛in. (3mm.) smaller than the hoops through which they have to pass — hence the skill required. Four balls are always used and in singles, each player has two balls. Blue and black are always partners against red and yellow but whoever wins the toss may choose the colours with which to play. The mallet with which the player makes his shots is made of wood and weighs 2¾-3¾lbs. (1.247-1.701kg.) although the most common weight is 3-3¼lbs. (1.360-1.474kg.). The head of the mallet is ideally 9in. (22.86cm.) long and has a diameter of 2¼-2½in. (5.71-6.35cm.); both square and round mallets are employed. The shaft of the mallet is best made from hickory although both metal and nylon shafts are used. There are twenty-six points in a full game and the score is calculated by a rather complicated system as the difference between the maximum twenty-six points and that achieved by the loser.

It seems probable that croquet is derived from the game of Pall Mall or Paille Maille which was played in the sixteenth century (*see* pp.56 and 57). Randle Cotgrove's *Dictionary* of 1632 records 'Paille Maille is a game where in a round box bowle is with a mallet — struck through a high arch of iron (standing at either end of an alley) which he that can do at the fewest blows, or, at the number agreed on, wins.' (Whether the word mallet is derived from Mall is not known.) Paille Maille originated in France and was certainly being played at Languedoc as early as the thirteenth century. Le Jeu de Mail, another ancestor of croquet, was enjoyed by the despotic French King Louis XIV (1638-1715) and was also a game in which the ball was played with a mallet through successive hoops on the ground. Whilst Paille Maille is recorded as

being played in both France and Scotland during the latter half of the sixteenth century and the first half of the seventeenth century, it does not appear to have been as popular in England, although the Stuart Kings played it, presumably because of their close French associations. Charles II (1630-1685) is alleged to have played it on the site of what is now The Mall, the road which runs between Buckingham Palace and Admiralty Arch. In his diary for 15th May, 1663, Samuel Pepys records that he 'walked in the Park, discoursing with the keeper of the Pall Mall who was sweeping of it: who told me that the earth is mixed that do floor the Mall and that over all there is cockle shells powdered and spread to keep it fast which, however, in dry weather turns to dust and deads the ball.'

By the eighteenth century, Paille Maille seems to have disappeared from the English scene but was still being played in Ireland; it reappeared in England (apparently from Ireland) in the middle of the nineteenth century under the name of 'croquet' and was first played on Lord Lonsdale's lawn in 1852. At all events croquet does not seem to have arrived in time to be included at the Great International Exhibition in Hyde Park in 1851, where amongst the sports displayed were archery, fishing, real tennis, cricket, bowls and golf. The game's promotion and success is largely due to the efforts of John Jaques, of the famous family firm of John Jaques & Son, manufacturers of sports goods, who made the first croquet sets and wrote a book of rules on the game in 1857. (John Jaques was also responsible for the introduction of the card game 'Happy Families' known to millions of children with the original characters drawn by John Tenniel (1820-1914), later Sir John Tenniel, chief cartoonist of *Punch*.)

Croquet, requiring little athletic ability, was an immediate success, especially with women, at a time when their freedom of movement was considerably constrained by middle class Victorian conventions and the number of physical activities open to them were strictly limited. In 1867, the first public championships were held at Evesham in Worcestershire and organised by Walter Whitmore Jones (1831-1872), affectionately remembered as the man who transformed the game from the silliest of open air games to one of the most intelligent. Whitmore Jones appears to have emerged from the Evesham Tournament as croquet champion but there is very little evidence

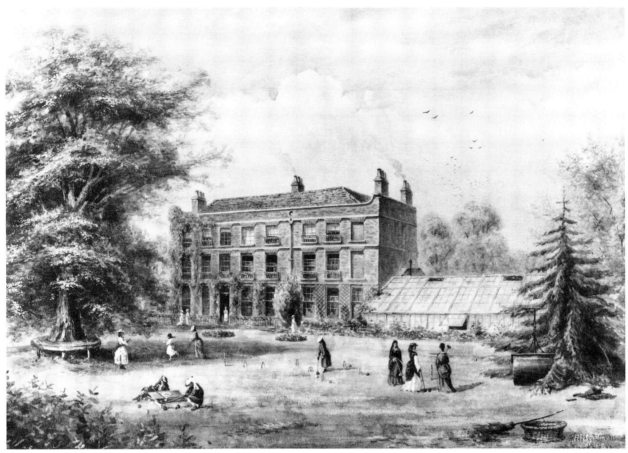

Plate 6/4. H.M. Goodman (op. 1870-1890s). 'The Croquet Game', signed and dated Feb. 1877. 11¼ in. x 17¼ in. Oscar and Peter Johnson.

that the first open championship was ever publicly advertised and his promotion appears to have consisted of a batch of letters inviting friends to play.

In December 1866 Jones began a series of three articles on croquet tactics for *The Field*. There were nine tactics in all of which the first two were as follows: (1) Keep your balls together (2) scatter your enemies (both sound pieces of advice applicable to all sportsmen). The second open championship in 1868 which was altogether a larger affair and took place at Moreton-in-Marsh 31st July – 1st August, was widely advertised in *The Field* and other publications. This time the championship was won by Walter Peel who beat W. Phipps in the final. In 1868 the All England Croquet Club (AECC) was formed and established its headquarters at Worple Road, Wimbledon in 1869; the Conference Laws of croquet were drawn up in 1870. In 1875 the AECC added the new game of lawn tennis to its programme and by 1882 lawn tennis had taken over to become the All England Lawn Tennis Club. Worple Road remained the headquarters of lawn tennis until 1922 when the All England Lawn Tennis Club & Croquet Association (AELTC) moved to Church Road.

In September 1869, the game further developed with the inauguration of the Ladies' Championship which took place on the lawn at Bushey Hall, Hertfordshire, the home of Mr. Edward Marjoriebanks. The seven entries comprised almost all the lady members of the AECC; the winner was Mrs G.C. Joad (1869 remains so far the only year in which a husband and wife won the Open and the Ladies' Championship respectively). During the 1870s croquet was at the height of its popularity, but the game's original promoter (who had by this time reversed his two last names to Walter Jones Whitmore)

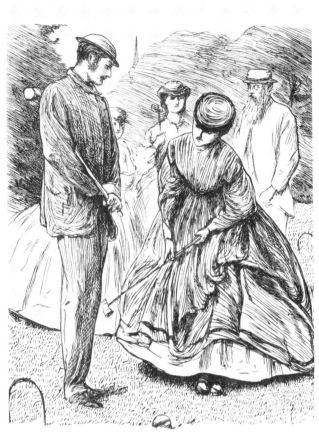

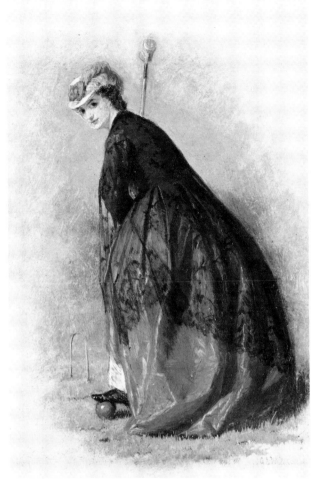

became very difficult to deal with and formed a breakaway organisation which he named the National Croquet Club (NCC) as a rival to the AECC. The two clubs bickered constantly and the leading sporting magazines, *The Field* and *Land and Water,* took sides in reporting the actions of the clubs. The editor of the latter magazine, Frank Buckland, was the son of the eccentric Dean of Westminster. Buckland had inherited the most amazing sense of smell and taste from his father and when lost one day in deep fog in London, is said to have knelt on the pavement, licked it and announced 'Ah Bayswater!'[1]

Eventually the NCC grew weary of Whitmore's troublesome nature and eased him, with some difficulty, out of the Secretaryship; subsequently the NCC was then able to join forces with the AECC on 16th March, 1871. This should have been the end of the Jones Whitmore saga, but he immediately formed a further rival group which he called the Grand National Croquet Club (GNCC). Despite the fact that the GNCC had no money, no ground and was an illicit organisation, they not only staged a successful tournament at Oxford which was won by Arthur Law against other prominent players, but managed to lay on the most spectacular tournament later that year (run on military lines under the command of General Sir James Hope Grant, the soldier brother of Sir Francis Grant, PRA, 1810-1878), of which croquet matches were only a small part of the large entertainment programme. This, at last, was the culmination of Whitmore's career and croquet as he had visualised it: amidst

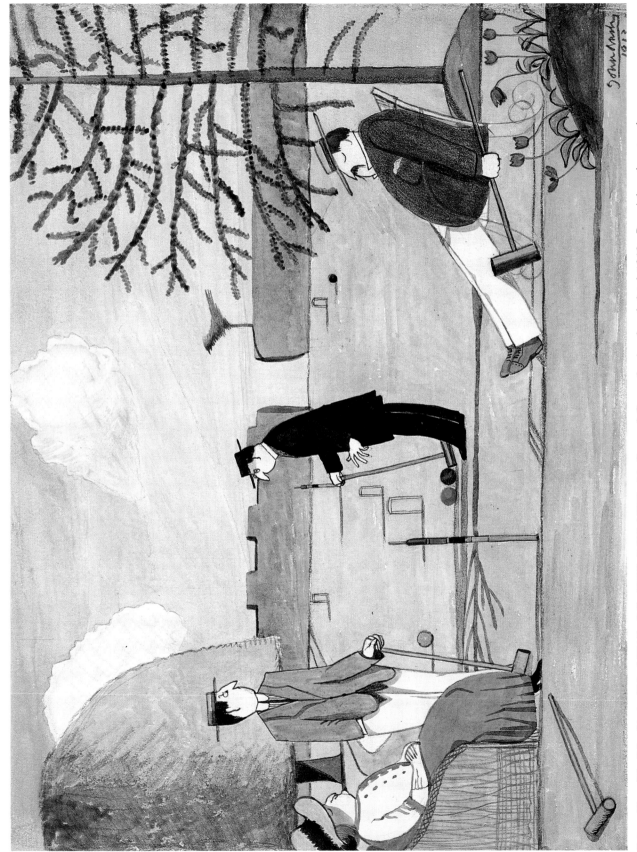

Colour Plate 27. John Nash, RA, NEAC, LG, SWE (1893-1977). 'A Game of Croquet', signed and dated 1913. Pen, ink and watercolour. 8¼ in. x 11in. Spinks, London.

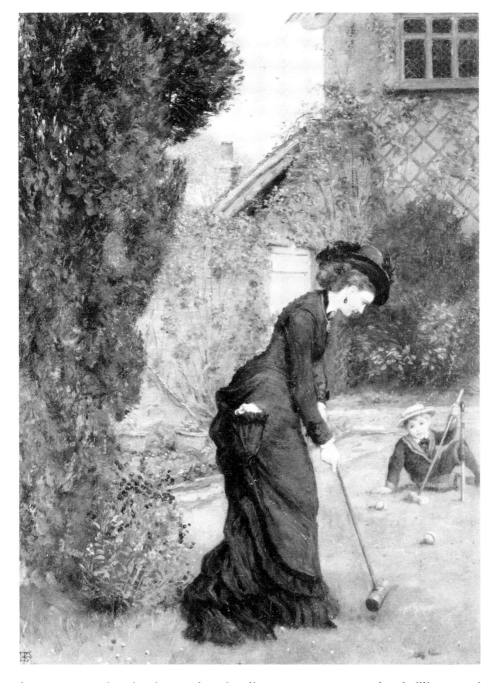

Plate 6/7. Thomas Davidson (op.1863-1893). 'The Winning Stroke', signed with monogram. 11 ½ in. x 8 ¼ in. Sotheby's.

the pomp and splendour, the dazzling extravagance, the brilliant and aristocratic company, he was the cynosure of every eye. He was never to play in public again for sadly within eighteen months he was dead.

Whilst croquet had become a highly skilled and tactical game, it had also become boring for spectators, which may to some extent account for its loss of popularity with women, c.1880, largely in favour of lawn tennis and bicycling, which were more active sports. The game must have been out of favour for about fifteen years because in 1894 *The Pall Mall Gazette* recorded the following: 'It is impossible to visit any part of the country without realising the fact that the long discredited game of croquet is fast coming into vogue again... this is partly owing to the abolition of ''tight croqueting'' '. This term refers to the method of placing one foot firmly on one's own ball and

croqueting the other ball as far away as possible.

In 1896, the United All England Croquet Association was formed, which did not have an immediate influence on the development of the game. The subsequent appearance of three great players from Ireland, where the game had long flourished, had an immediate effect. Of the three, Cyril Corbally (1881-1946), C.L. O'Callaghan (1895-1942) and Patrick Duff Mathews (1886-1960), Corbally was probably the finest all round player. He first appeared on the English croquet scene in 1902, winning the Open Championship at his first attempt. Thereafter, he entered on only seven occasions and won it five times. During a very short croquet career he also won the Men's Championship once and the Mixed Doubles twice. Unlike Corbally, Mathews was not a particularly good tactician but he excelled in the ability to pick up a break from the most unpromising situation. O'Callaghan entered the English arena in 1905; although he won eleven titles before his retirement in 1921, his main claim to fame rests on his attacking play and the style he adopted and popularised which became known as the 'Irish Grip': feet close together with the fingers of both hands pointing down and the mallet swung between the feet. Previously, and probably due to the ladies' long dresses, the mallet was swung to one side. In 1900 as croquet grew popular again and flourished, it was decided to drop 'United All England' for the simpler title of the Croquet Association. After some delays a new venue was found at the newly formed Roehampton Club in 1902, which remained the home of the Croquet Association for the next sixty years.

Women's croquet also flourished: probably the supreme woman croquet player of all time was Miss Dorothy Dyne Steel (1884-1965) who played between the two World Wars. This exceptional lady, known as 'D.D.', adopted a very upright style, and side stance, and appeared to exert no energy at all in the execution of her strokes. She was the equal of any man of her time in winning the Open Championship four times and the Women's Championship fifteen times, eight in succession, proving that in croquet an equality of play between the sexes is possible. So far as serious women rivals were concerned, only Miss N.S.L. Gilchrist, who certainly had a more beautiful style than D.D., and Mrs Beaton (Mrs de la Motte), deserve to be ranked in the trio of the greatest women players. Croquet continued to expand so that the number of associates increased from 200 in 1897 to 2,300 by 1914. There were 170 registered clubs and some 120 tournaments, with a choice on average of six tournaments a week, not to mention winter tournaments on the French Riviera.

Several major innovations were to have far reaching consequences for the establishment of the game. By 1914 the introduction of 'either ball' meant that the whole concept of the game was changed from one which, since its earliest days, had strictly maintained the playing of each ball in sequence, to a game in which players could choose which ball to play. At the same time came the introduction of the 3¾ in. hoop, still in use today. In 1922, the original turning

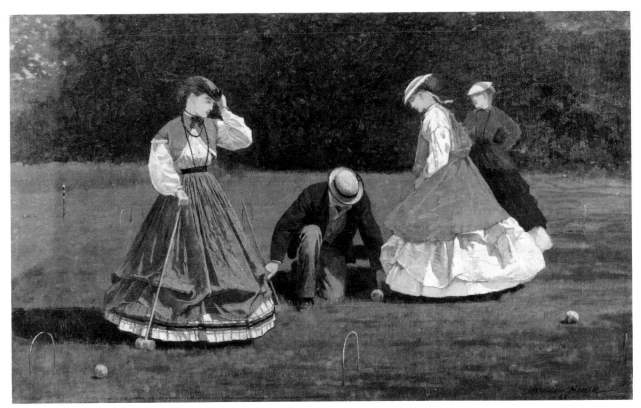

Plate 6/8. Winslow Homer (1836-1910). 'The Croquet Game', signed and dated 66. 6 ¼ in. x 10 ¼ in. The Art Institute of Chicago.

peg, set opposite the winning peg, was made redundant and the winning peg was moved to the centre of the playing area. The two centre hoops were therefore placed further apart, eliminating the women's 'easy mile' down the centre. The accurate placing of the pioneer balls at the next hoop thus became of paramount importance. The 'lift' shot was introduced in 1928, which eliminated the possibility of a championship game being won or lost on the initial toss and did much to redress the balance of the game. After the Second World War croquet, along with many other sports, took a battering. Whereas croquet had re-emerged with resilience in 1919, in 1945 the game was in the doldrums. Perhaps it represented a leisured way of life that never really existed any more after 1945.

During the late 1940s and early 1950s, the game readjusted and slowly gathered momentum. Handicapping, long a contentious subject, was finally resolved in 1978 when the Council decided to increase handicaps on a sliding scale whereby the high bisquiers, to their disadvantage, suffered no increase at all. The Council has done much to promote the game both at club and championship levels in organising the principal croquet events throughout the United Kingdom, but croquet is neither a spectator sport nor a team game so that inter-club competitions are almost non existent. Outside the United Kingdom, Association Croquet is only played on an organised basis in Australia, New Zealand and South Africa where each country has its own governing body.

In the 1980s croquet, in common with most sports and games, is finding the way forward with sponsorship. In March 1987, *The Times* reported: 'Croquet arrived in suburbia yesterday when a watch manufacturer invited anyone with a medium sized lawn to enter a new competition to find a national champion. The game is getting the largest sponsorship in its history from the Lassale

Company of Maidenhead who are spending £35,000 on their new competition.'

ROQUE AND GOLF CROQUET

In the United States, croquet is played with rather different rules and is called 'roque' being the French word for roquet. The first national association was founded in 1882. The term 'roquet' is also used in Association croquet when a player's ball hits another and 'croquet' is the term used when a roquet is followed up by the player placing his ball against that of his opponent.

Association croquet has evolved from the simple game of Victorian croquet which is still played as golf croquet and differs from Association croquet in one respect only, in that the croquet stroke is not used. Golf croquet is still played in the gardens of private houses and should be properly played with four balls coloured blue, red, black and yellow. Blue and black are partners against red and yellow and the balls are always played in sequence. In singles each player plays two balls; each turn consists of one stroke only, the object being to score the hoops in order. Unlike Association croquet, all the balls are always intended for the same hoop so that as soon as a hoop has been scored all the balls progress to the next hoop. The order of the hoops is the same as in Association croquet except that the peg is not played. If there is an equality of points after the rover hoop, the third hoop is contested to decide the game, otherwise the game ends as soon as one side has scored a majority of points.

The Japanese, who previously played a similar game called 'gateball', took up golf croquet seriously in the mid-1980s and are now skilled exponents of the sport.

ART

The lack of spectator appeal may have contributed to the fact that fewer paintings exist for croquet than for many other sports. On the other hand, there appears to be no steadfast rule for what constitutes a popular game in art. A passive game or sport does not necessarily mean that there are fewer paintings, for if that were the case rugby football would have twice the number of paintings compared with croquet or pigeon racing, for which the reverse is true. The explanation may lie in the link between money and gambling with which most sports have always been associated. Croquet, however, remained truly amateur for much longer than other more popular and spectator orientated sports and the demand to record great 'professionals' at play was rare. Always popular with women, croquet attracted female artists to depict the game (*see* Frontispiece). Many of the works of these talented amateur watercolourists survive and are a charming reminder of Victorian domestic life (*see* Plate 6/2). Croquet arrived too late in the century for amateur artists like Diana Sperling (1791-1862) to include it in the large number of sports she

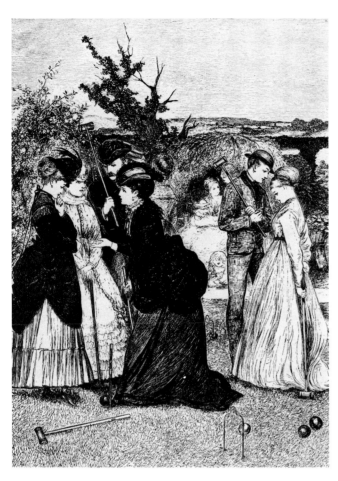

Plate 6/9. 'A Game of Croquet'. An illustration from Our Fathers by Alan Bott, published by Wm. Heinemann Ltd., 1931. 'As a game to be played by the head as well as by the hands, as one that requires forethought and imagination, croquet does not come far below whist, chess and billiards. Without wishing to break up the lawn parties for which croquet may be an excuse, we assure readers that nothing is better worth attention than this petted but perverted pastime.'

painted but the little sketch illustrated in Plate 6/3 is a good example of the many drawn at that time.

By far the greatest number of croquet pictures were painted between 1860 and 1880 and depict women in 'graceful attitudes' as recommended by the early rule books (*see* Plate 6/4). One of the first artists to immortalise the atmosphere of the game was John Leech (1817-1864) whose famous coloured frontispiece to *Mr. Punch's Pocket Book* for 1862 has the caption 'A nice game for two or more. Fanny, her eyes on his and placing her pretty little foot on the ball, she said "Now I am going to croquet you!" And croqueted he was completely.'

Another early artist to depict croquet was the illustrator George Louis du Maurier, PB, ARWS (1834-1896) whose two wood engravings for *London Society* in June 1864 and July 1865 (*see* Plate 6/5) show ladies in hooped skirts for whom the 'Irish Grip' might have been a tricky undertaking. Another artist to whom croquet appealed was the animal painter, Horatio Henry Couldery (1832-1893), although he visualised croquet played by dogs and painted accordingly. The Victorian artist, John Barker (op.1835-66), in common with many artists of the period, saw the game as it might have been played in the reign of Charles I (1600-1649) and exhibited the results at the British Institute in 1866. Thomas Cooper Gotch, RBA, RI (1854-1931) painted a tiny watercolour of a croquet lawn, and later artists such as Mrs. Humphrey (Miss Florence Pash) and Miss Emily Beatrice Bland exhibited croquet paintings in 1899 at the newly formed New English Art Club.

Sidney Street exhibitors of croquet paintings included Edward Hughes

(1832-1908) and Hector Caffieri, RI, RBA (1847-1932). George Elgar Hicks, RBA (1824-1914, *see* Plate 6/6), is known to have painted a large picture of a croquet party for which a preliminary sketch was auctioned at Christie's in 1972. Two of the most charming croquet paintings also show ladies at play: 'The Croquet Player' by Charles Green, RI (1840-1898) was painted in 1867 (*see* Colour Plate 26) and 'The Winning Stroke' (*see* Plate 6/7) was painted by Thomas Davidson (fl.1863-93). George Percy Jacomb Hood, RBA, RE, ROI, RBC, NEAC (1857-1929), that distinguished watercolourist of so many sporting scenes (*see* p.253), painted a croquet match at Hurlingham; Robert Brownwood Potts recorded a croquet tournament at Wimbledon and Henry Gardner (op. late 1890s), faithful to his usual stamping ground, painted croquet on the lawns of the Brighton Pavilion. A young competitor in the Champion Cup in 1902 was O.H. Birley who later became the well-known portrait painter, Sir Oswald Birley, RP, ROI, NPS, IS (1880-1952). Although Birley is known to have painted a number of landscapes, he did not paint his own sport.

During the 1860s, the American artist, Winslow Homer (1836-1910) produced a series of five oil paintings depicting croquet scenes (*see* Plate 6/8). The existence of these works stimulated the Yale University Art Gallery to hold an exhibition of croquet paintings, drawings and photographs in 1984. Homer's interest in the game coincided with the appearance of illustrated rule books heralding the game's transfer from England to the United States. The paintings and sketches for the rule books by Homer, show that he had a detailed knowledge of the rules and a familiarity with the conventions of the game.

Paintings of croquet were not confined to British and American artists, for one of the most delightful of all croquet scenes was painted by the French artist, James Jacques Joseph Tissot (1836-1902) in 1878 and shows elegant young girls playing the game informally on a garden lawn. Tissot's fellow countryman, Edouard Manet (1832-1883) was also captivated by the game and his 'Croquet Party' focuses on a lady about to make a winning stroke. In his painting 'Palo Alto Spring', the British born American, Thomas Hill (1829-1908) chose to depict a Victorian family croquet match where the members range in age from the grandparents to the youngest children dressed in the heavy flounces so beloved of that age. He showed that old and young could meet in the croquet arena on more equal terms than in any other game of skill. From the 1880s onwards, the number of decorative croquet paintings diminished, coinciding with the game's lack of popularity with women on both sides of the Atlantic. In the 1980s, croquet is currently enjoying a serious revival amongst players of both sexes and is played with great skill in Britain, America, Japan and elsewhere. The image of croquet in the arts may have been a negative one for the last one hundred years but is clearly set for a revival.

FOOTNOTE

1. It would have been interesting and fun at this stage to delve deeper into some of the eccentricities of these early Victorian pioneers of croquet but D.M.C. Prichard has recorded many of them in *The History of Croquet,* published by Cassell Ltd., London, 1981.

CHAPTER 7

Curling

The sport of curling, although now played in nineteen countries, namely: Scotland, England, Wales, Canada, USA, Sweden, Norway, Denmark, Holland, France, Luxembourg, Italy, Switzerland, Finland, Austria, New Zealand, Australia, South Africa and Japan, remains a mystery to many people, and for this reason the purpose of the game is set out before the history, as defined by the *Oxford Companion to Sport and Games*.

Curling is a game superficially akin to bowls, but played on ice usually by two teams of four players, each player using two curling stones and playing them at the direction of his captain ('skip'), alternately with his opposite number. A curler 'throws' the stones over 40yds. (36.58m.) to circles ('the house') cut on the ice and often coloured. These circles have a radius of 6ft. (1.83m.) whose centres (or tees) are 38yds. (34.75m.) apart. Inner circles may also be drawn at intervals of 2ft. (60.96cm.)

The object of the game is to place more stones nearer the tee (called 'the button' in Canada and the USA) than one's opponents. Rotation of play and the system of scoring is the same as in bowls. The ice on which curlers play is called a rink, which is also the name for a team of four players. In alignment with each tee, a centre line may be drawn to a point 4yds. (3.66m.) behind the tee. Four scores are drawn across the rink at right angles to the centre line, a) the tee, b) the hog score (1/6th of the distance between the foot score and the farther tee.) A stone which does not pass the further hog score, or 'hog', is removed from the ice. Similarly, a stone which passes the back score is removed. All games are decided by a majority of shots. A team, or rink, scores one shot for every stone which is nearer the tee than any stone of the opposing rink. All measurements are taken from the tee to the nearest part of the stone.

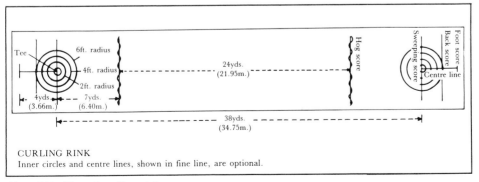

CURLING RINK
Inner circles and centre lines, shown in fine line, are optional.

Plate 7/1. Plan of curling rink.

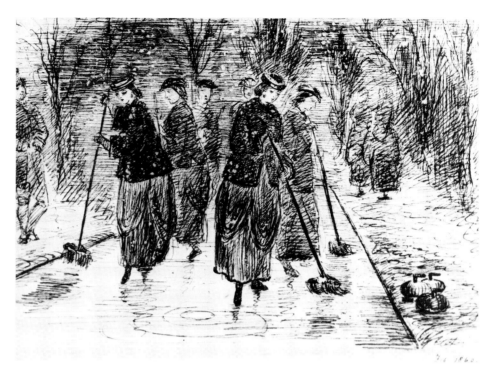

Plate 7/2. 'Sweeping the Rink'. A sketch, dated Feb. 1860, of the Countess of Eglinton and her ladies on a Cairnie-type artificial rink at Eglington. Scottish Curling Museum Trust.

Every stone which is not clearly outside the outer circle is eligible to count. The average weight of a curling stone is 40lb. (18.1kg.), and no stone, including bolt and handle, may be of greater weight than 44lb. (19.9kg.), or of greater circumference than 36in. (91.4cm.), or of less height than 4½in. (11.43cm.) part of its greatest circumference. A curler twists the handle of the stone when delivering it, to impart 'draw' to the stone which makes it run with a controlled swing to the left or right.

Each curler carries a brush, or a broom, often made of horse hair, but many materials are used. The two players not throwing in the team run alongside the moving stone and wait for the 'skip's' call to sweep. Efficient sweeping in front of a running stone can make the stone travel up to 12ft. (3.66m.) further than an unswept stone. A curler must release the stone before it has reached the nearer hog score. This is one of the basic curling rules which, by tradition, are short and simple. Umpires are seldom asked to act except when measuring the distance of stones from the tee at the conclusion of an end. Curlers themselves are expected to interpret the rules sportingly and to observe the courtesies of the game.

The precise origins of curling, 'Scotland's ain game', are lost in the mists of time, although the sport is by no means as old as football or even golf. There is also a question mark over the country in which the game originated — the Low Countries or Scotland. The case for the Low Countries rests on two known paintings, both painted in 1565 by Pieter Bruegel (1525-1569) in which a game, certainly very similar to that of curling, is being played on ice, perhaps using clods of turf. An engraving by C. Van Wieringen (1580-1635) after a painting by C. Van Baudous entitled 'Hyems' or 'Winter' certainly substantiates this theory. In this picture brooms are being used and the 'curling stones' seem to be large flat discs of wood with an upright wooden handle. The case for the origins of the game in Scotland is supported by the many finds of ancient curling stones (none so far have been found in Holland) and the references in early literature such as 'The Muses' Threnodie' by

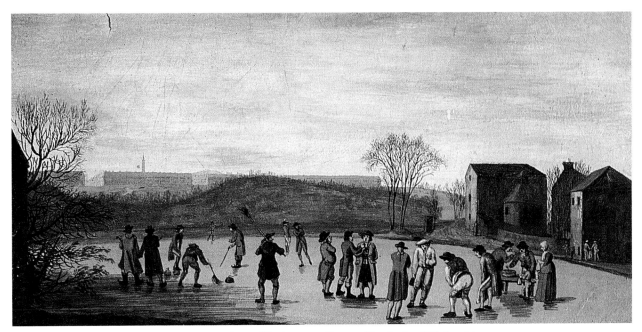

Colour Plate 28. David Allan (1744-1796). 'Curlers on Canonmills Loch, Edinburgh'.
Watercolour. Royal Caledonian Curling Club, Edinburgh.

Colour Plate 29. McLennan. 'Curling at Curling Hall, Largs', c.1833. Royal Caledonian
Curling Club, Edinburgh.

Plate 7/3. Sir George
Harvey, PRSA
(1806-1876).
'The Curlers'. National
Galleries of Scotland.

Henry Adamson (1638), a verse of which includes the line 'his allay bowles and
curling stones', which is believed to be the first written reference to the game.
It is unlikely that the game in Scotland started very much before 1600 although
David Smith[1] points out that there is a reference to a contest which took place
in 1540-1 between John Scalter, a monk in Paisley Abbey, Renfrewshire, and
Gavin Hamilton, a representative of John Hamilton, the Abbot. However, an
early curling stone 'The Stirling Stone' has the date of 1511 carved into it and
lies in the Stirling Smith Museum and Art Gallery. It is a 26lb. (11.79kg.)
kuting (or quoiting) stone, the first type used for curling and has rough finger
holes to enable the stone to be thrown along the ice with a quoiting action.

The early curling stones which varied in shape and size and weighed
anything from 5 and 6lbs. to 26lbs. did not resemble in any way the smooth
circular stones of the modern day, for they were more like boulders. The early
finger grip stones were superseded at the beginning of the eighteenth century
by stones with handles which were then delivered, as they are now, by
swinging the arm backwards and then forwards in an underarm motion before
throwing (not pushing) the stone along the ice. Often called 'channel' stones
because they were found in river channels worn smooth by the water, their
crude early handles were made of iron or wood and were usually inserted into
the stone by the local blacksmith. The introduction of handles meant that
stones of a far greater weight could be thrown, and the era of strong arm
curling was born. The largest and so far heaviest curling stone found is the
massive stone which sits outside Blair Castle, the residence of the Duke of
Atholl, and weighs in at an incredible 183lb. (83.18kg.). This stone supersedes
the better known Jubilee Stone which weighs 117lb. (53.07kg.) and is more
than four or five times heavier than the original curling stones of 5-26lb.
(2.27-111.82kg.). Thomas Pennant in his *Tour of Scotland* in 1769 described the
sport as: 'an amusement of the winter and played on ice by sliding from one
man to another great stones of forty to seventy pounds weight of hemispherical
form, with an iron or wooden handle at the top. The object of the player is to
lay his stone as near the mark as possible, to guard that of his partner, which
has been well laid before, or to strike off that of his antagonist.'

The vast weight of these stones is commented upon in a verse from the 'Curlers' March' written in 1792 for the Old Cannonmills Club: 'Now mark the dread sound as our columns move on, so solemn so awful so martial's the tone, the clouds resound afar whilst the waters groan, stable rock feels our shock as if stern Mars in transport spoke, such the thunder and crash of the Curling stone'.

Towards the end of the eighteenth century curling progressed from being a game of brute strength to a game of skill and finesse, and about this time curlers became aware that more circular stones gave a more consistent performance. Furthermore rounded stones not only ran consistently, but rebounded from other stones at angles which could be predetermined like cannons in billiards. Curlers also discovered that by turning the handle of the rounded stone to apply 'in-hand', or 'out-hand' rotation motions they could control the run of the stone like using the bias in bowls.

This discovery helped create more enthusiasm for the game and encouraged its great growth in Scotland during the nineteenth century when it was played in nearly every parish and by all classes of the population. In the last two decades of the eighteenth century and the first two of the nineteenth century, groups of curlers got together to form Curling Societies in much the same way and at much the same time that the golfers did. They organised rules and constitutions as the Sorn Curling Society records in 1795: 'being sensible that it will not only be proper for themselves but for the Benefit of the Whole Curlers and Community at large'. At the inaugural meeting of the Meikleour

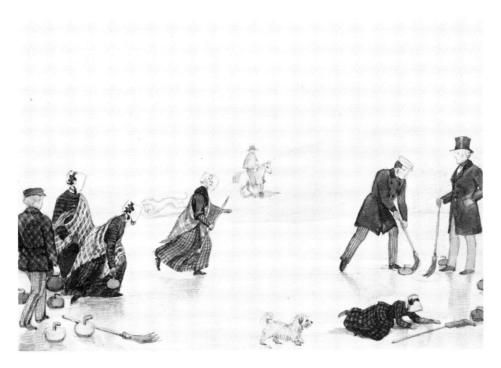

Plate 7/4. Jemimah Wedderburn (mid-19th C.). 'Sir George Clark of Penicuik and family at play on one of the ponds at Penicuik House', c.1847. Watercolour sketch. National Portrait Gallery.

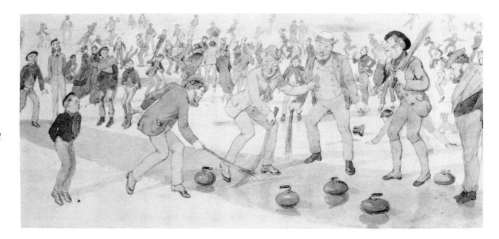

curlers in 1814 it was resolved 'That this meeting aware of the many advantages resulting from societies in general do most heartily and cordially approve that they themselves may be formed into such'. The Penicuik Curling Club formed in 1815 'for the improvement of Curling' and the Curlers of Peebles in 1821 felt that it would be much to their general advantage to constitute themselves into a Curling Club.

It is possible that the brotherhood which existed in many of these societies from their foundation stemmed from the Freemasons and as with the Companies of Golfers and Archers, curling was used as 'healthful exercises' to accompany their social evenings and dinners. Certainly the regulations adopted by the Sorn Curling Society involved the 'examination' of each curler at his admission and the transfer from members to the directors of the power 'to make a brother or brothers'. The regulations also included a resolve to 'assist misfortunate Members or Brethren so far as the funds will allow' and a further resolve to offer legal aid in civil matters to any members when necessary 'so far as the funds will allow' was further evidence that any aspiring member was getting a great deal more than curling when he joined. On the subject of the rules for the sport, the Societies were silent, their minutes being more concerned with recording the behaviour of their members on and off the ice. Many of the societies prohibited swearing and attempted to limit gambling on the results of the game. Fines were exacted from delinquent members as shown in the accounts of the treasurer of the Coupar Angus and Kettins Club in 1795. Five shillings of 'Cash for Oaths' was collected on four dates in 1795. (At twopence per oath that works out at a lot of swearing!)

In the early days of the societies the well intentioned self regulatory system worked well and on the whole continued to do so but later, in the nineteenth century, many of the complaints and indeed fines laid before the meetings, though no doubt an added entertainment, became ridiculous: Mr Charles Hill of Luthrie was fined the sum of 2/6d, his lady having presented him with a son and heir without consent of the club and poor Mr Pitcairn was fined 2d for being on the ice the previous day without a besom but with an umbrella instead. This gentleman fell foul of the club again in 1848 and was fined 1/- 'for being the first member who had submitted to chloroform for extraction of a tooth'. These misdemeanours were recorded in humorous prose in the minutes of the Abdie Club in Fife by its careful secretary, Mr George Dun, between 1831 and 1849. No doubt the fines helped to keep the club in funds

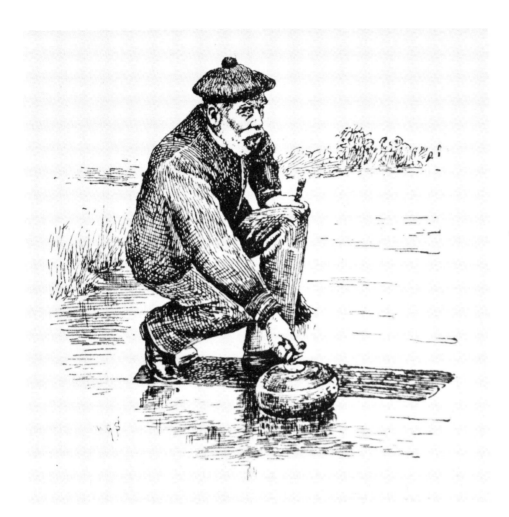

Plate 7/6. William Grant Stevenson, RSA (1849-1919). Drawn from a photograph and used to illustrate History of Curling *by John Kerr, published by David Douglas, Edinburgh, 1890.*

so that no apparent ill humour was felt from those from whom they were extracted.

In the early years of the nineteenth century the Curling Society which had the most influence on the game was that of Duddingston. That curling had existed in the parish before 1795, is clear from the first minutes of the Society formed on 24th June of that year, but the Society had enormous influence on the game, being the first to institute club badges and to set up a code of curling rules, which they had printed and made accessible to the other clubs and players. Curiously, the game at that time attracted a great number of clergymen both as players and recorders, for some of the best early books on the game have been written by ministers. The cloth claimed some responsibility for the invention of artificial curling ponds in the form of the Rev. Mr. Sommerville, the minister of Currie, who joined the Duddingston Curling Society in 1821. The Duddingston Curlers played upon Duddingston Loch (*see* Colour Plate 22) and most of the other societies played on stretches of natural water, of greater or lesser, but always substantial, depth. The disadvantage, however, was the time these stretches of deep water took to freeze and the potential danger of falling through the ice and drowning, a disaster suffered by the Kirkmichael Society which lost six curling members.

From the beginning of the nineteenth century, a number of artificial curling ponds had been constructed by flooding in November shallow areas with water contained by banks and letting out the water in the spring so that the grass

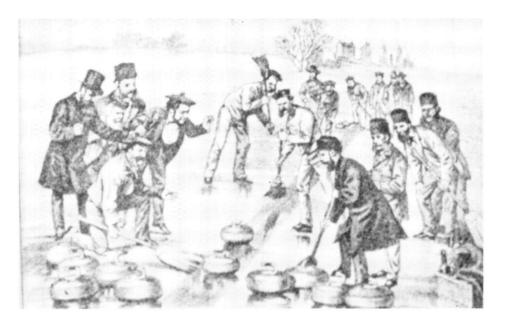

Plate 7/7. Unknown artist. Print from Ontario Branch Annual, *1878, used to illustrate* History of Curling, *by John Kerr, published by David Douglas, Edinburgh, 1890.*

previously covered by water could be used to feed livestock. Artificial ponds, whilst obviously an improvement, were not entirely satisfactory and did not greatly increase the amount of curling. Even the introduction of gas lighting, linked up to the village gas supply by means of gutta percha piping to his new pond in 1853, by Major Henderson of Westerton had not had a marked effect on increasing play.

John Cairnie of Curling Hall, Largs, had the idea in 1810 of not only creating an artificial pond free from grass and weeds but in 1827 he invented a clay pond over which, when frost seemed likely, a sprinkling of water from watering cans produced a thin skin of ice. Depth of water was therefore not required for curling, just watertight clay with a shiny surface. Cairnie's invention dramatically increased the number of days on which curling was possible and caused J. Gordon Grant in *The Complete Curler* (1914) to record a comparison made at Moffat between deep water and tarmac ponds over a period of seven years between 1906 and 1913. During this period there were forty days of play on the deep water pond and 240 on the tarmac pond.

A rival claim from the previously mentioned Dr Sommerville caused John Cairnie to publish his 'Essay on Curling and Artificial Pond Making' in 1833 which decided the argument officially and became, in any case, a marvellous record of how curling was played at the time in many parts of Scotland. The invention of the tarmac pond was, of course, immediately copied and improved by other curling clubs in Scotland. Two nineteenth century sporting Scots made their home in Wales and took the curling game with them. At their homes in Glamorgan they created rinks which worked on the piped water system. The Mackintosh of Mackintosh, Chief of Clan Chattan and Lord Lieutenant of Inverness lived at Cottrell where the 42yds. x 12yds. concrete curling rink can still be seen to the north of the now demolished mansion. Robert Forrest, head agent of the Plymouth Estate and also Deputy Lieutenant of Glamorgan built his own curling rink on similar lines at his home a few miles from Cottrell. There was a Glamorgan Curling Club in existence well before the First World War but the game seems to have declined in popularity between the Wars. Nowadays the headquarters of the Welsh Curling

Association is in North Wales but little curling exists in the south.

Whatever doubts there may be about the origins of the game there is no doubt that curling was introduced into Canada by the Scots. The minutes of the Royal Montreal Club record one amusing incident, shortly after the club was formed in 1807, of a French speaking farmer who, seeing the game played by Scots for the first time, exclaimed 'J'ai vu aujourd'hui une bande d'Ecossais, qui jetaient des grandes boules de fer, faites comme des bombes, sur la glace: après quoi ils criaient ''Soupe Soupe''; ensuite ils raient comme des foux. Je crois bien qu'ils sont vraiment fous!' which roughly translated bears out the theory that the French have always regarded the British as quite mad but when translated more carefully one is perhaps inclined to believe that they may be right.

With improved communications in the nineteenth century, sport in general and curling in particular broadened its horizons and began to look further afield for competition. One result was the county match and the first of these took place between Midlothian and Peebles in 1823 but it was the advertisements placed in the *North British Advertiser* in the summer of 1838 which brought about the formation of the Grand Caledonian Curling Club and the election of John Cairnie, of Curling Hall and the tarmac pond fame, as

Plate 7/8. George Denholm Armour, OBE (1864-1949). 'Our Artist in Scotland. Awful Result of His First Attempt to Become a Curler'. Pen and ink sketch. Sheriff David B. Smith Collection.

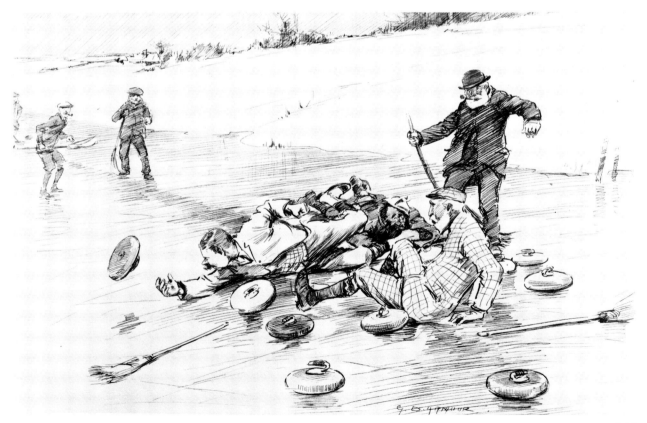

Chairman. In 1842 Royal patronage was sought and obtained but the resulting title the Royal Grand Caledonian Curling Club was thought to be too cumbersome and in 1846 the 'Grand' was dropped. By 1848, 187 clubs including two Canadian clubs, Montreal and Stadacona, and 8,000 curlers had joined the Royal Caledonian Curling Club and by the end of the Club's second decade there were 349 clubs, including eight in England, one in Ireland, twenty-three in Canada, and three in the USA.

In North America, the first inside rink was constructed by the Royal Montreal Curling Club in 1837. The North American problem was not the lack of outdoor ice and therefore possible playing days, but that they had too much and the biting frost and wind could often make curling impossible. Natural ice within a building seemed to be the solution and by the 1840s there were several of these covered curling rinks.

Both the Toronto Club and the Ottawa Club moved indoors in 1859 and 1868 respectively and the Grand National Curling Club of America was established in 1867. By the time the first team of Scottish curlers toured Canada in 1902-3 captained by the legendary John Kerr, most Canadian curling took place in covered rinks and these ice palaces contributed in no small way to the transformation of the game in Canada from a boisterous haphazard sport to one in which skill and technique could be developed. A return tour to Scotland by Canadian curlers was soon demanded. This was a much less predictable project for the rinks in Scotland still relied on nature to provide frost and ice.

It was obviously only a matter of time before the making of artificial ice released the curler from the bondage of the weather and made it possible for play to take place in hotter countries such as Africa. Professor Gamgee successfully patented the first mechanical water freezer on 7th January 1876 which was followed the next year by the opening in Manchester of the first artificially made ice rink which *The Graphic* recorded pictorially on 24th March 1877.

It was not until 1907 that Scotland opened its first indoor ice rink at Crossmyloof in Glasgow, and in 1909 the Canadians sent over their first team to play the Scots. Glasgow, with its new guaranteed ice rink, was obviously the main centre for the tour where all but three of the twenty-six arranged matches took place. The Canadians won twenty-three of the matches and the Scots lost all but three along with the cup that had been newly presented by Lord Strathcona, thereby disproving the old Scottish adage 'what we have, we hold'. Since 1910 tours have alternated between Canada and Scotland; every five years the teams play for trophies although the emphasis is and always has been on the social side. Undoubtedly the most prestigious trophy in the curling world is the International Olympic Committee President's Cup (formerly the Air Canada Silver Broom) played for each March at the annual World Curling Championship by the champion rinks of ten countries. In 1986, the championship was held in Toronto.

Oddly enough the Olympic Games have only twice featured curling. The first occasion was at the Winter Olympics of 1924 at Chamonix in the French Alps; Great Britain sent a team (selected by the Royal Caledonian Curling Club) which emerged as World Champions although the competition was not strong. The other event was at Lake Placid, New York State, USA, in 1932. One reason for forming the International Curling Federation in 1966 was to create an official body which could competently apply for the inclusion of curling in future Winter Olympics. In Canada and the USA artificial ice has gradually replaced natural indoor ice but the first club to install an artificial ice rink purely for curling was the Brooklin and County Club in Massachusetts in 1920. Even today natural indoor ice is still utilised in some curling venues.

In the twentieth century the role of the Royal Caledonian Curling Club has increased in importance. Within Scotland it is responsible for organising the national competitions which have increased in number and importance since the war, and it also has the duty of arranging international tours to and from Scotland. The present constitution provides for the representation of all affiliated clubs and associations by the election of their presidents as Vice Presidents of the Royal Club. Thus the Vice Presidents of the Royal Club represent Canada, USA, Sweden, Switzerland, New Zealand, Norway, France, Germany, Denmark, Italy, England, Holland, Wales and Finland.

Apart from the period during the eighteenth century when the curling stones were of exceptional weight, women have always featured in this sport despite the chauvinistic remark made in 1890 by the Rev. John Kerr that 'ladies do not curl — on the ice'. Apparently they did and a few years later in 1902-3 when Kerr was captain of the Scottish team the scales must have fallen from his eyes when his team was soundly beaten on at least three occasions by both the Ladies Montreal Curling Club, formed in 1894, and the St. Lawrence Ladies Curling Club at Quebec. Furthermore, only five years after his unfortunate remark, the first all female club, Hercules Ladies, of Elie, Fife, was admitted as a member of the Royal Club — a hitherto strictly male preserve — without so much as a protest. Rule 3 of the Peebles Club (24th December, 1821) shows that women there had shown an interest in the game

a generation before that: 'When Ladies come near the Rink and are disposed to play, the ''Skips'' shall have the privilege of instructing them to handle the Stones agreeable to the rules of the Game'.

One of the earliest women players was the Countess of Eglinton, wife of the 13th Earl (1812-1861) who was himself a keen player and had four artificial ponds on his estate. He was also responsible for presenting the Eglinton Jug (said to hold fourteen bottles of whisky) in 1851 to the curlers of Ayrshire for annual competition which is still the most highly prized trophy in the county. A number of watercolour sketches in the family's possession show the Countess, her family and female friends playing between 1859 and 1865 (*see* Plate 7/2).

Recently the increasing part played by women in the sport has resulted in ladies' tours; in most curling countries there are now national ladies' and national mixed championships.

ART

The sport of curling has always, it seems, appealed to artists and as a result there are many excellent paintings from all periods of the game's history. Quite why curling has caught the imagination of artists in preference to many equally attractive sports is not clear for certainly the icy conditions to which past artists would have been subjected in order to depict the 'roaring scene' cannot have been an incentive. Apart from the sixteenth century Dutch paintings of Pieter Bruegel (q.v.), which may or may not depict an original form of curling in that country, one of the earliest known 'foreign' artists to paint the sport was the English watercolourist, William Evans, RWS (1798-1877). This artist was born and educated at Eton College and in time succeeded his father, Samuel, as drawing master there. He is responsible for many high quality paintings showing typically and arguably English sporting scenes, cricket, fives and the Eton Wall Game (*see* Colour Plate 35) to name but a few. It is surprising, therefore, that he should have apparently stepped outside his usual stamping ground to paint 'A Curling Match at Polney Loch near Dunkeld' (*see* Colour Plate 33), but he was a keen visitor to Scotland and painted many watercolours on his visits. Scottish artists were on hand to record the game from its formative days; one of the best known was David Allan (1744-1796), who painted 'The Curlers at Cannonmills Loch, Edinburgh' (*see* Colour Plate 28). Often referred to as the 'Scottish Hogarth', David Allan is perhaps better known as a portrait and history painter. His formal groups include one of the cricket playing Cathcart family (*see* Plate 5/27) to whom Allan owed his early start.

One of Scotland's most eminent painters was Sir George Harvey, PRSA (1806-1876), who painted 'The Curlers'; the original large canvas by Harvey was exhibited at the Royal Society of Artists in 1835. The smaller study for

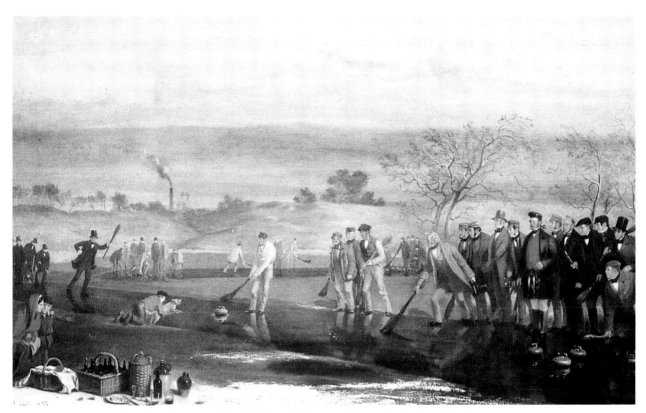

Colour Plate 30. John Levack (op.1856-1857). 'Curling at Rawyards Loch, Airdrie, Lanarkshire', signed and dated 1857. This picture shows the Blue Doo Colliery in the background. Monklands District Council.

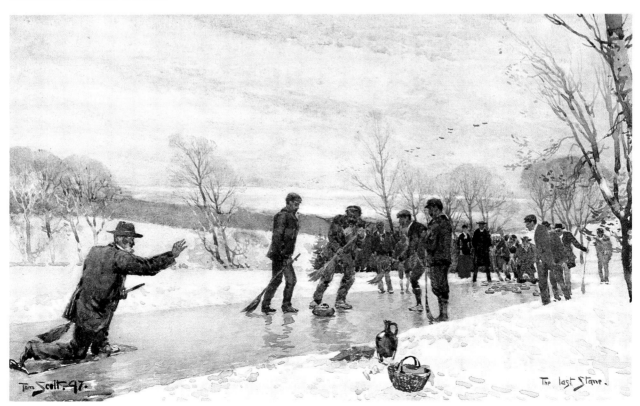

Colour Plate 31. Thomas Scott, RSA (1854-1927). 'The Last Stane', 1897, signed and inscribed. Private Collection.

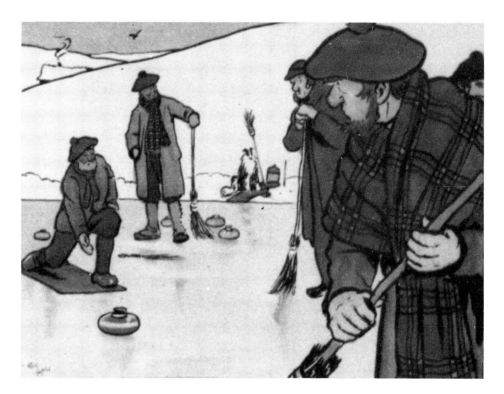

Plate 7/10. Cecil Charles Windsor Aldin (1870-1935). 'Curling'. Sheriff David B. Smith Collection.

this work is in the collection of the National Gallery of Scotland and is illustrated here in Plate 7/3. Two paintings by little known artists deserve mention. 'Curling at Curling Hall, Largs' (*see* Colour Plate 29) by McLennen, c.1833, shows John Cairnie delivering a stone from his famous foot iron, and 'Curling at New Farm Loch, Kilmarnock', c.1860 by the unrecorded artist John McKay (op.1841-60) depicts the Loch, several acres in size (formed in 1845) into which water was let in November and drained out again at the end of March. John McKay also painted a superb curling scene on a fine 18ct. gold presentation snuff box dated Edinburgh 1841 which is said to represent Duddingston Loch and its octagonal curling house.

After 1835, curling paintings began to appear quite regularly coinciding with the beginning of rail travel to Scotland which opened up the sport to a wider circle of enthusiasts. The Royal Scottish Academician, Charles Lees (1800-1880), painted two known curling paintings, one in 1848 entitled 'The Grand Match at Linlithgow Loch' and a later picture 'Curling on Duddingston Loch', painted in 1866, also features the octagonal curling house designed for the Duddingston Curling Society by William Playfair in 1824. Owned by the Royal Caledonian Curling Club, the painting hangs in the Central Scotland Ice Rink in Perth. Robert Anderson, ARSA, RWS (1842-1885) painted 'Curling on Duddingston Loch' in 1880, shown in Colour Plate 32. The first known picture of ladies curling is the delightful watercolour sketch by Jemimah Wedderburn probably depicting the family of Sir George Clerk of Penicuik playing on one of the ponds at Penicuik House, Midlothian in 1847 (*see* Plate 7/4).

'The Curling Match' by John Ritchie (op.1858-75) is particularly interesting and shows the game in a truly urban setting. A similar setting, as a reminder that the population in 1857 was one born out of industry, is depicted in the painting by John Levack 'Curling at Rawyards, Loch Airdrie Lanarkshire', where the winding gear of the Blue Doo Colliery can be seen in

the background (*see* Colour Plate 30). There is no key with the paintings which is a pity since the curlers are all carefully painted portraits of presumably notable worthies of the district.

A painting in the grand style was commissioned to celebrate the Jubilee of the Royal Caledonian Curling Club, befitting an association formed originally as the Grand Club in 1838; executed in 1899 by the talented Scottish portrait painter, Charles Martin Hardie, RSA (1858-1916), the painting is a tribute to the distinguished members of the established Royal Club (*see* Appendix).

By the second half of the nineteenth century, curling sketches were appearing in many of the illustrated periodicals including *The Graphic* and *The Illustrated London News*. The illustrator Charles Altamont Doyle (1832-1893), the father of Sir Arthur Conan Doyle (1859-1930), the creator of the legendary Sherlock Holmes, seems to have had a considerable interest in the sport (*see* Plate 7/5) and sketched several illustrations for various curling publications including *Curling the Ancient Scottish Game*, published Edinburgh in 1880, and *The History of Curling* by John Kerr (q.v.), which was published in 1890 (*see* Plates 7/6 and 7/7). Although born in London, where he worked most of his life as a civil servant, Doyle spent long periods in Scotland and eventually died in Dumfries in 1893. The artist and illustrator, George Denholm Armour, OBE (1864-1949) is more frequently connected with equestrian art but one of his many delightful sketches included a disastrous curling incident which he entitled 'Our artist in Scotland. Awful result of his first attempt to become a Curler' (*see* Plate 7/8). This illustrates only too vividly the mistake of taking to the ice to play a game one does not 'ken'. The painting entitled 'The Last Stane' by Thomas Scott, RSA (1854-1927) which is a delightful portrayal of the game in 1897, is painted with a clarity and a freshness (*see* Colour Plate 31).

Due to the advance of photography, paintings of curling during the twentieth century have not been numerous. Sponsorship, already the lifeline for many sports since the 1950s, has helped with media coverage to promote many sports into spectator orientated leisure activities which, in turn, has created an awareness that art is needed not only in sport but to be depicted on canvas as well. Established artists like Arthur Weaver are keen to depict 'the roaring game' (*see* Colour Plate 34) and it is to be hoped that newer artists will follow his lead to paint this decorative sport at the highest level.

FOOTNOTE

1. Smith, David B., *Curling, an Illustrated History*, published by John Donald Ltd., Edinburgh, 1981.

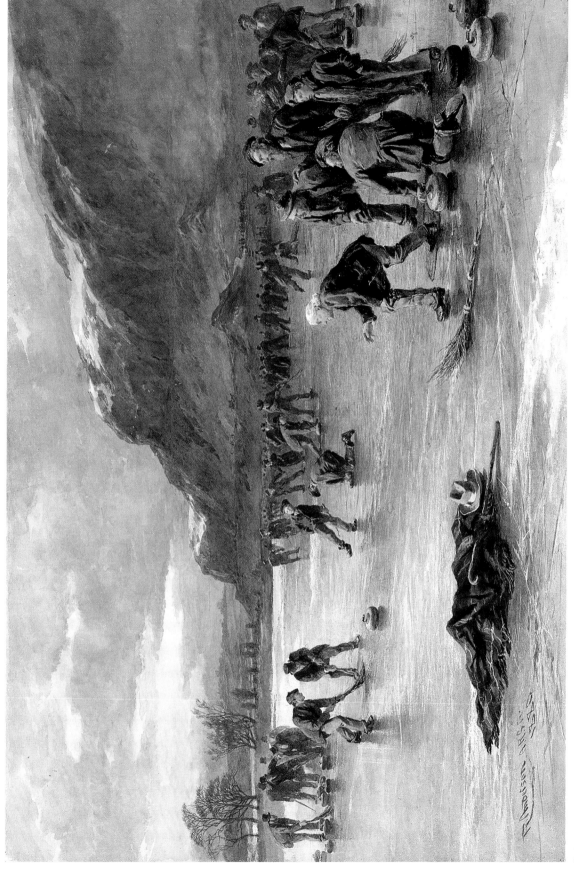

Colour Plate 32. Robert Anderson, ARSA, RSW (1842-1885). 'Curling on Duddingston Loch', signed and dated 1880. Caledonian Club, London.

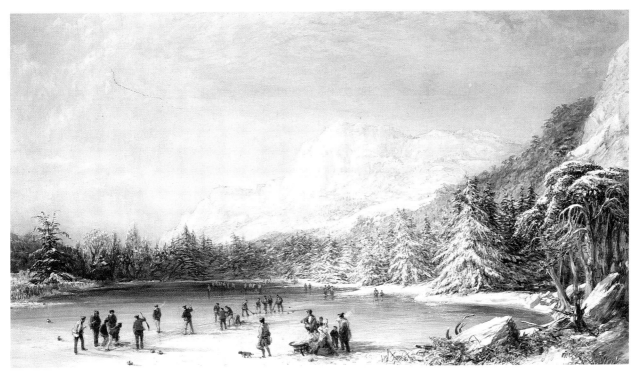

Colour Plate 33. William Evans of Eton, RWS (1798-1877). 'A Curling Match at Polney Loch, near Dunkeld'. Watercolour. 18½in. x 30½in. Richard Green Gallery, London.

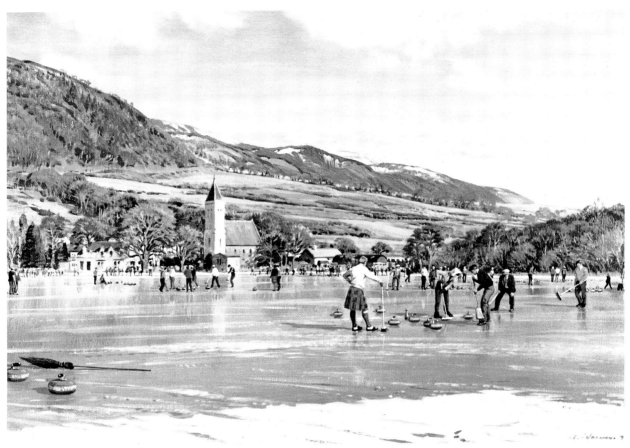

Colour Plate 34. Arthur Weaver (b.1918). 'Lake Monteith, near Stirling, Scotland', signed and dated 1981. Arthur Weaver and the Burlington Gallery, London.

CHAPTER 8

The Eton Wall and Field Game

The Wall Game, which is apparently unique to Eton, derives from the Field game and is one of the oldest forms of football in existence. It is played on a site at Eton College where a red brick wall separates College Field from the Slough Road. According to Cecil Lubbock, Keeper of the Wall between 1890 and 1891, 'in the old days' the game extended over a far larger area than the strip of about 5 x 118yds. in which the game is now confined. The wall the game is played along was built in 1717 and the first recorded game dates from 1766; prior to 1850 it was also played along another wall beside the Field. Although Eton College was founded in 1440, the exact beginnings of the game are difficult to date as full records do not begin until 1845 but it does not seem to have been played regularly until the beginning of the nineteenth century (*see* Colour Plate 35). Part of the original foundation of Eton included a school for boys which comprised seventy scholars or 'Collegers' as they later became known. The other boys who came to be educated at Eton were known as Oppidans (townsmen). These names are important in the history of the Wall Game because the main annual match still played is between two teams — the Collegers and the Oppidans — on the Saturday as near as possible to 30th November (St. Andrew's Day), the only occasion on which the game catches the public eye and the match gets regular press coverage. The rules of the game were first codified in 1849 and have since changed very little.

Wall colours date from around 1852, College Wall wear narrow purple and

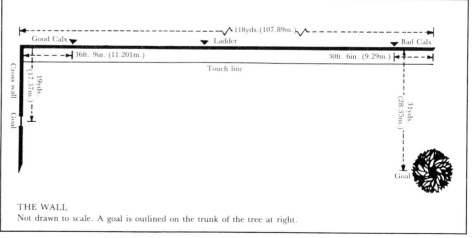

THE WALL
Not drawn to scale. A goal is outlined on the trunk of the tree at right.

Plate 8/1. Plan of the Wall at Eton.

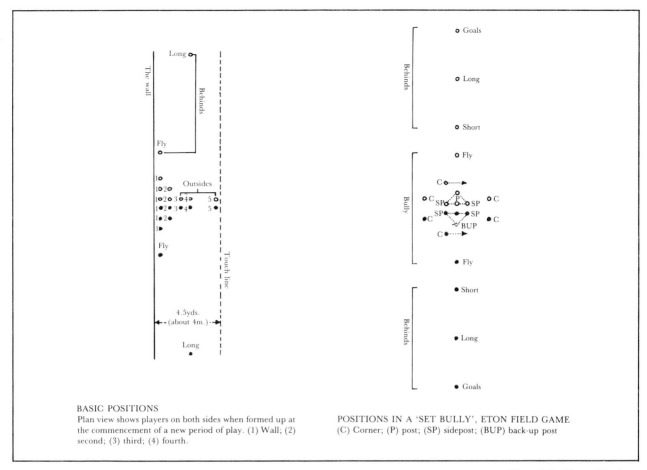

BASIC POSITIONS
Plan view shows players on both sides when formed up at
the commencement of a new period of play. (1) Wall; (2)
second; (3) third; (4) fourth.

POSITIONS IN A 'SET BULLY', ETON FIELD GAME
(C) Corner; (P) post; (SP) sidepost; (BUP) back-up post

Plate 8/2. Plan of basic positions in the Eton Wall Game.

Plate 8/3. Positions in a 'set bully', Eton Field Game.

white stripes and Oppidan Wall broad purple and orange stripes. Collegers start playing the game as soon as they arrive at Eton in order to acquire enough skill and experience to form a team, selected from the seventy scholars, strong enough to compete against the Oppidans selected from over 1,000 boys. From the beginning of the season at the end of September, until the match day at the end of November both teams regularly compete against scratch teams of old boys and masters. The only time that Oppidans and Collegers meet each other in contest is on the match day itself. The most famous player of the Wall Game, J.K. Stephen (College Keeper 1876 and 1877) who is reputed to have carried the entire Oppidan 'bully' on his back is remembered in a toast 'In piam memoriam' drunk in College after every St. Andrew's Day match.

The wall against and along which the game is played is 11ft. (3.3m.) high and 118yds. (107m.) long. The grass surface of the field is quickly reduced to dirt, or mud dependent on the weather. The game, which is quite different from any other kind of football, is not particularly attractive from the spectators' point of view being rather static with only rare periods of rapid movement which is probably due to the constraints of the site. The boundary of the playing area is marked at the left hand side of the long wall by a cross wall going off at right angles from it. From the junction of these two walls is a door 19yds. (17.3m.) along in the cross wall which is one of the two goals. The goal line is marked in white at the other end of the long wall where there is no cross wall to mark the boundary of the playing area. The goal at this end 31yds. (28m.) away from the wall was originally an old elm tree which is now

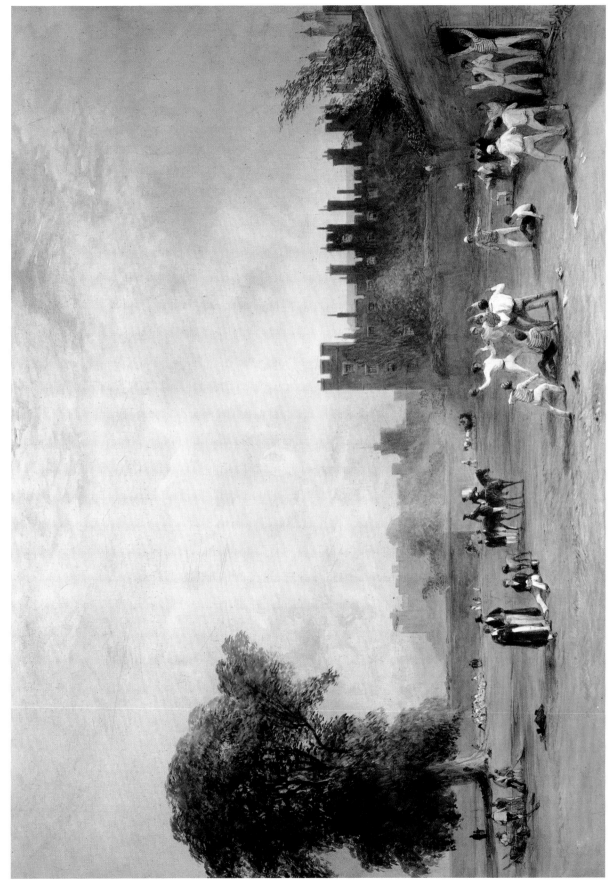

Colour Plate 35. William Evans of Eton, RWS (1798-1877). Drawing Master at Eton (1823-1853). 'The Wall Game at Eton', c.1850. 26½in. x 37in. Reproduced by permission of the Provost and Fellows of Eton College.

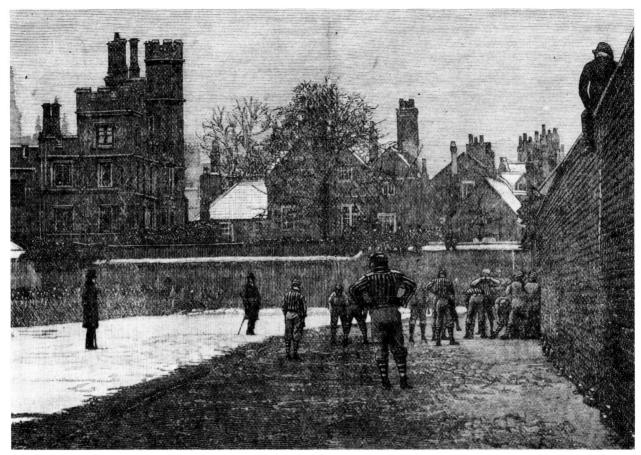

reduced to a stump with a section of its trunk outlined in white to simulate the door of the other goal. At either end of the long wall is a scoring area marked off by a white line on the wall and known as 'Calx' (which, as all classics scholars will know, is the Latin for chalk).

As the cross wall makes scoring easier, the area measured off at 36ft. 9in. (11.2m.) is known as 'Good Calx' and the area at the other end measuring 30ft. 6in. (9.29m.) is known as 'Bad Calx'. Somewhere nearer Good Calx than Bad Calx is a metal ladder on the Slough Road side of the long wall, the bolts of which are visible on the side where the game is being played and in each half of the game, or after a goal is scored, play starts again at the ladder. The object of the game, for readers who have perservered this far, is to propel the ball into the opponents' Calx and score there. The ball is round and about the size of a child's soccer ball. The ten players' positions are designated as follows — three walls, two seconds, a third, a fourth, a lines, a fly and a long. Walls are chosen for a combination of height, reach and weight: they play, as their name implies, right up against the wall itself. Seconds must be short and stocky as they play at or under the feet of the walls normally in a crouching position; third, fourth and lines are designated 'outsides'. The third and fourth are sturdy general purpose footballers and play in 'line abreast' outside the walls and seconds. Lines must be quick, agile players with a reliable kick which they must deliver at once if the ball appears near the touch line. Finally come the two 'behinds', the 'fly' short for the 'flying man', who stands behind the main mass (known as the 'bully'), and 'long' who stands some way back. Originally the Wall Game was played eleven a side but after the Second World War the

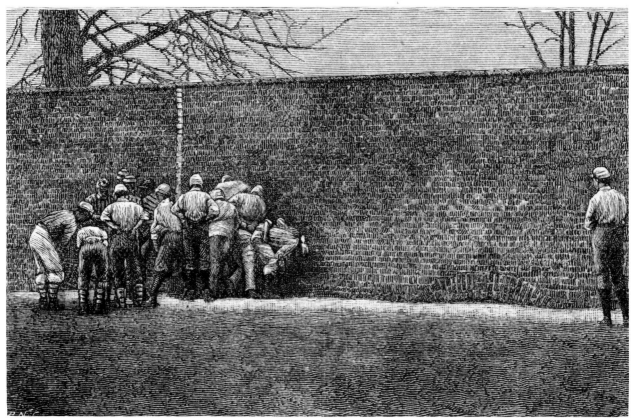

Plate 8/5. Eton Wall Game. An illustration from Boys' Own Paper, c.1881.

number of players was reduced to ten; the eleventh man who was dropped was a third 'behind' known as 'goals' who had very little to do in the game.

The 'flying man', in addition to his role of a behind has the duty of reporting on the position of the ball to his side and directing the efforts of his players. Some of the rules for this game include: not handling the ball, no forward passing of the ball, only sideways passing and no heeling the ball backwards. Serious injuries in the Wall Game are comparatively rare and in Cecil Lubbock's day, the walls and seconds wore special padded clothes and caps to protect them from being scraped against the wall. Nowadays if a player finds that he is being crushed into an intolerable position, he is entitled to shout 'air' at which instant the bully breaks up immediately, always supposing, of course, that his shouts have been heard in the first place.

'In the Wall game as in football, the object is to get goals but a goal is so seldom got that the scores are reckoned by the number of shies obtained. Three shies to two may perhaps be regarded as an average score, though a score of 10 shies is not rare'.[1] The game, as played at the present time, consists of two periods of half an hour with a five minute break in the middle, and is administered usually by one umpire, except on St. Andrew's Day, when two umpires and a referee are used.

Football at Eton, in some form or other, dates back to the school's foundation in 1440. Records show that in 1519 the headmaster, William Horman, produced a book in Latin on school life at that time which included the memorable line 'We will play with a ball full of wynde'. From these early beginnings three distinct football games evolved, the Wall Game, the Field Game and 'Lower College' which disappeared in 1863, the year the Football Association was founded.

THE FIELD GAME

Both the Wall and Field Game share many features in common but whereas the Wall Game is only played by teams drawn from the seventy scholars and a few enthusiasts from the rest of the school, the Field Game is taught to every boy in his first year and is still the official football game at Eton. Alfred Lubbock (father of Cecil) writing of his own experience of the Field Game in the 1850s and '60s in his book *Memoirs of Eton* (published in 1899) describes a game very similar to the one currently played which, although the rules have been altered slightly since 1850, remain unchanged in principle. Until 1971 the Field Game was played in the Michaelmas term and Rugby and soccer were confined to the Lent term. Since competition against other schools in the Field Game was impossible, owing to its exclusiveness, little time was available for the two national games, making competitive teams hard to raise. In 1971, therefore, soccer and rugby were transferred to the Michaelmas term and the Field Game to the Lent term. The rules of the Field Game were also altered with two main aims in mind (a) to reduce the number of drawn games and (b) to discourage deliberate kicking to touch which was beginning to spoil the game. The school field colours of light blue and red were instituted in 1862 and are not to be confused with the school mixed wall colours of red and blue stripes.

As with other forms of football, the object of the Field Game is to score goals. The goals are the same size as hockey goals — 12ft. wide x 7ft. high (3.66m. x 2.13m.) possibly inherited from the time in the 1830s when hockey was being played concurrently with football. The standard pitch 'Field' is 130yds. x 90yds. (118.8m. x 82.2m.), bounded by touch lines at either side and goal lines at either end, marked in whiting. In the field of play, 3yds. (2.74m.) for each goal line and parallel to it a dotted line called the three yard line is marked; 15yds. (13.7m.) from each goal line and parallel to it, there is a continuous line called the fifteen yard line. A round ball is used in the Field Game similar to a small soccer ball. As with the Wall Game, the rules include no handling of the ball by any player and the strict enforcement of the offside rule which restricts passing of the ball. Unlike the Wall Game, the Field Game is played by eleven players on each side, eight of whom form the 'bully'. The bully players are designated as one post, two side posts, one back up post, three corners and one fly (short for 'flying man'); the behinds are called 'short', 'long' and 'goals'.

Scoring goals in the Field Game is easier than in the Wall Game but still quite difficult owing to the small size of the goals through which the ball has to be kicked. An alternative method of scoring, somewhat more frequently employed, is to obtain a 'rouge' on the goal line. Rouge is a word that was used frequently in the 1830s to describe a period of violent activity and appears to be now unique to Eton. It was also used as a verb as in 'pushing and

rouging'. The *Oxford Dictionary* (4th edn. 1946), describes rouge as a noun and as 'a scrummage, a touchdown, in Eton football'. An interesting correspondence in *The Times* dated 13th October 1917 revealed that this word which is to be found in Vigfussen's *Icelandic Dictionary* must have come originally from Norway and was in quite general use certainly at the end of the nineteenth century in Yorkshire and Northumberland and even remoter parts of Cornwall, meaning 'to push about' or 'handle a person roughly'.

There are several rather complicated conditions under which a rouge can be scored but the principle is always the same that the ball is touched when beyond the line by an attacker after a mistake of some sort by a defender. In scoring, a goal counts as three points and a rouge also three points but additional points can be gained: if, for example, after a rouge has been scored the attacking side are successful in converting it into a goal by forcing it through the goal posts against the defending bully, two extra points are scored. The game is officially controlled by two umpires.

The school field matches now take place throughout February and the first part of March and the last rounds of the House Ties in the middle of March.

FOOTNOTE
1. Lubbock, Alfred, *Memoirs of Eton,* published 1899.

CHAPTER 9

Fives

Some sort of fives has existed since very early days and as with rackets may have derived from pelota, the early Basque wall game played with the hand; since 1857 pelota has been played with the long curved basket known as the chistera strapped to the arm. To hit a ball against a wall with the hand or with a piece of wood is instinctive to most small boys, and is the main reason why fives grew and prospered amongst the early public schools, each school adapting the rules and court design over the years to its own character and requirements, so that at the present day there are a number of variations of the game under the names of the schools.

Whilst little recorded detail of the game exists in the public schools before 1825, the chapter on fives in Joseph Strutt's *The Sports and Pastimes of the People of England,* 1801, states that Queen Elizabeth I (1533-1603) was entertained at Elvetham in Hampshire by the Earl of Hertford in 1591: 'after dinner about 3 o'clock, ten of his lordship's servants, all Somersetshire men, in a square green court before her Magestie's windows, did hang up lines, squaring out the forme of a tennis-court and making a cross line in the middle: in this square they (being stript out of their dublets) played five to five with hand-ball at bord

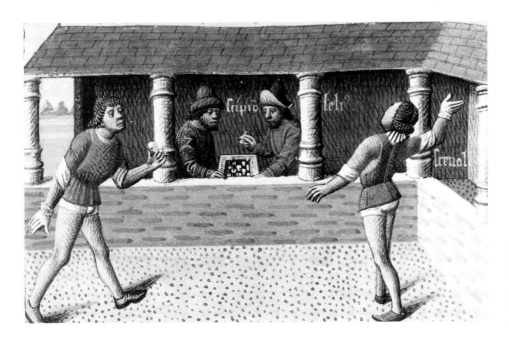

Plate 9/1. A miniature from an English 15th century manuscript in the British Library, shows two men playing fives, each wearing a white glove on his right hand. British Library.

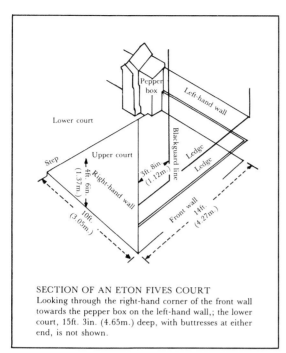

SECTION OF AN ETON FIVES COURT
Looking through the right-hand corner of the front wall towards the pepper box on the left-hand wall,; the lower court, 15ft. 3in. (4.65m.) deep, with buttresses at either end, is not shown.

Plate 9/2. Section of an Eton fives court.

and cord as they terme it, to the greatest liking of her highness'. Later historians doubted Strutt's accuracy in ascribing this game to fives, believing it to have been an improvised game of tennis. They may well be right, as the description, given originally by John Norris, fits neither game as we know it today, although the terms 'bord' and 'cord', which refer to the line traced across the lower part of the wall, survive in modern fives and squash.

The reference in the description to the ten Somersetshire men is interesting as a reference a few years later in the church registers at Locking, near Banwell, outside Weston-super-Mare in Somerset, in the 1630s, makes one wonder whether at that date fives, like hurling, predominated in the West Country. Fives was played in the West Country against the walls of inns and more frequently, church towers, where the glaziers were often called in, it seems, to repair the stained glass windows. The entry in the 1635 Locking register reads: '17 pence spent when I was called to Wells to prevent those that played Fives in the churchyard 8th January'. In 1754, the Bishop of Bath and Wells ordered that the game of fives should cease to be played against church towers as undoubtedly over one hundred years of glaziers' bills were beginning to be felt with some pain by the exchequer.

There is evidence that the game was in full swing in London as early as 1742, from an advertisement in the *Daily Advertiser* of 28th October of that year which states that Mr Thomas Higginson kept a fives court at the bottom of St. Martin's Street on the left hand in Leicester Fields: 'it's for Fives playing only either with Rackets, Balls or at hand Fives at 2d., 3d. or 4d. a game'. The court at St. Martin's Street had been adapted for tennis as well as fives, as an advertisement of 23rd February makes clear: 'and the other Tennis court is in St. Martin's Street next door to the stable yard near Hedge Lane, Leicester Fields. It's built like the Tennis courts at Oxford and Cambridge. It's made out of the Fives court into a carre Tennis court. Tennis at 8d. or 12d. for a four game set, note any gentleman may speak either court for their own play for any day or hour or Fives playing in either court with Tennis and other balls'. The business-like proprietors of public courts were quick to spot changes of fashion in the current popular games and to adapt their courts accordingly. From these advertisements it is clear that the tide of fashion for single walled fives was already on the ebb. The resourceful Mr Higginson, therefore, turned his attention to boxing as a suitable alternative, and ran these courts until his death in 1783. The floor of the fives court at the Minerva Rooms, St. Martin's Street, Leicester Fields was originally used as the venue for sparring contests and exhibitions. Later the coloured boxer, Bill Richmond (1763-1829), known as 'the black terror', suggested to Thomas Cribb (1781-1848), the boxing champion of England at that time, that the introduction of a raised stage might

improve matters so far as the viewing and paying public was concerned. Richmond was also the first pugilist to spar at the fives court stripped to the waist 'in order that spectators might derive a more competent idea upon the art of Boxing'.

In 1780, from a report by John Howard on the 'State of the Prisons in England and Wales', we find that fives was being played at the Fleet and the King's Bench prisons, and later in 1812 James Neild recorded:[1] 'part of the ground next the wall is appropriated for playing at Rackets and Fives'. In 1832, Pierce Egan published his *Book of Sport and Mirror of Life* in periodic issues at threepence each. Issue XV on Rackets included William Hazlitt's magnificent obituary to the champion fives player, John Cavanagh, who died in January 1810: 'When a person dies who does anything better than anyone else in the world which so many others are trying to do well, it leaves a gap in society. It is not likely that anyone will now see the game of Fives played in its perfection for many years to come — for Cavanagh is dead, and has not left his peer behind him.' Cavanagh was an Irishman by birth and a house painter by

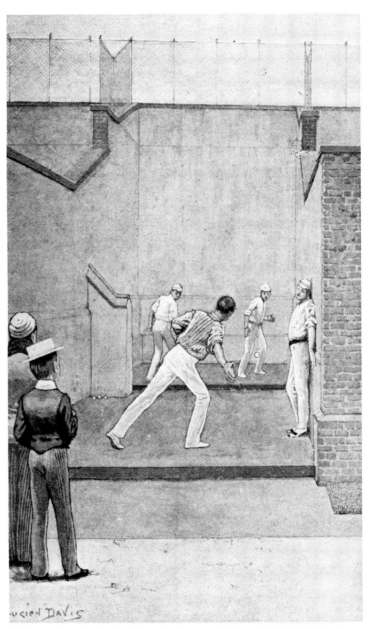

Plate 9/3. Lucien Davis, RI (1860-1941). 'Fives' from Lawn Tennis, Rackets and Fives, *reproduced from the Badminton Library series, published 1890.*

profession, and later on in his tribute to him, Hazlitt quotes an amusing story: 'He had once layed aside his working dress and walked up in his smartest clothes to the 'Rosemary Branch' to have an afternoon's pleasure. A person accosted him and asked him if he would have a game. So they agreed to play for half a crown a game and a bottle of cider.' Needless to say Cavanagh's opponent could not take a game from the champion, but not recognising him, persevered until the inevitable conclusion was reached and Cavanagh's identity revealed. According to Hazlitt, the opponent was not amused, but it is to be hoped that his sporting qualities were revived by the cider. The game of single-walled fives suffered a catastrophic decline shortly after, if not as a direct result of Cavanagh's death, but it survived in the public schools.

ETON FIVES

Eton fives is a handball game played by pairs in a three walled court, the design of which is based on an area outside the Chapel at Eton. Some of the original

hazards have been incorporated into the modern court and game. A game of Eton fives consists of twelve points and matches are generally the best of five games. One player of a pair guards the upper court and his partner the lower. Points are scored by the pair serving; the purpose of the server on the top step is to dominate the game, which requires skill, speed, an accurate eye and volleys with either hand. The partner in the lower court acts as back up. Each player wears protective leather gloves, and the ball, which is painted white and roughly the size of a golf ball, is a composition of cork and rubber.

During the first half of the nineteenth century, fives became popular at Eton, partly because there were no organised school games and partly because the buttresses and walls of the College loaned themselves to the evolution of the Eton game. Eton is indebted to Dr E.C. Hawtrey, an old Etonian and sometime Headmaster who captained the 'I Zingari' cricket team, founded in 1845 (see p.93). He was once dubbed 'Nitidissimus Hawtrey' by the facetious William Bolland on account of his fastidious appearance. Hawtrey decided in 1840 to organise the game and to build the first block of fives courts on which all modern courts are modelled. The walls were built of sandstone to reproduce the effect of the chapel walls, but the distance between the front wall and the 'pepper box', modelled on the original small buttress against the chapel wall, was increased. The existence of the 'pepper box' is important as it is the main and essential difference between Eton and Rugby fives. The fall of the court floor was lessened by as much as half, thus making the game both easier and faster. Only the 'deadman's hole', originally a drain for surplus rainwater, and the coping on the front wall remained unaltered.

Although the first rules of the game, as played at Eton, were codified in 1887,[2] they were not universally adopted by other schools until 1931, when the first authoritative set of laws was published by the Eton Fives Association (EFA). Eton fives courts vary in dimensions, but all have a ledge running across the front wall, making a horizontal line, 4ft. 6in. (1.37m.) from the ground. Running across the court is a shallow step, 10ft. (3.05m.) from the front wall, dividing the court into an inner, or upper court and an outer or lower court. The lower court is 15ft. 3in. (4.65m.) in depth and 14ft. (4.27m.) wide. At the end of the step, projecting from the left hand wall, is the 'pepper box'. The game of fives is now played at over fifty centres throughout England, and also in Australia, Malaysia, Europe and Nigeria.

RUGBY FIVES

Rugby fives is a less complicated game than Eton fives due to the simple form of the court, which, although larger, contains four walls and no hazards. As the name implies, the game originated at Rugby school, and was certainly the 'in game' being played there in 1813. The Winchester fives court is also plain with four walls similar to the Rugby fives court but is not quite rectangular having a buttress or tambour reminiscent of the one to be found in real tennis

courts where fives were often played. After the formation of the Rugby Fives Association in 1927, the dimensions of the different courts for this game were standardised in 1931 which made competitive play much easier. The official measurements for a standard Rugby fives court, are 28ft. long x 18ft. wide (8.5m. x 5.5m.). The height of the front wall is 15ft. (4.6m.), the height of the back wall is 6ft. (1.8m.), the height of the side walls is 15ft. (4.6m.), (for the first 12ft. (3.7m.), measuring from the front wall), then sloping down to 6ft. (1.8m.) at the back. A board, the top of which is 2ft. 6in. (0.76m.) from the floor, spans the front wall from side to side. Since the ball used is small, hard and white, the walls are painted black and the floor is usually red. Before the formation of both Eton and Rugby Fives Associations, fives of all denominations had been catered for under the auspices of the Tennis Racquets and Fives Association, founded in 1907.

Fives is one of the ball games that demands ambidextrous skill and is also one of the few games that remains entirely amateur. Each year at the end of March, four major championships are competed for. In Eton fives the men's championship is for the Kinnaird Cup, given in 1924 by Lord Kinnaird, and in Rugby fives, the singles title is for the Jesters Cup. The famous Jesters Club was originally started as a cricket club in 1928, but is now more renowned for court games. Membership is by invitation only, and includes not only players of both Eton and Rugby fives, but also players of real tennis, rackets, and squash rackets. The schools' competitions are for doubles only in Eton fives but in Rugby fives, they are for both singles and doubles. Winchester fives players compete in the Rugby Fives competitions, as well as their own championship, which is now an annual event. The Eton Fives Association formed in 1931 has forty affiliated schools and the Rugby Fives Association (RFA) fifty. The Eton Fives Association includes numerous Old Boys Clubs and the Universities of Oxford and Cambridge. The RFA has fewer Old Boys but ten Universities and three of four other institutions such as the Bank of England and Manchester YMCA, both of whom have long fives histories. Fives has by tradition been considered an unsuitable game for women,

presumably because of the physical hardness required in both hands. Nowadays, women have their own and mixed championships, which are firmly established in Eton fives. The first ladies' Rugby Fives, National Singles tournament, was played in December 1985, at St. Paul's School, London. Rugby fives was introduced into the USA, c.1884, by Endicott Peabody, the headmaster of Groton School, Groton, Massachusetts, who built the first fives courts.

BAT FIVES — a variation of fives, but played with a bat and not a gloved hand, has been popular at Radley School, since 1855. The nearest version to bat fives is American racket ball.

ART

Fives is another of the court games which possibly due to exclusivism, suffers from a lack of pictorial representation.

The watercolourist, Robert Dighton (1752-1814), included the game amongst his many sporting sketches. Perhaps the best known painting is of the Fives Court, St. James's Street, Haymarket, painted c.1818, by the little known artist, T. Blake (fl.1818-1831). This picture is probably better known for the boxing match it depicts, rather than the court on which the match is held. The painting illustrates the uses that the fives court were put to, when the game went out of fashion, at the beginning of the nineteenth century, and shows the raised stage instigated by Bill Richmond, the coloured boxer. Blake also painted a watercolour sketch of the same subject, but an etching and an uncoloured aquatint, published by Charles Turner in 1821, shows a number of differences between the print and the painting.

A set of six engravings by E. Rudge, the art master at Rugby School (1824-1841) is interesting; in one, boys are shown playing wall fives against the west wall of the School building (*see* Plate 9/4), and in another, fives bats are being used in the old quad. In the illustration of the west wall game, the low back wall does not appear to have the height to make a successful fives court. Dr. Thomas Arnold (1785-1842), lived in the part of the building nearest the tree, and Thomas Hughes (1822-1896, author of *Tom Brown's Schooldays*) in the study on the ground floor near the mortar boarded Master depicted in the engraving.

FOOTNOTES

1. James Nield wrote on the general state of prisons in England, Scotland and Wales in 1812; *see* Lord Aberdare, KBE, *The Willis Faber Book of Tennis and Rackets,* published by Stanley Paul, London, 1980.
2. 'Rules of the Game of Fives as played at Eton', by A.C. Ainger, an old Etonian.

CHAPTER 10

Golf

All ball games have their origins to some degree in antiquity, and have evolved to become the individual games and sports we know today. In writing a brief history of golf the problem is where to find the recognisable beginning of the sport. The Romans played a game called 'paganica' using a leather ball stuffed with flock, and in England in the fourteenth century a similar game was played called 'cambuca'. A game which closely resembled golf and which was thought by many people, before recent research by those excellent historians Henderson and Stirk,[1] to be directly responsible for the modern game of golf was the game of 'Pall Mall', which originated in Italy, as can be seen from a painting by Paul Bril painted in Rome in 1624. Pall Mall was also played by the French ('Pele Mel' or 'Jeu de Mail'). The game was played in England at the beginning of the seventeenth century, and in 1717 Monsieur Lauthier wrote a small treatise on how to play it, together with the rules, called appropriately enough 'Jeu de Mail' which he had published in Paris. Lauthier describes the rules for playing Pall Mall on a court which had a prepared surface and boundary; the object of the game was to drive the ball through the series of iron hoops like croquet, and from the illustrations and clubs displayed in the British Museum, it would appear that the game was quite complicated.

It is not known when the original course was first established in Pall Mall, St. James's, but Charles I (1600-1649) was certainly playing the game, c.1629.

Plate 10/1. Golf, or Bandy-ball. (From a manuscript in the Douce Collection.) Topham Picture Library.

The Dutch artist Adriaen van de Venne (1589-1662) painted a miniature of the game being played with mallets along a straight alley with a vertical post at the end (*see* Appendix), c.1625, whilst Frederick, King of Bohemia was in exile in The Hague. Charles I may well have learned the game from his sister Elizabeth Stuart, who was married to Frederick. It would appear that Charles I was a very early player in England, for Samuel Pepys (1633-1703) wrote in his diary 2nd April, 1661: 'To St. James Park where I saw the Duke of York [later James II 1633-1701] playing at Pele Mele the first time I ever saw the sport.' It was after the restoration of Charles II (1630-1685) in 1660, that the original course became the thoroughfare known today as Pall Mall, and a new course was made in The Mall which runs from Trafalgar Square to Buckingham Palace.

Although the game of Pall Mall went out of fashion in England in the eighteenth century, interest in the game still flourished in France, particularly in the south. Here the resemblance to the modern game of golf was more marked, and 'Jeu de Maille à la Chicane' was clearly a game to be played in the open countryside, particularly along roads towards a definite target. Morever, a club with one end lofted was already in use to cope with the rough terrain.

A description of golf in France is given in *Historical Gossip About Golf and Golfers*, published in Edinburgh, 1863. In Holland a version of golf was played as early as 1296, and continued to be played throughout the fourteenth and fifteenth centuries (*see* Plates 10/2 and 10/3). Inexplicably, Dutch golf ceased to be played about the beginning of the eighteenth century and in its place appeared 'Kolf' (club) or 'Het Kolven', a game played over a short distance and often indoors using heavier clubs and larger balls. This version was in turn to lose its appeal when Scottish golf was introduced in 1890.

In the light of recent research, it now seems likely that the game of golf was introduced to Holland by the Dutch wool or fish traders (*see* Colour Plate 40 and Plate 10/4). The Dutch fishermen at that time sold the Scots fish caught off their own coasts, particularly the east coast of Scotland, where golf was a local game.

Golf was certainly played in Scotland as early as 1457, and is mentioned in an act of Parliament during the reign of James II, but few early Scottish records and documentation from 1300 have survived and portraits and landscape paintings were virtually non-existent. A little later in 1501, the Treaty of Glasgow was signed to achieve peace between England and Scotland. James IV of Scotland (1488-1513) took up the game and thus began the long association of the Stuart Kings of Scotland and England with the game of golf. In 1567, Mary Queen of Scots was charged with playing golf and Pall Mall

at Seaton House, East Lothian a few days after the murder of her husband, the Earl of Darnley. Pall Mall or Peille Meille is said to have originated in Italy, so it seems a logical possibility that the Queen was introduced to the game by her Italian lover, David Rizzio, who was murdered in her presence by her husband Darnley in 1566. Her son, James VI of Scotland (1566-1625) brought the game to England on his accession to the throne in 1603.

The earliest description of the Scottish game of golf was found in a Latin grammar for schools (Aberdeen, 1632) now in Aberdeen University Library, which mentions bunkers, iron clubs, holes and sand used for teeing up. Six years later in 1638, the preface to the *Muses' Threnodie* or *Mirthful Mournings on the death of Master Gall* by Henry Adamson, mentions that not only was James Gall, a citizen of Perth, a man of 'goodly nature and pregnant wit' but that his many and much loved pastimes included 'Golf, Archerie and Curling.'

The legendary match took place, c.1681-2, between James, Duke of York (1638-1701, later James II of England) then resident at Holyrood, and John Patterson, a shoemaker, against two English nobles. The young Duke of York seems to have been

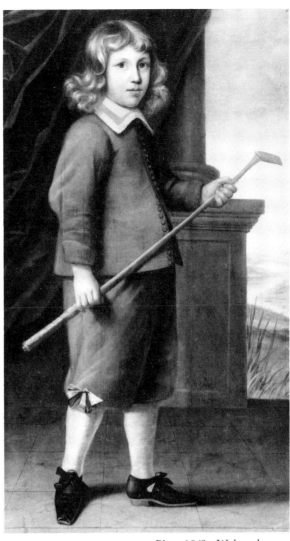

Plate 10/3. Wybrand-Simonsz de Geest, the elder (1592-1659). 'Portrait of a boy with a golf club'. 46in. x 26¾ in. Sotheby's.

a very versatile and keen sportsman, because he not only played Pall Mall, but also real tennis (*see* pp.310-11). In his diary of 1687, Thomas Kincaird, a young Edinburgh golfer, gives a description of how to swing a golf club but reveals nothing about the game, the course, or how far those playing hit their shots, and it is not until 1743 that there is a clear description of the golf ball in Thomas Mathison's poem 'The Goff': '. . . the work of Bobson; who with matchless art shapes the firm hide, connecting every part, then in a socket sets the well-stitched void and thro' the eyelet drives the downy tide; crowds urging crowds the forceful brogue the feathers harden and the leather impels, swells . . .'.

By the beginning of the eighteenth century, the game was attracting more and more influential and well-to-do Edinburgh citizens to the golf links at Bruntsfield (*see* Plate 10/6) and Leith. The exact date of the establishment of Bruntsfield is unknown except that its centenary was celebrated in 1861. Societies were formed by Edinburgh worthies for the purpose of meeting together, arranging matches and wagers, and for dining. The way in which those golfing societies were organised on similar lines to those of the Society of Freemasons was surely no accident, and once the Grand Master Mason of Scotland, William St. Clair of Roslyn (*see* Colour Plate 36), and his fellow

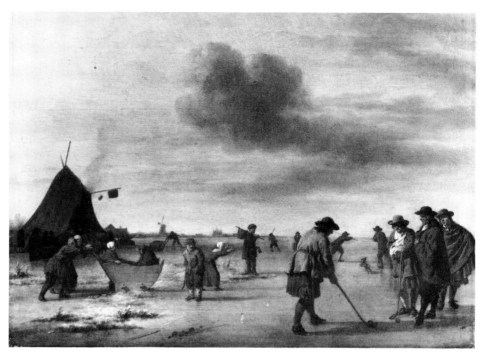

Freemasons had been observed laying the foundation stone of a new golfing house at Leith in 1767, there can be little doubt that the attractive idea of playing golf before banqueting was organised by the freemasons. Furthermore, recent evidence has revealed that between 1743 and 1765, 186 golf clubs and over 1,000 balls were exported from Leith to John Deas of South Carolina. (John Deas, who originated from Leith, was the first provincial Grand Master Mason in America.) A little later another ardent freemason, John Whyte-Melville, was depicted in a painting by Sir Francis Grant, PRA (1810-1878) in his role as Captain of the Royal and Ancient Golf Club of St. Andrews. Elected in 1823, this gentleman had the unique distinction of being re-elected in 1883, although he died before he could take office. Whyte-Melville was also Provost of St. Andrews and was therefore a gentleman of great influence. His son, George John, was Captain of the Royal and Ancient in 1851, commanded the Turkish Horse in the Crimean War (1852-1854) and was the well-known fox hunting author, G.J. Whyte-Melville.

The city of Edinburgh presented a trophy in the form of a silver golf club in 1744 to the 'Gentlemen Golfers' at Leith to be competed for annually. This was a similar gesture to the one they made to the Royal Company of Archers, who competed annually on the same links for the silver arrow presented to them in 1709. From these beginnings there evolved the Honourable Company of Edinburgh Golfers which was followed in 1754 by a similar association of golfing enthusiasts in St. Andrews which later became the Royal and Ancient Golf Club in 1834. The Royal and Ancient became the body responsible for running the Open Championship in 1919 and the Amateur Championship in 1920, which was first instituted by the Royal Liverpool Club at Hoylake in 1885.

The first written rules of golf were drawn up in 1744 by the Gentlemen Golfers at Leith and these thirteen 'Articles & Laws in Playing at Golf' were adopted, with one minor change of procedure, by the Society of St. Andrews Golfers in 1754. At that time the accepted number of holes was twenty-two but the number was reduced to eighteen in 1764. Until the 1830s, therefore, the

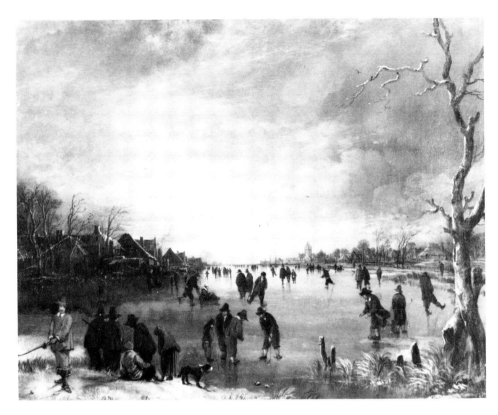

Plate 10/5. Aert van der Neer (1603-1677). 'Winter landscape in the late afternoon', signed with double monogram. 16in. x 20¼in. Christie's.

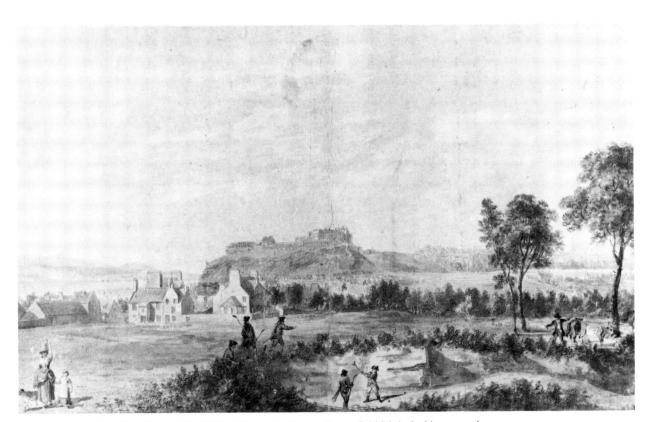

Plate 10/6. Paul Sandby, RA (1725-1809). 'View of golfers on Bruntsfield Links looking towards Edinburgh Castle', signed and dated 1746. 11½in. x 18in. British Museum.

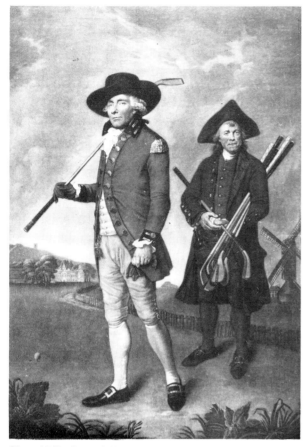

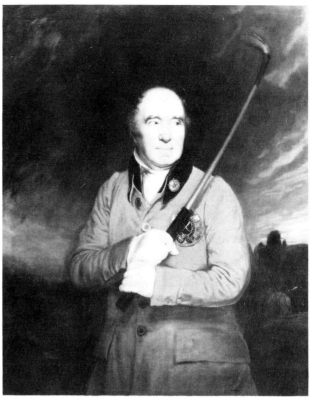

Plate 10/8. William Bradley (1801-1857), signed and dated 1818. 'George Fraser, First Captain of the Manchester Golf Club'. 44in. x 36in. Manchester City Art Galleries.

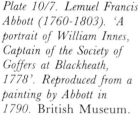

Plate 10/7. Lemuel Francis Abbott (1760-1803). 'A portrait of William Innes, Captain of the Society of Goffers at Blackheath, 1778'. Reproduced from a painting by Abbott in 1790. British Museum.

Gentlemen Golfers and their successors, the Honourable Company, were generally acknowledged to be the custodians of the game's traditions and, as such, were consulted by newly formed clubs and societies on matters of golfing law. St. Andrews became the supreme authority on the rules from 1897 onwards. The United States Golf Association (USGA) was formed in 1894, when the largest established American golf club was about five years old.

In 1848, the gutta percha ball replaced the old wooden ball and the feathery ball, which was at least 200 years old (Kincaird, q.v., had referred to it in 1687). The new ball, which was cheaper and more reliable since the feather ball tended to burst, made it possible for more people to play golf, especially in Scotland, and had an almost immediate effect on the game there. Less dramatic, but of similar significance, was the change from ash to tough hickory for club shafts.

During the early to mid-1800s, the first golf celebrities made their appearance, including the legendary Alexander McKellar, known as the 'Cock o' the Green', who died c.1813. This amazing character appears to have become completely obsessed by the game, playing all and every day except Sundays, leaving his wife to run his small tavern in the New Town, Edinburgh. He is depicted in a sketch by John Kay (1742-1826) who went out to the links at Bruntsfield, Edinburgh in 1803 especially to draw him for his book entitled *Kay's Edinburgh Portraits,* published in 1838. Strangely, McKellar does not appear to have been a member of any of the Scottish golfing societies, through which came the expansion of golf to England and America.

Allan Robertson (1815-1859), and 'Old Tom Morris' (1821-1908) were also

Plate 10/9. English School, c.1830. 'The Young Golfer'. Pencil and watercolour. 11in. x 9in. Bonhams.

celebrities. Alan Robertson, using the new gutta percha ball, was the first golfer to hole St. Andrews in 79. Tom Morris was painted by the artists James Patrick and Sir George Reid, PRSA HRSW (1841-1913, *see* Plate 10/19). Both Robertson and Morris were feather ball makers; the balls cost three shillings each and about six a day could be made, whereas the new gutta percha ball cost between sixpence and one shilling. When the balls first appeared on the market, it is alleged that Allan Robertson attempted to buy them all up to maintain his monopoly

Plate 10/10. Macneil Macleay, ARSA (op.1830-1870). 'Members of the Royal Perth Golfing Society playing on the links', signed and dated 1866. 17in. x 27in. Sotheby's.

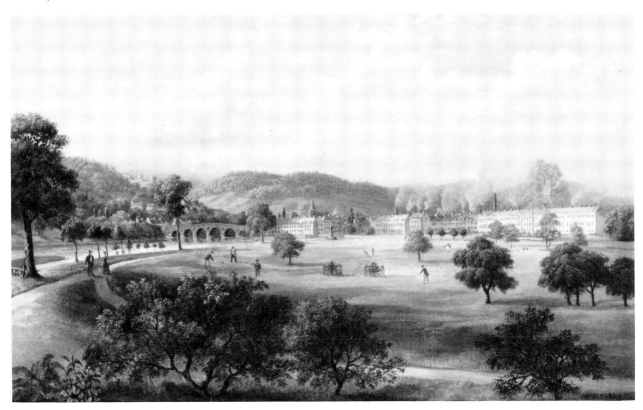

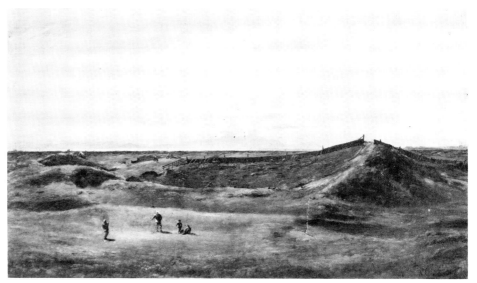

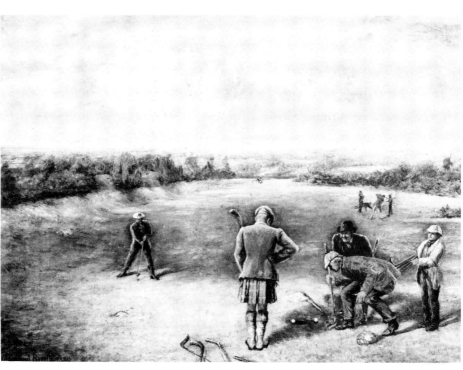

with the feather ball. Both men were outstanding professional golfers, hired as ball and club makers for their respective links, Prestwick in the case of Tom Morris, who was apprenticed to Allan Robertson for four years, and St. Andrews for Allan Robertson. Tom Morris was actually born in St. Andrews but adopted Prestwick as his club for some fifteen years after a row with Robertson; after Robertson's death in 1859 he returned to St. Andrews, where he was 'Custodian of the Links' until a few years before his own death in 1908.

It was the Prestwick Club which, in 1857, organised a successful inter-club tournament to be played at St. Andrews which, unlike Prestwick, had an eighteen hole course, and on 17th October, 1860 arranged an event for professional golfers which a year later became known as the Open Championship. Eight stalwarts competed (although St. Andrews claim that

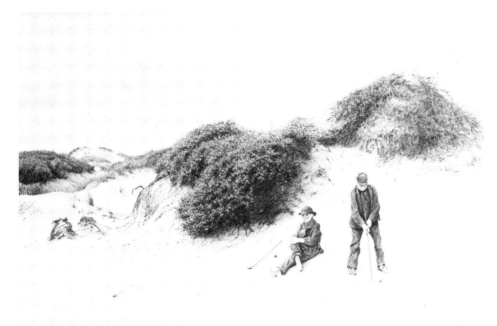

Plate 10/13. R.H. Rutherford (op. 1883-1897). 'Caddie Boys practising Golf behind Ainsdale, Lancs.', signed and dated 1893. Watercolour. 8¾in. x 13in. Phillips, Chester.

only six were 'stalwart', the other two were not — one man called Smith taking 130 to go round) over three rounds of the Prestwick twelve hole course with the winner, Willie Park sen. of Musselburgh, receiving a gold sovereign. His son, Willie Park jun., won the Open in 1887 and 1889.

One of the best known portraits of a golfing celebrity is that of 'Old Alick', the holemaker to the Royal Blackheath Golf Club, painted by R.S.E. Gallen, c.1835 (*see* Colour Plate 39). This eccentric character was born in 1756 and died in 1840; formerly a caddy to the club, he became a holemaker after he retired. Although the Blackheath Golf Club was traditionally instituted in 1608, there is no evidence of its existence before 1766, unlike the Honourable Company of Edinburgh Golfers (1744), the Royal and Ancient Club of St. Andrews (1754) and Bruntsfield Links Golfing Society (1761).

Blackheath Common, where the game was first played in England, lies adjacent to the royal grounds of the ancient Greenwich Palace, and it was here, his favourite home, that James I of England and VI of Scotland (1566-1625) spent most of his reign. Although there is no evidence that James played golf himself, it has been recorded that amongst the many gifts with which he was presented were two golf clubs.

History records that the tennis playing Prince Henry (*see* p.309), the eldest son of James I, also played at golf when the Court was at Greenwich. The story is told that one day when practising his golf swing, he almost struck his tutor, Sir Adam Newton, the Dean of Durham, who taught the Prince at Charlton in close proximity to Blackheath. In the life of Prince Henry Frederick by the author 'W.H.', traditionally thought to be William Haydon, in 1634, the Prince is alleged to have said 'Had I done so, I had but paid my debts.'

The artist, Lemuel Francis Abbott (1760-1803), who taught among others the sporting artist Ben Marshall (1767-1835), painted two well-known golfing portraits, both associated with Blackheath. 'The Blackheath Golfer' was a portrait of William Innes (1719-1795), M.P. for Ilchester from 1774 to 1775 and also Captain of the Society of 'Goffers' at Blackheath in 1778. The original painting no longer exists, but from a print taken by Abbott in 1790 which has

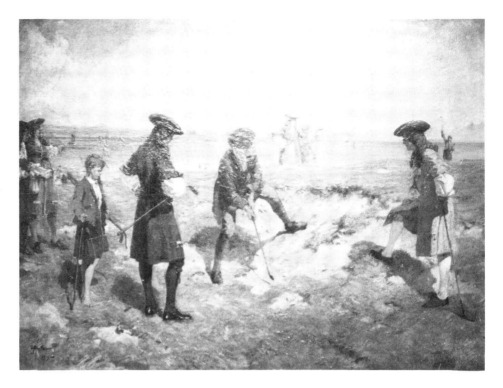

Plate 10/14. Allen Stewart (1865-1951). 'The First International Foursome', signed and dated 1919. The players are dressed in Carolean costume. United States Golf Association Golf Museum.

Plate 10/15. Walter Dendy Sadler, RBA (1854-1923). 'Stymied', signed. 22in. x 32in. Topham Picture Library.

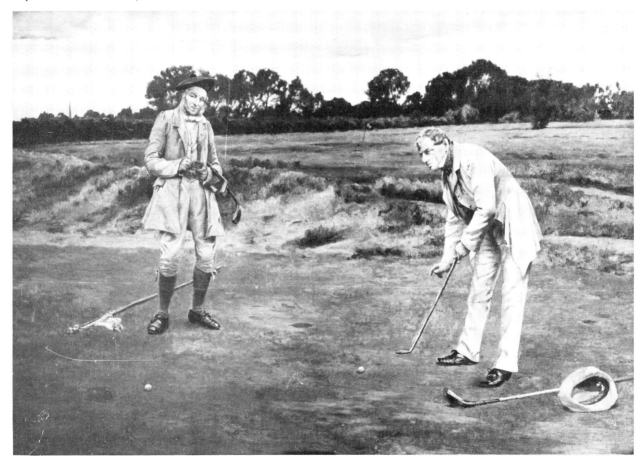

180

Plate 10/16. Joseph Morris Henderson, RSA (1863-1936). 'The Lighthouse Green at Turnberry', signed. 16in. x 20in. Sotheby's.

been reproduced countless times over 200 years (*see* Plate 10/6), it shows Innes holding a club over his shoulder whilst a long-suffering caddie stands holding seven or eight clubs under his arm; the golf bag did not come into use until the 1890s.

Recent facts have come to light about the fate of this picture and were published in *The Compleat Golfer*[2]. Innes apparently left the painting in his will 'to his dear friend Agnes Palmer', by whom he had a son and daughter. The son, William Palmer, became Chaplain to the East India Company; he was a prominent shareholder in the Company and left £700,000 in his will, a fabulous sum in 1795! One of William's sons was General Palmer, a distinguished Indian Army soldier; in his memoirs, he states that as long as he could remember there had stood in his father's house a portrait in oils, seven feet high, of William Innes, whom he, General Palmer, believed was a relative of his and the portrait depicted this man playing golf accompanied by a caddie. Palmer had watched his house burnt down by the mutineers in Lucknow on 30th May 1867, with the portrait inside. Abbott's painting of Henry Callender, the Club's first Captain General, is in the possession of the Royal Blackheath Golf Club and shows that worthy gentleman 'standing in uniform of Blackheath Society of Golfers resting club on ground' (published and engraved by W. Ward in 1812).

In the early nineteenth century plans were drawn up for new golf courses in England for which Scottish help was hired, and from Scotland came designers and professionals like Willie Dunn, and later Donald Ross. The term 'links' came to be associated with seaside courses. The first English club to be established in the nineteenth century was the old Manchester Golf Club formed in 1818; George Fraser was the first Captain and his appointment was commemorated in a painting by the Manchester portrait painter William Bradley (1801-1857, *see* Plate 10/8). It was, however, the Royal North Devon at Westward Ho, the first seaside links on which golf was played in England,

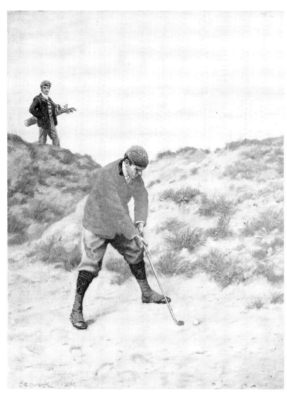

Plate 10/17. Charles Edmund Brock, RI (1870-1938). 'The Bunker', 'The Drive' and 'The Putt', signed and dated 1894. Sotheby's.

'The Bunker'. 16in. x 12in.

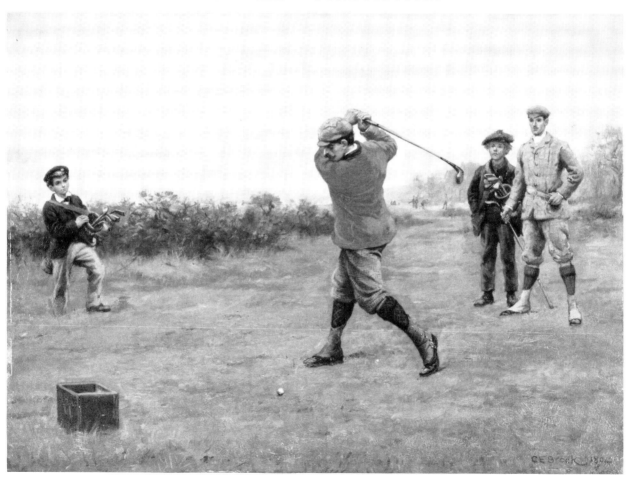

'The Drive'. 12in. x 16in.

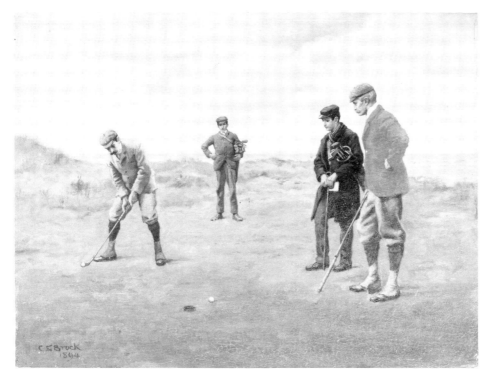

'The Putt'. 12in. x 16in.

established with the help of Tom Morris (q.v.), which really set the pattern for the modern courses in England. The Club, which was instituted on 4th April, 1864 with the Prince of Wales as Patron and Lord Clinton and the Earl of St. Stair as Vice Patrons, had the distinction of raising John Henry Taylor (1871-1963), who became the first professional to beat the Scots at their own game, for he won the Open Championship five times and was runner-up five times. Golf was spread beyond the borders of its native land by expatriate Scots, particularly by officers of Scottish regiments, so that the Royal Calcutta (1829) and the Royal Bombay (1842) are the oldest golf clubs outside the British Isles. In Ireland, the Royal Belfast (1881) was the first golf club to be formed, and in Europe that at Pau in 1856 led the way.

By the late 1800s, wealthy members of the middle class flocked to Scotland for their holidays using the rapidly expanding railway network. St. Andrews and North Berwick were favourite places, and there the visitors took up the game of the old leisured class. Women and children also learned the game on these Scottish holidays, and women's golf was born at St. Andrews, with the inauguration of the first Ladies' Golf Club in 1867. This was followed on 8th June 1868 by the formation of another club for women at Westward Ho; known as the Westward Ho and North Devon Ladies Club, it had forty-seven full members, and twenty-three associate male members. Westward Ho had its own women's nine hole course on Northam Burrows close to but separate from the main course. It also had its own professional who was Andrews, the brother of the steward at Royal North Devon; only he was allowed to teach the women, the men's club professional was forbidden to do so. Play was at first confined to every other Saturday between 1st May and 31st October and no golf club could be used on the course other than a wooden putter.

A picture of women at play, 'Ladies Golf 1873', shows that the sport in England was genteel to a degree. It was clearly more important to conceal an ankle than to execute a full swing, and the dress, decorative as it was, suggests

183

that a complete golf stroke was physically impossible. Not so in Scotland where the women, trained from early childhood, made short work of their opponents. American women from the very beginning refused to be pushed into the background and excluded from the activities of their clubs. The clubs in Britain, whether social or golf, were mainly a male preserve. The English Victorian male largely disapproved of this apparently unfeminine mode of exercise and enjoyment, and actively sought ways to discourage any further development in women's golf other than as a putting game. Despite their efforts, the women's game progressed, and in 1893, the British Ladies' Golf Union (LGU) was formed. In the same year the first English Ladies' Championship was played over nine holes at Lytham and St. Anne's Golf Club, where there were thirty competitors and the championship was won by Lady Margaret Scott.

As Britain's empire expanded, golf spread around the world. The game had been played in a small way in America prior to the foundation of the St. Andrews Golf Club of Yonkers in 1888. This course was primitive, but by 1895 the Open Championship links at Newport, Rhode Island were laid out. As late as 1899 leading professionals like Harry Vardon (1870-1937) met little opposition on tours in America.

The Carnoustie Club in Scotland, drawn from the artisans of the town, produced a remarkable number of emigrés who could be found playing golf and tending courses all over North America. The rise of American golf was signalled when W.J. Travis won the British Amateur Championship in 1904. Another feature of the growing dominance of America was the appearance of the Haskell ball (originally stamped 'Pat. April 1899') which quickly captured the market. This new ball, named after Coburn Haskell and made by the

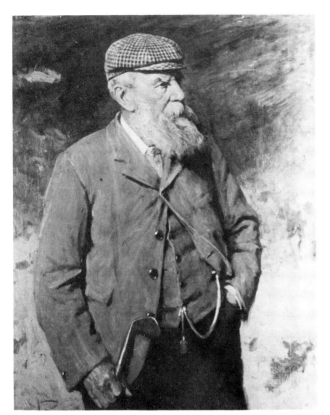

Plate 10/19. Sir George Reid, PRSA, HRSW (1841-1913). 'Portrait of Tom Morris, Sen,'
Painted in 1903. Royal and Ancient Golf Club of St. Andrews.

Plate 10/20. A Lady Golfer. Unknown artist. 24in. x 17¾in. Sotheby's.

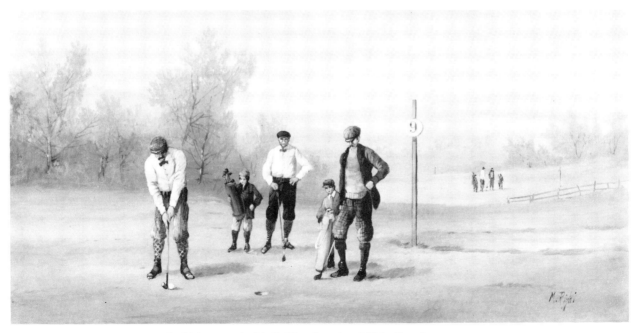

Plate 10/21. M. Righi (op. early 20th century). 'A Golfing Scene', c.1910. Signed.
8in. x 15¼in. Sotheby's.

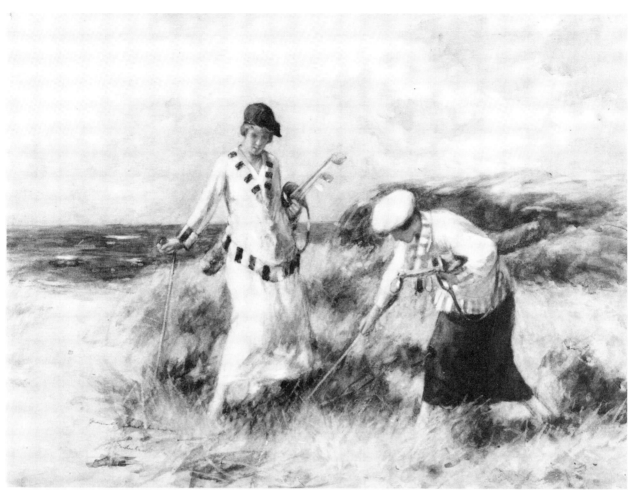

Plate 10/22. Robert Gemmell Hutchinson, RSA, RSW, ROI (1855-1936). 'The Lost Ball', signed. 17½ in. x 23½ in. Watercolour. Sotheby's.

Goodrich Tyre and Rubber Company of Akron, Ohio, with which Haskell was involved, was to completely revolutionise the game but its early beginnings were not without problems. In the first place it was very difficult to control and became known as 'bounding Billy' for the enthusiasm with which it travelled over the greens. This was largely rectified by giving the ball an Aggripa cover, but, more dramatically, it became the centre of the greatest legal action in the history of golf over the infringement of patents. Furthermore, club design was changed to suit the new ball, the heads becoming deeper, and the scare-head design changed the socket joint.

The status of the golfing professional in Great Britain remained low certainly until the end of the nineteenth century, if not well into the twentieth. The masters of the game were generally called by their surnames, and even champions such as James Braid (1870-1950) never entered his own club house by the front door at Walton Heath where he was the professional. J.H. Taylor did much to increase the status of professionals and promote their image, until they became national figures even outside the then narrow world of sport. This was helped by the increasing number of tournaments and the continued efforts of the three times Open champion, Henry Cotton (1907-1987), who on being appointed to Ashridge Golf Club in 1937 made the bold stipulation that he be made an honorary member of the club. Interestingly, golf is one of the few games that started with professional champions as opposed to amateur players who later became professionals.

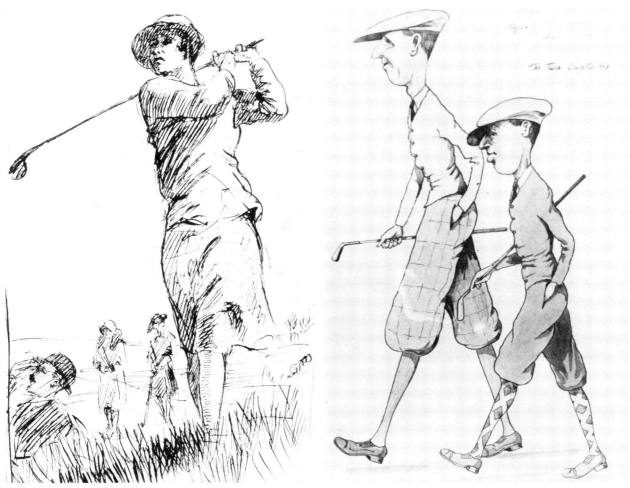

The golden era of British golf remains without doubt the twenty years prior to 1914 and was dominated by three great professional champions, J.H. Taylor, Harry Vardon and James Braid who were known as the 'Great Triumvirate'. They reigned virtually unchallenged, with Vardon, who won a record six Open Championships and the IUS Open Championship, as perhaps one of the greatest golfers of all time. On the other hand James Braid, the first man to win the Open Championship five times, was difficult to beat in a foursome. Wagers, which accompanied most games and sports, were not absent from the game of golf. *Sporting Intelligence* reported a foursome match played for £200 a side in 1909 between the veterans Braid and Taylor on the one side and the young professionals, C.H. Mayo and George Duncan on the other. Braid and Taylor won by eight up and seven to play.

Golf as an amateur game, wrote a correspondent to *Baily's Magazine* in 1909, was still for 'the rich, the comparatively rich or the make believe rich man'; but E.A. Lassen, the amateur champion wrote in the same year: 'For those amateurs, who like myself, only Golf at weekends, with occasional evening rounds in the summer, the cost should not exceed, including subscriptions and a Golfing holiday, £2 per week and in that sum I am including every expense that appertains to the game, viz, clubs, balls, food, drinks, train fares, caddies, etc.'

Golf on an international level was marked by the first appearance of the great American players in the 1920s — Walter Hagen (1892-1969) and Robert

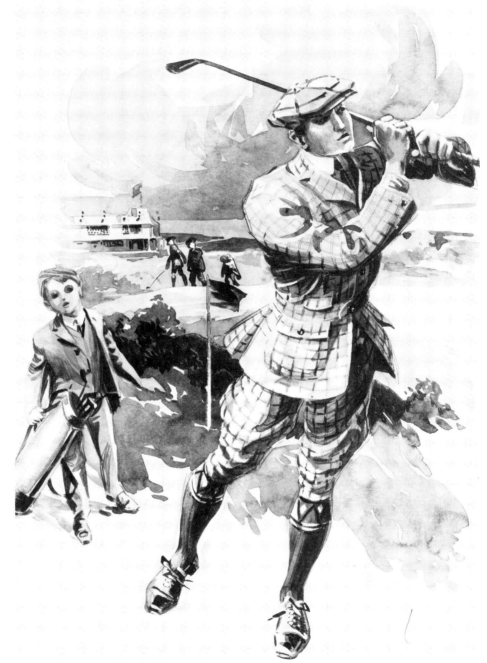

Plate 10/25. American School. A player and his caddie. 12⅜ in. x 8⅝ in. Grisaille. The Wingfield Sporting Gallery, London.

Tyre (Bobby) Jones (1902-1972). The American tide of success in both the Open and Amateur championships on both sides of the Atlantic was only stemmed when in 1934 Henry Cotton broke through to begin a run of British victories which lasted until after the Second World War. Winner of many national titles and sponsored tournaments, he won the Open Championship in 1934, 1937 and 1948. Subsequently the game was dominated by two players from the Commonwealth, Australia's Peter Thompson and South Africa's Arthur (Bobby) D'Arcy Locke (b.1917), until the American champion Arnold Palmer (b.1929) won the Open in 1961 and re-established American dominance. Today golf is played worldwide and is perhaps the most popular participant outdoor sport in the world. The rules governing the game still follow their Scottish origins: since 1897, the Royal and Ancient Golf Club of

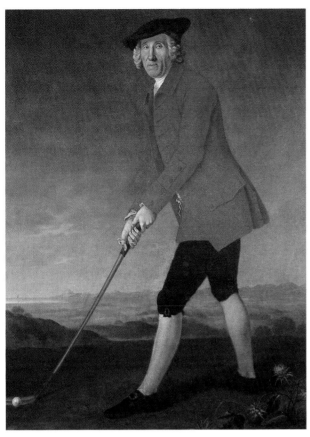

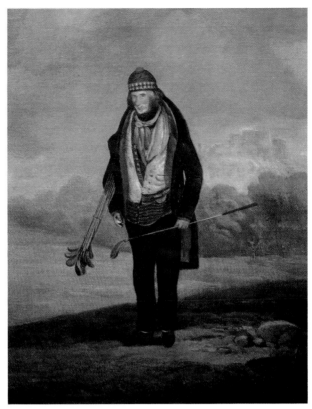

Colour Plate 37. C.H. Robertson. 'Caddie Willie on Bruntsfield Links', c.1824. (Portrait of William Gunn.) Royal Blackheath Golf Club.

Colour Plate 36. Sir George Chalmers, Bt. (1720-1791). 'Portrait of William St. Clair of Roslyn'. Captain of the Honourable Company of Edinburgh Golfers and a Grand Master of Scotland, died 1788. By kind permission of the Queen's Bodyguard for Scotland (Royal Company of Archers).

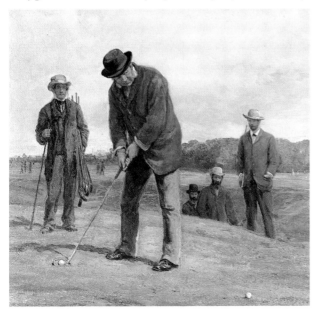

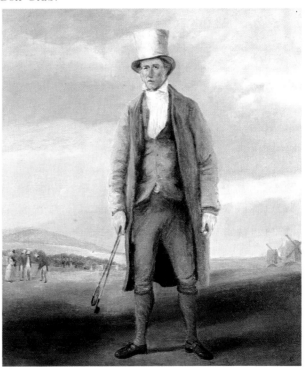

Colour Plate 38. Heywood Hardy, ARWS, RP, RE, RWA (1842-1933). George Glennie the famous amateur golfer of the early 'gutta ball' era, putting with a cleek. Royal Blackheath Golf Club.

Colour Plate 39. R.S.E. Gallen. 'Old Alick', c.1835 (1756-1840), the holemaker to the Royal Blackheath Golf Club. Royal Blackheath Golf Club.

St. Andrews has been the main authority on the rules of the game and shares with the United States Golf Association, formed in 1894, the universal regulation of all golf.

ART

By the end of the sixteenth century, Dutch and Flemish artists often painted landscapes in which games like golf were featured. Hendrich Avercamp (1585-1634) painted at least two pictures, and Aert van der Neer (1603-1677), and the two van de Veldes several more; some of these paintings showed the game being played on ice (*see* Plates 10/4 and 10/5). The Royal and Ancient Golf Club of St. Andrews own a painting possibly by Adam van Breen, in which a golf-like game is being played on ice, and is dated c.1680 by the Royal Scottish Academy (*see* Colour Plate 40). Many of these paintings were shown in 1971 at the Tate Gallery in an exhibition of Dutch and English landscape artists.

One of the earliest English watercolour artists to depict the game was Paul Sandby, RA (1725-1809); his 'View of Golfers on Bruntsfield Links looking towards Edinburgh Castle', dated 1746, (*see* Plate 10/6) is probably one of the first pictures of Scottish golfers although the Royal and Ancient have an unsigned and earlier oil painting of an extensive view of St. Andrews from the golf course, c.1720, with figures in periwigs and cocked hats playing golf in the foreground. The Scottish artist David Allan (1744-1796) painted a portrait of William Inglis (who was the Captain of the Honourable Company of

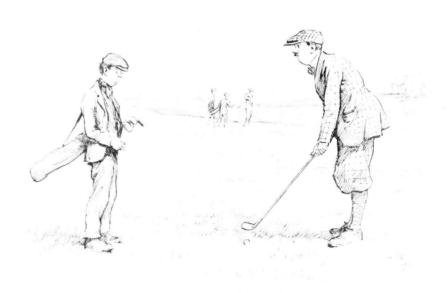

Plate 10/26. George Loraine Stampa (1875-1951). 'Golf', signed with initials and dated 1925. 8in. x 11in. Pen and ink sketch. The Wingfield Sporting Gallery, London.

190

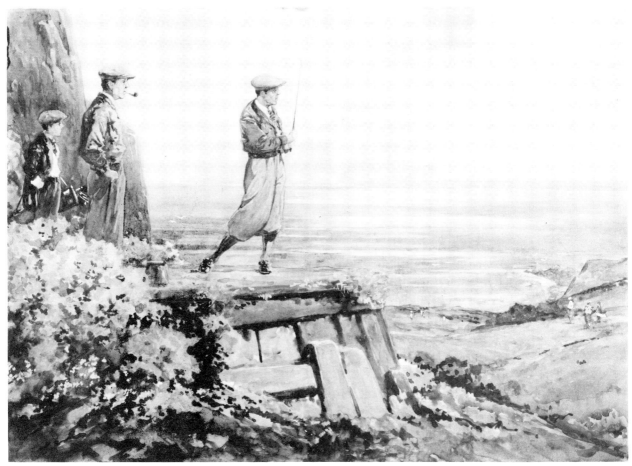

Plate 10/27. Harry Rowntree (1880-1950). Golfers. Inscribed Mrs. H. Rowntree. 15in. x 21¼ in. Watercolour. Sotheby's.

Edinburgh Golfers 1782-1784) on Leith Links and another Scottish artist, Sir George Chalmers, Bt. (1720-1791), painted a noble portrait of the previously mentioned William St. Clair of Roslyn, Captain of The Honourable Company of Edinburgh Golfers and a Grand Master Mason of Scotland (*see* Colour Plate 36). As with other sporting subjects many of the best paintings were achieved by artists who were themselves participants in the sport and in the case of golf this is no explanation. Sir Henry Raeburn, RA (1756-1823) was not only a leading Scottish portrait painter who painted many prominent sportsmen of his time, but he was also a keen golfer playing on his local links at Leith. His portrait of James Balfour, Treasurer of The Honourable Company of Edinburgh Golfers, is particularly fine as is his portrait of John Grey, another well known golfer of that era.

Many excellent paintings exist of golfing personalities and scenes, several of which have already been mentioned in the history of the game and are listed in the Appendix. One of the most delightful watercolours, dated c.1830, is the small sketch of a young golfer with his golf club carried casually on his shoulder (*see* Plate 10/8). The feather ball lies tantalisingly near the hole, which looks considerably larger than today's 4½ in. (108mm.) diameter hole. From the 1870s onwards the number of paintings of golfing scenes and personalities increased with the popularity of the game. The watercolour artist Samuel Bough, RSA (1822-1878) depicted 'A Match at St. Andrew's' and another of 'Bruntsfield Links Golf Club in 1871'. Charles Lees, RSA (1800-1880), the pupil of Sir Henry Raeburn, RA, painted many Scottish sporting scenes

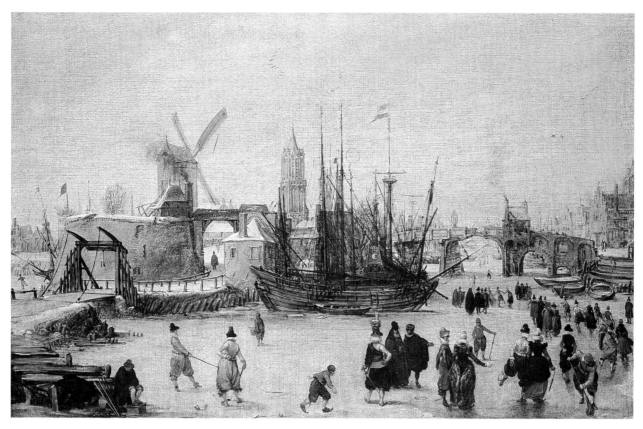

Colour Plate 40. Attributed to Adam van Breen, c.1680. 'Ice on the Scheldt', unsigned. 25in. x 35½in. Presented to the Royal and Ancient by Lord Boothby in 1949. Royal and Ancient Golf Club, St. Andrews.

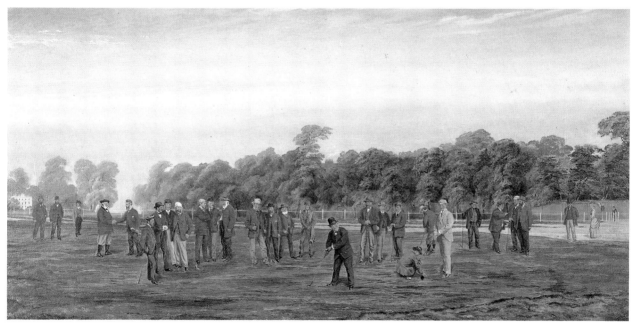

Colour Plate 41. Francis Powell Hopkins (1830-1913). 'Golf at Blackheath, 1875'. Royal Blackheath Golf Club.

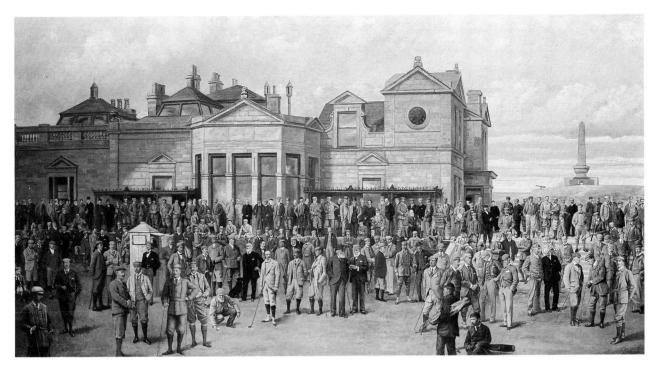

Colour Plate 42. 'Captain Driving off', signed. 60in. x 108in. The painting, which shows the Rt. Hon. James Balfour, MP, Captain of the Club, 1894, outside the clubhouse, was painted at the London studios of Messrs. Dickinson and Foster, from photographs of some 200 members. Royal and Ancient Golf Club, St. Andrews.

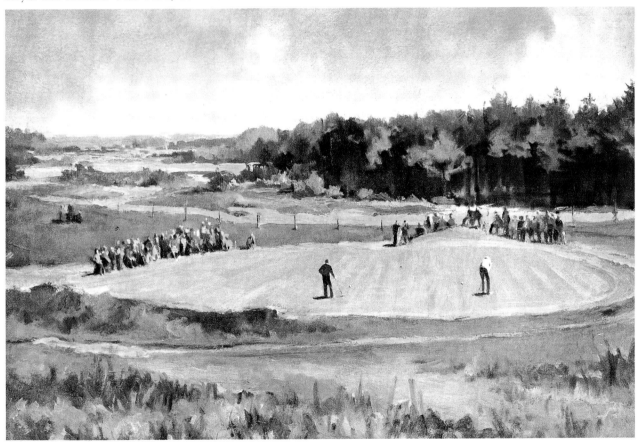

Colour Plate 43. F. Laurent. 'The Amateur Championship, 1954'. Wiggins Teape Group.

Coronation
Foursomes
Moor Park
1937

Ken

including curling and golf; his painting of 'The Match between Sir David Baird and Sir Philip Anstruther and Major Playfair and John Campbell of Saddell on the 15th green of the Old Course at St. Andrews', which is owned by the Royal and Ancient, can be regarded as one of the great classic pictures in this field. Another classic artist, for whom the game of golf held a great attraction, was Sir John Lavery, RSA, RA, RHA (1856-1941) who painted several golfing scenes and personalities, centred around his favourite course, including 'The Golf Course at North Berwick' which he painted when he was staying with Sir Patrick Ford, a portrait of 'Lady Astor playing Golf at North

Berwick', and 'North Berwick Golf Course from the Ladies Tee in 1918'. During the 'Illustrators' Era', the period from the start of *Punch* in 1841 to the early 1920s the number of artists to depict the game of golf was legion. Many artists were themselves enthusiastic golfers which perhaps contributed to the skill with which they portrayed their subjects. Golf may therefore claim a high percentage of the good quality paintings of ball games produced during the twentieth century. With the present world-wide enthusiasm for golf and the concurrent fast growing interest in acquiring paintings of the game, the future development of golf and its art looks promising and may encourage top class artists to depict outstanding events and the public to commission and acquire such memorable highlights.

FOOTNOTES

1. Henderson and Stirk, *The Compleat Golfer*, published Gollancz, 1982.
2. Ibid.

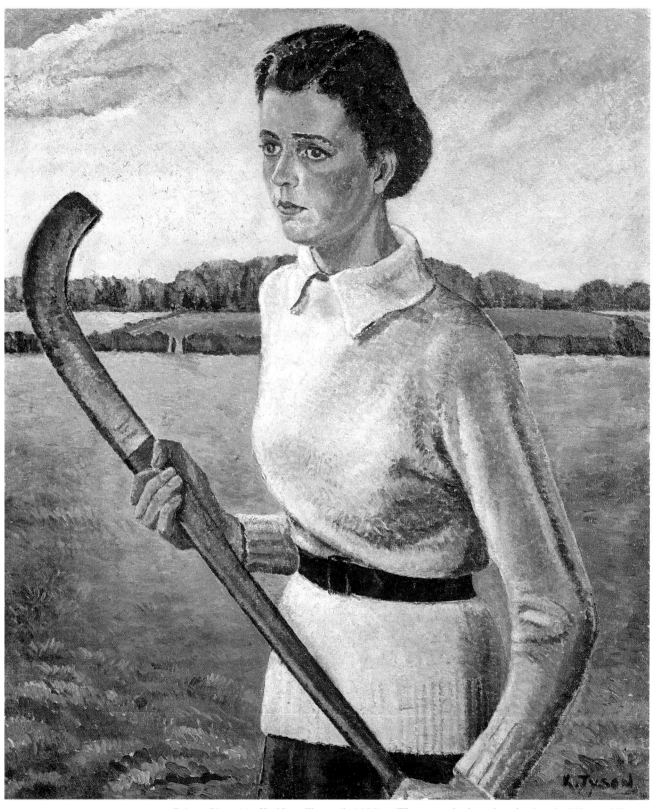

Colour Plate 44. Kathleen Tyson (b.1898). 'The young hockey player', signed. 30in. x 25in.
The Wingfield Sporting Gallery, London.

CHAPTER 11

Hockey and Lacrosse

Despite genuine claims to an ancient ancestry, modern field hockey only began to be played as an organised game in the mid-nineteenth century. The name appears to have derived from the word 'hochie' mentioned as one of the forbidden sports in the Galway statutes of 1527. There is a celebrated fifth century BC Greek carving found on a wall in Athens in 1922 showing two men 'bullying' for a ball with sticks very similar to modern day hockey sticks, while other players, carrying similar sticks, look on. Even earlier than this date are drawings found on a tomb wall, which was built about 2,000BC at Beni-Hasau, near Minia in the Nile Valley, showing the same 'bully' being performed by two players standing square to each other with their curved sticks pointing downwards. In the pre-Christian era, different variations of stick and ball games were played in many parts of the world. The Arabs, Greeks, Persians and Romans each had their own version. The Romans played a game which they called 'paganica' in which a feather filled ball was hit with a stick until one or other side scored a goal; there seems very little doubt that they were probably also responsible for introducing hurling, bandy ball, hoquet and club and ball into Europe and ancient Britain. Possibly the earliest known written reference to hockey in England is given by St. Clement, the Northumbrian Bishop of Lindisfarne in the seventh century who claimed to have had his first revelation whilst playing hockey, a game at which he apparently excelled.

One of the most detailed records of the early game comes from Argentina where the sixteenth century European settlers recorded the habits and pastimes of the Arancano Indians, who played a game called 'cheuca' in which two sides attempted to drive a ball through opposing goals. This game, or one very similar, was also played by the Aztecs of Central America and by most of the tribes of North America from a very early date. Possibly at the same time that cheuca was being played, cambuca (Latin for a curved stick, also known as 'comocks' or 'cammock') was being played in England. Shinty, a similar game to hockey, flourished in Scotland, hurling in Ireland, jeu de mail in France and ket kolven in the Low Countries. Surprisingly, no pictorial evidence appears to exist of any stick and ball game similar to hockey between the fifth century BC and the early fifteenth century, although another written description appeared in the fourteenth century in *Foedera* written by the Englishman, Rymer, which describes cambuca played in 1363 as 'a game of crooked stick or curved club or playing mallet with which a small wooden ball is propelled forward'. Two years later, in 1365, cambuca and bandy ball, a similar game,

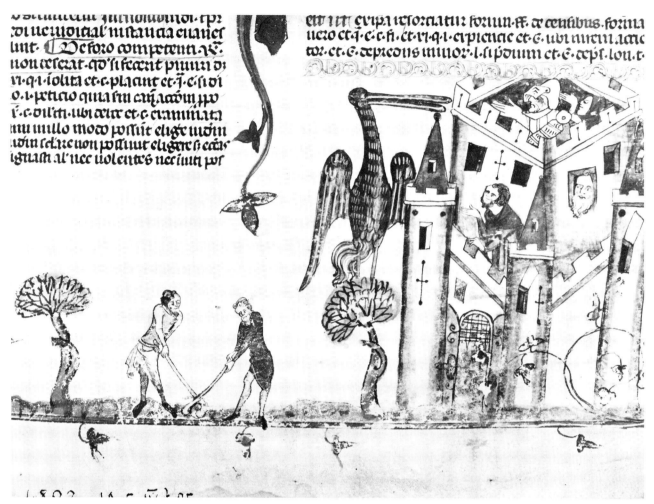

were among the several sports banned by the English King Edward III (1312-1377) because they diverted the attention of the people away from archery practice needed for war training. In 1388, since the edicts had apparently little effect, Richard II (1367-1400) was even firmer than his grandfather in decreeing that all balls and sticks had to be destroyed.

Modern field hockey, it seems, has evolved from one game under many names, but there is no doubt that a game called hockey was played at English public schools early in the nineteenth century (*see* Plate 11/2). In the case of Eton, whose history is perhaps better documented than many other schools, hockey appeared even earlier. A reference in the *History of Eton College 1440-1910* by Maxwell Lyle, published in 1911, states 'Hockey is not mentioned by that name in "Nugae Etonenses" [an account of the school written in 1765/6] but it must have been in vogue in the school in about 1751 because Charles Cornwallis, afterwards Governor General of India, playing with Shute Barrington, afterwards Bishop of Durham, received a blow which disfigured one of his eyes for life'. Hockey is also referred to by Christopher Stone in his book on Eton in 1909.[1] He states that Provost Goodall, who was elected in 1809, mentioned that the boys played it in his time. Since Goodall died in 1840, the game must therefore have been in full swing well before that date. In 1832, G.W. Lyttleton (later the 4th Lord Lyttleton), wrote in the school magazine that Eton could claim superiority in the game that year proving not only that the game was well established but claiming that 'Eton

Plate 11/2. 'Hockey among the Blues', October 1883. From a contemporary print. 7¾in. x 10½in. Mercian Sports.

is almost the only place in England in which this ancient game is kept up'. There is no evidence that it was an organised game at that time and may well have been played in leisure hours. Lord Lytton wrote in 1853:[2] 'On the common were some young men playing at Hockey. That "old fashioned" game, now very uncommon in England except at schools was still preserved in the primitive vicinity of Rood by the young men and farmers'. This remark confirmed Lyttleton's statement of 1832 but it is interesting to learn that the game was already considered old fashioned by the middle of the nineteenth century. The first hockey club is generally agreed to have started at Blackheath where a minute book dated 1861 is headed 'Blackheath Football and Hockey Club'. The exact year of its foundation is not established but the first entry makes it clear that it was before that date and Philip A. Robson in his *Manual of Hockey,* 1899, writes of meeting men who played the game before 1840.

Hockey, an eleven a side stick and ball game, is played on a pitch 100yds. x 60yds. (92m. x 50m.), but the early Blackheath games which took place on the heath itself were played on an area 270yds. x 70yds. (247m. x 64m.) and was a far from gentle game involving a great deal of hacking and indiscriminate slogging. The Blackheath players used a square black solid rubber 'ball' which frequently had to be boiled to be kept elastic and which was 'not to exceed 7 ounces in weight'. Members of the Teddington Cricket Club, who wished to hit a ball about when the weather was too wet for a game, used a cricket ball. From the moment that a free running cricket ball was used the game of stick and ball took on a whole new aspect. Thus the Teddington Hockey Club was formed in 1871, originally to give winter exercise in preparation for the summer cricket matches. This date, therefore, marks the official start of the modern game of hockey as it is played today and the Hockey Association recognises Teddington as the oldest club in the world with a continuous history.

Several other cricket clubs followed Teddington's lead including Richmond

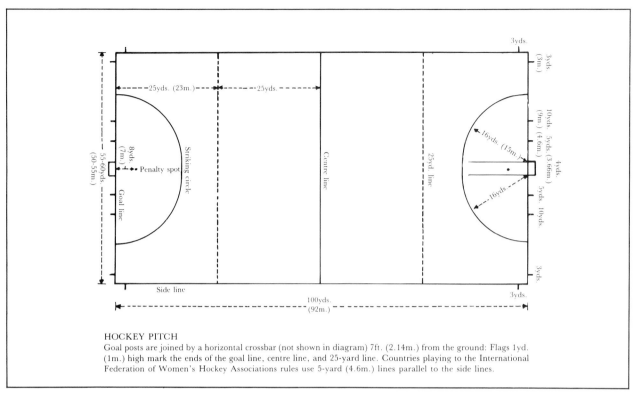

3yds.

3yds.
(3m.)

25yds. (23m.) 25yds.

10yds.
(9m.)
5yds.
(3.66m.)
5yds.
(4.6m.)

55–60yds.
(50–55m.)

8yds.
(7m.)

Penalty spot

Striking circle

Centre line

25yd. line

16yds. (15m.)

16yds.

4yds.

5yds.

10yds.

Goal line

3yds.

Side line

3yds.

100yds.
(92m.)

HOCKEY PITCH
Goal posts are joined by a horizontal crossbar (not shown in diagram) 7ft. (2.14m.) from the ground: Flags 1yd.
(1m.) high mark the ends of the goal line, centre line, and 25-yard line. Countries playing to the International
Federation of Women's Hockey Associations rules use 5-yard (4.6m.) lines parallel to the side lines.

Plate 11/3. Plan of hockey pitch.

in 1874, and Middlesex, whose first traceable minute book of 1874 records that a discussion took place on the rules of the game where it was resolved that rule 3 be altered to read: 'A player may not stop the ball with his hand nor shall he in any case raise his stick above his shoulder'. (Much later, in fact in 1938, this rule was changed to read 'the prohibiting of any part of the body *except* the hand to stop the ball', but for the season 1986/87 the stopping of the ball by the intentional use of the hand was no longer permitted.) The Surbiton minute book records a match between Surrey and Middlesex at the Oval in January 1876 which can probably be regarded as the first official county match and which Surrey won by five goals to nil.

Inter-club matches were not very popular in the early 1870s, and in any case there were still very few clubs, but in April 1875 on the initiative of a Richmond club member, a meeting was held to form the first Hockey Association, which was not an overall success and by 1882 had collapsed. By 1886, hockey clubs were springing up all over the country and a national association became increasingly necessary. At a meeting on 18th January 1886, the Hockey Association (HA) was formed, with Trinity College Cambridge, whose hockey club had been founded in 1883, being an original member. The first President of the HA was HRH Prince Edward, Duke of Clarence (the eldest son of Albert Edward, later Edward VII (1841-1910)) who at the age of twenty-two graciously accepted the role, and was a fairly obvious choice because the Prince had played the game at Cambridge where the Trinity College Hockey Club is said to have been started for his benefit. Unfortunately, the Prince died of influenza nine years later in 1892 and the role of HA President was then taken over by his father.

The Blackheath Club, which had always played a very independent game, in 1886 were reluctant to accept the new Association's rules; as a result they broke away to form, with a number of West Country clubs, the National

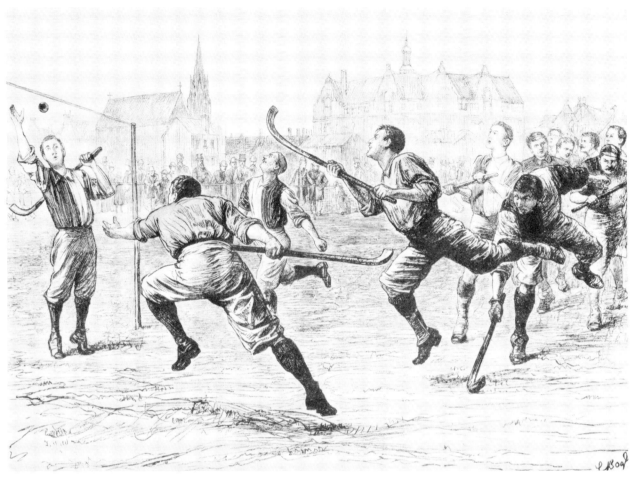

Hockey Union, which disintegrated in 1895 while the HA went on from strength to strength.

The first women's hockey club was formed at Molesey, Surrey, in 1887, followed by clubs at Ealing and at Wimbledon in 1889, which remains the oldest surviving women's hockey club in the world. The Wimbledon hockey club for men had been formed in 1883. Women had undoubtedly played the game earlier than these dates imply but owing to the stiff Victorian conventions which ruled middle class female society at that time, it was played with some discretion. The early players of the late nineteenth century were considerably hampered by their clothes which included petticoats (soon discarded), corsets, high stiff collars, ties, skirts to within an inch of the ground and often five or six yards in circumference, topped by a straw hat skewered to the head by means of a vast hat pin (*see* Plate 11/9).

The first international men's match took place in 1895 between Ireland and Wales which Ireland won 3 – 0; this was followed by a women's team from Ireland who played a home team at Brighton on 10th April, 1895, the forerunner of women's internationals, which was greeted enthusiastically.

In 1895, the rules of men's hockey were adopted at the first meeting of the Ladies' Association which was held in London on 23rd November. The new organisation then made formal application to join the Men's Association but was turned down on the grounds that the HA could not officially recognise the Ladies' Association. From that moment, the two Associations went their

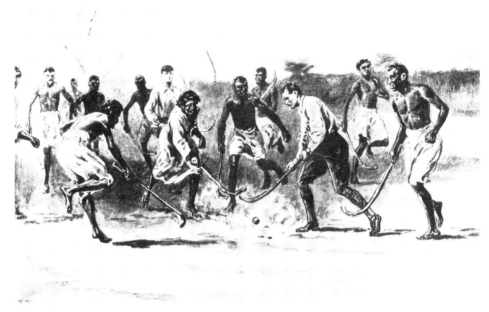

Plate 11/5. Stephen T. Dadd (op.1879-1915). 'A Hockey match in Somaliland, January 1902', signed 'S. T. Dadd from photos'. 'The York Hockey Club is well known in hockey circles, and has played a prominent part in the game in the North. The members are all keen at the game, but unfortunately, owing to their military duties, the services of many excellent players have been lost to the club all too soon by being ordered off to serve their country in foreign parts. That they do not forget their hockey when from home is well illustrated by our picture of natives of Somaliland being coached at the game by Captain Gordon Salmon, who figured as one of York's most prominent forwards last season. It will be noticed that the sticks are very primitive, cut out of solid wood. The game is a rather wild exhibition, the natives not understanding that it is their duty to hit the ball and not their opponent. It amused the natives, and helped the promoters of the game to enjoy themselves and keep their hands in during a most lonely time when with the Somaliland Field Force.' Mercian Sports.

separate ways and in 1896 the women changed their name to the All England Women's Hockey Association by which name it has been known ever since.

In 1900 at a meeting of the HA held at the Cannon Street Hotel in London with 'two representatives of England, two of Ireland and two of Wales and an additional representative of England as Chairman', the International Rules Board was formed. From the Board's early days it was clear that other issues were on the agenda for discussion besides the rules. The new Board introduced umpire status which meant that an umpire, in addition to giving a decision after an appeal, could also make a decision without appeal. Seven years later in 1907 umpires were given power to make all decisions without having to wait for an appeal. In earlier days, any disputes were usually settled by the captains of opposing teams, and a referee was only called when appealed to by either side. Later, two umpires replaced the captains in this respect. As the role of the umpire became increasingly important, it seems appropriate at this stage to define the difference between an umpire and a referee as stated in *The Oxford English Dictionary.*

To umpire: To settle or decide (a matter in dispute) as umpire: to decide between persons.

Umpiring: The action of acting as an umpire especially of deciding doubtful points in games.

A Referee: One to whom any matter of question in dispute is referred for decision. 'That a referee shall be chosen by the umpires to whom all decisions shall be referred.'

The most significant rule changes made since the early Rules Board days have been the prohibiting of any interference with sticks, in 1938 the prohibiting of the intentional use of any part of the body except the hand to stop the ball (a change from the first part of rule 3 made in 1874, but now ruled illegal), the penalty stroke replacing the penalty bully (1963), the discard of the 'roll in' (1970) and the abandoning of the 25yd. (23m.) bully (1975).

In 1908 men's hockey was included in the Olympic Games in London, in which England were the victors. England retained her title the next time hockey was included in the 1920 Olympics in Antwerp, but the game was omitted from the 1924 Olympics in Paris, because it did not have an international controlling authority demanded by the National Olympic Committee. This technicality was amended 7th January 1924 when the Fédération Internationale de Hockey sur Gazon (FIH) was formed by representative countries (with the exception of the countries of Great Britain); its primary objectives were to ensure that hockey was included in future Olympic Games to promote the game throughout the world. The FIH has never had direct control over the organisation of hockey within member countries since all its dealings are with the National Associations.

The FIH flourished up to the Second World War and grew rapidly afterwards, due to the efforts of Réné George Frank (b.1898), a Belgian hockey official who was largely responsible for the success of the FIH. By the early 1970s, the growth of the FIH was measured to some degree by the sixty nations who were then members; when the countries of Great Britain did at last join the FIH in 1970, arrangements were made for the International Rules Board to be absorbed within the FIH framework, thus unifying men's hockey throughout the world.

Women's hockey had spread to the USA by the end of the nineteenth century and shortly afterwards was taken up in the Netherlands, Germany, Switzerland, Australia, New Zealand and South Africa. In 1924, the women's alternative to the FIH, the International Federation of Women's Hockey Associations (IFWHA) was formed. It may seem strange to us in the late twentieth century but so strong was the influence of Victorian convention that British women players of most sports were still concerned as late as the 1960s that they should not play for prizes. For many years it was not considered seemly for a woman to play for financial gain or to take part in anything more than friendly competition — something that never bothered corresponding players from the United States or indeed most other countries — to the detriment of the British. Despite these concerns, competitive women's hockey has grown enormously since the 1960s both nationally and internationally.

In the 1950s and '60s competitions increased in number and led to the

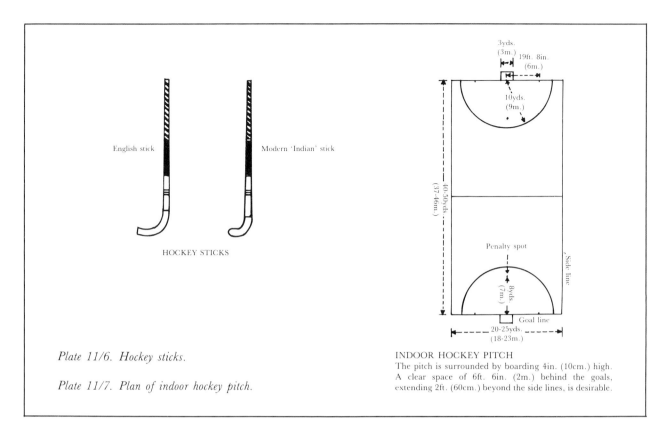

3yds.
(3m.)

19ft. 8in.
(6m.)

10yds.
(9m.)

40-50yds.
(37-46m.)

Penalty spot

8yds.
(7m.)

Side line

Goal line

20-25yds.
(18-23m.)

English stick

Modern 'Indian' stick

HOCKEY STICKS

Plate 11/6. Hockey sticks.

Plate 11/7. Plan of indoor hockey pitch.

INDOOR HOCKEY PITCH
The pitch is surrounded by boarding 4in. (10cm.) high.
A clear space of 6ft. 6in. (2m.) behind the goals,
extending 2ft. (60cm.) beyond the side lines, is desirable.

decision to start a World Cup in the 1970s. Before the Second World War, the two most successful countries in international play were England and India but since England failed to enter a team for the Olympic Games between 1920 and 1948, hockey and India became almost synonymous, for in no other country did the modern game develop so remarkably. Hockey had originally found its way to India via British servicemen in the late 1890s, although a similar but unorganised game called 'khiddo khundi' had been played there earlier in the century.

Apart from the Olympics and an annual women's international event held at Wembley Stadium, the game had never attracted great crowds except in India and later Pakistan, where hockey was regarded for many years as the national game of both countries. In the 1960s, however, the game began to lose some of its attraction which was shown in India's less impressive international results and home attendances declined. Pakistan, West Germany and the Netherlands took up the running.

Hockey remains an amateur game for both men and women, although professional coaches are used for international competitions. Commercial sponsorship makes the amateur status more difficult to sustain each year, a problem shared with many other sports.

INDOOR HOCKEY

Many sports and games have 'spin offs' which are variations of the original game. A recent newspaper report stated that crew members of the aircraft carrier HMS *Illustrious* had been seen indulging in a game of deck hockey and certainly this game, involving between four and six players, was one of the games played regularly on board the great passenger liners during the first

three decades of the twentieth century. In 1910 hockey, which was first played indoors in an exhibition hall in Berlin, was also featured in Hamburg and later matches were played in a ballroom in Berlin. An experimental form of indoor hockey called 'flick hockey' was played in Leeds in England in 1927 but the game did not catch on and there is no later record of it.

After the Second World War, indoor hockey was taken up again in Hamburg in 1947 and soon spread to other countries. In 1952 it was decided at a meeting in Hamburg that the International Hockey Federation should take over the management of indoor hockey for the good of the game as a whole. The first book of rules was produced in German in time for the 1952/53 winter season and was later translated into French and English. The now famous Berlin inter-town tournament, established in 1956, is one of the indoor events of the winter. The first official league match in the British Isles was played in September 1970 in Hall No.3 of the Meadowbank Stadium, Edinburgh under the auspices of the Scottish Association's East District.

In 1975, Britain had nearly thirty leagues in operation throughout the country. The first officially approved men's international tournaments began in 1972 and for women in 1975, although the first recorded women's match took place in 1974. There is a growing interest in this game worldwide although West Germany, as befits the pioneers of the game, still have dominant and powerful teams that are difficult to beat.

STREET HOCKEY

With increasing urbanisation, old games are being adapted to suit the changing environment. One of the fastest and most exciting is street hockey, a six-a-side team game played with sticks and a ball. Originally, it was played in the streets of such places as Battersea and Wembley and although unorganised, existed well before the Second World War. Matches in those days tended to be between the residents of streets and in the summer the whole area combined to play a summer Olympics in which street hockey topped the bill. Refurbished sticks and cast off equipment from local ice hockey teams were used and the players wore the old type strap-on roller skates along with whatever padding they could construct. After the war, the game didn't really get going again until the late 1970s with the development of the modern eurethane skate wheel, originally developed in 1965 in California for skateboards; it was found that a smaller version of the wheel gave the roller skates a much faster, smoother and a more comfortable ride. By 1982 there were several teams around London but no leagues, official rules or competitions.

Alastair Gordon, an experienced sports administrator, contacted all the existing teams and organised the first championship, now an annual event, on 16th January 1983, and in the following May he formed the London Street Hockey Association. As the sport grew and spread around the country, the

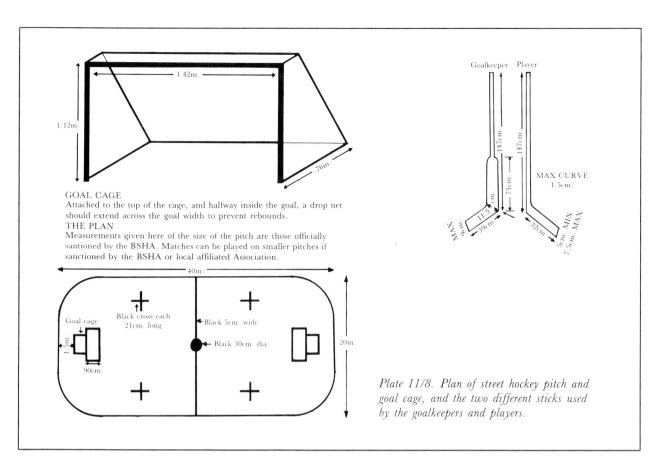

GOAL CAGE
Attached to the top of the cage, and halfway inside the goal, a drop net should extend across the goal width to prevent rebounds.

THE PLAN
Measurements given here of the size of the pitch are those officially santioned by the BSHA. Matches can be played on smaller pitches if sanctioned by the BSHA or local affiliated Association.

Plate 11/8. Plan of street hockey pitch and goal cage, and the two different sticks used by the goalkeepers and players.

British Street Hockey Assocation was formed in 1985, to act as the governing body. The BSHA is now an integral part of the European Street Hockey Association and organises regular exchange matches and competitions with teams from six European countries, which include Holland, Germany, Switzerland, Italy and Austria where the game is enthusiastically played.

Great Britain has been split into twelve separate regions including Northern Ireland, Scotland and Wales and representatives from each form the executive committee of the BSHA. Since 1982, street hockey has rapidly developed into an extremely popular winter sport (the season runs from late October until the end of May) which is as exciting to watch as it is to play. Teams with swashbuckling names compete — the 'Kingston Buffaloes' from Hull, the 'Street Warriors' from Battersea, who won the championship in 1987, and the 'Streetforce Titans' from Camden, the current holders of the national championship, are just a few whose names, like those of the American football teams, create legendary heroes. Only six players from each team are allowed on the pitch at any one time, the normal line-up being a goal minder, two defence men and three forwards but because of the speed of the game, substitute players are considered essential and a team usually carries up to fifteen players, of which a maximum of twelve can be kitted-up ready to play at any one time. The pitch should be 40yds. x 20yds. with rounded corners, gates to allow the players on and off and penalty boxes colloquially known as 'sin bins' (enclosed areas with seating just off the pitch where penalised players go to serve their time) for each team. A minor penalty is for two minutes, a major penalty for five minutes and a misconduct penalty is ten minutes. A game normally lasts for twenty minutes each half and is monitored by two

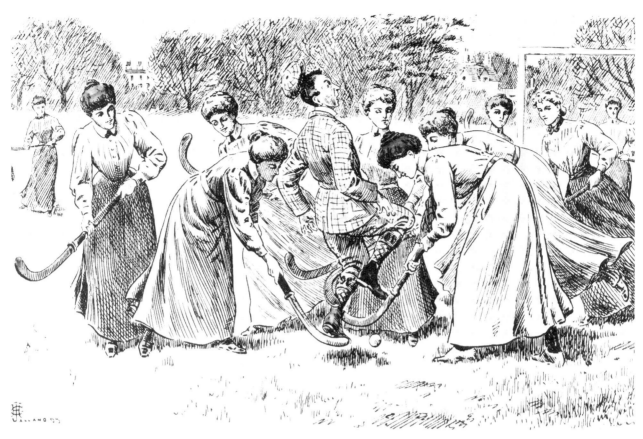

Plate 11/9. George Herbert Jalland (fl.1888-1908), 'Our Ladies Hockey Club, 1899'.
Mercian Sports.

*Plate 11/10. Henry
Cotterill Deykin (b.1905),
'The 50th Inter-Universities
Hockey Match at Beckenham,
1950'. 19½in. x 23½in.
(Note the television cameras
on the scaffold.)*
Henry Cotterill Deykin.

referees. The lines of the pitch are marked in any suitable contrasting colour such as yellow or red. The game is an amateur game and no individual is allowed to seek or receive payment for taking part as a player. Good teams, however, increasingly seek and find sponsorship.

In concept street hockey is similar to ice hockey from which it originates, but since street hockey is played with a ball and not with a puck it lies within the scope of this book. It will be interesting to see whether this new sport can be successfully portrayed artistically and whether it will attract the talents of top class artists.

LACROSSE

Lacrosse is the national ball game of Canada and was officially adopted in 1867 when the country became a British Dominion. Said to derive its name from the curved netted stick with which it is played and which looks like a bishop's crozier or 'crosse' (French) the game was so named by the Jesuit missionaries to Canada.

The present game which developed from the old game played by the North American Indians, consists of two teams of twelve players on each side. The ball is flung by and carried in the crosse — a bent stick with a net stretched across the bent end — the object of the game being to throw the ball through the opponents' goal and to defend one's own at all costs.

The original game as played by the Indians had as many as a thousand men on either side and the goals might be as far as half a mile apart. The teams generally belonged to different tribes and their games were preceded by solemn dances; the players were stimulated to greater efforts by their wives who beat them with canes. The American artist, George Catlin (1796-1872) whose long residence amongst the Indians afforded him an intimate knowledge of their habits and customs, wrote 'The beautiful game of ball is decidedly the favourite and most exciting of the American tribes'. Among the forty-eight tribes that he visited, he found the game played all over Canada under very similar conditions, the only variance being in the layout of the ground and the different construction of the sticks used.

In 1867 Captain Johnson of Montreal brought to England a team of eighteen Indians, amongst whom were representatives of the tribes of Algonquins, Oneidas, Cayugas, Onondagas, Senecas and Iroquois. During their stay they played exhibition games at Lords, the Oval and other venues which was reported in *The Field* of 3rd August, 1867 as follows. '... last week for the purpose of introducing the national game of Canada into England. The Iroquois tribe inhabit Lower Canada near Montreal and several of Captain Johnson's company were the same that performed the game before the Prince of Wales when in Canada in 1860. On Tuesday last a private performance took place at Beaufort House, Walham Green, under the patronage of Lord

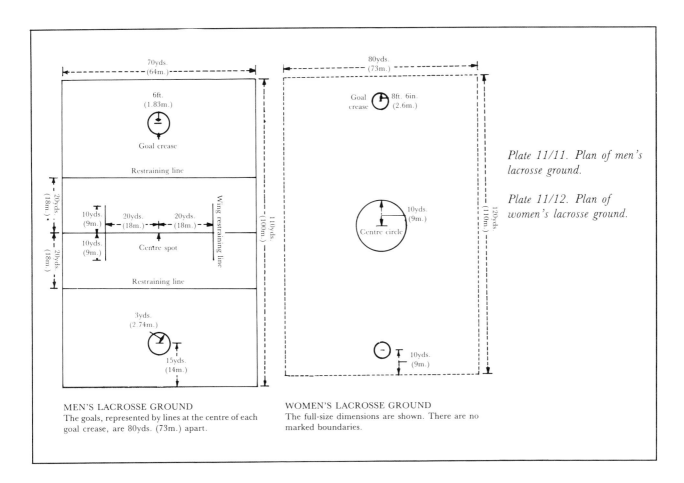

Plate 11/11. Plan of men's lacrosse ground.

Plate 11/12. Plan of women's lacrosse ground.

MEN'S LACROSSE GROUND
The goals, represented by lines at the centre of each goal crease, are 80yds. (73m.) apart.

WOMEN'S LACROSSE GROUND
The full-size dimensions are shown. There are no marked boundaries.

Ranelagh at which members of the press and a few friends only were present. The Indians looked very smart in their blue and red drawers, the Chiefs of each side being distinguished by feathers in their caps and other ornaments.'

The visit awakened an interest in lacrosse and an association was immediately formed to promote the game in Great Britain, but interest in the game was shortlived. In 1876 a visiting team of Canadians from Montreal played a series of very professional exhibition games. They were subsequently invited to Windsor to play before Queen Victoria and to Hurlingham where the Prince of Wales took a lively interest. This time interest in the game not only revived but continued and by the following year a number of associations had been formed; the North of England Lacrosse Association in 1879 and the South of England Association the following year. The English Lacrosse Union was then formed to co-ordinate the activities of the two Associations. By 1875 lacrosse had spread to New Zealand and Australia, where the game has always remained popular, particularly in Adelaide, Melbourne and Perth.

Women's lacrosse evolved into a different game in concept, shape and rules from the men's game. First played with eight and then ten women a side, by 1899 the twelve a side team was established in the playing positions as we know them today.

Men's teams consist of ten players: a goalkeeper, three defences known as point, cover point and third man, a left wing defence, a centre, a right wing midfield and three attacks known as third, second and first home, the last a crease man. Women's teams consist of six attacks (first, second and third home, right and left attack and centre) and six defences (goalkeeper, point,

cover point, third man, right and left defence); the aims and tactics of both attacks and defences are similar to those in men's lacrosse.

In 1912 the Ladies' Lacrosse Association was formed, which has become the official body now known as the All England Women's Lacrosse Association (AEWLA).

At the present time (1988) it is estimated that there are 2,000 men and 40,000 women players, with seventy women's teams throughout Britain.

ART

Unlike Association football, another winter sport, field hockey does not have a legacy of fine paintings, possible due to hockey's continuing amateur status and the lack of big money attached to the game. One of the earliest etchings of hockey is to be found in the Brewhouse Gallery at Eton. Part of a series entitled 'Eton sketched by "Quis" ', published in Oxford in 1841, 'After twelves and After fours', shows the Eton boys playing at hockey with sticks raised above their heads, where Rule 3 ('. . . nor shall he in any case raise his stick above his shoulder') is clearly not in evidence. 'Quis' is thought to have been William Leader Maberley (1799-1885) who was a student at the College. *Punch* produced a wealth of talented hockey sketches, some funny, some sad, but all depicting the game with detailed accuracy. The works of artists like George Herbert (G.H.) Jalland (fl.1888-1908) are particularly sought after and his pen and ink drawings of very large ladies at mixed hockey matches show that the fair sex on the field could be formidable opposition (*see* Plate 11/9).

In common with many of the more recent organised sports, the few twentieth century hockey pictures that have been painted are now highly prized as records of the game's development. The talented artist, John Cosmo Clark, CBE, RA, RWS, NEAC (1897-1967) is known to have included hockey amongst the sports he painted for the Peacock public house at Islington in 1931; he also painted several sporting scenes for Hutchinson's National Gallery of Sports and Pastimes before it closed in 1951. 'The 50th Inter-Universities Hockey Match at Beckenham' which took place in February 1950 (*see* Plate 11/10) is further evidence that the game is suitably enhanced by a sympathetic approach on canvas; painted by Henry Cotterill Deykin (b.1905), this match was one of a series of twenty-two sporting events that Deykin was commissioned to paint during the early 1950s.

FOOTNOTES

1. Stone, Christopher, *Eton painted by E.D. Brinton, described by Christopher Stone*, published A. & C. Black, London, 1909.
2. Miroy, Nevill, *The History of Hockey*, published Lifeline Ltd., 1986.

CHAPTER 12

Hurling and Shinty

Hurling is the national game of Ireland and whilst a game of ancient origin, is still very actively played today, particularly in the south and south east of that country. It is one of the fastest of all team games played on foot and has a close affinity with both hockey and the Scottish game of shinty. All games last for sixty minutes, except championship games which are of seventy minutes duration, and are played fifteen a side with sticks and a ball. The object of the game, in common with shinty and hockey is to drive with broad bladed sticks (the hurley or caman) the small ball through the goal posts set at opposite ends of a pitch — 150yds. x 90yds. (137m. x 82m.). The goal posts which stand 21ft. (6.4m.) apart and are usually 21ft. (6.4m.) high are set in the centre of the endlines. There is a cross bar 8ft. (2.4m.) from the ground and a goal, which counts for three points, is scored when the ball is driven between the goal posts and *under* the crossbar. One point is scored if the ball is driven between the goalposts but over the crossbar. Hitting an opponent with the stick, tripping, holding and so forth are fouls. A 'puck' is hit and a free hit is given to the attacking side from the 65 metre line, if a defender sends the ball over his own goal line.

Hurling is one of the oldest recorded games and is first mentioned in ancient Irish records in a description of the Battle of Moytura (c. 1272BC) in which the Tuatha de Danaan invaders defeated the resident Firbolgs, first in a hurling match, then in a subsequent battle for the Lordship of Ireland. The Brehorn Laws, which are the oldest Irish legal code and existed for centuries before the Christian era, even provided for compensation for any player hurt in the game by stick or ball. Later Irish records of 200BC record that Lowry Loingsearch, who became King of Ireland, was mute as a child. He received a sharp blow from a caman (stick) whilst playing a game of hurling and in his agony spoke for the first time. Irish records, usually so detailed, do not record what he said. Hurling is also mentioned in some of the ancient Irish folk tales and in the exploits of Finn MacCool and his Fianna which date from the second century AD, the story stressed the hurling powers of Finn's warriors. The handsome Diarmuid of the Love Spot scored the decisive goal in a hurling game at Tara and so delighted the High King that the monarch told him to ask, as a reward, any favour he wished which, of course, in true fairy tale fashion was a request for a kiss from the King's daughter.

Hurling seemed to be unaffected by the coming of Christianity or the constant raids of the Norsemen. Even the Anglo-Norman invasion of 1169,

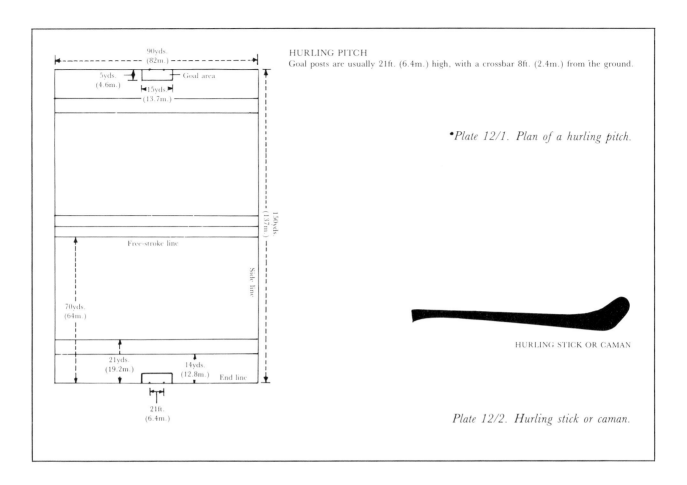

HURLING PITCH
Goal posts are usually 21ft. (6.4m.) high, with a crossbar 8ft. (2.4m.) from the ground.

90yds.
(82m.)

5yds.
(4.6m.) Goal area

15yds.
(13.7m.)

Free-stroke line

150yds.
(137m.)

Side line

70yds.
(64m.)

21yds.
(19.2m.)

14yds.
(12.8m.) End line

21ft.
(6.4m.)

•*Plate 12/1. Plan of a hurling pitch.*

HURLING STICK OR CAMAN

Plate 12/2. Hurling stick or caman.

which affected nearly everything else in Ireland, did not dilute the popularity of hurling. By 1366 hurling was being played so enthusiastically that a Parliament in Kilkenny decreed 'that the commons of the said land of Ireland use not henceforth the game which men call hurlings with great clubs at ball along the ground'. It was considered in Ireland, as in England, that men were not spending enough of their leisure time in military training, practising archery and so forth. The statute of Kilkenny proved so ineffectual that another was passed in 1527 at Galway, which again forbade the 'hurling of the little ball with hooked sticks or staves'. Some time before the English peasant leader Wat Tyler was killed in 1381, hurling must have reached England as his rebellion is referred to in Gregory's *Chronicle* as the 'hurlying time', i.e. a time of tumult and commotion.

The next one hundred and fifty years saw Ireland torn by famine and war but hurling survived and was indeed very much alive when the English traveller John Dunton wrote a description of the game in the late seventeenth century. From his account, it seems that the caman was about 3½ ft. (1.06m.) long and crooked into a broad blade at the lower end. The ball, larger than that used today, was often made of kneaded cow hair and teams consisted of ten, twenty or thirty players. Even then the solo run with the ball balanced on the blade of the stick — a move requiring great skill — was a spectacular feature of the game. According to Dunton, the goals 'were 2-300 yards apart, on a level plain, the barer of grass the better'. Earlier in 1602, Richard Carew wrote an account of hurling in his *Survey of Cornwall* from which it seems that there were two kinds of hurling game — one hurling to goals, the direct

à monasterii eii infringere cupit subito peuss intierie.

IIII. Quom corpore ipsi ad lindiffarnense insula ppm̃ q̃n
œ fluct maris expectauerint quisq; oms sicci pedib;
transirent. pdidit sicq; ibidem miserabilit̃ indiu.

uom q̃da furtim q̃m monasterio eii ppetuerat ipsi

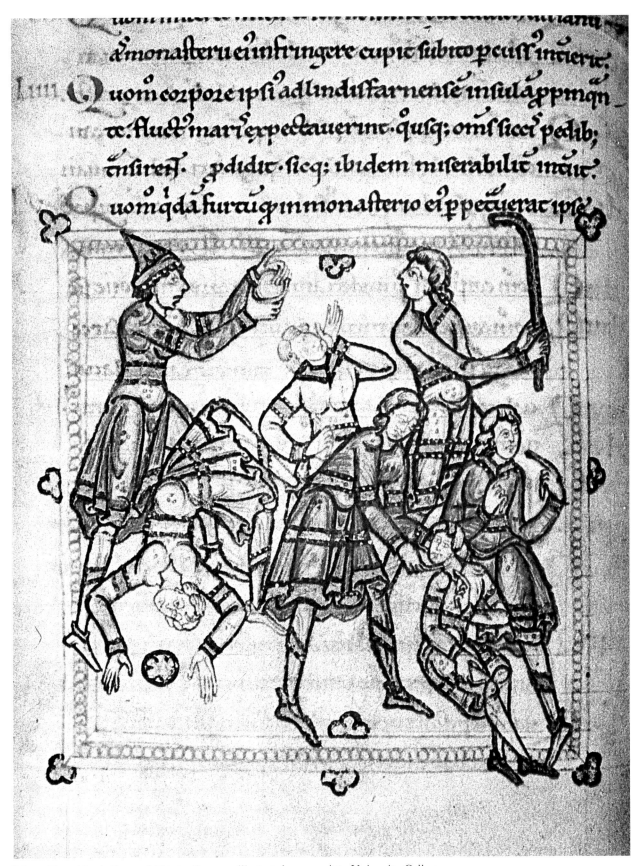

*Colour Plate 45. A Game of Shinty, from an illustrated manuscript, University College,
Oxford.* Bodleian Library, Oxford.

Plate 12/3. Peter Deighan, 'The 100th Hurling Final 1987 — Galway 1-12 Kilkenny 0-9', signed and dated '87. 24in. x 30in. Painted for and the property of The Gaelic Athletic Association (Ireland).

ancestor of the modern game of hurling — and another 'hurling to the Countrie' which was more 'diffuse and confuse' and involved many more people, town against town, even parish against parish. 'Their goals are either those Gentlemens houses, or some towns or villages three or four miles asunder, of which either side maketh choice after the neernesse to their dwellings.' From Carew's account, it would seem that this sort of hurling had very little relationship to hurling at goals, as it does not seem to have been played with sticks at all. A great deal of running with the ball (which appears to have been made out of silver and given to the winner as a trophy) seems to have taken place and some players were mounted on horseback. It may also have been a game in which large wagers were involved. A game played by the Romans called 'harpastum' (a word probably derived from 'harpago', to snatch or take by violence) is much more likely to have been the origin of this game which seems to have been confined to Cornwall and the remoter parts of England and Wales.

For about one hundred years between the mid-eighteenth and nineteenth centuries, hurling became less popular and the Gaelic Athletic Association was founded in 1884 with one of its main objectives 'to bring the Hurling back to Ireland'. Championships were set up and the All Ireland Championship was

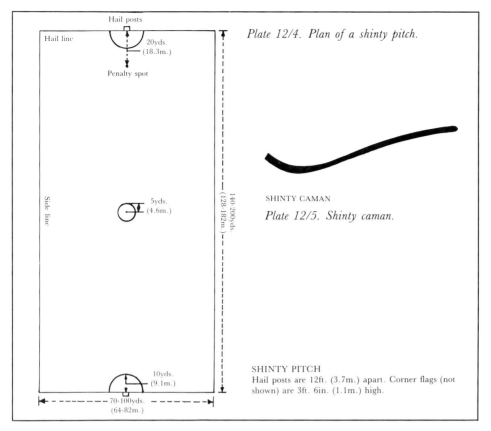

Plate 12/4. Plan of a shinty pitch.

Hail posts

Hail line

20yds.
(18.3m.)

Penalty spot

Side line

5yds.
(4.6m.)

140-200yds.
(128-182m.)

10yds.
(9.1m.)

70-100yds.
(64-82m.)

SHINTY CAMAN
Plate 12/5. Shinty caman.

SHINTY PITCH
Hail posts are 12ft. (3.7m.) apart. Corner flags (not shown) are 3ft. 6in. (1.1m.) high.

founded in 1887. The number of players on each team was reduced first to seventeen from the original twenty-one and then to the present number of fifteen a side. Although hurling will probably never exceed Gaelic Football in popularity, crowds of up to 75,000 have attended the All Ireland Championship finals, and whilst the game has never taken hold outside Ireland, the future of hurling now seems assured in that country and a widespread drive in the 1970s succeeded in renewing interest and enthusiasm in many areas where the game had become moribund.

The All Ireland Hurling Final takes place on the first Sunday in September each year at Croke Park, Dublin, the headquarters of the game's governing body, the Gaelic Athletic Association (GAA). The leading counties in the senior All Ireland Championship are Cork, Tipperary and Kilkenny. Other counties to have won the senior titles include Wexford, Limerick, Dublin, Galway, Clare, Waterford and Laois.

CAMOGIE

Camogie is a modified form of hurling with similar rules and is Ireland's native field sport for women. Unlike hurling there is no body charging, an essential part of the men's game and any unnecessary physical contact with an opponent is expressly forbidden. The pitch is also shorter at 100-120yds. x 60-75yds. (91-110m. x 55-68m.). The player uses a 'camog' which is a diminutive of the hurler's 'caman' and is shorter and lighter being usually about 3ft. (91cm.) long in the handle. The game is played between two teams of twelve aside with sticks and a ball. A distinctive feature of the game is the second crossbar across the top of the goal posts which are 20ft. high (6.1m.). A point is scored when

Plate 12/6. British School, c.1840. 'The Shinty Players'. 30in. x 38in. Attributed to D. Cunliffe (1826-1855) and to A. Smith of Mauchline (1840). Witt Library, Courtauld Institute of Art.

the ball passes between the crossbars in this upper scoring space but a ball driven under the lower crossbar which is 7ft. (2.1m.) high counts as a goal and equals three points. The goal posts are 15ft. (4.6m.) apart.

The game was first played competitively and in public at Navan in Ireland in the autumn of 1904 and a controlling body, the Camogie Association of Ireland was founded later that year. The association, with a membership of over 400 clubs and 10,000 players, organises All Ireland and Provincial Championships on a county basis in senior and junior grades but county championships are organised by the county committees.

SHINTY (CAMANACHD)

Shinty, the popular name for camanachd, is derived from the Irish game of hurling and is the native stick and ball game of the Scottish Highlands. Originally the same game was played in both countries, but the two games drifted apart over the centuries to develop separate identities. Modern shinty is played twelve a side. The duration of the game is ninety minutes, forty-five minutes each way on a field 140-200yds. x 70-100yds. (128-182m. x 64-82m.). The sticks used are called camans — as in Irish hurling — and the object of the game, in common with hurling, is to get the ball through the opposing goal.

These are known as 'hails' and are formed by goal posts 12ft. (3.7m.) wide and 10ft. (3.048m.) high with a crossbar. Shinty also has much in common with hockey, and to a lesser degree with lacrosse. The camans are shorter than hockey sticks with a heavier blade but the broad blade of Irish hurling is unknown in Scotland. The game of shinty is probably faster and more violent than hockey and there is no 'sticks' rule — players can strike with either side of the caman — and an attacker is offside only if standing in the opposing ten yard area when the ball enters it.

Although the game has been 'toned down' since its violent early days, shinty is still very tough as well as skilful. This is illustrated by an interesting discourse which took place in the House of Commons in 1950 between Lord Malcolm Douglas-Hamilton (Conservative, Inverness), and the late Hugh Gaitskell (1906-1963), when the latter was Chancellor of the Exchequer. Lord Douglas-Hamilton asked the Chancellor if he would consider remitting the purchase tax on shinty sticks in the forthcoming Budget to which the Chancellor, in the true evasive manner practised by all experienced politicians, refused to commit himself. Lord Douglas-Hamilton persevered: 'Are you aware that the old Highland game of Shinty pursued with its customary vigour does often involve the breaking of sticks and the high cost of replacement is in danger of impairing this vigour?'

Since shinty was first brought to Scotland by invading Irish, the history of the early game is shared with that of hurling, although it was a game that intrigued the twelfth century King, Alexander I of Scotland (1107-1124). Despite various Lowland laws on Sunday Observance, the game survived over the centuries, although Sunday play did eventually die out. Thomas Penant in his *Tour of Scotland* in 1769 lists among the ancient sports still practised in the Highlands 'the shinty or the striking of a ball of wood or hair'. MacIan's *Clans of the Scottish Highlands* records: 'When there is a numerous meeting, the field has much the appearance of a battle scene. There are banners flying, bagpipes playing and a keen melée round the ball' (*see* Plate 12/6). In January 1821, the *Edinburgh Evening Courier* described 'most spirited camack matches in Badenoch' and at about the same time the *Highland Home Journal* recorded a memorable game played upon Calgary Sands between the Campbells and the Macleans of Mull — won on that occasion by the Macleans; the Campbells left the field 'vanquished and crest fallen'. Interestingly, the game 'crossed the borders' in 1841 and came south to London, with the Highlanders playing a match at Copenhagen Fields near Islington.[1]

In the mid-nineteenth century, shinty became less popular in Scotland as did hurling in Ireland at a comparable time, but towards the end of the century, thanks mainly to the efforts of Captain Chisholm of Glassburn, there was a revival. Both he and the Glasgow Celtic Society, who instituted a Cup competition in 1879, drew up and published a code of rules but in 1887 when Strathglass played Glen Urquhart fifteen a side on a pitch 300yds. x 200yds. (264m. x 182m.) at Inverness, it was discovered that the codes under which

the two teams played differed wildly and Chisholm therefore revised his rules. In the south of Scotland clubs played under the Celtic Cup rules so that by 1892 inter-club games were severely hampered by the lack of uniformity. In 1893, in an attempt to put the matter right, representatives of the leading clubs met at Kingussie to form the Camanachd Association which has been the leading authority on the game ever since. Captain Chisholm of Glassburn became the first chief and 'one of the keenest wielders of the caman in the North'; Simon, Lord Lovat was elected President. The Challenge Trophy which carried with it the Shinty Championship of Scotland was instituted in 1895 and first played for in April 1896, since when it has been competed for annually except during the two World Wars. After the First World War the Sutherland Cup was started to provide a competition for younger players. Since 1972, a bi-annual contest between Ireland and Scotland has been played. Despite the attractions of better publicised sports and the fact that the game has no international competition, shinty nevertheless has a strong following.

FOOTNOTES

1. Rev. J. Ninian Macdonald, OSB, *Shinty — a short history of the ancient Highland Game,* published Robt. Carruthers & Son, Inverness, 1932.

CHAPTER 13

Lawn Bowls, Ten Pin Bowling Nine Pins and Skittles

The modern game of lawn bowls developed with the introduction of bias which changed the whole concept of the game enabling bowls to run in curved paths which took them round obstructions to their desired positions and developed into a very different game from bowling in alleys or skittles. Exactly when bias was discovered is hard to determine. William Fitzstevens, writing in 1174,[1] mentions the game of half ball played with the aid of fifteen conical pins; the object of the game was to knock down the twelve pins previously arranged in a circle by sending the half ball round the two additional pins placed at the back of the circle, which, because of the shape of the ball, gave it tremendous bias making it travel in a curved direction. The half ball was undoubtedly the origin of the biased ball today. Unromantically, it puts paid to the traditional story that bias was the discovery of Charles Brandon, Duke of Suffolk, who is alleged to have cut off the partly rounded wooden top of the bannisters of a neighbouring house to replace his split bowl in order to finish

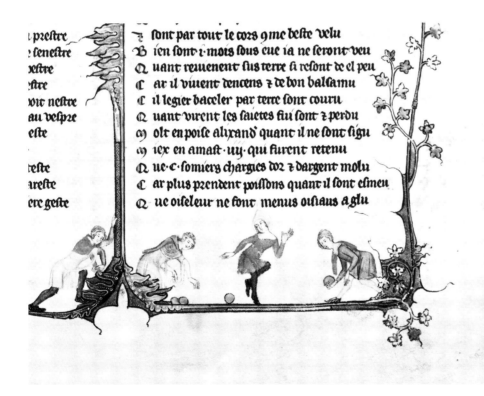

font par tout le cors g̃ mc beste velu
ien font 1 mots sous cue ia ne feront veu
uant reuuenent fus terre fi refont de el peu
ar il vuient dencens 7 de bon balsamu
il legier baceler par terre sont couru
uant virent les saietes fui font 7 perdu
olt en poise alixand̃ quant il ne font figu
iex en amast uy qui furent retenu
ue c fomiers chargies d̃r 7 dargent molu
ar plus prendent poissons quant il font esmeu
ue oiseleur ne font menus oisiaus aglu

Plate 13/1. A section from the illuminated borders of the 'Romance of Alexander', depicting a game of bowls in the 14th century. This manuscript was written in 1338 and illuminated by Jehan de Grise, probably in Flanders, 1338-1344. Bodleian Library, Oxford.

219

91. BOWLING.—XIV. CENTURY.

Below these we see three persons engaged in the pastime of bowling; and they have a small bowl, or jack, according to the modern practice, which serves them as a mark for the direction of their bowls: the action of the middle figure, whose bowl is supposed to be running towards the jack, will not appear by any means extravagant to such as are accustomed to visit the bowling-greens.

92. BOWLING.—XIV. CENTURY.

his game played at Goole in Yorkshire in 1522.

There are many references to bias in Shakespeare's plays including the most famous reference of all in 'King John', Act II, Scene ii (1595) in which commodity is likened to bias:

'Commodity, the bias of the world;
The world, who of itself is peiséd well,
Made to run even, upon even ground,
Till this advantage, this vile-drawing bias,
This sway of motion, this Commodity,
Makes it take head from all indifferency,
From all direction, purpose, course, intent:
And this same bias, this Commodity,
This bawd, this broker, this all-changing world,
Clapped on the outward eye of fickle France,
Hath drawn him from his own determined aid,
From a resolved and honourable war,
To a most base and vile-concluded peace.'

The mathematician Robert Recorde mentions bias in his book *The Castle of Knowledge* (published in 1556) when he wrote: 'A little altering of the one side

220

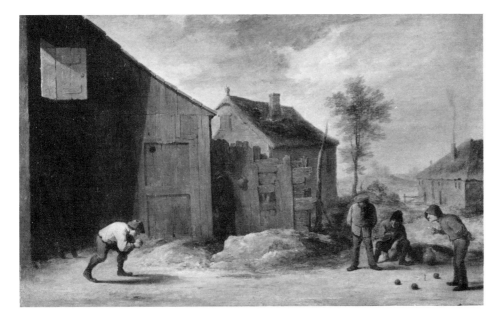

Plate 13/3. David Teniers the Younger (1610-1690). 'Peasants playing at Skittles' (a misleading title as they are clearly playing bowls) c.1636-39, signed. 13 ¾ in. x 22 ½ in. Torrie Collection, University of Edinburgh.

maketh the bowl to run biasse waies'. Later in 1633, Hendrich Van Etten in his *Mathematicall Recreations* describes bias as: 'Of a deceitful Bowle to play with all: Make a hole in one side of the Bowle and cast molten Lead therein, and then make up the hole close, that the knavery or deceit be not perceived: you will have pleasure to see that notwithstanding the Bowle is cast directly to the play, how it will turne away side-wise: for that on that part of the Bowle which is heavier upon the one side than on the other, it will never goe truly right, if artificially it be not corrected; which will hazard the game to those which know it not; but if it be knowne that the leady side in rowling, be always under or above, it may go indifferently right; if otherwise, the weight will carry it always sidewise'.

Other references to the unsportsmanlike manipulation of the biased bowl were made by Gervaise Markham (1568-1637) in his *Country Contentments,* published in London in 1615, and George Whetstone, that Elizabethan 'Agony Aunt' on the Does and Dont's for the youthful gentry, especially those coming to London from the country. Whetstone considered it a sin to tamper with the weight and balance of a ball in order to mislead the unwary novice and wrote strongly on the subject in *A Mirrour for Magestrates of Cyties,* published in 1584. Gradually the previously limited game of bowls progressed to one in which movement of the target — the jack — and nearby bowls by the delivered biased bowl, offered great tactical scope. A biased bowl can draw about six feet in thirty yards but it varies with the bias of the bowl used and the speed of the green. The aim is not to knock down a set of pins but to leave one's bowl as near to the jack as possible. Bowls as well as bowling at pins in alleys were included in the sports banned by Edward II (1312-1377) in his original edicts of 1361 as a pastime likely to interfere with archery, a practice necessary for the use in 'warfare'. Although the edicts were standardised by Henry VIII (1491-1547), bowling prospered in the reigns of Elizabeth I (1533-1603) and James I (1566-1625), but only for people of 'Worship and Qualitie' worth one hundred pounds or more. John Aylmer, a sixteenth century Bishop of London, was found playing bowls on a Sunday afternoon using language as he did so which 'justly exposed his character to reproach'.

Traditionally Vice Admiral Sir Francis Drake (1540-1596) was playing a

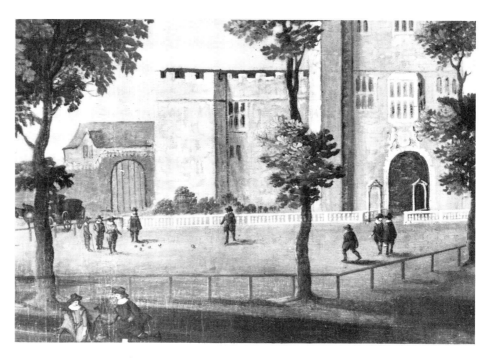

game of bowls with the Port Admiral Sir John Hawkyns on Plymouth Hoe on 19th July, 1588 when the Spanish Armada appeared. Occasionally doubt has been expressed as to whether the game was actually played since there is evidence that Drake was not in charge of the Fleet. The Lord High Admiral of England, Lord Charles Howard, 2nd Baron of Effingham (1536-1624) was supposedly in charge of the arrangements to combat the Spaniards. Whether the story was true or not, many nineteenth century artists chose to believe it and depicted Drake playing at bowls with the Spanish Fleet in the background. Certainly it is known that Drake was particularly fond of the game and a number of biased bowls of the period have been dug up on the Hoe.

Bowling, like tennis, was played at Cambridge University by 1618 and at the Inns of Court in London, gentlemen also played the game with intermittent restrictions. In 1634 at Gray's Inn, it was ordered 'that there be noe Bowlinge in the Bowlinge Greene in the terme time, or readinge time, or time of prayers in the vacation' which did not leave much, if any, time for bowling. Despite the bans which applied in both England and Scotland, bowls continued to be played in both countries particularly by people 'of Worship and Qualité'. The game was popular during the sixteenth century, particularly in and around Edinburgh, due in part perhaps to James IV (1488-1513) who had one of the earliest recorded greens in Scotland attached to his palace at Holyrood where he competed with his friends for small stakes. James V of Scotland (1513-1542) was also a keen bowler as was James VI, later James I of England (1567-1625), who encouraged his sportsman son, Henry, Prince of Wales, to play the game at Hampton Court. Both Charles I (1600-1649) and Charles II (1630-1685) were particularly fond of bowls. Charles I made a bowling green at Spring Gardens (which is now Charing Cross) and later, when he was in captivity at Carisbrook Castle, Isle of Wight, a green was provided within the castle ramparts so that the king could indulge his favourite pastime. Charles II is remembered for the code of Laws he drew up for the game in 1670. He also laid down a green at the eastern end of Windsor Castle at a cost, including bowls, of £20. 7s. 11d. The account dated 11th May, 1663, presented by the

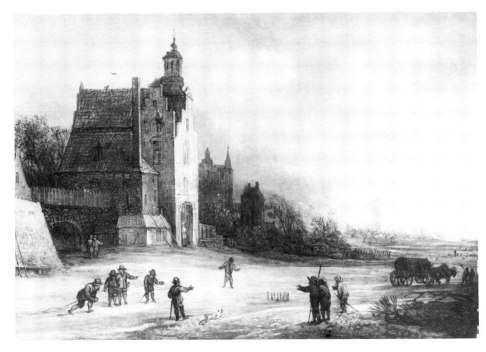

Plate 13/5. Frans de Momper (1603-1660). 'Soldiers playing skittles, a view of Breda beyond'. 16in. x 21 ¾ in. Sotheby's.

man who constructed the green, is now preserved in manuscript form in the Royal Library at Windsor.

With the arrival of the Hanoverians after the death of Queen Anne in 1714, the game was no longer played by the Royal family. Bowls, it seems, was not a game close to the hearts of the House of Hanover and with the exception of the visit by Queen Victoria's son, the Duke of Edinburgh, to the St. Kilda Bowling Club in Melbourne in 1868, it was not until King Edward VII (1841-1910) became a patron of the English Bowling Society when it amalgamated with the Imperial Bowling Association in 1905, that the link between the game and the Royal family was resumed. It therefore comes as little surprise that by the time that Joseph Strutt was writing *The Sports and Pastimes of the People of England,* first published in 1801, the game in this country was not often played and he had to write of the game virtually from memory. In Scotland it was a different matter and in 1848/49, a committee was formed, headed by W.W. Mitchell, a Glasgow solicitor, to draw up a code of laws to govern the game. These laws were immediately accepted as a standard code and have remained in force virtually unchanged. A further important event occurred in 1857 when the 13th Earl of Eglinton and Winton (1812-1861), the same Earl who was an enthusiastic curler and rackets player (*see* p.152) presented a magnificent silver cup for competition between the Glasgow and Ayrshire Clubs. The Scots not only prepared excellent greens, a skill in which they had become proficient through their experience with their golf greens, but their enthusiasm for the game spread its influence worldwide.

The Scottish Bowling Association (SBA) was formed in 1892; apart from general policy and administrative duties, the SBA promotes and organises the Scottish championships each year. In England the game began to regain popularity at the beginning of the twentieth century and regional clubs and associations were formed. The English Bowling Association (EBA) was formed in 1903 and is the largest bowling association in the British Isles with 2,683 affiliated clubs (1986). The EBA was a founder member of the International Bowling Board (IBB), instituted at Cardiff, Wales, on 11th July, 1905. The

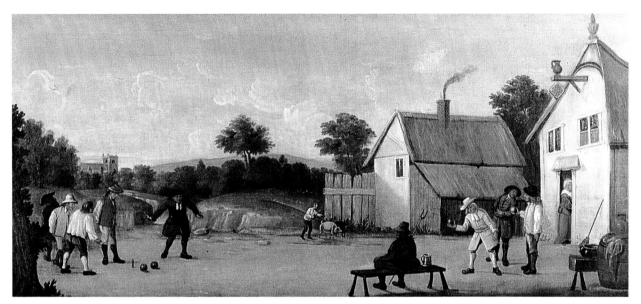

Colour Plate 46. Unknown artist. Late 17th century. A game of bowls said to represent a scene outside a Suffolk inn, which is one of the earliest known pictorial references to the game of bowls in England. 24in. x 54in. J.E.B. Hill.

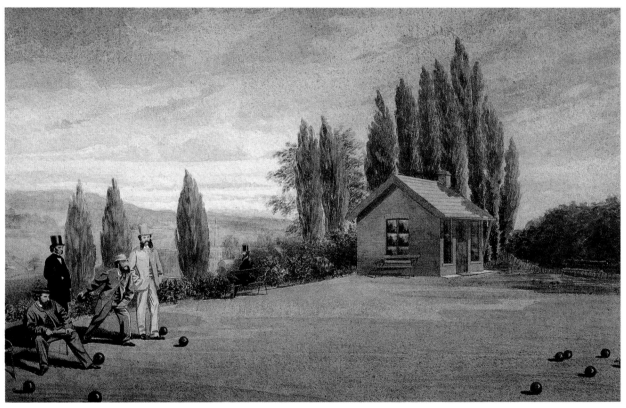

Colour Plate 47. English School. 'Gentlemen Playing Lawn Bowls', c.1880. Watercolour. 9¾ in. x 15¾ in. The Wingfield Sporting Gallery, London.

Plate 13/6. William Kent (1685-1748). 'Bowls at Stowe House', c.1735. Pen and ink and brown wash. 12in. x 18½in.
British Museum.

first president of the EBA was William Gilbert Grace (1848-1915), the famous cricketer (q.v.), under whose leadership bowls took a large step forward. A great champion of competitive sport (though not for women) he experimented with indoor play on a carpet laid along one of the galleries at Crystal Palace. This was a great success and resulted in the first indoor club at Crystal Palace, in 1907. In 1933 the EBA indoor section was formed and in 1971 this became an independent body with the founding of the English Indoor Bowling Association. Play now takes place at more than 280 centres in the British Isles, 220 of which in 1987 were in England. Although the cost of establishing these centres is in the region of £250,000 to £1,000,000, they are proving very popular.

All over Britain and in various parts of the world, level green outdoor bowls is played by clubs affiliated to the International Bowling Board. The participating countries include the United Kingdom, Australia, New Zealand, the USA, Canada, Israel, Spain, South Africa and a number of third world countries.

The required size of the playing green is 40yds. x 44yds. (36.58m. x 40.23m.); the green is surrounded by a ditch, approximately 2ins. (5.1cm.) deep and 12ins. (30.5cm.) wide and further enclosed by a bank sloping from the perpendicular.

WOMEN'S BOWLING

Nowadays women participate fully in the game, as indeed they did in earlier times; fourteenth century illustrations depict mixed bowling. Very little evidence exists that women played much after the seventeenth century until the beginning of the twentieth century, when in 1906 the London County Council (LCC) reserved one rink in each park for women's play. In 1907 the Victorian Ladies Bowling Association was formed, which is the oldest women's Bowling Association in the world.

At the time of the formation of the Ladies Association there were no organised competitions for women other than an occasional 'friendly'

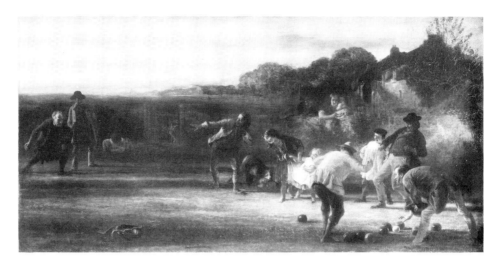

tournament laid on by the men's clubs and it was not until the English Women's Bowling Association (EWBA) was instituted in October 1931, that the first tournament for women was held. The driving force behind the formation of the EWBA was Claire Johns (1880-1967), known as the 'Mother' of English women's bowling, who was also the first president of the Sussex County Women's Bowling Association begun in 1931. The Inter-County Championships for women began in 1953 and today more than 53,000 women play bowls at clubs affiliated to the EWBA; in 1951 the English Women's Indoor Bowling Association (EWIBA) was formed.

CROWN GREEN BOWLS

Crown green bowls, which is virtually confined to the Northern and Midland areas of England, North Wales, and the Isle of Man, is a variation of the game in which the centre of the green is higher than its boundaries. Whilst the game shares a common ancestry with other forms of bowls, it is believed to have evolved from using rough patches of ground in the poorer parts of the country; many of these rough greens were attached to public houses. Nowadays the game, which is governed by the British Crown Green Bowling Association (BCGBA) formed in 1932, is played on an area usually 40yds. (36.6m.) square of short grass of which the surface of the green is not only variable but slopes gently upwards from the sides to a central crown 8in. – 18in. (20.3cm. – 45.7cm.) higher than the sides. Betting always was, and still is, widespread in the crown green game both among the participants and between members of the public and bookmakers. The betting privilege is claimed under a clause of the Betting Commission Report of 1924 and is strictly controlled by the BCGBA, who are justifiably proud that over the years such tournaments as the Talbot and Waterloo Handicaps have raised in excess of £100,000 for charity.

These two historic tournaments have acted as a catalyst for the game. The Talbot Handicap was first staged in 1873 by Robert Nickson, the owner of the Talbot Hotel in Blackpool; the Waterloo Handicap, begun in 1907 and held at the hotel of that name in Blackpool, remains the showpiece of the game, which is immensely popular. The crown green game is heavily sponsored by breweries, and there are tournaments, with substantial cash prizes every week, from early Spring until the Autumn.

TEN PIN BOWLING, NINE PINS
AND SKITTLES

At the end of the nineteenth century the great Egyptologist, Sir Flinders Petrie (1853-1942), discovered the tomb of an Egyptian child, c.5200 BC, in which was also evidence of a game very like ten pin bowling. Bowls must have been played by the early civilisations; the game spread from Egypt to Greece and Rome and to other parts of Europe during the Roman colonisation. During this period the game was depicted in many sculptures and paintings and shows that games based on rolling bowls at hoops or targets existed several thousands of years ago. Evidence that the game was played in England by the thirteenth century is found in a manuscript in the Royal Archives at Windsor and depicts two men bowling towards a small cone shaped object which, presumably, represents the target — or jack. A similar game was also played in France called 'carreau' although, according to Joseph Strutt (q.v.), sketches of the French game as found in the *Book of Prayers,* appear to show no target. Three people are depicted playing the game each with one ball which they are seen bowling towards a fourth smaller ball — presumably a jack. This may, in all probability, bear a closer resemblance to the modern game of bowls than the English version of the same date.

In 1361, Edward III (1312-1377) passed a law, which continued with varying degrees of enforcement until 1845, prohibiting certain games, including bowling which was thought might divert men from archery practice to prepare them for war. Admittedly the law was intended for what James I (1566-1625) was later to call in 1618, 'the meaner sort of people' but despite

Plate 13/9. Tom Browne, RI (1872-1910). 'The Old Hand'. Lawn bowls in Elizabethan costume. Reproduced in Cassell's Magazine, *1905/6.*

such restrictions, by the time that Henry VIII (1491-1547) came to the throne, bowling was well established. Henry added to his Whitehall Palace 'divers fair tennice courts, bowling alleys and a cockpit' on the site of the present Treasury Office. Paradoxically this same monarch, whilst promoting bowling on the one hand, sought also to restrict it by standardising in 1541 the 'banned sports' statutes instituted by Edward III. As the unlawful sports included both tennis and bowling, of which the King was passionately fond, it is no wonder that despite the bans the sports survived and even flourished. During the reigns of both Elizabeth I (1533-1603) and James I (1566-1625), sustained efforts were made to control the bowling alleys and greens which had become dens of vice and gambling. Bowling venues prospered in London but only for people of 'Qualitie' which means were defined by 'all men of worship which may dispende one hundred pounds yerely and upwardes'. Bowling alleys were first made of slate or hardened clay and at the height of this sport's popularity in England, few Elizabethan houses were without their own bowling green or alley. Lord North in 1581 paid sixteen pounds and ten shillings for 'Building a howse over my bowling alie' and in 1620 Clement Cotterell was granted the right to manage twenty-four bowling alleys (for the better sort of society) in London and Westminster, and many more in the surrounding area.

Whilst the Elizabethan preference was for the gentler art of lawn bowling, they nevertheless participated in alley bowling, originally known as skittles, using cannonballs for play. Skittles, known as skittle pins, and nine pin alleys were usually associated with taverns and fairs (hence no doubt, the expression 'Beer and Skittles', although this expression is derived more probably from George Crabbe's comment 'All the joys that ale and skittles give' in his poem 'The Paris Register', written in 1807.). Both games originated in Europe; skittles came to England from Germany in the Middle Ages and nine pins went to America from Holland, taken there by Dutch settlers in the eighteenth century. When the game became ten pins is uncertain but legend has it that in order to get around the ban placed on nine pins in Connecticut in 1841 and later in New York, due to the intense gambling which ruined the game's

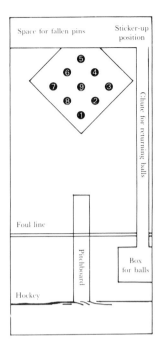

SKITTLES ALLEY

The pins are shown set up in diamond formation: (1) front; (2) right front second, or quarter; (3) right corner; (4) back right second; (5) back; (6) back left second; (7) left corner; (8) left front second; (9) landlord. The hockey is a thin piece of wood about 2½ in. (63mm.) high.

Plate 13/10. Plan of skittles alley.

reputation, the tenth pin and the now familiar ten pin triangle was brought in to replace the nine pin diamond formation which was especially banned in the prohibition. A similar ban was placed on skittles and all related games in England in 1800 due to widespread and uncontrolled gambling. A picture exists, dated 1803, depicting ten pin bowling in Suffolk which appears to suggest that ten pin bowling was the way around the ban.

The Prince of Wales (1841-1910), later Edward VII, inherited a bowling alley at Sandringham which was later made into the Library. Sandringham, purchased in the 1860s, became notable for its shooting parties; it is said that the Prince of Wales was always a little reticent about the bowling alley which was apparently considered to be rather 'fast'. The story exists of a clergyman who was staying at Sandringham in order to preach the sermon at the local church the next morning. He was persuaded to retire to bed early but the following day at breakfast the deception was spoiled by a fellow guest who told him 'You were lucky to get off so well last night: they got me into the bowling alley and kept me there till 4a.m.' The reticence, on the part of the Prince of Wales, reflects perhaps the regard in which bowling alleys were held at this time in Great Britain. It is, therefore, to America that we must look for the development of this simple game into a highly competitive and organised sport.

Whilst in America in the mid-nineteenth century there was a boom in the building of indoor bowling alleys, the sport did not really become organised until the formation of the American Bowling Congress (ABC) in 1895. An earlier, but unsuccessful, attempt to form a Bowling Association had been

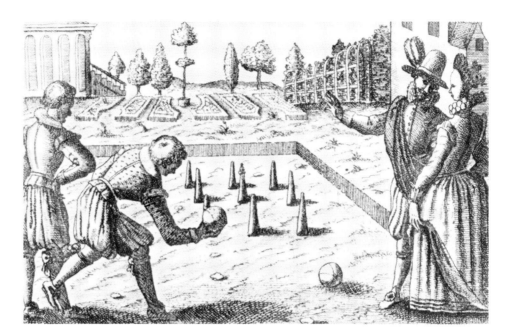

made in 1875 in New York. The ABC formulated rules and standardised the equipment. The original bowling pins in 1895 were made of highly polished maple and whilst little variation was made to the size of the pins, increasing costs required alternative materials to be found. Firstly, laminated pins were used and then in 1950 these were replaced by plastic bases and, eventually after exhaustive tests, wholly synthetic pins were used after 1962. Likewise with the ball, over which there were many early debates, the first ten pin balls were wooden (lignum-vitae) and of such density that they would not float. There were no finger holes and the early ball had a tendency to crack and chip. The first balls with finger holes were introduced in the early 1900s and, in 1905, hard rubber balls ended the use of wood. The original rubber balls were red but black became a more popular choice until plastic balls in bright mottled colours replaced them in the 1960s.

Enthusiasm for ten pin bowling has grown rapidly since the Second World War; it is now claimed to be the largest participant sport in the world, with more than 4,000,000 male members and 3,000,000 members of the Women's International Bowling Congress, founded in St. Louis in 1916. By the mid-1970s, more than forty-nine countries participated in the sport, each with its own National Association. The Professional Bowlers Association was formed in 1958 intended to promote lucrative tours for top players. Enthusiasm for the game is perhaps due, in no small part, to the ABC who have turned ten pin bowling into a highly organised and respectable sport with modern bowling centres sporting automatic pin shotters and score indicators (approved in 1952), a far cry from the rough and tough saloon alleys, lit by kerosene lamps, in the early twentieth century. The British Bowling Association was formed in 1961 and in the same year, ABC accepted an invitation to become affiliated to the Fédération Internationale des Quillers (FIQ), an international organisation based in Helsinki, which covers a number of bowling games.

Although the game's hey-day was definitely in the fifteenth and sixteenth centuries, skittles or nine pins continued to be played in England by both sexes of all ages. Today there is no governing body for skittles other than for Old

English Skittles and, therefore, the rules tend to vary from region to region. One of the more comprehensive rule books for a local league is that issued by the Bridgwater Town and District Skittle League in Somerset and its tolerances underline the differences in equipment and situation. Old English Skittles is one of the more popular and skilful varieties of skittles practised today and has the advantage of a ruling body, the Amateur Skittles Association, formed in 1900 to organise competitions and keep records. Skittles is still widely played on the Continent, from whence the game originated, although ten pin bowling has taken over in many areas.

ART

The celebrated seventeenth Continental painter of bowling scenes was David Teniers the Younger (1610-1690); his painting shows four men bowling to a peg, each player having one bowl (*see* Plate 13/3). Some of the oldest paintings of bowls and skittles are to be found in Vienna at the History of Art Museum; paintings of these sports were more common amongst European artists than with their English counterparts.

One outstanding seventeenth century exception is the painting of a game of bowls said to represent a scene outside a Suffolk inn (*see* Colour Plate 46), believed to be one of the earliest known historical references to the game of bowls in England. Now in a private collection, it was previously in the Hutchinson collection of British Sporting Art dispersed in 1951. Eighteenth century paintings of English bowling are represented by William Kent (1685-1748) whose pen and ink sketch of bowls at Stowe House c.1735 is in the collection of the British Museum (*see* Plate 13/6). 'A Game of Bowls' on the bowling green outside the Bunch of Grapes Inn at Hurst, Berkshire is a charming watercolour by the artist Michael Angelo Rooker (1743-1801) now in the Paul Mellon Collection (*see* Appendix). The artist John Collet (1725-1780) is remembered for his series of lively and amusing sporting sketches of cricket, shooting and hunting. One series entitled 'Ladies Recreations' shows the redoubtable Miss Tippapin playing at skittles (*see* Appendix). While many of the original paintings are lost, almost all were engraved by Carrington Bowles and Robert Sayer between 1778 and 1780. Often labelled a satirical painter of caricature subjects, Collet never reduced

Plate 13/12. A View of a Skittle Ground and Rules and instructions for Playing at Skittles. Published by G. Kearsley, at No.46, in Fleet Street, 1786. Rob Dixon.

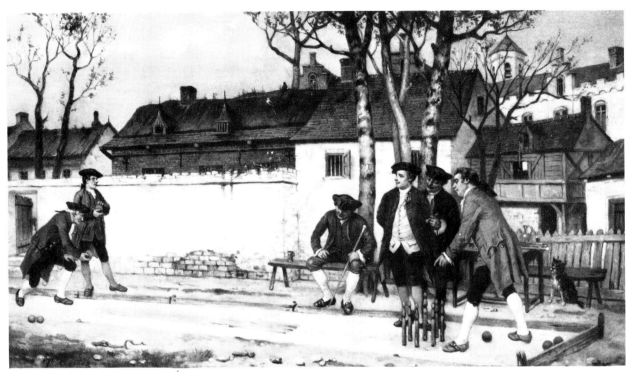

Plate 13/13. Theodore Ceriez (Belgian, 1832-1904). 'A game of skittles', signed. 8½ in. x 14½ in. Christie's.

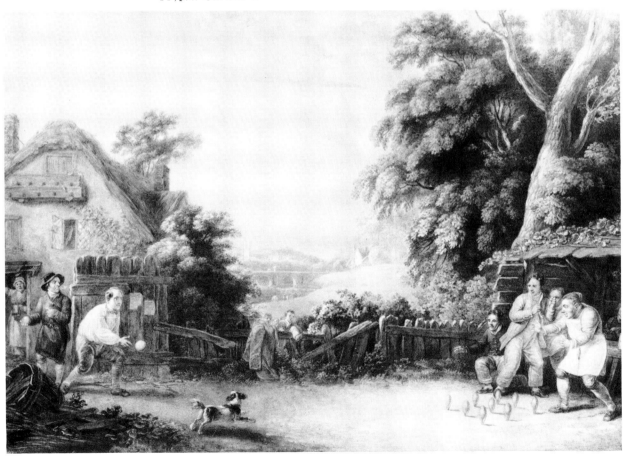

Plate 13/14. William Marshall Craig (1765-1834). 'Skittles', signed. Watercolour. Lacy Scott, Bury St. Edmunds.

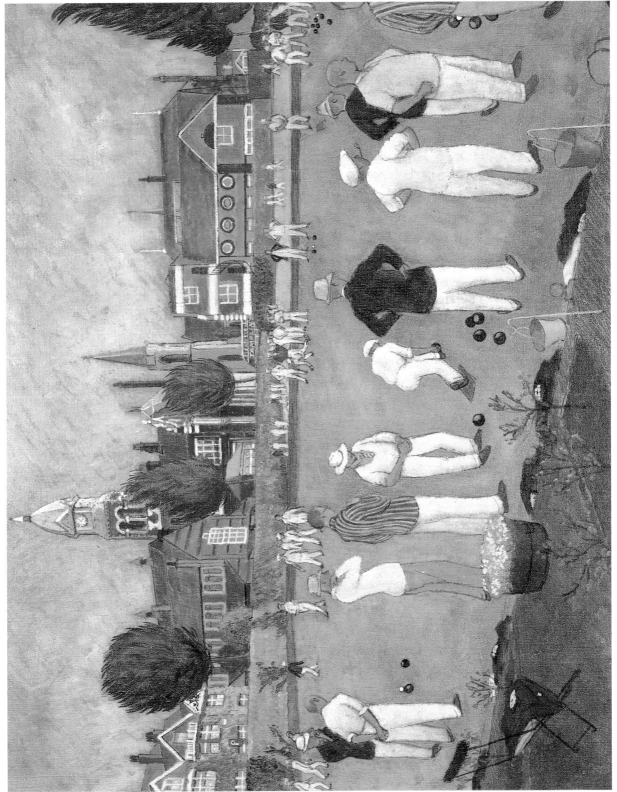

Colour Plate 48. Henry Cotterill Deykin (b.1905). 'President's Day at the Eastbourne Bowling Club', August 1951. 19½in. x 23½in. The Wingfield Sporting Gallery, London.

233

his characters to ridicule, on the contrary, and unlike Rowlandson (to whom he was related by marriage) he was a great champion of women. His game of bowls, in the Paul Mellon Collection, shows six men tense with excitement following the progress of the final bowl, watched by spectators from an art pavilion in the background. A small oval sketch in pen, ink and watercolour, it has nevertheless captured all the drama of the moment in a way that many bowling artists were unable to follow. Really successful sporting pictures should be able to convey to the viewer the moment of tension, the thrill of the game. Aspiring artists in this subject might do worse than to study Collet's little watercolour. Old paintings of bowls often depict the game in play on gravel or sand, much as the game of boule is played in towns and villages throughout France. Lawns on which bowls are now played date from around 1832 when the lawn mower was invented. Previously in paintings where the game is shown on a green area it would in all likelihood be camomile, a plant popular in Elizabethan times.

A great fashion amongst later nineteenth century and Edwardian artists resulted in a spate of paintings depicting sportsmen in the costumes and settings of an earlier age. A past master of this form of romantic art was Heywood Hardy, ARWF, RE (1842-1933) but he was by no means alone and lawn bowls was a game that lent itself well to this treatment. Artists were also

Plate 13/15. Sarah Ferneley (1812-1903). 'A game of skittles'. 27in. x 44½in. Sotheby's.

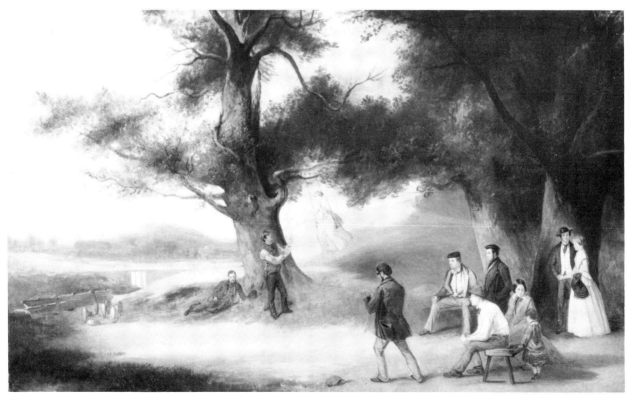

234

inspired by the traditional tale of the Armada in flight while Sir Frances Drake nonchalantly finished his game of bowls on Plymouth Hoe, which was largely promoted by the Duke of Braganza who wrote in a pamphlet in 1624: 'Did we not carry our business against England so secretly as to bring our navy to their shores while their commanders were at bowls?'

As we have already seen, history has dealt less romantically with the legend. It nevertheless became the subject for a number of bowling pictures; 'The Armada in Flight' by the Victorian Royal Academician John Seymour Lucas (1849-1932) is a fine example, while 'News of the Armada' and 'Plymouth Hoe' by Alan Stewart (1865-1951) show two further versions of the Drake story (*see* Appendix).

'The Old Hand' depicting lawn bowls in Elizabethan costume (*see* Plate 13/9) by the Edwardian illustrator Tom Browne, RI (1872-1910) was reproduced in *Cassell's Magazine* (1905/1906) while Frank Cox (op.1870-90) chose to portray his lawn bowls players on the bowling green at Hampton Court in the later costume of Queen Anne's reign (*see* Appendix). A fine watercolour (c.1880) by an unknown artist shows several gentlemen playing the game in formal Victorian costume (*see* Colour Plate 47).

Given that bowling can provide a lively and decorative subject for an artist, top class twentieth century scenes are not as well represented as they might be. The contemporary artist Henry Cotterill Deykin (b.1905) is now retired. He was fortunate in finding Geoffrey Pugh who commissioned twenty-two grass based games and sports paintings for the Atco Mower Factory. Deykin painted

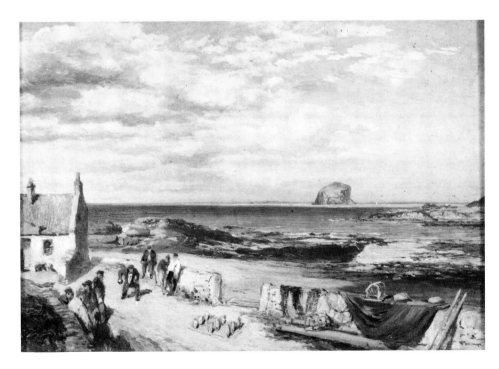

Plate 13/16. Samuel Bough, RSA (1822-1878). 'A Game of Skittles on the Shore Road, Bass Rock'. 7in. x 10in. Sotheby's.

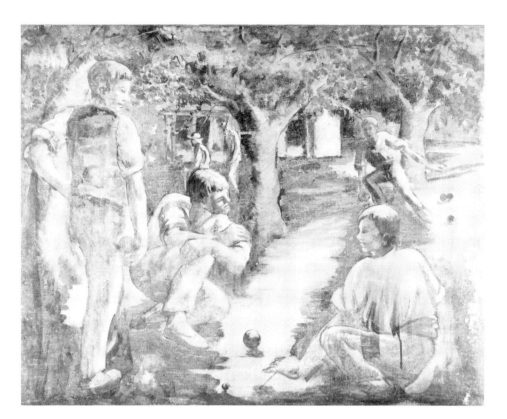

Plate 13/17. French School, c.1940. 'Les Jouers de Boules'. 28¾in. x 36in. Sotheby's, Sussex.

the bulk of the commission between 1949 and 1951 including 'President's Day at the Eastbourne Bowling Club' signed and dated 1951; this scene shows the Club matches in full swing on a bright and breezy August day (*see* Colour Plate 48). A friendly match on the ancient green at the sixteenth century George Inn, Solihull was Deykin's other lawn bowls commission which he also finished in 1951. Although Deykin has never described himself as a sporting painter, he thoroughly enjoyed working on the commission which came about as a result of a speculative painting of a cricket match on the Leamington ground; the painting was subsequently bought by Geoffrey Pugh, the then Club captain.

We have discussed the possible reasons for the scarcity of patrons and commissions during the twentieth century, we have also seen how the change from private to commercial patrons gradually took place, of whom Geoffrey Pugh was an early example. It seems that the direction in which an artist wishes to go must lie with him if the subject and style of his paintings, from which commissions will be received, decides the direction. A fine example of a contemporary illustration of this sport is shown in Plate 13/17.

FOOTNOTE
1. In his treatise on the life of his friend Thomas à Becket, Archbishop of Canterbury, Fitzstevens gave a vivid picture of life in London at that time.

CHAPTER 14

Lawn Tennis

Lawn tennis is derived from royal or real tennis and the two games have much in common. Both are played over a net in either singles or doubles games, and require the ball to be returned either on the volley or after it has struck the ground once, and are scored by points of 15, 30, 40, deuce, advantage and game, and by sets won by the first player to reach six games, although in real tennis the winning margin can be a single game, i.e. 6 – 5. One other difference in scoring between the two games can cause confusion: in lawn tennis the server's points are called first, in real tennis, because service can change in the middle of a game, it is the winner of the last point whose score is called first.

The first written record of this game appears in the form of 'Field Tennis' described by William Hickey in 1767... 'The game we played was an invention of our own and called Field Tennis which afforded Noble Exercise'. Evidently the popularity of the game grew because, in 1793, *The Sporting Magazine* reported that: 'Field Tennis threatens ere long to bowl out cricket. The former game is now patronised by Sir Peter Burrell, the latter has for some time been given up by Sir Horace Mann'.

In the early 1870s, Major Clopton Wingfield (1830-1912) was busy developing the game of lawn tennis (*see* Plate 14/3); he called it 'sphairistike' (the name used by the Greeks for their gymnastic ball games as recorded by Homer) and the patent he applied for in 1874, and received, was for 'a portable court for playing the ancient game of tennis'. A somewhat similar game had been played at Edgbaston by Mr. J.B. Pereira and Major T.M. Gem in 1868, who in 1872 founded the first lawn tennis club in the world, the Leamington Lawn Tennis Club, but the patentee is the one who may fairly be said to have his name associated with the invention. Wingfield's boxed tennis sets, comprising equipment and rules, sold well and very soon the game became all the rage amongst the Victorian middle classes, both at home and abroad. It is certainly recorded as being played by the officers at the British Garrison in Bermuda in 1874, the year that it was patented. Interestingly, it was from this garrison in the same year that an American woman, Miss Outerbridge, obtained equipment and took it to the United States where lawn tennis was first played at Camp Washington. The United States Lawn Tennis Association was founded in 1881 when the first US championships were held.

Wingfield's original court was shaped like an hour-glass, restricted in the middle at the net to 24ft. (7.31m.), compared to a width of 30ft. (9.2m.) at the

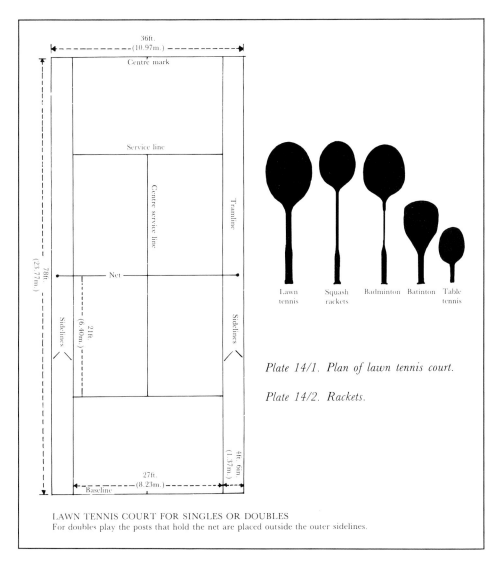

Plate 14/1. *Plan of lawn tennis court.*

Plate 14/2. *Rackets.*

LAWN TENNIS COURT FOR SINGLES OR DOUBLES
For doubles play the posts that hold the net are placed outside the outer sidelines.

base line, and the scoring was by single points (1, 2, 3, etc.), as in the game of rackets. This original scoring system was actually used the following year in 1875 by the Marylebone Cricket Club, the governing authority of rackets and tennis, when they published a code of rules. It was not until the All England Croquet Club at Wimbledon (founded in 1868) decided seven years later to add lawn tennis to its programme and nine years later to its title to boost flagging interest and membership and to hold a championship in 1877, that the racket scoring was changed to the 15, 30, 40, deuce, advantage and game scoring of real tennis. This scoring system has been used in lawn tennis ever since, with only one major variation in the 'tie-break'. The tie-breaker was originally introduced at an official tournament in Philadelphia in 1970 but not used at Wimbledon until the following year.

In drawing up their rules and regulations in 1877, the Committee, a large number of whom were illustrious figures in the game of real tennis, decided to abandon Wingfield's hour-glass court in favour of a rectangular court of 78ft. x 27ft. (23.77m. x 8.23m.) with the net suspended from posts 3ft. outside the court, and to allow one fault on the service without penalty; the height of the net to be 5ft. (152.4cm.) at the posts and 3ft. 3in. (0.99m.) in the middle. The Championship of 1877 was not a world breaking event in itself; in June

that year *The Field* magazine, which played a major part in the early promotion of the game, made an announcement that 'The All England Croquet and Lawn Tennis Club, Wimbledon propose to hold a lawn tennis meeting open to all amateurs on Monday, July 9th, and following days. Entrance Fee £1.1.0d. Two prizes will be given — one gold champion prize to the winner, one silver to the second player'. *The Field* subsequently told its readers it would be putting up, in addition to the prizes mentioned, a silver challenge cup worth £25. The announcement of the impending tournament appealed mostly to the British middle and upper classes from which about 200 spectators made their way to Wimbledon to watch Mr Spencer W. Gore (1850-1906), an Old Harrovian and a skilled rackets player, beat Mr W.C. Marshall, who were the two survivors of the original entry of twenty-two.

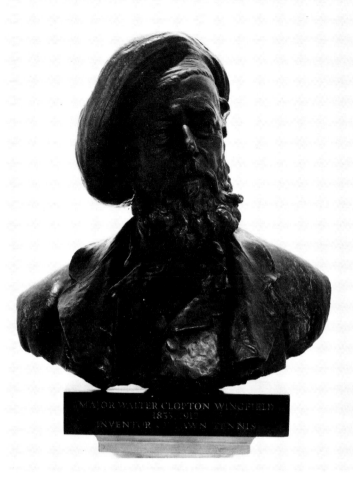

Plate 14/3. Bust of Major Clopton Wingfield (1833-1912), the inventor of lawn tennis. The Lawn Tennis Association.

Gore's win, whilst not in doubt, opened the way to a number of arguments since he had won it primarily on a volley game which, while not technically in breach of the rules, had not been anticipated. He wrote afterwards: 'As the majority of my opponents were real Tennis players who hit the ball over the net at such a height as to make volleying exceedingly easy, this net volleying was successful'. The next year, however, the winner of the championship defeated 'this net volleying' by simply tossing the ball over the volleyer's head so that the effort of running backwards after the ball completely tired out the volleyer. Shortly after the Lawn Tennis Championship in 1877 the Marylebone Cricket Club renounced its authority over the game in favour of the All England Club at Wimbledon.

The arrival on the tennis scene in 1879 of the Renshaw brothers, William Charles (1861-1904) and his twin brother Ernest, probably did more than anything else to attract attention to the game's spectacular and exciting possibilities (*see* Plate 14/7). These two brilliant English players dominated the game during the 1880s and '90s and William Renshaw's record of seven victories for the men's singles title at Wimbledon stands supreme (although Helen Wills Moody (b.1905) was to win the women's singles title eight times during the 1920s and '30s); he and Ernest, who won the singles title in 1888, won the doubles title seven times and perfected the 'smash' hit. After their retirement in 1893, the crowds at Wimbledon declined for a time and there

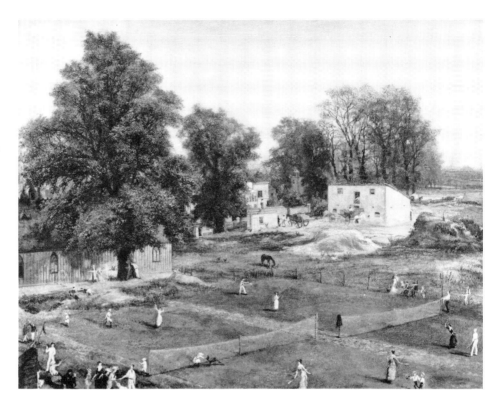

Plate 14/4. George William Mote (1832-1909). 'A tennis party', signed. 18in. x 24in. Sotheby's.

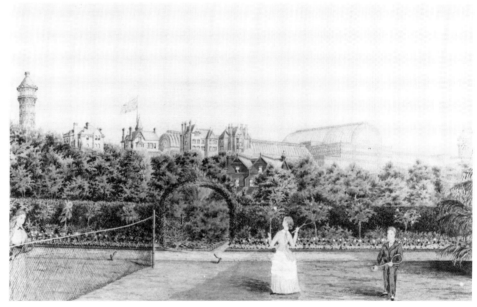

Plate 14/5. English School, c.1880. 'Children playing tennis near the Crystal Palace'. Pen, ink and watercolour. 15½in. x 23½in. Bonhams.

were many complaints that the glamour had gone out of the game. The number of spectators increased to 1,100 in 1879 but swelled to 3,500 in 1885 for one afternoon alone to watch Willie Renshaw play the final. The celebrated lawn tennis critic and historian, Arthur Wallis Myers (1878-1939) wrote: 'Special trains brought the denizens of Mayfair, the Clubs and the City to Wimbledon'. Myers is also remembered for founding the International Lawn Tennis Club in 1924.

The decision to lower the net at the posts to 3ft. 6in. (1.06m.) eased the task of the ground stroke player and was regarded as a fair height for the

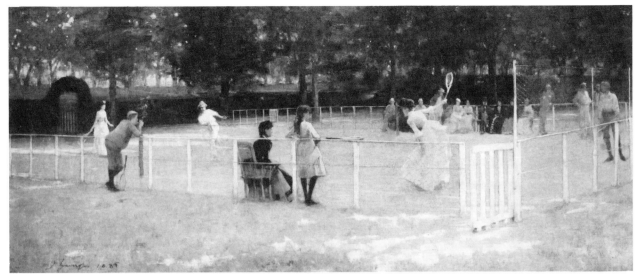

Plate 14/7. Some English lawn tennis players: 'Sane critics foretold, a year or two ago, that the lawn tennis vogue would soon be on the wane. These prophecies have failed of fulfilment at Wimbledon, the number of spectators this year having reached between 2,000 and 3,000 on the days of greatest interest. Our illustration is of leading lawn tennis celebrities — back: E. de S.H. Browne, Rev. J.T. Hartley (Champion 1879, 1880), C.W. Grinstead, Miss Maud Wilson (Lady Champion), H.F. Lawford (winner of Wimbledon Gold Prize this year), W. Renshaw (Champion 1881, 1882, 1883, 1884); front: E. Renshaw (winner of Gold Prize, 1882, 1883), and Miss Watson'. An illustration from Our Fathers by Alan Bott, published by Wm. Heinemann Ltd., 1931.

development of all kinds of skill, furthermore, the service line had been moved in to its present distance of 21ft. (6.40m.) from the net in an attempt to restrict the power of the server. By the early 1880s, almost all male competitors were using the overarm or overhand service. An interesting photograph taken in 1906 at 1/1000th of a second by the pioneer action photographer, G. W. Beldham (1868-1937), shows that overarm serving for women was certainly in operation by then.

In 1882, the All England Croquet Club became known as the All England Lawn Tennis Club; later in 1902, Croquet was reinstated in the title as The

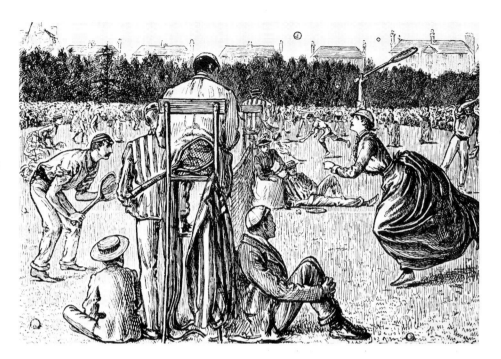

Plate 14/8. 'Ladies and Gentlemen's Doubles, at the South of England Tournament'.
An illustration from
Our Fathers *by Alan Bott,*
published by
Wm. Heinemann Ltd.,
1931.

All England Lawn Tennis and Croquet Club.

In 1884 a Ladies' Championship was inaugurated and was won by Miss Maud Watson (*see* Plate 14/7) from an entry of thirteen. (It is fair to say that the Irish had been the pioneers of competitive lawn tennis for women and had held a tournament on asphalt at the Fitzwilliam Club in Dublin in 1879 at which the standard of play was said to have been very high.) One proposal before the committee of the 1884 Championship would have caused much amusement to modern female players, for it had been suggested that women players should be allowed five minutes rest between each set, but was firmly rejected by the obviously progressive Victorian committee. In 1879, a Men's Doubles Championship was inaugurated at Oxford University. The event continued to be held there until 1884 when it was transferred to the All England Club. Oxford was later to play an important part in the foundation of the Lawn Tennis Association in 1888.

The All England Mixed Doubles were first played at the Northern Tournament which alternated between Manchester and Liverpool but it was not established even there until 1888 when Ernest Renshaw and Miss Hillyard became the first champions. Neither the mixed nor the ladies' doubles was given championship status at Wimbledon until 1913.

In 1883, two American brothers, C.M. and J.S. Clark, made their first appearance at Wimbledon where they played two exhibition matches against the Renshaws. Although the Clarks lost, their participation paved the way towards international matches and an offer from Dr. Dwight, the President of the United States National Lawn Tennis Association (USLTA). In 1900, he wrote to invite a British team to compete for a Challenge Cup donated by a leading American player, Dwight F. Davis (1879-1945), in Boston that year; the Americans won this first competition 3 – 0. Meanwhile in England, the Renshaws' place had been taken by another pair of brothers, the Dohertys — Reginald Frank (1874-1910) and Hugh Lawrence (1876-1919), known as 'Little Do' and 'Big Do', who between 1897 and 1906 reigned supreme when one or the other brother won the title every year except one. In 1907, Laurie

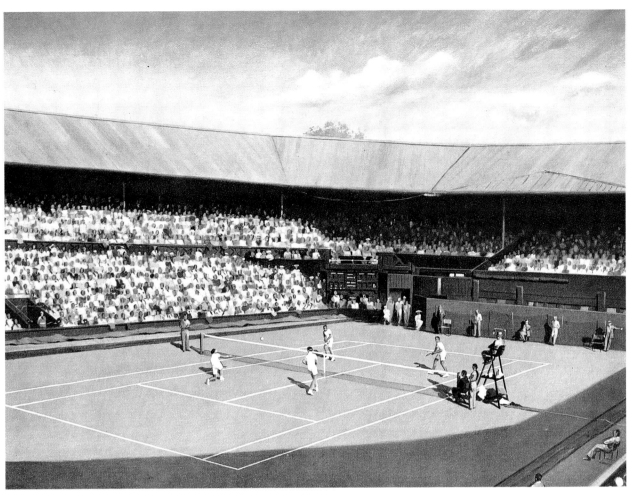

Colour Plate 49. Arthur Nash. 'All England Lawn Tennis Doubles Championship, 1954',
signed. Wiggins Teape Group.

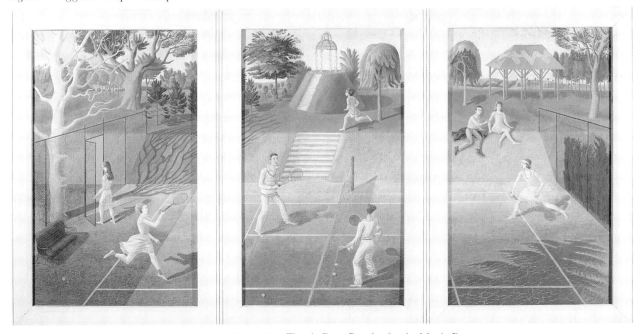

Colour Plate 50. Eric William Ravilious (1903-1942). Tennis Door Panels, for the Music Room
in Geoffrey Fry's Portman Court flat, 1930. The City of Bristol Museum and Art Gallery.

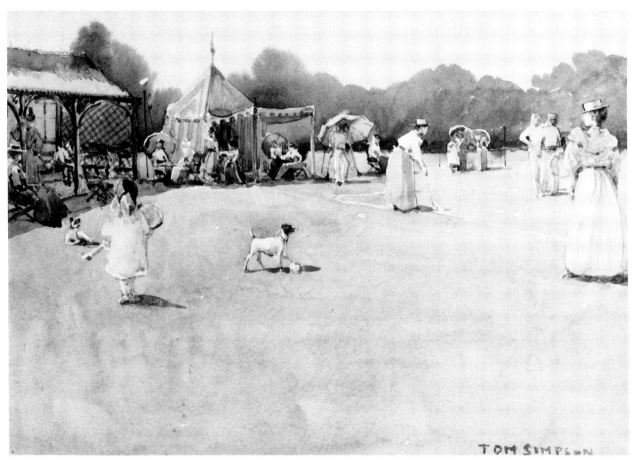

Plate 14/9. Tom Simpson, RI (1887-1926). 'The tennis party', c.1890s, signed. Watercolour. 9in. x 13in. The Wingfield Sporting Gallery, London.

Doherty did not defend his title and for the first time the Wimbledon Men's Singles Championships went abroad, won by the Australian Sir Norman Everard Brookes (1877-1968), Australia's first notable lawn tennis champion and a clever left handed volleyer. He and Anthony (Tony) Frederick Wilding (1883-1915), the New Zealand player and four times Wimbledon champion from 1910 to 1913, then went on to take the Davis Cup from Great Britain and retained it until 1912. To make matters worse, Britain also lost the Ladies' Singles Championship in 1907 to the American player, Miss May Sutton who had previously won it in 1905 at the age of seventeen, and was the first overseas player to win a Wimbledon title. She played as an American, although she was born in Plymouth, England; her father, a Royal Navy captain, had emigrated to Pasadena when his daughter was six years old.

Thereafter, it could be said that Wimbledon was no longer a tournament at which the British excelled in the game they had invented. Interestingly, on this subject, Norman Brookes was reported in the *Sydney Referee* in 1919 to have affirmed that in his opinion the game in England would never improve appreciably until it was taught in the schools. The idea that the game was one of 'patball' had to be overcome along with the attitude of 'the masters of the big schools who still think that Lawn Tennis is merely a game for girls and unathletic curates — garden party stuff, they think'. This, according to *Baily's Magazine* in 1920 was a perfectly justifiable criticism of the attitude to the game at that time, less than seventy years ago. Appropriately in 1913, since international play was expanding, the International Lawn Tennis Federation

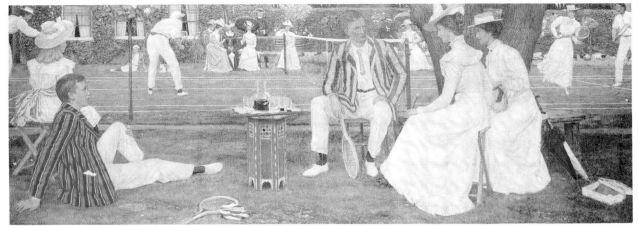

Plate 14/10. Charles March Gere, RA, RWS, RBSA, NEAC (1869-1957). 'The Tennis Party', 1900. 15in. x 42in. This painting is said to represent members of the artist's family, including his sister Edith, who was married to Henry Payne, RWS (1868-1940), the stained glass artist. Cheltenham Art Gallery and Museums.

Plate 14/11. Alphonse Vermeylen (1882-1939). 'Au Tennis', signed. 28in. x 36½in. Sotheby's.

(ILTF) was founded as the world-wide governing body to which at the present time 129 countries are affiliated.

Since the First World War, only Frederick John Perry (b.1909) won the Men's Singles Championships for Britain in 1934, 1935 and 1936 and helped the British team to regain the Davis Cup in 1933. For the women, Miss Kathleen McKane (Mrs L.A. Godfree, b.1897), Miss Dorothy Round (Mrs G. Little, b.1905), Miss Angela Mortimer (Mrs J. Barratt, MBE, b.1932), Miss Adrienne Shirley (Ann) Haydon (Mrs P.F. Jones, MBE, b.1938) and Miss Virginia Wade, MBE, (b.1945) have won the Ladies' Singles Championship at Wimbledon.

In 1922, the present Club in Church Road, Wimbledon was built for the sum of approximately £140,000. The new Wimbledon was formally opened by King George V (1865-1936) on 26th June and The All England Club moved from its old premises at Worple Road. The imposing new Centre Court was

Colour Plate 51. Henry Deykin (b.1905). 'View from the competitors' sun roof during the Lawn Tennis Championships at the All England Club, Wimbledon, 1950', signed. 20in. x 24in. The Wingfield Sporting Gallery, London.

Plate 14/12. Louis V. Pierson (American, 1870-1950). 'Lawn Tennis at the Burtons', dated 1905. 26in. x 30in. This men's match is believed to be at The Burtons, St. Paul, Minnesota, one of America's early courts. Sotheby's.

able to accommodate 15,000 spectators, three times as many as its old counterpart in Worple Road. Besides the change of venue, 1922 was also the year in which the challenge round was abolished in the men's and ladies' singles and the men's doubles events. Previously, the holder of a championship did not have to compete in the knock out competition but only had to play the challenge round itself against the winner of the all comers.

In 1923 the first Wightman Cup was played for (the Cup is a tall silver vase which was presented by the former American champion, Mrs Hazel Hotchkiss Wightman (1886-1974) of Boston); it is an international event played alternately in Britain and America each year between British and American women's teams and consists of seven matches — five singles and two doubles — played off on three (formerly ten) consecutive days. The Federation Cup, inaugurated in 1963, is also played for by women and is an international competition founded to commemorate the fiftieth anniversary of the ILTF and takes place annually at varying venues.

The game during the 1920s and early '30s was largely dominated by the French, for in addition to the legendary Susanne Lenglen (1899-1938), there appeared four brilliant players. Known as the 'Four Musketeers', they were Henri Cochet (1902-1987) whose individual performances comprised the Wimbledon Singles Championship in 1927 and 1929, the US Championship in 1928 and the French Championship in 1926, 1930 and 1932; Jacques 'Toto' Brugnon (1895-1978), the doubles specialist; Jean René Lacoste (b.1905) who won the Singles Championship in 1928 against Cochet and who, with his three compatriots, captured the Davis Cup for France in 1927, and Jean Borotra (b.1898) the first of the four to win the men's singles title at Wimbledon in

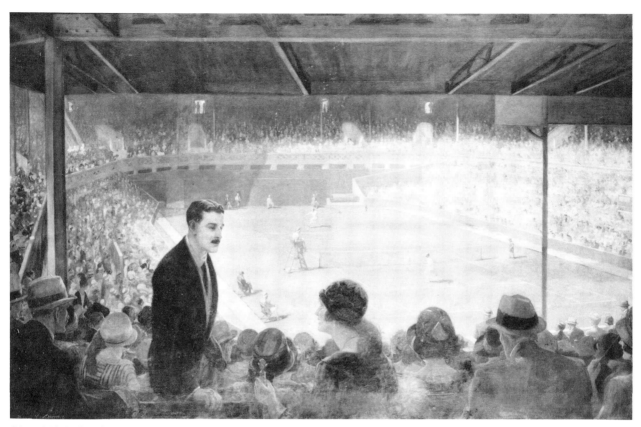

Plate 14/13. Marjorie Violet Watherston, SWA (c.1905-1970). 'The 1923 Ladies' Wimbledon Singles Final', signed. The match between Suzanne Lenglen of France and Kitty McKane of England (later Mrs Godfree) was won by Suzanne Lenglen, 6 – 2, 6 – 2. Miss McKane won the title as well as the mixed doubles in 1924 and 1926. Sotheby's.

1924 against Lacoste. Borotra's black Basque beret, which he wore for almost all his appearances on court, made him a gift for cartoonists and the public loved his showmanship; fast surfaces suited him best and he was an unorthodox and audacious volleyer.

In 1926 HRH the Duke of York (1895-1952, later King George VI) played with his equerry, Sir Louis Grieg, later the Chairman of the All England Club, in the men's doubles championship at Wimbledon. The match was played on No. 2 court and drew a great crowd but the Duke and his partner were unfortunate to play against two former champions and were eliminated in the first round. Although the Duke never competed at Wimbledon again, he thoroughly enjoyed his match and maintained a life long interest in the game and its progress. His elder brother, HRH The Prince of Wales (1894-1972, later the Duke of Windsor) was also an enthusiastic lawn tennis player and the sculptor, Charles Sargeant Jagger (1885-1934) cast a bronze of the Prince holding a tennis racket in 1928 (*see* Plate 14/17).

Until the 1920s, lawn tennis remained an amateur sport but as the game became an increasingly popular spectator attraction, it was no longer possible for first class players to regard it in the light of a purely leisure activity. This was a problem that lawn tennis shared with almost all other sports but previous spadework had already been done by other sporting organisations in this direction and there were patterns to follow. The first professional lawn tennis tournament at which former amateurs played for money was promoted at Madison Square Gardens, New York, on 9th October, 1926 by C.C. Pyle (better known as 'Cash and Carry') who had previously organised a successful coast to coast walking contest. He persuaded Suzanne Lenglen, the greatest of all women players, and the graceful French champion who had won the

Wimbledon Ladies' Singles Championship six times between 1919 and 1926, to turn professional for a sum reputed to be $100,000. From 1930 onwards it became more or less customary for the great champions to join the professional ranks where they could and did extend their playing lives profitably.

After the Second World War, the Lawn Tennis Association (LTA) of Great Britain endeavoured to persuade the rest of the tennis world that 'open' tennis was inevitable. For a long time these efforts were blocked by the International Lawn Tennis Federation (ILTF) but in December 1967, after a dramatic meeting of the LTA in London, it was announced that all distinction between amateurs and professionals was to be abolished and that all competitors would

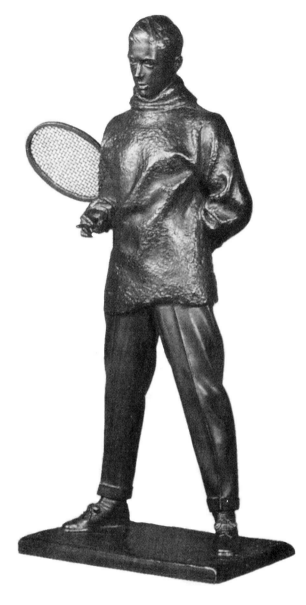

Plate 14/16. Arthur Rackham, RWS (1867-1939). 'Playing tennis from the baseline', signed with initials. A self-portrait. Pen, ink and watercolour. 10½ in. x 6in. The Wingfield Sporting Gallery, London.

Plate 14/17. A bronze figure of HRH The Prince of Wales, cast after the model by Charles Sargeant Jagger, 1922. Christie's.

be regarded as 'players'. This meant that the 1968 Wimbledon Championships would be open despite the disapproval of the ILTF which subsequently threatened the LTA with expulsion. Eventually a reluctant compromise was reached in Paris in March 1968, whereby open events were to be allowed for all players under the control of their national associations. The first open tournament was played at Bournemouth in April 1968; Rodney George (Rod) Laver (b.1938) won the first open Wimbledon in the same year, the only man to achieve the 'Grand Slam' of the four major singles titles, of Australia, France, England and the USA, both as an amateur and in open competition.

Inevitably the game of lawn tennis in Great Britain centres on Wimbledon but that does not mean that excellent recreational and competitive lawn tennis is not played elsewhere. The sport is dependent on the numerous clubs and amateur players throughout the country and the LTA, based at Barons Court in London, is administered by a council on which the English county associations, the national associations of Scotland and Wales and certain other lawn tennis bodies are represented, including the All England Club with whom

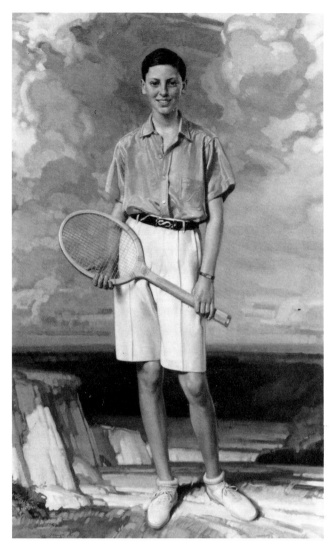

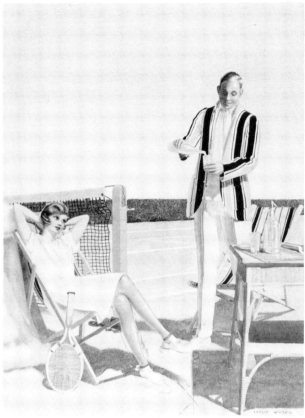

Plate 14/19. Leslie Wilson. 'Between Sets', c.1934, signed. 22in. x 15¼in. Sotheby's.

Plate 14/18. David Jagger, RP, ROI (1892-1958). 'The Tennis Player — portrait of Lord Foley aged 14', signed and dated 34. 38½in. x 44in. Sotheby's.

the LTA shares the responsibility for staging the Wimbledon championships. The original game of lawn tennis has developed from a leisurely pastime for the middle classes to become one of the most competitive multinational sports, played on both lawn and hard courts, which has created a multimillion dollar industry and its own superstars. The amateur status from which this sport feeds still provides its own problems in a rapidly developing world and the increasing expenses of the game.

STICKE

Towards the end of the nineteenth century, a curious game evolved from Major Wingfield's game of lawn tennis, called sticke, an abbreviation of 'sphairistike', which was played in a type of tennis court made entirely of wood. There are very few of these courts still in existence but it appears, from records, that there was no standard layout. Some sticke courts had grilles and dedans as in real tennis, others were constructed without. The game appears to have been a form of lawn tennis played on a real tennis court without chases, using a lawn tennis net, rackets, and balls which were usually dyed red. The

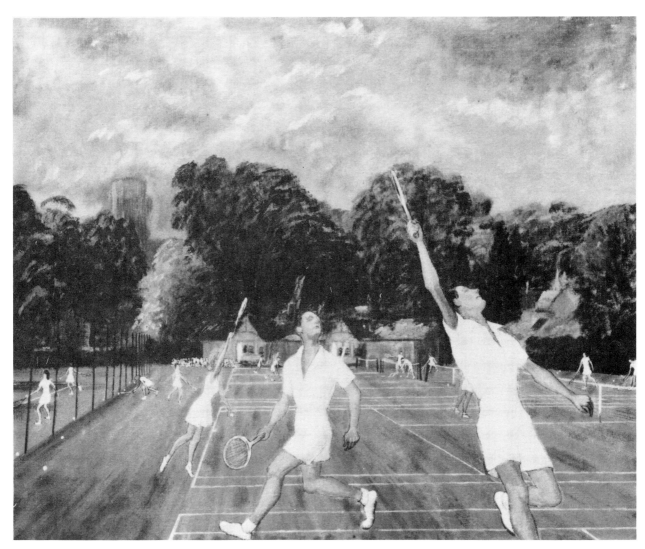

Plate 14/20. Henry Deykin (b.1905). 'Warwick Boat Club, August 1950' (now chiefly a tennis club), showing Warwick Castle in the background. 19½in. x 23in. Henry Deykin.

game was taken up with enthusiasm by the British Army both at home and abroad.

In 1909 a sticke court was built at Queens Club in London (founded in 1886) but it was destroyed during the Second World War along with the two squash courts. A sticke court, built originally in 1907 with a penthouse around three walls, is still in use at Knightshayes Court, near Tiverton in Devon. Another fine court, built entirely of wood with a penthouse on one side only, exists at Hartham Park, Corsham in Wiltshire, now the property of the Bath and Portland Cement Company.

ART

In the early years of tennis the parochial attitude of the British towards the game as being suitable for vicarage lawns only, was reflected in the paintings of the time so that before 1920 very few paintings exist of serious competition.

The Edwardian era spawned a number of artists who painted scenes set in earlier and more romantic backgrounds, perhaps as a reaction against the relentless encroachment of industry and urbanisation. Lawn tennis, a relatively new game, did not lend itself to this treatment, but while the game remained leisurely and decorative, it could be painted. The charming

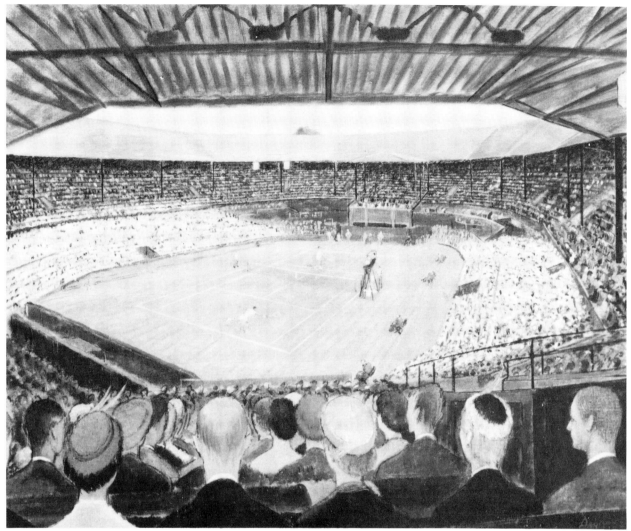

Plate 14/21. Henry Deykin (b.1905). 'The Centre Court at Wimbledon', signed. Budge Patty defeating Frank Sedgman in the final, 7th July 1950. 19½ in. x 23½ in. One of the twenty-two paintings of grass based sports commissioned for the Atco Mower Company. Henry Deykin.

watercolour, for example, by Tom Simpson, RI (1887-1926) perfectly illustrates the situation and whilst decorative, gives little indication that the game was or could become anything other than a gentle recreation for the privileged classes (*see* Plate 14/9).

There were many artists who painted delightful pictures of lawn tennis: Edith Hayllar (1860-1948) exhibited her 'Tennis Players' at Sidney Street in 1884, where her sister Mary Hayllar had previously exhibited 'Marking the Tennis Court' in 1882. The most famous of all lawn tennis paintings, 'The Tennis Party' painted by Sir John Lavery, RA, RHA, RSA (1856-1941) in 1886 (*see* Plate 14/6), hangs in Aberdeen Art Gallery, but Lavery is known to have made several sketches for it (one of which dated 1885 was auctioned at Christie's on 22nd November, 1973).

Both Henry Gardner (op.1870-1890) and George Percy Jacomb-Hood, RBA, RE, ROI, RBC, NEAC (1857-1929), were artists who painted lawn tennis. Gardner depicted a tennis scene at Brighton in watercolour in 1890, and Jacomb-Hood exhibited his 'Game and Set' at Sidney Street where he exhibited between 1884 and 1888. George William Mote (1832-1909, *see* Plate 14/4) and the American, Louis V. Peirson (1870-1950) painted tennis party scenes, the latter artist's work entitled 'Lawn Tennis at the Burtons' (*see* Plate

14/12) and dated 1905 is believed to be of the Burtons, St. Paul, Minnesota, one of America's early courts. One of the most elegant and charming pictures 'A Lawn Tennis Party' painted by the Edwardian artist, Charles March Gere, RA, RWS, RBSA, NEAC (1969-1957) hangs in the Cheltenham Museum and Art Gallery (*see* Plate 14/10). Fairlie Harman, NEAC (Viscountess Harberton, 1876-1945) who was another artist attracted by the game, exhibited her painting 'After a game of Lawn Tennis' at the New England Arts Club in 1916.

Many of the talented black and white illustrators used tennis as a subject to illustrate the numerous magazines and periodicals which had their heyday between 1880 and 1914. The legendary Arthur Rackham, RWS (1867-1939), looking uncharacteristically aggressive, sketched a delightful self-portrait entitled 'Playing tennis from the baseline' (*see* Plate 14/16). Lucien Davis, RI (1860-1941) was another illustrator who drew many tennis scenes, most notably for the Badminton Library edition of *Lawn Tennis*. David Louis Ghilchik (1892-1972) used tennis as the subject for many of his cartoons (*see* Plates 14/14 and 14/15) gently poking fun at the 'rabbits' and the 'chinless' young men of the 1920s and '30s. Dudley Cleaver (op.1890-1908), a contributor to the *Penny Illustrated Paper* in the 1890s, sketched many pen and ink portraits of lawn tennis personalities in the early 1900s, including Mr. N. Rhodes, Miss Eastlake Smith, Mr. A.W. Gore, Miss Coles, Mr. Garidia and Mr. A.F. Wilding, the winner of the Men's Singles Championship. Underneath his portrait of a miserable looking umpire is inscribed 'The office of umpire is not a matter of much competition among club members'.

Sport has become so international during the twentieth century that there is inevitably some overlap into foreign waters: the charming painting 'Au Tennis' by Alphonse Vermeylen (1882-1939) again shows a gentle scene of carefree recreation (*see* Plate 14/11), but in quite a different mood is the painting by Marjorie Violet Watherston (c.1905-1970), depicting the 1925 Ladies' Wimbledon Singles final, which is amongst the first to show a painting of serious competitive tennis (*see* Plate 14/13). Suzanne Lenglen of France won the match 6 – 2, 6 – 2 against Kitty McKane (now Kitty Godfree) of Great Britain, who won the Championship in 1924 and 1926.

It is interesting that the majority of paintings of lawn tennis were produced before the Second World War. Since then, tennis, along with most other competitive professional sports, has become international big business. The depiction of intensely competitive, exciting and aggressive sport demands from artists a different technique and attitude from the traditional approach to tennis, and few have taken up the challenge.

CHAPTER 15

Netball and Basketball

NETBALL

Basketball was first played in England by young ladies at Madame Osterberg's College of Physical Education at Hampstead in London and was taught by Dr. Toles, a visiting American. In 1897, the original basket goals were replaced by rings, a larger ball was introduced and American rules were adopted. These rules were adapted in 1901 by a sub-committee of the Ling Association founded in 1899 for physical training teachers. The Association called the new game netball, since rings and net goals now replaced the baskets, and they drafted and published a new set of rules for the game in a limited edition of 250 copies. The Ling Association remained responsible for the game's development and the revision of the rules until they became the responsibility of the All England Netball Association (AENA) in 1946. With the formation of the new game in 1901, the ball was reduced from 31in. (78.7cm.) in circumference as used in America to 27in. (68.5cm.), the size of the regulation football, thus prudently avoiding the manufacture of a special ball. The goal ring was reduced from 18in. (45.7cm.), as used in American basketball, to 15in. (38.1cm.) in diameter. Unlike basketball, netball is played

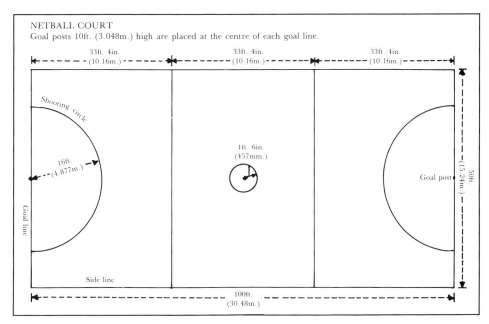

NETBALL COURT
Goal posts 10ft. (3.048m.) high are placed at the centre of each goal line.

Plate 15/1. Plan of a netball court.

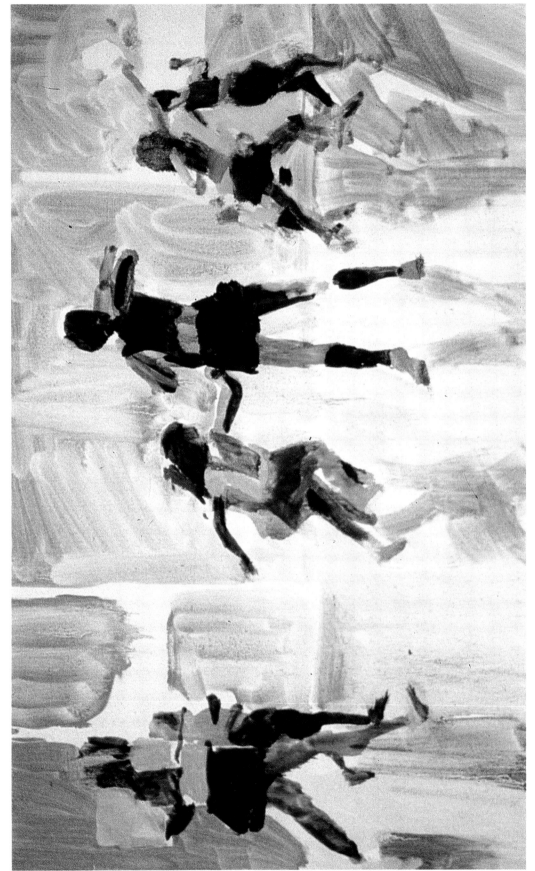

Colour Plate 52. Sarah Butterfield. 'The Netball Match', signed. 17in. x 24in. Sarah Butterfield.

by two teams of seven players, usually females. The game follows the same pattern as basketball where goals are scored through a goal ring set 10ft. (3m.) high, but the 'dribble' does not exist in netball which is a swift passing throw and catch game.

In 1905 the English rules were introduced into the USA, Canada, France and South Africa; between 1908 and 1920 the game spread to India, New Zealand and Australia. As the game was originally promoted by physical training teachers, it was quickly adopted by girls' schools, especially in urban areas where space was at a premium. They took the game with them to colleges and founded Netball Clubs so that by 1924, the London and Home Counties Netball Association was formed which, in turn, with the Ling Association, led to the formation of the All England Netball Association (AENA) in 1926. The first All England inter-county championship was held in 1932 and the first broadcast of a netball game occurred in 1947. Although netball has still to be recognised by the Olympic Committee as part of the Olympic Games programme, the game has had an International Federation since 1961 with a current membership of thirty-five countries. The first World tournament was played in England in 1962 and has been repeated at four yearly intervals in other countries. Unlike basketball, netball does not always lend itself to spectator participation as unless the two teams are well matched, the high rate of scoring leaves the final result in no doubt from fairly early on in the game and the remainder of the hour's play can seem lengthy to the onlooker. The court is now a standard size of 100ft. long x 50ft. wide (30.48m. x 15.24m.). The rules state that the game can be played on any 'firm surface' either inside or outdoors. Unlike basketball, it can be played on grass, especially in hot countries where the ground is baked hard, but not at top competition level.

Whilst netball may not become a media 'star', it undoubtedly benefits from being an adaptable game ideally suited to twentieth century urban dwellers.

BASKETBALL

Basketball is a five-a-side ball game which originated in the USA at the end of the nineteenth century and is now played worldwide. Unlike most contemporary sports, basketball did not evolve from an earlier game and, like Rugby League, has a definite birth date: it was invented in 1891 by Dr. James Naismith (1861-1939) while he was at the YMCA Training School at Springfield, Massachusetts (*see* Plate 15/3). Naismith, who was educated at McGill University in Canada where he obtained degrees in medicine and theology, later became Professor of Physical Education at the University of Kansas, and the Naismith Memorial Basketball Hall of Fame to which outstanding players, coaches, contributors and officials are elected, was founded in his honour in 1959. Naismith's medical training stood him in good stead for as the result of a study of physical stresses to which the basketball player was subjected, he was able to allay fears during the 1930s that there was

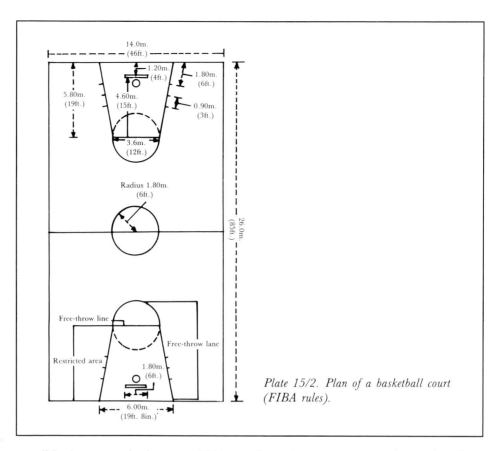

Plate 15/2. Plan of a basketball court (FIBA rules).

possible danger to the heart and kidneys from the strenous exercise undertaken by the players.

The game of basketball resulted from a brief given to Naismith to design an indoor team game for a group of YMCA secretarial students (all male) who were fed up with the compulsory formal gymnastics they had to perform as exercise. Perhaps the doctor was reminded of a game played by the earliest inhabitants of Central and South America where 'courts' bounded by stone walls and set among groves of trees have been found dating from the seventh century BC. The game, known as pok-tapok, was played with a rubber ball filled with sacred plants giving rise to the suggestions that the game formed part of a religious ceremony. In Mexico in the sixteenth century, there was a similar game called ollamalilzli where players used a solid rubber ball to score goals through stone rings. The successful scorer was reputed to win the novel prize of the clothing of all the spectators giving rise, no doubt, to the origin of modern day streaking.

Whether these ancient games influenced Dr. Naismith in his quest for a new indoor team game is not known; he may have read in the *Encyclopaedia of Athletics* (1818) of a game played in Florida in which the players attempted to throw the ball into a basket attached to the top of a pole. His own game was first played on 20th January, 1892 in the gymnasium at the YMCA with rules he had devised the previous month. As the class consisted of eighteen students, the game was played between two teams of nine and two peach baskets were nailed to the balcony 10ft. (3m.) high, one at each end of the gymnasium. There were thirteen rules for the original game which became so popular that later that year Naismith was inundated with requests for the rules which he incorporated into a booklet. These rules still form the basis of the modern game

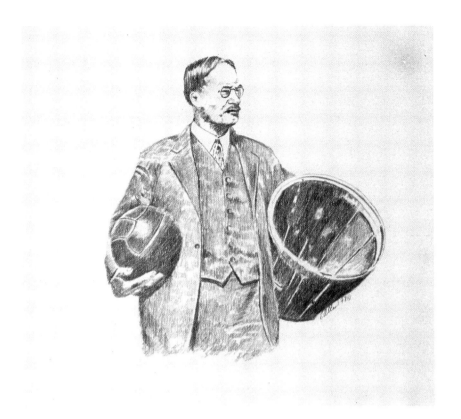

Plate 15/3. R. Allen.
'Dr. James Naismith'.
Charcoal drawing, 1978.
18in. x 28½in.
Naismith Memorial
Basketball Hall of Fame,
Springfield,
Massachusetts, U.S.A.

although the significant difference between this and Naismith's original game is the 'dribble', a system devised of bouncing the ball on the floor and then touching it again. Once the dribbler catches the ball or allows it to come to rest in his hand, he is not permitted to start another dribble. Dribbling was not encouraged by Naismith nor indeed was personal contact, a rule which still holds good today and which can carry a penalty of one, two or three free goal shots to an opponent. Other breaches of the rules, known as violations, include running with the ball ('travelling'), kicking or punching the ball, making an illegal dribble or causing the ball to go out of bounds. The game, which is very fast, is controlled by two officials, aided by three table officials, and matches consist of two twenty minute periods of play with a ten minute interval in between. The game is won by the team scoring the greater number of points, a system not shared with netball which is won by the number of goals. Should the scores be level at the end of full time, overtime is played until a winner emerges; each period of overtime consists of five minutes.

Although Naismith never specified the number of players that should comprise a team, by 1895 it was decided to limit the number to five, seven or nine, depending on the size of the gymnasium. Shortly after this date the number of players on court at any one time was standardised at five with teams consisting of ten or twelve players in total. In 1895 the YWCA requested a copy of the rules from the Men's Association and adapted them to make the game less strenuous for women. From these rules, the game of netball subsequently developed independently.

The only problem with Naismith's original conception of using peach baskets as goals was that after a goal was scored the ball had to be retrieved by means of a ladder which caused a tedious delay. By 1900 the peach baskets were replaced by iron rings with bottomless nets.

Basketball competitions were held as early as 1895 and a campaign to have

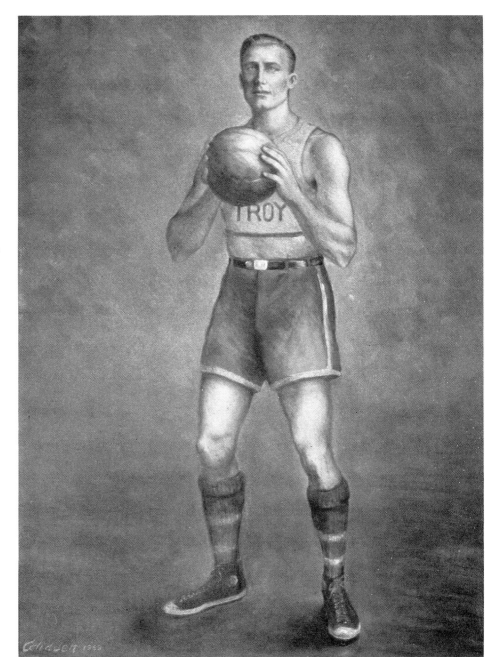

basketball included in the Olympic Games was launched in 1904. The campaign was not successful until the 1924 Games in Paris when the First International Exhibition Tournament was staged between teams from France, Italy, Great Britain and the USA. The tournament was won on that occasion by the London Central YMCA, but the game was still not accepted by the International Olympic Committee as part of the Olympic programme of competing sports until the 1936 Olympic Games in Berlin when the USA became the first Olympic champions out of twenty-two competing nations. In 1932 the Fédération Internationale de Basketball Amateur (FIBA) was formed at a meeting in Geneva; their original offices were in Rome but were later established in Munich. The year 1936 also saw the founding of the Amateur Basket Ball Association (ABBA); a National Executive Committee was also formed in the same year which instigated the National Championship for

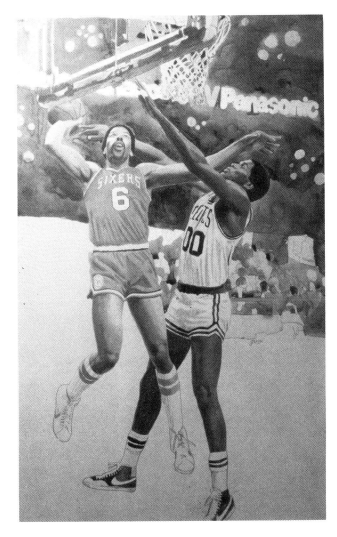

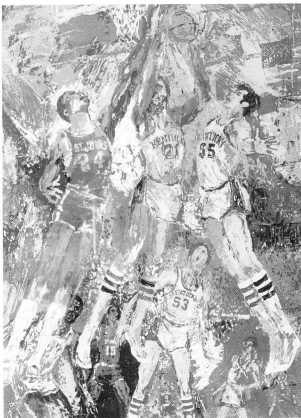

Plate 15/6. Leroy Neiman. Untitled. Collegiate game action between St. John's University (NY) and the University of Kentucky, 1978. Acrylic on canvas. 27in. x 36¼ in. Naismith Memorial Basketball Hall of Fame, Springfield, Massachusetts, U.S.A.

Plate 15/5. Guzzi. Professional National Basketball league action between Julius Erving of the Philadelphia 76ers (No.6) and Robert Parish of the Boston Celtics, c.1983-86. Watercolour. 17in. x 26in. Naismith Memorial Basketball Hall of Fame, Springfield, Massachusetts, U.S.A.

which a trophy was presented by the great-grandson of George Williams Williams, the founder of the YMCA, and has been played for ever since. By 1952 the number of competing teams had reached twenty-seven and, as a result, it was decided in future to limit the competition to sixteen countries decided by previously played qualifying tournaments thoughout the world. By 1973 the membership of the FIBA had reached 133 national federations and current membership now stands at 165.

ART

Since the direction of sporting art became increasingly unclear at the beginning of this century, it is small wonder that paintings of the newer sports remain scarce. This particularly applies to netball and basketball, and indeed to most of the games which take place on a court. Although both sports respond well to being painted and reflect the present enthusiasm of the public for speed and movement (*see* Colour Plate 52) and their concern against the more violent and cruel sports, they have not yet caught the imagination of artists.

CHAPTER 16

Polo

There are few team games in the world which equal polo for speed and excitement, calling for courage, stamina and precision on the part of the players. Whilst these qualities are also required for both ice and street hockey, the additional attributes necessary for polo are superb horsemanship on the part of the player and similar qualities of courage, stamina and a fine turn of speed on the part of his partner, the pony.

The game of polo (or 'chaugun' as it is called in Kashmir and Tibet, meaning a mallet) originated in ancient Persia over 2,000 years ago in the valleys of the Tigris and Euphrates. Even in those days it was the sport of kings and cavalry officers, and was portrayed by the early Persian artists as a sort of equestrian ballet performed before the King and accompanied by an orchestra of pipes and drums.

The Persian poet, Firdausi, the pen name of Abul Kasim Mansur (AD940-1020) described the opening of a game, played between the Persians and the Turkomans, in what has become known as the 'Iliad of Persia'

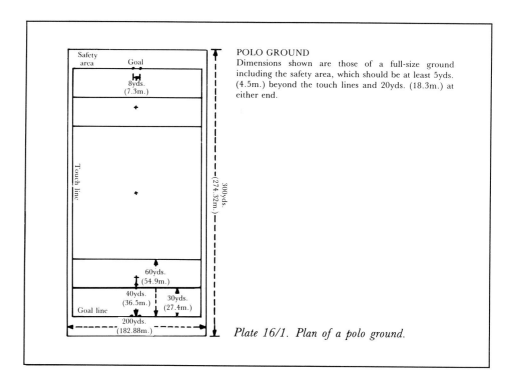

POLO GROUND
Dimensions shown are those of a full-size ground including the safety area, which should be at least 5yds. (4.5m.) beyond the touch lines and 20yds. (18.3m.) at either end.

Plate 16/1. Plan of a polo ground.

Plate 16/2. Polo in the sixteenth century: The Emperor Akbar playing with his courtiers. From the Badminton Library Series, *published 1891.*

dedicated to the Sultan Mahmud of Ghazna and finished around AD1010: 'Then the band began to play, and the air was filled with dust. You would have thought there was an earthquake so great was the noise of trumpets and cymbals. Then the king started the game by throwing in the ball in the correct manner'. (A proper code of rules must have been in operation in Asia at about the time that King Canute (c.994-1035) was trying to check the rising tide in England.) Even today the important polo matches echo the old Persian tradition and are often heralded by military bands, trumpeters and equestrian displays amid a colourful array of bunting and flags.

If the historian Tabari is to be believed, polo was already an old tradition by the time of Alexander the Great (356-323BC); Tabari records how the Persian King, Darius III (c.370-330BC), refused to pay his customary tribute to Alexander, and how, when the young Macedonian threatened invasion, Darius sent him a chaugun stick and ball suggesting that playthings were more suited to Alexander's immaturity and inexperience than the weapons of war. Several centuries later, a similar action was taken by the French Dauphin in 1414 who sent Henry V of England (1387-1422) some tennis balls with the advice that he would be better employed playing tennis than making war — advice which Henry V, like Alexander, did not take and both defeated their tormentors with characteristic swiftness.

Although originally of Persian origin, for centuries polo was also the favourite game among the chiefs and emirs in northern India, and the Emperor Babar (1494-1530) frequently mentions the game as being common in his time. A century later, Abul Fazil, the Chief Minister to the great Mogul Emperor Akbar who reigned from 1542 to 1602, gives an account of the game in his work *Akbar Nameh,* and tells us that the Emperor was an extremely able player. At that time, according to three English brothers on a visit to Akbar's Court, there were twelve horsemen in all with the King. The brothers' secretary, George Mainwaring, wrote:[1] 'so they divided themselves six on one side and six on the other, having in their hands long rods of wood about the bigness of a man's finger, and at one end of the rods a piece of wood nailed on like a hammer. After they were divided and turned face to face, there came one in the middle and threw a ball between the companies, and, having goals

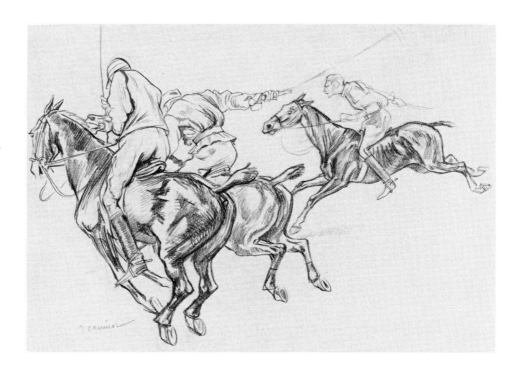

Plate 16/3. Pierre-Georges Jeanniot (1848-1934). 'Polo'. Signed in pencil. Black chalk sketch. 10¾in. x 16in. Sotheby's, Sussex.

made at either end of the plain, they began their sport striking the ball with their rods from one to the other in the fashion of our football here in England'. This report by Mainwaring slightly contradicts that of Abul Fazil who wrote: 'there are not more than ten players, but many more keep themselves in readiness'.

From Persia, the game spread to China and from there in the sixth century to Japan where it was known as 'diaku', meaning to 'strike the ball'. An eighth century reference to the game which occurs in Basil Hall Chamberlain's *Classical Poetry of the Japanese,* runs as follows: 'In the first moon of the fourth year of the period Zhiuki (AD 727), the nobles and courtiers had assembled in the fields of Kasuga and were diverting themselves with a game of polo when the sky was suddenly overcast and the rain poured down amid thunder and lightning'.

During the nineteenth century, polo almost died out in Japan during the rebellion that ended the feudal system, but by the 1880s it had obviously been revived, for a report of the game in Japan was given by a correspondent to *The Times* in 1889 from Tokyo, with a description of a game which more closely resembled that of lacrosse on horseback: 'The balls, unlike our own, which were made of willow root and weighed 5.5ozs., painted white, were made of paper 1.7ins. in diameter and weighed 1.25ozs.'. The sticks they used were of 0.5in. in diameter, 3ft. 8in. long and opened out at the end to form a sort of silken racket 'just loose enough to sink into a saucer shaped hollow when weighted with the ball'. The stick used by the Japanese appears to be much the same as that described by the Byzantine historian, Cinnanus, and there is little doubt that the Japanese must have got the game from the Corean Tartars, for whether called chaugun, diaku or polo, in what ever form it may be played, it seems inseparably connected with the hitting of a ball with a stick of some sort from horseback.

Although the game was popular among the Mogul emperors of Hindustan up to the sixteenth century, there are no known references to polo on the

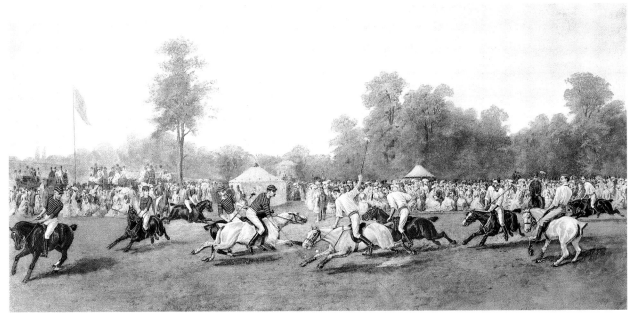

Colour Plate 53. George Earl (op.1856-1883). 'Polo Match at Hurlingham'. Between the Horse Guards (Blues) and The Monmouthshire Team, 7th July, 1877. Print from the original. 11½ in. x 23½ in. The Hurlingham Club.

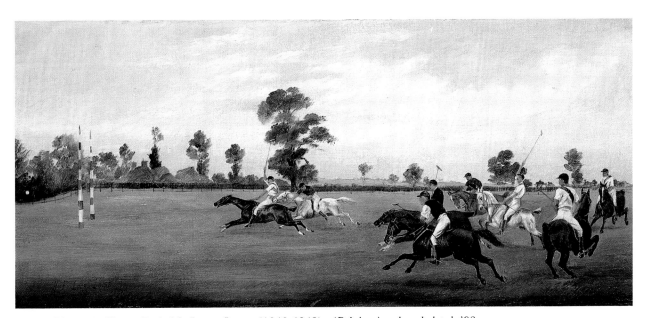

Colour Plate 54. Henry Frederick Lucas Lucas (1848-1943). 'Polo', signed and dated '93. 10in. x 22in. Inscribed 'Rugby' on the reverse. Rugby Polo Club was established in 1892, and played an important part in promoting county polo. The Wingfield Sporting Gallery, London.

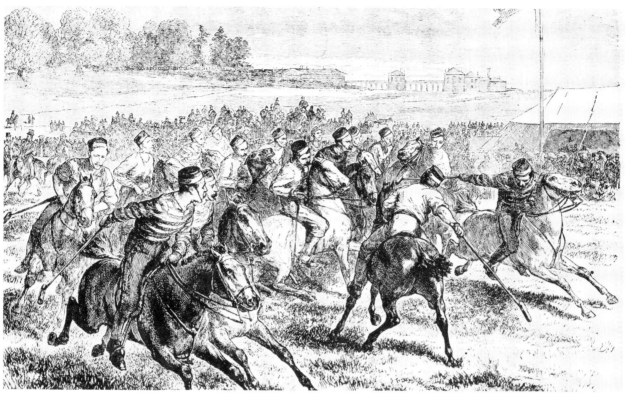

Indian subcontinent during the seventeenth and eighteenth centuries. By the
beginning of the nineteenth century, the game picked up from the Chinese by
the Tibetans and named 'pulu', their name for the willow root from which the
ball was made, was played in almost every valley in Little Tibet and Ladahk,
and by 1845, the players had been joined by a large number of European
officers and settlers. In 1854, tea planting was started by the Europeans in the
Manipuri valley of Cachar, and some of the planters soon joined in the sport.
A young subaltern in the Bengal Army, Lieutenant Joseph Sherer, later Major
General, also played his first game of 'pulu' with the Manipuris in 1854.

After the Indian Mutiny, Sherer and Captain Robert Stewart, the
Superintendent of Cachar, founded the first European polo club there in 1859.
By 1863, the game had reached Tonghoo in Burma, and by 1864 Captain
Kinloch of the Rifle Brigade, one of India's better known big game hunters,
having seen and played polo at Srinagar, the capital of Kashmir, brought it
down to Meerut, north-east of Delhi, where his regiment took it up. By 1865
the game was firmly established in Bengal, by 1867 in Madras and by 1870
throughout British India.

In 1869, the 10th Hussars, having read about polo in *The Field*, took it up,
although the 9th Lancers (who played such an important role under Colonel
Drysdale in the Indian Mutiny) were to take a strong lead in the game's
development. The first official inter-regimental match on a British ground was
played at Hounslow in 1869 between the 9th Lancers and the 10th Hussars.
The teams were eight a side and the match was reported in *The Morning Post*,
who referred to it as a new game called 'Hockey on horseback' and recorded
that the players were mounted on active wiry little ponies about twelve and a
half hands high.

Interest in the game spread, and in 1872 the Lillie Bridge ground, West

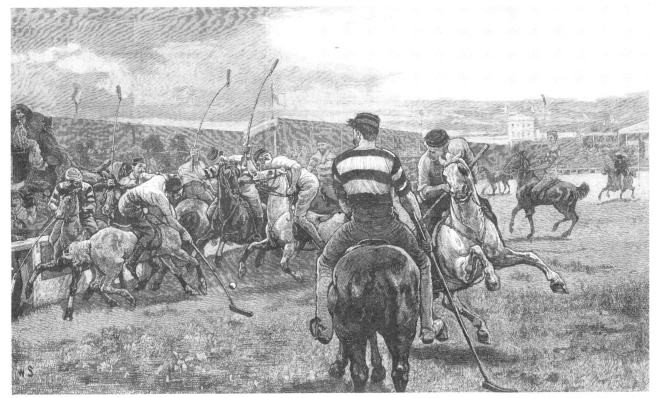

Brompton, became the headquarters of the polo players (*see* Plate 16/5). Two years later in 1874, the headquarters were transferred to Hurlingham and a delightful note in *Baily's Magazine,* July 1874 states: 'A great gathering at Hurlingham on the 13th to open the new Polo ground, which is not equal, by the way, to that of the Polo Club at Lillie Bridge, where Royalty comes to assist, and Society descends upon the pleasant place in crowds. Ladies made frantic efforts to get tickets and those that did not were rather dangerous to approach.' The Hurlingham ground was a rectangular lawn 300yds. long x 160yds. wide (fifty yards shorter than the corresponding chaugan maidan at Srinagar), and the goal posts at either end of the lawn were set 8yds. apart compared to the 10yds. at Srinagar. Though somewhat larger than the ground at Lillie Bridge, the ground at Hurlingham was still much smaller than most Indian grounds and it was not until the formation of the Polo Club at Eden Park, Beckenham, in Kent, in 1897 that a full sized ground was made. The Hurlingham Club was originally founded in 1869 by Mr Frank Heathcote, the organiser of most of the shooting competitions at that time, as a meeting place for those pigeon shooters who had been forced to give up their establishments, such as The Old Red House at Battersea and Hornsey Wood House, through building development. Due largely to the management of Captain the Honourable J.D. Monson (afterwards the 8th Lord Monson) the Hurlingham Club expanded both socially and in size, and for the next twenty years after the formation of the Polo Club in 1885, remained virtually unrivalled (*see* Colour Plate 55).

In 1878 the property next door to Hurlingham, which had previously belonged to the Ranelagh family, became available, and the Ranelagh Club was formed, originally for pony racing, as a separate club from Hurlingham, but not as a rival with many members of each club passing freely between the

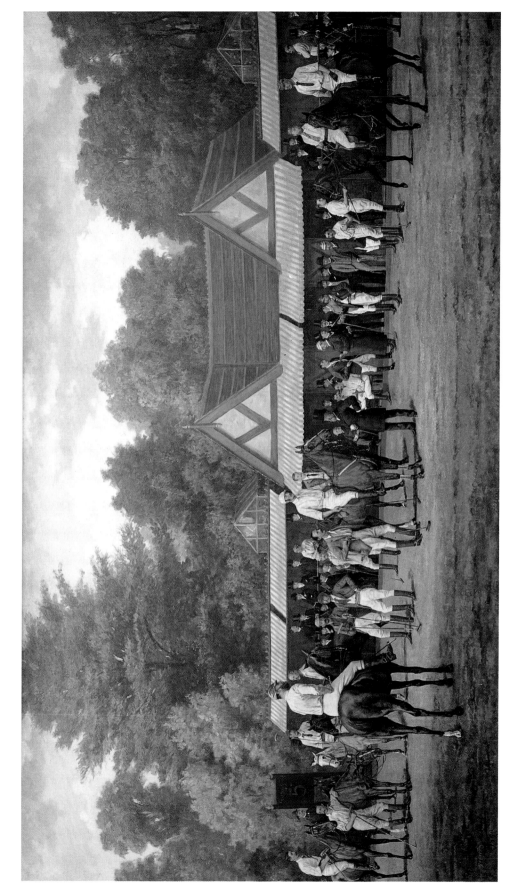

Colour Plate 55. Henry Jamyn Brooks (op.1890-1909). 'The Hurlingham Polo Team mounted in front of the pavilion, 1890', signed and dated 1890. 42in. x 90in. The Hurlingham Club.

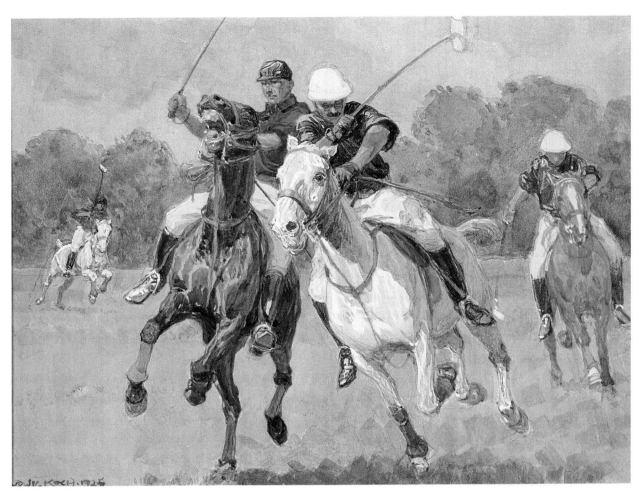

Colour Plate 56. Ludwig Koch (Austrian, 1866-1934). 'Riding Off', signed and dated 1925. Watercolour and gouache. 9½in. x 12½in. Sotheby's, Sussex.

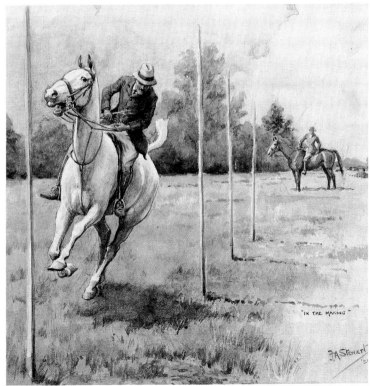

Colour Plate 57. Frank Algernon Stewart (1877-1945). 'In the Making', signed and dated '21. Watercolour. 9in. x 9in. Sheila Hinde Fine Art, Sussex.

Plate 16/6. Lionel Dalhousie Robertson Edwards, RI, RCA (1878-1966). 'Ranelagh v. Royal Horse Guards Subalterns, Sat. June 17th, '99. Result RHG 8 goals, Ranelagh 1'. Signed and dated 1899. Pen and ink sketch. 14in. x 10in. This drawing is interesting because it depicts a match at Barn Elms, after the Ranelagh Club had moved from its old site beside the Hurlingham Club in 1894. The Wingfield Sporting Gallery, London.

two and playing on both polo grounds. Unfortunately the Ranelagh Club had not been able to negotiate a long enough lease to give it the necessary condition of permanence with the result that the developers acquired it for building, and the Club moved in 1894 to Barn Elms, a property with more than 100 acres close to Barnes Common (*see* Plates 16/6 and 16/7).

The Polo Club was established in 1873 with HRH the Prince of Wales as Patron, Earl Spencer, a keen sportsman, as President and Lord Valentia, ex-10th Hussars and Master of the Bicester Hounds, as Vice-President. The new sport, very appealing to a nation of equestrian sportsmen, quickly established itself in England, and polo clubs were formed all over the country.

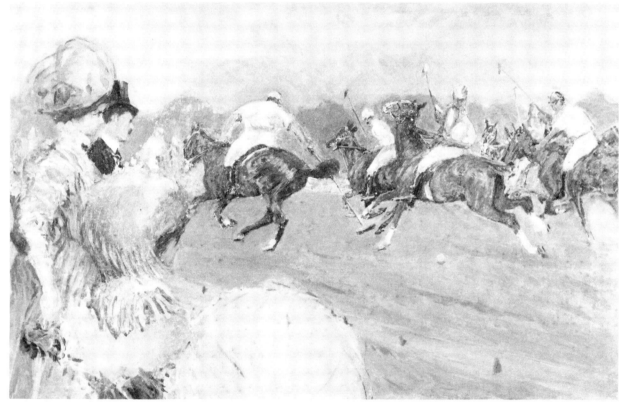

The County Polo Association was formed in 1897. Amongst the earlier clubs were those at Monmouth, Liverpool, Manchester, and Preston near Brighton, while on the Continent the game also spread rapidly to Paris, Spa in Belgium, and Baden Baden.

Queen Victoria, possibly because her eldest son the Prince of Wales was Patron of the Polo Club, disliked the game intensely, and records in a letter she wrote to her Private Secretary, Sir Henry Ponsonby, that it was no wonder that public interest in the Highland Games she was hoping to promote came to nothing when 'the love of low sports like pigeon shooting, and foolish and even cruel ones like polo are on the increase'.

In the matches of the early 1870s, the game had been played by teams of eight a side, but by 1873 this number was reduced to four and the backhand stroke was also introduced; the rules of the game were drawn up originally by

Plate 16/7. Unsigned watercolour, c.1902, of a polo match, showing the new Ranelagh Club pavilion at Barn Elms, Barnes. 7½in. x 20½in. The Wingfield Sporting Gallery, London.

Plate 16/8. Charles Gilbert Joseph Holiday (1879-1936). 'A game of polo'. Gouache. 9½in. x 15in. Sotheby's, Sussex.

271

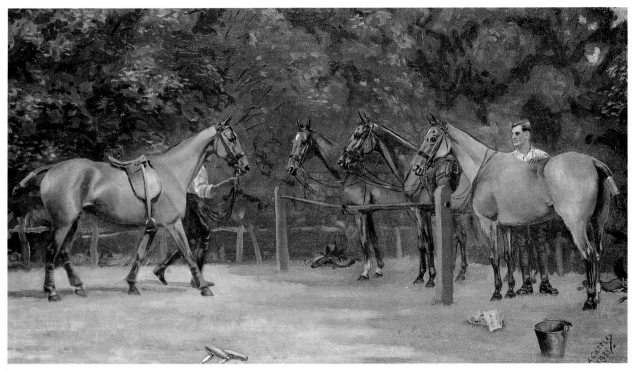

Colour Plate 58. George A. Cattley (1899-1980). 'Polo Lines', signed and dated 1933. 14¼in. x 25¼in. This artist was a staff instructor at the Military Riding School at Weedon. The Wingfield Sporting Gallery, London.

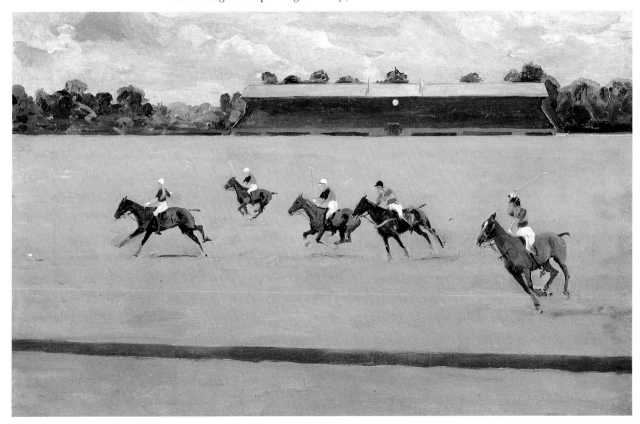

Colour Plate 59. Charles Walter Simpson, RBA, RI, ROI, RSMA (1885-1971). 'H.R.H. The Duke of Windsor, when Prince of Wales, playing polo at Cowdray Park'. 21in. x 32in. Royal Exchange Art Gallery, London.

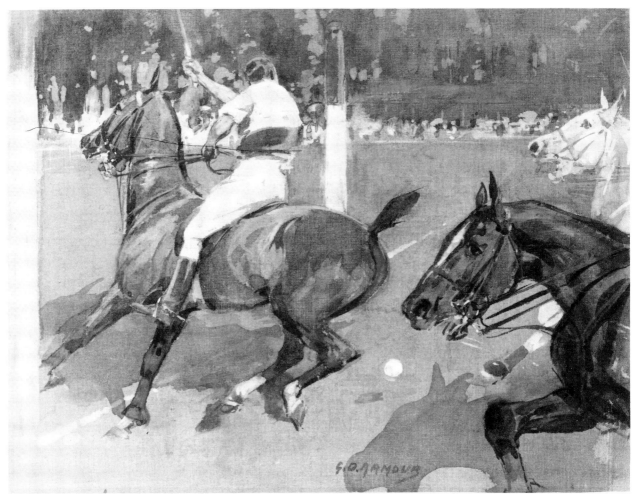

Plate 16/9. George Denholm Armour, OBE (1864-1949). 'Saving a goal, Polo'. Signed. Pencil, watercolour and gouache on linen. 10¾ in. x 13¾ in. Spinks, London.

the committee at Hurlingham.

In 1872 polo was played in Ireland at Phoenix Park, Dublin, under the organisation of that fine player, Mr John Watson, who became a leading member of the All Ireland Polo Club and who had a major role in drawing up the original Hurlingham Club rules. The formation of the All Ireland Polo Club in 1874 made it, with Hurlingham, the oldest existing club in the United Kingdom by the beginning of the century by which time there were also sixteen polo clubs in Ireland representing approximately 300 players, exclusive of the regimental players who were to be found playing in Ireland wherever garrisons were quartered. The early Irish game of polo had been referred to as 'hurling on horseback' after an ancient game apparently common only to Ireland and parts of Cornwall. There are points about hurling that mark its ancestry and there is in the use of the shoulder in hustling an opponent a link with the game of polo.

The early games in both Ireland and England were played on small ponies, approximately thirteen hands high, but with the new rules larger ponies of approximately fourteen hands were used when the game became a fast galloping one instead of the slow dribbling game of the early 1870s. The height limit for ponies was finally abolished in 1919 in order to increase their availability and thereby reduce the price, although with the introduction of the thoroughbred horse into the game prices were, if anything, raised rather than

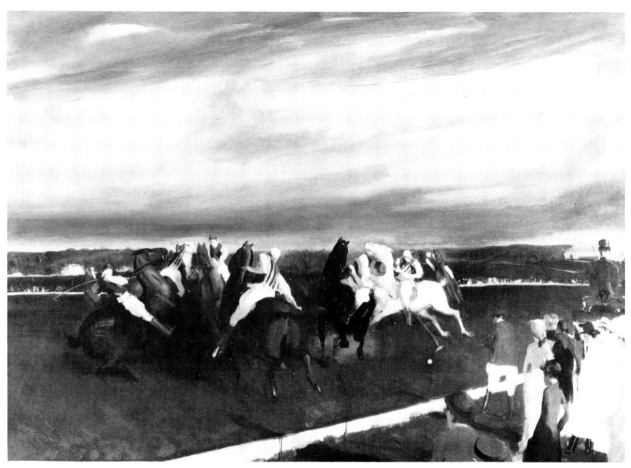

Plate 16/10. George Wesley Bellows (American, 1882-1925). 'Polo at Lakewood, 1910', signed. 45¼ in. x 63½ in. Columbus Museum of Art, Ohio, Columbus Art Association Purchase.

lowered. By the beginning of the twentieth century, the standard of polo playing in Ireland was very high indeed, and the Irish bred ponies were eagerly sought after by both the English and Irish players.

In 1876 James Gordon Bennett, jun., the son of the founder of the *New York Herald Tribune,* and himself the proprietor of that newspaper, saw polo being played at Hurlingham and exported it back to the United States, together with a plentiful supply of sticks and balls. He then dispatched New York's leading riding master, Harry Blasson, to Texas to purchase suitable ponies, and by the end of 1876 he had staged his initial demonstration game in Old Dickels indoor riding academy on the corner of Fifth Avenue and 39th Street. Interest in the game spread quickly and in 1886, Hurlingham was invited to send a team to play for a Challenge Cup, later called the Westchester Cup, against a representative American team at their ground at Newport, Rhode Island, which resulted in a resounding defeat for the Americans. The English team, captained by John Watson, brought the Cup away with them, together with many pleasant recollections of the hospitality of their opponents. It was not until 1902 that the Americans felt fit to throw down the gauntlet for the Westchester Cup again. Although they won the first match, they failed to retrieve the Cup, and it was not until 1909 under the expert captaincy of Harry Payne Whitney of the Meadow Brook Club, Long Island, that the American side were able to carry home the Westchester Cup for the first time.

In India the game flourished, although the ponies used for polo (as reported by a correspondent of *The Field* in 1888 under the signature of 'Turbot') were as small as twelve hands high which perhaps contributed to the fact that the

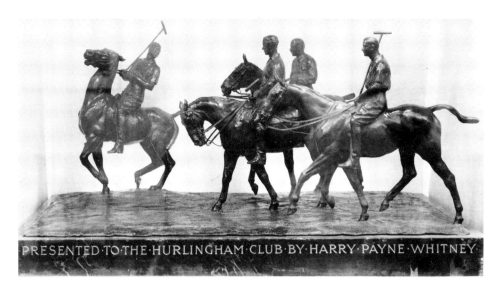

PRESENTED·TO·THE·HURLINGHAM·CLUB·BY·HARRY·PAYNE·WHITNEY·

Plate 16/11. Herbert Haseltine (American, 1877-1962). A bronze of a polo group, 1911. Presented to the Hurlingham Club by Harry Payne Whitney. The Hurlingham Club.

slow dribbling game was played on in India for several years after it was abandoned in England. A good deal of rough and tumble ensued especially when the game first started. The ball was placed in the centre of the ground and the five men on each side rode in from their respective goal lines clawing and snatching to gain possession of the ball which was an exciting but dangerous feature of the game.

The first set of rules drawn up in 1873 by the Polo Committee at Hurlingham were for the Club's use only, and other polo clubs throughout England and Ireland were at liberty to use them or modify them as they pleased. It was never envisaged, even at Hurlingham, that the game of polo referred to by a journalist in the 1870s as a 'patrician sport', might become anything more than a passing fashion as it was thought to be too expensive to gain widespread popularity. By 1905 it became obvious that this was not the case and that a standard set of rules would have to be adopted, and the suitably updated Hurlingham Rules were used. The development of polo after the reconstruction of the Ranelagh Club at Barnes in 1894 was so rapid, that the demand for time and space for play was quite beyond the powers of Hurlingham and Ranelagh to satisfy. For a short time the Wimbledon Club had a considerable success, but it was too far from the centre of London and players would not drive the extra distance or travel in crowded trains on a Saturday afternoon. The Eden Park Club near Beckenham, Kent, founded in 1897, fared better as did the polo clubs at Roehampton and Woolwich. The next club to be founded was the London Polo Club at the Crystal Palace which was close enough to both Woolwich and Eden Park to use each other's grounds. A note in *Baily's Magazine* of 1900 records the London Polo Club: 'This club evidently meets a want for it gathers a good many players, and Major Herbert is able to arrange some good matches. Among the leading players at the club are Sir Charles Wolsley, Mr Brammall, Lord Huntingdon, Dr MacArthur and, last but not least, Major Herbert himself who must be, I suppose, looked upon as a veteran from the Polo point of view though his play still shows keenness'.

In 1888, the Americans instituted the handicapping system. The first official handicapper was H.L. Herbert, and in 1890 the American Polo Association was founded in New York. By 1901 American players were taking part in over one hundred tournaments held on the grounds of twenty clubs, competing for

Plate 16/12. Edmund Blampied, RBA, RE (1886-1966). 'Polo as it is not played in England'. Inscribed ''With the 'sangfroid' of a Bradman this pony sits on the ball''. 14in. x 11in. One of a set of three. Bonhams.

thirty-five sets of cups and other special prizes, for in the United States as in England polo had become a highly fashionable and elite game.

In 1898, Sir John Barker founded his Grange Stud which specialised in the breeding of polo ponies; with his stallion, Sandyway, and others, he was to make the Grange strain the most influential in the polo world, although pony breeding in the Argentine was also to have a great impact on American polo. In 1909, after the Americans had won the Westchester Cup for the first time, *The Times* correspondent reported: 'It may be said at once that the better team had won. British ponies were outplayed and our team didn't play together... The Englishmen were outponied and had had no practice together. The Americans owe their success entirely to the brilliance of their attack which thanks to their splendid ponies and wonderful quick and strong hitting, they developed to perfection'.

In 1911, in the knowledge that the next battle for the Westchester Cup must

Plate 16/13. Edmund Blampied, RBA, RE (1886-1966). 'Polo as it is not played in England'. Signed and inscribed "Of course, this does on occasion happen however intelligent the pony". 14in. x 11in. One of a set of three. Bonhams.

be on American soil, and therefore to be played under American conditions, England now suspended the off-side rule, which the Americans had themselves suspended in 1909, all their practice from then on being without that restriction. Nevertheless, the Americans were victorious by the narrow margin of 4.5 to 3 and 4.5 to 3.5. In his autobiography, *Bridle and Brush*, G.D. Armour made reference to the speed the game had achieved by 1913, very largely influenced by the Americans: 'all round I think they [the Americans] were better mounted than our men, had faster ponies and of course had then, as now we also have, no size limit. . . I think the American influence speeded up polo as it did racing, and I am sure that the pace at which these international games go necessitates those taking part being in the youthful prime of life and absolutely fit to stand the strain entailed, to say nothing of the ponies'. In 1913, the Americans were again victorious, by the slimmest of margins, but in 1914 the tables were turned and the Hurlingham team carried home the Westchester Cup.

By 1877, polo was being played in Argentina and in 1883 the Flores Club was founded on the outskirts of Buenos Aires. In 1892 there were more clubs in the country than there were in Great Britain; the leading Argentine polo family of the early days was that of Trail, with the North Santa Fé team composed for a time entirely of Trails, the most famous of whom was J.A.E.

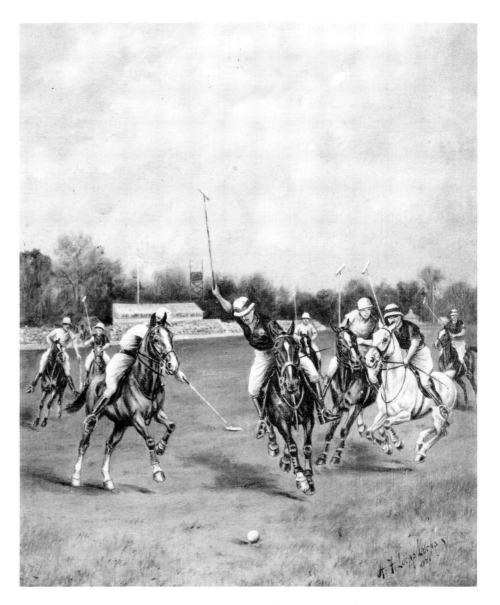

'Johnnie' Trail who later came to play in England in 1914.

Promoted by the English and the Americans, polo was also played in Chile, Uruguay, Colombia and Brazil from the turn of the century onwards, but neither the scale of the game nor the standard of play were anything like that of Argentina, the principal factor being pony power. The small South American ranch horse bred in alfalfa country and trained to work cattle had all the characteristics of handiness, smooth gallop, temperament and stamina required for a top class polo pony. The ponies were also plentiful, all they lacked was quality, and quality could be added by breeding with the English throughbred.

Despite the fact that polo had been played by women in ancient China, the participation of women was actively discouraged when the game began in England, partly due to the strictures of Victorian morality and partly because the game was considered (by men) to be too physically taxing and dangerous. There were, however, many excellent horsewomen on both sides of the Atlantic, and women's polo certainly got under way in the United States during the 1920s and '30s, which was brilliantly depicted by G.D. Armour in

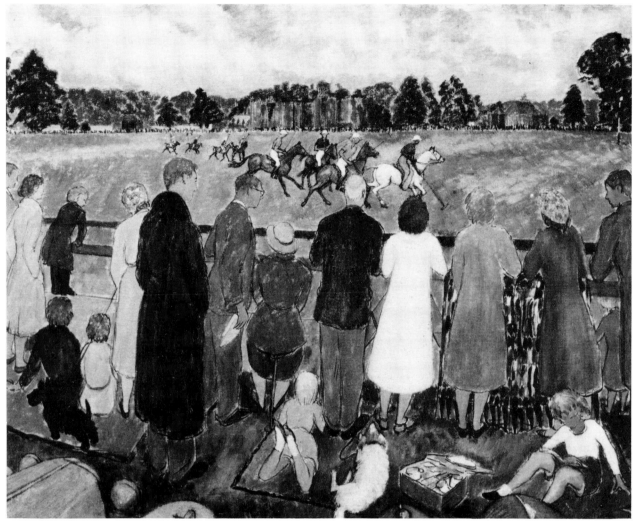

Plate 16/15. Henry Cotterill Deykin (b.1905). 'Polo at Cowdray Park, Sussex'. Cowdray Park defeat Henley 6.5 to 9. 27th August, 1951. 19¾ in. x 23¾ in. Henry Cotterill Deykin.

a wickedly amusing little sketch at the time. Furthermore, the women had their own team, 'Old Aitken' captained by that brilliant horsewoman Mrs Hitchcock, the mother of Tommy Hitchcock jun., who became the 'Golden Boy' of American polo.

Polo, surprisingly, was also played by the Royal Navy. The Malta Club which was founded in 1874 is one of the oldest surviving clubs in the world, and numbered the Admiral of the Fleet, the Marquis of Milford Haven, the father of Lord Louis Mountbatten, and Admiral Sir George Neville among their playing members. Naval polo flourished also in the West Indies and in particular in Cuba, where Prince George (later George V), then in command of HMS *Thrush,* often played. The Royal Navy's 1928 team was impressively composed of Admiral Sir Roger Keyes, Lt. W.C. Eyken, Lt. Cdr. Lord Louis Mountbatten (who under the pseudonym of 'Marco' wrote about the game) and Admiral of the Fleet, Earl Beatty. One of the Navy's most important and lasting contributions to the game was the part it played in promoting polo in New Zealand, where it was established in 1888.

The Auckland Polo Club was formed, followed by another club at Christchurch, and in 1890 the Savile Cup, presented by the Earl of Onslow (the New Zealand Governor at the time) was played for on the Auckland ground. In Australia, the game apparently has an even older tradition, as it

was established there by an officer of the 10th Hussars and his brother in 1876. Older than either of these Australasian foundations is the Singapore Polo Club, which was founded in 1866 by the officers of the Buffs on a ground 300yds. x 80yds. opposite the Raffles Hotel.

British polo suffered a temporary setback when several of her top class players were killed in the Boer War (1899-1902) — Major H.S. Dalbiac, who also wrote on polo, the Earl of Airlie and P.J.W. Le Gallais were just three casualties from this field. On the other hand a note in *Baily's Magazine* of 1900, headed 'Plymouth Polo Club', read as follows: 'This garrison Polo club seems to have suffered less from the war than Plymouth. Perhaps this is because they are a United Service Club, and the players are drawn from both Army and Navy'.

After the First World War British polo suffered a terrible setback, as not only had many fine players been killed but dozens more young players who had been coming on strongly in 1914 had also perished. Furthermore, British polo faced severe financial difficulties — as the Americans grew richer, so the British became poorer, with American polo expanding and British polo diminishing. Although both sides were eager to see a revival of the closely fought pre-war Westchester matches, this was denied them as Britain never fielded a team strong enough to prevent the Cup being carried home by the Americans each time it was contested (*see* Colour Plate 60), and in 1939 the Americans took it home permanently.

Elsewhere in the world, in those countries not involved in the war, polo flourished in the 1920s and '30s, in particular in Argentina who sent a team to England in 1922 and proceeded on a tour of successive victories, including triumph in the English Open. They went on to beat the Americans in the 1924 Olympics in Paris, in which Britain also competed, but the heights were achieved by the Argentinian team in the 1936 Berlin Olympics when they won the gold medal in impressive style with a string of magnificent ponies, with a fast improving Britain second, and Mexico third. From that date, Argentina became the leading polo nation, and by the 1970s with perhaps 5,000 players, all the world's 10 goalers, and most of the 8s and 9s, was in an unassailable position.

In India, during the 1920s and '30s, one player in particular, Rao Rajah Hanut Singh, dominated the game. Born in 1900, the son of Sir Pertarb Singh, a keen polo player, Hanut started to play the game at the age of ten. He returned to India in 1918 from the Western Front with a polo handicap of 5. Within a month, it was raised to 8 and by 1919 to 9, the rating he kept until 1939.

In Australia, between the wars, the game was to be dominated by one family, the Ashtons, four brothers from New South Wales. The Ashton brothers became sheep ranchers and their ponies doubled as stock horses for cattle and sheep graziers. After an amazing sea journey of forty-eight days from Australia to England in 1930, the four brothers formed the Goulburn

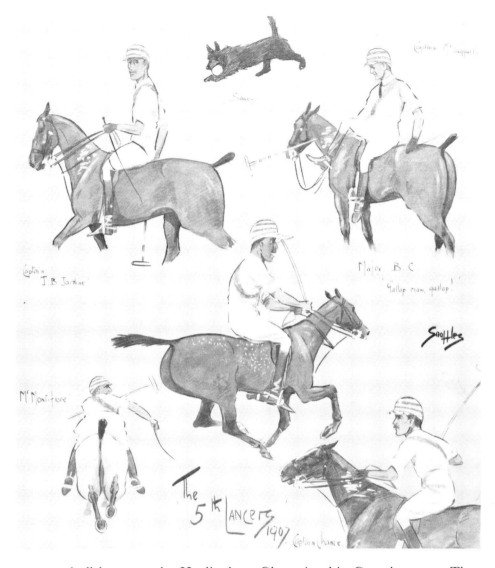

Plate 16/16. Charles Johnson Payne ('Snaffles', 1884-1967). 'The 5th Lancers, 1907', inscribed and dated 1907. Watercolour and gouache. 13in. x 11½ in. Phillips.

team and all but won the Hurlingham Championship Cup that year. They travelled on to the USA winning five of the seven matches they played, proceeded back to Australia to win the New South Wales Championship Countess Dudley Cup in 1934 and 1935, and returned to England in 1936. In 1937, they won the Hurlingham Championship Cup which had just eluded them seven years before.

The Second World War was a major set-back for the game. The United States lost their team leader, Tommy Hitchcock jun., on a training flight over Salisbury Plain in 1944. Meanwhile, the Argentinians had so perfected their game that Buenos Aires became the acknowledged centre of the polo world, and having won the Cup of The Americas on all six occasions since 1936 (the USA having won it initially in 1928 and also in 1932) no further challenges were made until after 1980. However, the United States fought back, and by the 1980s boasted 120 clubs with over 2,000 names on the handicap lists, but in India, the seedbed of early polo, the game never recovered after the war.

In 1945, the outlook looked bleak for British polo. In 1939, the once glorious Hurlingham pitches had been leased to Fulham Borough Council as allotments, and later in 1951 they were compulsorily acquired by the London County Council as public recreation grounds. Ranelagh suffered much the

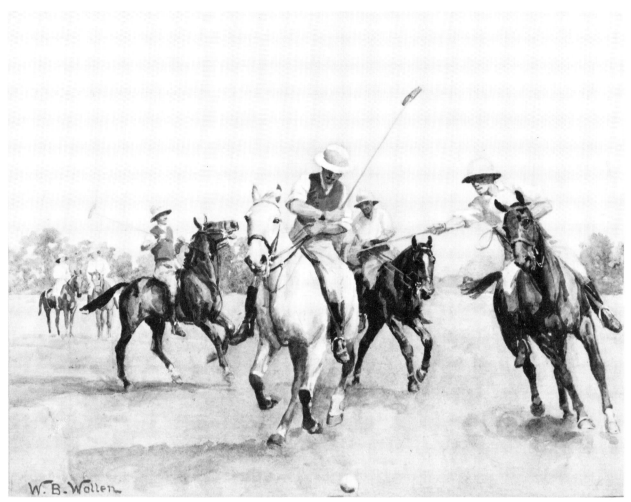

Plate 16/17. William Barnes Wollen, RI, ROI, RBC (1857-1936). 'Polo', signed. Watercolour. 11 ¾ in. x 15in. Sotheby's.

same fate, and although Roehampton kept one ground open for the benefit of the Roehampton Open and the County Tournament until as late as 1952, London polo in its pre-war form was finished. Furthermore, the army, which had been the backbone of polo, had been mechanised; this factor, coupled with short term postings and longer parade hours, dealt a savage blow to the game for a time. In the 1950s, polo began to revive again. The Bathursts, the 7th Earl and his brother, restarted the Cirencester Park Club in 1952, and the Kirklington Park Club was revived by Alan Budgett in 1954, but it was Lord Cowdray who was largely instrumental in reviving national polo in the post-war years, and who substituted Cowdray Park for Hurlingham as the replacement headquarters of British polo (*see* Plate 16/15 and Colour Plate 61). At about the same time, Major Archie David, whose own club, Friar Park at Henley-on-Thames, was suffering from lack of support, suggested the foundation of a new club based on the Household Brigade (the Household Cavalry and Brigade of Guards) at Windsor Great Park. This club, later named the Guards Polo Club, was established in 1955 and became, with ten playing pitches, the largest in Europe. The Queen's Cup, first presented by Her Majesty in 1960, is the club's premier high goal tournament. The Cowdray Park Gold Cup for the British Open Championship which began in 1956, remains the cordon bleu of British polo and the climax of the season.

Besides the nineteen clubs in England, there are two in Scotland, one near Edinburgh on the Earl of Morton's estate and one at Scone Palace, the estate

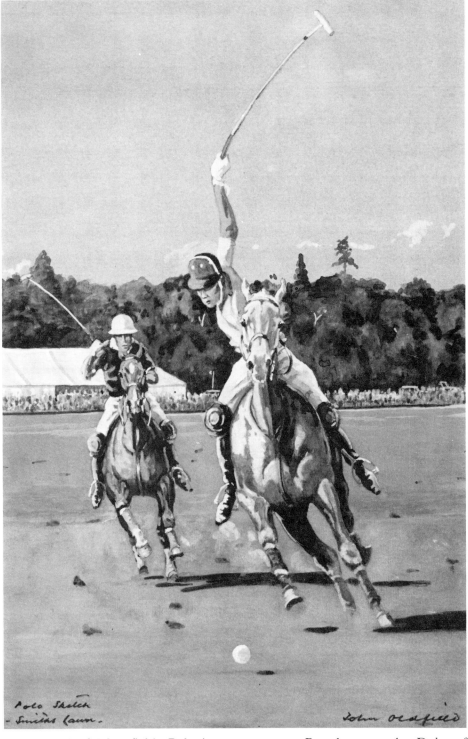

Plate 16/18. John Oldfield (b.1918). 'Polo sketch — Smiths Lawn', 1987, signed. Watercolour. John Oldfield.

of the Earl of Mansfield. Polo is once more a Royal game; the Duke of Edinburgh began playing in 1950 in Malta, and has since encouraged the interest in his son, HRH The Prince of Wales.

Recently many polo players have turned professional due to escalating costs, but polo is more about teamwork than individuals. Although the last decade has seen increasing tournament sponsorship for most sports, it is team sponsorship, now so widely utilised in the USA, which is needed for British polo to continue successfully in international play.

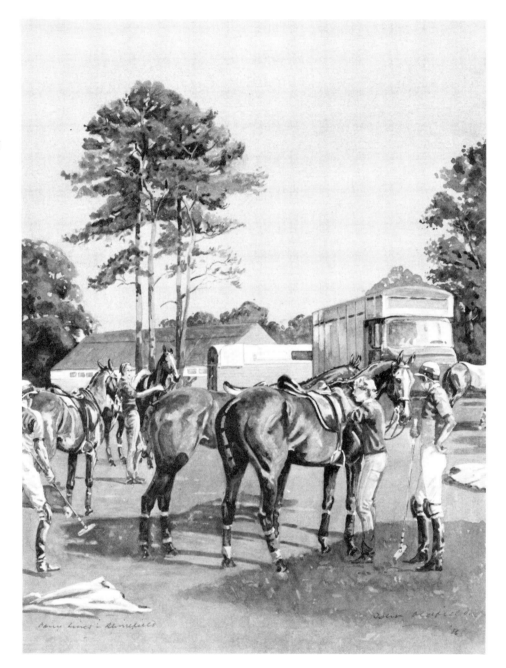

BICYCLE POLO

Bicycle polo was probably invented in Ireland by R.J. Mecredy in 1891, a former racing cyclist who had remained an active member of the Ohnehast Cycling Club of Dublin and who was then Editor of the *Irish Cyclist*. On 10th October, 1891, a report appeared in the magazine *Cycling* under the heading 'Polo on Wheels' as follows: '. . . on arriving at the Scalp [some twenty miles from Dublin, Co. Wicklow] the game of Cycling Polo was inaugurated and promises to be immensely popular with members'. The report continued: 'After a few games there were hardly any collisions and these only occured when the riders were travelling a very slow pace. One would think that Polo

is a sport which would peculiarly gladden the heart of the cycle repairer but there was not even a bent pedal. R.J. Mecredy is enthusiastic about it and hopes to get a few matches when it is generally known'. Forty cyclists were present at that first meeting and enthusiasm quickly spread, so that in 1895 the first Bicycle Polo Association was formed in London and in 1901 the first international match was played between England and Ireland at the Crystal Palace in London, Ireland winning 10-5. By 1908 the game had spread across Europe and another international match took place at Shepherds Bush Stadium in connection with the Olympic Games, although not part of the official programme, at which Ireland beat Germany 3-1.

After the First World War the game declined until 1930, when the present governing body within the UK, the Bicycle Polo Association of Great Britain, was founded. By 1937 the game was being played in many district leagues and a year later the first of the modern series of home internationals between England, Ireland and Scotland was staged. These were run off in 1938 and

Plate 16/20. John Oldfield (b.1918). 'Rhinefield — Polo', signed and dated '87. Watercolour.
John Oldfield.

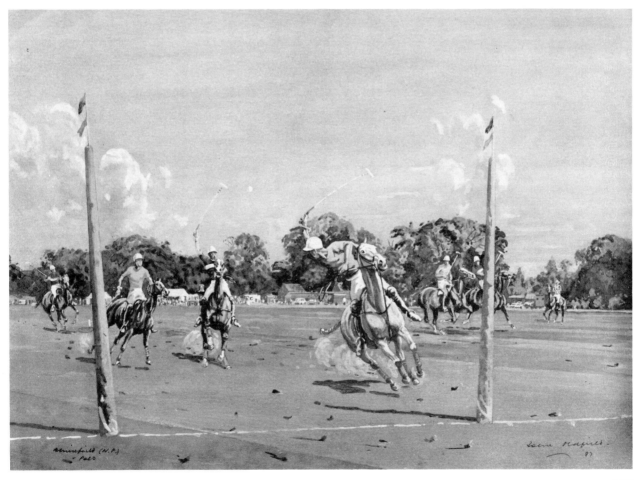

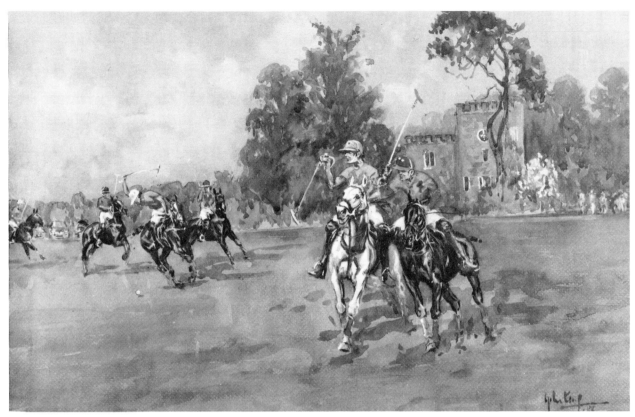

Plate 16/21. John King
(b.1929). 'The
Warwickshire Cup 1986 at
Cirencester Polo Club',
signed and dated '86.
Watercolour.
14¼in. x 20¾in.
John King, and
Malcolm Innes Gallery,
London.

1939 and in consecutive seasons between 1946 and 1951. There was then a lapse of fifteen years until the series was revived in 1966. The internationals are played on a knock out basis at a tournament traditionally held in September, the winning country holding the Albert Lusty Trophy. In 1968 a world body, the International Cycle Polo Federation, was formed in Mexico City by representatives from India, the United Arab Republic, the USA, Sri Lanka, Singapore, Belgium and France; Britain applied for membership in 1970.

The game in Europe freely modifies the basic rules of polo: a smaller pitch is used, roughly the same size as a football pitch (on which the game is often played) and the teams (both men and women) number six on each side, one of whom is a reserve, rather than four. However, as played in the United Arab Republic, India, Pakistan, Sri Lanka, Malaysia and Singapore, no concessions are made for bicycle riding and the game remains similar to the parent game of polo.

WATER POLO

Early in the game's history in the late nineteenth century, the game more closely resembled that of football and the basic aim, as in Association Football, is for the attacking side to get the ball into the net of the defending side, usually after a series of passing movements. The team for water polo consists of seven players, one of whom must be the goal keeper, and six reserves, who may be used as substitutes. The first international water polo took place between

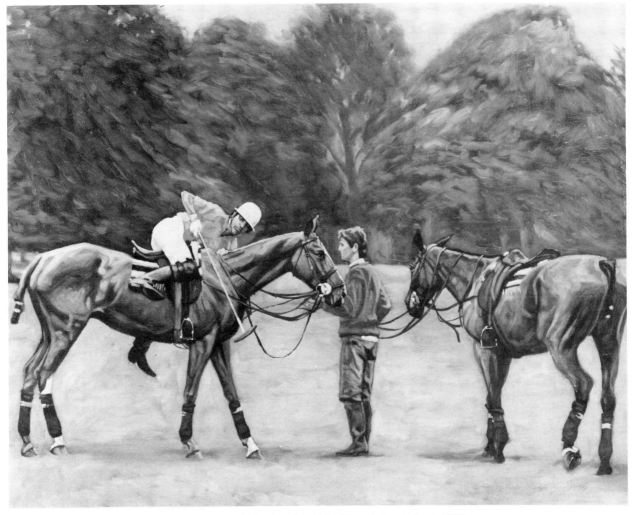

Plate 16/22. Edward Kennedy. 'Changing Ponies', signed 'Eddie Kennedy' and dated 1987.
27½in. x 35in. Christie's.

England and Scotland at the Kensington Baths in London on 28th July, 1890, but there was no conformity of rules and since England were the hosts, the match was played under their rules which permitted 'ducking'; despite this the Scots won 4 – 0.

Since the Second World War the game has always been dogged by constant changes of rules, efforts to promote a better game have resulted in the division of the water polo playing nations into two quite distinct groups. These are the big powers, Hungary, Russia, Yugoslavia and East Germany, Italy and Cuba for whom water polo has become a national sport involving their players in many hours of practice and training, and the other nations whose teams must be prepared largely on an amateur basis and who generally cannot compete with the full-time 'amateurs'.

Despite this division, water polo is one of the events in most major swimming competitions, such as the World Championships, Olympic Games, European Championships and Pan American Games, with the exception of the Commonwealth Games. Although water polo has been played by women for many years, the first World Championship for women was held in Madrid in 1986 and was won by the team from Australia.

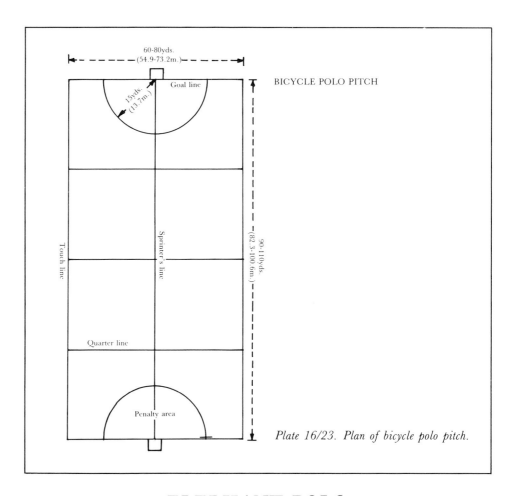

Plate 16/23. Plan of bicycle polo pitch.

Within the diagram:
60-80yds.
(54.9-73.2m.)
BICYCLE POLO PITCH
Goal line
15yds.
(13.7m.)
90-110yds.
(82.3-100.6m.)
Touch line
Sprinter's line
Quarter line
Penalty area

ELEPHANT POLO

A variety of polo which has its origins in Nepal, it is not normally played in Britain, although recently a British Elephant Polo Team was formed in order to participate in an international match and in 1983 the first Elephant Polo Championship was held in Nepal. Elephant polo rules are essentially the same as those for equestrian polo, with one or two variations: players must not interfere with an opponent's stick, women players can use two hands, elephants should not be encouraged to stop suddenly and must not be allowed to reverse. The rules do not perhaps convey a tangible image of the game; more revealing by far is the description that it resembles 'playing one handed golf from the top of a double decker bus with a puncture'. This statement does not take into account that the field contains a further seven double decker buses carrying seven more one handed 'golfers'.

The 100th anniversary of the first international polo match played on ponies between the United States and Great Britain at the Westchester Polo Club, founded in 1887 by James Gordon Bennett, coincided with the centennial celebrations of the *International Herald Tribune,* also founded by Bennett. In order to commemorate these historic events, the *Tribune* sponsored a challenge match which was played at the Royal County of Berkshire Polo Club on 16th July, 1987, between a team from the US Polo Association and a team of British riders. In a more frivolous mood, they also sponsored the first British Elephant Polo Championship between the British Elephant Polo Team and an international team of celebrities in which two teams of elephants played two

fifteen minute chukkas on a specially shortened pitch. The match, whilst no doubt hilarious for the participants, left the spectators in little doubt that elephant polo in this country was not a serious rival to equestrian polo.

ART

By the turn of the century, the new fast game of polo gave a very talented group of equestrian artists and illustrators enormous scope to enlarge their subject matter, confined as it had been to hunting, steeplechasing, racing and coaching scenes. Artists like G.D. Armour (1864-1949), a polo player himself who covered polo matches in the early 1900s for *Country Life,* was a particularly skilful player of the game (*see* Plate 16/9), but he was by no means the earliest. Artists such as Henry Frederick Lucas Lucas (1848-1943, *see* Plates 16/14 and Colour Plate 52), R.E. Galindo (b.1881), Richard Caton Woodville (1856-1927), George Earl (op.1857-1896, *see* Colour Plate 53), and Henry Jamyn Brooks (exh. 1890-1909, *see* Colour Plate 55), as well as those three fine equestrian artists all born in the same year, Cuthbert Bradley (1861-1943), Joseph Crawhall (1861-1913) and George Derville Rowlandson (1861-1930) had all produced fine polo paintings before 1900. Cuthbert Bradley wrote several articles on polo, many of which he also illustrated including his series of 'Polo Prospects' which he did for the *Badminton Magazine* (1896), halving his work load with George Herbert Jalland (op.1888-1908). Lionel Edwards (1878-1966) was a prolific artist and illustrator. His polo sketches done at Ranelagh in 1899 are remarkable, for he was only twenty-one in that year (*see* Plate 16/6). One of the most enchanting stories ever written about polo with delightful illustrations by this artist is the 'Maltese Cat', by Rudyard Kipling (1865-1936), which tells the anthropomorphic story of the inter-regimental final between two polo teams in the British Raj of the 1890s, and gives a far clearer account of the game played in India at that time than many other sources.

Although Sir Alfred Munnings was born in 1878, the same year as Lionel Edwards, he painted polo scenes after 1900, as did Cecil Aldin (1872-1935), Charles Johnson Payne ('Snaffles', 1884-1967, *see* Plate 16/16), Gilbert Holiday (1879-1937, *see* Plate 16/8 and Colour Plate 60), the American Paul Brown (b.1893), George Cattley (c.1899-1980, *see* Colour Plate 58) and Terence Cuneo (b.1907).

By far the greatest number of polo paintings were produced between the 1880s and the 1930s; the art declined with the game from the 1940s to the 1960s but has revived again in the last two decades due to Royal patronage and increased public interest.

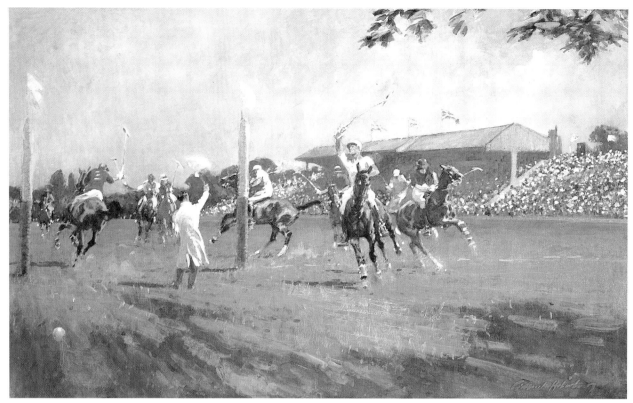

Colour Plate 60. Charles Gilbert Joseph Holiday (1879-1937). 'The Westchester Cup', played at the Hurlingham Club, June 1936, signed. 11¼ in. x 18½ in. The Hurlingham Club.

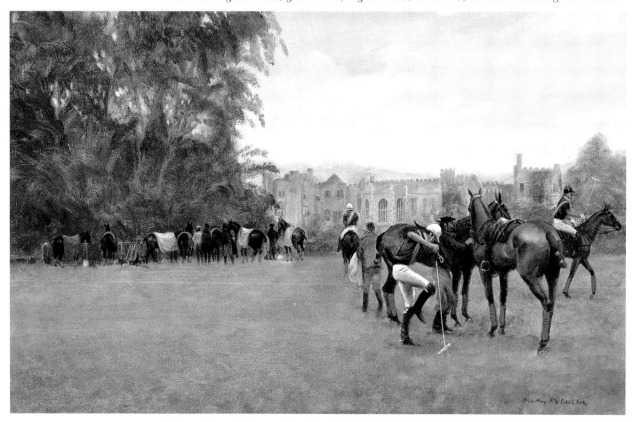

Colour Plate 61. Henry Koehler (b.1927). 'Changing Ponies, Cowdray Park 1986', signed. 16in. x 24in. Wilton Antiques Ltd.

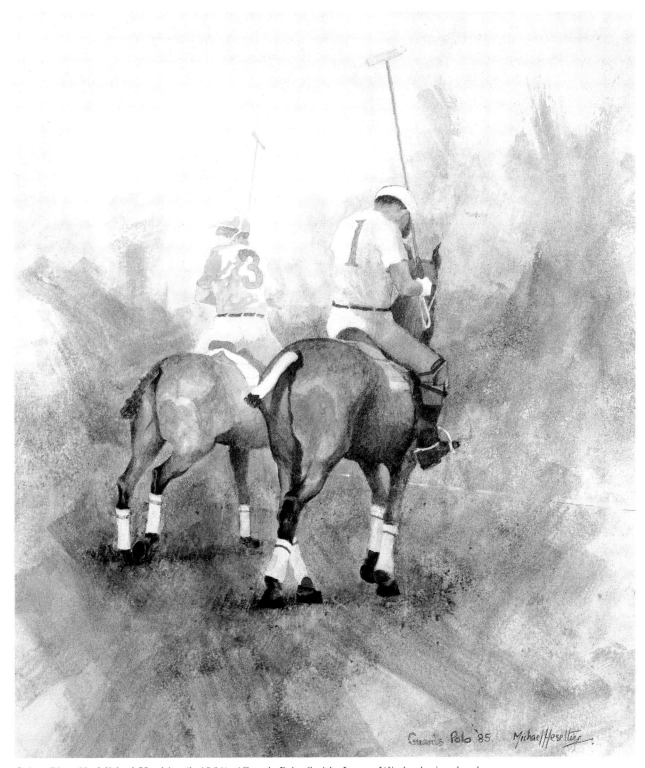

Colour Plate 62. Michael Heseltine (b.1961). 'Guards Polo, Smiths Lawn, Windsor', signed and dated '85. Watercolour. 11½in. x 10in. The Wingfield Sporting Gallery, London.

CHAPTER 17

Rackets and Squash Rackets

According to T.F. Dale in his book *Polo Past and Present*, published in 1905, 'Racquets [sic] carefully taught by a good professional is the best apprenticeship to Polo'.

The game of rackets, probably of Basque origin, is played against a wall and not across a net. Rackets resembles pelota in its various forms; 'frontons' (pelota walls) are still to be found in many Basque villages and towns, although the game never spread to Northern Europe. Joseph Strutt in *The Sports and Pastimes of the People of England,* 1801, makes no mention of the game of rackets, probably for the very good reason that rackets appears to have started in the debtors' prisons in the mid-eighteenth century (*see* Plate 17/1 and Colour Plates 63 and 65)

Rackets was certainly played at the Fleet Prison in 1749, and in 1780 John Howard published a report on 'The State of the Prisons in England and Wales'. He had visited the Fleet in 1776 and writes at one point in his report: 'I mentioned the Billiard table, they also play in the yard at Skittles, Mississippi — a sort of bagatelle usually played on a board, but not dissimilar also to the game of Billiards, Fives and Tennis, etc.' (Fives was sometimes confused with rackets as illustrated in a print of 1788 entitled 'Fives, played at the Tennis Court, Leicester Fields' which clearly is rackets; the print, which is in the British Museum Collection, is by an unknown engraver after the work of Robert Dighton (1752-1814) and was published by Carrington Bowles.) In 1780, the old Fleet Prison was destroyed during the Gordon Riots, but it was soon rebuilt and reopened in 1782. Rackets continued to be popular there and a good view of the 'bare' or rackets ground in 1808 is shown in Pugin and Rowlandson's *The Microcosm of London...*[1] (*see* Colour Plate 65). Rackets at the King's Bench Prison is also illustrated in *The Microcosm...* (*see* Colour Plate 63), as well as in a print drawn by Theo Lane, engraved by Geo. Hunt and published by Charles Hunt of Covent Garden, in 1810.

The first American rackets court was built in Allen Street, New York in 1793, by James Knox, who had acquired the site. Knox had learned to play the game in Halifax, Nova Scotia, where he had sought refuge during the American Revolution.

In 1832, Pierce Egan published his *Book of Sports and Mirror of Life* in periodic issues at 3d. each. Volume XV was entitled 'The Game of Rackets' (*see* Plate 17/2); the principles of the game as written by Egan are as follows: 'At Rackets the ball is struck against what is called the head wall and returned at the bound to the same wall — each player endeavouring to strike it against the wall in

such a way that his adversary may not return it. He who does not return it loses a point (or as is technically termed 'an ace', or has his 'hand out'), that is to say forfeits the situation in which he would be able to add to his score of the game.' This excellent sporting journalist, to whom history is much indebted for his description of many of the sports fashionable at the beginning of the nineteenth century, recorded: 'Many distinguished members of the prize ring have been good players at Fives and Rackets and it may be remembered that the celebrated Jem Belcher [1781-1811] lost his eye at the game'. Losing an eye playing rackets seems to have been a normal hazard in those days and Belcher was in good company with old Powell, a professional teacher of rackets and the owner of a court, and an unnamed friend of an excellent player called Morris who, despite the handicap of a lost eye, was able to play under his leg — a talent for which there must have been very little call.

Charles Dickens (1812-1870) gave a graphic description of the game among the impecunious denizens of the Fleet Prison in *The Pickwick Papers*: 'The area formed by the wall in that part of the Fleet in which Mr. Pickwick stood, was just wide enough to make a good racket-court; one side being formed, of course, by the wall itself, and the other by that portion of the prison which looked (or rather would have looked, but for the wall) towards St. Paul's Cathedral... Lolling from the windows which commanded a view of this promenade, were a number of persons... looking on at the racket-players, or watching the boys as they cried the game'.

From the prisons, rackets spread to the taverns, the most famous in London being The Belvedere, Pentonville and The Eagle in City Road where rackets was first played in an open court. A description of the court and the rules is given in Donald Walker's *Games and Sports*, published in 1837: 'The Rackets ground presents in the first place a very high wall of about forty feet or more in width and at the top of the wall is a network of about five feet in height to prevent those balls going out that happen to be struck above the coping of the wall... The player who commences, or the server, stands in the centre of the ground, in a space marked out for the purpose... If he fail to serve it above the red line it is called a 'cut' ball and if it falls outside the line it is called a 'short' ball and his opponent may accept it or not as he chooses... The in-player, or server, is out if he serves three 'cut' balls, if he strikes the wood which runs along the walls at about eighteen inches from the bottom, if he misses the ball twice with his racket in attempting to serve it, if the ball falls out of bounds, or if he wilfully obstructs his opponent's stroke... If a ball falls on the line it is called a 'live' ball and is played again... A marker is always required at this game. His duty is to keep the balls well covered with chalk so that they may leave a mark upon the wall, to watch carefully whether the ball falls in or out of bounds, to call the game as each stroke is made and to be ready to be referred to if necessary by the players.'

By the early nineteenth century, the popular spectator sport of the taverns was destined for a different future in the more exclusive confines of public

Plate 17/1. 'A word of advice from an old pro in a debtors' prison'. The first game of rackets was played against a single wall within the debtors' prisons of England prior to 1800. From the Badminton Library Series, Lawn Tennis, Rackets and Fives, published in 1890.

schools and private clubs. Harrow can claim to have been the first public school to play rackets, developed in the school yard when that was enlarged in 1821 (*see* Colour Plate 64). The earliest covered court was built by the Royal Artillery at the Woolwich Depot. The Marylebone Cricket Club built a court at Lords next to the old tennis court in 1844. The first covered court at Harrow, which was opened in 1865, is slightly larger than standard and is still in use today.

The Public Schools Rackets Championship which started in 1868, was first played at the Old Prince's Club in Hans Place, Belgravia which was opened in 1853 and demolished due to development in 1886. According to a contributor to *Baily's Magazine* in 1886, while the open air game against a single wall was common enough in schools, rackets in the close court was a game comparatively little known in England when the celebrated match court at Prince's Club was opened, and . . . 'After Prince's had become an institution, close 4 walled racket courts built on the model of Prince's became common at schools and in places of fashionable resort and at a few country houses'. The Championship was subsequently played at Lords in 1887, and thereafter at Queens Club, except in 1941 when it was played at Wellington College, Berkshire. Both Oxford and Cambridge had courts which led to the first University Match in 1855 played at Oxford. New courts followed at Torquay, Manchester, Liverpool and Eastbourne. The 13th Earl of Eglinton (1812-1861), a keen rackets player, was one of the first to install a private rackets court at Eglinton Castle. Nowadays the only known private court is that at Buckhurst Park in Sussex, built in 1857 by Colonel Lord West to commemorate the capture of Sebastopol where he had commanded the 21st Royal North British Fusiliers.

Rackets balls, between 1859 and 1890, were sold by the gross, costing between 16s. and 24s. for new balls, and 10s. a gross for recovered balls. The 'Wilson' ball which was used in the latter half of the nineteenth century (described in detail in *The Book of Racquets,* by J.R. Atkins, published in 1872), was smaller than the present day ball, had a diameter of 1-1½ in. and weighed less than 1oz. There is however some evidence that the balls used in 1850 were both larger and heavier. The Wilson ball was made and manufactured by J. Wilson of 17 Roman Road, Victoria Park, London, who also manufactured rackets. The ball was made of compressed cloth soaked in water, which when saturated was rolled into a ball and secured with strong hempen thread, then placed in a 'cup' made of iron or wood and compressed in a screw press. The resulting 'core' was then further wound with damp worsted thread with further pressings until it had reached the correct dimensions. The finished 'core' was then placed on a piece of sheepskin, smooth side out, which had been clamped and stretched. The four corners of the sheepskin were pulled up and secured with stout thread, the overlapping pieces were cut off and the four seams were stitched together in a similar way to the lacing of a boot. The finished ball would then undergo further pressing and 'baking' to dry it. The game at

Harrow at the corresponding time was played with leather covered balls called
'best fives', originally sold by an old lady called Arnold, who was more
commonly known as 'Old Polly'.

From early in the twentieth century, rackets ball manufacture passed to
Jeffrey Maling of Woolwich, later to be taken over by Edward J. Bailey who
became the main rackets ball supplier until 1952. The Bailey ball, though
never consistent, was similar to construction to the Wilson ball, but was
slightly heavier at 35g. and measured 1.56in. in diameter. As the game spread
via the army to Hong Kong, Malta, Canada, India, Buenos Aires and Burma,
so the 'core' of the ball was frequently found to be made from old uniforms
and in one or two cases piping from uniform trousers has been found. The balls
used in America at this time differed slightly in that their core was made of
solid rubber then bound with damp cloth.

The polythene based G6 ball devised in the mid-1950s by Bill Gordon and
John Thompson at Marlborough College, revolutionised the game and was
officially adopted in 1956 as the championship ball throughout Great Britain.
The new ball, which has a diameter of 1½ in. and weighs 28g., is virtually
indestructible, keeps its shape and has a consistent bounce, can be produced
quickly and cheaply in large quantities. In 1963, the North American Rackets
Association gave the ball recognition and it has been used in American and
Canadian championships ever since.

Increased interest in rackets in recent years has resulted in more national competitions being played than ever before, particularly with the recent development of sponsored competitions.

SQUASH RACKETS

Squash rackets, the newest of the bat and ball games to become universally popular is derived from the older game of rackets with which it has much in common. It is said to have originated at Harrow School, c.1820, by boys knocking a soft ball about in a confined space known as the 'corner' while awaiting their turn to play rackets. The soft ball, which could be squashed in the hand, gave rise to the name for the new game to distinguish it from rackets, although originally it was referred to as baby rackets. By the end of the century squash courts had been built at private houses as well as public schools, universities and West End social clubs and written references to the game first appeared in the *Badminton Library of Sports and Pastimes* in 1890. The squash racket frame is made of wood, carbon fibre or metal and is strung with gut or nylon. The racket is 3in. shorter than the one used for rackets, furthermore it is not as strong since it hits a lighter ball.

The overall length of the squash racket must not exceed 27in. (68.5cm.) and the strung area must not exceed 8½in. x 7¼in. (21.6cm. x 18.4cm.); the official dimensions have not changed since the rules were standardised in 1922. The ball which has an outside diameter of just over 1½in. (3.8cm.) and weighs 360-380g., is made of rubber or butyl or a combination of both, is hollow and 'squashy' and is now often green in colour, although black prevailed for many years. Squash is normally a singles game but doubles, so popular in America, are also played in Britain although there is only one double size court in Edinburgh. Doubles played on a singles court have become popular and National Doubles Championships are now played on singles courts, although four people playing in such a confined space can be tricky. The court, which is a rectangle, 32ft. x 21ft. (9.754m. x 6.401m.), is said to have been based on the old Rugby fives court (Lord Desborough used this design for the Bath Club Courts which were amongst the earliest squash courts to be built in London). The court consists of four walls, with the rear wall nowadays often of transparent material for improved spectator viewing, and play is bounded by 'height' lines on the surrounding walls; out of court lines are drawn across the front wall parallel to the floor at 15ft. (3.6m.) and across the back wall at 7ft. (2.1m.). A line on each side wall joins the 15ft. x 7ft. lines. The ball can be hit against any wall but must from every stroke hit the front wall above the 'board' which runs at a height of 19in. (48.3cm.) from the ground, before being played by the opponent. If the ball goes below the 'board' the stroke is lost.

The object of the game is to hit the ball out of the opponent's reach so that he cannot win a rally. A game consists of nine points except when an equal

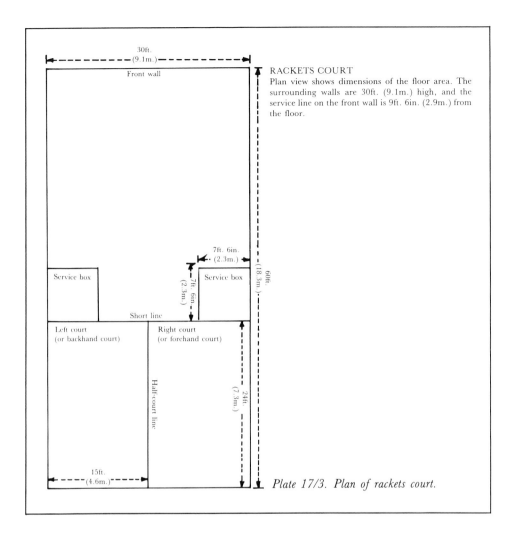

30ft.
(9.1m.)

Front wall

RACKETS COURT
Plan view shows dimensions of the floor area. The surrounding walls are 30ft. (9.1m.) high, and the service line on the front wall is 9ft. 6in. (2.9m.) from the floor.

7ft. 6in.
(2.3m.)

60ft.
(18.3m.)

7ft. 6in.
(2.3m.)

Service box

Service box

Short line

Left court
(or backhand court)

Right court
(or forehand court)

Half-court line

24ft.
(7.3m.)

15ft.
(4.6m.)

Plate 17/3. Plan of rackets court.

score of eight points has been reached. The player who reaches eight points first then has the option of setting the game to ten which, if he does not claim, goes to the first player to reach nine points. It is important to remember that a player can score a point only if he started the rally as server. A match is won by the player who gets three games first. The game is presided over by a referee and marker, the latter calls the score and also acts as a referee in the absence of that official. There are twenty-five rules and four appendices.

In 1928 the Squash Rackets Association (SRA) took over the administration of the game from the Tennis and Rackets Association (founded 1907) and was until 1967, when the International Squash Rackets Federation was formed, the leading world authority for the game. Nowadays, the SRA is only responsible for squash in England but with 9,000 courts and over 3,000,000 players in the country, this is probably just as well. A sub-commmittee of the Tennis and Rackets Association had laid down rules in 1922 but prior to that the game had been fairly haphazard, lacking uniformity of court and ball which detracted somewhat from the game's progress. By the early 1930s, squash had become very popular. Courts were even built in five of the large cruise liners of the time, the *Queen Mary*, the *Carinthia*, the *Empress of Britain*, the *Franconia* and the *Nieuw Amsterdam* and more than sixty hotels before the Second World War boasted squash courts although, for various reasons, no more than a dozen survive today.

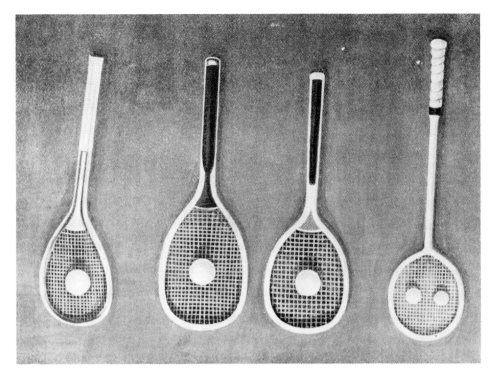

Plate 17/4. Rackets, from the Badminton Library Series, Lawn Tennis, Rackets and Fives, published in 1890.

The army also adopted the game and built a number of courts in the North West Frontier region of India and in Egypt. This was to have a profound effect on the game since champions like F.D. Amr Bey (Amr Pasha, b.1910), Open Champion from 1932 to 1937, and Amateur Champion from 1931 to 1937 (except for 1934) and the professional Mahmoud Karim, who won the British Open championship 1947 to 1949, both came from Egypt, while the outstanding Khan family of professionals who dominated the game in England and the United States after the Second World War came from Pakistan. The Royal Air Force also contributed greatly to the game by building courts on all its stations and by starting the RAF Championship in 1928. The Royal Navy Championship and the Army Championship were both started in 1925.

The growth of high level competitive squash in Great Britain was comparatively slow since for a long time it was regarded as a sport for relaxation. Spectator attendance was, until the advent in the 1980s of four walled transparent perspex courts and television coverage, necessarily confined to the limited spectator accommodation of the court. Professional players, who were few and far between, came mainly from Pakistan and Egypt after the Second World War. The role of the professional in this country was almost solely confined to that of coaching. The only competitions which he could enter therefore were the Men's Open Championship of the British Isles first played in 1930 and the Professional Championship of the United Kingdom.

The Women's Open Championship was first played in 1922 as was the Amateur Championship held at the Bath Club in Dover Street, the scene of sixteen successive Amateur Squash Rackets Championships. The Bath Club Cup was also founded as a three-a-side competition for London West End social clubs although in recent years the Cumberland Cup for five-a-side teams within a seventeen mile radius of central London has become rather more popular. On a knock-out basis the senior competition in England is regarded as the inter-country championship first started in 1929 but with the foundation of the International Squash Rackets Federation (ISRF) in 1967, the

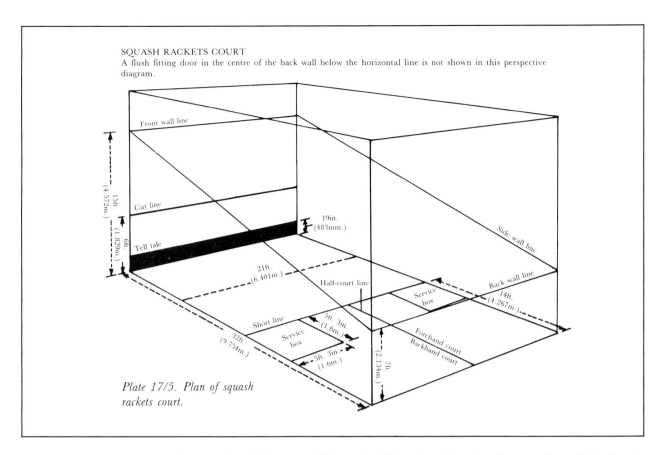

SQUASH RACKETS COURT
A flush fitting door in the centre of the back wall below the horizontal line is not shown in this perspective diagram.

Front wall line

Cut line

Tell tale

15ft.
(4.572m.)

6ft.
(1.829m.)

19in.
(483mm.)

21ft.
(6.401m.)

Side wall line

Half-court line

Service box

Back wall line

14ft.
(4.267m.)

Short line

32ft.
(9.754m.)

Service box

5ft. 3in.
(1.6m.)

5ft. 3in.
(1.6m.)

Forehand court
Backhand court

7ft.
(2.134m.)

Plate 17/5. Plan of squash rackets court.

International Amateur Championships played under the auspices of that body can be considered to be the senior tournament in the game from the point of view of the team as well as the individual event. In 1951, the Amateur Veterans Championship was started for players over the age of forty-five and from 1965 a Veteran Open Championship has been staged.

The game has been increasingly played internationally with Australia replacing Britain in the 1960s as the leading nation but Sweden, Pakistan, Egypt, USA, New Zealand and Canada are all contenders at the higher level.

The commercial development of squash courts became significant in the late 1960s when the popularity of the game ensured a profitable return on capital. Thereafter clubs with up to twenty courts began to be established. Despite its origins, squash can be said to be a truly democratic game, it is also essentially a twentieth century urban game most suited to the needs of men and women in sedentary occupations in towns and cities who need exercise all the year round but are limited for space. Nowadays the game is played by thousands of women but in the early days squash courts were almost all to be found in exclusively male establishments which made access to them extremely difficult for women. The first Women's Championship was played in 1922 at the Queens Club, London but these courts were destroyed during the war and thereafter the Championship was played at the Landsdowne Club. In 1933 the Wolfe-Noel Cup was presented by the then Ladies Champion, Susan Noel (Ladies Champion in 1932, 1933 and 1934) and Elizabeth Wolf (Captain of the first team which went to America) for a bi-annual competition between Great Britain and the USA, which remains the only official competition to be played for between the two countries. In 1934, The Women's Squash Rackets Association (WSRA) was formed and this led to a number of national and

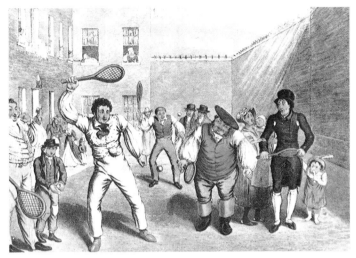

Colour Plate 63. Augustus Charles de Pugin (1762-1832) and Thomas Rowlandson (1756-1827). 'Rackets at the King's Bench Prison', c.1808. From The Microcosm of London... *Vol. II, in the Collection of the British Museum.* National Squash Library.

Colour Plate 64. 'Squash Rackets at Harrow'. Reproduced in the Badminton Library Series, Lawn Tennis, Rackets and Fives, *published 1890.* National Squash Library.

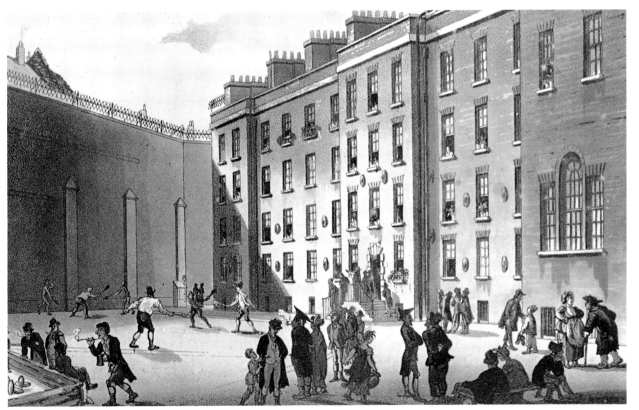

Colour Plate 65. Augustus Charles de Pugin (1742-1832) and Thomas Rowlandson (1756-1827). 'Rackets at the Fleet Prison'. Aquatint by Joseph Constantin Stadler, published by Ackermann, 1808. 9in. x 11in. From The Microcosm of London... Vol. II, in the Collection of the British Museum. National Squash Library.

international competitions for women including the great Regional Championships, the County Championships, the Club Competitions and the Junior Championships.

Owing to confined space, most squash courts are unable to offer much in the way of spectator accommodation although the new innovation of transparent walls has done much to help this problem allowing an overall 15,000 spectators to view the Hi Tec British Open Championship played at Wembley Conference Centre in 1987. Television has done much to promote this sport although it has not yet been successful in achieving star viewing. Indeed on Thursday, 16th April 1987, *The Times* headed its sports page: 'Why Squash Rackets will find it difficult to succeed as a television sport'. It went on to point out that the reason, in the writer's opinion, lay in the fact that the players do not stand opposed but play side by side, contrary to the public's idea of a satisfactory duel where opponents face each other in combat. These minor obstacles and the fact that the sport is so young may explain why there are very few paintings. There is perhaps no other physical sport which suits twentieth century urban life as well as squash. Unaffected by weather, travel problems or expense, being relatively cheap to play, the future of squash should therefore be assured and may now perhaps encourage clubs and associations to commission paintings of this exciting modern game to commemorate events and personalities.

SQUASH TENNIS OR RACQUETS spelled the French way, is an American variation of squash rackets and is basically played with a lawn tennis ball, although both the racket and the ball are smaller and the ball is tightly covered with netting. This has the effect of making the ball at least twice as fast as a squash ball and the game is therefore one of extraordinary speed. In addition, the court is only 18ft. 6in. wide, 2ft. 6in. less than the British court which makes manoeuvrability all the more vital. Although there have been USA squash tennis championships since 1911, dating from shortly after the game's birth at the end of the nineteenth century, the game is not as popular as that of squash rackets.

RACKETBALL is another variation on the game of squash rackets and was originally invented in 1950 by Joe Sobek at the Greenwich YMCA, Connecticut, USA, as paddle rackets played on a racquetball court 40ft. x 20ft. It was introduced into Britain in 1976 and adapted for play on a standard squash court 32ft. x 21ft. The British Racketball Association was formed and staged inaugural British National Championships in 1984.

FOOTNOTE
1. *The Microcosm of London or London in Miniature, the Architecture by A. Pugin, the Manners and Customs by Thomas Rowlandson,* 1808.

CHAPTER 18

Real Tennis

Real tennis is generally supposed to have started in the thirteenth century in the monastic cloisters of France. The game was not without its critics, for William Durandas, Bishop of Meaux, in 1326 quoted Jean Beleth, a theologian from Paris, in support of his case against these games. Both Durandas and Beleth disapproved of Bishops, and even Archbishops, taking part in these ball games at Christmas and Easter, and condemned them as 'pagan rituals'. Later on in 1485, the Council of Sens, 'Forbade all priests and all in Holy Orders to play tennis without shame in a shirt and undecent undress'.

The curious shape of the modern real tennis court leaves little doubt that it was originally played in a cloister which is borne out by early illustrations. The game was also known in those days as 'Cache', 'Jeu de Bonde' or, more popularly, as 'Jeu de (la) Paume' (palm game). The word 'tennis' is generally believed to have come from the French word 'tenez' (hold or take heed) and it is thought that the players called 'tenez' before each service. Early tennis was often played five a side by ten players. One practice in tennis that dates back to its very earliest days is scoring in points worth fifteen each until a total of sixty is reached to win one game. The first mention of scoring in fifteens occurs in the Middle English poem on the Battle of Agincourt describing the siege of Harfleur in terms of a tennis match.[1] Since this battle concerns the English King Henry V (1387-1422) and the French Dauphin, it is perhaps the moment to mention one of the most famous of all Shakespearian quotes concerning the tennis balls sent by the Dauphin in 1414 to the English King. The balls arrived with a message to the effect that Henry might be better employed in playing tennis than making war — advice, incidentally, that Henry did not take — hence the battle. William Shakespeare (1564-1616) in Henry V, Act 1, Scene II, described the story thus:

King Henry. 'What treasure, uncle?'

Exeter. 'Tennis-balls, my liege.'

King Henry. 'We are glad the Dauphin is so pleasant with us:
His present and your pains we thank you for:
When we have matched our racket to these balls,
We will in France, by God's grace, play a set
Shall strike his father's crown into the hazard.'

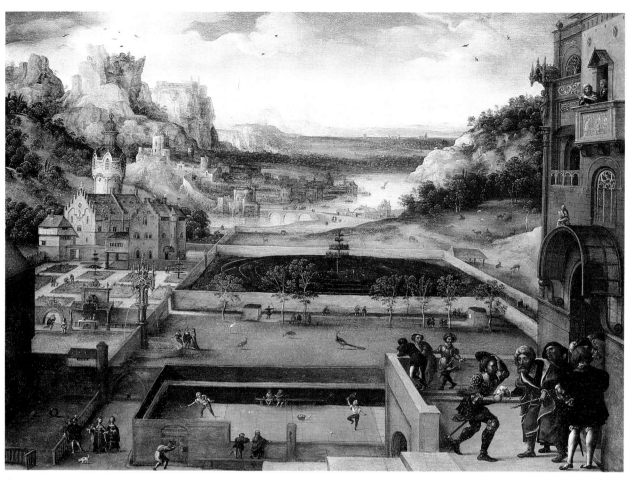

Colour Plate 66. Lucas van Gassel (1480-1555). King David giving his letter to Joab. Panel. 13in. x 17¾in. Richard Green Gallery, London.

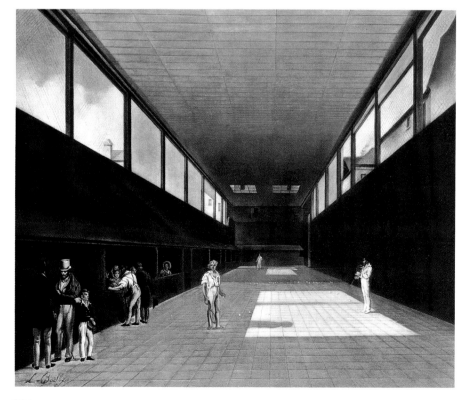

Colour Plate 67. Leopold Louis Boilly (1761-1845). 'The interior of the Jeu de Paume, Versailles', signed. 15¾in. 19¼in. A print after the original painting, which is in a private collection in the USA. Chris Ronaldson.

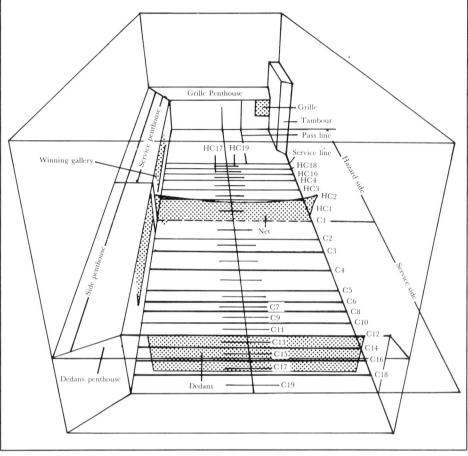

REAL TENNIS COURT

Perspective view looking towards the hazard side. Numbered lines on the service side of the net have the following conventional designations; (C1) chase the line; (C2) chase first gallery; (C3) chase the door; (C4) chase second gallery; (C5) chase a yard worse than last gallery; (C6) chase last gallery; (C7) chase half a yard worse than six; (C8) chase six; (C9) chase five and six; (C10) chase five; (C11) chase four and five; (C12) chase four; (C13) chase three and four; (C14) chase three; (C15) chase two and three; (C16) chase two; (C17) chase one and two; (C18) chase one yard; (C19) chase half a yard. Lines are numbered correspondingly on the hazard side. (HC) Hazard chase.

Plate 18/1. Plan of real tennis court.

Without doubt, tennis was first played with the bare hand (i.e. Jeu de Paume). Because this was painful, gloves were then worn — an excellent example is the Basque glove known as a 'passaka' used for an ancient game played in a trinquet, a form of court developed from the hazard side of a tennis court. There followed wooden bats and battoirs and eventually a battoir with a head strung with sheep gut in the form of a primitive racket.

For a considerable time both hand and racket were used, but in the account given of the tennis game at Windsor in 1506 between Henry VII of England (1457-1509), the King of Castile, and Philip, Archduke of Austria, the King of Castile played with a racket and was handicapped by fifteen as a result. By 1555, when Antonio Scaino wrote his magnificent treatise,[2] courts still existed for play with the hand, but clearly his own preference, and no doubt that of most of his contemporaries, was for the game with the racket, and indeed by the end of the sixteenth century, the racket was the accepted equipment.

The Old Testament story of King David lusting after Uriah's wife, Bathsheba, and devising to send Uriah to the front, to increase his chances of being killed — a plot in which it may be said the King was wholly successful — curiously captivated the imagination of several sixteenth century artists. In

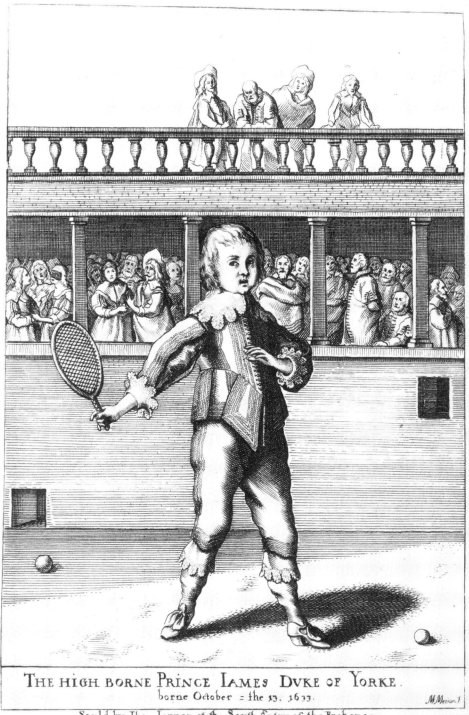

THE HIGH BORNE PRINCE IAMES DVKE OF YORKE.
borne October = the 13. 1633.

M.Merian.f

Sould by Tho: Ienner at the South Entry of the Exchange.

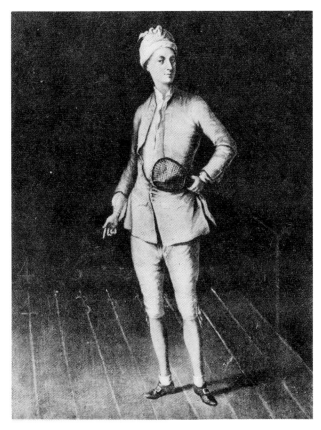

Plate 18/3. Attributed to Arthur Devis (1711-1787). 'The Tennis Player'. Courtauld Institute of Art, London.

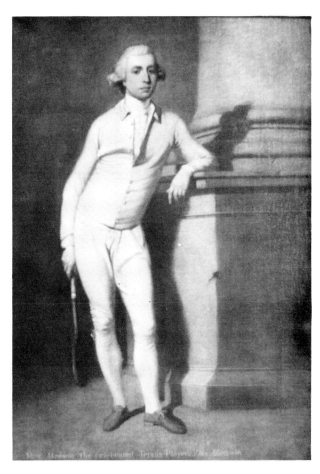

Plate 18/4. John Hamilton Mortimer, ARA (1741-1779). 'Monsieur Masson the celebrated Tennis Player'. 29in. x 23⅞in. A mezzotint after this painting by Richard Brookshaw (1736-1800) published by J. Wesson, 1769, is in the collection of the British Museum. Private Collection.

each of their similar paintings, a tennis court features in the background which has no apparent connection with the Old Testament story but does illustrate that a tennis court was a normal feature of many sixteenth century aristocratic houses. Interestingly, in both the painting by the unknown artist entitled 'David and Bathsheba', dated 1559, and in the painting by the French artist Lucas van Gassel (1480-1555), the tennis courts are open, not enclosed, and the games are being played with rackets (*see* Colour Plate 66).

Tennis rackets did not become powerful instruments until much later in the eighteenth century. In those days the vertical strings of the racket were twice the thickness of the horizontal strings and the latter were wound round each of the vertical strings instead of being threaded through them as they are today. Sometime around 1856, the system of stringing changed, gut of equal thickness was used and the horizontal strings were threaded through the vertical. The French proved to be the best makers of tennis rackets and they included Borelly, Lavergne, Tison and Leclercq. John Dynan and his son were the first known English makers and by 1780 they were acknowledged to be as good as the French.

Real tennis balls have not changed dramatically since the thirteenth century except in their weight; basically they were hard round balls made of leather or cloth and stuffed with wool or dog hair, and according to Shakespeare in *Much Ado About Nothing* (Act III, Scene II), sometimes with human hair. A very interesting ball found in the roof of Westminster Hall, and now in the London Museum, shows that they were made of bound leather stuffed with hair and

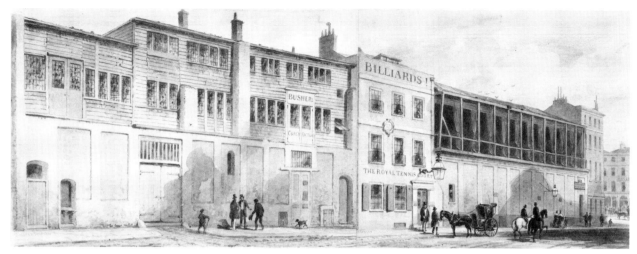

weighed about 1oz., lighter than the modern ball of 2.5 – 2.75oz.

The surface of a real tennis court is made of stone slabs, reflecting the courtyard on which the game was originally played.[3] No two courts are exactly the same and each is influenced by its origins. The net across the court is 5ft. high at either end and is lowered in the middle to 3ft. which is very similar to the dimensions of Major Clopton Wingfield's original net for lawn tennis (*see* pp.237-8).

The rules for real tennis are very complex: service is given from the service end of the court, the other end is the hazard end, and a serve has to bounce on the penthouse (sloping roof) that runs along the side of the court, before landing in the service box at the other end (*see* Plate 18/1). A rally then starts (paradoxically called a rest) and the ball is struck to and fro across the central net, although it may also bounce off any of the walls or penthouses and still remain in play. There are a number of openings around the court, if the ball enters some of these, a point is scored, but other areas score 'chases', which are the unique and very complicated features of real tennis, as they determine if and when the players should change ends. The basic tactics are for the server to try to win as many points as possible by attacking the tambour (buttress) in his opponent's backhand corner, while the receiver attempts to gain the service end by setting a chase. In Great Britain and in other countries outside France, the chase is measured in yards. In France the chase is measured in Norman feet. The score goes 15, 30, 40, game. In France in the Middle Ages the number 60 had a special significance as representing a complete whole. The 40 is a corruption of 45. At 40 all, the score is called 'deuce', from the French 'a deux', meaning that one of the players has to win two more points to win the game.

From existing evidence, real tennis was played in Scotland during the reign of Alexander III (1249-1286), and had spread from the monasteries to become the sport of kings. Alexander's mother was a Frenchwoman, Marie de Couci, and the ties between the two countries were always strong. King James I of Scotland (1406-1436) was a keen tennis player as well, but his playing days were cut short when he was assassinated. A more direct tennis fatality was that of Charles VIII of France (1483-1498) who struck his head against a door lintel going into the tennis court at Amboise, and died as a result. Another famous fatality was the first known French king to play tennis, Louis X (the Quarrelsome, 1314-1316), who played tennis very energetically in the Forest

*Plate 18/6. Louis Charles
Auguste Couder
(1790-1873). 'Le Serment
du Jeu de Paume'. Engraved
in aquatint by Jazet.
Musée National du
Château de Versailles.*

of Vincennes, drank a beaker of cold water, caught a chill, which turned into
a fever, and died. Just over two hundred years later, a similar fate awaited the
eighteen year old Dauphin, François, son of the tennis loving François I
(1494-1547).

The short tennis career of Henry, Prince of Wales (1594-1612), the heir of
James I (1566-1625), offers a reminder that games taken too seriously can end
in tears or, in some cases, fatally. According to the prince's biographer
Thomas Birch in 1760, tennis was 'his greatest diversion'; so enthusiastic was
he about the game that despite the cold he played on 24th October, 1612 in
his shirt and caught a chill from which he never recovered and died on 6th
November. Caravaggio is known to have killed a friend in a quarrel over a
game of tennis, and Horace Walpole, 4th Earl of Orford (1717-1797) that
eccentric lover of coursing, stoutly maintained that the death in 1751 of
Frederick, Prince of Wales, the eldest son of George II (1645-1760), was not
due to a cricket ball but to a blow on the head three years previously by a tennis
ball (*see* p.84).

On a lighter note, an amusing story is told about François I, a very keen
tennis player, whose opponent on one occasion was a monk. The game was
fairly equal until with one brilliant stroke the monk beat the king: 'Oh', said
François, 'voici un bon coup de moine'. 'Ce sera, Sire, un bon coup d'Abbe
quand il vous plaira!' There happened to be a priory vacant at the time to
which the monk was appointed Abbot as a reward for his good play. François
I was also responsible for sending Henry VIII of England some of the great

Plate 18/7. Jacques Louis David (1748-1825). 'Le Serment du Jeu de Paume'. An unfinished version painted in 1791. Musée National du Château de Versailles.

white hounds of La Vendée which were used for stag hunting.

No history of real tennis would be complete without mention of that giant among sportsmen, Henry VIII (1491-1547). His father, Henry VII, had been an ardent player and undoubtedly encouraged his son. Certainly during the first years of Henry's reign he was a dedicated player and according to Joseph Strutt, in *The Sports and Pastimes of the People of England,* 1801, in the thirteenth year of his reign he played at tennis with the Emperor Maximilian for his partner against the Prince of Orange and the Marquis of Brandenborow: 'The Earl of Devonshire ''stopped'' on the Prince's side and Lord Edmond on the other side and they departed even handles on both sides after eleven games fully played.'

Henry VIII is usually credited with having built the earliest real tennis court at Hampton Court Palace in 1532. The court that Henry built no longer survives; the present court at the Palace was built in 1625, approximately 50yds. from the site of the original court, and refurbished in 1661. The King had already built and improved the courts at his own palace of Whitehall (previously York House), where he had 'divers fair tennice-courts, bowling-allies and a cockpit'.

In Scotland, tennis continued to be popular and James V (1513-1542) built a court at his Palace of Falkland in 1539. This court is still in use although it suffers from the disadvantage of being an open court subject to the vagaries of the weather. James I, although not an active tennis player himself, and presumably undeterred by the death of his eldest son (q.v.), also recommended it to his younger son as exercise becoming a prince. An early print in the British Museum depicts Prince James, Duke of York, later James II of

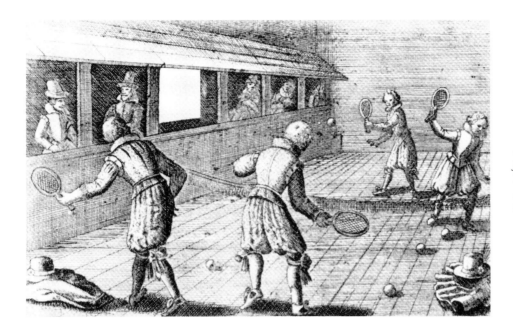

Plate 18/8. 'Royal Tennis' from The Past of Pastimes *by Vernon Bartlett, published by Chatto & Windus, 1969.*

England (1633-1701), playing tennis in front of spectators with a very short handled racket (*see* Plate 18/2). This same Prince was seen by the diarist, Samuel Pepys on 2nd April, 1661 playing Pele Mele in St. James's Park, London, so was obviously an enthusiastic sportsman (*see* p.172). The Royal Tennis Court was established in 1673 on the site of the first court, which was built in 1634 and destroyed in the Great Fire of 1666.

The first reference to the game in North America seems to have been in 1659, when Peter Stuyvesant, Governor of New York, decreed that tennis and a number of other games must not be played on 15th October which was a day of Universal Fasting and Prayer.

During the eighteenth century, tennis suffered a decline in popularity in both France and England and the owners of the courts sought other ways of using them in order to supplement their incomes. Many tennis courts were found to be suitable venues for boxing and sparring exhibitions such as the Royal Tennis Court at Windmill Street, Haymarket which Pierce Egan records in his *Boxiana* (1821), which was used for the match between Abraham Belasco and Philip Sampson on 29th February, 1820. Later, the topographical artist, Thomas Hosmer Shepherd (1793-1864) painted the Royal Tennis Court in St. James's Street, Leicester Square as it appeared in 1850 (*see* Plate 18/5). Frederick Grace (1779-1859) commissioned Shepherd to make a series of watercolours of old London buildings before they were demolished. The Royal Tennis Court in St. James's Street finally closed its doors in 1866.

A celebrated exponent of the game was Raymond Masson, born in Paris in 1740, who by the age of twenty-five could beat all other rivals. He is immortalised in a painting by John Hamilton Mortimer, ARA (1740-1779), and certainly played in England c.1760 (*see* Plate 18/4). Probably the greatest 'paumier' of all was J. Edmond Barré, who was born in Grenoble in 1802; the son of a tennis court master in the Rue Mazarine, his father became 'Paumier de Roi' in 1826 with a pension of 1,200 francs. Edmond Barré was appointed 'Paumier de l'Empereur' in 1855. He was equally well known in England, where he played each year in London, Brighton, Cambridge and Oxford. The Victorian artist and etcher, Valentine Walter Bromley (1848-1877), is known

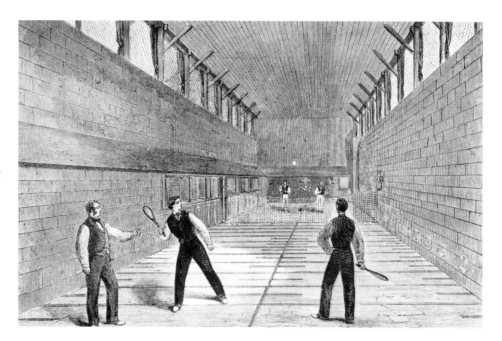

to have made a print of Barré in the act of delivering a service, which he published in 1849. The French artist, Leopold Louis Boilly (1761-1845), is responsible for perhaps the finest painting of real tennis in which he depicted a game in progress at the tennis court at Versailles (*see* Colour Plate 67). Two further tennis paintings deserve mention for they record the most remarkable event in tennis history; 'Le Serment du Jeu de Paume', painted by Louis Charles Auguste Couder (1790-1873), and engraved in aquatint by Jazet, is now in the Gallery at Versailles (*see* Plate 18/6). It records an incident in 1789 concerning the constitutional powers of France when the tennis court at Versailles, used for the meeting of the Convention on 20th June of that year, became an historical monument preserved for the nation for all time. This is commemorated by a bronze plaque on the wall of the court, which has ever since been regarded as a very special monument to the history of the French Revolution.

An unfinished version of the same event was painted by Jacques Louis David (1748-1825), in 1791 and is also in the Gallery at Versailles (*see* Plate 18/7). David's political activities as an ardent revolutionary and a senior member of Robespierre's secret police ended speculation as to why the painting was never finished when documents revealed that it was David's signature which had sent many high ranking officials to the guillotine. For two years David worked on the canvas, eventually abandoning it since few of the original heroes of the National Assembly were still around. Those were turbulent times in France and David may have been uncomfortably reminded of his actions by the painting. Couder (q.v.) is said to have been a pupil of David, but David was exiled to Brussels in 1805 by Napoleon for his part in the murder of Louis XVI, when Couder was only fifteen years old.

The Revolution sounded the death knell for tennis in its native land from which the game never really recovered. In June 1883, the Versailles court was officially inaugurated as a museum of the Revolution. However, in England there was a distinct revival among the Victorian elite and in 1841 Prince Albert, on a visit to the Duke of Bedford at Woburn with the Queen, according

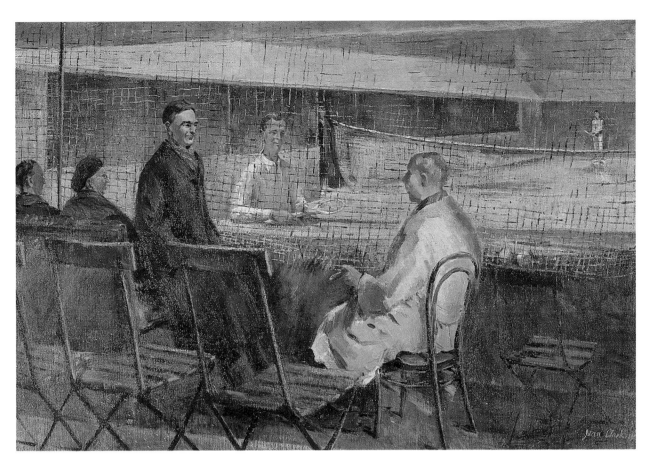

Colour Plate 68. Jean Clark, RWS, NEAC (b.1902). 'The Dedans', 1951, signed and dated 1951. 24in. x 36in. Lord Aberdare.

to her diary of 28th July, 'tried to play at Tennis'. He obviously enjoyed the experience because the Queen later recorded that he had another attempt in 1845 when staying with the Duke of Wellington at Stratfield Saye, an estate previously owned by Lord Rivers, the patron of the sporting artist, Jacques Agasse (1767-1849).

One of the results of the mid-nineteenth century real tennis revival was the inauguration of the MCC tennis prizes, the Gold and Silver Racquet Cups in 1867, followed by the Amateur Tennis Championship at Queens Club in 1888 which, except in wartime, have been annual events ever since. Queens Club and Hampton Court have remained the main centres of the game although Hampton Court, where tennis has been played for 450 years, is recognised as the premier court.

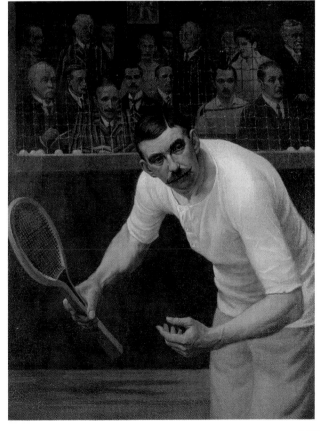

Colour Plate 69. Unknown artist. 'Portrait of Peter Latham' (1865-1953), the Real Tennis World Champion 1895-1905 and 1907-8. 46in. x 38in. Queens Club, London.

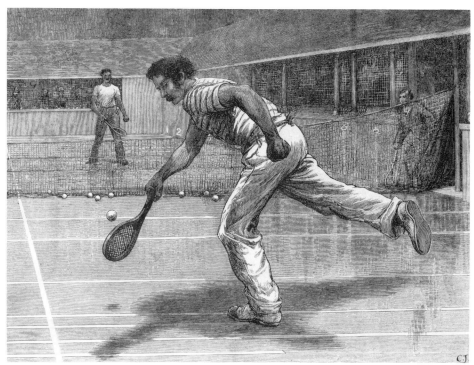

Plate 18/10. Tuxedo Club Court. Print, dated Dec. 15th, 1899. Chris Ronaldson.

Plate 18/11. The opening of the new Prince's Club, Knightsbridge, by the Prince of Wales. The tennis match between Mr A. Lyttelton[4] and Mr. Charles Saunders. Print. 16½ in. x 22½ in.

The World Championship, which has always been open to both amateur and professional players, although amateurs have found it difficult to beat professionals in championship play, is the oldest of all world championships and was first held by the Frenchman Clergé from c.1740-1750. Tennis requires both professionals as well as amateurs and the 'paumier' is essential to the

game's survival.

The turn of the century saw the dominance of the game by Peter Latham (1865-1953) one of the all time greats of both tennis and rackets, who became the only holder of both World Championships (*see* Colour Plate 69). A contributor to *Baily's Magazine* wrote in 1895: 'It is the most interesting of all ball games played in a court, and athletes who have yielded to its fascinations will complacently desert raquets [*sic*] or lawn tennis in its favour'. In Britain, the tennis boom continued until the outbreak of the First World War in 1914. By the 1900s many women had joined the ranks of players, one of the most notable being Lady Wentworth of Crabbet Park, Sussex (of Arab horse fame), who opened her own court in 1907. Whilst she was undoubtedly one of the best women players, she described herself in *Who's Who* as 'World's Lady Tennis Champion', a title she assumed without challenge.

Meanwhile, in America and Australia, courts were being opened everywhere. James Gordon Bennett, jun. (q.v.) did not, it seems, confine his sporting interests entirely to polo (*see* p.274). In 1879, he felt obliged to atone for a misdemeanour he committed by instructing a young man to ride one of his polo ponies into the Reading Rooms at the Newport Club on Rhode Island where predictably it misbehaved. His subsequent resignation was immediately accepted by the Club. To retrieve the situation, he built the Casino Club opposite his home on Bellevue Avenue with twenty-two lawn tennis courts, a real tennis court, a theatre and a squash tennis court. This complex was finished in time for the National Lawn Tennis Tournament held there in 1880, but the real tennis court was never much used owing to the humidity in the summer. America subsequently produced the amateur champion tennis player, Jay Gould (b.1888) who dominated the amateur game in his own country from 1906 until he retired in 1926, after winning the National Championship every year. Another great tennis champion appeared, appropriately in France, in 1921; Pierre Etchebaster (b.1893), led the game in a unbroken reign until his retirement in 1954.

After the First World War, three new courts were built in the early 1920s; in 1922 in Dublin, in 1924 at Tunbridge Wells from a converted fives court of 1886, and in Chicago in America.

At the present time, real tennis is experiencing a modest boom with the Australians in a very dominant position having taken the World title in 1987 from Chris Ronaldson, the British professional at Hampton Court, who held it in an unbroken span from 1981 (*see* Colour Plate 71). There are now four known courts in Australia — two in Melbourne, one in Ballarat and one in Hobart, founded in 1875; three of these have been built since 1974. One court

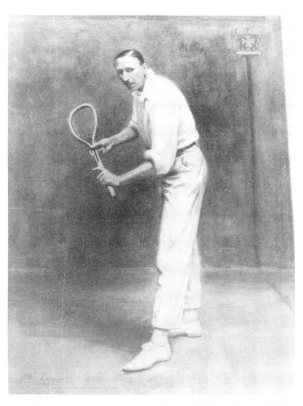

Plate 18/12. Henry (Hal) Stephen Ludlow (b.1861). 'Evans Baillie Noel',[5] signed and dated 1904. Watercolour. 23½in. x 17in. Private Collection.

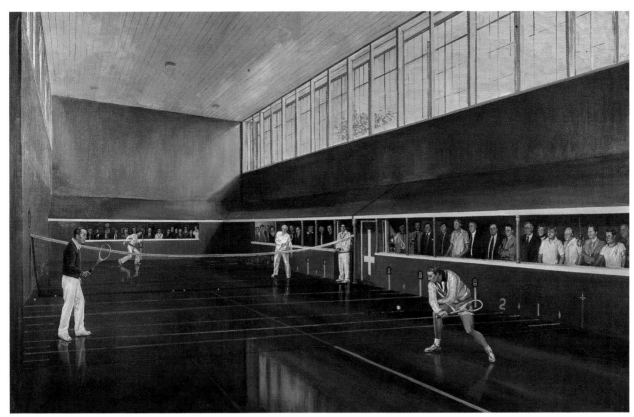

Colour Plate 70. Anthony Hobson, PhD, NDD, ATD, FRSA, FSEAD, Hon. FHS. 'The Dinner Match at Leamington', signed and dated '82. 60in. x 96in. The painting contains forty-four portraits and was commissioned by the Leamington Tennis Court Club. The Leamington tennis court was opened in 1846.

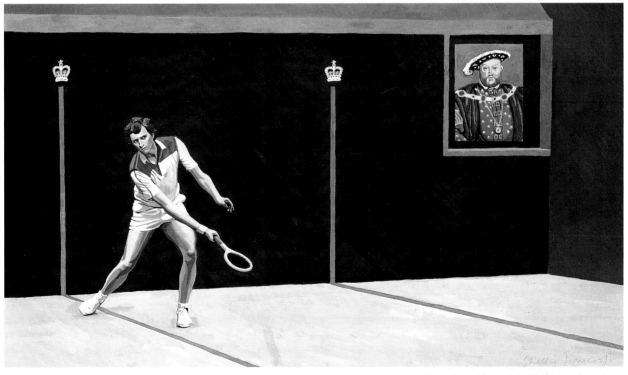

Colour Plate 71. Shelley Bancroft (b.1955). Portrait of Chris Ronaldson, World Champion, Real Tennis 1981-86, signed. Painted in 1984. 9¾in. x 18in. Chris Ronaldson.

has been built in France at Bordeaux in 1978, and two old courts have been resurrected in England — one in Newcastle upon Tyne and one privately in Kent — bringing the present world total of active courts to thirty-five, with eighteen of these in Britain, which compares favourably to the twenty-nine in 1974 but is just over half the number there were in play in 1930. Women's real tennis has also seen a revival.

ART

Real tennis, because it is a court game like fives, rackets, badminton and squash, to be successfully portrayed, calls for the talents of a particular kind of artist. The architectural design of the court is as important in the painting as the players themselves. The difficulty with painting court games is that if an architectural artist is employed the players are often stiffly portrayed and too precise, and if a figure artist is used then insufficient attention is paid to the court. Real tennis is another court game which does not benefit from an abstract treatment on canvas which blurs the detail of the game. A particularly successful combination was achieved by Jean Clark, RWS, NEAC (b.1902) in the painting of 'The Royal Court at Hampton Court' which she exhibited at the Royal Academy in 1950. A year later, in 1951, the same artist, who was married to John Cosmo Clark, CBE, RA, RWS, NEAC (1897-1967) himself the painter of many sporting scenes, was commissioned by the late Alderson Horne (1863-1953), a great tennis enthusiast, to paint 'The Dedans' (*see* Colour Plate 68). The painting shows Horne, wearing his familiar black beret, sitting amongst former champions, right to left Peter Latham (q.v.), Clarence Aberdare (1885-1957) and Jim Dear (b.1909) is on court. The distinguished contemporary portrait painter Anthony Hobson has also shown that real tennis can be portrayed successfully on canvas. Colour Plate 70 shows his painting of 'The Dinner Match at Leamington' which includes forty-four portraits and was commissioned by the Leamington Tennis Court Club in 1982.

FOOTNOTES
1. Harris, Nicholas, 'History of the Battle of Agincourt and of the expedition of Henry V into France in 1415', 2nd edn., published by W. Pickering, London, 1832; reprinted H. Pordes, London, 1971.
2. Scaino, Antonio, *Del Givoco della Palla di Messer,* originally published in three parts in Venice, 1555. Translated into English by W.W. Kershaw, published by Strangeways Press Ltd., London, 1951.
3. According to the accounts dated November 1532, John Budd of Chislehurst supplied 4,100 paving stones and was paid 16s. per 1,000 for the floor of the Hampton Court Palace tennis court, built by Henry VIII.
4. The Rt. Hon. Alfred Lyttleton, KC (1857-1913), played cricket for Cambridge University, Middlesex and England. A multiple 'blue' he also played Association football for England against Scotland, and was the best lawn tennis player of his time. He entered Parliament in 1895.
5. Evans Baillie Noel won the Amateur Rackets Championship in 1907 and an Olympic medal for rackets singles in 1908. He was the Queens Club Secretary 1914-1928 and the tennis and rackets correspondent to *The Times* before the Second World War. He wrote two volumes of *A History of Tennis* in 1924 and *First Steps to Rackets,* 1926.

CHAPTER 19

Rugby Football

Rugby football is the modern development of an ancient ball game and is distinct from Association football in the handling and carrying of the ball. In fact, the game's origins are probably more closely akin to those of hurling and camp ball than to football. Whatever the distinctions, football and the rugby version both have their origins in the ancient civilisations of the Greeks and Romans. The Romans played a game called harpastum which was very probably introduced by the Greeks since harpastum is derived from the Greek verb 'to seize'. From descriptions of the Roman game, it seems that the ball was run with between two teams and there are several similarities, including the scrummage, to the modern game of Rugby football.

Apart from these tenuous origins, Rugby football's more immediate history lies in the game's development at Rugby School sometime in the early nineteenth century which is attributed to William Webb Ellis (1807-1872) who, in 1823, during his schooldays there, was alleged to have broken the rules of football by picking up the ball and running with it towards his goal. This simple act is commemorated in a plaque set into the Close wall at the school and was unveiled on 1st November, 1923 to mark the centenary of the game.

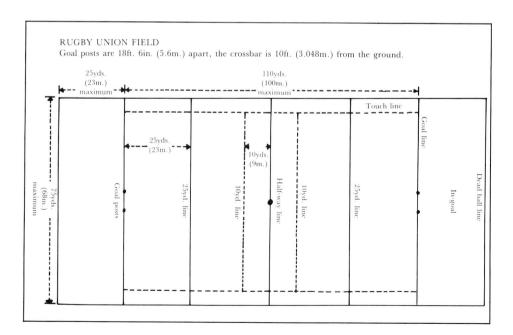

Plate 19/1. Plan of Rugby Union field.

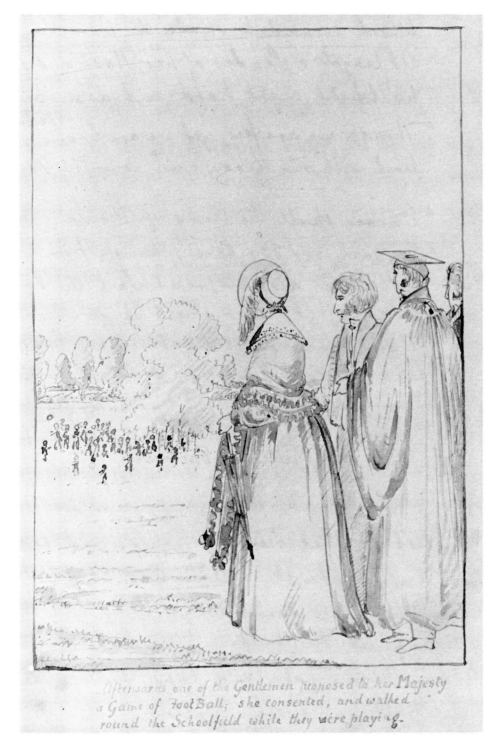

Plate 19/2. Jane Arnold (b.1821). The Dowager Queen Adelaide watching the boys playing football at Rugby School in 1839, with Dr Arnold and his two sons. Mrs Mary Moorman.

Historians of the game, such as Sir Montagu Shearman, and the Rev. F. Marshall, writing at the end of the nineteenth century, attributed the origins of the game to the ancient game of harpastum without reference to William Webb Ellis. As far as it is known, Rugby was the only school to develop the game from football, but earlier reports of games very similar to that evolved at Rugby have a bearing on its background.

Richard Carew in his *Survey of Cornwall,* 1602, described the game of football as having little kicking but a great deal of carrying the ball and running with

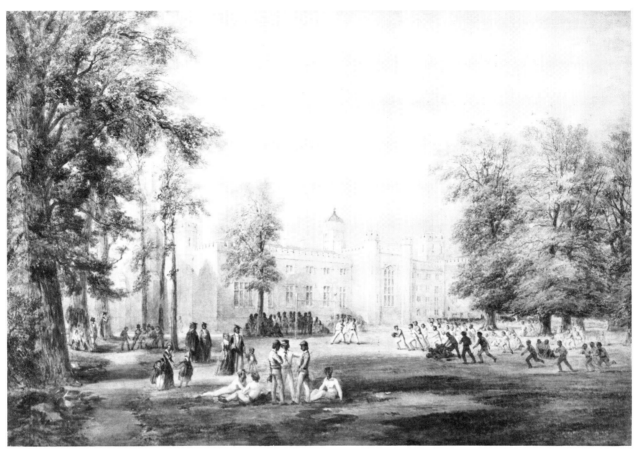

Plate 19/3. George Barnard (op.1832-1890). 'The School from the Close', signed and dated 1852. 24in. x 36in. Rugby School.

it, called 'hurling over country' and 'hurling to goal' with numerous players. In 1823, Major Moor of Bealings in Suffolk, gave the following description of a 'noble and manly sport' — the game of camp ball: 'Each party has two goals, ten or fifteen yards wide which are placed 150 or 200 yards apart formed of the thrown off clothes of the players. The parties stand in a line facing each other about ten yards distance midway between their goals and that of the adversaries. An indifferent (neutral or impartial) throws up a ball about the size of a cricket ball midway between the confronted players and makes his escape. The rush is to catch the falling ball. He, who can first catch or seize it, speeds home, making his way through his opponents and aided by his own sidesmen. If caught and held, or rather in danger of being held, for if caught with the ball in his possession, he loses a snotch, he throws the ball (he must in no case give it) to some less beleaguered friend more free and more in breath than himself.'

Sir Frederick Moreton Eden, in his *Statistical Account of Scotland,* described the great game at the Cross of Scone as follows 'every year the bachelors and married men drew themselves up at the Cross of Scone on opposite sides. A ball was then thrown up and they played from two o'clock till sunset'. The game was this: 'he who at any time got the ball in his hands ran with it until he was overtaken by a player of the opposite party and then, if he could shake himself loose from those who were holding him, he ran on; if not he threw the ball from him unless it was wrested from him by one or the other party but no person was allowed to kick it. If neither side won, the ball was cut into equal parts at sunset.' Eden also mentioned that in a certain parish in Midlothian

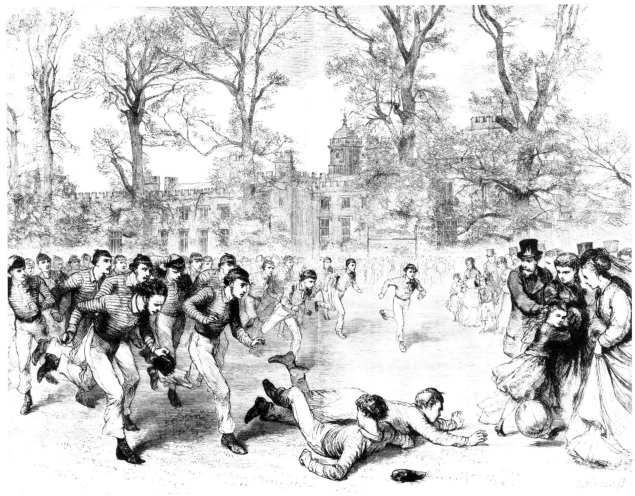

it was the custom for the married women to play the single women yearly on Shrove Tuesday and the married women always won.

Thomas Hughes (1882-1896), the author of *Tom Brown's Schooldays*, said that when he went to Rugby in 1834, whilst running with the ball in order to get a try was not absolutely forbidden, it was nevertheless pretty suicidal to attempt to do so. He suggested that the practice did not start until about 1838-39 when a fast tough boy called Mackie popularised it. In 1841-42 when Hughes was captain of Bigside at Rugby 'running in' with the ball was allowed subject to three conditions: that the ball was caught on the bound, that the player who caught it was not 'off his side' and that he did not hand the ball on but touched down himself behind the opposing goal. From then on the game developed rapidly and in 1846, the school published *The Laws of Football as played at Rugby School* and revised them in the following year. The new rules allowed that any player could now 'run in' providing that he did not take the ball from the ground or through touch; but if held in a scrummage he was not allowed to pass the ball to any other player on his side. Only the player holding the ball might be held and while hacking was allowed, it was not considered fair to hack and hold at the same time. In any case, hacking was only to be done below the knee and no hacking was to be inflicted with the heel; there was still no positioning. At that time games at Rugby School might involve up to 300 players, some drawn up behind the goal line but the majority involved

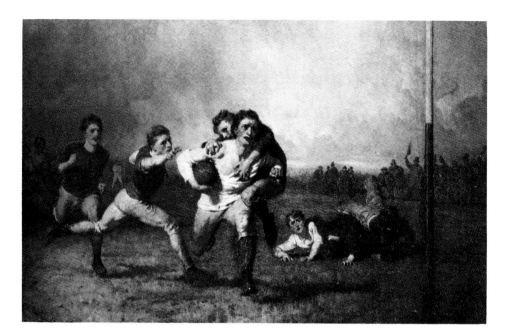

in one enormous scrummage with a few optimists on the outside hoping for an opportunity to seize the ball and run or kick it towards their goal. The famous description of the match 'School House v. School', supposed to have been played in 1835 in *Tom Brown's Schooldays,* lucidly illustrates the early evolution of the game and gave rise no doubt to the remark by a Frenchman that if the English called this playing, then what would they call fighting?

Between 1840 and 1860, some sort of football existed as a winter game for most public and grammar schools, and as the boys left school, they went on to play at universities and in the towns. In 1839, the first Rugby club on record was formed at Cambridge by an old Rugbeian, Mr A. Pell; games were played on Parker's Piece until 1881.

Until 1863 all variations of football were indivisible but it was apparent that two distinct forms of football had evolved, the dribbling game played at such schools as Eton, Harrow, Westminster and Charterhouse and the handling game as played at Rugby, Marlborough and Cheltenham. Whilst the ground rules could be agreed between the two groups, it particularly incensed the dribblers that the handlers could be allowed to pick up the ball in the middle of a game. After 1863 the division took place between Association football and Rugby football (*see* p.30), and in the following year there were reckoned to be about twenty Rugby clubs operating in the London area. The game had also spread to the North of England and Scotland where matches were recorded in the 1850s. In 1870 the Scottish Rugby players challenged England to an 'international' match, which took place on 19th November, 1870 at the Oval and led eventually to the formation of the Rugby Football Union and a decent code of play. Only one member of the side representing Scotland came from a Scottish club and it was said that the sole connection one team member had with Scotland was a liking for its whisky.

The first true international match was announced in a letter to *The Scotsman* on 8th December, 1870 by representatives of West of Scotland, Edinburgh Academicals, Merchistonians, Glasgow Academicals and St. Andrews challenging a team from the whole of England. The challenge was accepted by Blackheath

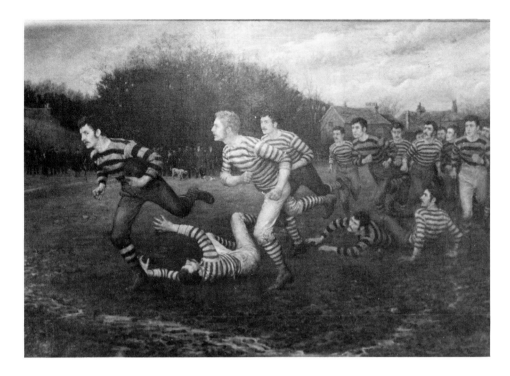

but the necessity of forming a team drawn from the whole of England contributed to the urgency of creating a governing body for Rugby. The match was finally played on 7th March, 1871 at Raeburn Place, Edinburgh, where Scotland won the only goal before a crowd of around 4,000.

Rugby needed its own governing body. The rules in existence at that time still allowed twenty-five players or more on each side and hacking persisted. Whilst hacking might do little permanent damage to a schoolboy, it was a very different matter for a grown man but to many players it was still considered to be part of the masculine image of the game. In the December of 1870, the Secretaries of the Blackheath and Richmond Rugby Clubs wrote a letter to the press inviting other clubs to join them in 'forming a code to be generally adopted'. The result was a meeting at the Pall Mall Restaurant at 1 Cockspur Street, London on 26th January, 1871 under the Chairmanship of E.C. Holmes, an old Rugbeian, which was attended by thirty-two representatives of twenty-one clubs and at this meeting the Rugby Football Union (RFU) was formed. The fifty-nine laws drawn up by the committee were drafted by L.J. Maton of Wimbledon Hornets and approved in the June of that year, the laws abolished 'hacking over' and 'knocking on' and it was now permitted for a player to pass the ball back to another member of his side, thus laying the foundations for a passing game.

Teams of fifteen players were introduced into the Oxford v. Cambridge Match in 1875 and thereafter in all matches, including internationals. This was the result, perhaps, of remarks by such as the historian Sir Montagu Shearman[1] who complained that in the earliest Anglo-Scottish Internationals 'a quarter of a hundred of heavyweights appeared to be leaning up against each other for a period of five minutes or thereabouts while occasionally the ball became accidentally disentangled from the solid globe of scrummagers and the remaining players then had some interesting bursts of play between themselves'. The earliest matches of VXs had ten forwards, two attacking half backs and three mainly defensive backs but by 1880, it had become customary

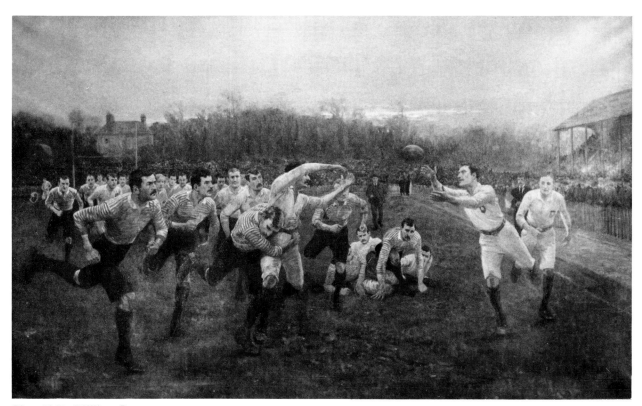

Plate 19/7. William Barnes Wollen, RI, ROI, RBC (1857-1936). 'Yorkshire v. Lancashire', signed and dated, 1895. 58¼ in. x 94¼ in. Rugby Football Union, Twickenham.

to play three-quarters with two halves, one back and nine forwards, the three-quarters adopting a more attacking role than the halves.

By 1872 British residents had formed the first Rugby club in France at Le Havre and in 1873 Scotland formed its own Scottish Rugby Union (SRU). In 1879 the Irish Rugby Union was formed and in 1880 that of the Welsh. In 1886 the International Rugby Football Board was instituted, largely as the result of a dispute about 'knocking back' during the Scotland v. England match in 1884 and the refusal of the Scots to allow the RFU to continue to interpret the rules. Tempers were allowed to cool the following year and fixtures were only resumed in 1886 on the understanding that England would join an International Board which would settle all further disputes in the future.

In 1887 the Prince of Wales (later Edward VII) became the Patron of the Rugby Football Union. Meanwhile the RFU introduced a system of scoring by points — three points for a goal and one point for a try. Victory was still decided by the number of goals but if none were scored a majority of points for tries would count. In 1891 the Board revised the point system to two points for a try, three for a penalty goal and five for a goal from a try (the try not to count) and four for any other goal. This was again changed in 1894 when the try was revalued at three points and in 1905, the penalty goal was reduced to three points. There were no further changes in the point system until 1949 when the dropped goal was similarly cut down from four to three points. The try was, however, increased in value to four points in the 1971-72 season.

In 1894, as a result of rumours that certain northern clubs were offering inducements to talented players to join them, the committee of the RFU passed a law which laid down 'that the name of the Society shall be the Rugby Football Union' but more importantly, 'only clubs composed entirely of amateurs shall be eligible for membership' and 'the Society's Headquarters

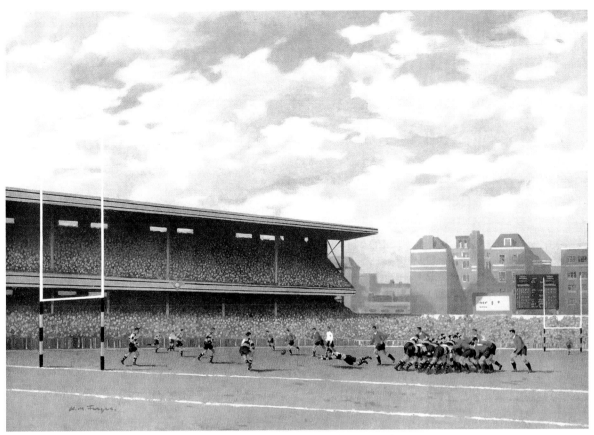

Colour Plate 72. Wilfred M. Fryer, SMA (b.1891). 'The Barbarians Tour', 1954, signed. Wiggins Teape Group.

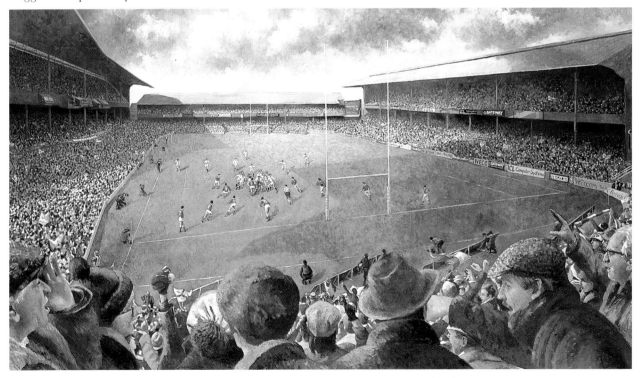

Colour Plate 73. Sherree Valentine-Daines, UA, SWA (b.1956). 'England v. Wales at Twickenham, 1986', signed. Signed verso by players. 34 ½ in. x 58 ½ in. The Wingfield Sporting Gallery, London.

shall be in London where all general meetings shall be held'. This led to the withdrawal of twenty-two leading Yorkshire and Lancashire clubs who immediately formed the Northern Rugby Football Union in 1895, later to become the Rugby Football League in 1922.

Two memorable events created long term advantages for the game of Rugby Union. The first occurred in 1877 and came in the form of a letter headed 5 Bank Hall Street, Calcutta, 20 December, 1877, addressed to H.J. Graham Esq., Hony. Secy. and Treasurer, Rugby Football Union (Wimbledon):

Dear Sir, I regret to say that the Calcutta Football Club has ceased to exist, it being now found quite impossible to get sufficient men together to play even a scratch game. This is the result of a variety of causes, but chiefly from the fact that some of the old members that started the club in 1872 and kept it going, have been dispersed over India or gone home, etc. and there has never been enough new blood to supply the loss. Then the great and rapid development of Polo has proved a fatal blow to Football here, it being considered (as it requires no training or condition) so much more suitable for this climate. Lastly the loss of the ''Blues'' who

Plate 19/8. George Loraine Stampa (1875-1951). 'Seen anything of Muriel lately?', signed and dated 1935. Pen and ink sketch. 7¼ in. x 10in.
The Wingfield Sporting Gallery, London.

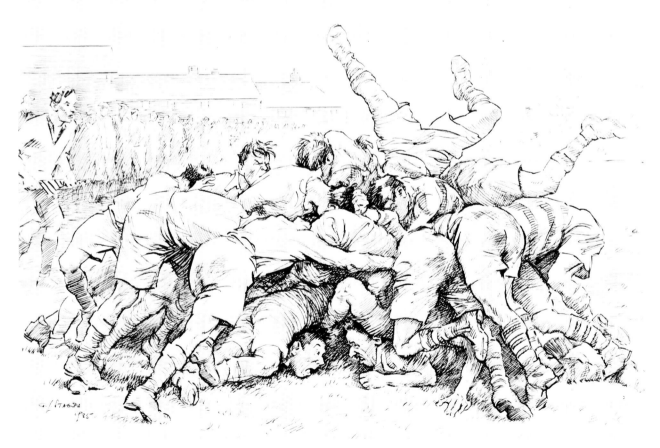

were undoubtedly a mainstay of Football in Calcutta. This being the case, I proposed at a meeting of the last of the few remaining members of the Club held on Tuesday last, the eighteenth inst., as the best means of doing some lasting good for the cause of Rugby Football and as a slight memento of the Calcutta Club, that the funds remaining to the credit of the Club should be devoted to the purpose of a Challenge Cup and presented to the Rugby Union to be competed for annually in the same way as the Association Cup, or in any other way the Committee of the Rugby Union may consider best for the encouragement of Rugby Football. This proposition was carried unanimously and I now write to beg you to place the matter before the Committee of the Rugby Union and beg their kind acceptance of a cup and also to enquire if the Committee would prefer one of Indian workmanship or the money remitted for the purchase of a cup at home? The sum of money at my disposal, at the present rate of exchange, is about sixty pounds sterling. Hoping to be favoured with an early reply and with every good wish for the success of Rugby Football, I remain, Dear Sir, Yours ffy, G.A. James Rothney, Capt. Hony. Secy. and Treasurer of the late C.F.C.

The RFU Committee graciously accepted and wisely, it seems, voted in favour of an Indian cup which was made from the silver melted down from the rupee pieces withdrawn from the bank when the Calcutta Cup officials closed their account. It is of the finest Indian chased work with three snake cobra handles and an elephant surmounting the lid and stands about 18in. high. This was a generous gesture from a defunct club which was determined to help the game at all costs. The Calcutta Cup became the most famous Rugby trophy in the world and is competed for annually by England and Scotland on the anniversary of Rugby's oldest traditional match on the nearest Saturday to 7th March; the RFU retains possession of the Cup, whoever wins the match. Since 1879, the date of every match, the name of the winning team and the names of the two captains have been recorded round the base.

The second event was the purchase, in 1907, of ten and a quarter acres at Twickenham for the sum of £5,572. 12s. 6d. by a dedicated sportsman, Mr William Williams, who urged the RFU to make their headquarters there. The Union at that time was rather a forlorn body, still feeling the effects of the northern split and the devastating lessons learnt at the hands of the first New Zealand All Blacks on their visit to Great Britain in 1905-6. Nevertheless, the sum of £20,000 was found to build two stands at the ground with accomodation for about 30,000 spectators and the first match took place on 2nd October, 1909 when Harlequins beat Richmond 14 – 10.

The first overseas Rugby tour was to Australia in 1888, commemorated by a gold medal now in the RFU Museum at Twickenham which was presented to one of the players. In the summer of 1891 the first British team visited South Africa as guests, all expenses paid and won all their matches. The team's

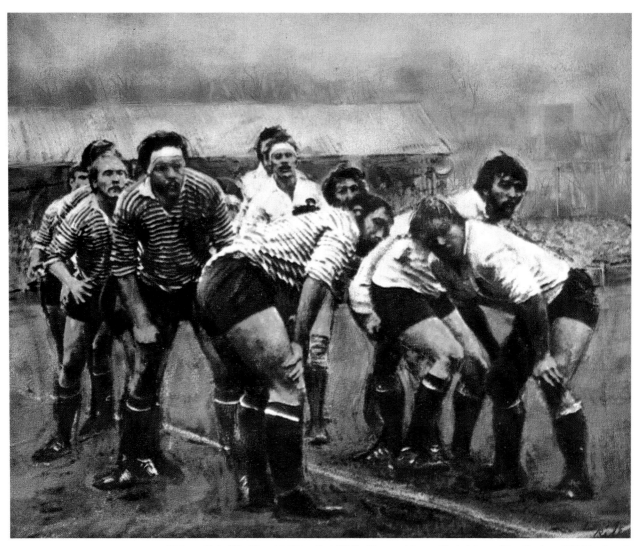

Colour Plate 74. Harold Riley (b.1934). 'Lancashire v. Yorkshire at Headingley, 1981', signed. Presented to the Rugby Football Union by the Lancashire County Rugby Football Union on the occasion of their centenary. The painting shows Bill Beaumont, Fran Cotton and Jim Sydall. Rugby Football Union, Twickenham.

second visit took place in 1896, where they won nineteen of the twenty-one matches and three of the four internationals. The third British team to visit South Africa in 1903 won only eleven of the twenty-two matches played. The first Springboks, under the captaincy of P. Roos, arrived in the British Isles from South Africa in 1906 and lost only two of their twenty-eight matches (to Scotland and Cardiff) scoring 553 points against 79. Both Australia and New Zealand have proved formidable opponents, the Wallabies and All Blacks having powerful teams, against whom the British have found it hard to win. Between 1889 and 1971, Britain has played twenty-two official international matches against teams from overseas Rugby Union countries and have won only five since the 1924 visit to South Africa. The British Isles Rugby Union Touring Team (BIRUTT) has become known as the British Lions. In 1948 when Eire became a full and independent Republic, although the title had to be changed to the British and Irish Rugby Union Touring Team, the initials conveniently remained the same.

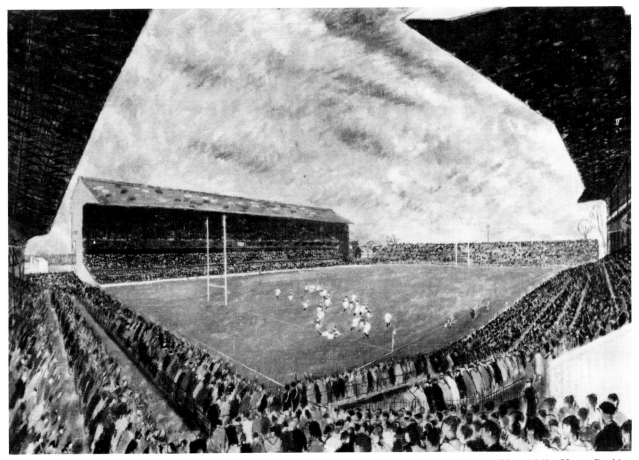

Plate 19/9. Henry Deykin (b.1905). 'Rugby Football at Twickenham, England v. France, 29th February, 1951', signed. 19½ in. x 23½ in. Henry Deykin.

RUGBY LEAGUE FOOTBALL

Unlike the majority of sports whose origins may be lost in the mists of time, this sport is able to date its beginnings precisely to 29th August, 1895. On this date, twenty-two northern clubs broke away from the parent RFU to form the Northern Rugby Football League. The cause of the break was a disagreement over the compensation that the northern clubs wished to pay their players for money lost by taking time from work to play football; the RFU which represented the strictly amateur status could not agree.

Within three years of the break, professional status was adopted by the Northern League (though with the proviso that each player had to follow some other employment besides that of football) and they also set out to make the game as attractive as possible to spectators and amended the rules with this in mind. The new body reduced the number of players in a team from fifteen to thirteen and the number of forwards in a scrum from eight to six. Furthermore, a tackled player was allowed to retain the ball up to a point regulated by the play-the-ball rule which eliminated loose mauls which are so much a feature of the Rugby Union game. Ground gained by a kick to touch (except from a penalty award) does not count unless the ball lands in the field of play before crossing the touch line. The result is that tactics differ considerably from those of Rugby Union and have been designed to attract spectators by attaching greater rewards to the skills of running and passing.

As with Rugby Union this young sport, less than a hundred years old, has begun to attract the talents of the sporting painter. Contemporary artists, with

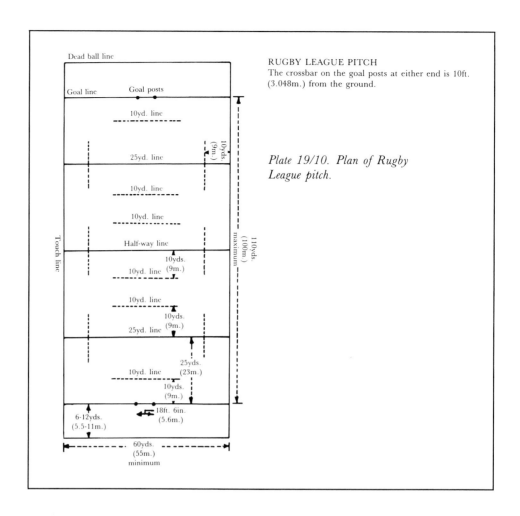

Within the diagram:

Dead ball line

Goal line Goal posts

10yd. line

25yd. line

10yd. line

10yd. line

Half-way line

10yd. line

10yd. line

25yd. line

10yd. line

Touch line

6-12yds.
(5.5-11m.)

60yds.
(55m.)
minimum

10yds.
(9m.)

110yds.
(100m.)
maximum

10yds.
(9m.)

10yds.
(9m.)

25yds.
(23m.)

10yds.
(9m.)

18ft. 6in.
(5.6m.)

RUGBY LEAGUE PITCH
The crossbar on the goal posts at either end is 10ft.
(3.048m.) from the ground.

*Plate 19/10. Plan of Rugby
League pitch.*

increased interest in the game, have found a widening and ready market for the sale of their work. Amongst the older and better known artists to portray this challenging subject are John Cosmo Clark, RA, RWS, NEAC (1897-1967) and Roy de Maistre (b.1894).

ART

Rugby Union has perhaps not lent itself as an artistic subject as well as many other sports. Despite this, those artists who have attempted to portray the game have been successful in their efforts as, for example, the painting of 'A Winter Scene at Rugby School — Football', c.1859 by Edward Harwood (b.1814, op.1844-72) which he exhibited at the RA, and which was presented to the School House by the 2nd Viscount Cowdray in 1928.

The first pictorial representation of the game of Rugby football was sketched by Jane Arnold (b.1821), who was the elder daughter of Dr Thomas Arnold (1795-1842), the famous headmaster of Rugby School. Miss Arnold was for a brief time the fiancée of Bishop Cotton who introduced the game to Marlborough School when he became headmaster there in 1852. The sketch depicted in Plate 19/2 shows the Dowager Queen Adelaide, the widow of William IV (1765-1837), when she visited Rugby School in 1839, the man in the mortar board is the great Dr Arnold, and the other men in the foreground are his sons, Matthew Arnold, the poet (1822-1888), in the middle, and

Thomas Arnold, jun. (1823-1900) on the right, watching the boys at the school playing football.[2]

The painting of a Rugby football match 'Newport v. Cambridge', by William Barnes Wollen, RI, ROI, RBC (1857-1936), exhibited at the RA in 1879, now hangs at Twickenham, as does the painting 'Yorkshire v. Lancashire' which Wollen painted in 1895 (*see* Plates 19/6 and 19/7). Ernest Prater (op.1897-1914) was an Edwardian artist who painted several pictures of football including 'A Dash from the Scrimmage' which was one of only four paintings he exhibited at the RA between 1897 and 1904. He and several other contemporary artists created the clean cut image of the British sportsman at play, largely for *The Boy's Own Magazine* at that time. Many of the talented artists and illustrators who depicted Rugby football worked for newspapers and periodicals before the age of mass photography and, therefore, most sketches were undertaken in black and white.

Paintings of Rugby football, in common with many other sports, were few in number during much of the twentieth century. A long overdue revival began in the 1950s which is illustrated by the painting of the international match at Twickenham in 1951 between England and France which gave France her first victory there and shows B. Boobyer scoring England's only try (*see* Plate 19/9). The artist, Henry Deykin, painted a series of sports in the early 1950s, which included hockey, bowls, lawn tennis and Association football as well as Rugby football. Nowadays the sport is not confined to the talents of male artists as the subject has been well portrayed in the attractive painting by Sherree Valentine-Daines in Colour Plate 73. The fine painting in Colour Plate 74, by Harold Riley of a 'Roses' match between Yorkshire and Lancashire at Headingley painted in 1981 and presented to the Rugby Football Union by the Lancashire Rugby Union on the occasion of their centenary, shows that contemporary artists are more than equal to the task of interpreting this popular and keenly followed sport.

FOOTNOTES
1. Author of *Football — its History for Five Centuries*, 1885, and also contributed to *Athletics* and *Football* in the Badminton Library Series, 1899.
2. The sketch was reproduced in *Dr Arnold of Rugby* by Norman Wymer, by courtesy of Robert Hales Ltd., 1953.

Abbreviations

A	Associate
attributed	reasonably supposed to be by the artist quoted
ARA	Associate of the Royal Academy
ARCA	Associate of the Royal Cambrian Academy
ARHA	Associate of the Royal Hibernian Academy
ARPE	Associate of the Royal Society of Painters and Etchers
ARSA	Associate of the Royal Scottish Academy
ARSW	Associate of the Royal Scottish Watercolour Society
ARWS	Associate of the Royal Watercolour Society
b.	born
Bt.	Baronet
BM	British Museum
BWS	British Watercolour Society
c.	circa
CBE	Commander of the Order of the British Empire
CFC	Chelsea Football Club
d.	died
edn.	edition
exh.	exhibited
F	Fellow
FA	Football Association
FE	The Arts Council of Great Britain Football Exhibition
FRS	Fellow of the Royal Society
FRSA	Fellow of the Royal Society of Arts
FSA	Fellow of the Society of Antiquaries
GI	Glasgow Institute of Fine Arts
H	Honorary
illus.	illustrated
inits.	initials
inscr.	inscribed
LG	London Group
LSC	London Sketch Club
MCC	Marylebone Cricket Club
mono.	monogram
NA	National Academy of Design (New York)
NEAC	New English Art Club
NS	National Society of Painters, Sculptors and Gravers
NT	National Trust
NWS	New Society of Painters in Watercolours, 1831. RI from 1881
OBE	Officer of the Order of the British Empire
OM	Member of the Order of Merit
op.	operated/worked: denotes the period in which the artist was most active and is used when the dates of birth and death are not known. Dates shown without this prefix (e.g. 1850-1933) are the years of birth and death.
OWS	Old Society of Painters in Watercolours, 1804. RWS from 1881
P	President
PP	Past President
PRA	President of Royal Academy
PS	Pastel Society
pub.	published
q.v.	*quod vide* ('which see')
repro.	reproduced
RA	Royal Academy, Royal Academician
R & A	Royal and Ancient Golf Club, St. Andrews
RBA	Royal Society of British Artists
RBC	Royal British Colonial Society of Artists
RBSA	Royal Birmingham Society of Artists
RCA	Royal Cambrian Academy, Manchester (if an artist studied at the RCA, this refers to the Royal College of Art, London)
RE	Royal Society of Painter-Etchers and Engravers
RFU	Rugby Football Union
RGI	Royal Glasgow Institute of Fine Art
RHA	Royal Hibernian Academy
RI	Royal Institute of Painters in Watercolours
ROI	Royal Institute of Oil Painters
RP	Royal Society of Portrait Painters
RSA	Royal Scottish Academy, 1826 (Royal 1838)
RSMA	Royal Society of Marine Artists
RSW	Royal Scottish Society of Painters in Watercolours
RWA	Royal West of England Academy
RWS	Royal Society of Painters in Watercolours
SA	Scottish Academy before Royal Charter
s. & d.	signed and dated
SS	Society of British Artists, Suffolk Street, RBA from 1887
SWA	Society of Women Artists
UA	United Society of Artists
USA	United States of America
VP	Vice-President
w/c	watercolour

Appendix of Artists

To provide a complete record of all the artists of ball games would have proved an impossible task and the book is not intented to be simply a dictionary of artists. The entries in this appendix have therefore been selected to illustrate the wide range of paintings in existence. Artists who painted a particular sport have been listed under the appropriate heading. Popular sports such as Association football, cricket, golf and polo have been strictly limited in number.

All paintings are oil on canvas unless otherwise stated. Measurements are given height by width. An asterisk against an entry denotes that the painting is illustrated in the book.

American Football

Bartell, George.
Brodie, Howard (b.1916). Illustrator for *Yank Magazine* during Second World War.
Brown, Rick.
***Burnham, Patrick** (British, b.1939). 'American Football', appliqué, 48in. x 28in. *The Wingfield Sporting Gallery, London.*
***Carroll, Larry.** 'Joe Theisimann', 1980. Acrylic on board. *National Football League, NY.*
Christopher, Tom. Portrait of Randy Gradishar, Denver Bronco's middle line backer, 1979.
Corning, Merv. 'The first 50 years 1969'. Mixed media on board.
'Carl Eller, 1974', w/c.
*'Jack (Hacksaw) Reynolds', 1979.
Dean, F. Bruce.
Doust, Dan. 'The Gladiators'. Stylised woodcut, s. & d. 1965, and No.2 of an edn. of 25. *The Harry Langton Collection.*
***Doutreleau, Pierre.** A Parisian who painted American football. Large oils 1970s. 'Football Players'. *National Football League, NY.*
Forbes, Bart John (b.1939). Illustrator for *Time* magazine. 'Walter Payton', 1980. Artists dyes on board.
French, Lisa.
Fuchs, Bernie (b.1932). Illustrator for *Sports Illustrated, Redbook* and others. Artist of the year, 1962; youngest member of the Society of Illustrators Hall of Fame.
Gaadt, George (b.1941). Illustrator for advertisements, editorial and children's books.
'New England Patriots, 1979'. Mixed media on board.
'Super Bowl XII Game Programme illustration 1978'. Mixed media on board.
Gomez, Ignacio.
Grove, David. Illustrator; President of the Society of Illustrators, San Francisco.
'Joe Federspiel', 1978.
*'Jeff Siemon', 1978.
Isom, Joe. 'Alan Page', 1972. Minnesota Vikings defensive tackle. Acrylic.
Johnson, Doug. 'John Gilliam', 1978, of the Minnesota Vikings 1960s-1970s. Acrylic.
Keller, Lou. 'Keith Lincoln', 1974. San Diego Chargers half back 1960s.
*'Hugh McElhenny', 1973. *National Football League, NY.*
Kelly, Gary.
Kleenmann, Ron.
Lamb, Jim. 'Minnesota Vikings', 1979. Acrylic on board.
Lee, Bruce. 'Joe Ehrmann', 1980. Baltimore Colts' defensive tackle. w/c.

***Leffel, David.** 'O.J. Simpson', 1974. Buffalo Bill's running back. *National Football League, NY.*
Mallard, Jeremy. Painted a series of players — 'William Perry (The Fridge)', Chicago Bears; 'Dan Marino' (Miami Dolphins), etc.
McMacken, Dave. 'George Halse', 1976. Chicago Bears coach and owner 1920s. Acrylic and airbrush.
Moreau, Alain. 'Brad Vaylett', 1978. NY Giants line backer.
Moscoso, Victor.
Moss, Donald (b.1920). Worked for *Sports Illustrated* for over 20 years; designed US stamps, 1976.
Nagel, Pat.
Neiman, Leroy (b.1929). Outstanding sports artist who has included American football in his work.
Oden, Dick. 'John Hannah — New England Patriots Guard', 1982. w/c.
Palombi, Peter.
Ramos, Mel. 'Ezra Johnson', 1980. Green Bay Packers defensive end. w/c.
Ren, Chuck. 'Philadelphia Eagles', 1980. Acrylic on board.
'Super Bowl XIVth Theme Art', 1980. Acrylic on board.
Roblee, Brian.
Rockwell, Norman (1894-1978). 'The Referee'. This picture was used on the front cover of the *Saturday Evening Post*, 21.10.1950. *The Norman Rockwell Museum, Stockbridge, Massachusetts, USA.*
Schwartz, Daniel (b.1929). Illustrator for several national magazines; first illustration, 1953 for *Theatre Arts*.
Storey, Ross Barron (b.1940). Illustrator for *Life* and *This Week* magazine.
Weller, Don.
White, Charles.
Willardson, Dave. 'Bronko Nagurski', 1972 of the Chicago Bears 1920-1930s. Airbrush.

Association Football

Allinson, Adrian Paul, ROI, RBA, LG, PS (1890-1959). 'At the Goal Mouth', football at Stamford Bridge, Chelsea. Exh. FE, 1953. (*See also* cricket).
Aumonier, James, RI (1832-1911). 'Football Match'. Exh. RA 1888.
Ayrton, Michael, RBA (b.1921). 'Arsenal v. Aston Villa, 1952'. 26½in. x 41in. Exh. FE 1953.
Badmin, Stanley Roy, ARCA, RWS (b.1906). 'Here they come! — the Valley'. w/c. 15½in. x 9½in. Exh. FE 1953.

Baumer, Lewis Christopher Edward, RI, PS (1870-1963). *Punch* artist of football scenes.
Berkeley, Stanley, RE (1855-1909). This artist illustrated the *Athletics and Football* edition of the Badminton Library series published in 1888 of which 'The Association Game' is the frontispiece.
Brill, Frederick (d.1985). 'Chelsea Football Ground', s. & d. 1952. w/c. 31¾in. x 24½in. Exh. FE, 1953.
Brooks, Henry Jamyn (op.1890-1909). An Association football match between Oxford and Cambridge Universities in 1905, s. & d. 1908. *Queens Club, London.* (*See also* Polo).
Buckman, Edwin, ARWS (c.1841-1930). Football (A Scrimmage)', 1886, signed. 8½in. x 28½in. *Bonhams.*
Chamberlain, Christopher (1918-1984). 'Chelsea plays Arsenal', signed. 47½in. x 95¾in. Painted for the 90th Anniversary of the FA in 1953, exh. FE, 1953. *FA Collection.*
Clark, John Cosmo, RA, RWS, NEAC (1897-1967). Association football is believed to be amongst the sporting subjects that this artist painted in 1931 many of which were exhibited in the (Hutchinson) National Gallery of Sports and Pastimes, London.
Colquhoun, Ithell (b.1906). 'The Game of the Year', inscribed c.1953 with the title. This painting may have been inspired by England's great match with Hungary. *Harry Langton Collection.*
Critchlow, M.B. 'Craven Cottage'. 23½in. x 36in. Exh. FE 1953.
Cruikshank, Isaac Robert (1786-1856). 'A Football Match'. 9½in. x 13½in. Published by George Hunt. *Arthur Ackermann & Son, London.*
Cundall, Charles, RA, RWS, RP, RSMA, NS, NEAC (1890-1971). 'Arsenal v. Sheffield United', s. & d. 1936. 24¾in. x 35¾in. *Phillips.*
'Chelsea v. Arsenal' at the Stamford Bridge Ground, Chelsea, showing the old 'E' stand, which was demolished in 1972. *Chelsea Football Club. (See also* billiards, cricket.)
***Cuneo, Terence Tenison, RGI, PIPG** (b.1907). 'FA Challenge Cup Final', between Tottenham Hotspurs and Burnley, s. & d. 1962. 4ft. x 6ft. Painted for the FA Centenary in 1963. (*See also* polo.)
Daniels, Alfred, RWS, ARCA, FRSA (b.1924). 'Fulham Football Club'. 48in. x 31½in. Exh. FE 1953.
Davis, Lucien, RI (1860-1941). Sketched football scenes for the *Badminton Magazine* in the 1890s. (*See also* billiards, cricket, fives, golf, hockey.)

Deane, Frederick A. 'A portrait of Frank Swift'. 27in. x 35in. Exh. FE, 1953.

de Maistre, Roy (1894-1968). 'Footballers' (No.204) at the XIVth Olympiad Sport in Art Exhibition at the V & A, London 1948.

Deykin, Henry Cotterill (b.1905).
*'The Cup Final at Wembley, 1951', inscribed 'Milburn scores again, April 28th 1951'. *Henry Deykin*.
'Aston Villa v. W. Bromwich 1950', signed 19½in. x 23½in. *Henry Deykin*. (*See also* cricket, croquet, golf, hockey, lacrosse, lawn bowls, lawn tennis, polo, Rugby, football.)

Dighton, Robert (1752-1814). 'Football in the market place, Barnet'. w/c. *BM Collection*. (*See also* billiards, cricket, fives, rackets.)

Dunston, Bernard, RA, RWA, NEAC (b.1920). 'A game of Football'. 6½in. x 13½in. *Sotheby's, Sussex.*

Fox, Lilla 'Boys Playing Football'. Drawing. 25in. x 17½in. Exh. FE, 1953.

Freeth, H. Andrew, RA (1912-1986). 'Watford Football Club Dressing Room'. 36in. x 28in. Exh. FE, 1953.

Gillett, Edward Frank, RI (1814-1927). 'The Cup Final, Southampton v. Sheffield United, at Crystal Palace in 1902'.

Griffith, Mark. 'The Goalie's anxiety at the Penalty Kick'. Powder paint on paper. 14½in. x 11¾in. *Bonhams*.

Guthrie, Sir James, PRSA, HRA, RSW (1859-1930). Henry, son of the Rev. Munro Gibson, DD, painted ¾ length holding a football and looking to the left. s. & d. 1881. This painting is included in the catalogue of Guthrie's works compiled by J.L. Caw in 1932 and taken from Guthrie's own catalogue. The painting was owned at that time by Dr H.W. Gibson of Hampstead.

Hemy, Thomas Marie Madawaska (1852-1937). 'Football at Harrow School', the field with a match in progress. Etching. 11in. x 23¾in. Pub. Dickenson 1888 by W. Cox.
'Sunderland v. Aston Villa', s. & d. 1895, 17¼in. x 29in. *FA Collection*. (*See also* Rugby football.)

Hopkins, Arthur, RWS, RBC (1848-1930). *Punch* artist of football scenes.

Hopkinson, John (b.1940).
*'Manchester City Football Club Supporters', 1980s. Ink and crayon. 18⅞in. x 23¼in.
*'Tottenham Hotspur Football Supporters', 1980s. Ink and crayon. 23½in. x 19in.
*'Supporters Outside Tottenham Hotspur Football Club', 1980s. Ink and crayon. 19¼in. x 23¾in. *The Wingfield Sporting Gallery, London*

Jones, Andrew S. 'The Sending Off', signed. 18in. x 20in.

Jones, Stanley Robert, ATD (b.1927). 'The Final Whistle'. 19½in. x 29in. Exh. FE, 1953.

Kaufman, Wilhelm (Austrian).
'Footballers'. Exh. at the XIVth Olympiad Sport in Art Exhibition at the V & A, London 1948 (No. 198).

Kessell, James E., RBSA (b.1915). 'Coventry v. Bournemouth, March 15, 1953'. 26½in. x 34¼in. Exh. FE, 1953.

Koethe, Wolfgang. Contemporary German artist who has lived and worked in Great Britain for some time; he painted the England-Germany World Cup Final of 1966.

Krishna, Mary, ARCA (1909-1968). 'Chelsea v. West Bromwich Albion'. 19½in. x 23½in. Exh. FE, 1953. *Harry Langton Collection.*

La Dell, Edwin, ARA, RBA, ARCA (1914-1970). 'Stamford Bridge'. 14in. x 20½in. Figures outside the turnstiles of Chelsea Football Ground'. *Anderson and Garland, Newcastle, Tyne & Wear.*

Linley Sambourne, Edward (1844-1910). *Punch* artist of football scenes.

Lowry, Lawrence Stephen (1887-1976). 'Going to the Match'. 35½in. x 27½in. Exh. FE, 1953. Prints after this work were published by the Medici Society, 1972.

May, Phillip William, RI, NEAC (1864-1903). *Punch* artist of football scenes.

*Morden, W.G. 'The F.A. Cup Final at Wembley, 1959'. *Wiggins Teape Group.*

*Nelson, Paul. 'Village Football', signed and dated 1953. Exh. FE, 1953.

Parker, Charles H. (1858-1930). 'The Football Association Cup Final at Crystal Palace'. Hand coloured engraving with key. *Harry Langton Collection.*

*Prater, Ernest (op.1897-1914). 'The Football Match'. w/c. 10¾in. x 18in. Probably used for illustration purposes and bears the stamp of a Leeds agent, Alfred Cooke Ltd., on the back, with date March 31st, 1913. *Bonhams*. (*See also* Rugby football.)

Proudfoot, James, RP, ROI, NS (1908-1971). 'Football', signed. 35in. x 27½in. Exh. FE, 1953. (*See also* golf).

Raven Hill, Leonard (1867-1942). *Punch* artist of football scenes.

Reynolds, Frank, RI (1870-1963). *Punch* artist of football scenes.

Rogers, Claude Maurice, PLG, NEAC (b.1907). 'West Bromwich v. Chelsea', 1952-53. Exh. FE, 1953.

Rousseau, Henri (French, 1844-1910). Painted a romantic picture of the game of football in 1908, which hangs in the Solomon R. Guggenheim Museum, NY.

Scott, Septimus Edwin (b.1879). 'The Big Match'. Poster paint and w/c. *Harry Langton Collection.*

Spear Ruskin, CBE, RA (b.1911). 'Footballers', signed. 30in. x 20in. *Christie's*. (*See also* billiards, cricket.)

Townsend, Frederick Henry, ARE (1868-1920). *Punch* artist of football scenes.

Toynbee, Lawrence (b.1922). 'Midweek Practice at Stamford Bridge'. 43in. x 34½in. *Private Collection.*

Uhlman, Frederick (b.1901). 'The Goal'. 33¾in. x 18½in. Exh. FE, 1953.

Ward, Louis, RWA, FCSD (b.1913). 'Football'. 16in. x 20in. *20th Century Gallery, London.*

*Weber, Paul. 'The Young Footballers', s. & d. 1922. 15in. x 10in. *Sotheby's.*

*Webster, Thomas, RA (1800-1886). 'Football', c.1839. Exh. RA 1839, No.363. *British Museum*. (*See also* cricket.)

Weight, Carel Victor Morlais, CBE, RA, RBA, RWA (b.1908). 'The Village (Football) Cup Tie', painted in 1938 and set in Norfolk. 36in. x 51in. *Sotheby's*. (*See also* cricket.)

Wollen Barnes, William, RI, ROI, RBC (1857-1936). Exhibited 'A game of Football' at RA in 1879. Also drew football illustrations for *Cassell's Magazine* 1906/7. (*See also* polo and Rugby football.)

Badminton, Battledore and Shuttlecock

*A.T. 'Girl with Shuttlecock', signed and dated 1902. w/c. 15in. x 10¼in. *Chris Beetles Ltd.*

Alma Tadema, Lady (1852-1909). A picture of a game of Battledore and Shuttlecock after a painting by this artist was reproduced in the *Art Journal* in which two young girls are playing watched by a woman with a baby on her knee.

Bartlett, Charles William (1860-c.1928). 'Before the match' (small girl with racket and shuttlecock seated on a garden chair), s. & d. '91. 17in. x 14½in. *Phillips.*

Bouvier, Joseph (op.1839-1889). Anglo-French artist who painted sugary subjects in sugary settings, such as 'Fairies by Moonlight'. His painting 'Ready to Play', s. & d. 1889, 40in. x 31in., shows a young boy dressed as a girl in pink and white frills, armed with a shuttlecock racket in his right hand and a bunch of flowers in his left. *Sotheby's.*

*Burr, Alexander Hohenlohe (1835-1899). 'A game of Battledore', signed. 10¾in. x 17¾in. *Bonhams*. (*See also* cricket.)

Cameron, Sir David Young, RA, RSA, RWS, RE (1865-1945). 'Battledore and Shuttlecock'. 14in. x 17in. *Glasgow AG and Museum.*

*Davis, Louis. 'The Shuttlecock Player', s. & d. '71. 17½in. x 13½in. *Christopher Wood Gallery.*

Drew, Mary (op.1880-1901). A painting by this artist of a girl with a badminton racket and a shuttlecock entitled 'I cannot play alone' is in the Southampton Art Gallery. (*See also* cricket.)

Hamilton, Hugh Douglas (1734-1806). 'Charles, Powell Leslie at play — his shuttlecock and racket on the floor beside him'. Pastel. 22in. x 15in. *Sotheby's, London.*

Hardy, W.F. 'Tug of War' depicts a terrier and a girl fighting over a wrap after the girl has been playing shuttlecock, her shuttle and racket are on the floor. s. & d. 1891. 9½in. x 7½in. *Bonhams.*

Hayman, Francis, RA (1708-1776). 'Battle dore & Shittlecock' [*sic*]. 11¾in. x 14¼in. Engraving by Nathaniel Parr (1723-c.1751) after the painting, which is lost. Part of a series for the decoration of the Supper Room at Vauxhall Gardens. Pub. T. & J. Bowles 1743. *British Museum*. (*See also* cricket.)

*Herdman, Robert, RSA, RSW (1829-1888). 'Little girl with shuttlecock', s. & d. 1866. 45in. x 32½in. *Lawrence, Crewkerne.*

Hunter, Robert (op.1752-1803). Portrait of Owen O'Malley (b.1771) standing full length holding a shuttlecock and a racket. 49in. x 39¼in. *Sotheby's.*

***Knapton, George** (1698-1778). Portrait of Master Francis Burrell ¾ length in a brown coat and blue and silver waistcoat holding a battledore, a shuttlecock on the table beside him. s. & d. 175? and inscribed. 29⅞in. x 25⅛in. *Christie's.*

***Lance, Miss Eveline** (1859-1893). 'Outdoor Play', signed with mono. w/c. 8in. x 6in. *Chris Beetles Ltd.*

Millais, Sir John Everett, Bt., PRA (1829-1896). This distinguished artist drew a sketch of battledore and shuttlecock in his *Sports for Rainy Days* (1851) from the *Highland Sketch Books* of 1853.

***Smith, Carlton Alfred, RI, RBA, ROI** (1853-1946). 'A game of Shuttlecock', s. & d. '96. w/c. 10in. x 7in. *Bonhams.*

***Tomlinson, Maud** (b.1859). 'Not played Badminton for some time — kept turning my back on the Shuttlecock'. Repro. *Country Life* magazine, 12.12.1985. Diarist and illustrator.

***Unknown artist.** 'Young Boy with Shuttlecock Racket', early 19th century. w/c. 4¼in. x 3⅝in. *Private Collection.*

Basketball

***Allen, R.** A portrait of Dr. James Naismith, 1978. Charcoal drawing. 18in. x 28½in. *Naismith Memorial Basketball Hall of Fame, Springfield, Massachusetts, USA.*

***Glidden.** A portrait of Edward A. Wachter, Capt. of the Troy (NY) YMCA team, 1896-1904, 1963. 29½in. x 39in. *Naismith Memorial Basketball Hall of Fame, Springfield, Massachusetts, USA.*

***Guzzi.** Professional National basketball League action between Julius Erving of the Philadelphia 76ers (No.6) and Robert Parish of the Boston Celtics, c.1983-86. w/c. 17in. x 26in. *Naismith Memorial Basketball Hall of Fame, Springfield, Massachusetts, USA.*

McDonald, Tommy. A portrait of James Naismith, 1980. 14in. x 18½in. This painting was commissioned by the Hall of Fame. *Naismith Memorial Basketball Hall of Fame, Springfield, Massachusetts, USA.*

***Neiman, Leroy.** Untitled, Collegiate game action between St. John's University (NY) and the University of Kentucky, 1978. Acrylic. 27in. x 36¼in. *Naismith Memorial Basketball Hall of Fame, Springfield, Massachusetts, USA.*

Billiards and Snooker

***Bateman, Henry Mayo** (1887-1970). 'A Good Leave', s. & d. 1921. 13in. x 8¼in. *Christie's. (See also* lawn tennis.)

***Béraud, Jean** (1849-1936). 'La Partie de Billard'. 13in. x 19in. *Richard Green Gallery, London.*

Boardman, S.R. (op.1940s). 'The Sergeant Major Playing Snooker'. Ink and blue wash. *Christie's.*

Bunbury, William Henry (1750-1811). Exhibited a billiards painting at the RA in 1784. A print after this painting, or another similar, entitled 'The Billiard Player', pub. Watson & Dickinson of 158 New Bond Street, London, 15th November, 1780. *Clare-Padmore-Thurston Group of Billiard Table Manufacturers.*

***Cook, Beryl.** 'Bar Billiards', signed and dated, 1978. 26in. x 30in. *Bonhams.*

Cruikshank, George (1792-1878). 'April — The Finishing Touch'.

***Cundall, Charles, RA, RWS, RSMA, NA, NEAC** (1890-1971). 'Thurston's Leicester Square Match Hall', s. & d. 1938. *Clare-Padmore-Thurston Group. (See also* Association football, cricket.)

***Davis, Lucien, RI** (1860-1941). This artist created many billiards sketches for the *Badminton Library Series* published during the 1880s. *Clare-Padmore-Thurston Group.* A number of billiards prints were made in 1896. *(See also* Association football, cricket, fives, golf, hockey.)

Degas, Edgar (1834-1917). 'The Billiard Room at Menil-Hubert', c.1892. 25½in. x 31¾in. *Staatsgalerie Stuttgart.* Degas painted two versions of the billiard room at Menil-Hubert, the château home in Normandy of his childhood friends, the Valpinçons.

Dighton, Joshua (op.1820-1840). 'A Game of Billiards', signed. 9in. x 13¾in. *Sotheby's.*

Dighton, Robert (1752-1814). A print after his billiards painting, pub. R. Sayers, 53 Fleet Street, London. *(See also* Association football, cricket, fives, rackets.)

Giles, James William, RSA (1801-1870). This artist painted a w/c of the billiard room complete with resplendent billiard table at Old Balmoral Castle in 1855. 12in. x 18in. (Repro. in *Queen Victoria's Life in the Scottish Highlands* by Delia Miller, pub. Phillip Wilson 1985). The billiard room also doubled up as the library and was only 32ft. x 17ft. The Queen complained that she and the Duchess of Kent were forever having to get out of their chairs 'to be out of the way of the cues'.

***Hamilton, John.** Corny, comic, Continental billiards scenes, but well painted (c.1920s). 10in. x 16in. *The Wingfield Sporting Gallery, London.*

James, P.F. Portraits of members of the Press Club playing billiards. *Burlington Gallery, London.*

Johnson, James. 'Playing billiards in the long gallery', c.1940. *Sir William Bromley Davenport, Bt.*

Lambert, E.F. (op.1823-1850). A billiards etching, engraved by G. Hunt, 1827.

Landseer, Sir Edwin Henry, RA (1802-1873). 'The Snooker Player', signed with mono. Pen and ink. 4in. x 5in. *Phillips. (See also* cricket, croquet.)

***Lees, Derwent, NEAC** (1885-1931). 'The Billiard Hall', 1914. 16in. x 24in. *Sotheby's.*

***Longstaff, Capt. John** (op.1891-1920). 'Portrait of Walter Lindrum' (the professional billiard player who became so famous during the 1920s and '30s). 50in. x 40in. *Clare-Padmore-Thurston Group.*

***McInnes, Jos.** 'A Snooker Match'. 11¾in. x 18¾in. *The Wingfield Sporting Gallery.*

***Mortimer, John Hamilton, ARA** (1741-1779). 'The Reverend Charles Everard and two others playing Billiards'. *National Trust, The Bearsted Collection. (See also* real tennis.)

Oldenburg, Claes (American, b.1929). 'The Billiard Table', 1967, signed. Coloured felt marker. 14½in. x 17¾in. *Christie's.*

***O'Neil, Henry Nelson, ARA** (1817-1880). 'Billiard Room of the Garrick Club'. 37½in. x 61in. *Garrick Club, E.T. Archive Ltd.*

***Pyne, William Henry** (1769-1843). Print after his painting of 'Billiards', engraved by G. Hunt. *British Museum.*

Rogers, W.G. Irish artist who painted an amusing billiards scene in w/c, s. & d., '09. *Burlington Gallery, London.*

Rowlandson, Thomas (1756-1827). 'The Billiard Table'. A print after this painting was pub. by Ackermann. *(See also* cricket, rackets.)

***Shakespeare, Percy** (1907-1943). 'Billiards in the Officers' Mess of H.M.S. Vernon' (a land based training college), signed. 28in. x 36½in. *Sotheby's.*

***Spear, Ruskin, CBE, RA** (b.1911). 'Alex Higgins Playing a Snooker Shot'. 15in. x 18in. *Sotheby's. (See also* Association football, cricket.)

Strutt, Rosa Jameson (1861-1938). 'Kittens at Play on a Snooker Table', signed. w/c. 13½in. x 25½in.

***Thackeray, Lance, RBA** (d.1916). Painter, illustrator and writer who specialised in sporting subjects often of a humorous nature. Became well known for his set of billiard room scenes showing both men and women at play at the turn of the century. Set of four prints after the work of this artist. *Clare-Padmore-Thurston Group.*

***Unknown artist.** 'Portrait of Edwin Kentfield'. *Clare-Padmore-Thurston Group.*

***Van Gogh, Vincent** (1853-1890). 'Le Café de Nuit'. *Yale University Art Gallery, Bequest of Stephen Carlton Clark.*

van de Venne, Adriaen (Dutch, 1589-1662). 'A Game of Billiards', c.1625. One of the earliest representations of the sport. Van de Venne painted the billiards game as one of 102 miniatures which were made into an album representing a panorama of contemporary life in Holland which includes several games and sports *(see also* golf). The album was probably presented in 1626 to the Prince of Orange, Frederick Hendrick, by his nephew the so called Winter King of Bohemia. Both he and the Prince appear in the album several times and were both keen sportsmen. The album came to the British Museum from the collection of the Earls Spencer at Althorp in Northamptonshire where it had been since the 18th century. *The Trustees of the British Museum.*

Ward, Sir Leslie Matthew 'Spy' (1851-1922). Grandson of the sporting artist James Ward RA (1769-1859). Three *Vanity Fair* cartoons of billiards players: 'The Champion', Mr. John Roberts; 'He might be', a portrait of H.W. Stevenson; 'The French Republic', a portrait of Jules M. Grevy. *(See also* cricket, golf.)

*Werner, Carl Friedrich Heinrich, RI
(1808-1894). A Continental billiards game,
s. & d. 1861. 9in. x 13¼in. *The Wingfield
Sporting Gallery, London. (See also* cricket.)

Cricket

Alken, Samuel Henry (Gordon) (1810-
1894). Known as Henry Alken, jun., he
was the eldest son of the sporting artist
Henry Thomas Alken, sen. 'The cricket
match between the Greenwich and Chelsea
Hospital Pensioners'. w/c. 9¼in. x 4½in.
MCC Collection.

*Allan, David** (1744-1796). 'The Cathcart
Family', c.1784-5. 47½in. x 61½in. *Royal
Academy of Arts and the Cathcart Family.*

*Alleyne, Francis** (op.1774-1790). 'Portrait
of William Wheatley', 1786. Oval. 14in.
11in. *MCC Collection.*

Allinson, Adrian Paul, ROI, RBA, LG, PS
(1890-1959). 'Backyard cricket at Stoke on
Trent'. *MCC Collection. (See also* Association
football).

*Almond, Mr.** 'Lumpy Stevens', 1783.
Oval. 11½in. x 9½in. *Courtauld Institute of
Art and Lord Sackville.* Mr. Almond appears
to have been an itinerant artist who painted
a number of small portraits of the servants
of the 3rd Duke of Dorset at Knole, Kent,
which he visited in 1783.

Anderson, John Corbet (1827-1907). Attrib.
'Thomas Barker of Nottingham', c.1845.
21in. x 16½in. Umpire and groundsman
of the MCC standing in black coat and
brown trousers on a cricket field.

Appleyard, Joseph (1908-1960). 'The Fourth
Test Match at Headingley March/July
1953'. 24in. x 35¾in. Exh. Yorkshire Artists,
1953 (No.64a). *Anderson and Garland, Tyne
and Wear.*

*Arnesby-Brown, Sir John Alfred, RA**
(1866-1955). 'Waiting to hear the results of
the great Notts. v. Surrey match, August
1892', signed. 9½in. x 10½in. *Sotheby's.*

Aveling, H.J. London portrait and figure
painter who exhibited five pictures at SS
1839-1842 including one of a cricket match
played by members of the Royal Amateur
Society at Hampton Court Green, 3.8.1836.

Barker, Thomas Jones, of Bath (1815-
1882). 'A Cricket Match at Pontypool,
Monmouthshire'. 14in. x 25in. *Spink and
Son Ltd.* Repro. *Country Life*, 26.7.1984.

Barraud, Francis James (1856-1924).
'Rossall School, view from the cricket
field'. *Christie's.* This artist, the son of
Henry Barraud, the equestrian and cricket
playing artist, is perhaps best known for his
painting of 'Nipper' the terrier which
belonged to his brother Mark, a scenic
artist, which was used for years as the
symbol of 'His Master's Voice'.

Barraud, Henry (1811-1874). 'Portrait
Group of Members of the MCC outside the
Pavilion at Lord's', c.1870-74. 28in. x 60in.
Museum of London.

Barrable, George Hamilton (op.1873-87)
and **Ponsonby-Staples, Sir Robert, Bt.**
(1853-1943). 'England v. Australia at Lords',
1886. 58in. x 117in. *MCC Collection.*

Barron, Hugh (1747-1791). 'The Children
of George Bond of Ditchleys, South Weald
Essex Playing Cricket', s. & d. 1768.
41¾in. x 55in. *Tate Gallery.* This is probably
the painting that Barron exhibited at the
RA in 1768 entitled 'Young Gentlemen at
Play'.

*Batson, Frank** (op.1892-1904). 'Playing out
time in an awkward light'. 48in. x 72in. Exh.
RA, 1901. *Nottinghamshire County Cricket Club.*

Baxter, Thomas (1782-1821). A portrait of
Honest Baxter of the Surrey Cricket Club
as a young cricketer holding his bat on
Richmond Green. *Sotheby's.* Baxter was a
porcelain painter at Worcester and Swansea
who ran an art school in London 1814-
1816; when he returned to Worcester he
exhibited 16 works at RA between 1802-
1821.

*Beach, Thomas** (1738-1806). 'Mr. and
Mrs. Thomas Tyndall of The Fort, Bristol
and their children', 1797. 104in. x 74in.
Witt Library, Coutauld Institute.
'The children of Sir John William de la
Pole', s. & d., 1793. 79½in. x 55½in. Exh.
RA, British Art 1934. *Collection of Sir John
Carew Pole, Bt.*

*Beechey, Sir William, RA** (1753-1839).
'The Revd. Lord Frederick Beauclerk as a
boy'. 28¾in. x 23¼in. *MCC Collection.*

*Beerbohm, Sir Max** (1872-1956). 'W.G.
Grace'. Pen and ink sketch. 8in. x 12¾in.

Blake, William (1757-1827). Illustrations
for his books of poems *The Echoing Green I
and II, Songs of Innocence* (1789) and *Songs of
Innocence and Experience* (1820s).

Boitard, L.P. (op.1737-1763). An engraving
of a 'Match Ticket for 18th June 1774'.
MCC Collection.

*Bough, Samuel, RSA** (1822-1878). 'Cricket
Match at Edenside, Carlisle', c.1850. 24in.
x 35in. *Carlisle Museum and Art Gallery. (See
also* golf, lawn bowls.)

Bowyer, William, RA. Portrait of Richard
Hadlee in the art of batting. Exh. RA
Summer Exhibition, 1988 (No.49).
'The Bicentenary match between the MCC
XI and the rest of the World XI', signed
and dated, 1987. 39in. x 59in. *MCC Collection.*
*'Botham', 1985, s. & d. '85. *William Bowyer.*

Brock, Charles Edmund, RI (1870-1938).
Illustrated Miss Mary Mitford's book *Our
Village (see* text and also golf).

Bradley, Edward (op.1824-1867). 'Durham'.
A cricket match in a field with Durham
Cathedral and Castle to the right. s. & d.
1849. Pen and some bodycolour on white
paper. 14½in. x 11½in. *MCC Collection.*
On the cricket ground the highly decorated
tents represent The Gentlemen of the
University. The All England Eleven and
the third is that of the Durham Club. The
sketch is taken from the small hill in Pellew
Wood.

Bromley, Valentine Walter (1848-1877).
London portrait painter, watercolourist
and illustrator who painted several cricket
celebrities. 'Portrait of George Parr',
c.1850. 59½in. x 44½in. *MCC Collection.*
Exh. 'British Sporting Paintings', Hayward
Gallery, London (1974); George Parr

(1826-1891); 'The Lion of the North' was
in succession to Fuller Pitch, the first batsman
in England and was one of the greatest of
all Nottinghamshire cricketers. 'At the
Eton and Harrow Match', c.1878. Engraving.

*Brooker, Harry** (op.1895-1918). 'The Game
of Cricket', s. & d. 1904. 27½in. x 35½in.
Royal Exchange Art Gallery, London.

*Brookes, Peter.** Cricket illustrator of
England, Their England, by A.G. Macdonell,
pub. Folio Society 1986. *The Folio Society.*

Brooks, Henry Jamyn (op.1890-1909). 'Rugby
School — New Big Side Cricket'. An
engraving after this work by F.G. Stevenson
dated 1890, 21in. x 14in., is recorded in
British Prints, Ian McKenzie, Antique
Collectors' Club, 1988. (See also polo).

Brown, Ford Madox (1821-1893). 'Humphrey
Chetham's Life Dreams', 1886. Wall
painting, Great Hall, Manchester Town
Hall.

Brown, J. 'Cricket Match at Stonehenge',
s. & d. 1830. w/c. 12in. x 17in. *Salisbury and
South Wiltshire Museum.*

*Bruce, Ralph.** 'Tourists opening match at
Worcester, 1954', signed. *Wiggins Teape
Group.*

Buck, Adam (1759-1833). 'Portrait of Master
Edward Currie holding a cricket bat', s. &
d. 1830. w/c. 10¾in. x 8½in. *Sotheby's.*

Burgess, William (1805-1861). 'Kent v.
All England at Canterbury, 1845'. Coloured
lithograph. 13½in. x 19½in.

*Burney, Lt. James.** 'Students playing
cricket at the Royal Naval Academy,
Gosport' (Cold Harbour). w/c. 14in. x
21½in. *Rutland Gallery, London.*

Burr, Alexander Hohenlohe (1835-1899).
'A Game of Cricket — Youth and Age'.
18in. x 26in. *Harvert Consultancy (Holdings)
Ltd., Dundee. (See also* battledore).

*Calderon, Philip Hermogenes, RA** (1833-
1898). 'Captain of the Eleven', 1898. Exh.
posthumously at the FAS 1907. *Thames County
Primary School, Blackpool.*

Chalon, Alfred Edward (1780-1860). 'John
Talbot Clifton with a cricket bat', s. & d.
1834. w/c. 20in. x 16in. *Lytham Hall
Collection.* J.T. Clifton was born in 1819,
the eldest son of Thomas Clifton, Squire of
Lytham; J.T. Clifton became Squire on his
father's death in 1851 and was MP for
North Lancashire.

Childe, James Warren (1778-1862). 'Two
Young Cricketers', 1817. Miniature. 7in.
x 5½in.
'A Cricket Match', c.1740-5. 19¼in. x
23¼in. *Tate Gallery.*

Cole, J. (after Hubert Gravelot). 'The second
Part of Youthful Diversions'. Engraving.
13in. x 17in. Lettered, engraved and sold by
J. Cole, pub. 7.5.1739.

*Collet, John** (c.1725-1780). 'Miss Trigger
and Miss Wicket', c.1780. Mezzotint.
13in. x 10in. *MCC Collection.* Part of a
series of sports that Collect painted entitled
'Ladies Recreations'; some of the original
paintings survive, all were mezzotinted and
published by Carrington Bowles in 1788.
(See also lawn bowls).

Collier, The Hon. John (1850-1934). 'Portrait of A.N. Hornby Esq. Captain of The Lancashire Eleven', 1893. *Blackburn Museum and AG.*

*Cooper, Alfred Egerton, RBA, ARCA (1883-1974). 'A Cricket Match at Lords', s. & d., 1938. 26½ in. x 59¼ in. *Sotheby's.*

Copley, John Singleton, RA (American 1738-1815). 'Richard Heber as a Boy'. 65¼ in. x 51³/₁₆th. *Yale Center for British Art, Paul Mellon Collection.*

Cotes, Francis, RA 1726-1770). 'Lord Lewis Cage of Millgate Park Maidstone Kent', aged 15 holding a curved cricket-bat with a two stick wicket and a ball to the left. 66½ in. x 43½ in. *Collection of The Lord Brocket.* A coloured mezzotint, 21½ in. x 14½ in., by L. Busiere after this work was pub. by Graves 1929. Exh. Parker Gallery, London 1950.
'The Revd. Charles Collyer as a Boy'. 35¾ in. x 27⅜ in. *Yale Center for British Art, Paul Mellon Collection.*

Crombie, Charles E. (1885-1967). Illustrated *The Laws of Cricket*, 1906. (*See also* golf.)

Cruikshank, Isaac Robert (1789-1856). 'North east view of the Cricket grounds at Darnall, Near Sheffield, Yorkshire', dated 1827. Pen and brown ink. Darnall was an important ground for about four years, from 1825, but it failed financially, probably because it was too far from Sheffield (three miles). After 1829, no important matches were played there. *British Museum Collection.*

Cundall, Charles, RA, RWS (1890-1971). 'A Hastings Cricket Festival', s. & d. 1953. 50in. x 30in. *Collection of Hastings Borough Council on loan to the Museum & AG.*
*'The Test Match', s. & d. 1938. 42in. x 60in. *MCC Collection.* (*See also* Association football, billiards.)

Curtis, John Digby (op.1790-1827). 'A Cricket Match at Newark-on-Trent, 1823. 22in. x 36in. *MCC Collection.*

Cutler, Cecil E.L. (op.1886-1934). Putney based artist who painted a number of fine portraits and racing scenes. He produced a w/c portrait of W.G. Grace, s. & d. 1895. 10in. x 8in. *Burlington Gallery, London.*

Dagley, Richard (1765-1841). 'Benjamin Disraeli at the Wicket'. 21½ in. x 11⅜ in. *MCC Collection.*

Danloux, Henri Pierre (1753-1809). 'The Masters Foster', s. & d. H. Danloux f ano 1792. 45½ in. x 37½ in. *Private Collection.*

*Davis, Lucien, RI (1860-1941). 'Bonnor [George John Bonnor — 1855-1912] stood still at the Crease at Lords, Sherman [Tom Sherman — 1825-1911] keeping wicket'. Grisaille. 9in. x 6in. Original illus. for July/December issue of *Badminton Magazine*, 1896. *The Wingfield Sporting Gallery, London.* This artist illustrated all the cricket articles written by A.C. Coxhead for this publication. (*See also* Association football, billiards, fives, golf, hockey.)

Davis, Richard Barrett, RBA (1782-1854). 'Landscape with Children Playing Cricket', s. & d. 1827. 18in. x 21in. Present whereabouts unknown.

de Wint, Peter (1784-1849). 'The Cricketers', c.1815. w/c. 22¼ in. x 34¾ in. *V & A.*

Deykin, Henry Cotterill (b.1905). 'In recognition of their work', a study of the men behind the scenes, groundsmen and their equipment (Leamington Cricket Ground) August 1951. Signed. 19½ in. x 23½ in. *Sotheby's.* Previously in the collection of the late Geoffrey Pugh, the Club Captain.
'Cricket on Frenchay Common, Nr. Bristol', Frenchay Cricket Club v. Clifton Cricket Club, 8th August 1950. Signed. 17½ in. x 25½ in. *Sotheby's.*
*'Lords. England v. West Indies, 2nd Test match of the 1950 series', May 1950, signed. 19½ in. x 23½ in. This is already a period piece, since there are several more large stands and the older ones have gone, including the one in the foreground.
'Country house cricket at Ascot Park, Warwickshire. Coventry Hobos v. Ascot Park', signed. 19¾ in. x 23¾ in. *Sotheby's.*
'Leamington Cricket Club v. Free Foresters at Leamington, 1949', signed. 20¼ in. x 24¼ in. *Sotheby's.* Previously in the collection of the late Geoffrey Pugh, the Club Captain. (*See also* Association football, croquet, golf, hockey, lacrosse, lawn bowls, lawn tennis, polo, Rugby football.)

*Dickinson, Lowes Cato (1819-1908). 'Portrait of Sir Spencer Ponsonby-Fane, founder of the I. Zingari Cricket Club, with a cricket match in the background. Signed. 52in. x 38in. *Sotheby's.*

Dighton, Robert (1752-1814). 'Cricket played by the Gentleman's Club, White Conduit House', 1784. Engraved by an unknown engraver. Etching and aquatint. *British Museum Collection.* (*See also* Association football, billiards, fives, rackets.)

Dodd, Joseph Josiah (1809-1880). 'The Cricket Match at Tonbridge School'. A lithograph after this work by W.L. Watson, 20in. x 31¾ in., is recorded (*British Prints*, by Ian McKenzie, pub. Antique Collectors' Club, 1988).

Drew, Mary (op.1880-1901). 'A Woolwich Cadet (?) in a Cricket Cap', c.1890. *Private Collection.* (*See also* badminton.)

Drummond, William (fl.1830-1865). 'A Young Batsman', s. & d. 1848. Pencil and w/c. 18¼ in. x 12½ in. *Sotheby's.*

East, Sir Alfred, RA, RI, PRBA, RE (1849-1913). 'The Cricket Field, Stratford on Avon'. *Christie's.*

Edridge, Henry, ARA (1769-1821). 'A Young Cricketer'. Pencil and w/c. 14¾ in. x 10¼ in. *Private Collection.*
'Philip Wodehouse at the age of 13', s. & d. 1802. Pencil and grey wash. 13in. x 9in.

English School.
*'A Young Cricketer', c.1830. 11¾ in. x 9½ in. *The Wingfield Sporting Gallery, London.*
*'A Cricket Match at Canford Manor, Dorset'. 18½ in. x 29in. *Lord Wimborne.* Repro. in *A Country House Companion* by Mark Girouard, pub. Century Hutchinson Ltd., London 1987.

Evans, William, RWS (1798-1877). 'Cricket on College Field, Eton'. w/c. 26in. x 37in. *Eton College.* (*See also* curling, Eton Wall Game).

Eyre, Edward (op.1771-1798). 'The Cricket Match', c.1798. w/c. 7¾ in. x 10½ in. *Sotheby's.* The match represented is said to be that played between Kingscote Club and eleven gentlemen of Oxford on 7.8.1788, for 100gns. at the Kingscote ground, Sussex. Kingscote won by six notches (scoring being recorded at this time by notches cut in a stick). Very little is known about this Sussex artist except that he exhibited 15 landscapes at the RA 1771-1776.

Fearnley, Alan (contemporary artist). 'The County Cricket ground at Taunton'. *Somerset County Cricket Club.*

Fisher, William Mark, RA, RI, NEAC (1841-1923). 'Village Cricket' (No.154). Exh. at the XIVth Olympiad Competition and Sport in Art Exhibition at the V & A, London, 1948.

Foster, Myles Birket, RWS (1825-1899). 'Landscape with a Cricket Match in Progress'. 13¾ in. x 5½ in. *Sotheby's.*

Gainsborough, Thomas, RA (1727-1788). 'John Frederick Sackville, 3rd Duke of Dorset', 1782. 30in. x 25in. *Collection of Lord Sackville, Knole Park.*

Gardner, Daniel (1750-1805). 'Frederick Francis Baker', c.1780. Gouache and pastel. 20in. x 16in. *Private Collection.*
'The Rumbold Family'. Gouache and pastel. 43¾ in. x 31½ in. *Private Collection.*

Garland, Henry (op.1854-1890). 'The Winner of the Match: Excelsior Cricket Club, Islington', s. & d. 1864. 31in. x 53in. *MCC Collection.*

Goodall, John Strickland, RI, RBA (b.1908). 'Cricket'. An original w/c from *An Edwardian Summer*, pub. Macmillan, London.

Gore, Spencer Frederick (1878-1914). 'The Cricket Match', s. & d. 1909. 16in. x 18in. *City of Wakefield Metropolitan District Council.*

Grant, Duncan James Corrowr, LG (b.1885). 'A County Cricket Scene', mid-1950s. w/c. 9in. x 13in. *Bill Minns.*

Grant, Francis, Sir, PRA (1803-1878). 'Cricketing Scene'. Pen and wash. Present whereabouts unknown. (*See also* golf.)

Haddon, David W. 'Four of the Eleven'. (boys playing cricket), signed and inscribed. 7in. x 9in. *Sotheby's.*

Hall, Sydney Prior (1842-1922). 'Eton v. Harrow Match at Lords — a Boundary Hit'. Repro. in *The Graphic*, 22.7.1899.

Hardie, Charles Martin (1858-1916). Scottish portrait painter who exhibited a portrait of a boy playing cricket at the RSA in 1896. (*See also* curling.)

*Hayman, Francis, RA (1708-1776). 'Cricket in Mary Le Bone Fields'. 34in. x 43in. *MCC Collection.*

'Henwood, Thomas (op.1842-1854). 'The Scorer', 1842. 14in. x 12in. *MCC Collection.*

*Hicks, George Elgar (1824-1914). 'Three young Cricketers', 1883. 113½ in. x 84in. *The Witt Library, Southampton City AG.*

Highmore, Joseph (1692-1780). 'The Rev'd John Duncombe', s. & d. Jos: Highmore/ pinx. 1766. 30in. x 25in. *The Master's Lodge, Corpus Christi College, Cambridge.*

Horton, Miss Etty (op.1892-1903). Exh. two paintings at SS in 1892 and 1893, one of which may have depicted a cricket scene entitled 'Stumped'.

*****Hudson, Thomas** (1701-1779). 'Mrs Mathew Michell and her children', c.1757-58. 76in. x 64in. *Leicestershire Museum and AG.*

Hunt, William Henry, RWS (1790-1864). 'The Boy Batsman'. w/c. 15½in. x 10in. *MCC Collection.*

James, Robert (1809-1853). 'Tossing for Innings', c.1843. 35¼in. x 57in. *MCC Collection.*

Jeffreys, William (1723 or 1730-1805). 'Cricket at the Free School Maidstone'. Pen and wash. *Maidstone Public Library.*

Jellicoe, John F. (op.1865-1903). London illustrator and minor sporting artist whose 'Cricket for Ladies', 9½in. x 13in., was pub. in *The Sporting & Dramatic News.*

Joy, Thomas Musgrave (1812-1866). This artist painted 'A Cricket Match at Christchurch', from which a print was taken.

*****Kinsella, E.P.** German artist of cricket subjects at the turn of the century: 'The Hope of His Side', c.1900, signed. w/c. 13in. x 8½in. *Christie's.*

Kirby, Thomas (op.1796-1847). 'Portrait of Pierce Wynne Yorke' (1826-1891) of Erdigg Hall standing full length in a brown coat and white breeches holding a cricket bat. 51¼in. x 39½in. *Christie's.*

Koehler, Henry (American, b.1927). 'Cricket at Hurlingham', s. & d. 1986. 12in. x 24in. *Patridge Fine Art, London.* Painter of many sports subjects. (*See also* lawn bowls, polo).

La Dell, Edwin, ARA, RBA, ARCA (1914-1970). 'Lords', 15½in. x 22½in.. *Sotheby's, Sussex.*

Landseer, Charles, RBA (1799-1879). Attrib. 'The Duke of Wellington batting, with the Three Graces at the Wicket'. Etching. 3in. x 5in. *MCC Collection.*

Landseer, Sir Edwin Henry, RA (1802-1873). 'Lords'. 11⅞in. x 7¼in. *Formerly MCC Collection.* (*See also* billiards, croquet.)

Laporte, George Henry (1799-1873). 'Lords Cricket Ground'. An engraving after this work, 5in. x 7in., by Ebenezer Stalker, is recorded (*British Prints*, by Ian McKenzie, Antique Collectors' Club, 1988).

Linnell, John, sen. (1792-1882). 'The Game of Cricket', s. & d. 1874. 27½in. x 38½in. *Christie's.*

Lobley, Robert (contemporary artist). 'Cricket on Kew Green', signed. w/c. 10in. x 13in. *The Wingfield Sporting Gallery, London.* Articles noting this artist's ability to capture the atmosphere of British sporting life have appeared in both *Country Life* and *The Field*, written by Nicholas Usherwood.

Ludovici, Albert, RBA (1820-1894). Portrait of a bearded cricketer (not W.G. Grace), s. & d. '79. 17in. x 21in. *Phillips.*

Marshall, Herbert Menzies (1841-1913). 'Cricket at Lords'. Marshall was Professor of Landscape at Queens College, London at the turn of the century.

Martin, David (1737-1797). 'John Campbell of South Hall', s. & d. 1771. 66½in. x 53¾in. Present whereabouts unknown.

Mathews, James (op.1880-1905). 'A Game of Cricket', s. & d. 1901. 5¾in. x 7½in. *Chris Beetles Ltd., London.* This Sussex painter was working towards the end of the 19th century in a style similar to Helen Allingham.

*****Metz, Conrad Martin** (1749-1827). 'Portrait of two boys dressed for cricket, one holding a bat in a wooded landscape', s. & d. 1776. 36in. x 20in. *Sotheby's.*

Miller, James (attrib.) (op.1773-1791). 'Carmalt School, Wandsworth Lane, Putney', c.1790. w/c. 11¾in. x 19¼in. *Museum of London.*

Morgan, John, RA, RBA (1823-1886). 'Ginger Beer', 40in. x 27in. *Sotheby's.* 'The Fight in the Country', s. & d. 1869. 27in. x 41in.

Morris, Richard (op.1830-1844). 'The Regents Park', dated 1831. Brown wash over etching. 4⅞in. x 18⅞in. Pub. by R. Ackermann. *Museum of London.*

Muirhead, David Thomson, ARA, ARWS, NEAC (1867-1930). 'The Cricket Match', s. & d. 1926. 20in. x 26¾in. *Phillips.*

Murray, Sir David, RA, RSA, RSW, RI (1849-1933). 'Cricket on the Village Green', at Pulborough, Sussex, s. & d. '91. 12in. x 14in. *Rutland Gallery, London.*

Nelson, Edmund Hugh (b.1910). Portrait painter, the brother-in-law of E.W. Swanton whom he depicted in a typically sporting pose, 1950. He also painted portraits of the author E.M. Forster at King's College, Cambridge and the historian G.M. Trevelyan for Trinity College, Cambridge.

Nelson, Phyllis. 'Farnham Cricket Ground from the West', s. & d. '51. 6¾in. x 7in. *Sotheby's.*
'Cricket at Maidstone, Kent', s. & d. 1969. 26in. x 12¾in. *Bonhams.*

*****Newton, Algernon Cecil, RA** (1880-1968). 'A Cricket Match at Bournville 1929', s. & d. 38½in. x 50½in. *Cadbury Schweppes.*

Nicholson, Sir William (1872-1949). 'A Cricketing Jug', signed bottom right with a monogram. Formerly in the artist's possession. Nicholson was also known for his *Almanack of Twelve Sports* (1898) in which the month of June is represented by a portrait of Alfred Mynn (1807-1861), the great Kent and England all-rounder.

Nixon, John (1760-1818). 'Harwich with a game of Cricket in progress', s. & d. 1785. Pen, grey ink and w/c. 4⅛in. x 7in. Inscribed 'Harwich'. Present whereabouts unknown.

Ouless, Walter William, RA (1845-1933). 'Portrait of A N Hornby Esq., Capt. of the Lancashire Eleven', 1900. 56in. x 41in. *Lancashire County Cricket Club.*

Payne, Arthur Frederick (1831-1910). 'A Cricket Match at Cowley, Oxford', June 1857. w/c. 5½in. x 7½in. *Private Collection.*

Payne, David (op.1882-1891). 'Cricket in Abberley Valley', s. & d. 1890. 28in. x 42in. *Sotheby's, Chester.*

*****Penny, Edward, RA** (1714-1791). 'Portrait of Sir William Benett', of Farnham, c.1743-44. 20in. x 14in. *Laing Art Gallery and Tyne and Wear Museum Service.*

Perry, Roy, RI (b.1935). Distinguished watercolourist of cricket scenes and a series of famous cricket grounds painted for the clubs from which prints were commissioned. *The Wingfield Sporting Gallery, London.*

Pine, Robert Edge (1742-1788). 'Portrait of the Rev. Robert Waugh' (1767-1810) standing full length with a cricket bat and ball in a landscape. 51in. x 40½in. *Christie's.*

Pissarro, Camille (1830-1903). 'Cricket on Hampton Court Green', s. & d. 1890. 21½in. x 29in. *The Ailsa Mellon Bruce Collection, National Gallery of Art, Washington.* 'Cricket at Bedford Park', s. & d. 1897. 21in. x 26in. *Jeu de Paume, Paris.*

Pollard, James (c.1792-1859). 'A Cricket Match at Copenhagen House, Islington'. 9¼in. x 11¾in. Present whereabouts unknown.

*****Pretty, E.** (op.1809-1811). 'Rugby School as it appeared in the year 1809', showing the boys playing cricket. Hand coloured etching aqua. by R. Reeve, pub. by E. Pretty (drawing master), June 1811. 10¼in. x 18¼in. *Christie's.*

*****Rickards, S.T.** (fl.1819). 'A Cricket Match, School House, Harrow'. w/c. 8¾in. x 12¼in. Engraved by W. Nicholls 1819, but the engraving does not include the boys playing cricket. *Sotheby's.*

*****Reid, John Robertson, RI, ROI** (1851-1926). 'A Country Cricket Match in Sussex', s. & d. '78. 42in. x 71in. *The Tate Gallery.*

Ritchie, John (op.1858-1875). 'Village Cricket', s. & d. 1855. 31½in. x 49¼in. *MCC Collection.*

Roberts, H. (op. 1737-1763). (After Louis P. Boitard). 'An Exact representation of the Game of Cricket'. Engraving, 1743. *MCC Collection.*

*****Roller, George, RPE** (op.1887-1896). 'Portrait of W E Roller going out to bat', signed. 96in. x 57½in. *Surrey County Cricket Club.*

*****Rowlandson, Thomas** (1756-1827).
*·'Rural Sports', or 'A Cricket Match. Extraordinary'. w/c. 9in. x 14in. *MCC Collection.*
'Cricket in White Conduit Fields', c.1790. Pen and w/c. *MCC Collection.* (*See also* billiards, rackets.)

Russell, John, RA (1745-1806). 'The Revd. John H. Chandler as a Boy', 1767. 49in. x 39in. *Private Collection.*
'The Sons of Thomas Pitt', s. & d. 1804. Pastel. 30in. x 25in. *Private Collection.*

Sablet, Jacques (1749-1803). 'Thomas Hope of Amsterdam playing Cricket at Rome', s. & d. 1792, inscribed 'Roma'. 24½in. x 19¾in. *MCC Collection.*

Sandby, Thomas (1721-1798). 'Cricket in front of an old mansion'. w/c. 13½in. x 21in. *Nottingham Castle Museum and AG.*

Scaddon, Robert (op.1743-1774). 'William Rice', s. & d. 1744. 59in. x 42½in. *MCC Collection.*

Schwanfelder, Charles (1773-1837). 'William and Charles Chadwick at Burley Lodge', s. & d. 1824. 39⅜in. x 33⅜in. *Temple Newsam House and AG, Leeds.*

Shelley, Samuel (c.1750-1808). 'Two Children'. 4in. x 3½in. Miniature oval. Present whereabouts unknown.

Shepheard, George (c.1770-1842). 'Twelve cricketers in Characteristic Studies', c.1795? Pen and wash. 8in. x 10in. *MCC Collection.*

Shepherd, Thomas Hosmer (1792-1864). 'Pensioners Hall, Charterhouse', c.1830. Brown wash and pencil. 3⅝in. x 5⅝in. *Museum of London. (See also* real tennis.)

Smith, Jane Sophia Clarendon, NWS (op.1858-1877). 'Four Children in a Summer Landscape', s. & d. September 1869. w/c. 19in. x 25in. Present whereabouts unknown.

*****Spear, Ruskin, CBE, RA** (b.1911). 'Portrait of F.S. (Fiery Fred) Trueman', 1963. 82in. x 26½in. *MCC Collection. (See also* Association football, billiards.)

Spooner, Arthur, RBA (1873-1962). 'The First Test Match — Tea Interval, Trent Bridge', s. & d. 1938. 36½in. x 57in. Exh. at the RA 1941. No.565. *Christie's.*

*****Stampa, George Loraine** (1875-1951). 'the Field, "ow's that?'' The Umpire, (throwing in the ball) ''Hout'', s. & d. 1925. 10in. x 14½in. *The Wingfield Sporting Gallery, London.*

Streatfield, Robert (1786-1852). 'Cricket at Spa, Belgium', c.1840. w/c. 4½in. x 8in. *Collection of William Drummond, Esq.*

Stuart, Gilbert (American, 1755-1828). (Attrib.) 'Portrait of young Master Day holding a Cricket Bat'. *Christie's.* Abraham Cooper painted later members of the Day family in 1838.

Tayler, Albert Chevallier, RBC (1862-1925).
*****'Eton v. Harrow at Lords, 1886'. *MCC Collection.*
A collection of 14 studies of cricketers, including portraits of J. Rhodes and N. Denholm Davis. These studies were part of a series of 48 drawings for Tayler's *The Empire's Cricketers* published by the Art Society in 1905 in weekly parts with a text by the cricketer and action photographer George W. Beldham. *Sotheby's, Sussex.*

Toynbee, Lawrence (b.1922). 'Cricket in the Parks Oxford', 1953, and 'Hit to Leg'. *MCC Collection. (See also* Association football and squash.)

*****Tuke, Sir Henry Scott, RA, RWS, NEAC** (1858-1929). 'W.G. in Ranjitsinhji's turban, at dinner, May 19 1908, at Shillinglee Park, Sussex', signed. w/c. 9½in. x 6¾in. *Christie's. (See also* Rugby football.)

Turner, Joseph Mallord William, RA (1775-1851). 'Wells Cathedral with a Game of Cricket', c.1795. w/c. 16in. x 21in. *The Lady Lever AG.*

Unsworth, Peter. Contemporary artist of cricket paintings.

Valentine-Daines, Sherree, UA, SWA (b.1956). 'England v. Australia. Old Trafford 1985', signed. 35in. x 18in. The reverse inscribed with 23 signatures of the players. On loan to the MCC Collection. *The Wingfield Sporting Gallery, London. (See also* Rugby football).

Walker, John (1747-1812). 'The Back of the Salvador House Academy, Tooting'. Aquatint by Francis Jukes after the work of this artist, pub. April 1787. *London Borough of Wandsworth, Public Library.*

Walton, Henry (1746-1813). 'A Cricket Scene at Harrow School', 1771. *Private Collection.*

Ward, John, ARCA, VPRP, RA (b.1917). 'The St. Lawrence Cricket Ground, Canterbury'. w/c. *Kent County Cricket Club.*

Ward, Sir Leslie ('Spy'), RP (1851-1922). Caricaturist for the weekly *Vanity Fair* magazine who produced 1,325 cartoons over nearly forty years. 'Spy' featured a number of famous cricketers amongst his series of sportsmen for *Vanity Fair,* including David Braid, Sir Pelham 'Plum!' Warner (1873-1963), George Hirst (1871-1954) the great all rounder, and Lionel Charles Hamilton Palairet (1870-1933), the great batsman.
'W.G. Grace'. Chromo. 12½in. x 7½in. Pub. *Vanity Fair* in the 'Men of the Day' (No.150, 9.6.1877).
'Lord Hawke'. Litho. 12½in. x 7½in.
'The Hon. F.S. Jackson', 1902. Litho. 12½in x 7½in. Entitled 'A Flannelled Fighter'.
'Lord Dalmeny', 1904. Litho. 12½in. x 7½in. Entitled 'In His Father's Footsteps'.
'The Demon Bowler' (Spofforth). Chromo. 12in. x 7¼in. Pub. in *Vanity Fair,* 13.7.1878. *British Museum.* Frederick Robert Spofforth (1853-1926) played for New South Wales, Victoria and Australia. In eighteen test matches against England (1876-1886) he took 94 wickets. *(See also* billiards, golf.)

Warwick, K.W. 'Summer Recreations at Eton College — a view from the Playing Fields', s. & d. 1906. 17¼in. x 25¼in. *Christie's.*

Washington, William (1895-1956). 'The cricket bat maker at his work bench'. Etching. 10¾in. x 8⅝in. Signed artist's proof dated 1934. Exh. Parker Gallery, London 1950.

Watts, George Frederick, OM, RA (1817-1904). 'The Cut', signed G.F. Watts. Pencil sketch. 13¾in. x 9¾in. *MCC Collection.*
'The Cut', 1837. Litho. 13in. x 10in. *MCC Collection.*

Weaver, Arthur (b.1918). 'Australia v. England at Lords'. Painted to commemorate the centenary of the test match played between the two countries. *MCC Collection. (See also* curling, golf.)

Webster, Thomas (1890-1962). Illustrator of sporting subjects and caricaturist. Several cricket sketches in pen and ink, 1932-1934. *Christie's.*

Webster, Thomas, RA (1800-1886). 'The Boy with Many Friends', s. & d. 1841. 24½in. x 35½in. *Corporation AG, Bury.* 'Rough and Tumble', s. & d. 1854. 8¼in. x 18¼in. *(See also* Association football.)

Weight, Carel, CBE, RA (b.1908). 'The First Cricket Match of Spring'. 16in. x 20in. *City AG, Manchester. (See also* Association football.)

Werner, Carl, Friedrich Heinrich, RI (1808-1894). 'A Cricket Match at Rome', 1850, s. & d. C. Werner, f. 1850 Rom. w/c. 6⅞in. x 10¼in..
'Cricketers Taking Refreshments', 1850, s. & d. C. Werner f. 1850 Rom. w/c. 6⅞in. x 10¼in. *(See also* billiards.)

West, Benjamin, PRA (American, 1738-1820). 'The Cricketers', 1763. 38⅞in. x 49in. *Private Collection.*

White, Ethelbert, RWS, NEAC, LG (1891-1972). 'Cricket on the Village Green, Hampstead Heath', 1915. 20in. x 24in. *Christie's.*

Whittock, Nathaniel (op. mid-19th C.). 'The Cricket Ground, Harrow'. 4¾in. x 7in. Litho.

Wills, The Rev'd James (op.1740-1777). 'The Andrews Family', s. & d. 1749. 43¼in. x 56⅞in. *Fitzwilliam Museum, Cambridge.*

Wollaston, John (op.1738-1775). 'Warner and Rebecca Lewis', c.1760. *Private Collection on loan to the College of William and Mary, Williamsburg, Virginia, USA.*

Wortley, Archibald Stuart (1849-1905). 'W.G. Grace at the Wicket', s. & d. 1890. 48in. x 34in. *MCC Collection.*

*****Wright, Gerry** (b.1931). Studied Maidstone Art School 1951-1953. 'Cricket on a Summer's Evening', signed. 24in. x 47½in. *The Wingfield Sporting Gallery, London.*

Wright, Joseph, ARA (of Derby, 1734-1797). 'The Wood Children', s. & d. 1789. 66in. x 53in. *Derby City Museum and AG.*
'The Thornhill Children', c.1790. 57in. x 48½in. *Private Collection.*

*****Wyatt, L.** 'A 19th Century cricketer standing before a tent' and 'A 19th Century cricketer at the wicket', signed. Pair, 12¾in. x 7¾in. *Christie's.*

Zoffany, Johann, RA (1733-1810). 'The Sondes Children', c.1764-5. 38in. x 48in. Exh. NPG London, 1976. *Collection of Michael Saunders-Watson.*

Croquet

Arnst, A. 'A Croquet game', signed. w/c. 13¾in. x 29¼in. *Sotheby's.*

Barker, John Joseph, of Bath (op.1835-1866). 'Croquet in the time of Charles II'. Exh. BI in 1866.

Bache, Otto (1839-1927). 'The Game of Croquet', signed with inits. 11¾in. x 15¾in. *Christie's.*

Bland, Miss Emily. 'The Game of Croquet'. Exh. NEAC 1897-1916.

Brownwood Potts, Robert. 'The Croquet Tournament, Wimbledon'. w/c. 10½in. x 15in. *Sotheby's, Sussex.*

Caffieri, Hector, RI, RBA (1847-1932). 'A Croquet Party'. Exh. SS, 1877/8.

Couldery, Horatio Henry (1832-1893). 'A Game of Croquet between two dogs'. *Sotheby's.*

*****Crook, P.J.** (Pamela June, b.1945). 'Ladies Croquet Match', 1986. 45in. x 55in. *The Portal Gallery, London.*

*****Davidson, Thomas** (op.1863-1893). 'The Winning Stroke', signed with mono. 11½in. x 8¼in. *Sotheby's.*

Deykin, Henry Cotterill (b.1905). 'Croquet at Hurlingham. The Ladies Field Cup Tournament, 3rd August 1950', signed. 19¼in. x 23¼in. *Sotheby's.* (*See also* Association football, cricket, golf, hockey, lacrosse, lawn bowls, lawn tennis, polo, Rugby football.)

*****Du Maurier, George Louis Palmella Busson** (1834-1896). 'Our Croquet Party'. Wood engraving by Horace Harral, c.1860. Illus. *London Society,* June 1864. *British Museum.*

Fairbairn, H.M. 'A game of Croquet', s. & d. 1908. 10¾in. x 14¼in. *Sotheby's, Sussex.*

Gardner, Henry. 'Croquet on the lawns of Brighton Pavilion', s. & d. 1890. 11¾in. x 14in. *Christie's.*

*****Goodman, H.M.** (op.1870-1890s). 'The Croquet Game', s. & d. Feb. 1877. 11¼in. x 17¼in. *Oscar and Peter Johnson.*

Gotch, Thomas Cooper, RBA, RI (1854-1931). 'A Croquet Game'. w/c. 4in. x 7¼in. *David Lay, Cornwall.*

*****Green, Charles, RI** (1840-1898). 'The Croquet Player', signed with mono. and dated 1867. w/c. 6½in. x 4½in. *The Maas Gallery, London.*

*****Hicks, George Elgar, RBA** (1824-1914). 'The Croquet Player', s. & d. 1864. 24in. x 16½in. *Christopher Wood Gallery.* (*See also* Rugby football.)

Hill, Thomas (1829-1908, English born artist who went to the USA in 1840). 'Palo Alto Spring', 1878. *Stanford University of Art.*

*****Homer, Winslow** (American, 1836-1910). 'The Croquet Game', s. & d. '66. *The Art Institute of Chicago.*

Hopkins, Arthur, RWS, RBC (1848-1930). 'The Last Game of the Season'. Originally drawn for *The Illustrated London News,* 1872. Repro. *The History of Croquet* by D.M.C. Prichard, pub. Cassell's, London 1981.

*****Howard, George, HRWS** (9th Earl of Carlisle, 1843-1911). 'Croquet at Naworth Castle'. 15in. x 20in. The players are the artist's children, Dorothy, Aurea, Charles and Hubert. *Sotheby's.*

Hughes, Edward (1832-1908). Exh. 'A Game of Croquet' at SS, 1864-1879.

Innes, Charles (contemporary artist). 'Croquet'. RA Summer Exh. (No.355) 1988.

Jacomb-Hood, George Percy, RBA, RE, ROI, RBC, NEAC (1857-1929). 'The Croquet Match at Hurlingham'. w/c. 8in. x 11¼in. Sotheby's, Sussex. (*See also* lawn tennis).

*****JNP.** 'Croquet', init. and dated 1872. Sepia wash. 4½in. x 7¾in. *The Wingfield Sporting Gallery, London.*

Keene, Charles Samuel (1823-1891). *Punch* illustrator of several croquet scenes.

Landseer, Sir Edwin Henry, RA (1802-1873). This distinguished Victorian artist made his debut at the RA at the age of 13. He exhibited a total of 43 paintings including a portrait of a gentleman standing in a beautiful garden with a croquet set beside him; entitled 'Prosperity' and exhibited in 1865 in the very early years of the game; the painting was designed to show an English gentleman surrounded by all the trappings of wealth and leisure. (*See also* billiards, cricket.)

Lavery, Sir John, RSA, RA, RHA (1856-1941). This artist, inspired by the success of 'The Tennis Party', 1885 (*see* lawn tennis), is known to have painted croquet in 1890. *National Gallery of Ireland Exh. Feb./March 1985.* (*See also* golf.)

Leech, John (1817-1864). *Punch* illustrator of croquet scenes. 'A Nice Game for Two or more'. Chromo. litho. 10¾in. x 24in. pub. Agnew & Son, 1865. *British Museum.*

Manet, Edouard (1832-1883). 'The Croquet Party', s. & d. 1873. 28½in. x 41¾in. *Staedelsches Kunstinstitut, Frankfurt.*

Mower, Martin. 'The Croquet Party', c.1913. *Isabella Stewart Gardens Museum.*

*****Nash, John, RA, NEAC, LG, SWE** (1893-1977). 'A Game of Croquet', s. & d. 1913. Pen, ink, w/c. 8¼in. x 11in. *Spinks, London.*

Pash, Miss Florence (Mrs. Humphrey). 'Croquet'. Exh. NEAC 1899.

Paxton, William McGregor. 'The Croquet Players, 1898'. *T.W.J. Valsam Collection.*

Pignoux (late 19th C.). Elegant figures playing croquet on a beach, s. & d. 1877. 13¾in. x 25½in. *Christie's.*

Sant, James, RA (1820-1916). 'Miss Martineau's Garden, 1873'. *Tate Gallery.*

Sloan, John (American, 1871-1951). 'Croquet', 1918. 16in. x 20in. *Formerly in the Kranshaar Galleries.*

Spurrier, Steven, RA, ROI, RBA, NS, PS (1878-1961). 'Croquet Tournament at Wimbledon — a Moment of Suspense'. Repro. *Black and White Magazine,* June 1903.

Stevens, Alfred (1823-1906). Belgian artist who worked in both France and England; a friend of James Jacques Tissot, both had croquet lawns in their gardens and were enthusiastic players and portrayers of the game. Manet's painting 'Partie de Croquet à Boulogne, 1871' records several of his friends playing the game.

Taylor, Liz (b.1940). Studied Rochdale Art College. w/c artist and international croquet player.
'The Hurlingham Tournament', s. & d. 1988. Pastel. 9½in. x 11¾in.
'Hitting the Peg', s. & d. 1988. Pastel. 9½in. x 11¾in. *The Wingfield Sporting Gallery, London.*

Tenniel, Sir John, RI (1820-1914). Painter and illustrator of Lewis Carroll's *Alice in Wonderland,* 1865, where Alice plays a game of croquet with a flamingo as a mallet and a hedgehog as a ball.

Tissot, James Jacques Joseph (1836-1902). 'Croquet', 1878. 35¾in. x 20in. *The Art Gallery of Hamilton, Ontario.*

Turner, Edwin Page (exh. 1880-84). 'Two children playing croquet in a cottage garden', s. & d. 1910. 24in. x 20in. *Woolley and Wallis, Salisbury.*

Curling

*****Aldin, Cecil Charles Windsor** (1870-1935). 'Curling'. *Sheriff David B. Smith Collection.* (*See also* golf, polo.)

*****Alexander, R.M.** (op.1880-1890). 'That should find him', 1883. Signed sketch. *Scottish Curling Museum Trust.* Sporting artist and illustrator best known for his angling scenes. Contributed to *Fores Sporting Notes and Sketches,* including his curling illustration entitled 'Hurrah you've got him!'

*****Allan, David** (1744-1796). 'Curlers on Canonmills Loch, Edinburgh'. w/c. 12in. x 25¾in. *Royal Caledonian Curling Club, Edinburgh.*

*****Anderson, Robert, ARSA, RSW** (op.1842-1885). 'Curling on Duddingston Loch', s. & d. 1880. 26½in. x 40in. *Caledonian Club, London.*

*****Armour, George Denholm, OBE** (1864-1949). 'Our Artist in Scotland. Awful Result of His First Attempt to Become a Curler'. Pen and ink sketch. *Sheriff David B. Smith Collection.* (*See also* polo.)

Browne, Tom, RI (1872-1910). This artist/illustrator became well known through a series of prints he did for the Johnnie Walker Whisky Company depicting their trademark. The print of Johnnie Walker as a Regency buck undertaking various sporting activities, depicts curling, c.1820. *The Wingfield Sporting Gallery, London.* (*See also* golf, lawn bowls.)

Cumming, W. Skeoch (exh. 1885-1906). Contributor to the illustrations for *History of Curling* by John Kerr, pub. Edinburgh 1890.

Doyle, Charles Altamont (1832-1893). Contributor to the illustrations for *History of Curling,* by John Kerr, pub. Edinburgh 1890. 'The Curling Match on Duddingston Loch'. w/c. 9in. x 7in. *Sheriff David B. Smith Collection.*
'The Winning Shot — Duddingston Loch'. w/c. 9in. x 7in. *Sheriff David B. Smith Collection.*
*'Curlers', c.1860. w/c. *Sheriff David B. Smith Collection.*

Duncan, Mr. 'The Curling Match at Montreal', 1855. Repro. *The Illustrated London News,* 17.2.1855 and described as 'That clever artist from Montreal'.

'Elf'. Caricaturist of 18 cartoons for *Vanity Fair,* 1908-1910. Dr. H.S. Lunn (of Travel Agency fame) in the act of throwing his stone, pub. *Vanity Fair* 'Men of the Day' issue, No.1193, 6.10.1909.

*****Evans, William, of Eton, RWS** (1798-1877). 'A Curling Match at Polney Loch, near Dunkeld'. w/c. 18½in. x 30½in. *Richard Green Gallery, London.* (*See also* cricket, Eton wall game.)

Gibb, J. 'Curling', s. & d. 1860. 12in. x 18in. *Christie's.*

Hardie, Charles Martin (1858-1917). 'The Grand Match between North and South at Carsbreck', 1899. 59⅛in. x 96½in. Exh. RSA in 1900. *Royal Caledonian Curling Club, Edinburgh* (*See also* cricket.)

*****Harvey, Sir George, PRSA** (1806-1876). 'The Curlers'. *National Galleries of Scotland.* An engraving 11½in. x 30in. after this work by William Howison, ARSA (1798-1850), is recorded (*British Prints* by Ian McKenzie, pub. ACC 1988). (*See also* lawn bowls.)

Lees, Charles, RSA (1800-1880). 'The Grand Curling Match of the Royal Caledonian Curling Club at Linlithgow', 1853. 59⅛in. x 96½in. *Royal Caledonian Curling Club, Edinburgh.* A print after this work by John Le Conte 1858, 22½in. x 37¼in., is recorded.
'Curling on Duddingston Loch', 1866. *Private Collection. (See also* golf.)

*Levack, John (op.1856-1857). 'Curling at Rawyards Loch, Airdrie, Lanarkshire', s. & d. 1857. 5ft. x 10ft. *Monklands District Council.*

McKay, John (op.1841-1860). 'Curling at New Farm Loch, Kilmarnock', c.1860. *Dick Institute, Kilmarnock.*

*McLennan. 'Curling at Curling Hall, Largs', c.1833. John Cairnie is shown delivering a stone from his famous foot-iron. Against the garden seat lies a large pair of compasses used for measuring shots. *Royal Caledonian Curling Club, Edinburgh.*

Reid, Samuel (1854-1919). A landscape painter in w/c, the brother of the artist Sir George Reid, RSW. Contributed a number of w/c illustrations to *History of Curling,* by John Kerr, pub. Edinburgh 1890.

Ritchie, John (op.1858-1875). 'A Curling Match', signed. 15in. x 27in. This scene may possibly depict the Royal Caledonian Curling Club. *Richard Green Gallery, London.*

*Stevenson, William Grant, RSA (1849-1919). Sculptor and animal painter who contributed a number of sketches, drawn from photographs, to *History of Curling,* by John Kerr, pub. Edinburgh 1890.

*Scott, Thomas, RSA (1854-1927). 'The Last Stane', s. & d. 1897. 11in. x 18in. *Private Collection.*

*Unknown artist. 'Sweeping the Rink'. The Countess of Eglinton and her ladies on a Cairnie-type artificial rink at Eglinton, Feb. 1860. *Scottish Curling Museum Trust.*

*Weaver, Arthur (b.1918). 'Lake Monteith, near Stirling, Scotland', s. & d. 1981. *Arthur Weaver and Burlington Gallery, London. (See also* cricket, golf.)

Wedderburn, Jemimah (mid-19th C.). 'Sir George Clerk of Penicuik and family at play on one of the ponds at Penicuik House', c.1847. w/c sketch. *National Portrait Gallery.*

Eton Wall Game

*Evans, William, of Eton, RWS (1798-1877). 'The Wall Game at Eton', c.1850. 26½in. x 37in. *The Provost and Fellows of Eton College. (See also* cricket, curling.)

Fives

*Davis, Lucien, RI (1860-1941). 'Fives', from *Lawn Tennis, Rackets and Fives,* repro. from The Badminton Library Series, pub. 1890. *(See also* Association football, cricket.)

Golf

Abbott, Lemuel Francis (1760-1803).
*'A portrait of William Innes [1719-1795], Captain of the Society of Golfers at Blackheath, 1778'. The original painting is in the collection of the *Royal Blackheath Golf Club, Eltham Lodge.* Mezzo. by Valentine Green, AE (1739-1813), 25¼in. x 16¾in., 1790. *British Museum.* William Innes was a friend of Henry Callender (q.v.).
'Henry Callender, Esq.' Insc. 'To the Society of Golfers at Blackheath'. Mezzo. by William Ward, AE (1762-1826), 25¼in. x 16¾in., pub. 1812. *British Museum.* Henry Callender was secretary, then Captain of the Royal Blackheath Golf Club in 1790, 1801 and 1807. The medal and epaulette are badges of office gained when he became the Club's first Captain General in 1808.

Aikman, George (1830-1905). Edinburgh landscape painter who exhibited 'Playing a Stymie', at RSA 1894 (the stymie was finally abolished in 1951). He also engraved several etchings of golfing greens after John Smart, RSA (q.v.).

Aldin, Cecil Charles Windsor, RBA (1870-1935). 'Westward Ho Golf Course', in Devon. Coloured chalk drawing. *Christie's. (See also* curling, polo.)

Allan, David (1744-1796). 'Portrait of William Inglis, Capt. of the Honourable Company of Edinburgh Golfers' 1782-1784. *Honourable Company of Edinburgh Golfers, Muirfield.*

Ambrose, Charles (op.1905). A magazine illustrator, who drew a long series of golf and tennis personalities, Harry Vardon, James Braid, J.H. Taylor, etc., for Edwardian publications.

*American School. 'A Player and his Caddie'. Grisaille. 12⅜in. x 8⅝in. *The Wingfield Sporting Gallery, London.*

Avercamp, Hendrick (Dutch, 1585-1663). 'Golf on Ice on the River Ijsel Near Kampen'. w/c. Repro. *Country Life,* 8.9.1977. *Christie's.*

Barclay, John Rankine (b.1884). 'Playing out of the dunes', s. & d. 1922. Etching. 9in. x 12in. *Christie's, Scotland.*

Bell, Thomas Blackmore (exh.1933-1938). 'A Golfer', s. & d. 1939. 32¾in. x 24¼in. *Sotheby's.*

Bird, Cyril Kenneth (1887-1965). Humorous b. & w. and poster artist who often signed work 'Fougasse'. Art editor of *Punch* 1937 and Editor 1949-1952. Illus. *So This is Golf,* 1923, and *A Gallery of Games,* 1920.

Bond, John Lloyd (op.1868-1872). 'Golfing on the Common', s. & d. 1870. w/c. 7½in. x 12¼in. *Christie's, Glasgow.*

Bough, Samuel, RSA (1822-1878). 'A Golf Match at St. Andrews', s. & d. 1868. *Christie's.* 'Bruntsfield Links Golf Club', s. & d. 1871. w/c. 11¼in. x 18in. Presented by Mr. Alexander Whyte (Captain) to Mr. Andrew Usher for winning the competition at Loffness, 18th May 1871. *Sotheby's, Glasgow. (See also* cricket, lawn bowls.)

*Bradley, William (1801-1857). 'George Fraser, First Captain of the Manchester Golf Club, s. & d. 1818. 44in. x 36in. *Manchester City Art Galleries.*

Bril, Paul (1554-1626). 'Landscape with Golfers', 1624. *Minneapolis Institute of Arts.*

*Brock, Charles Edmund, RI (1870-1938). 'The Bunker', 16in. x 12in., 'The Drive', 12in. x 16in., 'The Putt', 12in. x 16in., s. & d. 1894. *Sotheby's.* Distinguished Cambridge based illustrator and artist whose work depicting gold is one of the highest rank and includes a series of sepia prints of golfers in action on the links. Repro. by Leggart Bros. of London in 1894 from engravings by Frank Paton.

*Brodie, John Lamont (op.1841-1889). 'A Close Putt', s. & d. 1889. 17½in. x 23in. *Sotheby's.*

Brown, Michael. 'A championship on the course at Carnoustie', 1891. w/c. 8in. x 15¾in. *Sotheby's, Gleneagles.*

Browne, Tom, RI (1872-1910). This artist/illustrator became well known for the series of prints he made for the Johnnie Walker Whisky Company depicting their trademark with Johnnie Walker as a Regency buck undertaking various sporting activities. In this print Johnnie Walker is playing golf, c.1820. 13¼in. x 9½in. *The Wingfield Sporting Gallery. (See also* curling, lawn bowls.)

*Buchanan-Dunlop, Lt. Col. A.H., OBE (1874-1947). 'The Two Captains, Roger and Francis', dated May 19, 1923. Pen and ink sketch. The artist was twice Captain of the Royal Musselburgh in the 1920s and a member of the R & A and other clubs. He produced a number of pen and ink portraits of great golfers of the time, including Wilson, Darcorn, Tolley and others.

Buchanan, Fred. Illustrator of sporting scenes including golf for illustrated journals such as *Fun,* 1900, *The Graphic,* 1906 and *The Strand.* 'Aren't you a little off your game this morning Mr Smythe?', *Punch,* 18.5.1904.

Byles, William Hounson (op.1872-1940). 'The Ruling Passion — a golf scene'. *Mansell Collection.*

*Chalmers, Sir George, Bt. (1720-1791). 'Portrait of William St. Clair of Roslyn', (Captain of the Honourable Company of Edinburgh Golfers, and a Grand Master of Scotland, died 1788). 88in. x 60in. *By kind permission of the Queen's Bodyguard for Scotland (Royal Company of Archers).*

Chalmers, Hector (c.1849-1943). 'Golfing at Elie', signed and inscr. 11¼in. x 15in. *Phillips, Edinburgh.*

Chaulms, T. 'The Links with players of the Royal Liverpool Golf Club', s. & d. 1889. *Royal Liverpool Golf Club.* Repro. in *British Golf* by Bernard Darwin, pub. by Collins, 1946.

*Crawford, Robert Cree (1842-1924). 'The Golf Course', s. & d. 1874. 16in. x 27in. *Sotheby's.*

Crombie, Charles E. (1885-1967). This artist created the best known series of golf cartoons *The Rules of Golf* published by Perrier (the sparkling table water firm) as a book at the turn of the century. Titled in both French and English, the cartoons showed golfers dressed in medieval costume playing in impossible situations; the book has been republished at least once in recent years and prints after his work are numerous. Crombie's work was quite prolific and included several calendars. He was published in *The Bystander*, 1904, and *Punch* in 1902, 1907, 1908.

Cuyp, Aelbert (1620-1691). 'A Young Dutch Golfer', c.1647. *Richard Green Gallery, London.*

Davis, Lucien, RI (1860-1941). 'Golfing on Minchinhampton Common. A hazard on the Ladies Course', 1890. (*See also* Association football, billiards, cricket, fives, hockey.)

Davison, Jeremiah (c.1695-1745). 'Sir James Macdonald, 8th Bt. (1744-1766). Sir Alexander Macdonald, 9th Bt., and the 1st Lord Macdonald (1745-1795)'. 70in. x 58in. *Scottish National Portrait Gallery.*

Deykin, Henry Cotterill (b.1905). 'View of the 9th Hole on the Royal & Ancient Golf Club Links at St. Andrews, during the Eden Golf Tournament. G.T. Black beating P.R. Fallon, August 12th 1950', signed. 19½in. x 23½in. *Sotheby's London.* 'Royal Cinque Ports Golf Club, Deal the 4th hole, Sandy Parlour. Halford-Hewitt Tournament, April 1950', signed. 19½in. x 23½in. *Sotheby's, London.* (*See also* Association football, cricket, croquet, hockey, lacrosse, lawn bowls, lawn tennis, polo, Rugby football.)

Dollman, John Charles, RI, ROI, RWS (1851-1934). 'During the time of the Sermonses — a Minister of the Kirk approaching two golfers on the Links'. 34in. x 58in. *Harris Museum and AG, Preston.*

***English School.** 'The Young Golfer', c.1830, with his driving putter and feather ball. w/c. 11in. x 9in. *Bonhams.*

Fergusson, William. 'Nedderwich Hill Golf Course', signed. w/c. 9in. x 7in. *Sotheby's, Chester.*

Flower, Clement (op.1899-1913). 'The Triumvirate, 1913. Driving off'. Portraits of Harry Vardon, James Braid and John Henry Taylor. 60in. x 40in. *Royal and Ancient Golf Club of St. Andrews.*

Fripp, Iness (b.1867, exh. 1893-1939). 'Golfers', signed. 11in. x 19in. *Christie's.*

Fuller, Leonard John, ROI, RCamA (1891-1973). 'Miss Diana Fishwick, the Lady golf champion, 1930', signed. 36in. x 28in. Exh. RA (No.106) 1931. *Sotheby's, Chester.*

***Gallen, R.S.E.** 'Old Alick', c.1835 (1756-1840), the holemaker to the Royal Blackheath Golf Club. *Royal Blackheath Golf Club.*

Gaye, H.C. 'A view of a Scottish links course', signed. w/c. 9½in. x 13½in. *Bonhams.*

Ghilchik, David Louis, ROI (1892-1972). *Punch* cartoonist, founder member of SWE (1920) and a member of the London Sketch Club. Illustrated *The Rubaiyat of a Golfer*, by J.A. Hammerton, 1946. (*See also* lawn tennis.)

Gilroy, John, MA (Hon), ARCA, FRSA (1898-1985). A keen golfer, who drew many golf sketches. Best known as the artist who created the Guinness advertisements. *The Wingfield Sporting Gallery, London.*

Gordon Watson, Sir John, RA, PRSA (1788-1864). Scotland's leading portrait painter, after the death of his friend Sir Henry Raeburn, RA (1756-1823). 'A portrait of John Taylor', elected Captain of the Honourable Company of Edinburgh Golfers in 1807, 1808, 1814, 1823 and 1825. 'Portrait of Douglas G.C.L.A. Robertson', a member of Royal Ancient, standing full length on a fairway by a gate holding a wooden club in his right hand. 65in. x 35½in. *Sotheby's.*

Grant, Sir Francis, PRA (1803-1878). 'Portrait of John Whyte Melville', of Bennochy & Strathkinness, Captain of the Royal and Ancient Golf Club of St. Andrews, 1823. 96in. x 54in. *Royal and Ancient Golf Club of St. Andrews.* (*See also* cricket.)

***Hardy, Heywood, ARWS, RP, RE, RWS** (1842-1933). George Glennie the famous amateur golfer of the early 'gutta ball' era, putting at Blackheath with a cleek. *Royal Blackheath Golf Club.*

Hassall, John, RI (1868-1948). This talented artist and illustrator produced several strongly coloured sets of lithographs featuring golf, c.1900. These included 'The Links at St. Andrews' (exceptionally rare and perhaps the best set of golf prints of this era); 'Before' and 'After', a set showing a young boy on the tee; 'Where is it?', a pair showing a plump golfer seeking a lost ball on the beach; 'The Seven Ages of the Golfer', from cradle to the grave. There were also many posters, book and pottery illustrations, postcards and advertisements illustrating golf. Good sets of prints in unfaded condition are highly-prized especially when signed in pencil — original works are seldom sold. Hassall's best work was of brilliant colour and simplicity.

***Henderson, Joseph Morris, RSA** (1863-1936). 'The Lighthouse Green at Turnberry', signed. 16in. x 20in. *Sotheby's.*

Hodge, Thomas (1827-1907). 'Portrait of George Glennie', the famous amateur golfer, 1880. w/c. 8¼in. x 6in. Hodge, who provided many of the illustrations for the *Golf* issue of the Badminton Library Series, was also an extremely competent golfer, winning the King William IV Gold Medal three times and the Silver Cross. *Royal and Ancient Golf Club of St. Andrews.*

Hooch, Pieter de (Dutch, 1629-1681). 'The Golf Players'.

***Hopkins, Francis Powell** (1830-1913). 'Golf at Blackheath, 1875'. *Royal Blackheath Golf Club.* Golfing artist and journalist who wrote for *The Field* as early as 1863. He very often used the pseudonym 'Shortspoon' (a variety of golf club); his works include scenes at Westward Ho, Hoylake, St. Andrews and Sandwich.

***Hutchinson, Robert Gemmell, RSA, RSW, ROI** (1855-1936). 'The Lost Ball', signed. w/c. 17½in. x 23½in. *Sotheby's.*

Jones, Dave. 'Augusta National, The 13th Hole'. *Augusta National Golf Club.*

Kay, John (1742-1826). Sketch of Alexander McKellar (d.c.1813) the 'Cock o' the Green', included in *Kay's Edinburgh Portraits*, pub. 1838. (*See* text.)

Kimble, Julian. Captain of the London Sketch Club Golf Team for many years.

Knight, Charles (b.1865). The artist's father playing golf off the fairway, signed with inits. and inscr. 15in. x 10in. *Sotheby's.*

Lander, Edgar Longley (b.1883). 'The Idol of the Links', complete with her golf bag. Pencil drawing for *The Bystander*, May 1910.

***Laurent, F.** 'The Amateur Championship, 1954'. *Wiggins Teape Group.*

Lavery, Sir John, RSA, RA, RHA (1856-1941). 'North Berwick Golf Course from the Ladies tee', 1918. 'Portrait of Lady Astor' playing golf at North Berwick, signed. 24½in. x 29½in. *Christie's.* 'The Golf Course at North Berwick', 1922. 25in. x 30in. *Tate Gallery.* (*See also* croquet, lawn tennis.)

Lees, Charles, RSA (1800-1880). Pupil of Sir Henry Raeburn, RA (1756-1823). 'The Golfers, St. Andrews', 1847 (eng. Edinburgh) 20⅞in. x 33¾in., shows a match at St. Andrews, between Sir David Baird and Sir Ralph Anstruther on one side, and Major Playfair and John Campbell of Saddell on the other. The crowded scene is on the fifteenth green of the Old Course. *Royal and Ancient Golf Club of St. Andrews.* (*See also* curling.)

Lorimer, John Henry, RSW, RWS, RSA (1856-1936). 'Portrait of Frederick Guthrie Tait', Amateur Champion 1896-1898, standing receiving a club from his caddie, whilst holding another under his left arm. 120in. x 60in. *Royal and Ancient Golf Club of St. Andrews.*

Lousada, Mrs. Julian. Exh. 'The 7th Hole' at NEAC in 1911, her only year to exhibit.

Mackenzie, William G., ARHA (d.1925). 'Portrait of Old Tom Morris' (1821-1908). 33in. x 26½in. This artist exhibited regularly at the Royal Hibernian Academy until his death and is best remembered today for his portraiture.

***Mcleay, Macneil, ARSA** (op.1830-1870). 'Members of the Royal Perth Golfing Society playing on the links', s. & d. 1866. 17in. x 27in. *Sotheby's.*

McGhie, John (1867-1941). 'The Follow Through' (said to be a portrait of the golfer David Rintoul), signed. 24in. *Christie's.*

McGill, Donald Fraser Gould. Golfing Scene — 'Isn't it a pity, Mabel still has one femine trait — she will powder her nose', signed. Pencil and w/c. 8in. x 6in. *Christie's.*

Morland, John (b.1930). Wildlife and landscape artist who won the Gold Medal for the Royal Horticultural Society in 1979 for his botanical drawings. Better known perhaps for his series of twenty-four famous British Golf Courses and Links.

Morrison, Robert Edward, RCamA (1851-1925). Liverpool artist who studied at the Liverpool School of Art and in Paris at the Academie Julian under Bonquereau and Anthony Fleury. A portrait of John Ball with a golf club, s. & d. 1899, is in the collection of the Royal Liverpool Golf Club.

Nunes, E.F. Portuguese born artist and illustrator who sketched many golfing scenes.

Paton, Frank (1856-1909). 'The Royal and Ancient', at St. Andrews, 1794, an etching described in *Baily's Magazine*, 1895: 'This small print 6in. x 4in. shows 4 golfers in imaginary 18th century costume playing a hole at St. Andrews while four Caddies look on with clubs under their arms'.

Patrick, James (exh. 1880-1905). 'Portrait of Old Tom Morris', (1821-1908), repro. *Golf in the Making*, by Henderson & Stirk, 1979.
'Links Fair, Kirkcaldy', s. & d. 1894. 29in. x 50in. *Sotheby's.*

Pettafor, Charles (exh. 1880-1900). Golfers on a links course in a coastal landscape, signed. w/c. 49in. x 29½in. *Phillips, Scotland.*

Pimm, William E. (exh. 1890-1910). 'Putting on the 6th Green', signed. 15¾in. x 23½in. *Burlington Paintings, London.*

Pipeshank, George (op.1890-1900). A pseudonym used by John Wallace (1841-1905, q.v.) for the signature on a set of four lithographs published by the British tobacco company, Cope Bros and Co. Ltd. at the turn of the century. The illustrations dated at various years in the 1890s show British Parliamentary figures playing golf on the Scottish links with legendary figures like Old Tom Morris. They complement an extremely rare set of fifty tobacco cards sent out with their tobacco by Cope Bros and Co. Ltd., c.1900, with many of the illustrations by the mysterious 'Pipeshank'. The originals are the same size as the cards which make them unique as golfing miniatures.

***Proudfoot, James, RP, ROI, NS** (1908-1971). Pen and ink sketch of a lady golfer. 6in. x 4in. *The Wingfield Sporting Gallery, London.*

Rackham, Arthur, RWS (1867-1939). 'Putting', signed. Pen and ink sketch. 6in. x 8in. *Chris Beetles Ltd., London. (See also* lawn tennis.)

Raeburn, Sir Henry, RA (1756-1823). Scotland's leading portrait painter during his lifetime, who painted several notable golfing personalities. Charles Lees, RSA (q.v.), was his pupil.

***Reid, Sir George, PRSA, HRSW** (1841-1913). 'Portrait of Tom Morris Sen.', 1903. 46in. x 34in. *Royal and Ancient Golf Club of St. Andrews.*

Rennie, George Melvin (1802-1860). 'The Golf Course, Braemar, Deeside'. Inscr. 18¾in. x 28¼in. *Christie's, Scotland.*

Reynolds, Frank, RI (1876-1953). Artist and illustrator who contributed many golf sketches to *Punch*, for whom he became Art Editor. Also painted golf scenes — his early work — on pottery and porcelain.

***Righi, M.** (early 20th C.). 'A Golfing Scene', c.1910, signed. 8in. x 15¼in. *Sotheby's.*

Ritchie, J.W. (op. early 20th C.) 'F. Tait finishing the swing', s. & d. 1904. 16in. x 12in. *Christie's, Scotland.*

Roberts, Lunt. Keen golfer, artist and illustrator who drew many golfing sketches. Member of the London Sketch Club Golf Team.

***Robertson, C.H.** 'Caddie Willie on Bruntsfield Links', c.1824. (Portrait of William Gunn.) *Royal Blackheath Golf Club.*

***Rowntree, Harry** (1880-1950). 'Golfers'. Inscr. Mrs. H. Rowntree. w/c. 15in. x 21¼in. *Sotheby's.* A keen golfer, artist and illustrator, who drew many golfing sketches for *Punch* and was a member of the London Sketch Golf Club.

Ruggiero, Vincent, FRSA. 'View of the Clubhouse, the Royal and Ancient at St. Andrews'. 17¼in. x 23¼in. *The Wingfield Sporting Gallery, London.*

***Rutherford, R.H.** (op.1883-1897). 'Caddy Boys practising behind Ainsdale, Lancs.', s. & d. 1893. w/c. 8½in. x 13in. *Phillips, Chester.*
'Boys playing Golf', s. & d. 1893. w/c. *Eldon Worrall, Liverpool.*

***Sadler, W. Dendy, RBA** (1854-1923). 'Stymied', signed. 2in. x 32in. *Topham Picture Library.* Painted several golf scenes, usually set in Scotland, in olde worlde costume, a fashion very popular amongst Edwardian artists. (*See also* lawn bowls.)

***Sandby, Paul, RA** (1725-1809). 'View of golfers on Bruntsfield Links looking towards Edinburgh Castle', s. & d. 1746. w/c. 11½in. x 18in. *British Museum.*

'Shortspoon' the pseudonym for Major Francis Powell Hopkins (q.v.).

Simpson, Charles Walter, RBA, RI, ROI (1885-1971). ' A Golf Match at Prestwick', signed mono., reputedly showing Jim Barnes (Champion of the 1925 Open) teeing off at the first tee at Prestwick during a competition. 17½in. x 13½in. *Sothebys. (See also* polo.)

Smart, John, RSA, RBA, RSW (1838-1899). 'This for the hole Macrihanish', s. & d. 1889 and inscr. 18in. x 29in. Exh. RSW (No.120). *Sotheby's.*
'North Berwick Golf Links', repro. in *The Golf Book of East Lothian*, by John Kerr, pub. T. and A. Constable, Edinburgh, 1896.
'A View of the Golf Course at Stirling Castle — figures in the foreground', s. & d. 1890. 18in. x 29½in. *Sotheby's.*

Spindler, James H. (1862-1916). 'St. Andrews'. *Museum and AG, Dundee.*

***Stampa, George Loraine** (1875-1951). 'Golf', s. & d. 1925. Pen and ink sketch. 8in. x 11in. *The Wingfield Sporting Gallery, London.* (*See also* Rugby football.)

***Stewart, Allen** (1865-1951). 'The First International Foursome', in Carolean costume. *United States Golf Association Golf Museum. (See also* lawn bowls.)

Stevenson, William Grant, RSA (1849-1919). 'Golf'. An etching after this work dated 1892. 14¾in. x 24¾in., by Charles Murray, RE (1842-1923) is recorded (*British Prints*, by Ian McKenzie, pub. Antique Collectors' Club, 1988).

Taylor, John Whitfield (b.1908). 'A Hole in One', signed. Pen and ink sketch. 7in. x 9½in. *The Wingfield Sporting Gallery, London.*
*'In his Book, he sinks it', pen and ink sketch, signed. 7½in. x 9¼in. *The Wingfield Sporting Gallery, London.*

Thomson, Hugh (1860-1920). 'Golfers at the old third putting green, Wimbledon Common', s. & d. '97. *Sotheby's.*

Toynbee, Lawrence (b.1922). 'The Cape Bunker, Westward Ho', 1985. 24in. x 40in. Exh. FAS.

Unknown artist. 'Percy Allis', signed and inscr. 'Coronation Foursomes Moor Park, 1937'. w/c. 9½in. x 8in. *Christie's, Scotland.*
*An unidentified player. 'Coronation foursomes Moor Park, 1937', signed Ken. w/c. 9½in. x 6½in. *The Wingfield Sporting Gallery, London.*

van der Neer, Aert (Dutch, 1603-1677). 'Winter Landscape in the late afternoon', signed with double mono. 16in. x 20½in. *Christie's.*
'A River Scene in Winter'.

***van de Velde, Adriaen** (Dutch, 1635-1672). 'Golfers on Ice near Haarlem', s. & d. 1668. 11¹⁵/₁₆in. x 14¹⁵/₁₆in. *National Gallery.*

van de Velde, Esaias (Dutch, 1591-1630). 'Pleasure on the Ice'.

van de Venne, Adriaen (1589-1662). 'A Game of Pall Mall', c.1625. One of the few representations of this game said to be closely identified with the early game of golf. In this miniature painting by the Dutch artist, the Prince of Orange, Frederick Hendrick looks on as his nephew, recognisable by his order of the garter, the so called Winter King of Bohemia, takes aim. The picture is probably an allegory on the political scene stressing the common cause between the two men because they aim for the same goal. The Winter King, Frederick V was married to Elizabeth Stuart, daughter of James I of England (1566-1625) and elder sister of Charles I (1660-1649). This now extinct game was played with mallets along a straight alley at the end of which stood a vertical post. The two boys in the picture are probably the King's sons Charles Louis, and Frederick Henry, the latter a godson of the Prince of Orange. The album of 102 miniature drawings remains one of van de Venne's finest works and illustrates his remarkable talents as a draughtsman. *The Trustees of the British Museum.*

van Verstalen, Antoni (Dutch, 1594-1641). 'An Ice Scene', with skaters playing a golf-like game.

Vergett, Noel. Fashionable golfers grouped round a car, their caddies in the foreground, s. & d. 1920. w/c. 19in. x 24¾in. *The Wingfield Sporting Gallery, London.*
A mixed foursome leaving the last green, s. & d. w/c. 12¼in. x 17¼in. *Bonhams.*

343

Walker, Dame Ethel, ARA, RBA, RP, NEAC, SMP (1861-1951). A golfer with clubs and bag on the Golf Links Road, at Colwyn Bay, s. & d. 1908. w/c. 5½in. x 8¾in. *The Wingfield Sporting Gallery, London.*

Wallace, John (1841-1905). (*See* George Pipeshank.)

Ward, Sir Leslie ('Spy'), RP (1851-1922). 'Mr. Horace Gordon Hutchinson' (1859-1932). Chromo. 12½in. x 7½in., pub. *Vanity Fair,* 19.7.1890. Hutchinson was an eminent golfer from the early 1880s until 1907. He won the Amateur Championship in 1886 and 1887 and was a finalist on two other occasions. He was also the first Englishman to Captain the Royal and Ancient Club at St. Andrews.
'Hoylake' Horace Hilton. Chromo. 12½in. x 7½in., pub. *Vanity Fair,* 16.7.1903. Hilton (1869-1942) was one of the most scientific golfers. He won the Open Championship four times and became the first player and only British golfer to hold both the US and British Amateur titles at the same time. (*See also* billiards, cricket.)

Weatherson, J.T. 'A lady with a golf bag', s. & d. 1921. 17in. x 13in. *Christie's.*

Weaver, Arthur (b.1918). 'General view of the 4th Green — Boys Amateur Golf Championship at Sunningdale', s. & d. 1959. Gouache. 18⅜in. x 24⅜in. *Christie's, New York.* (*See also* cricket and curling.)

Wells, William Atkinson Page (1872-1923). 'Westward Ho Golf Links with players', signed. 12in. x 16in. *Sotheby's, Scotland.*

*__Wybrand, Simonsz de Geest (the elder)__ (1592-1659). 'Portrait of a boy with a golf club'. 46in. x 26¾in. *Sotheby's.*

Young, Harold (op.1931-1937). Figures on a golf course in the tropics, s. & d. '31. w/c. 10in. x 14¼in. *Bonhams.*

Hockey

Armour, George Denholm, OBE (1864-1949). 'The Easter Holidays', April 1904, signed. Pen and ink sketch. *Mercian Sports.* (*See also* polo.)

Belon, J. 'Les Jeux Scolaires au Bois de Boulogne — Les jeux de la crosse', March 1899. *Mercian Sports.*

*__Bogle, L.__ 'A Game of Hockey', signed. Pen and ink sketch. 7¾in. x 10½in. *Mercian Sports.*

Cleaver, Ralph (op.1893-1926). 'Varsity Match at Surbiton', March 1905. *Mercian Sports.*

Crowther, T.S.C. (op.1891-1902). 'The North and the South at Richmond 1892 — A Corner Hit', signed. Pen and ink sketch. *Mercian Sports.*

*__Dadd, Stephen T.__ (op.1879-1915). 'A Hockey Match in Somaliland — January 1902', signed 'S.T. Dadd from photos.' *Mercian Sports.*

Davis, Lucien, RI (1860-1941). 'The Members of a Ladies Hockey Club at Play'. Exh. RI, 1894. (*See also* Association football, cricket, fives, golf.)

Deykin, Henry Cotterill (b.1905). 'Hockey at Malvern Girls College, Kidderminster Club defeat the School 27th October 1951', signed. 17½in. x 25½in. *Sotheby's.*
*'The 50th Inter-Universities Hockey Match at Beckenham, 1950', signed. 19½in. x 23½in. *Henry Deykin.* (*See also* Association football, cricket, croquet, golf, lacrosse, lawn bowls, lawn tennis, polo, Rugby football.)

English School. 'Hockey on the Sand at Rossall School, 1891'. *Mercian Sports.*

Furniss, Harry (1854-1925). 'Hockey Sketches of the Fair Sex — January 1905', signed. *Mercian Sports.*

Jalland, George Herbert (op.1888-1908). 'Our Ladies Hockey Club, 1899', s. & d. '99. Pen and ink sketch. Inscr. 'One of the inferior sex who volunteered to umpire soon discovered his office was no sinecure'. *Mercian Sports.* (*See also* polo.)

Pegram, Frederick, RI (1870-1937). 'The English Ladies v. Irish Ladies Hockey Match at Richmond, 1901'. *Mercian Sports.*

Sykes, Aubrey, PPRI, PS. Contemporary painter in oil, pastel and w/c. 'The Hockeystick Maker', s. & d. '84. *Mercian Sports.*

Taylor, C.J. 'Hockey on the Ice', 1898. Pen and ink sketch. *Mercian Sports.*

*__Tyson, Kathleen__ (b.1898). 'The young hockey player', signed. 30in. x 25in. *The Wingfield Sporting Gallery, London.*

Hurling and Shinty

*__British School,__ c.1840. 'The Shinty Players'. 30in. x 38in. Attrib. to D. Cunliffe (1826-1855) and to A. Smith of Mauchline (1840). Repro. in *Country Life,* Dec. 1928. *Witt Library, Courtauld Institute of Art.*

*__Deighan, Peter.__ 'The 100th Hurling Final 1987 — Galway 1-12 Kilkenny 0-9', s. & d. 1987. 30in. x 24in. *Painted for and the property of the Gaelic Athletic Association (Ireland).*

Lacrosse

Begg, Samuel (op.1886-1916). Sketches for *The Sporting and Dramatic News* in 1896, show almost photographic precision. *Mansell Collection.*

Catlin, George (1796-1872). 'Lacrosse'. *Thomas Gilcrease Institute of American History of Art.*

Deas, Charles (1818-1867). 'The Indian Ball Game', s. & d. 1843. 29in. x 37in. *Thomas Gilcrease Institute of American History of Art.*

Deykin, Henry Cotterill (b.1905). 'A match at Wycombe Abbey School — The School defeats Dartford Physical Training College 15-9'. 20th October 1950', signed. 19½in. x 23½in. *Henry Deykin.* (*See also* Association football, cricket, croquet, golf, hockey, lawn bowls, lawn tennis, polo, Rugby football.)

Soper, George, RE (1870-1942). 'Saved' — the Lacrosse Match at Lords between Toronto and the South of England, 1902. *Mansell Collection.*

Lawn Bowls, Skittles and Ten Pin Bowling

Angellis, Pieter (1685-1734). 'A Game of Skittles', s. & d. 1727. 25in. x 29⁵⁄₁₆in. *Paul Mellon Collection.*

Baron, Henri C.A. (French, 1816-1885). 'Les Jouers de Boules', depicting bowlers playing on a stretch of dry clay or sand. *National AG, Sydney, Australia.*

Bennett, Frank Moss (1874-1953). An artist who chose to depict bowls in Elizabethan costume.

*__Bough, Samuel, RSA__ (1822-1878). 'A Game of Skittles on the Shore Road, the Bass Rock', 7in. x 10in. *Sotheby's.* (*See also* cricket, golf.)

*__Browne, Tom, RI__ (1872-1910). 'The Old Hand'. Lawn Bowls in Elizabethan Costume. Repro. *Cassell's Magazine,* 1905/6. (*See also* curling, golf.)

Buckman, Edwin, ARWS (1841-1930). 'Skittles'. Exh. RA in 1874.

*__Ceriez, Theodore__ (Belgian, 1832-1904). 'A game of skittles', signed. 8½in. x 14½in. *Christie's.*

Chapman, John Watkins (op.1853-1903). 'A Game of Bowls on the Lawn of Haddon Hall', signed. 13⅛in. x 19⅛in. *Christie's.*

Collet, John (1725-1780). 'A Game of Bowls'. Ink and w/c. 8in. x 10in. *Paul Mellon Collection.*
'A Game of Skittles'. Repro. in *The Oxford Illustrated History of Britain,* ed. Kenneth O'Morgan, pub. Oxford University Press, 1984. *The Lord and Lady Braye Collection.* This artist painted a series of sports entitled 'Ladies Recreations'. In one he depicts Miss Tippapin playing at Skittles. Some of the original paintings survive, all were mezzotinted and published by Carrington Bowles in 1778. (*See also* cricket.)

Cox, Frank E. (op. 1870-1894). 'Hampton Court in the Olden Times', showing a bowling green at the Palace, with players in Queen Anne costume.

*__Craig, William Marshall__ (1765-1834, Manchester drawing master who came to London in 1812). 'Skittles', signed. w/c. *Lacy Scott, Bury St. Edmunds.*

de Hooch, Pieter (Dutch, 1629-1681). 'Nine-Pins'. *Waddeston College.*

*__de Momper, Frans__ (1603-1660). 'Soldiers playing skittles — a view of Breda beyond', signed. 16in. x 21¾in. *Sotheby's.*

Deykin, Henry Cotterill (b.1905).
*'President's Day at the Eastbourne Bowling Club', August 1951. 19½in. x 23½in. *The Wingfield Sporting Gallery, London.*
'Bowls at the George Hotel, Solihull. A friendly match on the ancient green of the 16th Century Inn, August 1951. Ladies day'. (*See also* Association football, cricket, croquet, golf, hockey, lacrosse, lawn tennis, polo, Rugby football.)

*__Elgood, George Samuel__ (1851-1943). 'The Bowling Green, Berkeley Castle', s. & d. 1887. w/c. 15½in. x 23¼in. *Phillips.*

*__English School.__ 'Gentlemen Playing Lawn Bowls', c.1880. w/c. 9¾in. x 15¾in. *The Wingfield Sporting Gallery, London.*

*Ferneley, Sarah** (Mrs. Johnson, 1812-1903). 'A game of skittles'. 27in. x 44½in. *Sotheby's.*

Focardi, Ruggero (1864-1934). 'Le jeu de boules'. *Galleria d'Arte Moderna, Florence.*

*French School,** c.1940. 'Les Jouers de Boules'. 28¾in. ' 36in. *Sotheby's, Sussex.*

*Harvey, Sir George, PRSA** (1806-1876). 'The Bowlers', s. & d. 1850. *National Gallery of Scotland, Edinburgh.* The painting which does not represent any particular match was exhibited in the RA in 1850 (No.452). An engraving by William Henry Simmons (1811-1882) is in the British Museum. (*See also* curling.)

Hunter, George Sherwood, RBA (c.1855-1920). 'A Close Shave, who wins', depicts Breton peasants playing bowls. Exh. SS, 1882.

Ingalton, William (1794-1886). 'The Skittle Players'. Exh. RA 1817.

*Kent, William** (1685-1748). 'Bowls at Stowe House', c.1735. Ink and brown wash. 12in. x 18½in. *British Museum.*

Koehler, Henry (American, b.1927). 'Bowling at Hurlingham', 1986. 10in. x 14in. *Partridge (Fine Arts) Ltd.* (*See also* polo and cricket.)

Laloin, Cecil. A painting of bowls is mentioned in *Bowls Encyclopaedia*, by John P. Monro, pub. 1951.

Lucas, John Seymour, RA, RI (1849-1923). 'The Armada in Flight'. *Mansell Collection.*

Meissonier, Jean Louis (1815-1891) is known to have painted a picture of bowls.

Raverat, Gwendolen (1885-1957). 'The Bowl Players', s. & d. 1922. Wood engraving. 4in. x 6in. *British Museum.*

Rooker, Michael Angelo, ARA (1743-1801). 'A Game of Bowls on the Bowling Green, outside The Bunch of Grapes Inn, Hurst, Berkshire'. w/c. 8¾in. x 10¾in. *Paul Mellon Collection.*

Rossiter, Charles (b.1827, op.1852). 'A Game of Bowls', signed 9½in. x 8in. *Sotheby's, Sussex.*

Sadler, Walter Dendy, RBA (1854-1923). 'A Game of Bowls', signed. 48in. x 72½in. The painting shows a bowling scene of the Old English type, for there are neither ditches nor banks. *Richard Green Gallery, London.* (*See also* golf.)

Sperling, Diana (1791-1862). This amateur artist sketched a bowls scene amongst the many pictures she drew of sports and games. Many of her sketches were reproduced in *Mrs Hurst Dancing* by Professor Mingay, pub. Victor Gollancz.

Steen, Jan (1629-1679). 'Skittles in the Open Air'. *History of Art Museum, Vienna.* 'Nine Pin Players'. *National Gallery.*

Stewart, Alan (1865-1951). 'News of the Armada' and 'Plymouth Hoe, AD 1588', showing two further versions of the Sir Francis Drake story, repro. *The Complete Bowler*, by James Mansell. An original wash drawing 22in. x 29¾in. showing Sir Francis Drake, Lord Howard of Effingham, Sir Walter Raleigh and Sir John Hawkyns playing bowls interrupted by Captain

Flemming bringing the tidings of the Armada sightings, was exhibited at the Parker Gallery in 1950 by a print from the drawing. (*See also* golf.)

*Teniers, David, the younger** (1610-1690). The celebrated Dutch painter of bowling scenes. 'Peasants playing at skittles' (a misleading title as they are clearly playing bowls), c.1636-39, signed. 13¾in. x 22½in. *Torrie Collection, University of Edinburgh.*

Ten Kate, Johann Marie (Dutch, 1831-1910). 'A Game of Skittles', signed. 14in. x 18in. Shows an interesting wooden skittle run. *Sotheby's, Chester.*
'At the Bowling Alley', signed. 21¾in. x 27½in. *Phillips, Scotland.*

Thornhill, Sir James (1675/6-1734). 'Hanbury Hall (Worcs.) from the Bowling Green', c.1710. Brown ink with grey wash over pencil. (The house containing a ceiling painted by Thornhill was owned by Thomas Vernon, an eminent lawyer.) *British Museum.*

*Unknown Artist** (late 17th C.). A game of bowls said to represent a scene outside a Suffolk inn, which is one of the earliest known pictorial references to the game of bowls in England. 24in. x 54in. *J.E.B. Hill.* Previously in the Hutchinson Collection of British Sporting Art, which was dispersed in 1951.

Valkenborch, Lucas van (c.1580-1622). Two men playing a game of bowls. *History of Art Museum, Vienna* (No.7348).

Wilkie, Sir David, RA (1785-1660). 'Playing Skittles'. Pen and ink sketch for a painting commissioned by the Duke of Wellington. The finished painting, 'Chelsea Pensioners reading the Waterloo Despatch', became Wilkie's justifiably most famous painting but it was far from the original scene envisaged by the Duke of a jovial gathering of old contemptibles playing at skittles in the King's Road, Chelsea. The sketch is in the British Museum and the oil painting at Apsley House. Repro. *Country Life*, 25.2.71.

Wallis, Henry, RWS (1830-1916). 'A Game of Bowls', signed. 22in. x 36in. *Sotheby's.* Exh. London International Exhib., 1871.

Wilkinson, Gilbert (op.1935-1939). An engraving after his painting entitled 'Is it an Old Man's Game?' was repro. in *Illustrated*, 13.5.1939.

Lawn Tennis

Bateman, Henry Mayo (1887-1970). 'Discovery of a Dandelion on the centre court at Wimbledon' and many other w/cs covering not only lawn tennis but most other ball games. (*See also* billiards.)

Bridgman, Frederick Arthur (American, 1847-1928). 'Tennis at Vechiville'. 21¼in. x 31¾in. (Illus. *The Fine Art Trade Guild Journal*, Autumn 1987, p.35.)

Brewtnall, Edward Frederick, RWS, RBA (1846-1902). 'The Wimbledon Tennis Party', s. & d. 1891. w/c. 16½in. x 24in. *Wimbledon Lawn Tennis Museum.*

Brook, David (contemporary artist). 'The Tennis Match', s. & d. 1966. 12in. x 13in. *The Portal Gallery, London.*

Broomfield, Frances (contemporary artist). 'King George VI at Wimbledon, 1926'. 16in. x 22in. *The Portal Gallery, London.*

Browne, Gordon Frederick, RI (1858-1932). Tennis illus. for the story of 'Mazurka' featured in the *English Illustrated Magazine*, 1893. *Victoria and Albert Museum.*

Butterfield, Sarah (b.1953). Studied architecture; awarded Edgeton Coghill landscape prize 1977, Winsor & Newton Award 1978, Hunting Group Competition finalist 1987. 'Doubles Players', signed. 12in. x 16in. *The Wingfield Sporting Gallery, London.* (*See also* netball.)

Cleaver, Dudley (op.1890-1908). Pen and ink portraits of lawn tennis personalities including Mr Rhodes; Miss Eastlake Smith — covered courts Champion; Mr A.W. Cole; Miss Coles; Mr Garcia; and Mr A.F. Wilding — the winner of the Men's Singles Championship. *Queens Club, London.*

Deykin, Henry Cotterill (b.1905).
*'View from the competitors' sun roof during the Lawn Tennis Championships at the All England Club, Wimbledon, 1950', signed. 20in. x 24in. *The Wingfield Sporting Gallery, London.*
*'Warwick Boat Club, August 1950', (now chiefly a tennis club), showing Warwick Castle in the background. 19½in. x 23½in. *Henry Deykin.*
*'The Centre Court at Wimbledon', signed. Budge Patty defeating Frank Sedgman in the final, 7th July 1950. 19½in. x 23½in. *Henry Deykin.* (*See also* Association football, cricket, croquet, golf, hockey, lacrosse, lawn bowls, polo, Rugby football.)

*English School,** c.1880. 'Children playing tennis near the Crystal Palace. Pen, ink and w/c. 15½in. x 23½in. *Bonhams.*

Gardner, H. (op.1890s). 'Lawn Tennis at Brighton', s. & d. 1890. w/c. 11¾in. x 14in. *Sotheby's.*

*Gere, Charles March, RA, RWS, RBSA, NEAC** (1869-1957). 'The Tennis Party', 1900. 15in. x 42in. *Cheltenham AG and Museums.* This painting is said to represent members of the artist's family, including his sister Edith, who was married to the stained glass artist Henry Payne, RWS (1868-1940).

Ghilchik, David Louis, ROI, NEAC (1893-1973).
*'Rough or Smooth?', c.1920s, signed. Pen and black ink sketch. 8½in. x 12in. *The Wingfield Sporting Gallery, London.*
*'Yours partner', c.1920s, signed. Pen and black ink sketch. 10in. x 14in. *The Wingfield Sporting Gallery, London.* (*See also* golf.)

Gill, Arthur Eric Rowton, AER (1882-1940). 'The Tennis Player', c.1924. Wood engraving. 4½in. x 4⅛in. *Victoria and Albert Museum.*

Goodhall, John Strickland, RI, RBA (b.1908). Lawn tennis in an Edwardian setting. w/c. 12½in. x 14¾in. Exh. at Christopher Wood Gallery, London to celebrate the artist's 80th birthday, July 1988.

Grainger, James (contemporary artist). 'The King of Tennis'. 21in. x 14in. *The Portal Gallery, London.*

Guthrie, Sir James, PRSA, HRA, RSW (1859-1930). Lawn tennis featured in a number of paintings by this artist including two listed in the catalogue of Guthrie's works compiled by J.L. Caw in 1932. One, 19in. x 18in., s. & d. 1891 was owned by Miss A.M. Rankine of Glasgow and the other 24in. x 18in., s. & d. 1892 was owned by Mrs. George Burrell of Paisley.

Hayllar, Mary (Mrs H.W. Wells, op.1880-1887). 'The Lawn Tennis Season', s. & d. 1881. 7⅝in. x 9⅝in. *Chipperfield Bequest, Southampton AG.*

Hayllar, Edith (1860-1948). 'The Tennis Players — A Summer Shower'. 21in. x 17in. *Forbes Magazine Collection, NY.*

Holloway, W.H. (op.1919-1925). A painting entitled 'Fast work at the Net', showing four young men playing a doubles game was included in *Boys' Own Annual* 1924/25.

Hopkins, Arthur, RWS, RBA (1848-1930). 'H.F. Lawford v. W. Renshaw, in the 5th round'. Repro. *The Graphic,* and *Fifty Years of Wimbledon,* by A. Wallis Myers, pub. by *The Field* in 1926, for the All England Club.

Isenberg, H. 'Berliner Lawn Tennis Club E.V.I. Winturnier', s. & d. 1909. Litho. poster. 28in. x 18¾in. *Christie's.*

***Jagger, David, RP, ROI** (1892-1958). 'The Tennis Player — portrait of Lord Foley, aged 14', s. & d. '34. 38½in. x 44in. *Sotheby's.*

Khnopff, Fernand (Belgian, 1858-1921). 'Tennis Memories'. Pastel. Repro. as a book illus.

La Thangue, Henry Herbert, RA (1859-1929). 'Resting after the Game', s. & d. 1888. *Spinks, London.* This painting shows the artist's wife resting after a game of tennis and may well have been inspired by Lavery's 'The Tennis Party' (q.v.).

Laserstein, Lotte (b.1898). 'The Tennis Player'. Exh. Belgrave Gallery, London, November 1987. German-born artist who has lived in Kalmar, Sweden, since 1937. Studied art at the Berlin Academy under Erich Wolsfield.

***Lavery, Sir John, RSA, RA, RHA** (1856-1941). 'The tennis party', s. & d. 1885. 28in. x 71¾in. Exh. RA 1886, No.740 as 'The tennis match'. *Aberdeen AG and Museums. (See also croquet, golf.)*

Leslie, George Dunlop, RA (1835-1921). 'Portrait of Bessie Andrew' holding a tennis racket and in tennis attire, s. & d. 1888. *Mallams, Cheltenham.*

Miles, G. Francis (1852-1891). 'Pause in the Match', s. & d. 1883. *Wimbledon Lawn Tennis Museum.*

McKenzie, James Hamilton, ARSA, RSW, ARE (1875-1926). 'Portrait of a young girl holding a tennis racket', signed. 30in. x 18in. *Christie's.*

***Mote, George William** (1832-1909). 'A tennis party', signed. 18in. x 24in. *Sotheby's.*

***Nash, Arthur.** 'All England Lawn Tennis Doubles Championship at Wimbledon, 1954', signed. *Wiggins Teape Group.*

Nicholson, R.E. 'Distant tennis games', s. & d. w/c. 14½in. x 21½in. *Sotheby's.*

Patterson, Tom. 'The Tennis Match', s. & d. 1922. 12¼in. x 18¾in. *Christie's, Glasgow.*

Peploe, Samuel John (1871-1935). An artist known to have painted tennis scenes.

***Pierson, Louis V.** (American, 1870-1950). 'Lawn Tennis at the Burtons', dated 1905. 26in. x 30in. This men's match is believed to be at The Burtons, St. Paul, Minnesota, one of America's early courts. *Sotheby's.*

***Rackham, Arthur, RWS** (1867-1939). 'Playing tennis from the baseline', signed. Pen, ink and w/c. 10½in. x 6in. *The Wingfield Sporting Gallery, London.* (See also golf.)

***Ravilious, Eric William** (1903-1942). Tennis door panels, for the Music Room in Geoffrey Fry's Portman Court Flat, 1930. *City of Bristol Museum and AG.*

Ribera, Pierre (French, b.1867). 'The Tennis Party', signed. 8in. x 10in. *The Priory Gallery, Cheltenham.*

***Simpson, Tom, RI** (1887-1926). 'The tennis party', signed. w/c. 9in. x 13in. *The Wingfield Sporting Gallery, London.*

Spahn, Victor (b.1949, Paris). Original litho. 6 plates, 14 colours, printed in Paris 1986 on Arches paper. Edn. 250, signed by the artist and numbered. Artist's proofs 25. 23in. x 18in., pub. by CCA Galleries and the artist, 1987.

Toynbee, Lawrence (b.1922). 'Mixed Doubles 1980'. 12in. x 16in. Exh. FAS.

***Vermeylen, Alphonse** (Dutch, 1882-1939). 'Au Tennis', signed. 28in. x 36½in. *Sotheby's.*

***Watherson, Marjorie Violet** (Mrs Geare), SWA (c.1905-1970). 'The 1923 Ladies Wimbledon Singles Final', signed. *Sotheby's.*

***Wilson, Leslie.** 'Between Sets', c.1934, signed. 22in. x 15¼in. *Sotheby's, Sussex.*

Witherby, A.G. (known as 'Wag'). Caricaturist for *Vanity Fair* 1894-1895 and 1899-1901. Proprietor of *Vanity Fair* late 19th century. Produced a caricature of the Grand Duke Michailovitch of Russia 'who always plays up to the net' standing at the net complete with racket in the Prince's issue (No.15) of *Vanity Fair,* 4.1.1894.

Netball

***Butterfield, Sarah** (b.1953). 'The Netball Match', signed. 17in. x 24in. *Sarah Butterfield. (See also lawn tennis.)*

Polo

Aldin, Cecil Charles Windsor, RBA (1870-1935). Distinguished artist who included polo scenes amongst his work. (See also curling, golf.)

***Armour, Lt. Col. George Denholm, OBE** (1864-1949). 'Saving a Goal, Polo', signed. Pencil, w/c and gouache on linen. 10¾in. x 13¾in. *Spinks, London.* Author and illustrator of *Bridle and Brush,* pub. Eyre and Spottiswoode, 1937, which contains the artist's graphic descriptions and drawings for *Country Life* of the 1913 Westchester series in the USA. (See also curling.)

Barker, John Wright, RBA (1864-1941). The chestnut polo pony Dagmar in an open landscape. 18in. x 28in. *Bonhams.*

***Bellows, George Wesley** (American, 1882-1925). 'Polo at Lakewood, 1910', signed. 45¼in. x 63½in. *Columbus Museum of Art, Ohio, Columbus Art Association Purchase.*

***Blampied, Edmund, RBA, RE** (1886-1966). 'Polo as it is not played in England', inscr. 14in. x 11in. A set of three. *Bonhams.*

Board, Major John Arthur (1895-1965). Polo illustrator, sports correspondent and author of whom *The Times* said (obit. 26.6.1965): "As an illustrator to his own books and notably 'from the point to point' he had a remarkable gift for depicting the polo pony in action and catching the finer points of the game at high speed." Author and illustrator of *Polo,* pub. Faber, 1956.

Borein, Edward (American, 1873-1945). Polo sketches. Pencil, black ink and pen. 14in. x 18½in. *Christie's, NY.*

Bradley, Cuthbert (1861-1943). 'The Final of the Hurlingham County Cup, 1895', Rugby v. Chester, s. & d. 1895. 11½in. x 20¾in. *Sotheby's, Sussex.* This talented artist and writer also contributed polo sketches to Fores *Sporting Notes and Sketches.* He often used the pseudonym 'Whipster' for his journalistic work; also illustrated *Polo* by J. Moray Brown, pub. Vinton & Co., London, 1895.

***Brooks, Henry Jamyn** (op.1890-1909). 'The Hurlingham Polo Team mounted in front of the pavilion, 1890', s. & d. 1890. 42in. x 90in. *The Hurlingham Club.* (See also cricket.)

Brown, Paul (American, b.1893). 'A Shot by Miles', s. & d. '28. Pen, black ink and w/c sketch. 13⅜in. x 21⅛in. *Christie's, NY.* Author and illustrator of *Hits and Misses,* pub. by Derrydale Press, 1935, and *Polo,* pub. Charles Schribners and Sons, NY, 1949.

Brown, Major Cecil, MA, RBA (1868-1926). 'A game of Polo', signed and inscr. Silk laid on board. 11½in. x 8½in. *Sotheby's.*

***Cattley, George A.** (1899-1980). 'Polo Lines', s. & d. 1933. 14¼in. x 25¼in. *The Wingfield Sporting Gallery, London.* This artist was a staff instructor at the Military Riding School at Weedon. He was a Carbineer in the regiment which won the Inter-Regimental Polo Tournament in 1886 and 1887.

Cawthorne, Neil (b.1936). 'The Last Chukka, 1981'. Repro. *The World of Polo, Past and Present,* by J.N.P. Watson, pub. The Sportsman's Press, 1986.

Copley, John, PRBA, RE (1875-1950). 'The Polo Players'. This artist won 2nd prize with his etching in the Olympic Arts Competition in July/August 1946. 'Hurlingham Polo', 1947. Dry point. 14¾in. x 11in. *British Museum.*

Coverley-Price, Victor (b.1901). Known painter of polo scenes.

Crawhall, Joseph (1861-1913). Artist of several polo scenes including 'The Polo Player'. w/c. 4in. x 5in. *Glasgow Hunterian AG, University of Glasgow.*

Cuneo, Terence, RGI, PIPG (b.1907). 'Pony Lines, Cirencester 1972'. *The Sladmore Gallery, London.* Repro. *The World of Polo, Past and Present*, by J.N.P. Watson, pub. The Sportsman's Press, 1986. (See also Association football.)

Dadd, Frank, RI, ROI (1851-1929). Polo sketches for the Badminton Library Series of *Polo*.

*****Deykin, Henry Cotterill** (b.1905). 'Polo at Cowdray Park, Sussex'. Cowdray Park defeat Henley 6.5 to 9, 27th August 1951, signed. 19in. x 23¾in. *Henry Deykin.* The Henley team included Major A. David, E.C. Roarke, A.L. Roberts and the Maharajah of Jaipur. The Cowdray Park team included Commander P. Howes, Lord Cowdray, C. Smith Ryland and Lt. Colonel P.W. Dollar. (See also Association football, cricket, croquet, golf, hockey, lacrosse, lawn bowls, lawn tennis, Rugby football.)

Dickinson, H.B. — Lord Wavertree (formerly Colonel Hall-Walker) on 'First' a polo pony. 16in. x 20in. *Walker AG, Liverpool.*

*****Earl, George** (op.1856-1883). 'Polo Match at Hurlingham'. Between the Royal Horse Guards (Blues) and the Monmouthshire Team, 7th July, 1877. *The Hurlingham Club.*

*****Edwards, Lionel Dalhousie Robertson, RI, RCA** (1878-1966). 'Ranelagh v. Royal Horse Guards Subalterns, 17th June '99. Inscr. 'Result R H G 8 goals, Ranelagh 1 goal', s. & d. 1899. Pen and ink sketch. 14in. x 10in. Edwards would have been 21 years old when he sketched these polo scenes, probably as an illustration for a magazine. This drawing is interesting because it depicts a match at Barn Elms, Barnes, after the Ranelagh Club had moved from its old site beside the Hurlingham Club in 1894. *The Wingfield Sporting Gallery, London.*

Farrow, Will (Australian op. from 1919 in France and England). 'The Duke of Edinburgh on the polo field', signed. w/c and crayon. 21in. x 14¼in. Exh. August 27th – September 14th, 1968, Ansdell Gallery, Kensington, 'Portrait caricatures by Will Farrow'.

Gibbons, Ruth (b.1945). Polo scenes. *The Tryon and Moorland Gallery, London.*

Giles, Major Godfrey Douglas (1857-1941). 'Polo at Hurlingham'. 20in. x 41½in. *Sotheby's.* Repro. *The Dictionary of British Equestrian Artists*, by Sally Mitchell, pub. Antique Collectors' Club, 1986.

Girardot, Ernest Gustave. 'The Polo Player', s. & d. 1902. 13¼in. x 9⅜in. *Sotheby's, NY.*

Griffiths, P. 'The Polo Players', s. & d. 1961. *Blackburn Museum and AG.*

Hailey, Clarence Thomas (1867-1949). Although this artist is better known as a photographer of horses, he did paint them as well. 'Study of a polo pony', signed and inscr. 16in. x 20in. *Bonhams.*

*****Haseltine, Herbert** (1877-1962). American sculptor. A bronze of a polo group, 1911. Presented to the Hurlingham Club by Harry Payne Whitney. *The Hurlingham Club.*

Heathcote, E.S. (op.1880-1905). 'Polo Ponies', s. & d. 1898. 13in. x 16in. *Sotheby's, NY.*

*****Heseltine, Michael** (b.1961). 'Guards Polo, Smiths Lawn, Windsor', s. & d. '85. w/c. 11½in. x 10in. *The Wingfield Sporting Gallery, London.*

Holiday, Charles Gilbert Joseph (1879-1937).
* 'The Westchester Cup', 1936, signed. w/c. 11½in. x 18½in. *The Hurlingham Club.*
* 'A game of polo'. Gouache. 9½in. x 15in. *Sotheby's, Sussex.*

Jalland, George Herbert (op.1888-1908). Illustrator of polo scenes in *Mr. Punch's Book of Sports* and *The Badminton Magazine.* Portrait of the Earl of Harrington on his arab pony 'Umpire', in the act of striking a ball. Pen and black ink sketch. 6in. x 6in. *Christie's.* (See also hockey.)

*****Jeanniot, Pierre-Georges** (French, 1848-1934). 'Polo', 1835, signed. Black chalk sketch. 10¾in. x 16in. *Sotheby's, Sussex.*

Jones, Adrian (1845-1938). 'Hurlingham: "Nimble" "Cicely" "Dynamite" and "Lady Jane"', four polo ponies. 42in. x 61in. *Walker AG, Liverpool.*

*****Kennedy, Edward** (contemporary artist). 'Changing Ponies', s. & d. 1987. 27½in. x 35in. *Christie's.*

Kilburne, George Goodwin, RBA (1863-1938). 'The Hunt Cup at Ranelagh'. This painting is referred to in *Baily's Magazine*, Vol.74, p.55, July 1900.

*****King, John** (b.1929). 'The Warwickshire Cup 1986 at Cirencester Polo Club', s. & d. '86. w/c. 14¼in. x 20¾in. *John King, and Malcolm Innes Gallery, London.*

*****Koch, Ludwig** (Austrian, 1866-1934). 'Riding Off', s. & d. 1925. w/c and gouache. 9½in. x 12½in. *Sotheby's, Sussex.*

*****Koehler, Henry** (b.1927). 'Changing Ponies, Cowdray Park 1986', signed. 16in. x 24in. *Wilton Antiques Ltd.* (See also cricket, lawn bowls.)

La Fontaine, Thomas Sherwood (b.1915). 'A Polo Match', signed. 28in. x 36in. *Christie's, NY.*

Liebermann, Max (1847-1935). 'Polo Players'. Pen and black ink sketch. 11½in. x 8⅞in. *Christie's, NY.*

Longueville, E. (19th/20th C.) 'Study of the polo pony "Czar", 7th Hussars', s. & d. 1905. 13½in. x 17in. *Sotheby's, Sussex.*

*****Lucas Lucas, Henry Frederick** (1848-1943). 'Polo', s. & d. '93. 10in. x 22in. Inscr. 'Rugby' on the reverse. *The Wingfield Sporting Gallery, London.* Rugby Polo Club was started in 1892 at Barby Rd., where they had two boarded polo grounds. Rugby, with supporting Liverpool and Edinburgh Clubs played a very important role in promoting county polo and by the turn of the century they had also perfected team play with one of the best teams in the country. Rugby was the best mounted team between 1900 and 1904. After the Second World War during which polo took a terrible knock and many of the grounds had been requisitioned, John Board (q.v.) wrote in 1947: 'Rugby is thought to be the future headquarters of British Polo', but it was not to be.

*****England v. America at Hurlingham', s. & d. 1921. 17in. x 15in. *Sotheby's.*

Luyt, A.M. (Dutch). 'Polo Players'. Exh. at the XIVth Olympiad Sport in Art Competition and Exhibition at the Victoria and Albert Museum, 1948 (No.195).

McNeill, August (op.1900-1914). Polo sketches 'Riding Him Off' and 'Out by Himself', signed. These sketches appeared in a national newspaper early in the 20th century.

'M.R.' Unknown. Caricaturist of the *Vanity Fair* stable who contributed two cartoons between 1900 and 1901. One was an amusing portrait of HH the Maharaja of Patiala, GCSI, complete with polo stick and ball, which was published in the Prince's issue (No.21) of *Vanity Fair*, 4.1.1900. The Maharaja, known for his unique riding breeches, wore his hair Sikh fashion in a turban secured by an elastic strap, which added to his unusual appearance.

Munnings, Sir Alfred James, PRA, RWS, RP (1878-1959). Celebrated equestrian artist who included polo amongst his work.

Mynors, Stella (op.1920s). 'The Earl of Londesborough on the polo field', signed. Mixed media. 21¼in. x 28in. *Bonhams.*

*****Oldfield, John** (b.1918).
* 'Pony Lines — Rhinefield', s. & d. '86. w/c. 21¼in. x 9in. *Tryon and Moorland Gallery, London.*
* 'Polo sketch — Smiths Lawn', 1987, signed. w/c. *John Oldfield.*
* 'Rhinefield — Polo', s. & d. '86. w/c. *John Oldfield.*

Paite, George (1868-1941). This artist collaborated with Claude Prescott on a painting entitled 'The old Polo Grounds', s. & d. May '92. Grisaille. 18in. x 24in. *Christie's, NY.*

Payne, Charles Jackson 'Snaffles' (1884-1967). 'Carpet Beaters v. Bobbery Wallahs'. Repro. *The World of Polo Past and Present* by J.N.P. Watson, pub. The Sportsman's Press, 1986.
* 'The 5th Lancers, 1907', depicting the Regimental polo players. w/c. and gouache. 13in. x 11½in. *Phillips.*

Ponsonby, William (20th C.). 'The Polo Match', s. & d. 1942. *Phillips.*

Roche, Christopher J. (20th C.) 'Polo', signed with pencil vignettes. 16in. x 23in. *Woolley and Wallis, Salisbury.*

Rowlandson, George Derville (1861-1930). 'Games of Polo, s. & d. 1902. A pair. 41in. x 28in. *Christie's.*

Scott, Septimus Edwin, ROI (b.1879). A fine painting of a game of polo drawn exclusively for *The Bystander*, May 1910. Inscr. 'An exciting moment in the "Galloping Game" — Will he score?'

***Simpson, Charles Walter, RBA, RI, ROI, RSMA** (1885-1971). 'H.R.H. The Duke of Windsor, when Prince of Wales, playing polo at Cowdray Park'. 21in. x 32in. *Royal Exchange Art Gallery, London.* This artist also painted the final of the Buenos Aires Challenge Cup which was originally reproduced in *Country Life*, 21.7.1928. (18in. x 12½in., signed mono. C.S.) (*See also* golf.)

St. Clair-Davis, Heather. 'Full Tilt'. Repro. *The World of Polo, Past and Present*, by J.N.P. Watson, pub. The Sportsman's Press, 1986.

***Stewart, Frank Algernon** (1877-1945). 'In the Making', s. & d. '21. w/c. 9in. x 9in. *Sheila Hinde Fine Art, Sussex.* Repro. *Antique Collecting*, Dec. 1987.

Trickett, W. Wasdell (op.1916-1939). 'The polo pony "Nell" ', s. & d. 1923. 13¾in. x 18in. *Bonhams.*

Tulloch, Maurice (1894-1974). Talented equestrian artist and a serving army officer who took up serious painting after retirement. Illustrated *Tournament Polo* by General Sir Beauvoir De Lisle, pub. Eyre and Spottiswoode, 1938. Repro. *The Dictionary of British Equestrian Artists*, by Sally Mitchell, pub. Antique Collectors' Club, 1985.

***Unknown artist.** Unsigned w/c, c.1902, of a polo match showing the new Ranelagh Club pavilion after the Club moved to Barn Elms, Barnes in 1894. 7½in. x 20½in. *The Wingfield Sporting Gallery, London.*

V.A.B. 'A game of polo at the West Somerset Polo Club, Dunster', signed with inits. w/c. 9½in. x 13½in. *Sotheby's, Sussex.*

Van Dongen, K. 'Polo ponies, Deauville'. Gouache and w/c. 19¼in. x 25¼in. *Georges Blache, Versailles.*

Voss, Franklin B. (American). 'Grooms bringing the polo ponies into the field', s. & d. 1941. 26½in. x 40½in. *Christie's, NY.*

Walenn, Gilbert (contemporary artist). 'Polo Players', s. & d. 1962. Pencil and w/c. 14½in. x 21¼in. *Bonhams.*

Wanklyn, Miss Joan (contemporary artist). 'Smiths Lawn, 1967'. Repro. *The World of Polo, Past and Present*, by J.N.P. Watson, pub. The Sportsman's Press, 1986.

Whitcombe, Susie (b.1957). 'The Coronation Cup'. Repro. *The World of Polo, Past and Present*, by J.N.P. Watson, pub. The Sportsman's Press, 1986.

***Wollen, William Barnes, RI, ROI, RBC** (1857-1936). 'Polo', signed. w/c. 11¾in. x 15in. *Sotheby's.* (*See also* Association football and Rugby football.)

Wright, George (1856-1942). 'Washing Down Polo Ponies'. Exh. Tryon and Moorland Gallery, London, 1983.

'At the stables', signed. 12in. x 18in. *Christie's.* In 1901 Wright moved to Rugby, which had an excellent ground, and his polo paintings date from this period.

Rackets and Squash Rackets

Dadd, Stephen T. (op.1879-1914). Artist and b/w illustrator of many sporting scenes; contributed racket illustrations to *The Illustrated London News* including the Public School Championship at Queens Club in 1888 and The World Title (rackets) the 1911 match between Charles Williams and J. Jamsetje of India (the first overseas player to hold the title between 1903-1911) when he lost to Williams at Prince's Club, London. (*See also* hockey.)

Dighton, Robert (1752-1814). 'Fives played at the Tennis Court, Leicester Fields'. Engraving by an unknown engraver. 7in. x 8½in., pub. Carrington Bowles, 1788. *British Museum Collection.* The game depicted rackets and not fives in the modern sense. Fives did not really acquire its own identity until the middle of the 19th century (*see* text). (*See also* Association football, billiards, cricket, fives.)

Lane, Theodore (1800-1828). 'Rackets', an etching by this artist aqua. by G. Hunt, 8¾in. x 12¼in., is recorded in *British Prints*, by Ian Mackenzie, pub. Antique Collectors' Club, 1987.

Pugin, Augustus Charles de (1762-1832) and **Rowlandson, Thomas** (1756-1827). (*See also* billiards, cricket.)

*'Rackets at the Fleet Prison', c.1808. Col. aqua. by Joseph Constantine Stadler (op.1780-1824). 9in. x 11in. Pub. R. Ackermann 1808 (pl. to *The Microcosm of London...*, Vol. II, facing p.44). *British Museum Collection. National Squash Library.*

*'Rackets at the King's Bench Prison', c.1808. From *The Microcosm of London...* Vol. II. *British Museum Collection. National Squash Library.*

Stella, Jacques (1606-1657). 'Les Jeux et Plaisirs de L'Enfance'. Four engravings, 5½in. x 4¾in., after the work of this artist by the artist's niece Claudine Bouzonnet (1636-1697), were pub. in Paris, 1657. Three of them show naked infants playing early rackets and ball games including La Paume and are amongst the earliest prints depicting racket games. *Sotheby's.*

Toynbee, Lawrence (b.1922). Painter of many sports scenes including squash.

Real Tennis

***Bancroft, Shelley** (b.1955). Portrait of Chris Ronaldson, World Champion, Real Tennis, 1981-86, signed. Painted in 1984. 9¾in. x 18in. *Chris Ronaldson.*

***Boilly, Leopold Louis** (1761-1845). 'The Interior of the Jeu de Paume, Versailles', signed. 15¾in. x 19¼in. A print after the original painting, which is in a private collection in the USA. *Chris Ronaldson.*

***Clark, Jean, RWS, NEAC** (b.1902). 'The Dedans', s. & d. 1951. 24in. x 36in. *Lord Aberdare. On loan to Queens Club, London.*

***Couder, Louis Charles Auguste** (1790-1873). 'Le Serment du Jeu de Paume', painted in 1848, engraved in aqua. by Jazet. *Musée National du Château de Versailles.*

***David, Jacques Louis** (1748-1825). 'Le Serment du Jeu de Paume'. An unfinished version painted in 1791. *Musée National du Château de Versailles.*

***Devis, Arthur** (1711-1787). Attrib. 'The Tennis Player'. *Courtauld Institute of Art, London.*

Griffin, Ann (contemporary artist). 'A Real Tennis Match'. 18in. x 16in. *The Portal Gallery, London.*

Hobson, Anthony, PhD, NDD, ATD, FRSA, FSEAD, Hon.FHS. Distinguished contemporary painter of several real tennis paintings in oil. These include portraits of the celebrated Jim Dear, the former Real Tennis and Rackets World Champion, and Henry Johns, for many years senior professional to the MCC at Lords.

*'The Dinner Match at Leamington', s. & d. '82. 60in. x 96in. The painting, with its forty-four portraits, was commissioned by the Leamington Tennis Court Club. *Anthony Hobson.*

***Ludlow, Henry (Hal) Stephen** (1861-1903). 'Evans Baillie Noel', s. & d. 1904. w/c. 23½in. x 17in. *Private Collection.*

***Merian, Matthäus, the younger** (1621-1687). 'The High Borne Prince James, Duke of York', signed. Etching. 7½in. x 5in. From the *True Effigies of... King Charles... with the... Royall Progenie.* British Museum.

***Mortimer, John Hamilton, ARA** (1741-1779). 'Monsieur Masson the celebrated Tennis Player'. 29in. x 23⅞in. *Private Collection.* A mezzo. after this painting by Richard Brookshaw (1736-1800), pub. J. Wesson 1769, is in the Collection of the British Museum. (*See also* billiards.)

***Shepherd, Thomas Hosmer** (1792-1864). 'The Royal Tennis Court', St. James's Street, Leicester Square (est. 1673), as it appeared in 1850. Ink, wash and w/c. 7in. x 17¾in. This court closed in 1866, but the first court on the site (now Orange Street), was built c.1634. *British Museum.* (*See also* cricket.)

***Unknown artist.** 'Portrait of Peter Latham' (1865-1953), the Real Tennis World Champion 1895-1905 and 1907-8. 46in. x 38in. *Queens Club, London.*

***van Gassel, Lucas** (1480-1555). 'King David giving Uriah his letter to Joab'. Panel. 13in. x 17¾in. *Richard Green Gallery, London.*

Rugby Football

Arnold, Jane (b.1821). Sketch of the Game at Rugby School. Repro. *Dr. Arnold of Rugby*, by Norman Wymer, pub. by Robert Hales.

*The Dowager Queen Adelaide watching the boys playing Football at Rugby School in 1839, with Dr. Arnold and his two sons (*see* text). *Mrs. Mary Moorman.*

***Barnard, George** (op.1832-1890). 'The School from the Close', s. & d. 1852. 24in. x 36in. *Rugby School.*

Berkeley, Stanley, RE (1855-1909). This artist illustrated the *Athletics and Football* edition of the Badminton Library Series pub. 1888, of which 'Collared — Mid-Victorian Tackling' is the frontispiece.

Breeden, W.L. (op.1882-1920). 'A Rugby Match', s. & d. 1893. *Harry Langton Collection.*

***Deykin, Henry Cotterill** (b.1905). 'Rugby Football at Twickenham, England v. France, 29th February, 1951', signed 19½in. x 23½in. This represents France's first win over England and shows B. Boobyer scoring England's only try. *Henry Deykin. (See also* Association football, cricket, croquet, golf, hockey, lacrosse, lawn bowls, lawn tennis, polo.)

Emmerson, Percy (op. late 19th C.). 'England v. Scotland', s. & d. 1892. 45¼in. x 34in. *RFU, Twickenham.* This painting shows Frederick Hodgson Rudd Alderson, who captained England in his international debut against Scotland at Raeburn Place, Edinburgh in 1891.

Foggie, David, RSW, ARSA, RSA (1878-1948). A pastel portrait of a Scottish Rugby player, in the late 1930s. *Harry Langton Collection.*

***Fryer, Wilfred, SMA.** 'The Barbarians Tour', 1954, signed. *Wiggins Teape Group.*

Harwood, Edward (b.1814, op.1844-1872). Exh. 'A Winter Football Scene at Rugby School', at RA, 1859. This painting was repro. and discussed in letters to the editor, *Country Life,* 10.11.1928, p.667.

Hemy, Thomas Marie Madawaska (1852-1937). 'Rugby School Big Side Football'. An engraving after this work dated 1890,

21in. x 14in., by F.G. Stevenson is recorded (*British Prints*, by Ian McKenzie, pub. Antique Collectors' Club, 1988). (*See also* Association football.)

***Hicks, George Elgar, RBA** (1824-1914). 'Will he do it?', s. & d. 1880. 34in. x 55½in. *RFU, Twickenham. (See also* croquet.)

Insall, Frank (op.1920s-1930s). 'The Try' painted specially for *Chum's Annual*, 1938, pub. Amalgamated Press Ltd., founded in 1892 by Sir Max Pemberton.

Jouclard, Adrienne (French, b.1882). 'Rugby Football in Jean-Bonin Stadium'. Exh. at the XIVth Olympiad Sport in Art Competition and Exhibition at the Victoria and Albert Museum, 1948 (No.105).

Lhote, André (op. early 20th C.). 'Les Joueurs de Rugby', c.1917, signed. 58¼in. x 70¼in. *Sotheby's.*

Platt, John Edgar (1886-1967). A colour wood cut 'The Scrum', 10in. x 15¼in., is recorded (*British Prints*, by Ian McKenzie, pub. Antique Collectors' Club, 1988).

Platt, John Gerald, ARE, ARCA (b.1892). 'Rugger'. Col. print. Exh. at the XIVth Olympiad Sport in Art Competition and Exhibition at the Victoria and Albert Museum, 1948 (No.253).
'Rugby Football — The Scrum', col. woodcut, exh. at 7th Annual Exhib. of Society of Graver Painters, London, 1922.

Prater, Ernest (op.1897-1914). 'A Dash from the Srimmage'. Exh. RA between 1897-1904. (*See also* Association football.)

Reynolds, Frank, RI (1876-1953). Illustrator of many sports, including Rugby football, often sketched for *Punch* in pen and ink.

***Riley, Harold** (b.18934). 'Lancashire v. Yorkshire at Headingley, 1981', signed. 39½in. x 48¾in. Presented to the RFU by Lancashire County RFU on the occasion of their Centenary. *RFU, Twickenham.*

Rodway, Eric (b.1914). 'The Rugby Player', s. & d. 1953. *Harry Langton Collection.*

***Stampa, George Loraine** (1875-1951). 'Seen anything of Muriel lately?', s. & d. 1935. Pen and ink sketch. 7¼in. x 10in. *The Wingfield Sporting Gallery, London.*

Stratton, Frederick (op.1901-1904). 'The Rugger Match', signed with inits. 30in. x 35in. Exh. Spinks, 1984.

***Thomas, W.L.** 'Football at Rugby', s. & d. 1870. Pen and ink sketch. *Rugby School.* This artist also contributed 'Rugby Boys at Football' to *The Boys' Own Magazine* (Midsummer), 1863, p.401.

Tuke, Henry Scott, RA, RWS, NEAC (1858-1929). 'Portrait of Johny Jacket', signed and inscr. 8in. x 10in. *Christie's.* (Johny Jacket was the full-back for Falmouth and England.) (*See also* cricket.)

***Valentine-Daines, Sherree, UA, SWA.** (b.1956). 'England v. Wales at Twickenham, 1986', signed. Signed verso by the players. 34½in. x 58½in. *The Wingfield Sporting Gallery, London.*

Wollen, William Barnes, RI, ROI, RBC (1857-1936).'
*****'Newport v. Cambridge', s. & d. 1879. 41in. x 59½in. Exh. RA 1879. *RFU, Twickenham.*
*****'Yorkshire v. Lancashire', s. & d. 1895. 58¼in. x 94¼in. *RFU, Twickenham. (See also* Association football, polo.)

Bibliography

GENERAL

Arlott, John (Ed.), *The Oxford Companion to Sports and Games*, Oxford University Press, 1975.

Ayres, James, *English Naïve Painting 1750-1900*, Thames & Hudson Ltd., London, 1980.

Badminton Magazine, The, 1895-1905, Longmans Ltd., London.

Baigell, Matthew, *Dictionary of American Art*, John Murray Publishers Ltd., London, 1980.

Baily's Magazine, Vols. I-CXVIII, 1922.

Beckett, J.V., *The Aristocracy in England 1660-1914*, Basil Blackwell Ltd., Oxford, 1985.

British Sporting Painting 1650-1850, a catalogue compiled by the Arts Council of Great Britain for their 1974 Exhibition.

Cassell's Magazine, 1904-1906, Cassell Ltd., London.

Cotton, Charles, *The Compleat Gamester*, London, 1674.

Connoisseur, The, March 1932 - March 1934.

Cross, Arthur Lyon, *A Shorter History of England and Greater Britain*, Macmillan & Co., London, 1920.

Cuppleditch, David, *The London Sketch Club*, Dilke Press, l978.

Dunning, Eric, and Sheard, Kenneth, *Barbarians, Gentlemen and Players*, Martin Robertson & Co., Oxford, 1979.

Encyclopaedia of Sports, The, Vols. I-IV, William Heinemann Ltd., London 1911.

England in the 20th Century (1914-1979), (No. 9 in the Pelican History of England), Penguin Books Ltd., Middlesex, 1965, reprinted 1986.

Egerton, Judy, *British Sporting and Animal Paintings in the Paul Mellon Collection, 1655-1867*, The Tate Gallery for the Yale Center for British Art, 1978.

Evans, Eric, and Jeffrey, Richard, *A Social History of Britain in Postcards*, Longman Group Ltd., 1980.

Fores' Sporting Notes and Sketches, 1886-1905.

Fussell, C.E. and K.R., *The English Countryman - his life and work from Tudor to Victorian Age*, Andrew Melrose Ltd., 1955.

Goldman, Paul, *Sporting Life - an anthology of British Sporting Prints*, British Museum Publications Ltd., London, 1983.

Graves, Algernon, *A Dictionary of Artists Exhibiting 1760-1893*, Kingsmead Reprints, Bath, 1901, 3rd edn.

Hermen, Frank, *The English as Collectors*, Chatto & Windus, London, 1972.

Houfe, Simon, *The Dictionary of British Book Illustrators and Caricaturists 1800-1914*, Antique Collectors' Club, Woodbridge, 1978, revised 1981.

Johnson, J., and Greutzner, A., *The Dictionary of British Artists 1880-1940*, Antique Collectors' Club, Woodbridge, 1976.

Landscape in Britain 1850-1950, Arts Council, 1983.

Lindsay, Donald, and Washington, E.S., *A Portrait of Britain between 1851-1951*, Oxford University Press, 1952.

Malcomson, Robert W., *Popular Recreations in English Society 1700-1850*, Cambridge University Press, 1981.

Mallalieu, H.L., *The Dictionary of British Watercolour Artists up to 1920*, Antique Collectors' Club, Woodbridge, 1976, 2nd edn. 1986.

Mangan, James Anthony, *Athleticism in the Victorian and Edwardian Public School*, Cambridge University Press, 1981.

McKelvie, Roy, *The Queens Club Story 1886-1986*, Stanley Paul & Co. Ltd., London, 1986.

Mr. Punch's Book of Sports, published for Punch Library by the Educational Book Company Ltd., 1912.

Mitchell, Sally, *The Dictionary of British Equestrian Artists*, Antique Collectors' Club, Woodbridge, 1985.

O'Morgan, Kenneth (Ed.), *The Oxford Illustrated History of Britain*, Oxford University Press, 1984.

Opitz, Glenn B. (Ed.), *Mantle Fielding's Dictionary of American Painters, Sculptors and Engravers*, Apollo Books, New York, 1984.

Osborne, Harold, (Ed.), *The Oxford Companion to Art*, Oxford University Press, 1970.

Patten, John, *Pre-Industrial England - Geographical Essays*, W. Dawson & Sons, Kent, 1979.

Paget, Guy, *Sporting Pictures of England*, Collins Ltd., London, 1945.

Paviere, Sidney H., *A Dictionary of British Sporting Painters*, F. Lewis Ltd., Leigh-on-Sea, 1965.

Pertrie, Harold, *The Origins of Modern English Society, 1780-1880*.

Pears' Cyclopaedia, 84th edn.

Pendred, G.L., *An Inventory of British Sporting Art in United Kingdom Public Collections*, Boydell Press, Woodbridge, 1987.

Peppin, Brigid, and Micklethwaite, Lucy, *Dictionary of British Book Illustrators - The Twentieth Century*, John Murray Publishers Ltd., London, 1983.

Pick, J.B., *The Dictionary of Games*, J.M. Dent & Sons Ltd., London, 1963.

Pierce Egan's Book of Sports and Mirror of Life, T.T. and J. Tegg, 1832.

Plumb, Sir John, McKendrick, Neil, and Brewer, John, *The Birth of a Consumer Society*, Europa Publications Ltd., London 1982.

Randall, David, *Great Sporting Eccentrics*, Comet Books, London, 1985.

Roebuck, Janet, *The Making of Modern English Society from 1850*, Routledge & Kegan Paul Ltd., London 1973, 2nd edn. 1982.

Rose, R.N., *The Field 1853-1953*, Michael Joseph Ltd., London, 1953.

Royal Society of British Artists 1824-1893 and The New English Art Club 1888-1917, The, Antique Collectors' Club, Woodbridge, 1975.

Snelgrove, Dudley, and Egerton, Judy, *British Sporting and Animal Drawings in the Paul Mellon Collection 1500-1850*, The Tate Gallery for the Yale Center for British Art, 1978.

Sparrow, Walter Shaw, *A Book of Sporting Painters*, The Bodley Head Ltd., London, 1931.

Sparrow, Walter Shaw, *British Sporting Artists*, The Bodley Head Ltd., London, 1922, 1965.

Sporting Magazine, The, Vol. I, 1792 and subsequent vols.

Sporting Review, Vol. VII, London 1842.

Sportscrapiana, a miscellany of 19th Century Anecdotes by celebrated sportsmen, Simpkin Marshall & Co. , London, 1986.

Strutt, Joseph, *The Sports and Pastimes of the People of England*, William Tegg & Co., London, 1801.

Titley, Norah, *A Bibliography of British Sporting Artists*, British Sporting Art Trust, Philip Wilson Publishers Ltd., London 1984.

Treuherz, Julian, *Hard Times - Social realism in Victorian art*, Lund Humphries, London, 1987.

Trevelyan, G.M., *English Social History*, Longmans, Green & Co., London, 1945.

Turnball, Harry, *Artists of Yorkshire - A short dictionary*, Thornton Gallery, Snape, 1976.

Vale, Marcia, *The Gentleman's Recreations, 1580-1630*, D.S. Brewer Ltd. and Rowman & Littlefield, 1977.

Walker, Stella A., *Sporting Art in England 1700-1900*, Studio Vista, 1972.

Walvin, Dr. James, *Victorian Values*, André Deutsch Ltd., London 1987.

Waters, M. Grant, *Dictionary of British Artists (Working 1900-1959)*, Vols. 1 and 2, Eastbourne Fine Art, 1975.

Who's who in Art, 21st edn., The Art Trade Press Ltd., Havant, 1984.

Wood, Christopher, *The Dictionary of Victorian Painters*, Antique Collectors' Club, Woodbridge, 1971, 1978.

AMERICAN FOOTBALL

50 Years of National Football League Excitement, Official Publication of the National Football League Association, New York, 1986.

The National Football League and You, Official Publication of the National Football League Association, New York, 1986/87.

ASSOCIATION FOOTBALL

Fabian, A.H., and Green, Geoffrey (Eds.), *Association Football*, Vols. 1-4, The Caxton Publishing Company Ltd., London, 1960.

Green, Geoffrey, *The History of the Football Association*, The Naldrett Press, London, 1953.

Pick, J.B., *The Dictionary of Games*, J.M. Dent & Sons Ltd., London, 1963.

BADMINTON, BATTLEDORE AND SHUTTLECOCK

A Short History, The Badminton Association of England.

BILLARDS AND SNOOKER

Clare, Norman, *Billiards and Snooker Bygones*, No. 136, Shire Publications Ltd., Princes Risborough, 1985.

Hendricks, William, *The History of Billiards - A Compleat Historie of Billiard Evolution*, published USA, 1974, 1977.

Trelford, Donald, *Snookered*, Faber & Faber Ltd., London, 1986.

CRICKET

Altham, H.S., *The History of Cricket*, George Allen & Unwin, 1938.

Bowen, Rowland, *Cricket, A History of its Growth and Development throughout the World*, Eyre & Spottiswoode Publishers Ltd., London, 1970.

Cunnington, Phillis, and Mansfield, Alan, *English Costume for Sports and Outdoor Recreations*, A. & C. Black Publishers Ltd., London, 1969.

Ford, John, in association with Thames Television Ltd., *This Sporting Land*, New English Library Ltd., Sevenoaks, 1977.

Simon, Robert, and Smart, Alistair, *The Art of Cricket*, Martin Secker & Warburg Ltd., London, 1983.

Swanton, E.W., Plumtre, G., and Woodcock, J., *Barclays World of Cricket*, Collins Publishers, London, 1986.

Warner, Sir Pelham, *Lords 1787-1945*, The Sportsman's Book Club, London, 1946.

CROQUET

Pritchard, D.M.C., *The History of Croquet*, Cassell Ltd., London, 1981.

CURLING
Smith, Sheriff David B., *Curling, An Illustrated History*, John Donald Publishers Ltd., Edinburgh, 1981.
ETON WALL AND FIELD GAMES
Lubbock, Cecil, 'The Eton Wall Game', published in *The Boys' Own Paper*.
The Official Rules of the Game, published by Eton College.
FIVES
Egerton, David, and Armitage, John, *Eton and Rugby Fives*, Seeley Service & Co. Ltd., London.
Rugby Fives Association Handbook, 1985-1987.
GOLF
Hutchinson, Horace (Ed.), *British Golf Links*, J.S. Virtue & Co. Ltd., London.
Stirk, D.I., and Henderson, I.T., *Golf in the Making*, Henderson & Stirk Ltd., Crawley, Hants, 1979.
'The Royal Game of Golf', *Baily's Magazine*, Vol. 46, Sept. 1886.
HOCKEY AND LACROSSE
Boys' Own Paper, The, 14.5.1888.
Miroy, Nevill, *The History of Hockey*, Lifeline Ltd., Staines, 1986.
LAWN BOWLS
Monroe, John P., *Bowls Encyclopaedia*, Wilke & Co. Ltd., Melbourne, Australia, 1951.
Pilley, Phil (Ed.), *The Story of Bowls from Drake to Bryant*, Stanley Paul & Co. Ltd., London, 1987.
LAWN TENNIS
Alexander, George E., *Lawn Tennis - Its Founders and Its Early Days*, H.O. Zimman Inc., Lynn, Mass., USA, 1974.
Alexander, George E., *Wingfield, Edwardian Gentleman*, Peter E. Randall, Portsmouth, NH, USA, 1986.
Smyth, J.G., *British Sports - Past and Present Lawn Tennis*, Batsford Ltd., London, 1953.
POLO
Armour, G.D., *Bridle and Brush*, Ashford Press Publishing, Southampton, 1986.
Dale, T.F., *Polo Past and Present*, Country Life, 1905.
Kimberley, Earl of (Ed.), *The Lonsdale Library of Sports, Games and Pastimes - Polo*, Seeley Service & Co. Ltd., London, 1936.
Millar, Delia, *Queen Victoria's Life in the Scottish Highlands depicted by her Watercolour Artists*, Philip Wilson Publishers Ltd., London, 1985. (Extract of a letter written by Queen Victoria to Sir Henry Ponsonby Fane, reproduced by the gracious permission of Her Majesty the Queen, for republication of material from the Royal Archives, which is subject to copyright.)
RACKETS AND SQUASH RACKETS
Aberdare, Lord, *The Willis Faber Book of Tennis and Rackets*, Stanley Paul & Co. Ltd., London, 1980.
Barnes, Simon, 'Why Squash Rackets will find it difficult to succeed as a television sport', *The Times*, 16.4.1987.
The Microcosm of London or London in Miniature, the Architecture by A. Pugin, the Manners and Customs by Thomas Rowlandson, 1808. *The Microcosm...* was the first of the major series of aquatint books published by Rudolph Ackermann from The Strand 1808-1816. *The Microcosm...* and its famous companion books *The History of the University of Cambridge* and *The History of the University of Oxford*, all of which were limited to 1,000 copies, were some of his most important achievements.
Noel, Susan, *More About Squash Rackets*, Hutchinson Library of Sports and Pastimes, 1948.
Noel, Susan, *The Sportswoman's Manual*, Hutchinson Library of Sports and Pastimes, 1948.
REAL TENNIS
Aberdare, Lord, *The Willis Faber Book of Tennis and Rackets*, Stanley Paul & Co. Ltd., London, 1980.
Scaino, Antonio, *Del Givoco della Palla di Messer*, originally published in three parts in Venice, 1555. Translated into English by W.W. Kershaw, pub. Strangeways Press Ltd., London, 1951.
RUGBY FOOTBALL
Marshall, Rev. F., and Tosswill, Leonard R., *Football, The Rugby Union Game*, Cassell & Co. Ltd., London, 1892, revised 1925.
Titley, Uel, and McWhirter, Ross, *Centenary History of the Rugby Football Union*, Rugby Football Union, 1970.

Index

The Antique Collectors' Club

The Antique Collectors' Club was formed in 1966 and now has a five figure membership spread throughout the world. It publishes the only independently run monthly antiques magazine *Antique Collecting* which caters for those collectors who are interested in widening their knowledge of antiques, both by greater awareness of quality and by discussion of the factors which influence the price that is likely to be asked. The Antique Collectors' Club pioneered the provision of information on prices for collectors and the magazine still leads in the provision of detailed articles on a variety of subjects.

It was in response to the enormous demand for information on "what to pay" that the price guide series was introduced in 1968 with the first edition of *The Price Guide to Antique Furniture* (completely revised, 1978), a book which broke new ground by illustrating the more common types of antique furniture, the sort that collectors could buy in shops and at auctions rather than the rare museum pieces which had previously been used (and still to a large extent are used) to make up the limited amount of illustrations in books published by commercial publishers. Many other price guides have followed, all copiously illustrated, and greatly appreciated by collectors for the valuable information they contain, quite apart from prices. The Antique Collectors' Club also publishes other books on antiques, including horology and art reference works, and a full book list is available.

Club membership, which is open to all collectors, costs £15.95 per annum. Members receive free of charge *Antique Collecting,* the Club's magazine (published every month except August), which contains well-illustrated articles dealing with the practical aspects of collecting not normally dealt with by magazines. Prices, features of value, investment potential, fakes and forgeries are all given prominence in the magazine.

Among other facilities available to members are private buying and selling facilities, the longest list of "For Sales" of any antiques magazine, an annual ceramics conference and the opportunity to meet other collectors at their local antique collectors' clubs. There are over eighty in Britain and more than a dozen overseas. Members may also buy the Club's publications at special pre-publication prices.

As its motto implies, the Club is an amateur organisation designed to help collectors get the most out of their hobby: it is informal and friendly and gives enormous enjoyment to all concerned.

For Collectors — By Collectors — About Collecting

The Antique Collectors' Club, 5 Church Street, Woodbridge, Suffolk

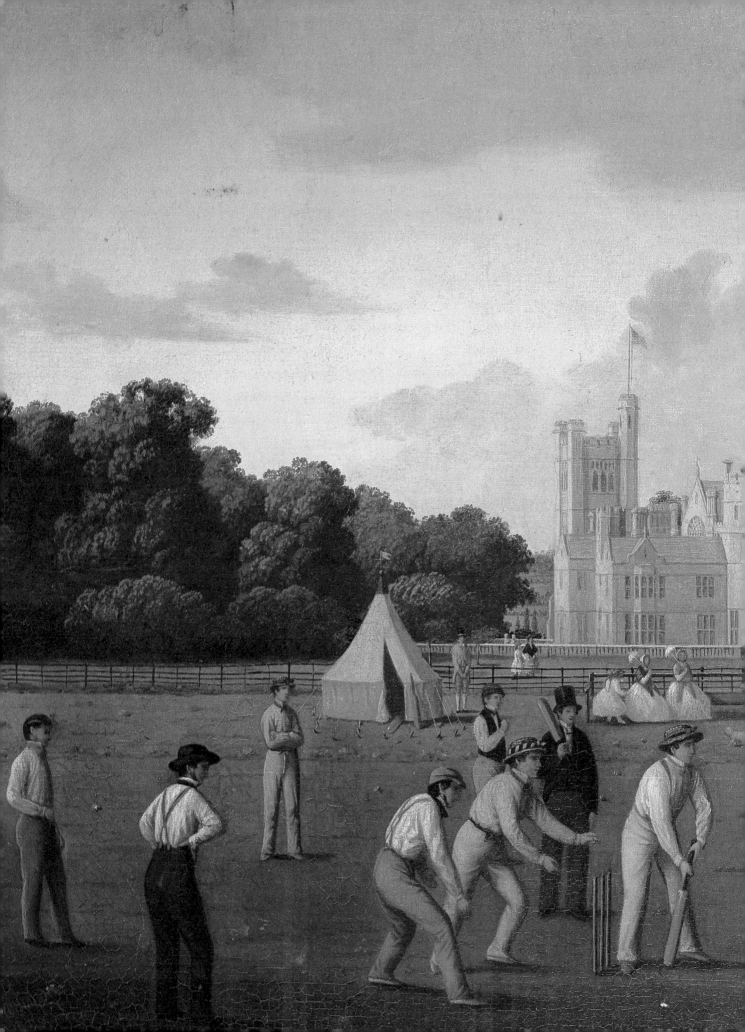